D0022548

FURNITURE
IN HISTORY
3000 B.C.–2000 A.D.

LESLIE PIÑA

Prentice
Hall

Upper Saddle River, NJ 07458

Library of Congress Cataloging-in-Publication Data

Piña, Leslie A., 1947–
 Furniture in history, 3000 B.C.–2000 A.D. / Leslie Piña.
 p. cm.
 Includes bibliographical references and index.
 ISBN 0-13-261041-8
 1. Furniture—History. I. Title: Furniture in history. II. Title.

NK2270 P56 2002
749.2--dc21 2002070431

Editor-in-Chief: Stephen Helba
Executive Assistant: Nancy Kesterson
Executive Editor: Vernon R. Anthony
Director of Manufacturing and Production: Bruce Johnson
Editorial Assistant: Ann Brunner
Managing Editor: Mary Carnis
Production Liaison: Adele M. Kupchik
Marketing Manager: Ryan DeGrote
Production Management: UG / GGS Information Services, Inc.
Production Editor: Nancy Whelan
Manufacturing Manager: Ilene Sanford
Manufacturing Buyer: Cathleen Petersen
Creative Director: Cheryl Asherman
Senior Design Coordinator: Miguel Ortiz
Printer/Binder: Courier Westford
Cover Designer: Carey Davies
Cover Photo: Phil Schaafsma, courtesy of Herman Miller, Inc.
Cover Printer: Coral Graphics

Pearson Education LTD.
Pearson Education Australia PTY, Limited
Pearson Education Singapore, Pte. Ltd
Pearson Education North Asia Ltd.
Pearson Education Canada, Ltd.
Pearson Educación de Mexico, S.A. de C.V.
Pearson Education–Japan
Pearson Education Malaysia, Pte. Ltd

10 9 8 7 6 5 4 3
ISBN 0-13-261041-8

for Ramón, Ravi, and Shirley

CONTENTS

Chapter 13
POSTWAR MODERN
Designed and Signed 290

Chapter 14
THE OFFICE
Nine to Five 333

Chapter 15
A ROUND 2000
Full Circle 364

PREFACE

\mathcal{F}urniture in History 3000 B.C.–2000 A.D. is a new approach to a very old subject. **The premise is that some time periods require closer study, and the focus is on innovation and change.** Duration of a style does not necessarily warrant duration of study. Analysis of details and variants within one style or period may not be as rewarding as the recognition of key moments and connections in the evolution of style.

The traditional periods and styles are covered first, with emphasis on accessibility—summaries, chronologies, key terms, designer contributions, reading lists, and illustrations with detailed captions in each chapter. Extensive margin notes of historical highlights and personalities place each topic in its historical context, without distracting from the focus on furniture. But this interpretation of history only begins with the standard material; it offers a fresh look at the subject of furniture by also investigating the later, modern movements and milestones.

The quickened pace, greater number of changes, and the complexity of these later periods have not yet been properly acknowledged in most histories of furniture. Yet, this recent material, some of which has only begun to unfold, is as relevant to the student of architecture and design as it is to the historian. Perhaps this change of focus, away from an emphasis on more stable early styles, will encourage others to investigate, write about, and illustrate a more recent and dynamic past as well.

The first third, Chapters 1 through 5, present the origins of the traditional styles of Western furniture, from ancient times through the eighteenth century. The next third, Chapters 6 through 10, take the reader through the nineteenth century, with its complex array of historic revivals, reform, and concurrent attempts toward modernism, into the twentieth century (changes rarely coincide with century marks). Finally, Chapters 11 through 15 explore many of the innovations and developments of the twentieth century, with photographs of modern classics, many of which are still in production. In an electronic world, where change is rapid and expected, this approach and examination of its effects on furniture in history should prove to be both timely and thought provoking. Familiarity with both traditional material plus previously overlooked modern contributions and contributors will help students and professionals make more educated choices today for better design tomorrow.

ACKNOWLEDGMENTS

Many people contributed to this project, and I would like to express my gratitude to them.
Credits:
Line drawings and some photographs are from early publications in the public domain; these are acknowledged in both captions and in the bibliography, and I am grateful to these past authors and illustrators.
Recent photographs were generously provided courtesy of various sources, especially furniture companies that have produced, and in some cases are still producing, these designs:

Arkitektura	Halcon	Memphis	Tendo
Artifort	Haworth	Palazzetti	Thonet
Baker	Herman Miller	Shaker Workshops	Vitra
Breuton	ICF	Steelcase	Zero U.S.
Cassina	Knoll	Stow Davis	
Design America	Kron		

Others were generously provided courtesy of auction houses:
Skinner, Inc., Auctioneers and Appraisers of Fine Arts, Boston and Bolton
David Rago Arts and Crafts, Lambertville, New Jersey
Treadway Galleries, Cincinnati, Ohio

Special thanks to Michael Ellison for his text on Scandinavia in Chapter 13; Nicole Guanieri for her French-English translations; Peter Schiffer of Schiffer Publishing for permission to use excerpts from books I had authored for Schiffer; to Dover Publishing for generous use of reprints; to Nadir Safai for Dunbar reprints; to the late Kay Rorimer for Rorimer photos; and to Gordon Harrell and Lorenzo Vigier for several items on the timeline.

I am grateful for the use of many libraries, especially the Ursuline College Library, OhioLink, Cleveland Public Library, the Kevin Smith Library of Case Western Reserve University, the personal libraries of Ralph and Terry Kovel and other collectors and researchers, and to the interlibrary loan system.

Thanks to Ursuline College for granting a sabbatical to work on this project; to Ramón, my better half, for constantly pushing me to do it; and to my editor Vernon Anthony and the staff at Prentice Hall for making a project into a book.

INTRODUCTION

Histories of Western culture usually begin in a past as remote as the material evidence permits. Pyramids, sun-bleached marble columns, blackened bronzes, and slip-painted pottery have yielded tidbits of information about past cultures to patient archaeologists and other scientists and historians. Yet for every gem of information uncovered, another remained secret. For every monumental ruin or royal tomb that has become as familiar as any icon of popular culture, countless undiscovered clues were silent.

These lost artifacts might have been destroyed by enemies or invaders—histories often focus on military and political conquests and events. Perhaps they were recycled—valuable materials were recarved or melted and recast to form more fashionable, or more practical, or more politically correct objects. Another possibility is that artifacts (stuff) wore out or broke from use. This least glamorous and probably most likely end for the majority of past material culture was the great historic rubbish heap and subsequent return to the earth from whence it came. Broken pots, abandoned houses, or homemade ornamental trinkets, if saved, might have answered even more questions than rare elitist items. "The sun is mirrored even in a coffee spoon." (Giedion 3). Yet, even if the common things that did not wear out held minimal value to their own makers and consumers, what chance would they have had of being preserved through the centuries?

The question then arises—if the majority of our material culture has not survived, then how can we be certain of our historical interpretations? The answer, of course, is that we cannot. Between the tall temples and the deep tombs was once the stuff of whole populations. Now that most common goods have vanished, historians have had to fill in enormous gaps with speculation based on both logic and fantasy. Material, and even written, culture has limits to what it can reveal, beyond which, later generations can only guess.

One class of items that is noticeably rare or even absent from remote classical civilizations, such as Egypt, Greece, or Rome, is furniture. Although there are a few precious ancient examples that time has preserved, most of the artistic and architectural styles are known through art forms made of more durable materials than wood. Since neither material evidence nor the written word indicate that ordinary functional furniture was particularly significant to the general populations of ancient times, it would seem sensible to acknowledge this. Even if furniture was once abundant in classical cultures, the present material evidence simply does not exist.

In our discussion of furniture, it may seem presumptuous to spend relatively little time exploring a period of more than four thousand years in the development of Western civilization. On the contrary, it is out of respect for cultures that are so rich in factual (or at least well-documented and interpreted) history so that it would be a travesty to cover them badly. And my intent is not to invent history, but to report from what is presently knowable. In other words, there is simply not enough early furniture to look at. It becomes a quantitative, and not necessarily a qualitative, issue. That leaves less than 500 years in which to focus the story. In addition, the non-Western world, or everywhere outside of Western Europe and the English colonies, recently called the United States, will also be largely excluded. Except for stylistic borrowing and curious imitations of sophisticated oriental and Islamic art, this discussion will exclude about as great a chunk of the populated land mass as it will of recorded history.

So the title *Furniture in History* must be qualified in both time and space. The focus of this history will be from about 1500 A.D. to the present, and the geographic focus will be on Western Europe, England, and its offspring, the United States. Even these relatively

narrow parameters indicate breadth that is far more ambitious than one text should attempt to cover. What I do hope to introduce is a sample of significant changes along with the individuals responsible for these innovations and fashions. I will not stretch more words and pictures onto styles of longer duration. On the contrary, if a style was conservative and changed little over time, there will be proportionately less to say and to show. On the other hand, if during a period of a few years there were numerous complex design issues, then more needs to be said about them.

Faster pace, greater number of changes, and relatively more complex time periods require more explanation and illustration. This is the premise that I am operating on—*innovation and change rather than duration and stability will determine the amount of coverage presented*. Practically speaking, for design students using this book, Jacobean is Jacobean, but nuances of Modernism in the twentieth century may each be distinct and significant. Whether a change occurred over a span of one hundred years or one hundred days is not at issue. What we will be looking at are a series of complex events dependent upon technology, materials, fashion, aesthetics, societal context, and human needs. These events, new furniture styles, will necessarily depend upon other events, or styles, from the past or other geographic areas.

Design influences are often easy to identify but difficult to prove. Besides the obvious borrowing that designers necessarily do, there is always the possibility that more than one designer came up with the same idea. After all, each benefited from similar abilities, views of nature, exposure to other designs, and goals. When one considers the possibilities, it is not surprising that there is so much variety throughout the history of furniture, but so little.

But the human form has remained about the same, and there has always been a need to sit and to recline. How comfortably, how ergonomically we have sat, has depended on design, and to a lesser extent, on materials. Upholstery was the first major historical change, especially by the eighteenth century. Technology and totally new materials has been the next major (ongoing) change, previewed in the early twentieth century and developed significantly by mid-century.

The pace quickened. Wood, the historic material of choice for the great majority of all furniture, has been replaced by other materials for a good deal of nonresidential furniture, as well as an increasing number of modern residential items. Yet function, practicality, and change are not universal priorities, and large segments of the population and many manufacturers continue to choose traditional styles made of traditional materials. At the opening of a new millennium, it is all available—from the authentic antique, to a range of good and bad reproductions and adaptations, to the most high-tech and innovative modern forms. It is important for design students to understand the similarities, the differences, and the reasons. Familiarity with furniture in history will help them to make better choices today for better design tomorrow.

Chapter *1*

ANCIENT AND CLASSICAL

It's All Greek to Me

CHAPTER CONTENTS

In addition to architectural principles and styles, the origins of many furniture forms date back to ancient Egypt and especially to classical Greece and Rome.

*T*he earliest years from which anything is known about furniture can be very roughly (or neatly, depending on one's point of view) divided into two periods and labeled (1) ancient, from about 3000 B.C. to slightly later than 500 B.C., and (2) classical, beginning about 500 B.C. and ending (depending on one's point of view) either about 300 B.C. or 500 A.D. around the "fall" of Rome.

It would be logical to expect that the later the period and the closer it is to the present, the more reliable, or at least the more abundant the historical evidence. Now any number of cultural biases can affect this evidence, whether it is in words, pictures, or things. One should always be a bit suspicious, for example, of political histories recorded by the victors or by the lack of documentation about an embarrassing event that a government might wish to forget. War and death have never been glamorous, but codes of chivalry and honor may once have been given good press to make battle appear more sporting. Those in power needed to do whatever was necessary to keep armies recruiting and the people rooting for their side. Life was difficult enough without risking death for someone else's cause. Examples of all kinds of similarly motivated cultural-historical biases probably occur daily and are selectively reported by the modern media. So it might be reasonable to assume (although rarely wise to assume anything without being prepared for surprises) that governing bodies, religious institutions, and crafty individuals in the past also had a very heavy editorial hand on the histories that have survived to the present. They have also influenced the preservation or destruction of material objects that reveal their own bits of the past.

With the advantage of time to distance any historical event, even a fragmented picture can come into better focus. When the participants have stopped moving and the dust has settled, the context will have become more apparent, and the connections will be more visible. Unfortunately for historians, all historic pictures have damaged and missing pieces. The challenge is to make the best conclusions, based both on what is there and what is not. We must therefore view any historical information or any piece of material culture carefully and with an open mind. Absolutely everything presented in the following pages, or any other pages, should be taken as an interpretation based on existing evidence that is subject to change when a better interpretation or additional evidence comes along.

With this in mind, one might assume that the length of time passed is inversely proportionate to the quantity and perhaps quality of evidence at hand. In other words, the more remote the historical time, the less existing evidence will be available. This seems logical, and in the case of the ancient world, it is mostly true. In ancient Mesopotamia, for example, people may have used furniture as early as the third millennium B.C., but unfortunately none is known to have survived. In ancient Sumeria, the climate was just humid enough to ruin rather than preserve material goods. In addition, the tombs that might have preserved pieces of furniture often disappeared along with their contents. The ancient Near East of Asia Minor, Syria, Palestine, and Persia was politically fragmented and usually at war. Whatever furniture the people had is only suggested in other art forms; pictures carved on stone seals and sculpture are all that remain.

EGYPT

Egypt, however, had a very dry climate plus a culture preoccupied with death, afterlife, and preservation. The belief that they *could* take it with them motivated an enormous expenditure of resources for mummification of bodies and accompanying goods for the next life. With both the physical environment and philosophical system unchanged over a great span of time, the unbelievable occurred, the assumption that time is the enemy of material goods did not hold true, and wooden furniture survived for thousands of years. Consequently, several hundred pieces of rather wonderful wooden Egyptian furniture three and four thousand years old can be seen and studied in museums.

3500–3000 B.C.
Linen cloth is used to make clothing in the Middle East; Sumerians begin writing and use carts with wheels; the potter's wheel is used in Mesopotamia; Egyptians use manure to grow crops and papyrus to write on.

3100 B.C.
Menes becomes the first ruler to unite Egypt.

3000–2500 B.C.
Oil-burning lamps and metal coins in Sumer; weaving looms, glass beads, 365-day calender, domesticated dogs, and Great Sphinx in Egypt; astronomy in Egypt, Babylonia, India, and China.

2580 B.C.
Egyptian King Khufu (Cheops) begins construction of the Great Pyramid at Giza using more than two million blocks of stone averaging about two and one-half tons each.

2500–2400 B.C.
Yak domesticated in Tibet, cat in Egypt; yams grown in Western Africa, peanuts in tropical America.

2300–2200 B.C.
Pottery in Central America.

2200–2100 B.C.
Eighty stones at
Stonehenge, England.

2000–1500 B.C.
Irrigation using Nile River
flooding in Egypt;
toothpaste in Egypt; glass
vessels in Egypt and
Mesopotamia; marble dam
built in India; decimal
system in Crete, Hittite
cuneiform inscription, and
Semitic alphabet; Bronze
Age in Western Europe;
guinea pig in Peru; alfalfa in
Iran.

1750–1700 B.C.
Code of Hammurabi, first
known set of written laws.

1500–1000 B.C.
Moses receives Ten
Commandments on Mount
Sinai; Tutankhamen
entombed; Sun Pyramid at
Teotihuacán, Mexico;
domesticated dog in North
America; soybean in
Manchuria; silk, beer, and
bronze bells in China.

1000–900 B.C.
Greeks use iron, build
Temple of Hera in Olympia;
King David and his son
Solomon rule Judah and
Israel.

Furniture Forms

Examples of refined and sophisticated ivory carving date a bit earlier than 3000 B.C. The Old Kingdom saw a high degree of skill—carved wood panels, relief decoration, carved doors, and statues. By the Middle Kingdom, large cedar coffins and ebony and ivory caskets were made. Ivory furniture supports—legs in the form of bulls and lions—were found in tombs along with wooden beds with woven covers. Remarkable use of materials and technologies occurred long before the time of Tutankhamen about 1350 B.C.

Seating

The stool was a common form for seating and ceremonial use. In the earliest periods, people sat on blocks of stone or timber trunks. An early three-legged stool was actually cut from stone, but the earliest wooden stools, which were cut from a single block, rarely survived. Only the most elaborate furniture was placed in the tombs, which explains why the common and cruder items quickly disappeared.

Early wooden stools employed mortise and tenon joinery and leather webbing. Many had animal legs, especially in the form of cats or dogs, in either three- or four-legged versions. The folding stool used an X-design—diagonal crosspieces on a pivot—connecting the seat to floor-level stretchers, or runners. This minimalist design provided efficient seating, portability, and stability—so much so that it represents one of the earliest furniture designs that is still in use today.

During the New Kingdom, the most popular stool was the lattice stool with four straight legs mortised and tenoned to the seat rails, stretchers, and lattices—vertical and diagonal struts—between the stretchers and seat rails. The curved seat surface was usually woven using reeds or rushes.

Other forms of stools include a round-legged version that brings up issues about manufacturing methods. Were the round legs made on a type of lathe or were they carved from a block of wood? A low stool, used more as a royal footrest than for seating, could be decorated by one of many sophisticated techniques perfected by the Egyptians. The quality and quantity of decoration was used to indicate status, and these stools were used to elevate royal feet and for ceremonial purposes.

An outgrowth of the stool was, not surprisingly, the chair, which developed during the Second Dynasty. The Early Dynastic period, even earlier in the third millennium B.C (3100–2686 B.C.), had stools and a high-back chair as a symbol of rank. A high-back chair with animal legs was used in the Old Kingdom (2686–2181 B.C.); by the Middle Kingdom, the chair could be seen with animal legs; and by the time of the New Kingdom, the open back was a popular form. By about 1500 B.C., chairs were already in use at lower levels of society. First made as stools with straight backs attached to them, they evolved into a more comfortable form with a slightly inclined back supported by struts.

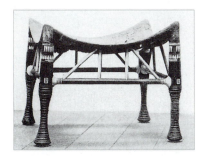

Egyptian lattice stool with curved seat.
(Schmitz)

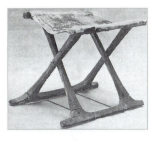

Egyptian folding stool with
leather seat. *(Hunter)*

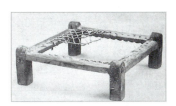

Egyptian low stool, frame
perforated for woven seat, circa
1500 B.C. *(Hunter)*

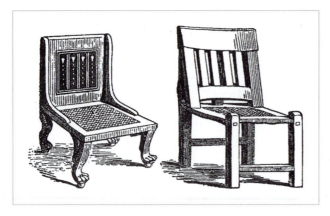

Egyptian chairs: one with animal feet, the other with plain legs. *(Birch)*

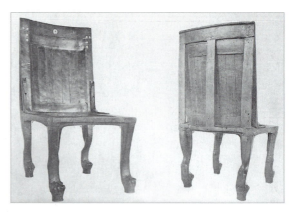

Egyptian wood chairs with inlay of bone and ebony, circa 1500 B.C. *(Hunter)*

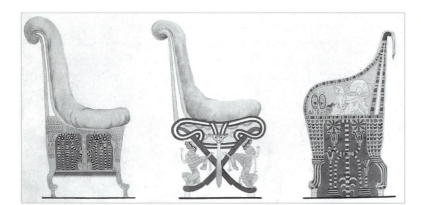

Rendering of Egyptian high-back chairs. *(Hunter)*

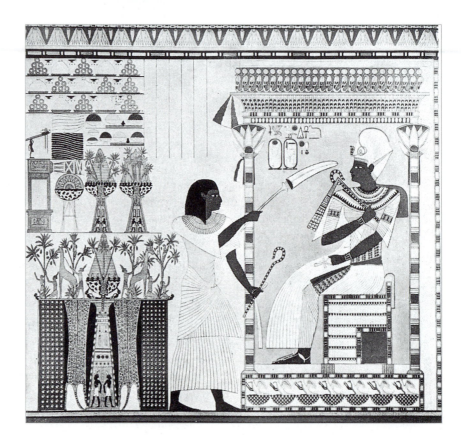

Egyptian mural depicting Tutankhamen on low-back throne. *(Hunter)*

Tables and Beds

Tables resembled stools in form, with either three or four legs supporting a horizontal top. As they are represented in relief sculpture and paintings, tables were used for dining, work, display, and placing religious offerings. Food was shown placed on tables, but it is not known whether people actually sat at them to dine. Tables were most often shown as rectangular with splayed legs connected by stretchers. Specialized items, such as vase stands, were also used. These small tablelike forms could be low or tall and narrow, like the later plant stand. Some had splayed legs and an upper railing to prevent the vase from slipping.

Another form of furniture resembling both the table and the stool was the bed because it too was essentially comprised of four legs and a horizontal surface. The surface was more complex, however, with side rails, a frame, and an optional head and/or footboard. The side rails were commonly supported by short animal legs. Then, regularly spaced slots drilled in the frame enabled woven leather strips to be secured. An alternative was to wrap the frame with linen cord or reed.

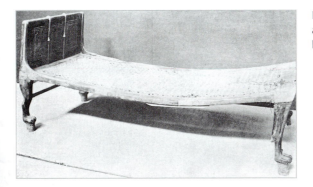

Egyptian bed with lion legs pointing away from the head- and footboards, circa 1400 B.C. *(Hunter)*

Storage

Storage furniture consisted of boxes or modified boxes. Chests were really boxes with legs, used as containers for clothing and household objects. Generally, boxes came with or without legs, with lids that opened, and with a wide range of decorating options. The tops were either flat, gabled like a miniature roof, or rounded with an **arch** rather than a pointed gable. They may have used frame and panel construction as early as the First Dynasty, but the method did not become widely used until the Sixth. Many boxes were equipped with carrying handles. These enabled large heavy items to be carried by several men.

In addition to the sophisticated construction of many of these boxes, the decorating techniques were impressive. **Inlay** or surface application of ivory or exotic woods, carving, painting, hieroglyphics, and gold **gilding** were used to embellish both large and small boxes. Small specialized containers, such as toilet boxes, were made in the Middle Kingdom with built-in slots to hold eight vases. They were often veneered and then polished to a high finish. By the New Kingdom, boxes were made to hold wigs, toiletry articles, and jewelry. They could be made from reed stems, with sliding lids, and might be coated with gesso to receive a painted faux finish of wood grain or ivory.

Materials

Wood has always been the material of choice for making furniture. Unfortunately, ancient Egypt had few native species of timber suitable for making furniture, and many of the woods they used had to be imported from Mediterranean countries, western Asia, and parts of Africa. Metal (copper) tools were used by the late predynastic period. The art of woodworking was probably learned in Egypt and created a demand for more wood. In addition to imported timber, they undoubtedly also acquired more knowledge about its use from

Egyptian boxes with gable lid and legs. *(Birch)*

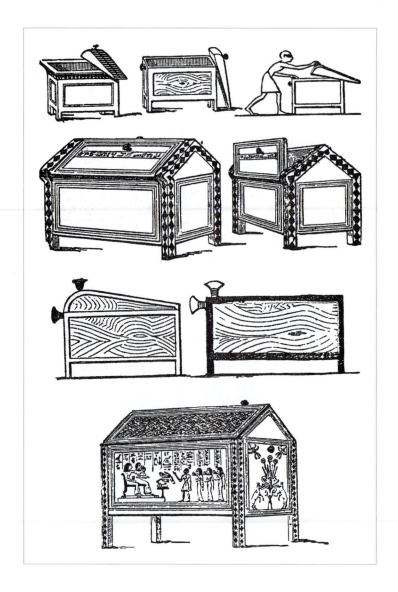

460–377 B.C.
Hippocrates, father of medicine.

Fifth Century B.C.
Halloween celebrated in Ireland.

450–400 B.C.
Carrier pigeons in Greece; slaves outnumber citizens by two to one in Athens under Pericles (ruled 443–428); Spartans use charcoal, sulfur, and pitch for chemical warfare.

people more accustomed to living with and using wood. By about 2700 B.C., large-scale importation was in effect.

The most widely used indigenous wood was acacia. Other native wood, such as date palm and dom palm, were less desirable for furniture making. Important imported timbers were ebony from the Sudan and cedar from Lebanon and Syria. Among the many other imports were ash, beech, boxwood, carobwood, cypress, elm, fir, hornbeam, juniper, lime, maple, oak, a strong black wood called persea, pine, plum, sidder, sycamore, and yew. Some woods were only used sparingly, such as boxwood, which was mainly for inlay.

With a climate that acted like a natural kiln, once properly dried, the wood remained stable as long as it remained there.

Methods

Crafting techniques were as impressive as the variety of woods used to make the royal furniture. Timber was rarely large enough to use straight planks, so the Egyptians developed various methods of "patchwork construction." Joints to connect smaller pieces included the butt, flat tongues or **dowels**, pegging, scarf joints, and tongue and groove. Dowels were known, possibly as early as the First Dynasty, about 3000 B.C., and mitered joints—simple miter, shoulder miter, double shoulder miter—were found from the Third Dynasty a

few hundred years later. The **dovetail** and mortise and tenon joints were used slightly later in the Fourth Dynasty. A simple early method called lashing was also common. Here, thongs of hide, leather, narrow copper bands, or linen string are used to tie parts together. In addition to tying and joining techniques, nails were used to attach metal to wood, and they were later applied to woodworking. Metal was also made into hinges and locks for furniture forms, especially boxes.

In addition to using solid and pieced planks and bending solid wood, the ancient Egyptians either invented or learned many construction and decorating techniques usually attributed to a much later date. A form of plywood, in which thin sheets of veneer were stacked, was known by the Third Dynasty. Veneering, especially covering the carcass with panels of ebony or ivory, was a popular decorating method. A related technique, marquetry, was used to cover a piece with a design made from contrasting colors of veneer pieces. Inlay of precious woods as well as ivory, faience, colored glass, and semiprecious stones was another important technique.

Other surface decoration included low-relief carving, gilding with silver and gold, and painting over gesso. Finishes of both clear and black varnish were also used. Even upholstery, something thought of as a rather latecomer in the development of furniture, was known in Egypt, and chair cushions were made with linen, flax, and leather.

Because the most elaborate furniture was made for the highest level of society, in both this life and the next, decorative motifs included symbolic meaning. The sun disc, or winged sun, ankh, and later the sphinx were religious and mythological symbols. Indigenous animals and plants—scarab, serpent, vulture, palmette and palm, papyrus, and lotus—were used both for their familiarity and symbolism.

Ordinary Egyptians probably did not enjoy furniture other than a stool or two and perhaps a crude table or chest. Peasants, not to mention a significant slave population, undoubtedly sat or squatted on the floor (ground) or may have used a mud bench covered with a woven mat. Upper-class Egyptians may have used furniture similar to that found in tombs; naturally it was less ornate and more utilitarian than pieces made with unlimited budgets for an infinite afterlife.

The most popular items of ancient Egyptian furniture were tables and stools, which like the architecture were based on the concept of post and lintel. Vertical support members—columns on buildings or legs on tables and stools—usually ended in decorative terminals in the form of a papyrus flower, lotus bud, or palm. Horizontal members—lintels in architecture and the framing elements of tables and stools—supported roofs, seats, and tabletops. This fundamental form provided the basis for the evolution of architecture and furniture design. Ancient and classical Greece, the next major stepping stone toward the emergence of modern Western civilization, took this basic post and lintel idea and added new technologies and new sets of design standards and regulations.

GREECE

Material evidence in ancient Greece is sparse before about the sixth or seventh centuries B.C. Sculpture, relief carving, and pottery vase paintings provide information about furniture that has long been lost. Much of what we think we know about classical furniture, as well as architecture, has been brought to us in the way of revivals and recent interpretations. After the rediscovery of the ruins of Pompeii and Herculaneum in the mid-eighteenth century, designers reinvented classical motifs and forms. Many residences in the United States looked like little Greek temples made of wood; banks and government buildings could afford to use stone and continued the fashion well into the twentieth century. Even Christian churches looked like Greek temples, and not without irony. Pattern books by Thomas Hope or Percier and Fontaine presented "classical" furniture that was as remote from classical Greece as the contemporary architecture.

280 B.C.
First lighthouse, at
Alexandria, light seen for
over thirty miles.

In 1933, British interior designer Terrance Harold (T. H.) Robsjohn-Gibbings saw a small bronze **klismos** chair. He became so inspired by the classical Greek form that he began an undertaking that helped to reintroduce a form of furniture that was seemingly lost. He studied thousands of Greek painted vases, made drawings of the furniture, and then opened an office on Madison Avenue in New York City in 1936 to introduce contemporary furniture and interiors based on classical Greek models.

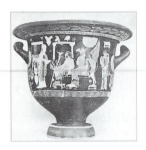

Grecian vase showing sofa with tapestry pillows and footstools, circa fifth century B.C. *(Hunter)*

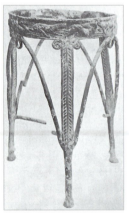

Grecian bronze table with volutes above the legs and animals cast around the seat. *(Hunter)*

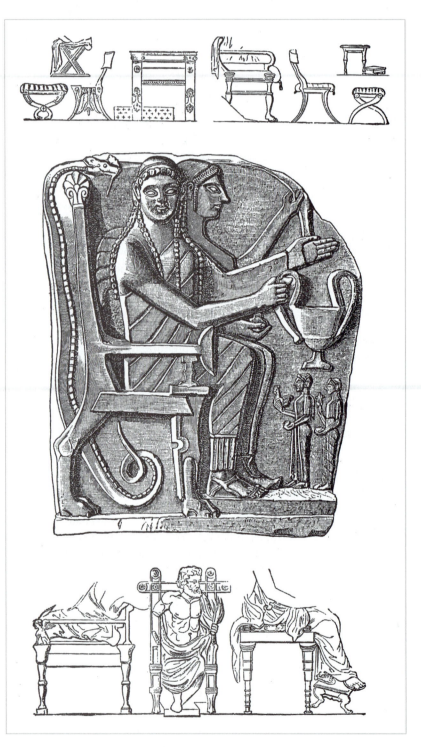

Grecian seating furniture: stools, *klismos* chair, and high-back chair with animal feet.
(Litchfield)

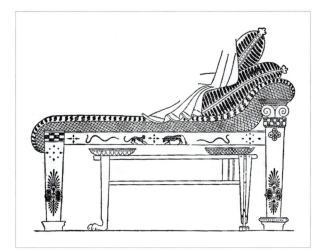

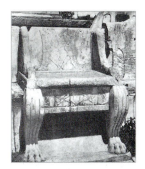

Marble chair, Athens. *(Hunter)*

Grecian table under couch with cushion and pillows. *(Litchfield)*

259–210 B.C.
Shih Huang-ti: political, military, and commercial unification of China, standardized written language.

215 B.C.
Great Wall of China built 1,400 miles long to keep out invaders.

213 B.C.
Shih Huang-ti orders all Chinese books burned to eliminate rival philosophies.

146 B.C.
Greece ruled by Romans.

First Century B.C.
Glass blowing in Syria, prototype of steam engine.

100–44 B.C.
Julius Caesar, military dictator and conqueror of Gaul (large portion of Western Europe).

63 B.C.–14 A.D.
Augustus Caesar, founder of Roman Empire.

6 B.C.–30 A.D.
Jesus Christ, founder of Christianity.

Furniture Forms

Originally from western Asia and Egypt via Crete and the Cyclades, elements of style were transmitted to Greece by the ninth century B.C. A highly developed style was found on art forms by the sixth century B.C., and seven basic forms of furniture were identified: throne-like chairs (*thronos*), stools, couches, footstools, tables, chests, and the *klismos* chair. These forms predominated during the classical period in Greece of the fourth and fifth centuries B.C.

The *thronos* was depicted in pictorial art forms as the seat of gods, goddesses, and royalty. A lofty seat, it was depicted with a footstool and was among the most elaborate of all Greek furniture forms. It often borrowed from Egyptian models, using animal feet and motifs such as a winged animal or sphinx.

At the opposite extreme, the most characteristically Greek furniture form was the *klismos* chair. Perfected by the fifth century B.C., the *klismos* remained popular for at least a century. Characterized by simplicity and elegant curved lines, especially the splayed legs, the *klismos* was one of the first forms to be reintroduced in the late eighteenth and nineteenth centuries.

The stool, or *diphros*, was the most democratic furniture form because it was used by Greeks of all stations. Borrowed from the Egyptians, the most common form of Greek stool used four turned legs, sometimes joined by stretchers, supporting a rectangular seat. A variation was the folding stool, or *okladias*, which resembled the modern camp stool. Although it appeared to fold, like its Egyptian prototype, the Greek version is only known in pictures. It is likely, however, that the Greek folding stool did actually fold.

Couches, or *klines*, were multipurpose furniture forms. They were used for reclining, for eating in a reclined position, and for sleeping. A relatively tall piece of furniture, the couch required a footstool. Four short legs, sometimes with lion's paw feet, supported a rectangular top. The stool, also used as a footrest with the throne chair, was sometimes replaced by pillows to assist with reaching the couch.

Tables were generally used for serving meals, and small individual tables could be placed at couches. They were tall enough to allow the diner to recline and reach the food, while being low enough to slide under the couch for storage. Even though the four-legged table was more popular in Egypt, the Greeks generally preferred the three-legged version. Both rectangular and circular tops were known, but the later circular version eventually replaced the rectangular.

Chests, like other Greek furniture forms, evolved from Egyptian models. The Greeks, however, usually preferred the flat top over earlier rounded or gabled alternatives. The feet were rectangular and might end in lion's paw feet.

51–100 A.D.
Nero, persecutor of the Christians.

54 A.D.
Claudius I, emperor of Rome, choked to death on a feather placed in his throat by his physician to induce vomiting after his wife served him poisonous mushrooms.

79 A.D.
Mt. Vesuvius erupts, buries Pompeii and Herculaneum.

105 A.D.
Chinese Ts'ai Lun invents paper.

Circa 150 A.D.
More than 1,000 spectators were killed when the wooden upper tiers of Rome's Circus Maximus collapsed during gladiatorial games.

200 A.D.
Chinese invent porcelain, and the whippletree, enabling two oxen to pull one cart.

Circa 250 A.D.
Chinese invent gunpowder.

280–337 A.D.
Constantine, first Christian emperor of Rome.

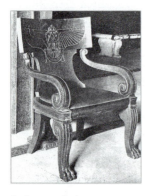

Early twentieth-century revival chair based on Athenian model. *(Hunter)*

Typical houses of the time were made of adobe brick, and were two stories with a central court, with spacious and well-lit interiors. Floors were of pebble mosaic, and tile bathrooms had drainage, terra-cotta tubs, washbasins, and latrines. Furniture was made from woods such as maple, olive, box, cedar, and oak. It was inlaid with precious metals or ivory, finished with wax, or painted bright colors. Seats of chairs, stools, and couches were of leather or fiber thongs stretched across the frame and covered by embroidered linen or wool mattresses. Embroidered cloth or animal skin was sometimes used under an embroidered cushion.

Many of the basic forms of furniture in the Western world had already been developed and used in classical Greece. Like the conservative approach of ancient Egyptians, the Greeks were less interested in change than in ideals. Materials and sophisticated crafting techniques were used for the perfection of a limited number of forms based on needs and cultural values.

REVIVALS

When the Renaissance artisans looked to ancient Grecian and Roman designs, the Greek ideals were often overlooked. Perfection of a limited number of simple forms was not necessarily a Renaissance value. Put very simply, Romans absorbed and altered Greek arts, and these Roman versions were further interpreted during the Renaissance. Greek principles would be stretched even further, when Greek architectural motifs unrelated to Greek furniture were imposed on eighteenth-century furniture forms. Greek furniture was misinterpreted by wealthy Europeans who required elaborate decoration but lacked information or scholarly research. The Greek revival was based on the rediscovery of a misunderstood ancient Greece. As Robsjohn-Gibbings wrote: "Fired by dreams of classical antiquity, English lords in lumbering coaches trailed by galloping retinues of valets, chefs, and architects, headed for Italy and Greece to study, document, and loot the defenseless past. . . . In the neo-Greek salons of Robert Adam, the Empire boudoirs of Empress Josephine and Madame Récamier was furniture with hazy reference to Greece but no Greek furniture." Just as Hollywood films portraying historical settings can be dated by their use of subtle or obvious overlays of contemporary fashion, so the eighteenth- and nineteenth-century interpretations of ancient furniture reveal as much about these later centuries as they do about ancient Greece.

ROME

Furniture from ancient Rome, like Greece, rarely survived. Other than stone or bronze examples, evidence of wood furniture comes primarily from pictorial evidence, such as relief sculpture on stone sarcophagi or fresco paintings. Roman interpretations of pure Greek forms had their own distinct identity. Where the Greeks sought perfection, the Romans preferred splendor and pomp. Instead of purity and simplicity, Romans opted for ornateness and complexity. Rather than discover new art forms, the Romans took over the discoveries of the Greeks.

As architect Louis Hellman aptly put it: "The Romans perfected the art of the take-over. First they took over the Etruscans, then they took over Italy, and finally they took over the whole world—or what they thought was the whole world—Europe, Asia Minor, North Africa. . . . Like movie moguls they took over Greek ideas and inflated them into big vulgar productions for the benefit of the state. Colonizing became conquering, administration became bureaucracy, an architecture became engineering. Where the separate Greek states imposed their order locally, Roman imperialism steamrollered over whole countries. . . ."

Furniture Forms

Greek design concepts employed by the Romans were often used in unusual ways, such as the application of classical orders onto the outside of the Colosseum. Most Roman furniture was comparable, in that it was based on Greek design, but changed according to

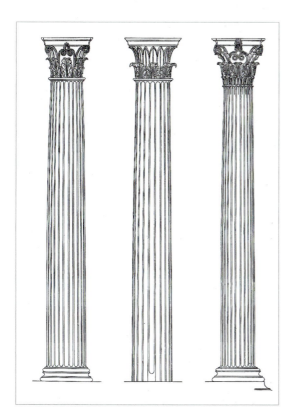

Greek Corinthian columns with **acanthus** leaf ornament.
(American School of Correspondence, 1906)

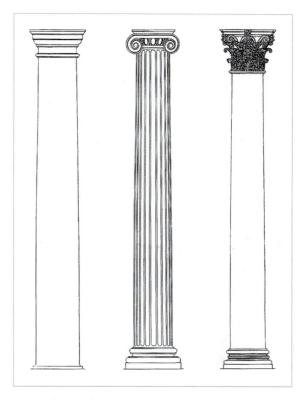

Roman classic columns. *(American School of Correspondence, 1906)*

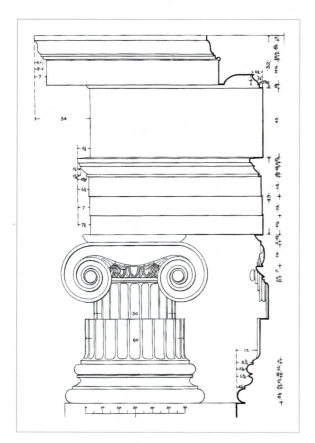

Greek Ionic order. *(American School of Correspondence, 1906)*

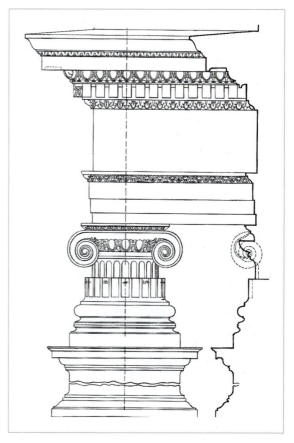

Roman Ironic order. *(American School of Correspondence, 1906)*

313 A.D.
Emperor Constantine I issues Edict of Milan.

330 A.D.
Constantine founds Constantinople.

337 A.D.
Christmas celebrated in Rome.

354–430 A.D.
St. Augustine, last important Christian theologian before Dark Ages.

Circa 400 A.D.
Chinese invent the umbrella.

410 A.D.
Visigoths sack Rome.

453 A.D.
Atilla the Hun dies.

455 A.D.
Vandals sack Rome.

476 A.D.
End of Roman Empire.

483–565 A.D.
Justinian I codifies Roman law.

Roman ideas. The Romans used a number of woods, especially maple, willow, beech, citron, cedar, oak, juniper, fir, holly, and lime. More costly woods, such as ebony, were used for making veneer and in inlay. In addition to exotic woods, materials such as tortoise shell, ivory, gold, and silver were used to make lavish inlay. Faux finishes, in which the appearance of richly grained woods was achieved with paint, were also popular. The difference between the Roman and Egyptian use of lavish materials and ostentatious display was that the Romans intended it for the living, and not for a belief in an afterlife.

Like the Greeks, Romans used a throne chair with animal feet and/or legs or other decoration like turning. A variant of the form was more of a tub chair with back and sides as a continuous unit. This served as the inspiration for a later classical revival tub chair. In fact, both Renaissance and eighteenth-century neoclassical furniture usually follows Roman models more than Greek.

The folding stool with distinctive X-form was often made of bronze, which had a better chance of survival than the wood versions. It might also have an additional low back, a Roman innovation. Similarly, the Grecian couch also had an alternative version with an added back. The couch, or *lectus*, was a popular Roman furniture form, especially with turned legs. By the end of the first century B.C., the Roman couch gained both a higher head and footboard and a back. In this instance, the Romans achieved quite a new form, compared to the couch designed by the Greeks.

An even more significant Roman contribution to furniture design is the table or *mensae*. Besides changing straight legs to curves and adding a variety of decorative features, Roman tables became more varied in their forms. One new form was a round or oblong top mounted on a central support. Another was a massive table supported on solid ends with elaborate shapes and ornament, sometimes in the form of a winged mythological character. This ostentatious innovation was later adopted for a popular model of the Renaissance. Another Roman table, like an elaborate tripod, was often in bronze. When surviving examples were uncovered in the eighteenth century, they became a favorite with furniture designers of the period. Other Roman furniture forms, like the chest or *arca*, were similar to Egyptian or Greek versions. However, a movable cupboard or *armarium* was a Roman innovation that became a model for the modern cupboard and bookcase.

After a period of political instability and cultural decline, Egypt was conquered by Alexander the Great in 332 B.C. When the Roman Empire absorbed Greek art and culture and ruled Greece in 146 B.C., it held the fate of Western civilization. Then, with the decline and fall of Rome in 476 A.D., followed by loss of the Latin language, and the end of the classical era, Western civilization was left to reinvent itself over the long period known as the Dark Ages.

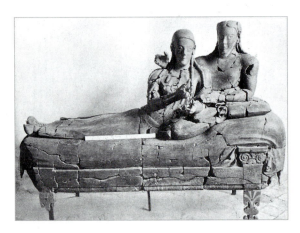

Etruscan terra-cotta sarcophagus. *(Ransom)*

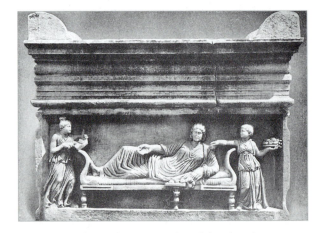

Roman sarcophagus showing couch with head- and footboards. *(Ransom)*

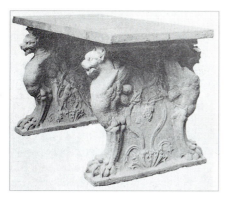

Roman marble bench, near Pompeii. *(Hunter)*

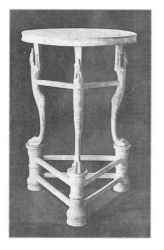

Roman three-legged table with circular top, with animal body for upper portion of legs. *(Hunter)*

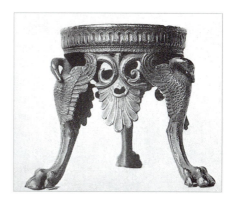

Roman three-legged table, bronze with elaborate animal legs and feet. *(Schmitz)*

Roman interior with *klismos* chair, cupboard, and tables. *(Litchfield)*

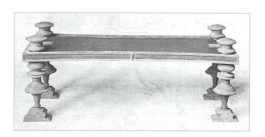

Roman couch, bronze. *(Hunter)*

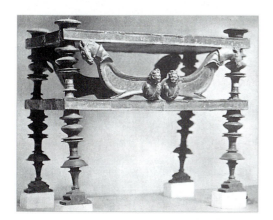

Roman couch restored as a seat, bronze. *(Ransom)*

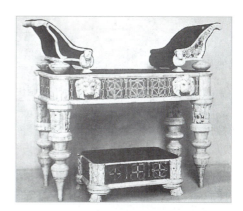

Roman couch restored as a seat, with stool. *(Hunter)*

Summary

- Ancient Egyptian burial practices have enabled the preservation of some of the finest examples of furniture.
- Egyptian items are sophisticated in design, crafting technology, and use of materials.
- Only the highest level of society enjoyed elaborate furniture, and most Egyptians had, at most, a few simple items.
- Classical Greek furniture did not survive, but instead comes to us primarily in the form of pottery vase paintings.
- Although the actual furniture has not survived, classical Greek and Roman styles inspired widespread revivals in the Renaissance and later.

Chronology

Egypt

3100–2686 B.C.	Early Dynastic Period: First and Second Dynasty.
2686–2181 B.C.	Old Kingdom: Third–Sixth Dynasty.
2200–2100 B.C.	First Intermediate Period.
2133–1633 B.C.	Middle Kingdom: Eleventh–Thirteenth Dynasty.
1674–1567 B.C.	Second Intermediate Period: Fifteenth–Seventeenth Dynasty.
1567–1085 B.C.	New Kingdom: Eighteenth–Twentieth Dynasty.

Greece

3000–1100 B.C.	Helladic Periods.
1100–700 B.C.	Dark Ages.
700–500 B.C.	Archaic Period.
500–300 B.C.	Classical Period.

Rome

753 B.C.	Rome is founded.
146 B.C.	Rome rules Greece.
330 A.D.	Constantine founds Constantinople.
476 A.D.	Fall of Roman Empire.

Key Terms

acanthus	dowel	inlay
arch	gilding	*klismos*
dovetail		

Recommended Reading

Baker, Hollis S. *Furniture in the Ancient World, Origins and Evolution 3100–475 B.C.* London: The Connoisseur, 1966.

Killen, Geoffrey. *Ancient Egyptian Furniture I 4000–1300 B.C.* Warminster, England: Aris & Phillips, 1980.

———. *Ancient Egyptian Furniture: Boxes, Chests and Footstools.* Warminster, England: Aris & Phillips, 1994.

Chapter 2

MIDDLE AGES:
Pull Up a Chair and Sit on the Floor

CHAPTER CONTENTS

Ceremonial furniture was enjoyed by the church and monarchy; feudal lords had sparsely furnished multiple houses; the peasants had little or no furniture.

CHESTS

BEDS

SEATING

CASE PIECES

TABLES

WHY WASN'T THERE MORE
FURNITURE IN THE MIDDLE AGES?

REGIONAL DIFFERENCES

edieval Europeans had little furniture regardless of their rank, wealth, or lack of both. There were neither opportunities nor reasons to accumulate furniture as a possession or as interior furnishings. The focus of the medieval house was a main (often the only) room called a hall (from the Latin *aula*). This great, or not so great, room was a combination living room, dining room, bedroom, and sometimes a kitchen with an open hearth in the center. In such a multipurpose room, floor space was more important than furniture. In order to maximize the use of this space, the few pieces of furniture were also multipurpose. Benches could be used as beds; beds were used as seats or writing tables; chests doubled as seats; and seats could be modified to serve as chests. After all, this rather undifferentiated furniture was essentially either a platform or a box. The concept of single-function furniture and specialized rooms in which to house it is a relatively modern idea.

In addition to the human inhabitants, animals were often found in the house, and animals required even more space than furniture. Even the wealthy homeowner had few rooms and few furnishings. Instead of building large houses and accumulating wealth in the form of possessions like furniture, the well-off medieval citizen used his discretionary wealth for charitable and religious purposes, to bribe officials, and to hire and support large armies. Feudal society with its system of land ownership required that the wealthy travel frequently, and since they needed shelter and security, they kept multiple dwellings. Rather than leave portable and vulnerable material possessions unattended in any one house, they found it practical to invest in multiple houses and leave them all sparsely furnished.

The only sedentary and wealthy segment of medieval society was usually the clergy in monasteries or in cathedrals. In fact, not unlike royalty, many clerics lived with the finest of material items. Naturally, the furniture was in appropriately ecclesiastical style, and the form and decoration were consistent with the religious architecture. Religion was closely integrated into secular life, and large homes often had their own private chapels complete with "church furniture." The wealthy often chose to add sumptuous ecclesiastical ornament to utilitarian pieces in other parts of the house. The poor, of course, had no choice and therefore no furniture.

486
Franks invade Gaul.

493
St. Patrick's Day celebrated in Ireland.

523
Pope Hormisdas leaves office and is succeeded by his son Pope Silverius until 537.

568
Lombards invade Italy.

570–632
Mohammad, founder of Islam.

589
Toilet paper in China.

610
Pretzels in Italy.

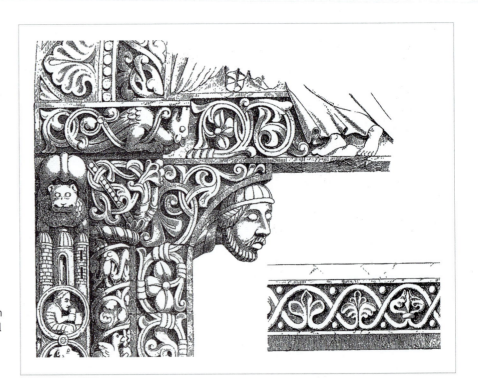

Carving and ornamentation found on furniture was adapted from medieval architecture: English Romanesque, Norman architectural ornament (ca. 1066–1180). *(Colling)*

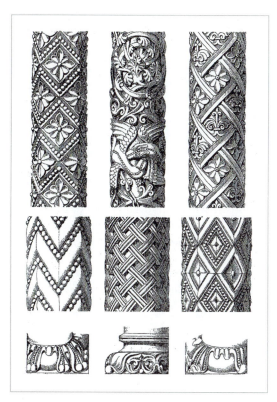

English Romanesque, Norman shafts and bases.
(Colling)

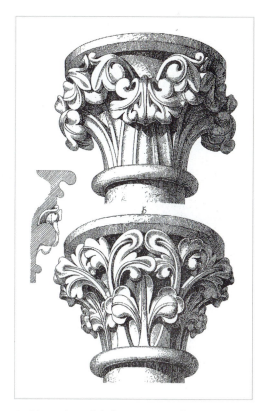

Gothic, Early English (ca. 1180–1280) capitals.
(Colling)

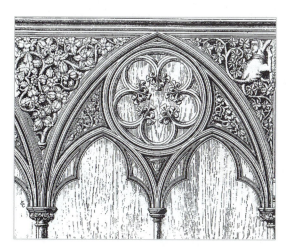

English Gothic, Early Decorated (ca. 1280–1350) oak
screen work. *(Colling)*

English Gothic, Decorated-style canopy and crockets. *(Colling)*

English Gothic, Perpendicular (ca. 1350–1485) oak poppy heads.
(Colling)

English Perpendicular-style cornice and bosses. *(Colling)*

622
First year of Muslim calendar.

641
Arabs conquer Palestine, Syria, and Iraq.

642
Arabs conquer Egypt and Persia.

CHESTS

If little medieval furniture existed, even less has survived, and furniture historian Penelope Eames suggests that chance rather than any meaningful pattern has determined what has survived. More medieval chests exist today than any other items. Chests were used to hold valuables and/or to transport them, like luggage, and the more portable chests probably did not survive because of use. Because these portable chests or **coffers** were also less likely to have ornamentation and aesthetic value, it was of little consequence that they wore out. Their most important feature was probably a domed or gabled lid to shed water and then some iron strapping for security. These were also called **arks**. Stationary chests, however, could be richly decorated with ivory, metal, or carving, and they were often deposited in churches and abbeys for safekeeping. Others were made for and used by the clergy. Because they were not exposed to the elements and were in a context that placed a higher value on tradition than on fashion, chests in churches simply lasted longer and looked

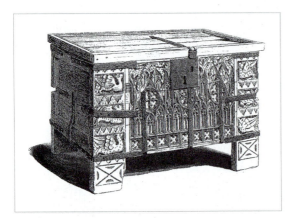

CHEST, ENGLAND.
Boxlike chest on legs, with Gothic tracery-style arches, trefoils, and quatrefoils carved onto the front, and iron straps and keyplate, circa early 1300s. *(Shaw)*

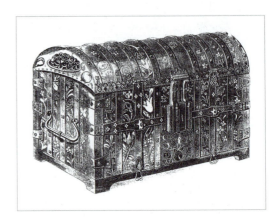

CHEST/COFFER, ENGLAND.
Coffer with iron straps, handles, and lock, with decorated surface, dated 1532 but typical in form of earlier medieval examples. *(Shaw)*

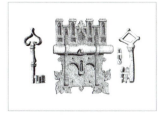

LOCK AND KEYS, FLANDERS.
Iron door lock with bolt and two keys from the church of St. Pitié, 1400s. *(Shaw)*

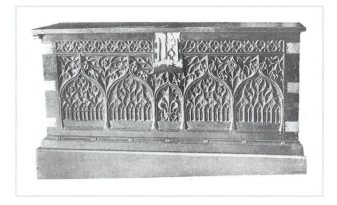

CHEST, SPAIN.
Gothic chest with carved arches and tracery. *(Hunter)*

742–814
Charlemagne, king of Franks.

748
First printed newspaper in China.

751
Arabs capture Chinese papermakers, spread art of papermaking throughout Arab world.

789
Charlemagne introduces the royal foot as a unit of measure.

800
Charlemagne crowned Roman Emperor; printing in China; blast furnace for making cast iron in Scandinavia.

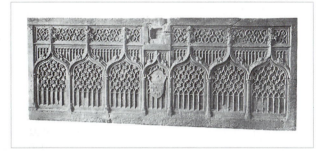

CHEST, FRANCE.
Gothic chest with very similar carved arches and tracery. *(Hunter)*

about the same regardless of age or date of construction. On the other hand, primitive stationary chests, simple dugouts hollowed from a single large log, probably did not wear out, but were discarded or recycled as firewood.

BEDS

As in ancient and classical times, art forms of painting and sculpture have provided valuable information about medieval furniture. Another important source is the written word, and medieval wills and inventories include lists and often descriptions of household items. Although more medieval chests exist today than other types of furniture, the most commonly mentioned item of furniture in inventories is the bed—not a wood framework, but bed clothes and hangings. Portable and often elaborate textiles were considered far more valuable than any utilitarian and cumbersome frame on which they could be hung. The

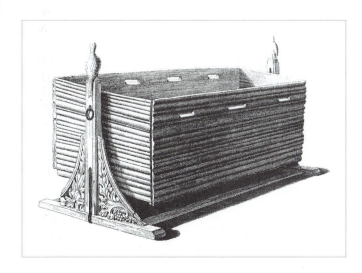

CRADLE, ENGLAND.
Cradle of Henry V, born 1387. *(Shaw)*

CHAIR, ENGLAND.
Abbott's chair with **X**-legs and cylindrical stretcher, early 1500s. *(Shaw)*

mattress, a mat covered with a sheet, was probably the most ubiquitous item in the medieval home. A household might have no possessions to store in a chest, but all of the family members slept and required something between their bodies and the ground.

The wealthy, as one would expect, had something more substantial to raise them off the floor. A platform evolved into a wooden framework with a canopy (the **bed of estate**), and from the thirteenth century on, the canopy was a symbol of privilege. It was not until the very late Middle Ages that the wood structure itself was considered valuable enough to decorate with elaborate carving. The resulting enclosed little room of hanging textiles provided warmth, privacy, and status.

SEATING

Status, power, and authority preoccupied the upper levels of medieval society, and seating became one of its symbols. The obvious example is the royal throne with its elevated height and exaggerated ornament, but there were other forms of seating with symbolic content. A form of chair known as a foldstool was known in dynastic Egypt and ancient Greece, and was used by Roman field commanders. The medieval faldstool (foldstool) was used by men of distinction, especially ecclesiastics. It was often richly decorated, but because there were no large surfaces, carving was not stressed. The faldstool was eventually replaced by the **X**-chair, which was neither collapsible nor light in weight. These **X**-chairs could be elaborately turned or carved and were used to symbolize supreme authority. They were among the class of **chair of estate** reserved for the ranking member of a household. The more private the occasion, however, the greater was the opportunity for those of modest social standing to use important seating. Even though an individual might not use a chair in the hall, he or she might have one in the bed chamber.

Chairs in the form of a single seat on legs with a back were not common in the Middle Ages. Ordinary seating more often took the form of a seat with legs and no back, or a stool, used in halls and chambers. If the seat was large enough to accommodate two or more persons, it was called a form. Add a back and we have a bench (although the term bench is now used to describe the backless form. The bench with a high back and arms was called a **settle**. Like the bed, it was not so much the wood structure that was valued, but the accessories. Textiles and other loose coverings, and occasionally attached upholstery, were costly and afforded something not yet seriously considered at this point in history—comfort.

From a modern perspective, the Middle Ages was completely without comfort, regardless of social and economic station. Because ecclesiastics, especially in ascetic monasteries, believed and preached the virtues of discomfort, anything near our standards of comfort would have to wait several centuries before society discovered its advantages and then demanded it.

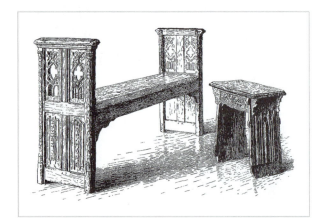

BENCH AND STEPPING STOOL, FRANCE.
Carved oak bench with panelled end supports, with stool also with solid ends, examples of portable seating furniture, circa late 1400s. *(Magne)*

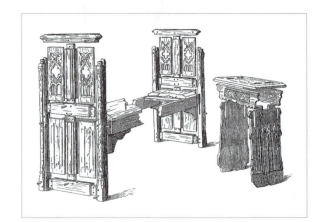

Analysis of construction. *(Magne)*

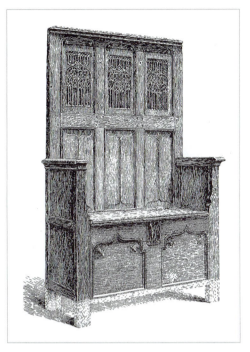

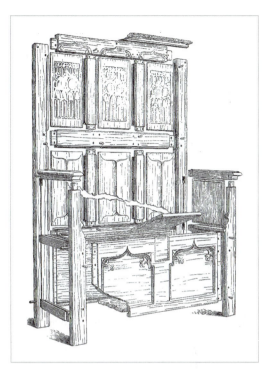

CHAIR, FRANCE
Wide rectilinear armchair of panel construction,
actually a chest on legs with attached wall panel,
circa late 1400s. *(Magne)*

Analysis of construction. *(Magne)*

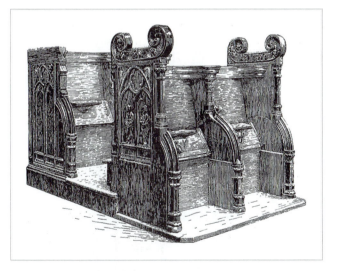

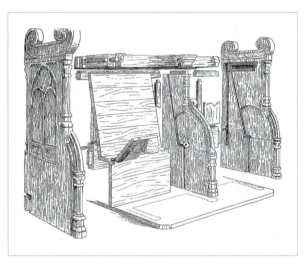

CLERGY CHAIRS, FRANCE.
Carved oak misericords for standing or perching, with animal head
decorative supports, circa 1300s. *(Magne)*

Analysis of construction. *(Magne)*

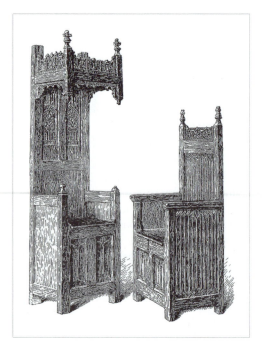

CHAIRS, FRANCE.
Carved oak high-back panelled chairs with and without decorated canopy, circa late 1400s. *(Magne)*

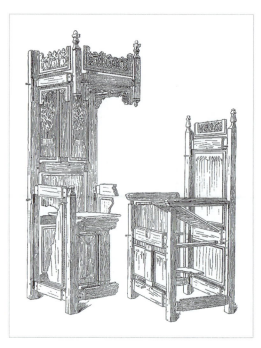

Analysis of construction. *(Magne)*

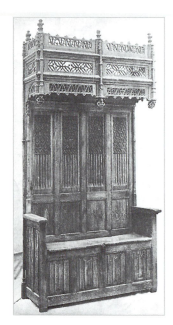

CANOPY CHAIR, FRANCE/FLANDERS.
Ecclesiastical chair of panel construction with Gothic canopy. *(Hunter)*

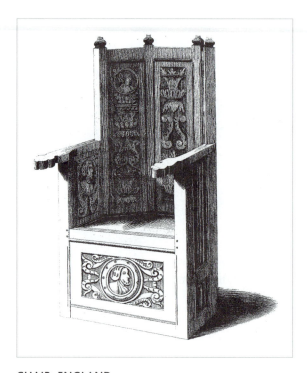

CHAIR, ENGLAND.
Boxlike chair with high back and Romayne work in front under the seat, late 1400s. *(Shaw)*

1066
Norman Conquest of
England, last successful
foreign invasion.

1070–1083
Bayeux Tapestry, 231-foot
long historical record of
contemporary English
culture and life.

1086
Magnetic compass in China.

1095
Pope Urban's speech in
Clermont, France, initiates
the First Crusade.

Circa 1100
Italians distill wine to make
brandy.

1101
Henry I of England
introduces the
measurement of the length
of his arm as a yard.

1107
Chinese invent multicolor
printing to make paper
money harder to
counterfeit.

1151
The Scrutage Tax allows
barons to pay the king a
sum of money instead of
following him to war.

1152
The "War of the Whiskers,"
lasting until 1453, begins
when Lady Eleanor divorces
French King Louis VII
because he shaved off his
beard and refused to grow
it back. (Lee 74)

1155
Chinese make the first
printed map and invent
rockets.

CASE PIECES

Technology was available, and the craft of furniture making might have taken other directions, but medieval society chose to emphasize the features of solidity, durability, and weight. Planks and primitive joinery of boards placed edge to edge and nailed and bound with iron strappings were the major construction methods. Furniture was perceived as functional rather than aesthetically valuable. Objects with aesthetic value were not for personal pleasure but for display, and display was intended for intimidation. Delicately crafted objects made of precious metals and stones symbolized power; they were intended for influence rather than enjoyment. These small portable art objects were to be displayed, stored, and moved about. The furniture was there only to provide a surface on which to display them, to store them, and to hold them when they were moved about. Textiles, plate (silver), and jewels were like money in the bank (of course, banks did not exist yet); they were investments invested with artistry, technical skill, and precious materials. Furniture was only to show off valuables to some visitors, and then to store it and protect it from being taken by others. It was not unusual for great medieval households to be open and accessible to outsiders. If "good fences make good neighbors," then good iron locks made even better strangers.

As long as the technology existed to craft extremely fine decorative arts objects, it just as easily could have been applied to furniture construction. But the attitude toward furniture and its function in society prevented doing so. Strength and endurance were all that were needed to protect really valuable objects, and form would follow function. Sturdy forms made of sturdy wood, namely oak, with iron fittings and locks (often of better quality than the piece of furniture) were logical choices dictated by need rather than fashion. Perceived more as fixtures that could be left behind with the house, the style of the furniture was relatively unimportant. Furniture was somewhat immune to the fashion and changing tastes that affected other facets of upper-class medieval society.

As long as the large and sturdy case piece, such as armoires, buffets, and *dressoirs*, were viewed as being a part of the house, they were often what are now called "built-ins," and few have survived because they really did go with the building. Even if the building remained over the centuries, then these built-ins were probably lost to modernization and remodeling. Few armoires that were fixed onto or into the walls in thirteenth-century London have survived, but more of the freestanding types have lasted. The medieval armoire was more like a modern cupboard and was used for hanging clothing like long robes on rods. (The medieval cupboard, cup + board, was an open board used to display cups and plate.) Later, armoires were made with drawers instead of shelves, and these evolved into **buffets**, *dressoirs*, or cupboards with rows of shelves and optional closed storage space.

More than the actual form of an item of furniture, the location in the house and its function helped to identify a piece. A case piece with boards or shelves used for dressing in the service quarters was known as a *dressoir*; a similar piece used to display plate in the hall or chamber was a cupboard; a buffet was used for serving as well as display in the hall. The fourteenth-century buffet was stepped, and the number of the display shelves were associated with degrees of wealth and status. A *dressoir*, however, in a less public area of the house, had no such association; its shelves were only for utility, and the number had no other meaning.

TABLES

Examples of early tables are rare, and most of what is known about them comes from art forms such as painting. Like other items of furniture, tables could be either fixed or movable, depending on the owner's lifestyle. If a person left the house or houses to travel, it was likely that storage furniture was built in and tables were fixed to floors. The

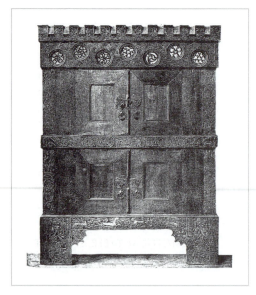

CHEST, GERMANY.
Gothic chest with four doors and carved panels,
1400s. *(Hirth)*

CHEST, GERMANY.
Gothic chest with carved motifs of tracery rose
windows, 1400s. *(Hirth)*

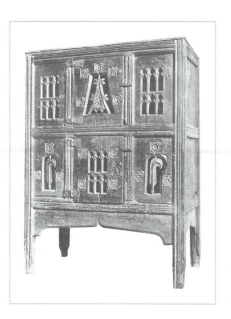

CUPBOARD, ENGLAND.
Two levels, each with pierced carving of Gothic
tracery, on four legs. *(Hunter)*

1162–1227
Gengis Khan, proclaimed
universal emperor of
Mongol chieftains in 1206.

1163
Notre Dame Cathedral
building begins.

1170
Archbishop Thomas à
Becket murdered.

advantages of movable tables also had to be considered. Because floor space was always needed in a multipurpose space, it was an advantage to be able to move the table around or out of the room; and because tables were essentially just platforms, their multifunctional use was obvious. One obviously multipurpose item was the **chair table** with a round back that could be easily converted to a table. In addition to dining, tables could be used for storage, writing, and even sleeping. A common form was the trestle, made of a plank with each end mounted on a sturdy support.

The issue of status versus function also had to be considered. Although the fixed table was considered only utilitarian and functional, the portable table could be made with more elaboration to signify wealth, and it could be moved to different locations. The most elaborately decorated tables and other items of furniture were perceived as furniture of estate, and the aesthetic and symbolic value exceeded the functional value. Medieval society did

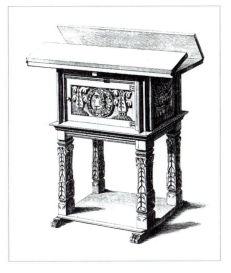

TABLE, ENGLAND.
Table with leaves that open out (the opposite of a drop-leaf that opens down) and Romayne work decoration, late 1400s. *(Shaw)*

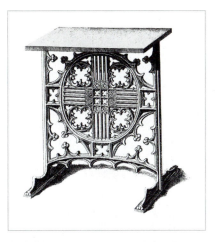

ECCLESIASTICAL TABLE, ENGLAND.
Small table with Gothic tracery-style support for the top, circa 1400. *(Shaw)*

not judge people by their furniture as they were judged by their other possessions like clothing, jewels, textiles, or plate. The special pieces, the furniture of estate, were looked at in the same way as other works of art and were therefore a reflection of its owner's wealth and status.

WHY WASN'T THERE MORE FURNITURE IN THE MIDDLE AGES?

There are several different opinions and explanations for the apparent lack of what could be called "high-end" medieval furniture. Perhaps the most simplistic is the idea that technological know-how was lost with the fall of Rome, and people had to start from scratch, so to speak. The goods were lost along with the talent to produce more. This explanation is at least partly acceptable. Classical civilization was lost when various groups of invaders swept across what had been the Roman Empire. Survival suddenly became a high priority to citizens who had been accustomed to fine material things. If they weren't killed, skilled artisans and their patrons found themselves in a different world. When and if they or their descendants regained or acquired status and wealth, there were no longer sufficient skilled artisans to make fine furniture.

Another theory, as we have seen, is that people of means had other priorities and values than building nice furniture. The rich preferred smaller, more portable valuables and saw furniture as purely functional extensions of houses; they were more interested in the fine vessels and tableware than in the table. As long as they had some food to eat, the poor would have been content to sit on the floor with neither table nor utensils.

Another idea is that rather than being lost, some art forms did stay alive, but on a smaller scale. The desire to have and the ability to create elaborate furniture did not suddenly disappear in Europe after the decline of Rome. Rather than being reintroduced during the Italian Renaissance centuries later, the skills actually survived the Dark Ages. Though on a much smaller scale than in ancient and classical times, precious materials were still used by the great artists and artisans, even during the Middle Ages.

This explanation makes sense if we look at the events toward the end of the period and see that the various skills and techniques credited to the Renaissance period did not

1286
Eyeglasses for reading used
in Italy.

1290–1295
Spinning wheel introduced
in Europe from the East.

Early Fourteenth Century
Gunpowder, metal-barrelled
gun, cannon, wheelbarrow,
mechanical clocks.

1307
Dante's *Divine Comedy.*

1325
A twelve-year war begins
when a regiment of Modena
soldiers invades Bologna to
steal a bucket. (Lee 74)

1338–1390
Alhambra Palace, Grenada,
Spain.

1340–1400
Geoffrey Chaucer.

1348–1350
Black Death, bubonic
plague, kills nearly a third
the population of Europe.

1350–1400
Plate armor.

1370–1440
Jan van Eyck.

1387
Chaucer begins *Canterbury
Tales.*

1400–1468
Johannes Gutenberg.

1412–1431
Joan of Arc.

Circa 1440
Movable type in Europe.

suddenly appear from nowhere. The arts of metalworking, enameling, ivory carving, and weaving were highly developed in the Middle Ages. Granted, only a very small segment of society could afford to own the objects and to pay for having them made. Conversely, there were few artisans skilled enough to craft the articles, and with such a limited patronage, there was no incentive for more aspiring craftspeople to learn the skills. The skills and the artisans existed, but in most cases they were employed to make articles for the church and/or for the state. The military undoubtedly kept talented metalworkers busy forging weapons and armor. If there had been a greater demand for fancy furniture, the supply certainly would have accommodated it. It is a little hard to imagine that an entire civilization of Greeks and then Romans enjoyed highly developed skills, and then all of a sudden no one knew how to make fine furniture. It is also difficult to believe that about a thousand years later, once again, there was an abundance of skilled furniture makers.

It might be arguable, however, that other aspects of medieval society—science, technology, philosophy, economics, and so on—went through dramatic changes during the Renaissance. The fine arts of painting and sculpture are among the best visual evidence to support this. Yet if any one of these aspects of culture is examined closely, one can see that nothing changed overnight, and there were years, decades, and generations of transitional periods, which varied according to geographic location.

There is good evidence that, for example, wood turning was practiced at least as early as the twelfth century, and there is record of a turners' guild in Cologne, Germany, in 1180. Paneled construction was used in France, Germany, and the Netherlands by the end of the fourteenth century. Late medieval furniture was made from thin panels that were fitted into a jointed framework of uprights and cross rails. A desire for more ornamented and lighter furniture and the advent of the sawmill in the early fourteenth century in southern Germany contributed to the popularity of paneled construction. It has been suggested that the demand for paneling probably led to the invention of the sawmill, and that the sawmill increased that demand but did not create it.

With an increasingly sedentary life, homes and their interiors became more elaborate, and wainscotting began to be used. Until sawn timber became available, however, these paneled wainscots could not become popular. The increased use of wood as a decorative element brought the material added attention. Rather than just a crude frame on which to hang fine textiles, the wood itself began to have increased value and importance. Wood carving replaced painting or covering the surface with metals or stones, and in the twelfth century Romanesque-style architectural motifs were carved onto furniture, followed by Gothic detailing that made furniture look like small buildings. Cupboards that might have been used in cathedrals were made with crenelated parapets and gabled roofs with dormers. Ornamentation on late medieval furniture was controlled by architecture. Motifs, such as **trefoils** and **quatrefoils**, first used for **tracery** and other decorative masonry on buildings, were translated to wood. Constructional forms, such as arcading and vaulting, were actually carved onto the furniture.

REGIONAL DIFFERENCES

All late medieval furniture used by the common people had similar forms regardless of the region or country in which it was made and used. A crude stool or table or chest had meager functional requirements and significant economic restrictions. Without resources for ornamentation or variety of materials, the basic box or platform looked and functioned about the same wherever it was, regardless of the regional language and culture. It was the upper-class furniture, with its need to impress and impose, that varied from region to region and even from household to household.

Because late medieval architectural styles, especially Gothic, were extremely decorative and impressive, it followed that the forms and motifs were used on furniture. The furniture makers looked to the architects and the masons for ideas. Regional and national differences in architecture were apparent even within the same stylistic boundaries. French Gothic looked different from English Gothic. Italy never joined in the widespread rage for

Gothic that swept the more northern areas, but in its limited use, Italian Gothic spoke a different language.

Furniture began to follow these regional variations in architecture and took on very distinct characteristics. To oversimplify these distinctions, the French followed the Gothic themes of tracery and cusping, becoming more and more sculptural by the late fifteenth

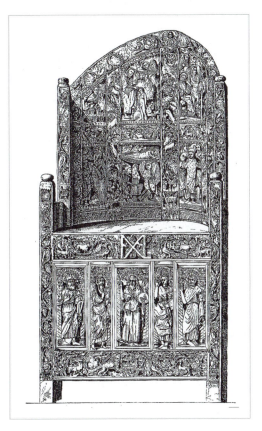

CHAIR, ITALY.
Elaborately carved ivory chair of St. Maximilian, at Ravenna, Italy, sixth century. *(Larbarte)*

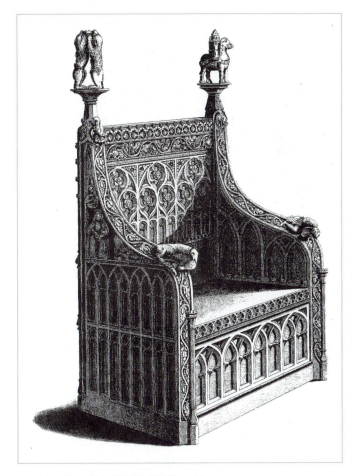

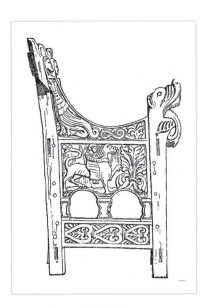

CHAIR, SCANDINAVIA.
Carved wood chair with mythological animal head and other figural carving, circa 1200. *(Litchfield)*

ECCLESIASTICAL CHAIR, ENGLAND.
Elaborate Gothic chair of boxlike form, similar to a settle but apparently for only one sitter, with tracery carving and animal finials, 1400s. *(Shaw)*

century. German furniture was heavier in proportion, and ornamentation leaned toward the Romanesque. Flemish furniture was sculptural like the French and made good use of the **linenfold** motif. Both French and Flemish styles were used in England and in Spain, but the Spanish used more coloring, gilding, and ornamental ironwork. Perhaps more than national or political differences, furniture followed geographic lines. Mountainous regions in the south favored low-relief carving on both structural and nonstructural parts. Inhabitants of the northern plains preferred more architectonic forms with deep sculptural ornament.

These diverse environments naturally produced different types of timber. Oak was prevalent in the north and was well suited to sculptural and high-relief carving. Softer woods like pine and larch were common in southern areas. When walnut and other hard and dense fruitwoods gained more attention in Italy, the ornamentation became increasingly more sculptural and more refined with crisp detail not possible with wider grained wood such as oak. By the middle of the sixteenth century in Italy, the practice of painting the surfaces of furniture was superseded by carving the tightly grained woods. And that brings us to the time of the Renaissance and the beginning of this history of furniture with an emphasis on innovation and change more than on duration.

Summary

- Furniture was not highly regarded in the Middle Ages.
- Medieval furniture included functional chests, multipurpose convertible pieces, and built-ins that stayed with the house.
- Theories for lack of high-style medieval furniture: The technology was lost with the fall of Rome, or furniture was considered a utilitarian part of the house, rather than art.
- Few pieces of furniture have survived from before about 1500.

Chronology

Circa 500–1100 "Dark Ages."

1000–1150 Romanesque architecture develops and flourishes in Western Europe.

1100s Wood turning used for furniture; marquetry used on furniture in Italy.

1180 Turners' guild in Germany.

1200–1400 Gothic architecture flourishes in France and parts of Europe and England.

Early 1300s Sawmill used in Germany, promotes use of paneled construction.

1300s Professional painters decorate furniture in Italy.

Late 1300s Paneled construction used in France, Germany, and Netherlands.

1400s Elaborately carved Gothic furniture resembles architecture.

1500s Transition period between Gothic and Renaissance styles; both are seen separately.

Key Terms

ark	chair table	settle
bed of estate	coffer	tracery
buffet	linenfold	trefoil
chair of estate	quatrefoil	

Recommended Reading

Eames, Penelope. *Medieval Furniture*. London: Furniture History Society, 1977.

Mercer, Eric. *Furniture 700–1700*. London: Weidenfeld & Nicolson, 1969.

Chapter *3*

RENAISSANCE AND BAROQUE
Made to Order

CHAPTER CONTENTS

The rise of capitalism and new secular wealth enabled widespread patronage of the arts, and centers of unprecedented creativity developed. The rediscovery of ancient Roman culture inspired the first major phase of neoclassicism, as exemplified by the Italian Renaissance. The art of Michelangelo and changing tastes brought a more dramatic and flamboyant style called Baroque.

*I*n the fourteenth century, bubonic plague, the Black Death, killed about one-third of the population of Europe. Entire cities were depleted. Although the scope of personal loss was unimaginable, there were some interesting and even positive results for the survivors. In other words, there were suddenly fewer people competing for the same amount of resources. Survivors were more likely to have more land, food, possessions, and opportunities. While the plague meant death to many, it meant new life for others, and with a redistribution of wealth came a redistribution of power. Because the process was seemingly random, individuals with little chance for advancement before the plague might have experienced drastic changes in their lives and world when it had passed. After the chaos and the cleanup, Europe began a transition toward new social, economic, and political structures. The papacy, which held a tremendous amount of power and influence, had been adversely affected when the popes were exiled to Avignon, France, beginning in 1305. However, the return of the popes from Avignon in 1377, in addition to creating the Great Schism—with both Roman and Avignonese lines of popes—gave the church more power. This precluded an earlier development of humanism that would come to characterize the Renaissance.

Medieval Europe had been divided into separate countries that were each ruled by kings and bishops, and the bishops were, in turn, protected by the kings. The kings financed large armies and the exploration and exploitation of new lands, and eventually became even more powerful and more wealthy than the church. Sources of income, their subjects, were not always sufficient for such costly ventures, and the kings began to borrow. This system of money borrowing and lending developed into the institution of banking, especially in Florence.

ITALIAN RENAISSANCE, 1450–1600

Prominent Florentine bankers, such as the Medici family, controlled money and politics. They also used a good deal of this wealth and power in a way that benefited many—by patronizing the arts on a grand scale. Florence and other Italian city-states looked to classical Rome as a model, though they knew little about ancient Rome or Greece. The so-called rebirth of classical culture in the Renaissance was really more interpretation and invention than revival. Italian Renaissance architecture, for example, was based as much on the more recent Romanesque as on classical Roman style. Classical orders and other elements were selected and then reassembled and applied, often arbitrarily, to contemporary Renaissance forms.

By the second half of the fifteenth century, the Early Renaissance, there had already been enormous changes and accomplishments in literature, painting, sculpture, architecture, and lastly, furniture. It was an intellectual period, one rich in experimentation and adventure. It was an age of splendid ceremonies, parades, and display. The Italian Renaissance culture borrowed freely from the superficial appearance of classical culture, but it ignored the Greek practice of moderation and perhaps its emphasis on proportion as well.

Florence, the star of Renaissance culture, led the artistic awakening in the fifteenth century. Venice, which had risen to the height of its political power in the early 1400s, was "behind" in the arts by several decades. Rome was dominated by the papacy, so its early Renaissance activities were more related to the church. Florence, with its impressive wealth from banking and commerce, was rich in festivals, social display, and material extravagance—and in artistic creativity. By the late 1400s, some of the greatest Renaissance architectural achievements were already standing. The first of the Renaissance super architects was Filippo Brunelleschi (1377–1446), who, like other "Renaissance men," was also a mathematician, sculptor, goldsmith, and clock maker. Neither Gothic nor classical, but based on both Gothic and Roman technology and classical elements, Brunelleschi's buildings were models of Renaissance style. Influenced by the treatise on architecture by the Roman architect Marcus Vitruvius Pollio (Vitruvius), Renaissance architect Leone Battista Alberti (1404–1472) wrote the first treatise on Italian Renaissance architecture, published posthumously in 1485. Although his building style was quite different from ancient

1444–1510
Sandro Botticelli.

1451–1504
Queen Isabella I, sponsor of Columbus; the beginning of most of South and Central America as Spanish colonies with Spanish culture, including the Inquisition.

1451–1506
Christopher Columbus.

1452–1519
Leonardo da Vinci.

1454
Gutenberg Bible printed at Mainz, Germany.

1460–1524
Vasco da Gama, reached India by sea.

1466–1536
Desiderius Erasmus.

1469–1527
Niccolò Machiavelli.

1471–1528
Albrecht Dürer.

1473–1543
Nicolaus Copernicus,
beginning of modern
astronomy and science.

1474
William Caxton prints first
book in England.

1475–1564
Michelangelo Buonarroti.

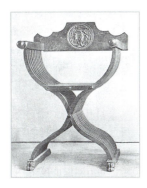

**CHAIR, ITALIAN
RENAISSANCE.**
Early Renaissance
savonarola chair with
carved animal feet and
medallion on back, fifteenth
century. *(Hunter)*

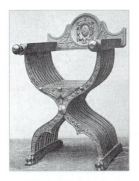

**CHAIR, ITALIAN
RENAISSANCE.**
Elaborately carved
savonarola chair with
animal feet and back
medallion, Florence, late
fifteenth century.
(Schottmuller)

Roman, he emphasized the laws of harmony, proportion, and balance. Classical features, such as columns, pilasters, and arches, were often used as decoration rather than structure.

Andrea Palladio (1508–1580), of the Late Renaissance, is considered the most influential of all architects in the neoclassical style. His combination of classicism and originality enabled the style to adapt to many settings. Perhaps the most notable setting, the natural landscape, is what gave the Palladian country house or villa its distinction. Consciously designed as part of the landscape, these villas could be viewed from every vantage point, and rather than focus only on the facade (as along a city street) all views were equally interesting. But his widespread influence can also be attributed to his publication of *I quattro libri dell'Architettura,* printed in just about every European country beginning in 1570. Illustrations of his buildings were used as models, and elements, such as the three-part Palladian window, have been used until the present day.

Furniture Forms

Though still under some Gothic and ecclesiastical influence, furniture followed architecture after the mid-1400s. Furniture, the last item on the medieval list of artistic priorities, finally rose as an art form. The Florentine workshops responsible for the design and execution of extraordinary architectural woodwork also began to produce domestic furniture. In Florence especially, the relationship between architecture, ornament, and furniture began to develop. Still, Renaissance architecture and painting were far more sophisticated than the art of making furniture, and the short list of major changes includes new forms, styles, and crafting techniques. Generally, receptacle and seating furniture became more distinct. Existing forms, especially chairs, became more popular; drawers on case pieces became more varied and common; **secretaries** and **credenzas** were found in early sixteenth-century Italy; and the sudden popularity of secular writing led to the specialized writing table.

Seating

Unlike the elegant proportions of the Greeks, the classical revival of the Renaissance was based on Roman interpretations. The first important domestic furniture design were the folding X-chairs, whose forms were derived from the Roman curule. These were known as the *savonarola* chair, often with a loose seat cushion, and *dantesca* chair, upholstered in velvet or ornamental leather. Relatively lightweight and portable, they could be moved around and used for multipurposes, from dining to writing. Introduced before 1500, these X-chairs increased in popularity until they were replaced by rectangular armchairs in the late 1500s. Stools continued to be used, with either a rectangular- or octagonal-shaped seat. Rather than legs, stools often came with a solid boxlike base. Other seating included the **sgabello**, or stool chair, usually of walnut, sometimes decorated with *intarsia*, with three or four legs and a high narrow back. Another high-backed seating item, the throne seat, was only found in the houses of the wealthiest patricians. Its high-paneled back was decorated with carving and **intarsia**, a technique using inlay of colored woods; a canopy covered the top; and the seat was raised on two steps. A less-intimidating and very popular form was the tall armchair, of rectangular shape and often upholstered with a velvet

FOLDING CHAIRS, ITALIAN RENAISSANCE.
Folding chairs with diagonal arms connecting the back
to the seat front, Venice, fifteenth century.
(Schottmuller)

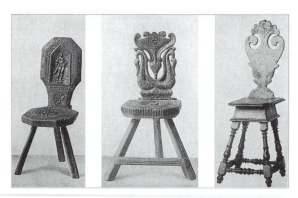

***SGABELLA* CHAIRS, ITALIAN RENAISSANCE.**
Three different *sgabella* stools/chairs, shown with three legs with and without stretchers and four legs with stretchers, with carving and inlay, Northern Italy, mid-sixteenth century. *(Schottmuller)*

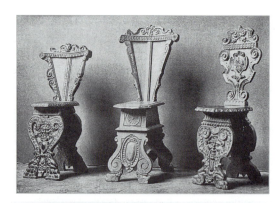

***SGABELLA* CHAIRS, ITALIAN RENAISSANCE.**
Three sgabella stools/chairs with pairs of slabs rather than legs (a more commonly found form) with varying amounts of carving, sixteenth century. *(Schottmuller)*

1478
Botticelli's painting, *Primavera.*

1478–1535
Sir Thomas More.

1480–1521
Ferdinand Magellan.

1483–1520
Raphael Santi.

1483–1546
Martin Luther, Protestant Reformation.

1485
Botticelli's painting, *Birth of Venus.*

seat. Benches without backs or arms were commonly found seating. A combination seat and chest, called a **cassapanca**, was introduced in the mid-fifteenth century. With its cushions for the master of the house to sit on, the *cassapanca* stood prominently in Florentine apartments, where it remained fashionable for a full century.

Storage

The multipurpose **cassone**, introduced earlier, remained as the most important article of furniture until it was replaced by more specialized pieces in the Late Renaissance. It was often beautifully painted by a fine artist, but by the late 1400s, the *cassoni* were painted less frequently and carved more. The lid could be either flat or shaped with an arch, and moldings were either plain or carved. A later form of *cassone* was shaped like an ancient Roman sarcophagus on a base or with lion feet. Decoration ran the full Renaissance gamut—from *intarsia* and paintings on flat surfaces to high-relief carving of figures and entire scenes. Marriage *cassoni* included coats of arms from both families and depictions of the actual wedding feast or procession. Small coffers or chests, called cassettes, resembled the larger *cassoni*, and were used to store jewelry, lace, and other small luxury items. Like the *cassoni*, the cassettes were decorated with painting, gilding, or **pastiglia**.

More vertical storage was accomplished with a variety of chests, cabinets, and cupboards. Not unlike medieval built-ins, Early Renaissance cupboards were often set right into the walls and fitted with shelves and doors. Later, an important article of movable storage was the credenza, which was normally rectangular, with its length greater than its

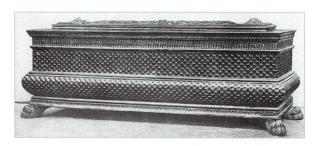

***CASSONE*, ITALIAN RENAISSANCE.**
Relatively simple *cassone* with lion paw feet and overall pattern of chip carving, Tuscany, mid-sixteenth century. *(Schottmuller)*

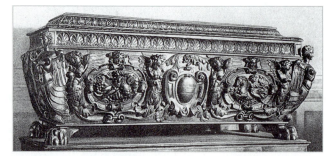

***CASSONE*, ITALIAN RENAISSANCE.**
Elaborately carved *cassone* with high-relief figural motifs and lion paw feet, Tuscany, late sixteenth century. *(Schottmuller)*

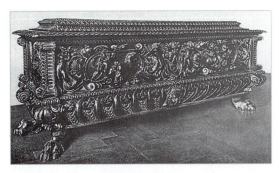

***CASSONE*, ITALIAN RENAISSANCE/BAROQUE.**
Late Renaissance or Early Baroque *cassone* with
elaborate figural and ornamental motifs and lion paw
feet, central Italy, early seventeenth century.
(Schottmuller)

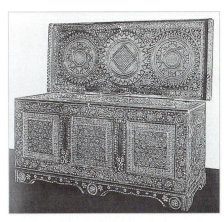

CHEST, ITALIAN RENAISSANCE.
Cortosina chest with surface covered in
intricate inlay instead of carving, Venice, circa
1500. *(Schottmuller)*

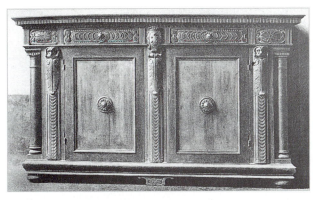

DRESSER, ITALIAN RENAISSANCE.
Rectilinear dresser on very short legs, with two doors, columns
on each end, and carved Medici coat of arms, Tuscany, sixteenth
century. *(Schottmuller)*

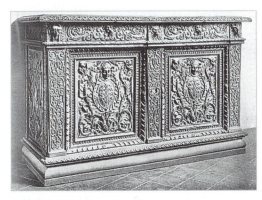

CHEST, ITALIAN RENAISSANCE.
Boxlike chest sitting directly on the floor without
legs, elaborately decorated with chip and relief
carving, sixteenth century. *(Schottmuller)*

1492
Columbus lands in New
World and "discovers"
America; da Vinci draws a
flying machine; graphite
used for pencils in England.

1495–1498
Da Vinci's *Last Supper*.

1498
Da Gama sails around the
Cape of Good Hope, opens
trade route to India.

1498–1500
Michelangelo's *Pieta*.

height. A typical credenza had an oblong top over a frieze with two or three drawers, which
was over two or three doors. A smaller version, called a credenzina, looked like one sec-
tion of the larger credenza. Another storage piece, the bookcase, was only making its intro-
duction during the Renaissance. Therefore it was found only in the homes of the wealthy
who were also collectors of books.

Tables, Beds, and Accessories

An item found in most well-furnished homes was the long narrow dining table, or trestle
table, with a long stretcher between the end supports. Center tables had round, hexagonal,
or octagonal tops supported by a central vase-shaped shaft with optional decorative sup-
ports. A writing table came with drawers on either side and a slanting top. Another Early
Renaissance item, a bed, was of simple rectangular form with paneled head and foot-
boards, and possible carved decoration. Wall mirrors of highly polished metal were hung
in ornate frames, which were more valuable than the actual mirror. Other accessories
included pedestals and wall brackets, especially during the Late Renaissance when antique
bronzes and marble sculpture were collected and displayed as interior decoration.

By about 1500, many of the Italian states of the High Renaissance enjoyed a period
of peace, prosperity, and creativity. The furniture of the early 1500s was similar to the

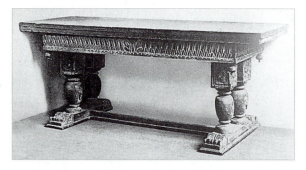

TABLE, ITALIAN RENAISSANCE.
Trestle-type table with pairs of massive legs resting on floor runners, low stretcher, carved apron, circa 1600. *(Schottmuller)*

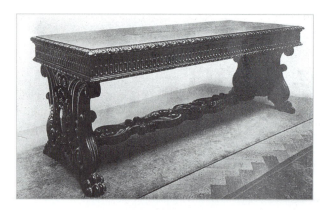

TRESTLE TABLE, ITALIAN RENAISSANCE/BAROQUE.
Long narrow table with trestle supports at each end and wide stretcher, ornate carving and lion paw feet, central Italy, early seventeenth century. *(Schottmuller)*

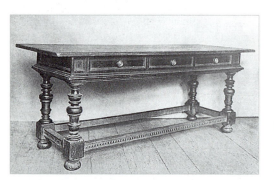

TABLE, ITALIAN RENAISSANCE/BAROQUE.
Long narrow table with turned legs ending in bun feet, connected by stretchers; the top is fitted with three drawers, Bologna, early seventeenth century. *(Schottmuller)*

1500
Da Vinci draws a helicopter and a wheel-lock musket; Chinese Wan Hu dies while trying to test a flying machine with gunpowder rockets tied to a chair.

1501–1504
Michelangelo's *David*.

1502
Peter Henlein's first pocket watch.

1503
Da Vinci's *Mona Lisa*; raw sugar refined.

1507
Dürer's painting, *Adam and Eve*.

1508–1512
Michelangelo paints the Sistine Chapel ceiling.

Early Renaissance, with more attention to detail. Walnut was still the preferred wood, and it was still joined with mortise and tenon joints as well as dovetails. Proportion was perfected, and there was more classical purity reflected in details such as moldings and pilasters. Relief carving, *intarsia*, *pastiglia*, and decorative painting were designed and executed with care. Turning was used, but furniture would rely more on this form of decoration in the seventeenth century.

LATE RENAISSANCE

The euphoria of the early sixteenth century ended, when, in 1527, Rome was attacked by groups of German and Spanish invaders. Two-thirds of the population was killed, and religious inquisitions demoralized the remainder. Art was destroyed, and artistic standards were lowered. Ornamentation became coarser, and display became more highly valued than perfection.

This later Renaissance phase also saw the early introduction of Baroque style with the work of super artist Michelangelo Buonarroti (1475–1564). Michelangelo stands out as marking the beginning of the Baroque style, especially with his masterpiece in fresco, the Sistine Chapel ceiling (1508–1512). His influence could be seen in other art forms with an increasing amount of bold modeling, exaggerated scale, and use of the human figure in a more sculptural style.

With Spanish rule in Italy, there was a marked decrease in intellectual freedom and the adventuresome spirit that had ignited the Early Renaissance. Cosimo (1537–1574) was cruel and tyrannical, and under his rule, pretentiousness and the purchase of titles were common. Relationships between artist and patron were weaker, and ornateness characterized the arts. The commerce that had given a foundation to the Early Renaissance was now replaced with militarism. Venice, however, was more artistically successful at this time because it was less influenced by Spain or the papacy.

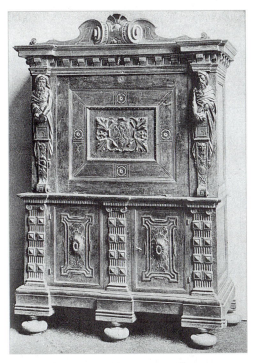

WRITING CABINET, ITALIAN RENAISSANCE.
Tall cabinet with term figures on each side,
supported by squat bun feet, Florence, late
sixteenth century. *(Schottmuller)*

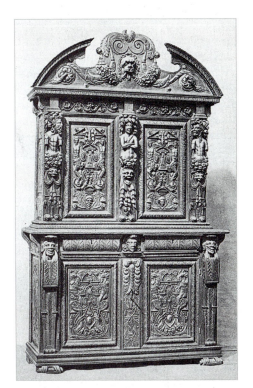

CUPBOARD, ITALIAN BAROQUE.
Ornate cupboard with broken pediment top,
figural carving, and term figures on the lower
tier, Lombardy, early seventeenth century.
(Schottmuller)

1509–1564
John Calvin, ideology
contributes to rise of
Protestantism.

1513
Machiavelli's *The Prince*;
Ponce de León discovers
Florida.

1516
Sir Thomas Moore's *Utopia*.

1517
Luther posts the Ninety-five
Theses to church door at
Wittenberg and begins the
Protestant Reformation.

1518–1580
Andrea Palladio, leading
Italian Renaissance architect
in classical style.

Furniture forms became more varied and more comfortable. The *cassone*, the single most important of all Italian Renaissance pieces, gradually became less prominent as other furnishings were used. Credenzas, cabinets, and chests of drawers, with doors, drawers, panels, and pilasters, gradually replaced the *cassone* as the primary storage piece. Instead of multiple *cassoni* in a household, there were fewer of them, and they usually took the sarcophagus form with lion feet.

Stylistic influences of sixteenth-century furniture came from quite different sources. Palladio, known for his use of restrained classicism and elegant proportions in architecture, also influenced furniture making in the Late Renaissance. On these pieces, ornamental carving was used with more care, and moldings were often left undecorated. On the other hand, Michelangelo, the master of movement, drama, and exaggerated scale, influenced many boldly carved and heavy moldings on interior architecture and furniture. Other manifestations of the taste for pomp and pretense were seen in an especially rich Italian technique called **pietra dura**. This type of inlay used cut and polished pieces of semiprecious stone rather than the colored woods of *intarsia*. The furniture was a contrasting dark tone, so ebony or other dark wood was used to hold the inlay. In addition to stone, ivory, mother-of-pearl, tortoise shell, and metals were used as inlay. This technique reached its height of technical virtuosity and popularity in the early seventeenth century, when Europeans outside of Italy sought examples of tables and cabinets made with *pietra dura*.

ITALIAN BAROQUE

The term baroque is from the Italian *barocco*, meaning misshapen pearl. It was used by later critics of the period following the Renaissance and its dominant style. Though the Baroque period of the seventeenth century followed the Renaissance chronologically, as a

1520
Magellan circumnavigates
the globe.

1521
Hernando Cortés
(1485–1547) conquers five
million Mexicans with 600
armed soldiers, partly
because the Aztecs are
demoralized by a smallpox
epidemic; a Swiss alchemist
introduces opium as a
medicine.

1528
The Courtier by Baldassare
Castiglione (1478–1529).

1532
Francisco Pizarro
(ca.1475–1541) conquers
the Inca Empire of Peru of
six million people with 180
armed soldiers, partly due
to a smallpox epidemic;
European culture has
dominated South America
and Mexico ever since.

1533–1603
Queen Elizabeth I (reigned
1558–1603).

1540
Cobalt used to make blue
glass.

1543
Copernicus's *On the
Revolution of Celestial
Bodies* and Andreas
Vesalius's *On the Structure
of the Human Body* are
published.

1547–1616
Miguel de Cervantes.

1550
Spanish cultivate tobacco.

1556
Platinum discovered;
earthquake in China kills
nearly one million.

style, it does not have clear boundaries. The characteristic features in architecture and interior furnishings—drama, movement, spacial volume, three-dimensionality, strong contrasts—were already introduced in the later stages of the Renaissance, especially in the transitional style called Mannerism.

The Protestant Reformation had begun in 1517, and the Northern style associated with it was austere, especially compared to Italian Baroque. To counter its effects and to contrast the Northern style, Italy built churches in a deliberately flamboyant Baroque style. Architects Giovanni Bernini (1598–1680) and Francesco Borromini (1599–1667) rivaled each other in designing their distinct classical interpretations. Where Florence had been the Renaissance center, Rome was the focus of the Baroque period. The church used art to awe its followers, and church interiors surpassed many palaces in the display of wealth, drama, and glitter. Sumptuous interior architecture, sculpture, and frescoes suggested a hereafter filled with spiritual and aesthetic delight. Bernini and other leading Baroque designers no longer used the static symmetry of classicism. Instead, even when symmetrical, draperies and even stone walls and ceilings undulated and writhed in continual motion.

Italian Baroque furniture of the first half of the seventeenth century was massive and generally rectilinear. Like the architecture, it was excessively, even obsessively, ornamented. Because drama and three-dimensionality were stressed, carving was the preferred decorating method. Not only relief, but sculpturesque carving, often enhanced with gilding was preferred. Exaggerated scale in both form and ornament was preferred. Cartouches, **banderoles**, volutes, and every type of scroll—foliated, C-scrolls, S-scrolls—were freely used. Where chiaroscuro, the use of light and dark to create contrast and dimensionality, was used in painting, Baroque sculpture and ornament also relied on light and dark to achieve its dramatic three-dimensional effect. Furniture was simply another blank canvas on which to paint Baroque extravagance.

By the mid-seventeenth century, the Italian Baroque style had culminated. Spanish influence yielded to French, after Louis XIV ascended to the throne in 1643 and France later defeated Spain in 1659. By the end of the century, Italy had adopted the French Baroque style and relinquished the artistic lead it had enjoyed during the centuries of the Renaissance.

SPANISH RENAISSANCE

During the Middle Ages Spain was ruled by the Moors from northern Africa, and their art and culture predominated. In 1492 the Christian Spaniards defeated the Islamic Moors by conquering Granada, and later, in 1607 the remaining Moors were expelled from Spain. Although the people were out of Spain, their rich artistic tradition continued to influence all of the arts, including furniture.

The sixteenth century was a significant period in Spanish history. This Age of Discovery brought enormous wealth from exploitation of the New World and numerous military conquests. Spain's "golden age" occurred under the reigns of Charles V (1519–1556) and his son Philip II (1556–1598). However, by the end of the century a great deal of this wealth was lost to the high cost of Catholic imperialism and the maintenance of overseas possessions.

The early Spanish Renaissance is known as Plateresque (silversmith's style) because of the abundance of intricate architectural ornament not unlike that of the silversmith. France and Italy had a strong influence in this early period. The second phase began with the reign of Phillip II in 1556 and is often referred to as Herrera style after Juan de Herrera, architect to Phillip II. Here the influence is Italian Renaissance classicism as introduced by Palladio. This more austere neoclassicism was soon replaced by a more elaborate, and more typically Spanish, Baroque. The main exponent of this Baroque style was the architect José Churriguera (d. 1725), and the so-called Churriqueresque style lasted until around 1800.

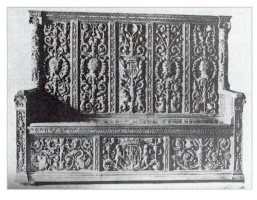

SETTLE, SPANISH RENAISSANCE.
Early Spanish Renaissance settle in "Plateresque" style, elaborately carved with the arms of Lacerdas. *(Hunter)*

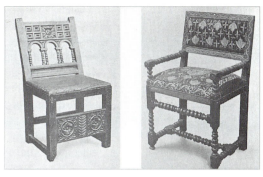

CHAIRS, SPANISH RENAISSANCE/BAROQUE.
Oak side chair with arcaded back, leather seat, and carved front stretcher; walnut armchair with turned arms and stretchers, upholstered in velvet with metal tacks, both seventeenth century. *(Hunter)*

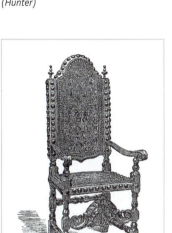

CHAIR, SPANISH RENAISSANCE/BAROQUE.
Walnut armchair with straight back, scrolled arms, Spanish feet, and ornately carved front stretcher, upholstered in embossed leather, early seventeenth century.

1561–1626
Francis Bacon, philosophy of science.

1564–1616
William Shakespeare: 38 plays, 154 sonnets.

1564–1642
Galileo Galilei: law of inertia, invention of telescope, astronomical observations, scientific method, proof of Copernican hypothesis.

1564
April Fool's Day in France.

Spanish Renaissance furniture was markedly different from its counterparts in Italy and France. Rather than emphasize elegance, opulence, and finished craftsmanship, the Spanish usually preferred rectilinear, bold, and simplified forms. The use of ornamental wrought iron for bracing tables and benches was another prominent feature, as well as the use of decorative nailheads. Walnut and oak were the preferred woods, and surfaces could be decorated with carving, painting, gilding, or inlay. *Taracea* is the term for an Eastern style of inlay using tiny pieces of bone, ivory, mother-of-pearl, metals, and exotic woods in intricate geometric patterns—one of the many Moorish influences. Rather than use classical motifs from Italian Renaissance furniture, the Spanish favored the Moorish stylized, conventionalized, geometric ornament.

Furniture Forms

The Spanish equivalent to the Italian *dantesca* and *savonarola* chairs was the X-chair called *sillón de caderas*, or hip-joint chair. This was borrowed from the Moors and understandably decorated with *taracea*, intricate geometric inlay. A popular Spanish Renaissance armchair was the *sillón de frailero*, or monk's chair, with leather seat and back. In the Late Renaissance period a rectangular armchair with a tall back was referred to as a Portuguese chair because of its probable Portuguese origin. Elaborate turning, tooled leather seats, and scrolled feet known as Spanish feet were other features. The side chair,

or *silla*, was also rectangular and featured an upholstered seat and back. *Bancos*, or benches, were of course very common and used along with stools and chairs. Wrought iron was used functionally as underbracing on benches as well as decoratively. Leather or even velvet upholstery might be added to more important benches.

The *cama*, or bed, was generally covered with textiles, and the degree and quality of these draperies depended on the wealth and status of the owner. The *mesa*, or table, came in a wide variety of sizes and forms. Long narrow walnut dining tables with thick removable tops supported by trestles originated in the monasteries. Turned or carved legs and decorative wrought-iron underbracing were also used on larger tables, while smaller gatelegs and very small portable tables were also found in many Spanish homes by the seventeenth century.

Storage focused on the *arca*, or chest, but also included more elaborate and specialized case pieces. The chest usually had a flat hinged top, and in addition to carving, painting, or gilding, the characteristic Spanish wrought-iron mounts or ornamental nailheads were used on chests. Bone and ivory inlay in typically Moorish geometric style, leather, or velvet might also be used for surface decoration. Cupboards could be built in and lined with ceramic tiles glazed in Moorish motifs. A freestanding *armario*, like the French armoire, did not become popular until the seventeenth and eighteenth centuries. A more common type of cupboard was the *fresquera*, a ventilated food cupboard that hung on a wall. The most elaborate storage piece was the *vargueño*, which doubled as a document storage piece and a writing desk. Ivory and wood inlay, typically in Moorish designs, were used to decorate the exterior, while a hinged drop front concealed an equally decorative interior of small doors and drawers.

The arts of Spain were influenced by cultures as diverse as the Moors and the French. By the late seventeenth century, Spanish Baroque showed features of both Italian and French style, and these became increasingly more sumptuous and ornate. During the first half of the eighteenth century Spain was ruled by a Bourbon king, Philip V, so French Baroque Louis XIV style was followed by the Rococo of Louis XV. However, in the provinces, furniture construction and even decoration followed the old Moorish ways. Even in the style centers that followed French fashion, Spanish cabinetmakers focused on a more limited variety of forms. But it was perhaps in the earlier work of the Spanish Renaissance that a real Spanish identity was created with its bold vigorous simplicity and ornamental metalwork.

FRENCH RENAISSANCE

Before becoming the leading continental power under Louis XIV, France followed Italian Renaissance styles in furniture and furnishings and used classical elements during its concurrent (1450–1600) French Renaissance. Military expeditions to Italy in the sixteenth century brought Italian art to France via the French nobility, and the French crown employed Italian artists and sent French artists to study in Italy. Because French Gothic had been enormously influential and successful, there was some resistance to the Early Renaissance style, which was developing rapidly in Italy. But the rediscovery of the classics and Italian wealth encouraged the French to adopt elements of the style, even if it was only superficially added to its own medieval forms.

Italian motifs were freely applied to medieval French furniture forms, which relied on early construction techniques of mortise and tenon and tongue and groove. Oak continued to be the primary wood for furniture until it was gradually replaced by the tighter grained walnut. The French architect and publisher of engraved drawings, Jacques Androuet du Cerceau (ca. 1520–1584) was a leading figure in the importing of Italian Renaissance style to France. His interest was primarily in the use of sculpturesque and high-relief carving, as was that of his contemporary, Hugues Sambin (ca. 1520–1601). Also an architect and publisher of a book of engravings, Sambin was known for his fantastic **term figures**. These decorative columns with male and female torsos were often accompanied by insects

and lizards in the style of pottery artist, Bernard Palissy. But of all the Italian influences, the use of **marquetry** and inlay was the most significant. The French then developed and perfected these arts, which would culminate under the reigns of Louis XIV and Louis XV.

French Renaissance style can be divided into three stylistic periods: (1) Francis I (1515–1547), a transitional style where Italian Renaissance motifs were still being applied to French medieval forms; (2) Henri II (1547–1559), when the king's Florentine wife Catherine de Medici brought Italian influence to the court and to its furnishings, followed by Charles IX (1560–1574) and Henry III (1574–1589); (3) Henry IV (1589–1610) and Louis XIII (1610–1643) when France began to develop its own style, which would blossom under Louis XIV.

With the assassination of Henri III in 1589, the reign of Henry IV marked the beginning of the Bourbon dynasty and a turning point in the evolution of French culture and art. The government became more centralized, and Paris began to be the center of intellectual and social activity. The Louis XIII style under the Bourbons in the first half of the seventeenth century had a cosmopolitan look because it borrowed from Italy, Spain, and Flanders. It was heavy, massive, and very solid. Rectilinear form prevailed, and decoration consisted of carving, turning, inlay, painting, and gilding. Turning reached its peak in both popularity and quality, and among the varieties used, spiral turning was the most common. This Late Renaissance period saw the use of Baroque ornament, much of which was borrowed from the Flemish. Novelty, spontaneity, and exaggeration were achieved through the unrestrained use of cartouches, shields, banderoles, draperies, swags with fruits and flowers, grotesques, masks, and cherubs.

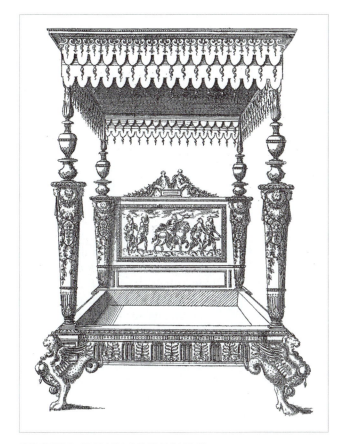

BEDSTEAD, FRENCH RENAISSANCE.
Four-poster bed with scalloped tester, elaborately carved headboard, and legs in the form of dragons, by Jacques Androuet du Cerceau, 1570. *(Hirth)*

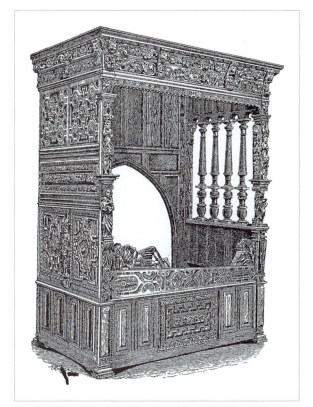

BEDSTEAD, FRENCH RENAISSANCE.
Carved oak bedstead enclosed on three sides with panels and spindles, with flat top, resembling a large box or chest, 1562.

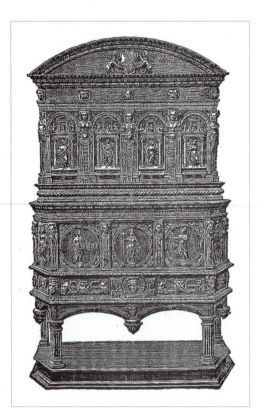

CABINET, FRENCH RENAISSANCE.
Carved oak cabinet with arched pediment, panels with figural motifs carved in relief, mounted on four straight legs resting on a platform, Lyons, late sixteenth century.

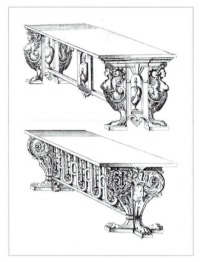

TABLES, FRENCH RENAISSANCE.
Two massive and elaborately carved (*tables a l'Italiennes*, designed by du Cerceau, sixteenth century. *(Hunter)*

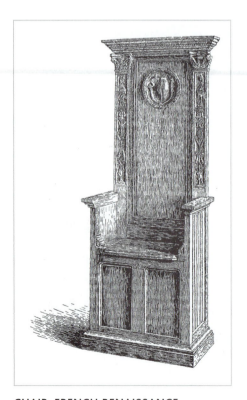

CHAIR, FRENCH RENAISSANCE.
Heavy boxlike chair of oak panels and tall straight back, resting directly on the floor without legs, sixteenth century. *(Magne)*

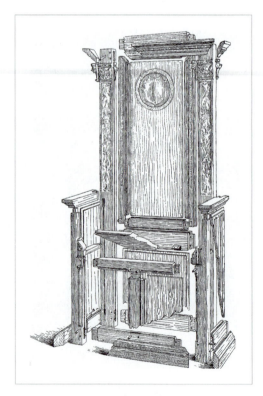

Construction drawing of boxy chair. *(Magne)*

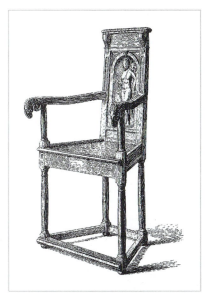

**CAQUETOIRE, FRENCH
RENAISSANCE.**
Oak *caquetoire*, designed to
accommodate wide ladies' skirts in the
late sixteenth century, a noticeable
contrast to the enclosed boxy chair.
(Magne)

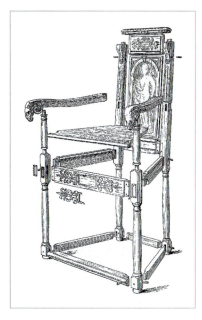

Construction drawing of *caquetoire* with
decorative inlay on front seat rail.
(Magne)

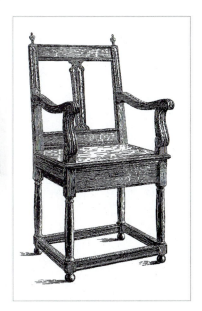

ARMCHAIR, FRENCH RENAISSANCE.
Oak armchair with rectangular seat and
back, columnar legs connected by heavy
stretchers, and curved arms, sixteenth
century. *(Magne)*

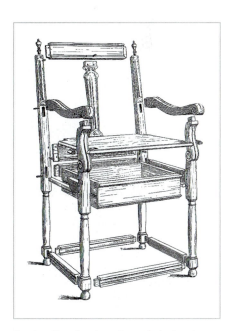

Construction drawing of armchair showing
mortise and tenon joinery. *(Magne)*

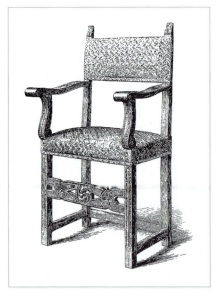

FAUTEUIL, FRENCH RENAISSANCE.
Early version of the *fauteuil*, an open
armchair with the addition of upholstery,
early seventeenth century. *(Magne)*

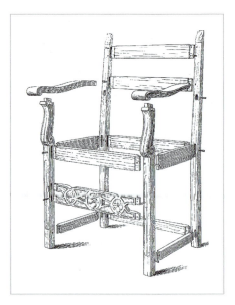

Construction drawing of *fauteuil*. *(Magne)*

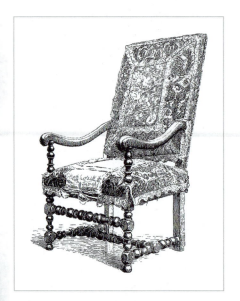

FAUTEUIL, FRENCH RENAISSANCE.
Louis XIII *fauteuil* with large rectangular
upholstered seat and back, curved arms, and
turned front legs and stretchers. *(Magne)*

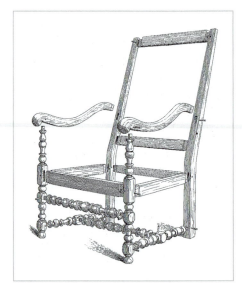

Construction drawing of Louis XIII *fauteuil*.
(Magne)

Furniture Forms

Chairs gradually changed from the massive Gothic boxy form under François I to lighter
forms with open arms. Early paneled wood backs with carved Renaissance motifs changed
to backs with carved solid splats, arcading, or turning. The ***caquetoire***, or conversation
chair, was introduced around the mid-sixteenth century with a high-paneled back and wide
seat at the front. An armless chair and a chair with a low seat were also introduced at this
time. Various stools and benches were abundant in the sixteenth century, many retaining
Gothic construction.

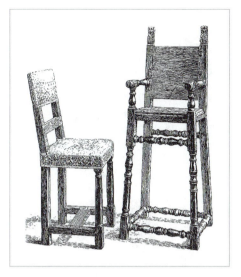

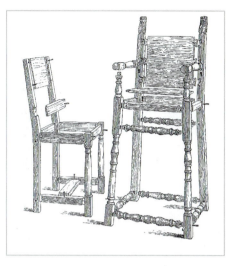

CHAIRS, FRENCH RENAISSANCE.
Small child's side chair, and high chair with
two rows of turned stretchers, Louis XIII
period. *(Magne)*

Construction drawing of child's chairs. *(Magne)*

1608
Hans Lippershey invents the
telescope; Captain John
Smith writes the first book
in America.

1608–1674
John Milton.

1609
Kepler's *Astronomia nova*.

1610
Galileo's ×30 power
telescope; forks used at the
dining table.

1611
Scientific papers on
rainbows, on snowflakes,
and King James *Bible*
published; sunspots seen
and Orion nebula
discovered.

1615
William Baffin journeys to
within 800 miles from the
North Pole.

Few early French beds have survived. The four-poster bed with a **tester** may have
been elaborately carved. As the century progressed, sumptuous textiles, especially silks,
were used by the wealthy to cover these rather monumental beds. Tables were also mas-
sive, especially the **trestle** table with removable top. Other large, richly decorated tables
with stretchers close to the floor resembled those of the Italian Renaissance.

Chests with carved decorations on the front resembled Northern versions more than
Italian *cassoni*. Cabinets, which were first imported from Italy and from Flanders, were
highly decorative. These differed from simpler cupboards because of the elaborate interior
fittings, such as small drawers, doors, and even secret panels. *Dressoirs* (dressers), buffets,
and armoires were other French Renaissance case pieces. The armoire evolved and became
more common in the sixteenth century. Architectural features like pediments made these
already large pieces even more imposing.

FRENCH BAROQUE

By the mid-seventeenth century, under Louis XIV (1638–1715), France became the most
powerful European country. With absolute power and self-proclaimed divine right to rule,
the king was not only the state, he also controlled businesses, science, and the arts. The
prevailing Baroque architectural style was, not surprisingly, theatrical and complex. Unlike
Renaissance architecture, with separate and defined elements and with a stable and static
appearance, Baroque was more dramatic and dynamic. Classical elements were still used,
but were often reinterpreted, even distorted, or integrated with sculpture. The Mansards,
led by François Mansard (1598–1666), known for applying the high-pitched "mansard"
roof to classical-styled buildings, were the leading French Baroque architects.

The Louis XIV style was largely the result of the king, his court, and the royal work-
shops he supported. As absolute monarch, the king chose the sun as his symbol, hence
the title Sun King. He built the Palace of Versailles, which stood as the symbol of his
court's brilliance. Renaissance classicism gave way to High Baroque with all its dra-
matic pomp and glory. By the mid-seventeenth century, French artists and artisans, no
longer dependent on Italy for inspiration, began to show unprecedented originality. The
king provided apartments and workshops at the Louvre for the most skilled artists to
work and reside.

This elite group of royally sponsored cabinetmakers and other artisans were organized in 1662 at the Gobelins, which became a state institution. Originally the tapestry workshops of the Gobelins family, in 1667 it was elevated to the Royal Manufactory of Court Furniture for all the decorative arts. This enabled the decorative arts to rise in status equal to painting, sculpture, and architecture, a practice that continued in the next century. This and the centralization of the arts under the crown account for the remarkably high level of quality in these arts under Louis XIV. Cabinetmakers like Italian-born Philippe Caffieri (1634–1716) and Jean Bérain (1638–1710) were responsible for some of the exquisite ornamentation that exemplified the furnishings. Domenico Cucci (ca. 1635–1704) was an Italian sculptor and furniture maker who became a naturalized French subject. He was one of the finest craftsmen at the Gobelins under Louis XIV, and he contributed to the overall grandeur of Versailles. The most renowned of all, however, was André Charles Boulle, head cabinetmaker to the king.

André Charles Boulle (1642–1732)

Though few pieces can actually be attributed to him, Boulle is known as the first great French *ébéniste*. Born in Paris, the son of a carpenter, Boulle was trained as a carpenter and a painter. He began his residence at the Louvre in 1672, at the age of thirty, and he provided a good deal of the furniture at Versailles. Boulle perfected a form of marquetry using ebony, tortoise shell, and various metals, and he also worked in various rare woods. Intricate designs of arabesques, foliage, and other motifs were executed with thin layers of these materials. The results were so extraordinary that it became known as **Boulle work**, and the art was carried into the next century, long after the Baroque style faded.

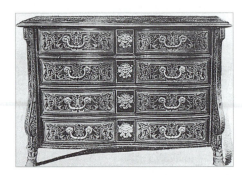

COMMODE, FRENCH BAROQUE.
Louis XIV commode by André-Charles Boulle, with eight drawers, each with a bail handle and inlaid design, on hoof feet. *(Strange)*

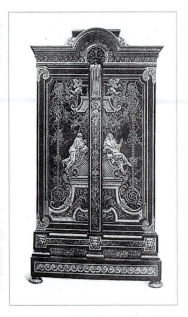

ARMOIRE, FRENCH BAROQUE.
Louis XIV ornate armoire by André-Charles Boulle, with inlay of ebony, copper, and mother-of-pearl and gilded bronze mounts. *(Hunter)*

DESK, FRENCH BAROQUE.
Boulle writing table or desk, with inlaid drawer fronts and eight scrolled and turned legs, Louis XIV. *(Strange)*

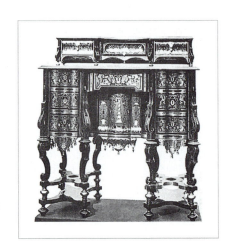

1630
John Billington is the first to be executed in America.

1632–1704
John Locke, basics of constitutional democracy.

1632–1723
Antonie van Leeuwenhoek.

1633
Roman Catholic Inquisition forces Galileo to retract his Copernican view that the Earth orbits the Sun.

1635
First public school in America.

1636
Harvard College founded.

1637
Descarte's *Discourse on Method*.

1638–1715
Louis XIV of France: builds Versailles but weakens France; in 1664 he uses cast iron pipes to bring water to the gardens.

1641
First American patent filed.

1642
Rembrandt's *Night Watch*.

1642–1727
Sir Isaac Newton.

1643
Mercury barometer; first American divorce.

1647
Yellow fever in the Americas.

Boulle's artistry on cabinets, armoires, commodes, and even clock cases marked the beginning of an era of unprecedented French marquetry art. The twenty workshops devoted to Boulle work in the Louvre were managed by Boulle and then by his sons Jean-Philippe and Charles-Joseph; his other sons, Pierre-Benoit and André-Charles worked independently. The Boulle tradition lasted until Charles-Joseph died in 1754. However, both good and bad imitators continued to do Boulle work as late as the nineteenth century.

Louis XIV Furniture

Like other furniture of the period, French Baroque was still essentially rectilinear, with curves used mostly as decorative features, such as carved scrolls or stretchers connecting chair legs. Although the furniture appears to be heavy and massive, much of it was intended to be placed along walls and moved as required. Woods used to make court furniture included ebony, walnut, oak, and beech; a variety of exotic woods were used to make marquetry. Other decorative techniques included carving, gilding, lacquering, inlay of semiprecious stone, and the use of gilded bronze hardware and ornament called ormolu.

Chairs were more important than ever. High rectangular backs, curving arms ending in volutes, tapestry upholstery, and curved cross or X-stretchers with a carved **finial** characterized the style. The seat was sometimes finished in long hanging fringe. Upholstered sofas were introduced and were also made to be used with matching armchairs, en suite.

Beds were monumental, particularly in their function of extravagant display of textiles. This drapery was often so complete, the occupant was in a miniature room, protected by drafts and completely private. The daybed, introduced about 1625, came into more general use at this time.

Tables came in a wide variety, but like chairs, were usually meant to be placed against walls. Tops of marquetry, stone mosaic, or solid colored marble made the tables extremely heavy and therefore relatively immobile. Smaller, specialized tables, such as for playing games, dressing, or working were introduced, but these were not fully developed until the next century. However, writing tables made by Boulle were popular.

Storage pieces—cabinets, chests, commodes, and cupboards—were ideal for decorating with Boulle marquetry or stone inlay. The marriage chest in the form of an arched coffer on a stand was a Boulle innovation. Commodes in sarcophagus form were inspired by the Italian, and an existing pair is attributed to Boulle himself. Boulle was one of the first to design large armoires for storing prints and drawings, their continuous surfaces being perfectly suited for his marquetry. Two- and three-door low cupboards were developed but became more popular in the next century.

DUTCH AND FLEMISH RENAISSANCE

Banking and commerce had enabled Florence to rise as a center of Renaissance art and culture in the fifteenth century. By the sixteenth century, Germany and the Netherlands replaced Italian states as centers of banking and trade. This new wealth and secular power, corruption in the Italian church, and the invention of printing led to the Reformation, enabling a Northern Protestant church to not only separate but to quickly spread.

Related to this separation and development of a new religion and economic structure, architecture and art also developed along different lines in the North. There, Gothic had been more highly developed in the Middle Ages, so classical elements were later added to otherwise Gothic forms. Generally, Belgium was most influenced by France, and Holland was influenced by Germany. Bustling commercial and industrial centers of Ghent, Brussels, Antwerp, Utrecht, and Amsterdam also became important centers of art and crafts.

The House of Burgundy united the Netherlands with Spain in the sixteenth century under Emperor Charles V, and the Burgundian court was well known for its luxury and opulence. Because the Netherlands economy was largely based on trade, and both the nobility and royalty loved luxuries, there was a climate of materialism that could rival any

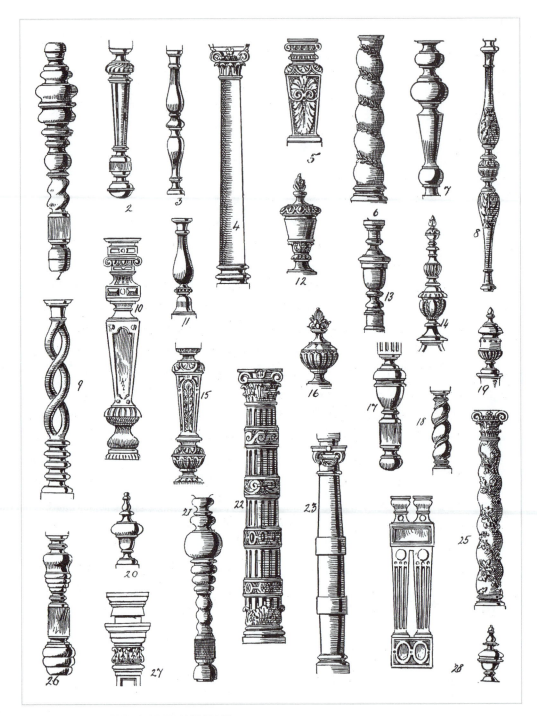

DETAILS, FRENCH RENAISSANCE.
Details of carved and turned legs used during the Louis XIII period in the first half of the
seventeenth century. *(Strange)*

***FAUTEUIL*, FRENCH BAROQUE**

Louis XIV *fauteuil*, a progression of chair style from the preceding period, now with luxurious tapestry or other fine upholstery and ornate Baroque carved legs with arched **X**-stretcher. *(Magne)*

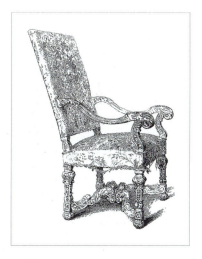

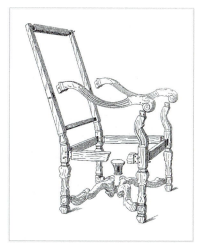

Construction of Louis XIV *fauteuil*. *(Magne)*

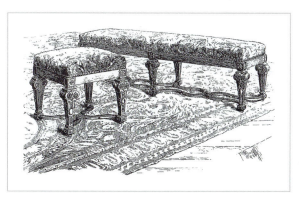

***TABOURET* AND BANQUETTE, FRENCH BAROQUE.**

Louis XIV square upholstered stool with short legs called a *tabouret*, with a long low upholstered bench called a banquette. *(Magne)*

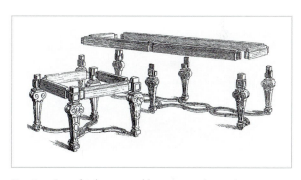

Construction of *tabouret* and banquette. *(Magne)*

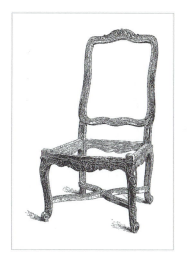

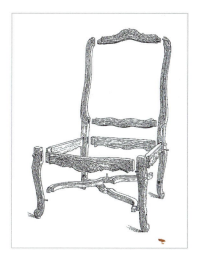

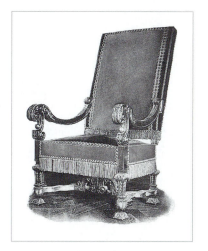

CHAISE, FRENCH BAROQUE.

Louis XIV side chair frame shown without upholstery; early use of the cabriole leg and foundation for the Rococo curvilinear style. *(Magne)*

Construction of chaise.

ARMCHAIR, FRENCH BAROQUE.

Louis XIV armchair, basically rectilinear in form but with curved arms and stretchers, with fringed velvet upholstery. *(Strange)*

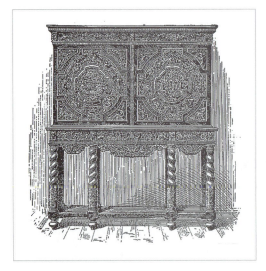

ARMOIRE, FLEMISH RENAISSANCE.
Ebony armoire with richly carved door fronts, supported by twist turned legs on small bun feet, sixteenth century. *(Hirth)*

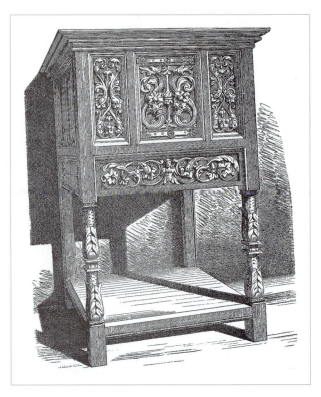

CREDENZA, GERMAN RENAISSANCE.
Boxlike cabinet with lower shelf and carved panels and front legs, 1530. *(Hirth)*

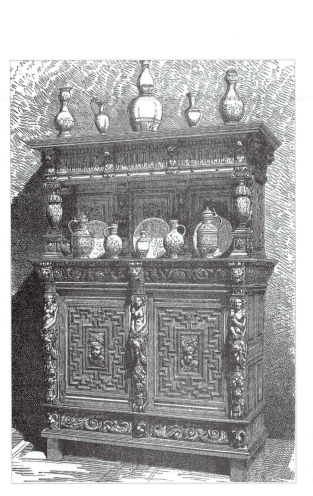

CABINET, GERMAN RENAISSANCE.
Massive cupboard with open top shelf, Flemish-style cup-and-cover supports, and Italian-style term figures bordering the two large doors, sixteenth century. *(Hirth)*

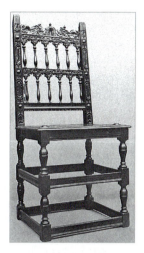

SIDE CHAIR, FLEMISH RENAISSANCE.
Walnut side chair with turned spindles on back in double rows of arcaded pattern, turned legs, and two rows of stretchers, early seventeenth century.
(Hunter)

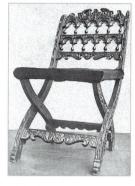

FOLDING CHAIR, FLEMISH RENAISSANCE.
Walnut folding chair with similar arcaded back and turned spindles, seventeenth century.
(Hunter)

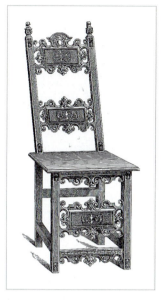

SIDE CHAIR, GERMAN RENAISSANCE.
Rectilinear side chair with scroll carving around splats and front stretchers, sixteenth century.
(Hirth)

1650
Date of Creation set at 4004 B.C. by Bishop Ussher; Cyrano de Bergerac suggests travel from the Earth to the moon in rockets; German physicist Otto von Guericke produces a vacuum; first coffee house in England (Oxford).

1651
Hobbes's *Leviathan*.

1656
Pendulum clock.

1657
First chocolate house in England (London).

1659
Surface features of Mars observed.

southern European region. From gold and silver plate to tapestries, from gilded leathers to fine furniture, the wealthy had insatiable appetites for decorative art objects. The intellectual climate further reinforced the taste for fine things.

Furniture Forms

Early Flemish Renaissance furniture was similar to French furniture of the period with basically massive rectilinear forms. Renaissance motifs were frequently blended with or grafted onto Gothic forms. Walnut began to replace oak, which allowed for much crisper and finer carving, and Flemish woodcarvers gained reputations for outstanding work throughout Europe. Like in France, designers and design codifiers published books of engravings. Hans Vredeman de Vries (1527-ca. 1604) was a Dutch painter who went to Flanders and published volumes on Renaissance/Mannerist architectural ornament in 1565. His son Paulus modified these very popular designs and published them again in 1630.

Flemish furniture of the sixteenth century was similar to medieval furniture and was permanently fixed or built into walls. In addition to cupboards, benches, and settles, even beds might be permanent by building them into the paneling of walls. The function of these enclosed spaces, like heavy textiles covering beds, was privacy and warmth in unheated rooms. Freestanding, but also permanent, beds sometimes had paneling extending to the floor in place of legs.

Tables were not unlike those of the Italian Renaissance, with rectangular tops supported by end trusses, brackets, legs, or pedestals. The draw-top table was a Flemish innovation. Storage cabinets were among the most elaborate and lavishly decorated of all Flemish Renaissance furniture. Figural supports, secret drawers, stone and ivory inlay, and skillful carving were found on the finest pieces. Chests were also vehicles not only for storage, but for the display of the finest workmanship, especially carving.

DUTCH AND FLEMISH BAROQUE

The separation of Europe into Catholic and Protestant regions had a profound effect on art, including furniture. Although Baroque painter Peter Paul Rubens, whose sensuous style represented southern Catholic Europe, was accepted in the southern Netherlands, he was initially rejected in the north. Eventually, northern provinces adopted a less exuberant version of Baroque style. After the Dutch East India Company was formed in 1602, Holland had a trade monopoly in the Far East. Chinese influence in the arts, commerce, and wealthy patrons all contributed to great artistic success in Holland. Rembrandt van Rijn and many other artistic geniuses provided Holland with an artistic golden age in the seventeenth century. Eventually, even furniture briefly drifted away from French influence and gained its own identity.

In 1685, the decorative arts were profoundly affected by a political event. The Edict of Nantes, which had granted religious freedom in France, was revoked. Many French Protestants, the Huguenots, were skilled artisans, and they fled to Holland, Germany, Switzerland, and England to seek refuge. Of all of the French Huguenots to settle in Holland, Daniel Marot (1666–1752) is the most famous. Architect, furniture designer, and ornament engraver for the French court, he emigrated to Holland and brought the Louis XIV style, complete with marquetry, inlay, and carving. He then carried the style to England, which accounts for many of the stylistic similarities between Holland and England at that time.

The Dutch were responsible for a number of new and distinct features on furniture. **Turning** was very important, especially for the structural members of chairs. Toward the end of the seventeenth century, the Dutch introduced the cabriole leg, which became a much more significant feature in England, on Queen Anne furniture. The Dutch also developed a hoop-shaped chair back using one continuous piece of wood. Ball or bun feet were used on different furniture forms, including the *kas* or *kast*. An oversized cupboard, the *kas* incorporated architectural features, innovative use of decorative moldings, often of contrasting woods to create bold geometric patterns.

Flemish Baroque furniture was very similar to French Louis XIII and even more so during the Louis XIV period. A characteristic chair with scrolled front leg, closely resembling French Baroque, often used cane seating instead of tapestry upholstery. A variety of spirally turned chairs, however, were similar to Dutch models. Items such as tables and cupboards also shared features with the French.

ENGLISH RENAISSANCE, 1500–1660

Unlike France, with an absolute monarch, England had both a king and a Parliament, and friction between the two resulted in war. In addition, in 1455 civil war called the Wars of the Roses broke out between the houses of Lancaster and York. By 1485 the Wars of the Roses ended, bringing an end to feudalism and new feelings of security and prosperity. The Tudor period (1485–1603) reflected close cultural ties between England, Germany, and the Netherlands.

The medieval hall with its central hearth evolved into long galleries with wall paneling and tapestries. Furniture forms increased, and a variety of chairs, dining tables, and cupboards filled these halls. Most early Tudor furniture in the first half of the sixteenth century was of frame and panel construction; finish was simply wax or oil; and upholstery was confined to beds and bedding, with a few loose seat cushions placed on wood chairs. English architectural features, such as the **Tudor arch** and **Tudor rose** motif, were incorporated into furniture ornament. But Italy had a strong influence on English Renaissance furniture under Henry VIII—in fact, it often looked as if Italian Renaissance art was grafted onto English medieval forms. In some cases, the form was also Italian, such as X-frame chairs, sometimes with carved medallion heads called **Romayne work**. Italian influence continued into the seventeenth century primarily through architecture. A restrained classicism was used by Inigo Jones (1573–1652), a follower of Palladio. Jones had visited

1664
England takes New York City from the Dutch.

1665
Philosophical Transactions published by the Royal Society in England; *Journal des Savants* published in France; Newton invents calculus, discovers that white light is made of colored light, and begins formulating the laws of gravity.

1666
Great Fire of London just after the Great Plague of London kills 75,000.

1671
First stoneware (Fulham Pottery).

1672–1725
Peter the Great.

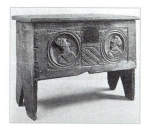

STOOL, ENGLISH RENAISSANCE.
Simple boxy oak stool with Romayne work carvings decorating the front, early sixteenth century. *(Hunter)*

Italy in the early seventeenth century and had acquired original drawings by Palladio, which formed the basis of the English Palladian movement in the early eighteenth century.

Not only Italian, but Dutch, German, and Flemish influences were found on English Renaissance furniture. Artisans came to England from Flanders and the Netherlands; pattern books made it easy to borrow German or Flemish designs and motifs; and furniture was imported from the Continent. Elizabethan style of the second half of the sixteenth century was especially influenced by Flemish elements. Bulbous turning found on legs of chairs and tables was soon given a more English character by the addition of elaborate carving. Typical of the period were these bold, bulbous **cup-and-cover** supports, also referred to as **acorn turning**, as well as other turned and carved features.

Not all furniture relied on bold carving. The wainscot chair was made of oak with a paneled back extending to the seat rail. Another distinctive, but less common, item called a "thrown chair" was made entirely of turned **spindles**. As more people accumulated more possessions, many Elizabethan innovations focused on storage. What had formerly been a chest, became a **settle**, with the addition of arms and a paneled back, often with linenfold carved decoration. The cupboard, a plain board on which cups stood, became increasingly complex. Though still an open form, the heavily carved **court cupboard** was as much of a display piece as the objects it was meant to display. When the bottom shelf became enclosed with doors, it became a **press cupboard** to store linens. Besides carving, inlay and marquetry was sometimes used to decorate items like storage chests, such as the easily identifiable Nonesuch chest. With its inlaid marquetry panels of architectural motifs, it was intended to resemble the Nonesuch Palace of Henry VIII.

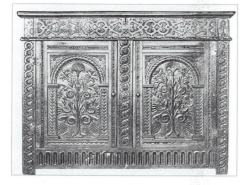

CABINET, ENGLISH RENAISSANCE.
Elizabethan cabinet with chip carving of poplar tree under arch motif on front panels, sixteenth century. *(Hunter)*

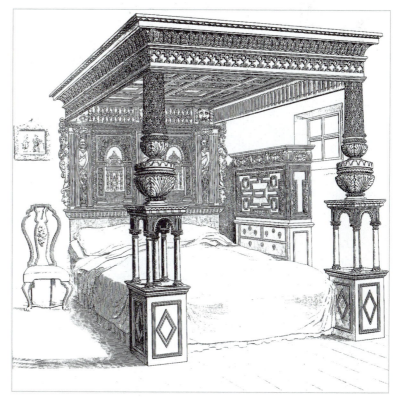

GREAT BED OF WARE, ENGLISH RENAISSANCE.
Giant bed of heavily carved oak with huge tester and paneled headboard, and foot posts with cup-and-cover and four-column supports, Elizabethan period. *(Shaw)*

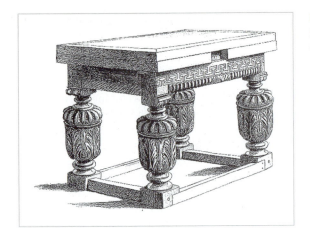

DRAW TABLE, ENGLISH RENAISSANCE.
Heavy oak draw table with massive stretchers at the floor and four oversized cup-and-cover leg supports, Elizabethan period. *(Shaw)*

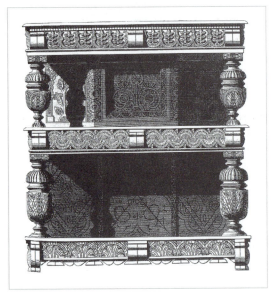

COURT CUPBOARD, ENGLISH RENAISSANCE.
Elizabethan court cupboard with huge acorn turnings (cup-and-cover) on each end of the two open shelves. *(Shaw)*

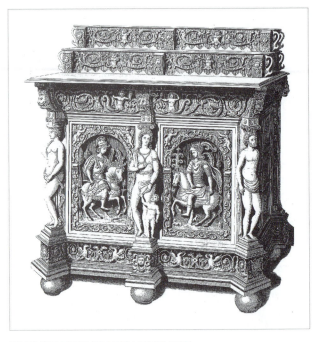

CABINET, ENGLISH RENAISSANCE.
Cabinet with two stepped shelves on top and two heavily carved doors enclosing the storage area beneath, with three sculptural figures on pedestals supported by bun-ball feet, Elizabethan period. *(Shaw)*

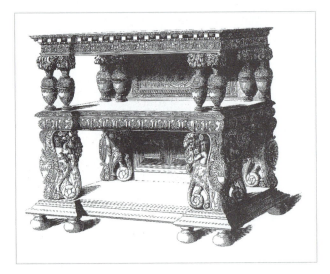

COURT CUPBOARD, ENGLISH RENAISSANCE.
Ornate court cupboard with eight cup-and-cover supports in the top tier and sculptural mythological figures supporting the bottom tier, with eight bun feet, Elizabethan period. *(Shaw)*

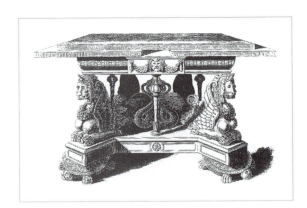

TABLE, ENGLISH RENAISSANCE.
Sculptural table with four massive legs carved into smiling winged unicorns with human female breasts, similar to a caryatid, resting on a platform and supported by grunting turtles, late Elizabethan period. *(Shaw)*

1674
van Leeuwenhoek discovers microbes.

1678–1741
Antonio Vivaldi.

1679
First pressure cooker.

1680
Dodo bird becomes extinct on Mauritius; minute hand on clocks.

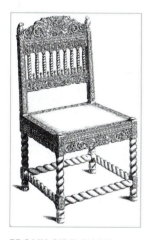

EBONY SIDE CHAIR, ENGLISH RENAISSANCE.
Spiral turned legs, stretchers, and back spindles, early seventeenth century, Jacobean period. *(Shaw)*

Jacobean Furniture

By 1600 massive furniture forms, such as beds with posts and paneled headboard supporting testers, were becoming more common among the upper class. The **draw-leaf table** now provided additional top size as needed. Under James I, the Jacobean style of the first half of the seventeenth century stressed slightly simpler lines from the previous Elizabethan. Many of the Elizabethan ornamental elements—gadrooning, Romayne work, masks, and caryatids—lost favor during the Jacobean period, while others—guilloches, strapwork, arabesques, and grotesques—continued to be used. Fluting, arcading, and the use of split spindles were also used to decorate Jacobean furniture.

The wealthy required display, so the carved decoration on, for example, a court cupboard was as much an item of display as were the objects placed on it. In addition to carving, other methods of decorating Jacobean furniture included turning, inlay, and painting. Inlay typically relied on floral or checkered motifs, and another popular motif, strapwork, could be either carved or painted. Oil, used to finish sixteenth-century furniture, was replaced by beeswax in the seventeenth century.

Jacobean seating furniture included chairs, benches, stools, and settles. The wainscot chair, introduced during the Elizabethan period, with its paneled back and open arms, continued to be used by the manor lord. Yorkshire-Derbyshire chairs had two elaborately carved crescent-shaped rails, but the boxy seat and turned legs were not unlike the more austere Cromwellian style at mid-century. During the early seventeenth century, however, comfort was gaining more attention, so upholstery was added to many seating forms. Fixed upholstering, with velvets, silk damasks, and needlework, was practiced by about 1620, followed by colorful "turkey-work," named after the Turkish carpets that inspired them. One new form of upholstered seating, the **farthingale chair**, had no arms to impede the female sitters with fashionably wide skirts. Unupholstered seating continued to be made, sometimes in novel forms. The so-called monk's bench (though not used by monks) was a bench with a seat that opened to a chest and a back that converted to a table. This idea of convertible furniture with its medieval origins would continue to fascinate furniture makers through the nineteenth century.

The bulbous turned supports used on court and press cupboards during both Elizabethan and Jacobean periods were also used on the large draw tables used for dining. In addition to these massive tables, a variety of smaller tables came into use. Oblong, oval, or octagonal tops were supported by columnar, fluted, or turned legs, usually joined by a floor stretcher. The gateleg with a single leaf and single gate was known earlier, but about 1620 the version with two drop leaves and two pivoting gatelegs was introduced.

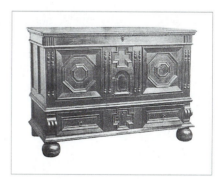

CHEST, ENGLISH RENAISSANCE/BAROQUE.
Transitional Jacobean–William and Mary chest with geometric moldings in place of carved panels, shows Dutch influence in panels and squat ball feet, late seventeenth century. *(Hunter)*

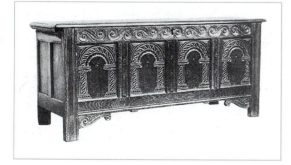

CHEST, ENGLISH RENAISSANCE.
Jacobean storage chest with chip carved panels, on four legs, early seventeenth century. *(Hunter)*

During the Jacobean period, for a short time under Cromwell, furniture was rugged looking. Appointed Lord Protectorate in 1642, the Puritan Oliver Cromwell required simplicity and austerity in all aspects of culture, including furniture design. In fact, anything with sensual appeal, including art, was associated with corruption and consequently banned. This period of religious wars and artistic stagnation had a distinctly harsh visual appearance. Chairs might have leather coverings with brass nails instead of velvets. With the restoration of the monarchy in 1660, English furniture design resumed its pre-Cromwellian taste for luxury.

ENGLISH BAROQUE, 1660–1714

High standards of construction were maintained through the trade guilds regardless of styling. The elaborate cup-and-cover turnings gradually became simpler, until they were no more than pillar supports. By the second half of the seventeenth century, turned elements prevailed, and the barley sugar twist was among the most popular and certainly the most graceful. By mid-century these efficient and attractive turnings were used not only for chair legs, but for supports on tables and dressers fitted with drawers. Other innovations at this time included the use of raised panels with mitered corners, similar to those used on the Dutch *kas*. Inlay of bone and mother-of-pearl were additional means of embellishment.

In 1660, when Charles II returned to England and the monarchy was restored, opulence and splendor once again became fashionable. The term cabinetmaker was introduced, along with new forms like the bookcase as a separate piece of furniture. Walnut became the preferred wood, replacing oak, and the period from about 1660 to 1730 is known as the "walnut period." The seventeenth century saw an expansion of world trade, and seafaring nations like Holland and England became centers. Porcelain was imported from China, lacquered goods from Japan, and oriental artistic influence swept through Europe. The fashion was so widespread that English and Continental workshops made their own versions of oriental furniture and decorative arts, called ***chinoiserie.***

In 1666 the great fire of London left nearly a quarter of a million people homeless and without furnishings. Once houses were constructed, people needed a quick method of providing relatively inexpensive furniture. Cheap cane chair seats and backs, inspired by Indian canework, filled the need and started a fashion that would persist into the eighteenth century. Cane was also used for elaborately carved and turned walnut seating furniture, from chairs to daybeds. These Charles II high-back chairs with scrolled front stretchers characterized the period and the style. Other items, especially tables, used barley sugar twists, bobbins, and other turnings. The gateleg table, introduced earlier, was made with drop leaves and extra turned legs that could swing out to support the extra top. Fall-front bureaus with overhanging tops, of walnut or oak, were also perched on slender turned legs.

The Revolution of 1688 brought William of Orange and his wife Mary to the English throne. When the monarchy was restored, England completely adopted Baroque style, employed by architects Nicholas Hawkesmoor (1661–1736) and Christopher Wren (1632–1723). Interiors used tall panels and pilasters with capitals for decoration. Whether on furniture or interior architecture, carving characterized the last thirty years of the seventeenth century. The most renowned woodcarver was Grinling Gibbons (1648–1720), and his naturalistic fruit, flowers, and birds represent some of the finest carving known. Patrons Charles II and Christopher Wren helped to spread his reputation and popularity.

Protestant Huguenots, many of whom were skilled artisans, fled religious persecution in France and settled in England, as well as in Holland. Dutch and German artisans also came to England, contributing their own stylistic elements. Daniel Marot (1666–1752), architect, furniture designer, and ornament engraver for the French court, fled to Holland and brought the Louis XIV style to Holland as well as to England. Marot introduced mar-

quetry, which was a highly developed craft in Holland. Panels of the delicate pieces of contrasting veneers were placed inside borders on a variety of furniture forms. Cabinets were fitted with drawers, doors, and marquetry panels, all perched on turned legs.

Typical William and Mary legs were shaped like an inverted cup, or umbrella, with carved X-shaped stretchers resembling those on Louis XIV chairs. In fact, a good deal of high-style William and Mary items bear a strong resemblance to Louis XIV furniture. Chair arms were scrolled with inverted S-shaped supports, and chair backs became taller than ever. Writing furniture became more varied and specialized and included the bureau and writing table, slant-front desk, kneehole writing table, and secretary cabinet. The dressing table, introduced about 1680, was in general use; the tallboy, or chest-on-chest, was introduced about 1700, along with corner cupboards and card tables; and items like tall case clocks and mirrors were also found in elegant rooms.

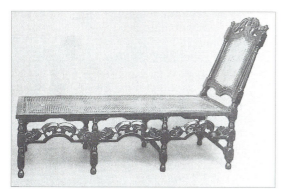

DAYBED, ENGLISH BAROQUE.
Charles II daybed with caned seat and headrest,
elaborately carved stretchers, 1660s. *(Hunter)*

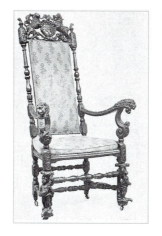

ARMCHAIR, ENGLISH BAROQUE.
Charles II armchair with elaborately
carved crest and legs in royal motifs,
upholstered, although caning was a
very popular alternative during the
period, 1660s. *(Hunter)*

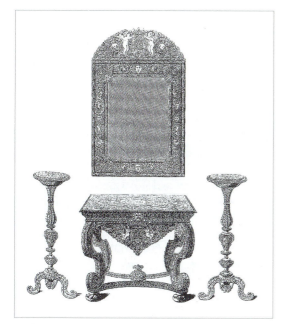

SILVER FURNITURE, ENGLISH BAROQUE.
Looking-glass with convex beveled frames with highest
part near the glass; table with four scrolled legs connected
by two curved stretchers joined by a large finial; and a pair
of candle stands with scrolled tripod legs, 1680s. *(Shaw)*

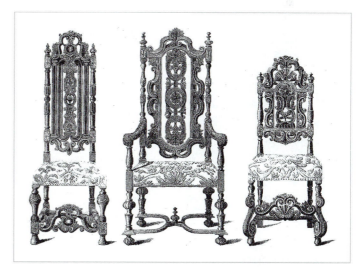

ARMCHAIR AND TWO SIDE CHAIRS, ENGLISH BAROQUE.
Left, tall-backed side chair with elaborately carved back, straight legs, and
front stretcher; center, armchair with similar legs and back, with two
curved cross stretchers topped by a finial; right, lower straight-backed
side chair with scroll legs and elaborate front stretcher, all with
upholstered seats, William and Mary period. *(Shaw)*

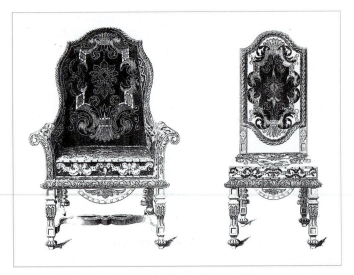

ARMCHAIR AND SIDE CHAIR, ENGLISH BAROQUE.
Armchair and side chair, each with straight carved legs and bottom seat rail and upholstered seat cushion; the armchair has scrolled arms and a shaped back; the side chair with tall straight back typical of the William and Mary period. *(Shaw)*

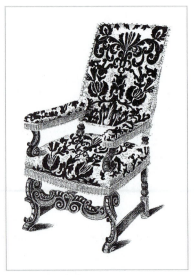

VELVET ARMCHAIR, ENGLISH BAROQUE.
High-backed armchair with velvet upholstery on seat, back, and arms, with scrolled legs and elaborate front stretcher, William and Mary period. *(Shaw)*

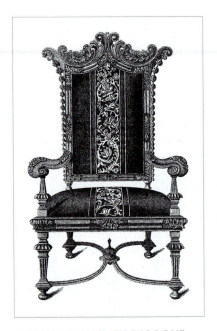

ARMCHAIR, ENGLISH BAROQUE.
Armchair with elaborately carved straight back and legs, curved cross stretchers with finial, and upholstered back and seat, William and Mary period. *(Shaw)*

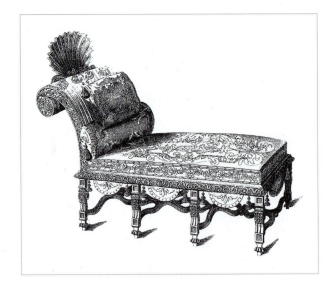

COUCH OR DAYBED, ENGLISH BAROQUE.
Daybed with eight carved legs and scrolled headrest topped by a large shell, upholstered seat, William and Mary period. *(Shaw)*

The English fashion for marquetry ended with the century, but one Dutch invention (perhaps originating in China) that would influence English furniture well into the eighteenth century was the cabriole leg. The curvilinear form was quite different from the curved ornamentation and detail used on rectilinear forms during the Renaissance. Introduced during the late Baroque period, the concept of curved construction elements would revolutionize English style, beginning with Queen Anne in the eighteenth century.

AMERICAN COLONIES

The arts in the American colonies were very low on the long list of priorities for several reasons. This group of people had left their homes in England and were extremely occupied establishing new lives in a new land. Beyond the basic needs of food, shelter, and some clothing, there simply was little or no time for other endeavors. The number of trained artists or artisans who happened to be in the colonies was small, and the number of potential clients was even smaller. Even after safe arrival to America, a skilled artist probably had little opportunity to use these skills.

For example, glassmaking never really succeeded in America until the nineteenth century with the invention of pressed glass. A small glass furnace, which was founded in Jamestown in the early seventeenth century, was short lived, and the product was crude by European standards. Crafts, such as furniture making, developed very slowly and followed English styles for a very long time. Even the highly developed mid- to late-eighteenth-century furniture industry continued to follow England's fashion lead. As with glassmaking, American crafts relied on Europe at least until the Victorian period with its increase in mechanization, wealth, and consumerism. Even then, it would be technology more than art where Americans would succeed most.

The earliest colonial American furniture looked like, and in fact often was, English. Though many colonists tried to keep up with styles, there was usually a time lag of several decades between what was fashionable in England and what finally arrived in the colonies. Because no American furniture has survived from the earliest years, pieces from the mid-seventeenth century are the earliest known. Joiners made these relatively crude oak cabinets, chests, and chairs until the end of the century, when a separate profession of cabinetmaking evolved.

Heavy turned and carved Jacobean-style furniture was comparable to many English pieces, and these were made and used even after the fashionable William and Mary style swept through England. Jacobean furniture of the first half of the seventeenth century in England was found in the American colonies in the second half and beyond, especially in the provinces. This provincial furniture, made locally by local craftspeople of local woods, did not adhere to the current fashions as did the so-called high-style furniture. So in addition to its simpler and more freely interpreted lines, provincial furniture was often made at a later date than comparable period pieces. Regional variations soon appeared in the colonies and took on a distinctly American appearance.

Chests are a good example, notably **Hadley** and sunflower or Connecticut chests, which were made in the Hadley area of Massachusetts and in parts of Connecticut. These rectangular boxes on straight legs were covered with chip carving in the form of scrolls and flowers, which were then painted. Other ornamental features used on chests included applied moldings, split spindles, and bosses. Besides the ubiquitous chest, American variants included tables and chairs as well. Turning was used to construct several versions of an armchair, notably the famous Brewster and Carver chairs. The Carver type had fewer turned spindles and none under the arms, while the elaborate Brewster chair had two rows of spindles on the back, under the arms, and under the seat. A chair based on the form of these turned chairs, but of much simpler design, was the slat-back and ladder-back chair. This practical, economical, provincial design has persisted into the twenty-first century. Although there were many American interpretative variations, even those colonists born in America considered themselves to be English, and they looked to England for guidance in matters of culture and the arts.

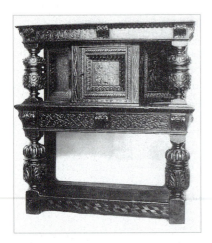

COURT CUPBOARD, AMERICAN.
Heavily carved oak court cupboard with massive cup-and-cover supports, identical to English versions a few decades earlier, mid- to late seventeenth century, American Jacobean. *(Hunter)*

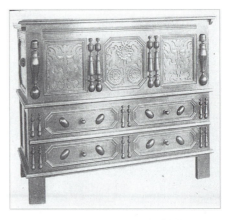

SUNFLOWER CHEST, AMERICAN.
Connecticut sunflower chest of oak or pine, with three chip carved panels, the center one with sunflower motif, applied split spindles and bosses, late seventeenth century, American Jacobean. *(Hunter)*

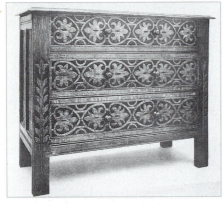

CHEST, AMERICAN.
Oak Jacobean chest with three wide drawers covered in a pattern of chip carving, on four rectangular legs, late seventeenth century. *(Hunter)*

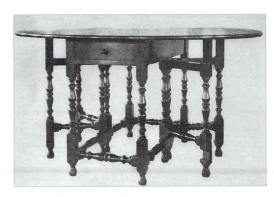

GATELEG TABLE, AMERICAN.
Jacobean table with four gates to support drop leaves, turned legs and stretchers, and a drawer for silver, late seventeenth century. *(Hunter)*

ARMCHAIR, AMERICAN.
Oak chair made almost entirely of turned work, with a rush seat; a common chair form used both in England from the sixteenth century and in the colonies from the seventeenth century.

Immigrants from other parts of Europe—France, Germany, Holland, and Sweden—also began to settle in the New World, and regional differences began to appear as early as the late seventeenth century. Dutch items, like the *kas* or *kast* storage chest, were popular, and the ball feet and more squat proportions of Dutch styling would soon give New York furniture its own regional distinction. But wealthy merchants in major centers like Boston continued to seek out the latest English styles.

Though most of the high-style American furniture during this period was modeled after English, there was still a considerable time lag. For example, William and Mary style was popular in England during the final decades of the seventeenth century; in America this style of furniture was made from about 1690 to 1730, long after it had ceased to be fashionable in England. Many of the regional or provincial forms—the butterfly and other tables—did not come into use in America until the eighteenth century. But significant regional differences would wait until the heavy ponderous Jacobean style and the Baroque William and Mary were replaced by the curvilinear Queen Anne and Chippendale styles in the next century.

Summary

- Early Renaissance furniture and decorative arts flourished along with fine art and architecture.
- Wealthy patrons enabled the crafting of heavily ornamented high-quality furniture.
- Florence was the leading Italian city for the arts, followed by Rome in the High Renaissance.
- Elaborate styles were known exclusively by the wealthy, and the common people had only the crudest and simplest furniture throughout Europe.
- Moorish control of Spain ceased by the end of the fifteenth century.
- Spain's golden age during the sixteenth century was a result of exploration and colonization.
- France followed Italy and the revival of classical style in the Renaissance.
- French Baroque, under Louis XIV, brought France to its height of artistic achievement and international leadership in style.
- Northern countries separated from the Catholic Church with the Reformation, and art and architecture developed with little Italian influence.
- England, influenced more by the Dutch than the Italians or French, developed its own Renaissance and Baroque styles.
- The American colonies followed English styles and gradually developed their own artistic identity.

Chronology

Italian Renaissance, 1450–1600s

1494–1495	French invasion of Italy.
1500	Treaty of Granada, followed by Spanish control of southern Italy.
1527	Sack of Rome by Spanish and German mercenaries.
1537–1574	Cosimo.

Spanish Renaissance, 1450–1600s

1519–1556	Charles V.
1556–1598	Philip II.

French Renaissance, 1450–1660

1483–1498	Charles VIII.
1498–1515	Louis XII.
1515–1547	Francis I.
1547–1559	Henry II.
1559–1560	Francis II.
1560–1574	Charles IX.
1574–1589	Henry III.
1589–1610	Henry IV.

French Baroque, 1660–1715

1610–1643	Louis XIII.
1643–1715	Louis XIV.

English Renaissance, 1500–1660

1485–1603	House of Tudor.
1485–1509	Henry VII.
1509–1547	Henry VIII.

1547–1553 Edward VI.

1553–1558 Mary.

1558–1603 Elizabeth.

English Baroque, 1660–1714

1603–1649 House of Stuart.

1603–1625 James I.

1625–1649 Charles I.

1649–1660 Protectorate of Cromwell.

1660–1689 Restoration.

1660–1685 Charles II.

1685–1689 James II.

1689–1714 House of Orange.

1689–1702 William III and Mary.

1702–1714 Anne (of Denmark).

Early American Colonial Period, 1607–1700

1607 Jamestown Colony founded in Province of Virginia.

1620 Pilgrims land in Plymouth, Massachusetts.

1626 New Amsterdam (New York) founded by the Dutch.

1664 England takes New York from the Dutch.

1692 Salem "witch" trials.

Designers and Makers

Jean Bérain (1638–1710, France) Court designer Louis XIV, focused on ornament.

André-Charles Boulle (1642–1732, France) Cabinetmaker to Louis XIV; his name is synonymous with an elaborate marquetry technique that became known generically as "boulle" marquetry.

Domenico Cucci (ca. 1635–1704, Italy/France) Italian sculptor and furniture maker who became a naturalized French subject; was one of the finest craftsmen at the Gobelins under Louis XIV and contributed to the grandeur of Versailles.

Jacques Androuet du Cerceau (ca. 1520–1584, France) Architect who published books of engraved designs of furniture and furnishings and brought Italian Renaissance style to France.

Inigo Jones (1573–1652, England) Architect who brought Palladian style to England

Jules Hardouin Mansart (1646–1708, France) Royal architect to Louis XIV; built Palace of Versailles.

Daniel Marot (1666–1752, France/Holland) Architect, furniture designer, and ornament engraver for the French court; fled to Holland and brought the Louis XIV style, which he later brought to England.

Andrea Palladio (1518–1580, Italy) Architect most responsible for the introduction and widespread use of neoclassical architecture in Italy.

Hugues Sambin (ca. 1520–1601, France) Architect, woodcarver, and publisher of a book of engravings, known for his fantastic sculptural term figures on furniture, and often considered to be the first French cabinetmaker.

Hans Vredeman de Vries (1527-ca. 1604, Holland/Flanders) Painter who published volumes on Renaissance/Mannerist architectural ornament, which served as pattern books for furniture makers; the books were modified and published by his son Paulus in 1630.

Key Terms

acorn turning	draw-leaf table	secretary
banderole	farthingale chair	settle
Boulle work	finial	*sgabello*
caquetoire	Hadley chest	spindle
cassapanca	*intarsia*	term figure
cassone	marquetry	tester
chinoiserie	*pastiglia*	trestle
court cupboard	*pietra dura*	Tudor arch
credenza	press cupboard	Tudor rose
cup-and-cover	Romayne work	turning, turnery

Recommended Reading

Boger, Louise Ade. *The Complete Guide to Furniture Styles*, enlarged edition. Prospect Heights, IL: Waveland Press, 1997.

Learoyd, Stan. *A Guide to English Antique Furniture: Construction and Decoration 1500–1900*. New York: Van Nostrand Reinhold, 1981.

Odom, William M. *A History of Italian Furniture from the Fourteenth to the Early Nineteenth Centuries,* second edition. New York: Archive Press, 1966.

Wilk, Christopher, ed. *Western Furniture: 1350 to the Present Day.* New York: Cross River Press, 1996.

Chapter 4

EIGHTEENTH CENTURY

"Best of All Possible Worlds"

CHAPTER CONTENTS

The Enlightenment interest in the arts, as well as philosophy and science, had a profound effect on furniture. Rococo ornamentation and the curvilinear form predominated in the first two-thirds of the century.

"THE BEST OF ALL POSSIBLE WORLDS"

In the once controversial and now classic satire, *Candide*, Voltaire's character Pangloss spoke of his eighteenth-century world as "the best of all possible worlds." It was the best and the worst, depending on one's position in society. European monarchs enjoyed the fruits of their subjects' labor. They built awesome palaces and filled existing ones (such as Louis XIV's Palace of Versailles) with furnishings representing the epitome of luxury, artistic and technical virtuosity, subtle beauty, and blatant decadence.

Of all the chapters in the history of Western furniture, the eighteenth century has proven to be the most intriguing for many students and scholars. It has probably inspired more books, articles, museum exhibits and accompanying catalogs, activity in the marketplace, and reproduction of its styles than any other period. Because there is a good deal of information about eighteenth-century furniture, the subject can be over-whelming and confusing. Rather than "cover" everything—an impossibility for any survey, no matter how well-intentioned—we will simplify, perhaps oversimplify, to convey its essence.

With no disrespect intended toward the countless designers and cabinetmakers of this marvelous century, we will focus on three names and their respective styles: Louis XV of France, Queen Anne of England, and Thomas Chippendale of England. Of course, the monarchs, by whose names these styles are known today, usually had little or nothing to do with the furniture other than to purchase and enjoy it, but for the sake of convenience and convention these names will be used. Distilled into its most dominant theme, elegance, the furniture of this period, covering at least the first two-thirds of the century, can be char-acterized by a predominance of curves, extraordinary design and technical virtuosity, and high cost.

The Queen Anne style in the first quarter of the eighteenth century (1702–1720) in England and through mid-century in America represents a milestone in the history of furniture design. The same can be said for *Régence* of the same period, followed by Louis XV furniture in France and throughout style-conscious European society. Thomas Chippendale subsequently took elements of each of these styles—Queen Anne, a lighter and curvy Baroque, and Louis XV, an even lighter and curvier Rococo—added a little English Gothic here and a sprinkle of Chinese flavor there, and demonstrated that the whole is indeed greater, or at least much different, than the sum of its parts. Chippendale style was synonymous with English furniture in the third quarter of the century and well into the fourth quarter in America. If we focus on these three names, then three names will be easily remembered, along with a fair visual identification of the century.

FRANCE: *RÉGENCE* AND LOUIS XV

The finest art, including furniture, cannot exist without wealthy and/or powerful patrons to support its artists and craftspeople. In France, from Louis XIV to the Revolution, the king and queen probably spent more money on architecture and interior decoration than all other sources of patronage (or other countries, for that matter). The Palace of Versailles was the most elaborate of the king's residences, even more than Fontainebleau or Com-piègne, where the court only resided for a few weeks each year. But there were other priv-ileged ranks in France, and dukes, bishops, and archbishops also contributed to the widespread artistic patronage in eighteenth-century France. The wealth and taste for fine things trickled down the social scale, and tax collectors and other bureaucrats amassed for-tunes by legitimate and other means. A significant bourgeoisie also included those in com-merce and even in the arts, as skilled artists and craftspeople were granted residence at the Louvre and paid handsomely.

French social structure was based on spending money, and fashion depended on who was spending it. There were basically two distinct categories of consumers; there were

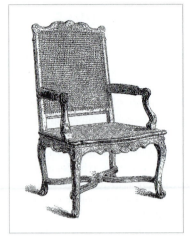

***FAUTEUIL*, FRENCH *RÉGENCE*.**
Régence fauteuil (open armchair),
walnut with cane seat, arms covered
in leather, early eighteenth century.
(Magne)

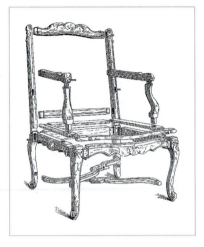

Construction analysis of *Régence*
armchair. *(Magne)*

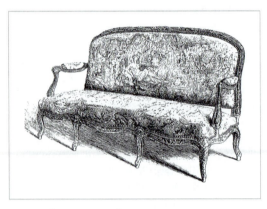

***CANAPÉ*, FRENCH *RÉGENCE*.**
Régence canapé (sofa), gilt carved walnut frame,
Gobelins tapestry upholstery, early eighteenth century.
(Magne)

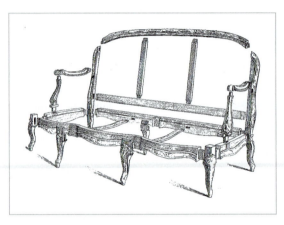

Construction analysis of *Régence* sofa. *(Magne)*

traditionalists, and there were innovators. The traditionalists with more conservative tastes traveled in certain social circles, which usually included the legal professions. They were also collectors of classical antiquities and of Far Eastern art. Innovators, on the other hand, consciously sought novelty and change. New styles were sometimes accepted more on this basis than on merit, while others contributed to the complexity and aesthetic delight of French art at this time. Whether one desired or disliked the old or the new, there was money to support both. Consequently, stylistic development was led by consumers as much as by artists and artisans. Of course, the royal court ruled taste, but there was also a sizable wealthy elite with discretionary time to spend with art dealers. These dealers, by flattering the tastes of their clientele, could also influence fashion and artistic patronage. The decorative arts flourished in France because there was the will, the way, and the means. Led by the royal court and the aristocracy, large segments of society also sought these fashionable goods; a proliferation of highly skilled craftspeople supplied them; and they were paid for by tax collections, earned income, and credit.

1713
Gabriel Fahrenheit
(1686–1736) makes a
mercury thermometer.

1717
Value of pi to 17 places.

1718
New Orleans founded by
French settlers; Englishman
James Puckle patented a
design for the first machine
gun, designed to fire round
bullets for Christian
conflicts and square ones
for heathen Turks.

1719
Daniel Defoe's *Robinson
Crusoe*.

1722
Easter Island discovered.

1723–1790
Adam Smith, economist.

Furniture

When ebony was first imported to France, it was so rare and costly that only the most skilled artisans could be trusted with it. The term *ébéniste*, referring to those elite who worked with ebony, was then used to describe any highly skilled cabinetmakers, especially those working with marquetry and veneer. The *ébéniste* was distinct from the *menuisier*, or joiner, who was also responsible for carving. Craftspeople working with upholstery and soft furnishings were called *tapissiers*.

The *Régence* period, from 1715 to 1723, when Philippe the Duke of Orléans was appointed regent for young Louis XV, was a transitional time in French furniture style. This period actually began as early as 1700, while Louis XIV was still in charge. As with all transitional styles, features of both the earlier and later periods were evident. Because of these transitions, dating stylistic boundaries is always an approximation; styles do not begin or end at a particular date.

Although some Baroque attributes, such as degrees of heaviness and grandeur and straight uprights on chair design, persisted, many of the features that would typify the Louis XV style were already present in *Régence*. Rococo, signifying lightness, frivolity, curvilinearity, and asymmetry, was in direct contrast to Baroque. The term **rocaille** means rockwork, specifically the artificial grottoes with natural irregular stones built in French gardens. *Coquille*, or shell, was a primary motif used in the resulting style, called **Rococo**. Inspired by the painter Antoine Watteau (1684–1721), Rococo ornament spread throughout the interior. Along with other painters, notably François Boucher, Watteau invented many of the decorative fantasies during both *Régence* and Louis XV periods. In addition to the abundant floral and shell motifs, Rococo borrowed themes from mythology and pastoral life, symbols of love, and a range of Near and Far Eastern interpretations. Decorative artists created pseudo-Chinese, pseudo-Turkish, and pseudo-Hindu figures wearing fantastic costumes, carrying parasol and peacock feather props, accompanied by dragons, in landscapes filled with pagodas, twisted trees, and sculpturesque rock formations. In the *Régence*, these fanciful new themes were freely mixed with more serious Louis XIV motifs; later, they would characterized the Rococo style.

Where Watteau and other painters introduced these themes, the cabinetmakers interpreted them on furniture. Charles Cressent (1685–1768), also a noted sculptor and bronze artist, became the leading *Régence ébéniste*. Rather than the dark ebony, he chose more warm-colored woods—amaranth, palisander, and violet wood—for veneer and marquetry.

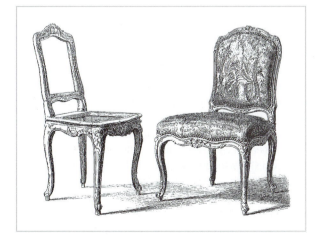

CHAIRS, FRENCH *RÉGENCE* AND ROCOCO.
Régence side chair of carved and painted beechwood with cane seat; Louis XV Rococo side chair, carved and painted beechwood with tapestry upholstery. *(Magne)*

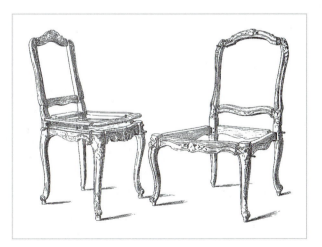

Construction analysis of *Régence* and Louis XV chairs. *(Magne)*

The **commode**, introduced about 1700, was an ideal form for the rich decorations. A storage piece with much more width than height, the commode would characterize eighteenth-century French furniture. Drawers and/or doors were smothered in ornamental marquetry or lacquered panels. Divisions between drawers might be disguised by overlapping the applied mounts and **ormolu**. Interior architecture such as paneling or other wall decoration might be mirrored in the decoration of the front. Further integration into the interior scheme was achieved by colored marble tops made to match the chimneypiece, often on the opposite side of the room. Single or pairs of coordinating corner cabinets, *encoignures*, might accompany the commodes. These came with angular or **bombé** lines and had one or two drawers. Carving was as important as the applied marquetry and ormolu, and each of these decorating methods was used on the variety of commodes, tables, and tall case clocks. Carving and gilt finishing were lavished on chairs, settees, mirror frames, and the cabriole legs that supported case pieces and tables, as well as seating furniture.

Louis XV Rococo

The practices and motifs that began to be used in the *Régence* period became more refined and varied during Louis XV. By 1720, the Rococo style had blossomed, and it was in full flower from about 1740 to 1755. Neither tables nor chairs required stretchers for added support, and the practice of using straight legs ceased completely. Lightness was achieved by thinning the material of the cabriole leg; support was achieved through good design. The **console table**, with its back supported by the wall, gave the illusion of lightness to the point of defying gravity.

Chairs were comfortable and varied. The *fauteuil* was an open armchair with a curved back in a variety of shapes, and a similar design was also made without arms. Perhaps the most typical chair was the **bergère**, an upholstered armchair with closed arms and a loose seat cushion. It might look like a *fauteuil* with a wider and deeper seat, or it might have more of a gondola shape. Sofas, chaise lounges, canapés, and daybeds were for multiple seating. Regardless of size, sofa and chair frames were allowed to show and were carved and finished or gilded. Upholstery material had recently included all kinds of needlework, tapestry, cut silk velvets, damasks, and brocades. The use of tapestry decreased after the *Régence*, but many Louis XV chairs were later reupholstered in tapestry in the nineteenth century.

The court of Louis XV represented the epitome of refinement and luxury and also superficiality and frivolous indulgence. Style setters, notably the king's mistresses Madame de Pompadour and Madame du Barry, contributed to the stunning interiors but also to the widespread public discontent that would culminate in the Revolution later in the century. Besides the promiscuity and scandal, French financial and political practices were badly handled. Overtaxation and reckless spending, added to wars, the loss of India and Canada to England, and widespread corruption gave the administration its colorful reputation.

The Rococo style was perfectly suited to the era. Historically criticized for its frivolity, it is also applauded for producing some of the most exquisitely designed and crafted furnishings in history. The period also had its positive side because its critics and philosophers, scientists and economists—Diderot, Montesquieu, J. J. Rousseau, Voltaire—helped to lay the foundations for the modern world in this Age of Reason, this Enlightenment period. There were over one thousand master cabinetmakers who stamped their work in the eighteenth century. This practice of signing each piece of furniture made for sale, in an unobtrusive place, was a means of quality control. Of the many giants of French cabinetmaking and ornament, Jacques (1678–1755) and Philippe Caffieri (1714–1774), Robert Martin (1706–1767), Juste-Aurèle Meissoniér (1695–1750), Jean François Oeben (ca. 1720–1765), Giles Marie Oppenord (1672–1742), and Jean Henri Riesener (1734–1806) stand out.

Jacques Caffieri was born in Italy and became a designer of ornament under Louis XIV. Together with his son Phillipe, they became the leading bronze artists of the Rococo style under Louis XV. Robert Martin is credited with producing the most finished **vernis martin** work, along with his brothers Guillaume, Simon Etienne, and Julien. They perfected an imitation Chinese lacquer that fueled the vogue for French lacquer work, as well

as making large quantities of lacquered furniture. Meissoniér was originally from Italy and was a student of the architect Borromini. An architect, painter, sculptor, goldsmith, and designer and collector of ornament, Meissoniér was known for his highly ornamental work. His use of asymmetry, complex curves, and abundant shell motifs influenced the development of Rococo style under Louis XV. Jean François Oeben was a German-born French master cabinetmaker. He specialized in Rococo-style marquetry and worked for Madame du Pompadour. He was the teacher of Jean Henri Riesener, who carried on Rococo style for Marie Antoinette. As with many of the great French cabinetmakers who worked for royalty, he died penniless. Giles Marie Oppenord was the son of a Dutch cabinetmaker working in Paris. He was appointed Architect in Chief to the French Regent and contributed to the development of Rococo.

In addition to the fabulous decorative work—gilt bronze ormolu, colorful marquetry, dynamic carving, delicate lacquer—the Rococo forms themselves were noteworthy. With the elimination of straight lines, ornamental symmetry, and the massiveness of most previous styles, it was suddenly conducive to make smaller and more versatile furniture—not necessarily versatile in a multifunctional sense, but in the development of specialized forms that could be easily moved about. The term *meuble*, or movable, referring to movable furniture such as chairs, is the word for furniture.

A variety of small chairs—*fauteuil en cabriolet, bergère en cabriolet*—were intended to be pretty and light and to provide both comfort and convenience. A range of delicate little occasional tables were designed with candle screens or with removable trays for breakfast, or fitted with jewel boxes. Gaming tables with a folding top mounted on a pivot were lined with green baize. The toilet table had an oblong top divided into three parts—the center part was fitted with a mirror, and the two side sections opened out into shelves for the toiletry articles. Small individual work tables were made so ladies could store their needlework, but these could also be used for reading or writing. The *table à écrire*, or writing table, was more specialized, with slender legs, at least one drawer fitted with compartments for writing materials, and a leather or velvet top. If the top was decorated with marquetry, a leather-covered shelf slid out for writing. A number of accessories—ornately framed mirrors, decorative three- or four-panel folding screens, candlestands, and reading stands—were made in many shapes and sizes, though smaller was generally the trend. Some items needed to have substantial height, such as tall case clocks and chiffoniers, tall

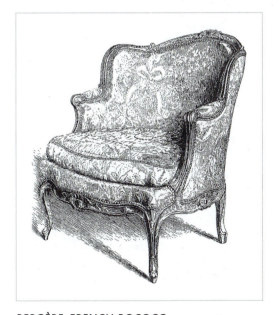

BERGÈRE, FRENCH ROCOCO.
Louis XV *bergère* (upholstered armchair), carved walnut, fully upholstered in floral silk. *(Magne)*

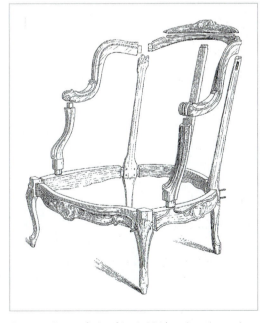

Construction analysis of Louis XV *bergère*. *(Magne)*

chests used primarily by ladies and fitted with five or six drawers. Bookcases, however, often had a length exceeding its height.

Because of a growing fascination with mechanical devices, there were also combination pieces. Not to save space, but to satisfy the desire for novelty and secrecy, this type of furniture was intended to transform itself or to cleverly provide hiding places by employing various spring mechanisms. Novel materials were also well received. Cabinetmakers made full use of various fruitwoods and native hardwoods, an array of exotic wood veneers, richly veined and colored marble, bronze mounts, luxurious upholstery textiles and leathers, and finishes including gold and lacquer. In addition, cane was fashionable for seats and chair backs, and porcelain plaques were incorporated into furniture in the later years of the style.

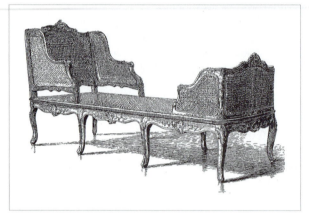

CHAISE LOUNGE, FRENCH ROCOCO.
Louis XV chaise lounge of two backs in different heights, carved walnut with cane seat and back. *(Magne)*

Construction analysis of Louis XV chaise lounge. *(Magne)*

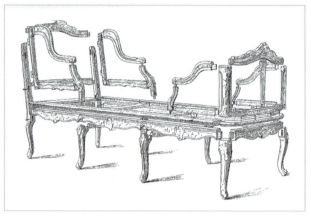

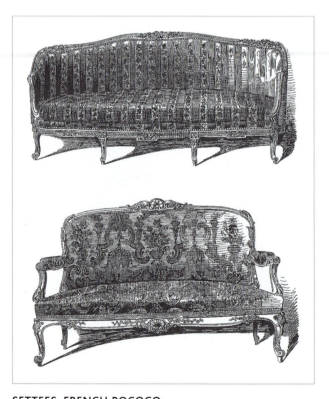

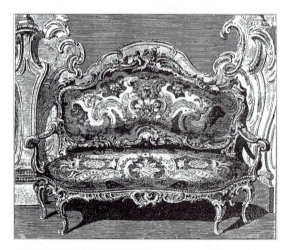

SETTEE, FRENCH ROCOCO.
Louis XV upholstered settee with ornate Rococo carved frame, designed by Meissoniér in 1735. *(Strange)*

SETTEES, FRENCH ROCOCO.
Louis XV upholstered settees, of both six- and four-leg style, mid-eighteenth century. *(Strange)*

INTERIOR, FRENCH ROCOCO.
Room interior with Louis XV furniture and architectural details, designed by Meissoniér, circa 1735. *(Hirth)*

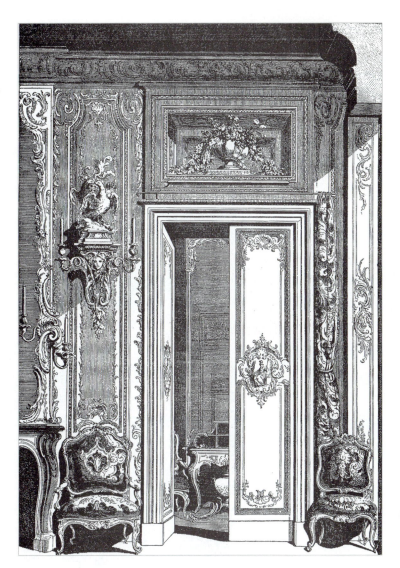

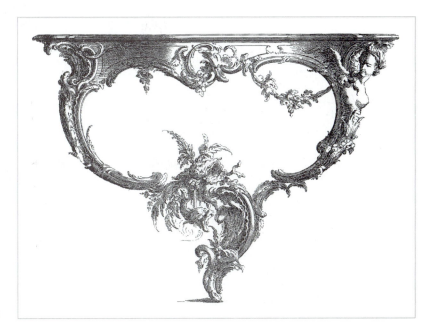

CONSOLE, FRENCH ROCOCO.
Louis XV console table with one asymmetrical carved front leg, 1740s. *(Hirth)*

GROUPINGS, FRENCH ROCOCO.
Louis XV seating furniture, and console
table with four heavily carved cabriole
legs with X-stretcher. *(Benn)*

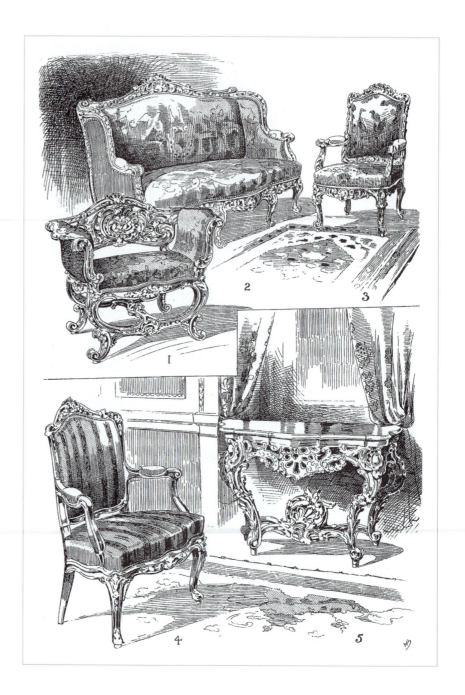

BUREAU, FRENCH ROCOCO.
Famous *Bureau du Roi*, the extraordinary desk made for Louis XV by Jean
Henri Riesener. *(Litchfield)*

COMMODE, FRENCH ROCOCO.
Louis XV commode in heavy Rococo style with ornate carving and decoration, gilded legs with high-relief rams' heads, 1739. *(Hunter)*

WORK TABLE, FRENCH ROCOCO.
Louis XV lady's work table with marquetry and ormolu and tall slender cabriole legs, illustrating a less fussy, elegant Rococo. *(Hunter)*

1726
Jonathan Swift's *Gulliver's Travels*.

1728–1792
Robert Adam, architect/designer who introduced Neoclassicism to England.

1732
Benjamin Franklin's *Poor Richard's Almanac*.

1732–1799
George Washington.

1733
Georgia, the last of the thirteen colonies, founded.

1736
Ship chronometer; England's witchcraft laws repealed.

1736–1819
James Watt, major figure in Industrial Revolution.

1741–1801
Benedict Arnold.

ENGLAND: QUEEN ANNE

Baroque was not subtle. High Baroque was ostentatious and was characterized by drama, movement, three-dimensionality, heaviness, extravagance, and opulence in all of the arts, including furniture. English Baroque of the late seventeenth century had already begun to undergo an interesting change after the Great Fire of London. The urgent need for furniture—a great deal of furniture—caused the style to become lighter. Although still stiff and straight-backed, chairs and settees used cane for seats and backs. In addition to lightness of material and design, the pieces were much more portable.

Building on this new idea of lightness, the Queen Anne style introduced the first truly curvilinear form and a gracefulness unseen in furniture to date. It was the beginning of the "golden age" of English furniture as well as the "age of walnut." The solid construction now used glued joints in place of wood or metal pins, and the curved forms relied on carved decoration. The use of marquetry ended when the new Queen Anne style began, about 1700.

The Chinese-inspired cabriole leg, recently introduced to England on Dutch furniture, became the most characteristic feature of the new style. Carved in one piece, it gave shape to the furniture. Where the Dutch cabriole leg was more tentative, the English gave it a more pronounced, robust, and very sculpturesque curve. A variety of foot shapes, notably the **ball-and-claw**, slipper, and pad foot also characterize the style. When used to support a curved chair back with solid shaped splat and formed seat, the result was a milestone in the history of style. The set-in upholstered seat, called a **slip seat**, did not obscure the graceful curve of the frame and could be easily changed. Crisp shell carving accented these graceful chairs, as well as the shaped elements of card tables with two or three folding tops, kneehole tables, bureaus, lowboys, and tall chests-on-stands. Even informal kitchen chairs introduced at this time, called **Windsors**, had shaped splats between the multiple spindles, plus cabriole legs (in England). The solid wood seats were shaped like saddles, making them surprisingly comfortable in addition to being functional, versatile, and attractive.

In 1709 a devastating frost destroyed most of the French walnut trees, so English furniture makers used native or American walnut. At about this time, a new wood, **mahogany**, began to be imported from the Americas. It was a beautiful, durable, worm-resistant, and workable material, but there was a substantial import tax on wood. When Sir Robert Walpole abolished the tax in 1733, it signified the start of the "mahogany age." Also at this time, about 1730, the direction of the wood grain on drawer interiors changed. Until then, the grain ran from front to back; after 1730, it generally ran from side to side. Also about 1730, the upholstery practice of double stuffing came into practice, whereby two separate layers of horsehair were used between the fabric casings, and then covered with the outer decorative material.

PEDESTALS, ENGLAND.
Pedestals designed by James Gibbs, early eighteenth century. *(Strange)*

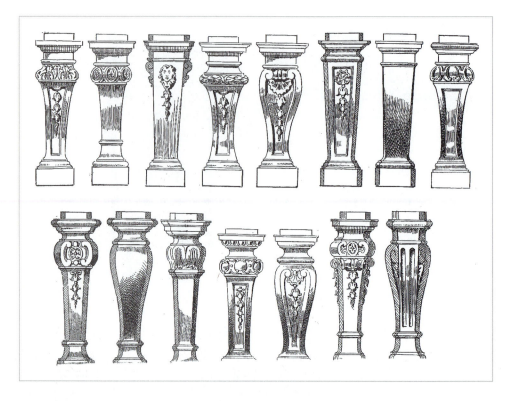

CHAIRS, ENGLAND, QUEEN ANNE.
Transitional and early Queen Anne chairs showing progression from chair with William and Mary legs and rush seat, to Queen Anne side chair with stretchers, to more high-style Queen Anne roundabout or corner chair. *(Hunter)*

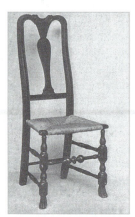
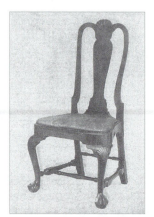
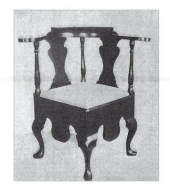

1742
First performance of Handel's *Messiah*; invention of Sheffield plate and the Celsius scale.

1743
American Philosophical Society, first scientific society in the United States.

Thomas Chippendale

From the reign of George I in 1714, through 1830, the period was known as Georgian. Though the Queen Anne style in England was losing favor by about 1720, features such as the cabriole leg with ball-and-claw foot and shell carving contributed to the varied synthesis of styles known as Chippendale. In the interim period, between the fading of Queen Anne and the publication of Chippendale's classic design book in 1754, William Kent (1685–1748) was a prominent figure, but with rather specialized architectural clientele. A painter, architect, and landscape designer, as well as furniture designer, Kent was known for bulky architectural furniture. His ponderous case pieces, especially cabinets, cupboards, and bookcases, looked very Baroque with their heavy broken cornices, carved pilasters, and solid plinth bases. The effect was accentuated by excessively carved scalloped shells, acanthus leaves, masks, and figures. By 1720 the Baroque style was no longer fashionable in France, yet England was not quite ready to commit itself to the frivolity of Rococo.

QUEEN ANNE FURNITURE, ENGLAND. Side chairs and armchair shown with and without stretchers; table, chest-on-stand, and low chest, all with cabriole legs and pad feet, early eighteenth century. *(Benn)*

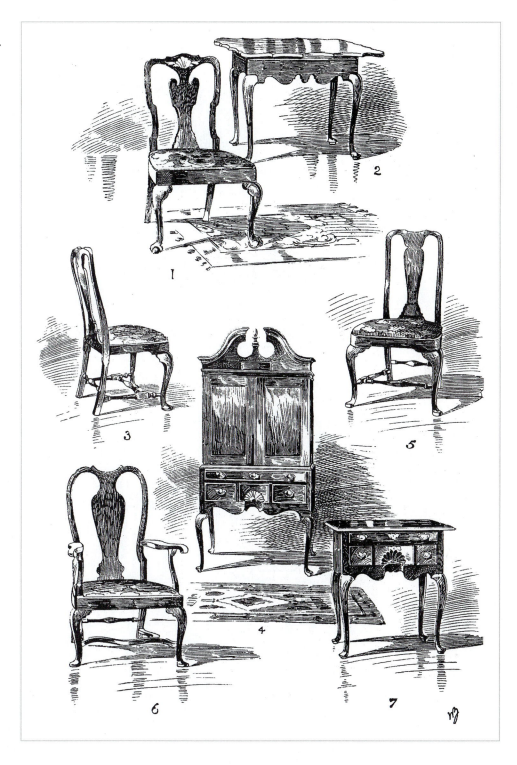

1743–1794
Antoine-Laurent Lavoisier, chemist.

In 1754 the publication of Thomas Chippendale's (1718–1779) *Gentleman and Cabinet-Maker's Director* almost single-handedly standardized the English furniture industry. The illustrated designs created such an overwhelming fashion that virtually all of fashion-conscious England participated. The style was so ubiquitous that the name Chippendale was later given to it—the first time an individual other than a monarch lent his name to a period style. Yet Chippendale did not create the designs. He ran one of London's largest cabinetmaking and decorating firms, and the design book was intended to promote

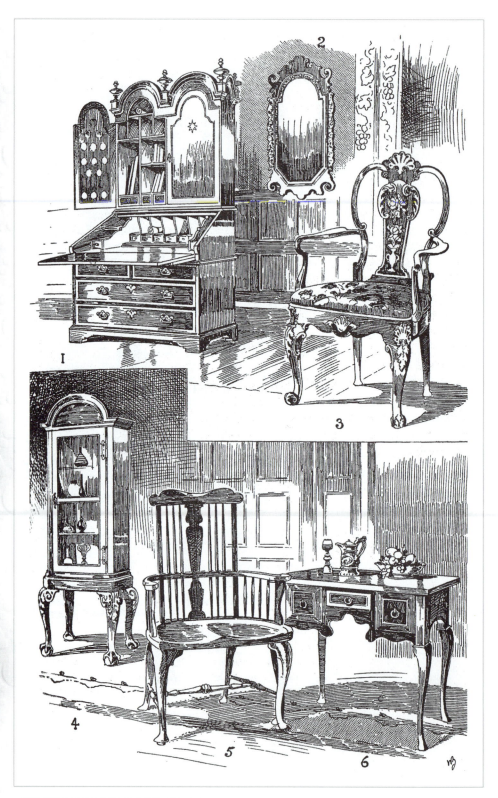

QUEEN ANNE FURNITURE, ENGLAND.
Secretary bureau, armchair, wall mirror, display cabinet, Windsor chair, and low chest or writing desk, early eighteenth century. *(Benn)*

his business, which employed forty to fifty artisans. Among them, Matthias Lock and Henry Copland are believed to have created many of the designs in the *Director*. Because the English did not follow the French practice of signing furniture (beginning in 1751), it is almost impossible to attribute many pieces to any maker. Thomas Chippendale, revered more as an arbiter of taste than a designer or maker of furniture, became affectionately known as the high priest of mahogany.

Three distinct influences can be found in Chippendale design: Gothic, Chinese, and Modern (meaning French Rococo). His French style consists mainly of Anglicized French forms with extravagant carved detailing. The characteristic French Rococo features— bronze mounts, ormolu, marquetry—were absent. The same traditional Georgian forms also displayed Gothic motifs of tracery, trefoils and quatrefoils, cusping, and cluster columns. Chippendale also reworked the Queen Anne chair by piercing the back splat with an array of ribbon motifs and scrolls, straightening the sides, and extending carved and curved ears at the ends of the crest rail. Rather than use the pad or slipper foot, Chippendale chose the ball-and-claw with its sculptural and highly decorative form. Other foot variations included hair paw, lion paw, and scroll. Simpler versions with straight **Marlborough legs**, plain or block feet, and no carving were also necessary because most everyone wanted Chippendale, but not everyone could afford it. Another of his simpler models was a ladder-back chair, also with straight legs. The most expensive Chippendale chair was his **ribband-back**, with exquisitely carved flowing ribbons forming the back splat. The seat on the ribband-back was normally fully upholstered, but the slip seat was also used on many chairs.

Table legs were even more varied than for chairs. Tables were supported on carved Chinese-influenced open fret legs, Gothic cluster columns, straight, or cabriole legs ending in various feet. Specialized forms, like the tilt-top tripod table, had three cabriole legs supporting a central pedestal. The tilt-top mechanism beneath the round top was called a birdcage, and everything was embellished with carving. Another tea table, called a **Pembroke table**, had four legs, one drawer, and a rectangular top with drop leaves on the long edges. (A sofa table will have them on the short edges.)

Case pieces were commonly propped on cabriole legs, but were also found on squat bracket and ogee feet, as the chest-on-chest. Tallboys, lowboys, bookcases, and a variety of bureaus and chests were embellished with carved motifs of rosettes, scrolls, acanthus leaves, shells, and ribbons. Broken scroll pediments and ornate finials topped many of the tall forms, and delicate fretwork was added to friezes and galleries. For added strength to the open fretwork, Chippendale used three-ply mahogany veneer, a concept that would influence furniture design and construction in later centuries. Fretwork was just one feature that gave his Chinese-style tables and chairs their flavor. Lattice-backs and even carved pagodas were found on chairs, and bamboo turning was used to imitate the oriental material. So-called Chinese rooms were filled with Chippendale interpretations, surrounded by both handpainted authentic and imitation Chinese wallpapers, perpetuating the fashion for *chinoiserie*.

There were, of course, other variants of Rococo style found on furniture, and the partners William Vile (1700–1767) and John Cobb (1710–1778) were among its most admired proponents. As cabinetmakers to George III, they made some of the most elaborate and expensive marquetry and inlay in England. Their work in the 1760s has been called a more Anglicized Rococo, whereas in the 1770s it became more Adamesque. However, because they produced no pattern book, their names are not as well known as their work might merit.

Since Chippendale was more an interpreter of fashion than an originator, he was not unaware of the strong influence the Adam brothers were having by the 1760s. As the Rococo designs began to lose their freshness and appeal, Chippendale and/or his son Thomas (1749–1822), began to work in the new Adam style. There is some irony in the fact that some of Chippendale's best work is in a style with which neither his name nor his *Director* is associated.

1770–1827
Ludwig von Beethoven.

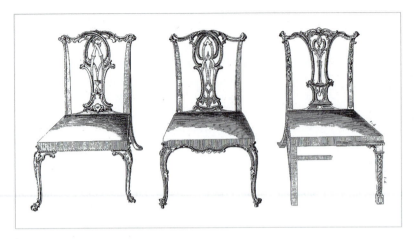

SIDE CHAIRS, CHIPPENDALE.

"Various Designs of Chairs for Patterns. The front Feet are mostly different, for the greater Choice. Care must be taken in drawing them at large. The Seats look best when stuffed over the Rails, and have a Brass Border neatly chased; but are most commonly done with Brass Nails, in one or two Rows; and sometimes the Nails are done to imitate Fretwork. They are usually covered with the same Stuff as the Window-Curtains. The Height of the Back seldom exceeds twenty-two Inches above the Seats: The other Dimensions are in Plate IX. Sometimes the Dimensions are less, to suit the Chairs to the Rooms."

SIDE CHAIRS, CHIPPENDALE.

"Three Designs of Chairs with Ribband-Backs. Several Sets have been made, which have given entire Satisfaction. If any of the small Ornaments should be thought superfluous, they may be left out, without spoiling the Design. If the Seats are covered with red Morocco, they will have a fine Effect."

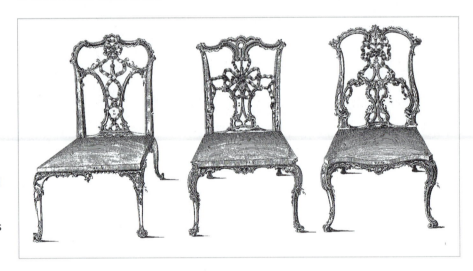

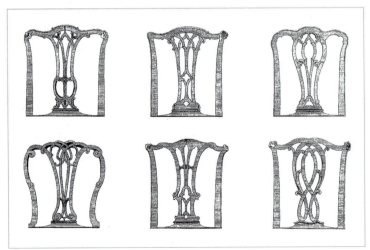

CHAIR BACKS, CHIPPENDALE.

"Six Designs for Backs of Chairs."

HALL CHAIRS, CHIPPENDALE.
"Designs of Chairs for Halls, Passages, or Summer-Houses. They may be made either of Mahogany or any other Wood, and painted, and have commonly wooden Seats. The Height of the Gothick Back is two Feet, four Inches, and the others one Foot, eleven Inches, and the Height of the Seat seventeen or eighteen Inches. If you divide the Height of the Back in the Number of Inches given, you will have a Measure to take off of the Breadth of the circular Parts of each Back. Arms, if required, may be put to those Chairs."

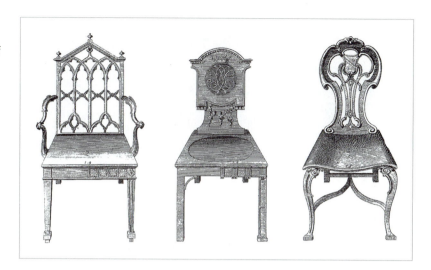

"FRENCH" CHAIRS, CHIPPENDALE.
"Designs of French Chairs, which may be executed to Advantage. Some of them are intended to be open below at the Back: which make them very light, without having a bad Efect. The Dimensions are the same as in Plate XIX; only that the highest Part of the Back is two Feet, five Inches: But fometimes these Dimensions vary, according to the Bigness of the Rooms they are intended for; a skilful Workman may alfo lessen the Carving, without any Prejudice to the Design. Both the Backs and Seats must be covered with Tapestry, or other sort of Needlework."

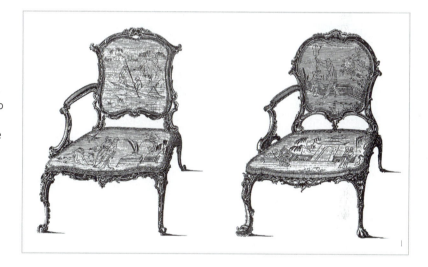

"CHINESE" CHAIRS, CHIPPENDALE.
"Designs of Chairs after the Chinese Manner, and are very proper for a Lady's Dressing-Room; efpecially if it is hung with India Paper. They will likewise suit Chinese Temples. They have commonly Cane-Bottoms, with loose Cushions; but, if required, may have stuffed Seats, and Brass Nails."

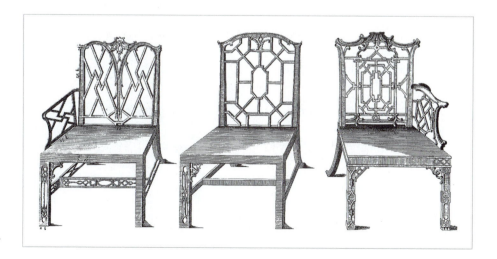

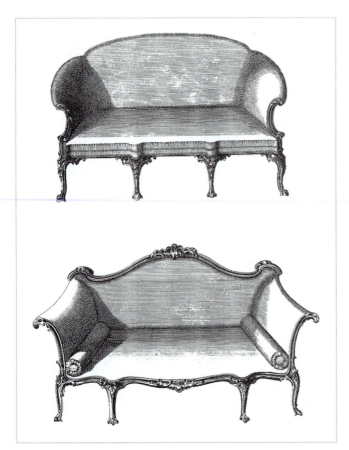

SOFAS, CHIPPENDALE.
"Designs of Sofas. When made large, they have a Bolster and Pillow at each End, and Cushions at the Back, which may be laid down occasionally, and form a Mattress. The upper Sofa, is designed to have the Back-Corners circular, which must look well. The Sizes differ greatly; but commonly they are from six to nine, or ten feet long; the Depth of the Seat, from Front to Back, from two Feet, three Inches, to three Feet; and the Height of the Seat one Foot, two Inches, with Casters. The Scrolls are eighteen or nineteen Inches high. Part of the Carving may be left out, if required."

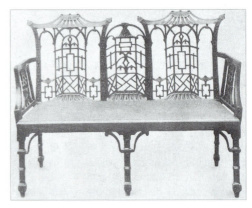

SETTEE, CHIPPENDALE.
Chinese Chippendale settee with delicate fretwork double back and pagoda crests. *(Hunter)*

SOFA, CHIPPENDALE.
"A Design of a Sofa for a grand Apartment, and will require great Care in the Execution, to make the several Parts come in such a Manner, that all the Ornaments join without the least Fault: and if the Embossments all along are rightly managed, and gilt with burnished Gold, the whole will have a noble Appearance. The Carving at the Top is the Emblem of Watchfulness, Affiduity, and Rest. The Pillows and Cushions must not be omitted, though they are not in the Design. The Dimensions are nine Feet long, without the Scrolls; the broadest Part of the Seat, from Front to Back, two Feet, six Inches; the Height of the Back from the Seat, three feet, six Inches; and the Height of the Seat one Foot, two Inches, without Casters. I would advise the Workman to make a Model of it at large, before he begins to execute it."

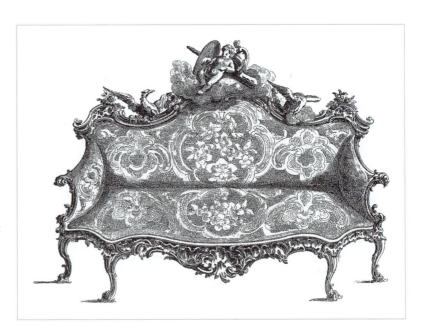

"GOTHIC" BED, CHIPPENDALE.

"A Design of a Gothick Bed, with a flat Tester. The Cornice will look very well, if rightly executed. A, is the Lath; c, c, c, the Pullies where the Lines are fixed to draw up the Curtins; B is an Ornament, made of Lace or Binding, for the Tester."

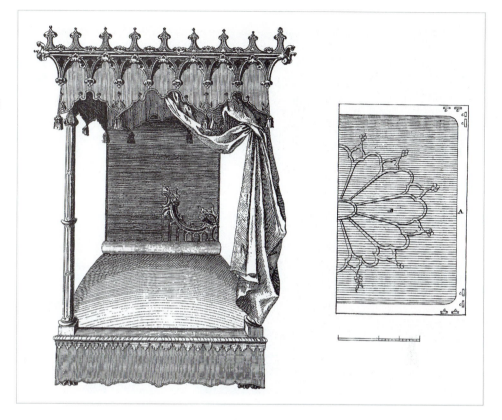

SIDEBOARD, TABLE, CHIPPENDALE.

"Side-Board. The Mouldings are at large. Dimensions vary according to the Bigness of the Rooms it stands in."

COMMODES, CHIPPENDALE.

"Two Designs of Commode-Bureau-Tables, with their Plans below, and proper Scales. The upper Drawer may be of the whole Length of the Table, and have Divisions. The Recess for the Knees is of a circular Form, which looks more handsome than when it is quite straight."

COMMODES, CHIPPENDALE.

"Two Commode-Tables. That in the Right is all Drawers in Front; the upper one may be a Dressing-Drawer, and of the whole Length of the Table. The ornamental Parts are carved out of Wood. That on the Left may be divided into nine Drawers, or have only three of the whole Length of the Table. The Dimensions are specified: The Ornaments may be of Brass, if required."

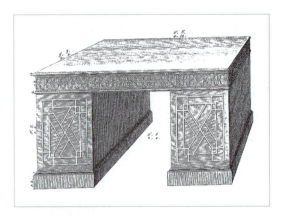

LIBRARY TABLE, DESK, CHIPPENDALE.

"A Library-Table. The Drawers in the upper Part must draw out at each End of the Table. It has Doors on both Sides, with upright Partitions for Books, and Drawers on the other Side within the Doors. The hollow Corners must be fixed to the Doors: and to open with them. The Mouldings are at large, with a Scale."

LIBRARY TABLE, DESK, CHIPPENDALE.

"A Library-Table. The Ends form an Oval, with carved Terms fixed to the Doors, which must be cut at the Astragal, and base Mouldings, to open with the Doors. On the Left are the Plan and the Upright, with fome Variations in the Terms, and a Scale, with the Mouldings at large."

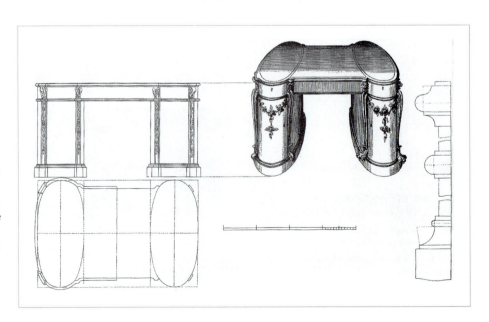

BOOKCASE, CHIPPENDALE.
"A Library-Bookcase. Take the whole Height of the upper Part of the Bookcase, and divide it into twenty equal Parts; one of which divide again into three equal Parts one Way, and into four the other (but any Breadth is the same); then divide one of those three Parts into twelve equal Parts, as you fee specified: then draw a Diagonal from Corner to Corner, and in one of the Divisions to take off Quarters, Halves, and three Quarters. The Mouldings are drawn from this Scale."

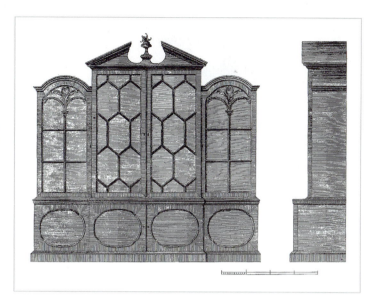

"GOTHIC" BOOKCASE, CHIPPENDALE.
"A Gothick Bookcase, with the Mouldings at large, and proper Centers to draw them by. A is the Plan of the Mouldings, which form the inner Work of the Doors, Half of which must be wrought on the Stile of the Door."

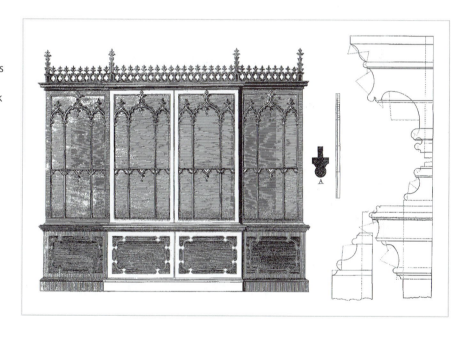

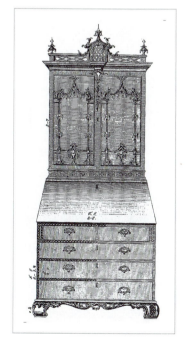

SECRETARY BOOKCASE, CHIPPENDALE.
"A Desk and Bookcafe in the Chinese Taste. The Doors of the Bookcase are intended for Glass, and the Frets at Bottom may be two Drawers: The Dimensions are fixed."

CABINET, CHIPPENDALE.
"The Mouldings are at large, and Dimensions fixed. Plate CXXI. hath different Feet."

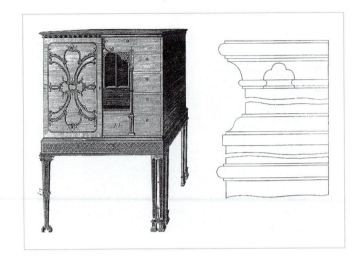

CHINA CABINET.
"A China-Cafe, withe Glass in the Front and Ends, to shew the China. The Profile is on the Right: Between the middle Feet is a small Canopy, for a Chinese Figure, or any other Ornament."

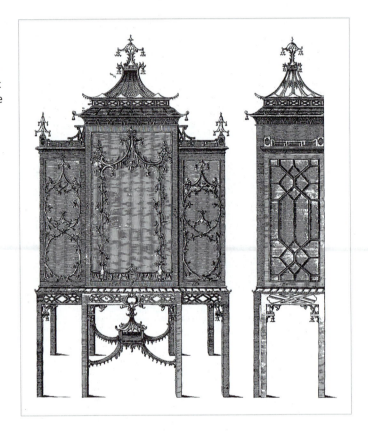

1755
University of Moscow founded.

1756–1791
Wolfgang Amadeus Mozart.

1758
Sextant and ribbing machine to make cotton.

AMERICAN COLONIES

The American colonies were different, and so was the furniture. Although ruled from overseas, the colonists had interests and priorities unlike those of subjects in England. The land in this New World was vast and uncharted; there was no European history in the form of cities, buildings, or indigenous art and literature. Colonists attempted to apply old cultural values to an untamed and unknown place.

Possessions were important. They represented a person's wealth, position in the new society, achievements, and potential for success. A person's material goods helped to define who he or she was, and inventories were a means by which it was recorded. By looking at these inventories one can gain some insight into colonial culture and values.

1759
Voltaire's *Candide*; first roller skates.

1760
Franklin's lightning rod; John Montagu, the Earl of Sandwich, invents the sandwich.

1761
Rousseau's *Social Contract*; first blast furnace.

1763
England acquires Canada; Treaty of Paris; England acquires Florida and Louisiana.

1766
Cotton velvet.

1766–1834
Thomas Malthus, population study.

1769
James Watt patents his version of the steam engine; Richard Arkwright patents hydraulic spinning machine; Joseph Cugnot's steam carriage is first automobile.

1769–1821
Napoleon Bonaparte.

Unless otherwise indicated, the illustrations on pages 76 though 82 are plates from Chippendale's *Director*. The captions, too, are from the *Director*. Although modernized here, the letter "s" was usually written as "f" in the eighteenth century but pronounced "s." Some captions describe more than one plate, some of which may not be shown. Slight changes or omissions in wording have been made so the captions can more accurately describe the plates. Original wording and capitalization have been retained in order to convey the eighteenth-century flavor and meaning.

Naturally, the items included were considered important, and other than land and buildings, these fall into roughly four categories: cattle and agricultural products, slaves, household and related goods, and cash (precious metal). Furniture was regarded highly and was included in these lists of possessions as indicated in the following excerpts from John Austin's early Rhode Island inventories:

Portsmouth, 1671: 200 sheep, 30 swine, negro man and woman, 2 cheese presses, *feather bed, table, settle, chairs*.

Newport, 1709: 320 sheep, olive wood, *looking glass, feather beds,* 12 silver spoons, silver porringer, 2 spinning wheels, *6 leather chairs*.

Newport, 1713: 473 sheep, 300 lambs, 1 bull, 56 cows, 9 negroes, 2 spinning wheels, *feather beds, desk*, 140 cheeses, great bible and other books, joiners tools.

Portsmouth, 1716: 40 sheep, 3 1/4 years service of Indian girl, *feather bed*, 5 spinning wheels.

New Shoreham, 1720: loom, *9 beds, 2 flock beds*, 3 spinning wheels, 30 loads of hay, 600 lbs. of cheese.

Providence, 1720: silver money, silver spoons and porringer, 5 swords and belt, 12 pictures, a negro man, woman, and boy, Indian girl's time.

Warwick, 1723: *feather beds*, 5 guns, saddle, bridle, *table, chairs*, carpenter's tools, rope-making tools.

South Kingstown, 1744: 140 sheep, 8 fat cattle, negro man, canoe, pair of gold buttons, hour glass, *desk*.

Furniture

Because these colonists clearly depended on agriculture for their living and lived far from any commercial centers, in the cities, furniture was most likely made by a member of the household or a neighbor. Not unlike medieval priorities of sturdiness and function, the expectations for a good piece of furniture most likely did not include high style or ornamentation. Plainness, straightforwardness, and serviceability were high on the colonist's list of desirable attributes for household furnishings, and the local carpenter might provide anything from cradles to coffins. As communities became more settled and overcame physical hardships, people began to look more toward leisure activities and finer possessions. The upwardly mobile colonists became more style conscious and looked to England for models. Important names in eighteenth-century colonial American cabinetry include Thomas Affleck (1740–1795), John Goddard (1723–1785), Benjamin Randolph (1737–1791), William Savery (1721–1787), and John Townsend (1732–1809).

Born in Aberdeen, Scotland, and trained in Edinburgh and London, Thomas Affleck came to Philadelphia in 1763, where he became the city's resident cabinetmaker. He helped to popularize Chippendale's Rococo-style furniture, and often took his designs directly from his personal copy of the *Director*. He was also known to use "Chinese Chippendale" fretwork. A close friend of Benjamin Franklin, Affleck usually worked in a more restrained version than his contemporaries, such as Benjamin Randolph. By the 1790s he began to use the Neoclassical style and made the chairs for Philadelphia's Houses of Congress.

Often called "the Chippendale of colonial America," Benjamin Randolph made elaborately carved mahogany chairs and was responsible for many of the fine Philadelphia highboys of the period. Another leading Philadelphia cabinetmaker, William Savery worked in the Queen Anne and Chippendale styles, specializing in chairs and cabinets.

John Goddard was born in Newport, Rhode Island, and by the 1760s was the town's leading cabinetmaker. He and John Townsend worked together in Newport primarily in the Chippendale style, without the frills that characterized Philadelphia furniture. Their families intermarried and included more than twenty cabinetmakers until after the Revolution; they were known for exceptional well-defined carving and **blockfront** case pieces.

Whether in Queen Anne or Chippendale style, American colonial furniture was made after the same models as English furniture. But because immigrants were also coming from places other than England—Ireland, Scotland, Germany, Holland, Sweden—regional differences could be seen, depending on where the furniture was made. Although the English continued to settle in all the colonies, others began to concentrate in specific areas. Germans settled in Pennsylvania, and many Dutch came to New York.

The misnomer "Pennsylvania Dutch" was actually "Pennsylvania Deutsch," the German-origin communities in Pennsylvania associated with a colorful regional style (although some Dutch also settled in Pennsylvania). Between 1727 and 1740 more than 50,000 Germans settled in Pennsylvania, and by the end of the eighteenth century, their population comprised about one-third of the state. These Pennsylvania Germans have preserved their traditions to the present day. Furniture, often massive and of oak, cherry, or walnut, was usually paneled or inlaid. But items made from the softer woods, such as pine, were decorated with traditional motifs in polychrome paints. Tulips, carnations, birds, hearts, stars, and geometric designs covered chests and other furniture forms in a pleasing and easily identifiable style.

Where folk art and craft was passed on through family and community tradition, an apprentice system further reinforced the many other regional variations that began to appear. For example, Philadelphia, where English pattern books were followed the most closely, was the most high style. It was known for its high chests in Rococo style, topped with architectural pediments (the same books were used for architecture and furniture) and sculpturesque finials in the form of urns, flames, and fruit-filled baskets. The Philadelphia ball-and-claw foot usually had a flattened ball and well-defined talons with webbing between them. New England was the slowest to accept new styles, and transitional elements, such as stretchers and straight turned legs, persisted on early Queen Anne chairs. Later, elegant Boston case pieces often used a *bombé* swell; these shaped chests, desks, and bookcases were not usually found in the colonies. The Massachusetts ball-and-claw had a side talon that raked slightly toward the back. New York furniture generally had heavier lines and proportions, and case pieces were often on feet, but not legs. The chest-on-chest was more popular in this area than elsewhere in the colonies. A carved edge pattern called gadrooning, was a Dutch motif, as were other characteristic New York features. New York ball-and-claw feet looked as if they were cut from cubes, with their squat form and indistinct webbing. Boston and especially Newport were known for the blockfront form. This distinctive Baroque shape, with its convex-concave-convex front, was expensive, yet sought after for its high quality and attractive lines.

Despite regional differences, there were overall trends and fashions that affected all of the colonies. Queen Anne became the dominant style about the same time that it ceased to be popular in England, about 1720; it remained strong in the Colonies until about 1760. William Kent's ornate architectural furniture had no effect on the Colonies, since there were neither sprawling mansions to house it, nor an aristocracy to commission it. The transition between Queen Anne and Chippendale was more subtle than between William and Mary and Queen Anne. When bulky turned front legs with stretchers, Spanish trifid feet, and straight stiles persisted, it was easy to identify these William and Mary remnants. Gradually, the prominent Queen Anne features—classical motifs of acanthus leaf and shell, curved cabriole leg, heart-shaped chair back, solid vase-shaped splat, and curved compass seat—replaced the Baroque.

When Chippendale's *Director* was published in England in 1754, it was immediately brought to the Colonies. The most high-style furniture makers and clients adopted the new style with enthusiasm. However, outside the major cities, Queen Anne style both continued to be used and combined with Chippendale in transitional pieces. Unlike the obvious differences between William and Mary and Queen Anne, these differences were often subtle. Both styles relied heavily on the cabriole leg and other curves; both used mahogany with carving as the primary ornamentation; both were made by the same artisans; and many of the furniture forms were the same.

Kneehole desks, highboys with bonnet tops, lowboys, and bookcases were among the important Queen Anne case furniture. When propped on cabriole legs, especially if they

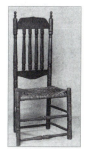

also had ball-and-claw feet, they could be almost indistinguishable from comparable Chippendale pieces. Details like drop pendants easily identified a piece as Queen Anne, but even the characteristic shaped tops were also used with Chippendale. The easy chair, or wing chair, a fully upholstered design, used the same basic form in both styles, but Chippendale designs often used straight legs. Other forms that were popular in both Queen Anne and Chippendale were tea tables, card and game tables, looking glasses (mirrors), tall case clocks, sofas, settees, roundabout chair, and Windsors.

The Windsor chair was used in England by about 1720, and it appeared in Philadelphia by the 1740s. It was different from the English version with its solid splat between the spindles and its optional cabriole legs. The American Windsor was made in a variety of low- and high-backed forms—comb back, hoop back, fan back. Seven or nine spindles were common, but this varied. Settees might have thirty-eight spindles. American Windsors had only plain or turned legs, not cabriole, and they were splayed at a larger angle than the English. In order to support the leg attachment, the saddle seat was normally thicker. As a provincial mainstay, the Windsors bridged both periods and beyond, to the present day.

Windsors were not normally used in formal rooms, such as parlors. These main "public" rooms were used for dining, writing, family activities, and entertaining guests. Sets of matching chairs lined the walls and were pulled out for conversation or placed around tables. The dining table was the plainest of all American Chippendale tables because it was intended to be covered with a cloth. Sofas, tall case clocks, and a variety of case pieces might also be placed against walls. Both the clocks and highboys had scroll or broken pediments or bonnet tops. Tea tables were relatively small and portable, such as the Pembroke and other English models. The pie-crust tilt-top tea table was a desirable Chippendale item in American parlors. With the top folded, it could be stored against the wall; with the top down, it was an elegant surface on which to serve the valuable and socially necessary tea.

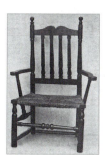
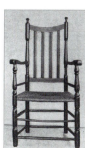
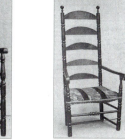
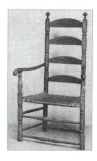

CHAIRS, AMERICA.
Early eighteenth century American banister-back chairs with rush seats and turned legs with stretchers. *(Hunter)*

CHAIRS, AMERICA.
Early eighteenth-century American slat-back chairs with cushion or woven seats and turned members connected by stretchers or slats. *(Hunter)*

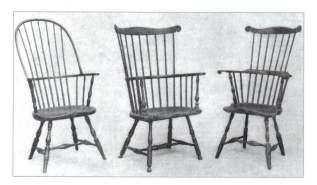

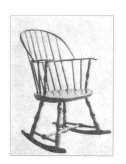

WINDSOR CHAIRS, AMERICA.
American eighteenth-century Windsor chairs showing bentwood bow-back or hoop-back and straight comb-back forms. *(Hunter)*

WINDSOR CHAIR, AMERICA.
Windsor rocking chair with bow back.
(Hunter 1923)

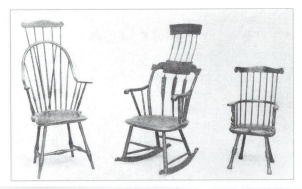

WINDSOR CHAIRS, AMERICA.
Three varieties of two-tiered comb-back Windsor chair, one with runners for rocking. *(Hunter)*

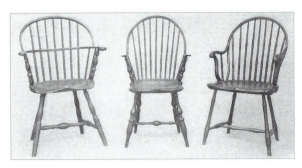

WINDSOR CHAIRS, AMERICA.
Bow-back Windsor chairs, one with continuous arm design. *(Hunter)*

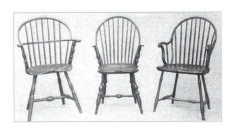

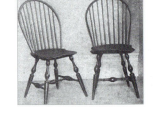

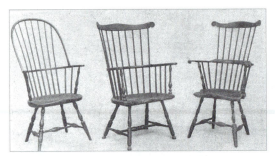

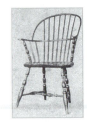

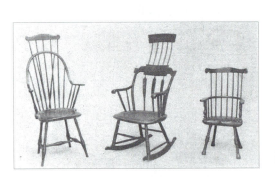

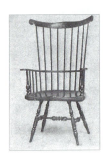

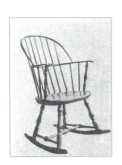

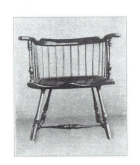

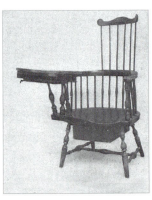

WINDSOR CHAIRS, AMERICA.
Examples of several eighteenth-century American Windsor chairs. *(Hunter)*

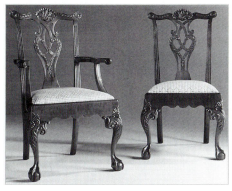

CHAIRS, AMERICA.
Philadelphia Chippendale armchair and side chair of carved mahogany, with cabriole legs and ball-and-claw feet, mid-eighteenth-century design. *(Courtesy of Baker Furniture)*

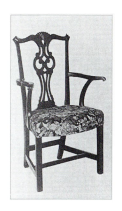
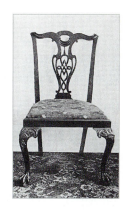

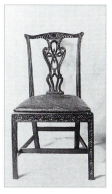
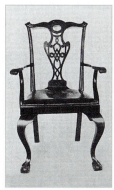

CHAIRS, AMERICA.
Variety of American Chippendale side chairs and armchairs, shown with straight legs and with cabriole legs ending in ball-and-claw feet.
(Northend)

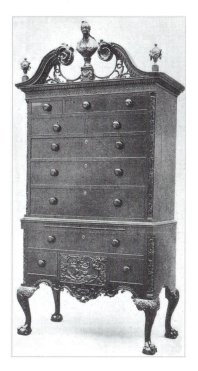

HIGHBOY, AMERICA.
American highboy with carved cabriole legs, broken scroll pediment, and bust finial, by William Savery, 1760–1775.
(Hunter)

Bedroom furniture included dressing tables, chairs, and perhaps a looking glass. Beds were often hung with fine textiles, which were changed to thin muslin in the hot summer months. Writing tables, bureaus, kneehole desks, and a variety of specialized forms were available and used throughout the house. As trade, prosperity, and the population increased, more material goods were made and used. Craftspeople were needed to build houses and furnishings for the waves of immigrants, and many of them became well known and prosperous. Architecture was primarily in provincial English styles until mid-century, when more elegant structures with classical detailing were built. Furnishings followed architecture, and the Colonies followed England. By the last quarter of the century, the Neoclassical style began to replace Chippendale's Rococo and Chinese. Not Adam, who catered to an elite class in England, but George Hepplewhite and Thomas Sheraton would set the standards for the American Federal style, firmly established by about 1790.

Summary

- The massive Baroque style in France evolved to become a lighter more graceful Rococo (1720s–1760s).
- The French Rococo and its characteristic curved forms, asymmetrical ornament, and carved shells, fruits, and flowers spread throughout Europe and England.
- The Queen Anne style in England (1702–1720) was the first to rely on curved form as well as decoration.
- Thomas Chippendale synthesized the latest fashions for French Rococo, plus Chinese and Gothic elements, and presented these in his influential style-setting book, the *Director*, in 1754.
- Colonial America followed English styles, usually with a noticeable time lag and regional difference: Queen Anne (1720–1760) and Chippendale (1755–1790).
- The Rococo curve and fussiness dominated the first two-thirds of the century, but was replaced by a straight-lined, symmetrical Neoclassicism.

Chronology

French Monarchs/Periods

1715–1723	Regency
1715–1774	Louis XV
1774–1789	Louis XVI

English Monarchs/Periods

1714–1727	George I
1727–1760	George II
1760–1820	George III

Designers and Craftspeople

Thomas Affleck (1740–1795, Scotland/United States) Early Philadelphia cabinetmaker known especially for his work using Chippendale's Rococo and Chinese styles.

Jacques Caffieri (1678–1755, Italy, France) Bronze artist and designer of ornament under Louis XIV and XV; inventor of rocaille bronzes.

Philippe Caffieri (1714–1774, France) Son of Jacques Caffieri, also a leading bronze artist and cabinetmaker in the court of Louis XV, executed some of the finest carved ornament.

Thomas Chippendale (1718–1779, England) Furniture maker, published the highly influential guide in 1754, *Gentleman and Cabinet-Maker's Director*, which popularized Rococo, Gothic, and Chinese taste in furniture.

Charles Cressent (1685–1768, France) Student of André-Charles Boulle, worked in Rococo style and became one of the greatest French *ébénistes* and makers of ormolu, although no pieces bear his stamp.

Grinling Gibbins (1648–1720, Holland/England) Woodcarver known for embellishing interiors with carved naturalistic fruit, foliage, and birds with exquisite detail.

John Goddard (1723–1785, United States) Known for fine well-defined carving and blockfront case pieces primarily in Chippendale style in Newport, Rhode Island.

William Kent (1685–1748, England) Painter, architect, and furniture designer who made relatively heavy architectural furniture between 1725 to 1750.

Robert Martin (1706–1767, France) Credited with producing the most finished *vernis martin* work, along with his brothers Guillaume, Simon Etienne, and Julien; they perfected an imitation Chinese lacquer as well as making lacquered furniture.

Juste-Aurèle Meissoniér (1695–1750, Italy/France) Architect, painter, sculptor, goldsmith, and designer of ornament; influential in the development of Rococo style under Louis XV.

Jean François Oeben (ca. 1720–1765, Germany, France) Master cabinetmaker specializing in marquetry and mechanical pieces; worked for Madame de Pompadour in Louis XV Rococo style; teacher of Riesener.

Giles Marie Oppenord (1672–1742, France) Son of a Dutch cabinetmaker working in Paris, appointed Architect in Chief to the French Regent and contributed to the development of Rococo.

Benjamin Randolph (1737–1791, United States) Often called "the Chippendale of colonial America," made elaborately carved mahogany chairs and was responsible for many of the fine Philadelphia highboys of the period.

Jean Henri Riesener (1734–1806, France) Studied under and worked for Oeben, carried on Rococo style for Marie Antoinette; appointed royal *ébéniste* to Louis XVI in 1774.

William Savery (1721–1787, United States) Chair and cabinetmaker, worked in the Queen Anne and Chippendale styles in Philadelphia.

John Townsend (1732–1809, United States) Known for fine well-defined carving and blockfront case pieces in Chippendale style, followed by Federal style work in Newport, Rhode Island.

Key Terms

ball-and-claw foot	*ebéniste*	rocaille
bergère	mahogany	Rococo
blockfront	Marlborough leg	slip seat
bombé	ormolu	*vernis martin*
commode	Pembroke table	Windsor chair
console table	ribband-back	

French/English Furniture Terms

armoire/wardrobe

bergère/upholstered armchair

bibliothèque/bookcase

buffet/buffet or sideboard

bureau/desk

cabinet/cabinet

canapé/sofa

caquetoire/conversation chair

chaise/side chair

chaise lounge/"long chair," chair for reclining

chiffonier/chest of drawers

coffre/chest

commode/low chest of drawers

console/table secured to the wall

dressoir/sideboard

encoignure/corner cabinet

escritoire/desk or writing cabinet; also writing box

etagère/open shelves

fauteuil/upholstered armchair with open arms

meuble/furniture, movable furniture

sécretaire/desk

tabouret/low rectangular stool

table/table

table à écrire/small writing table

vitrine/curio cabinet with glass front

Recommended Reading

Chippendale, Thomas. *Gentleman and Cabinet-Maker's Director*, 3rd edition. originally published London, 1762. First edition published 1754, reprinted New York: Dover, 1966.

Fitzgerald, Oscar P. *Four Centuries of American Furniture*. Radnor, PA: Wallace-Homestead, 1995.

Gilbert, Christopher. *The Life and Work of Thomas Chippendale*. London: Studio Vista, 1978.

Negus, Arthur, and Hugh Scully. *The Story of English Furniture*, Volumes 1 & 2, video. London: BBC Enterprises, 1986.

Verlet, Pierre. *The Eighteenth Century in France: Society, Decoration, Furniture*. Rutland, VT: Charles E. Tuttle, 1967.

Chapter 5

NEOCLASSICAL
A Capital Idea

CHAPTER CONTENTS

The Rococo curve lost favor, and political revolutions required new visual symbols; there was a return to classical forms and motifs, and straighter lines predominated.

FRANCE

 Louis XVI

 Directoire and Empire

ENGLAND

 Adam

 Hepplewhite

 Sheraton

 Regency

GERMANY

 Biedermeier

AMERICA

 Federal

 Empire (Greek Revival)

*T*he 1700 century mark coincidentally also brought the beginning of a major change in furniture design. For the first time in history, the curve became the basis of not only decoration, but structure, and the resulting Queen Anne and Rococo styles dominated the century—that is, until that same curve lost favor. The 1800 century mark was irrelevant to furniture design because the next significant change had occurred much earlier. By the 1760s, both France and England had begun to tire of Rococo, and the Louis XVI style in France and the Adam style in England accommodated the need for change by bringing the classics to the forefront once again.

FRANCE:

Louis XVI

Two concurrent forces led to the formation of the Neoclassical style in France, beginning in the 1760s. First, excavations of ancient Italian sites at Herculaneum and Pompeii (hence the term, **Pompeiion style**), beginning in 1738, and consequent publications aroused both scholarly and public interest in the **antique**. Second, the timing was right because the only sure thing about fashion is that it will always change, and the French were already growing bored with Rococo. Critics of the style published articles, while advocates of a new style began to make an impact.

One of the influential figures, Jacques-Ange Gabriel (1699–1782) succeeded his father as First Architect to the King. He employed the Neoclassical style as early as 1753, and even commissions for Louis XV, such as the Petit Trianon (1762–1764), already showed Palladian influences. This is not surprising because changes in architecture have generally always preceded those in furniture.

By the time Louis XVI ascended to the throne, the style given his name was already fully established. By about 1760, furniture in "the antique style" was being produced concurrently with Rococo. The decade of the 1760s was naturally one of transition, and just like *Régence* combined Louis XIV Baroque with Louis XV Rococo features, an unnamed period combined Rococo with Louis XVI Neoclassical. At first, classical ornament was applied to existing Rococo forms, until the forms themselves began to change. As the style pendulum had previously swung from straight to curved lines and from symmetry to asymmetry, its next swing brought a return of the straight line and symmetrical form.

The curved line of the new style became rigid, expressed as simple circles, ovals, and ellipses. The straight leg, which replaced the cabriole, was either four-sided or round. Chairs were not as comfortable as in the Rococo style, but they were equally elegant. The same forms, notably the *fauteuil* and *bergère*, persisted with only stylistic variations. Louis XVI *fauteuils* had either oval medallion or square backs. Upholstered *bergères* still had closed sides and used loose cushions with stripes as the prominent textile pattern. A variation, the gondola *bergère*, had a rounded back and semicircular seat. The semicircle was also used for commodes, with round fronts and tops and flat backs placed against walls. Other circular forms included a variety of tables and stands.

Because the furniture forms were still French and were only influenced by classical sources, the decorative motifs were used to express the new style. Border motifs—dentils, gadrooning, **guilloches**, bands of **acanthus** and other leaves, scrolls, olive or husk chains, and short rows of fluting—were used, along with details of columns and pilasters taken from classical architecture. Some of the popular antique motifs—Roman eagles, ram, goat, and lion heads, dolphins, cherubs, cupids, **griffins**, **sphinxes**, satyrs, wreaths, **anthemion** festoons of fruit or flowers, lyres, rosettes, *paterae*, medallions, and urns—were mixed with modern French floral compositions, which also characterized the style.

The complexity of Louis XVI style required the talents of some of the most skilled and talented designers and cabinetmakers, and Jean Henri Riesener (1734–1806) is considered the greatest cabinetmaker in the Louis XVI style. Born in Germany, he came to Paris as a young man to work for and learn from Oeben. (When Oeben died in 1765, Riesener married his widow.) He first worked in the Rococo style, with its opulent marquetry and gilt bronze

mounts, before adopting Neoclassical style—with its opulent marquetry and gilt bronze mounts. Some pieces were also decorated with panels of Chinese lacquer work and plaques of **Sevres** porcelain. His appointment as royal *ébéniste* to Louis XVI in 1774, plus the multipurpose mechanical table and other marquetry furniture for Marie Antoinette, brought him well-deserved notoriety. Riesener's commode for the king's bedroom in Versailles in 1775 was among the most expensive pieces of eighteenth-century furniture ever made.

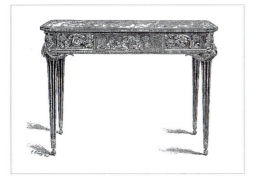

TABLE, FRANCE.
Transitional late Louis XV writing table, designed by Jean Henri Riesener for Marie Antoinette. *(Litchfield)*

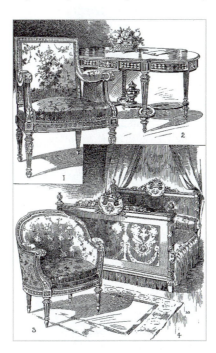

GROUPINGS, FRANCE.
Louis XVI *fauteuil*, table, and *begère*, all with tapered fluted columnar legs; and bed with straight columns flanking both head and foot. *(Benn)*

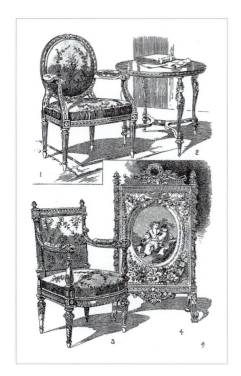

GROUPINGS, FRANCE.
Louis XVI fauteuils, showing both oval and rectangular backs, an atypical table with curved legs, and a screen with ornate frame. *(Benn)*

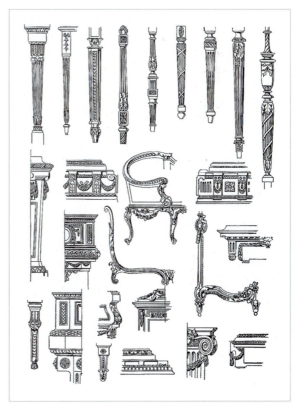

Details of leg types and other features of Louis XVI furniture. *(Benn)*

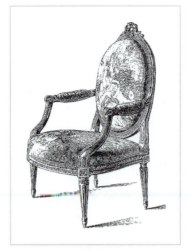

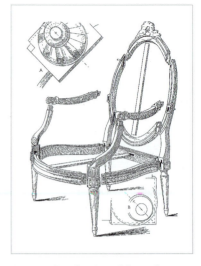

FAUTEUIL, FRANCE.
Louis XVI *fauteuil* with oval back,
padded arms, and tapered columnar
legs. *(Magne)*

Construction drawing of *fauteuil*.
(Magne)

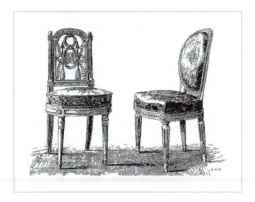

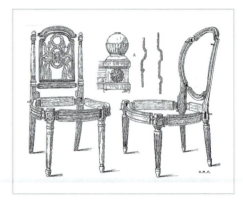

SIDE CHAIRS, FRANCE.
Louis XVI side chairs with both rectangular and
oval back, tapered columnar legs. *(Magne)*

Construction drawing of side chairs and detail
of finial. *(Magne)*

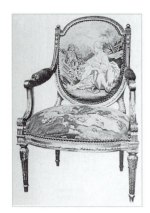

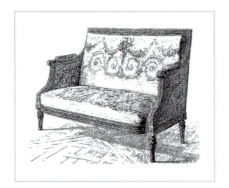

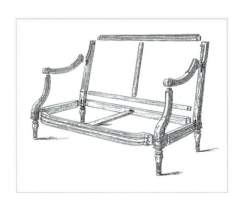

FAUTEUIL, FRANCE.
Louis XVI *fauteuil* with
figural tapestry upholstery.
(Strange)

CANAPÉ, FRANCE.
Louis XVI *canapé* (sofa) with straight back
and short tapered legs. *(Magne)*

Construction analysis of *canapé*. *(Magne)*

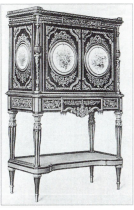

CABINET, FRANCE.
Louis XVI cabinet of
rosewood with bronze
mounts and Sevres
porcelain plaques, designed
by Weisweiler. *(Hunter)*

Directoire and Empire

As the style continued, there was a noticeable movement from a lighter, more graceful look to something heavier. By the end of Louis XVI's reign, the **Empire style** began to take form, even though its name would be taken from Napoleon's Empire (1804–1815). As the *Régence* style and period was a transition between Baroque and Rococo, the *Directoire*, with its use of military motifs, served as the transition between Louis XVI and Empire. France was ruled by the National Convention from 1792 to 1795, and in that year the Directory or Directorate was formed. The name *Directoire* is used for the furniture style from 1793 until 1804, when Napoleon pronounced himself emperor. Because both *Directoire* and Empire styles were Neoclassical, the differences were often subtle.

Generally, if the style appears to be more "academically correct," it is later. Interest in Greco-Roman style shifted from artistic interpretations to a perceived archaeological correctness. Unfortunately, none of the prototypes were examples of actual wood furniture, but ranged from vase paintings to bronze miniatures, and yes, designer's imaginations. Though too frequently criticized for lack of restraint and no lack of bizarre forms, the Empire style cannot be accused of being boring. Whether embellished with Napoleonic symbols or attempting to out-Greek the Greeks, the curule form legs, rolled-over backs, and asymmetrical couches could not be ignored.

Because much of the Empire style was politically motivated, it is no surprise that its symbols were popularized by the premier Napoleonic painter, Jacques-Louis David (1748–1825). After studying classical art in Rome, David returned to Paris in 1789, to be made, if only momentarily, painter to Louis XVI. (As a member of the National Convention, he also happened to vote for the king's execution.) An admirer of Napoleon, David influenced furniture design by including some of his own designs in his paintings and by popularizing many of the Empire motifs that were applied to furniture. But the most influential figures of the Empire style were Napoleon's architects—Charles Percier (1764–1838) and Pierre François Léonard Fontaine (1762–1853).

As with other arbiters of Neoclassical style, both Percier and Fontaine spent time in Italy studying and absorbing classical art and architecture. After David introduced them to Napoleon, they won the patronage of Josephine. Beginning in 1802, they published books, and in 1812 their *Recueil de Décorations Intérieures* promoted Greek art and the Empire style in both pictures and in words. Fontaine was appointed first architect to Napoleon the following year, and the influence he and Percier had on furniture design was profound.

Patronage had shifted from the royal court and an upper class preoccupied with fashion and luxury, to a self-appointed emperor obsessed with pomp and symbols. Comfort was exchanged for severity; soft fluffy cushions were replaced by the tight seat of a rigid Empire sofa that required an almost military posture from the sitter. Uninterrupted flat surfaces of cabinets gave an even heavier appearance than the bold sculpturesque carving found supporting sofas, chairs, and tables. Symmetry was used without forgiveness: Not only were right and left sides of forms and decoration mirror images of each other, but individual motifs were often the same. Even the placement of furniture in a room was often symmetrical and stiff. By creating a visual antithesis of the graceful flow and movement of the feminine and playful Rococo, the Empire style sought to embody masculinity and discipline appropriate to military rule. Only Josephine's swan motif brought relief from the parades of **caryatids**, winged sphinxes, lions, and chimeras with eagle heads. Napoleon's additional incorporation of Egyptian, Italian Renaissance, and Etruscan motifs transformed the original quest for Greco-Roman academic correctness into something of a stylistic free-for-all. When done well, however, Empire furniture was very effective, even beautiful. After nearly two centuries of mixed reviews, it is again enjoying increased interest and admiration.

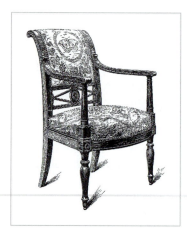

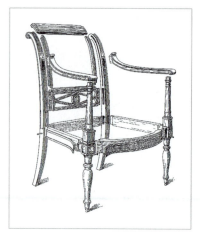

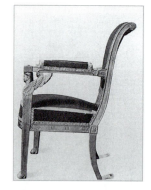

***FAUTEUIL*, FRANCE.**
Late eighteenth-century *Directoire fauteuil*, similar to but less ornate than Louis XVI. *(Magne)*

Construction drawing of *Directoire* chair showing curved stiles. *(Magne)*

***FAUTEUIL*, FRANCE.**
Early nineteenth-century Empire *fauteuil* designed by Percier and Fontaine with curved stiles and carved sphinxes supporting the arms. *(Hunter)*

***FAUTEUIL*, FRANCE.**
Empire *fauteuil* with curved crest rail and stiles and large sculptural figures from classical mythology as both arm supports and front legs. *(Magne)*

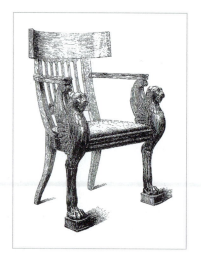

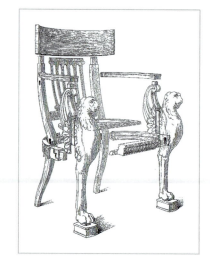

Construction analysis of *fauteuil*. *(Magne)*

SIDE CHAIRS, FRANCE.
Empire chaises (side chairs) with boxy seats; left with splayed back legs and stiles curving back; right with all legs splayed and stiles curving forward. *(Magne)*

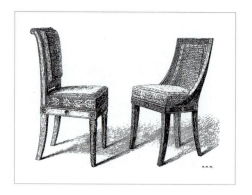

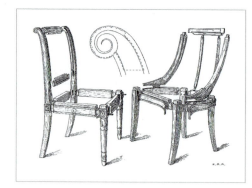

Construction analysis of chairs and detail of tip of stile. *(Magne)*

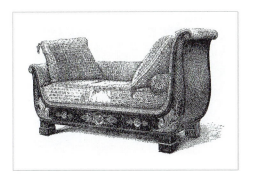

DAYBED, FRANCE.
Empire lit de repos (daybed) with one side higher than the other in a shape influencing the later sleigh bed, a popular American Empire form. *(Magne)*

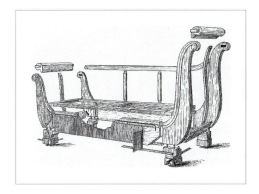

Construction of daybed. *(Magne)*

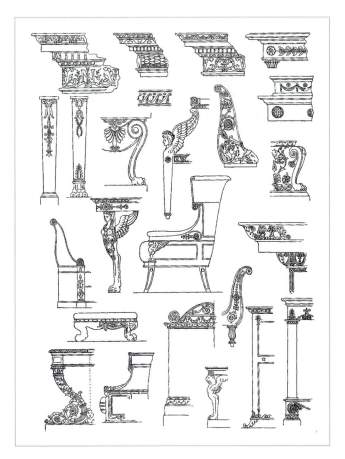

Details of French Empire furniture. *(Benn)*

CLOCK, FRANCE.
Drawing of a monumental Empire pendulum clock by Percier and Fontaine.

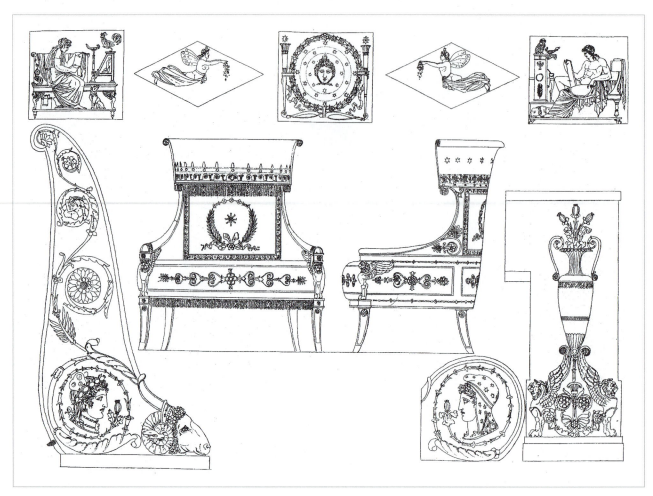

MOTIFS, FRANCE.
Drawing of an Empire *bergère* and various Neoclassical details and ornaments by
Percier and Fontaine.

CHAIRS, FRANCE.
Drawing of two similar Empire *fauteuils*, the bottom with short legs and wide seat and
back, by Percier and Fontaine.

FURNISHINGS, FRANCE.
Drawing of Empire *fauteuils*, bench with X-frame, candelabra, and tables by Percier and Fontaine.

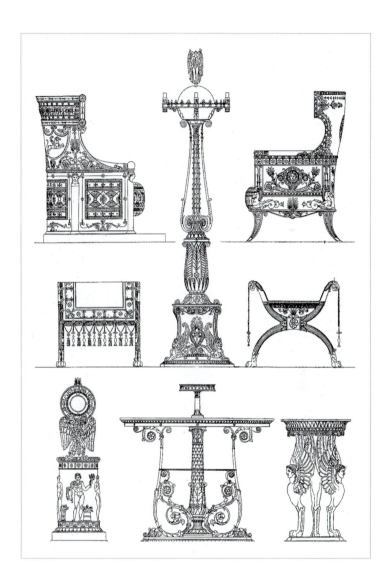

BED, FRANCE.
Drawing of royal Empire bed with long bolster cushion on each end and elaborate canapé with hanging textiles, by Percier and Fontaine.

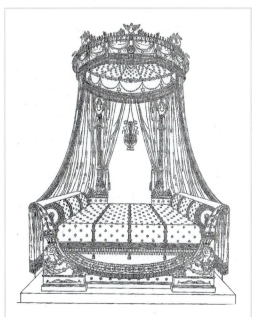

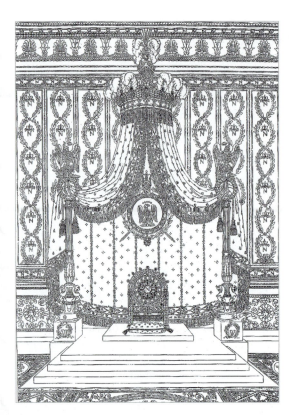

THRONE, FRANCE.
Drawing of Napoleon's throne and surrounding interior decoration by Percier and Fontaine.

ENGLAND

Adam

Robert Adam (1728–1792) is credited with bringing the Classical Revival style to England. The son of a Scottish architect, William Adam, Robert made the grand tour of Italy for three years absorbing classical architecture and design. In 1758 he returned to England and brought an original and very fashionable Neoclassical style. His brothers John, James, and William were also his partners in their London establishment.

The design motifs that Robert used became his personal hallmarks—goat or ram masks, flower festoons, winged griffins, urns, scrolls, *paterae*, lyres, sphinxes, and a particular husk, called "Adam husk." Robert Adam is known to have recorded at least 9,000 original designs, all in Neoclassical style.

Of his important architectural projects, the most comprehensive, perhaps the most outrageous, is Osterley, where Adam worked from about 1761 to 1781. In Osterley, Adam exercised his preference for total integration of architectural features, decoration, and furnishings. This harmonious whole, this epitome of gestalt in interior design, is one of the most remarkable qualities of Adam's style.

Originally an Elizabethan mansion built in 1577, the entire structure at Osterley needed to be modernized in order to accommodate Adam's ideas. Only then could he create its interior design of niches filled with classical sculpture, domed ceilings, urns on pedestals, Wedgwood vases, pilasters, panels with relief decoration, and plaster moldings. Intricate ceiling motifs are mirrored in carpet patterns. Not until Frank Lloyd Wright, one and a half centuries later, would an architect's work reflect such an obsession with harmony.

John Linnell (d. 1796) was a cabinetmaker and wood-carver who executed many of Adam's designs. An extraordinary thirteen-foot settee was designed to be in proportion with the long gallery in which it stood—a 147-foot room. Much of the furniture is made of mahogany with inlay of **satinwood** and harewood. Ormolu swags and rondels give it a definitely Louis XVI flavor, something other English Neoclassical furniture does not share. Among the very French-looking pieces are demi-lune, or half circular, commodes

covered with inlay and ormolu and chairs with oval backs. Other chair backs are square, and chair legs are often square tapered or columnar with scrolls and swags. Paint or gilding enhance the carved features.

Gilding was also used on fantastic framed mirrors, like the inverted heart-shaped models with three-dimensional figures at Osterley. Adam's decorative features—gilding, ormolu, and abundant inlay—plus the heavier Louis XVI forms restrict his furniture to formal and aristocratic settings. It also explains why the Adam style never caught on in the Colonies. Rather, a simpler, more restrained, some would argue more elegant, interpretation of Neoclassicism became the primary style in both England and America, and the names associated with its were Hepplewhite and Sheraton.

Hepplewhite

Like Chippendale, George Hepplewhite (d. 1786) was recognized after his design book was published. Unfortunately, Hepplewhite's *The Cabinet-Maker and Upholsterer's Guide* was published posthumously in 1788—he never lived to enjoy the fame it would bestow. His delicate and graceful lady's work tables, gentleman's dressing tables, tea tables, sofas, and chairs were, and still are, among the most highly regarded English furniture. Chair back forms included shield, heart, round/wheel, and camel. Eating habits had a strong influence on furniture, and a variety of tea, Pembroke, and dining tables were essential. The separate dining room carried the **sideboard** to new heights in both importance and specialized form. A three-piece dining table consisted of a drop-leaf centerpiece with two half-circle console tables at the ends.

Hepplewhite used inlay to enhance the minimalist forms, not conceal them. Satinwood from the West and East Indies, **boxwood**, amboyna with its tight little curves, and

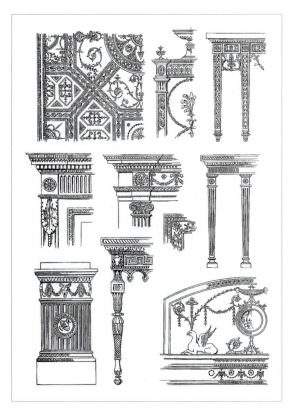

DECORATION, ENGLAND.
Interior architecture and furniture elements with typical Neoclassical motifs by Robert Adam circa 1770s. *(Benn)*

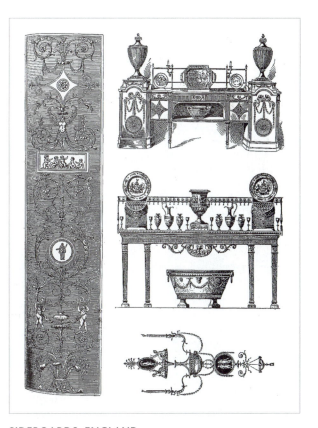

SIDEBOARDS, ENGLAND.
Sideboards with accessories and other Neoclassical ornamental motifs by Robert Adam. *(Strange)*

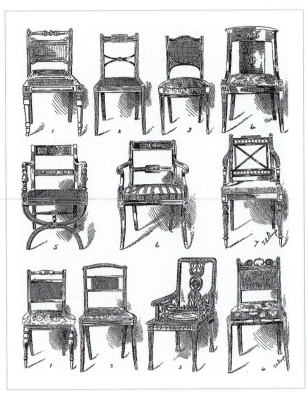

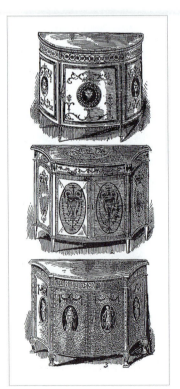

CHAIRS, ENGLAND.
Various chair designs, all with square or rectangular backs by Robert and John Adam. *(Strange)*

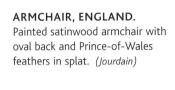

ARMCHAIR, ENGLAND.
Painted satinwood armchair with oval back and Prince-of-Wales feathers in splat. *(Jourdain)*

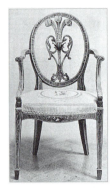

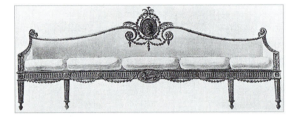

SETTEE, ENGLAND.
Very long five-seat settee design with medallion on crest rail by Robert Adam. *(Jourdain)*

COMMODES, ENGLAND.
Designs for ornately decorated Neoclassical commodes by Robert and John Adam. *(Strange)*

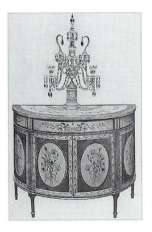

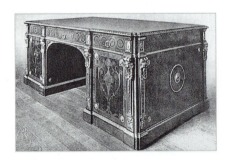

COMMODE, ENGLAND.
Commode veneered with harewood and satinwood and inlaid with floral bouquets in oval medallions by Robert Adam. *(Jourdain)*

DESK, ENGLAND.
Pedestal writing table or desk of rosewood, inlaid with tulipwood and satinwood, with chased and gilt ormolu mounts, designed by Adam and made by Chippendale. *(Jourdain)*

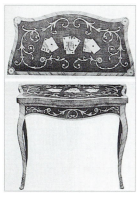

CARD TABLE, ENGLAND.
Card table veneered and
inlaid with harewood,
tulipwood, and other woods
with *trompe l'oeil* cards on
the top and atypical
cabriole legs. *(Jourdain)*

1788
George Washington elected
first U.S. president.

1789
United States Constitution;
inauguration of Washington;
French Revolution; Lavoisier's
Elements of Chemistry; soda
commercially made from
salt; discovery of uranium
and zirconium; riviting
machine introduced and
steel bridges become
popular; first U.S. patent for
steam-propelled land vehicle.

1790
Jacquard loom; first United
States patent filed.

1791–1867
Michael Faraday, electricity.

1791–1872
Samuel F. B. Morse,
telegraph.

1792
Washington re-elected U.S.
president.

1793
King Louis XVI guillotined;
Eli Whitney's cotton gin.

the richly colored and patterned Brazilian species—purplewood, zebrawood, kingwood, and tulipwood—all filled veneer inventories of cabinetshops. Thin bands of string inlay direct the eye around the form of drawer and door fronts, tabletops, and legs. Carving is minimal and shallow, preventing it from overpowering the straight lines or smooth curves. His characteristic Prince-of-Wales feathers are found on the shield-shaped, oval, or square backs of chairs, propped on slender reeded or fluted legs.

Whereas many of Adam's designs can be compared to ornate French forms, Hepplewhite's most delicate designs are comparable to the ultralight little Rococo tables used in lady's boudoirs. Though the antithesis of Rococo, these Neoclassical examples are also among the most dainty designs ever made from wood.

In order to better understand the designs Hepplewhite contributed, it is helpful to read his words in the Preface from *The Cabinet-Maker and Upholsterer's Guide* (the eighteenth-century usage of the letter "f" for "s" has been changed for easier readability).

> To unite elegance with utility, and blend the useful with the agreeable, has ever been considered a difficult, but an honorable task. How far we have succeeded in the following work it becomes not us to say, but rather to leave it, with all due deference, to the determination of the Public at large.
>
> It may be allowable to say, we have exerted our utmost endeavors to produce a work which shall be useful to the mechanic, and serviceable to the gentleman. With this in view, after having fixed upon such artices as were necessary to a complete suit of furniture, our judgment was called forth in selecting such patterns as were most likely to be of general use—in choosing such points of view as would shew them most distinctly—and in exhibiting such fashions as were necessary to answer the end proposed, and convey a just idea of English taste in furniture for houses.
>
> English taste and workmanship have, of late years, been much sought for by surrounding nations; and the mutability of all things, but more especially of fashions, has rendered the labours of our predecessors in this line of little use: nay, at this day, they can only tend to mislead those Foreigners, who seek a knowledge of English taste in the various articles of household furniture.
>
> The same reason, in favour of this work, will apply also to many of our own Countrymen and Artizans, whose distance from the metropolis makes even an imperfect knowledge of its improvements acquired with much trouble and expense. Our labours will, we hope, tend to remove this difficulty; and as our idea of the useful was such articles as are generally serviceable in genteel life, we flatter ourselves the labour and pains we have bestowed on this work will not be considered as time uselessly spent.
>
> To Residents of London, though our drawings are all new, yet, as we designedly followed the latest or most prevailing fashion only, purposely omitting such articles, whose recommendation was mere novelty, and perhaps a violation of all established rule, the production of whim at the instance of caprice, whose appetite must ever suffer disappointment if any familiar thing had been previously thought of; we say, having regularly avoided those fancies, and steadily adhered to such articles only as are of general use and service, one principal hope for favour and encouragement will be, in having combined near three hundred different patterns for furniture in so small a space, and at so small a price. In this instance we hope for reward; and though we lay no claim to extraordinary merit in our designs, we flatter ourselves they will be found serviceable to young workmen in general, and occasionally to more experienced ones.

Hepplewhite is straightforward about his intentions. First, uniting elegance with utility was clearly one of the goals of all good eighteenth-century designers, and their clients expected no less. The drawings for these elegant and useful articles aided the artisans producing the articles, as well as the client making a selection.

The issue of English taste and fashion is of utmost importance. If England is to serve as a model, the designs must be new and modern, and not rely on historic precedent. This applies to their use by both "Foreigners" and to "our own Countrymen" who happen to be located away from the style center, that is, London. He also makes a point to alert Londoners not to expect to see any frivolous novelty items. The intent is to present only the most useful and long-lasting designs, in the most elegant way possible. There is no doubt regarding Hepplewhite's success because his designs have withstood over two centuries of fashionable use, revival, and admiration.

The illustrations on pages 104 through 107 are plates from Hepplewhite's *The Cabinet-Maker and Upholsterer's Guide*. Some of the captions are also from the *Guide*. The eighteenth-century convention of using the letter "f" instead of an "s" has been retained in those captions and in the following excerpt about chairs:

"The general dimenfion and proportion of chairs are as follows: Width in front 20 inches, depth of the feat 17 inches, height of the feat frame 17 inches, total height about 3 feet 1 inch. Other dimenfions are frequently adapted according to the fize of the room, or pleafure of the purchafer."

Hepplewhite preferred mahogany where the natural wood was shown, either with or without carving. Seats were often covered in horsehair. He was also aware of the taste for chair frames of painted and japanned wood, often with caned seats and cushions.

Though known best for the shield-back chair, Hepplewhite also used the square back, which is usually associated with Sheraton.

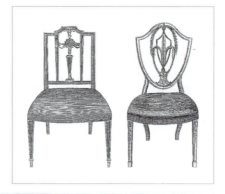

CHAIRS.
Two examples of both square-back and shield-back chairs, with tapered Marlborough, or four-sided, rather than rounded legs.

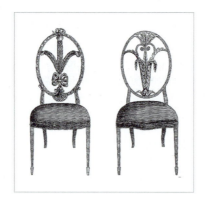

Examples of Hepplewhite chairs with oval backs and Prince-of-Wales feathers.

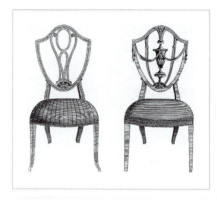

CHAIRS.
Two examples of Hepplewhite's famous shield-back chairs, the right with carved classical urn and Prince-of-Wales feathers motifs, with the more commonly found tapered Marlborough legs.

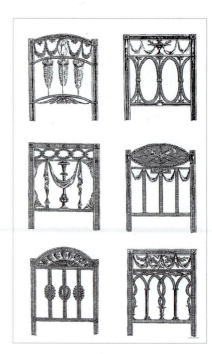

Drawings for Hepplewhite chair backs.

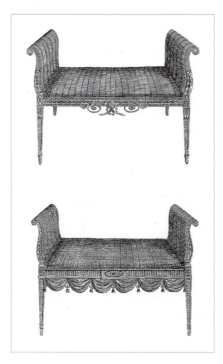

WINDOW STOOLS.
"The upper one is applicable to japan-work, with ftriped furniture; the under one of mahogany, carved, with furniture of an elegant pattern feftooned in front, will produce a very pleafing effect. The fize of window ftools muft be regulated by the fize of the place where they are to ftand; their heights fhould not exceed the feats of the chairs."

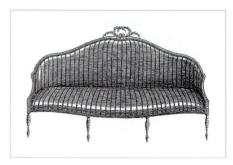

SOFA.
Sofas were also intended for either mahogany or japanned finish. Recommended length was 6' to 7', depth 30", height of seat frame 14", and total height of back 3',1".

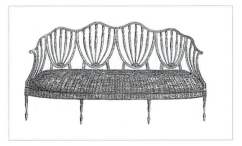

BAR-BACK SOFA.
"This kind of sofa is of modern invention; and the lightnefs of its appearance has procured it a favourable reception in the firft circles of fafhion. The pattern of the back muft match the chairs; thefe alfo will regulate the fort of frame-work and covering."

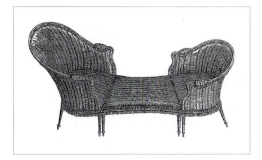

DUCHEFSE.
"This piece of furniture is derived from the French. Two Barjier [*bergère*] chairs, of proper conftruction, with a ftool in the middle, form the duchefse, which is allotted to large and fpacious anti-rooms; the covering may be various, as alfo the frame-work, and made from 6 to 8 feet long."

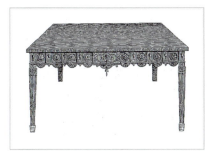

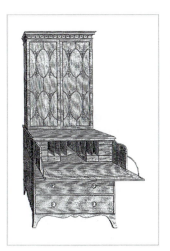

SIDEBOARD.
Though similar in appearance to a table, this piece is considered to be a sideboard without drawers.

SECRETARY AND BOOKCASE.
These were usually of mahogany or a lighter colored wood. The fall front is used for writing when open and conceals the slots and drawers when closed. Doors in the upper portion enclose the shelves for books, and an early practice of storing books in drawers is served by the lower portion with its large drawers.

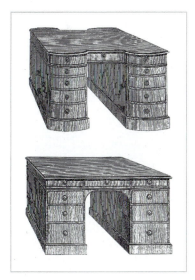

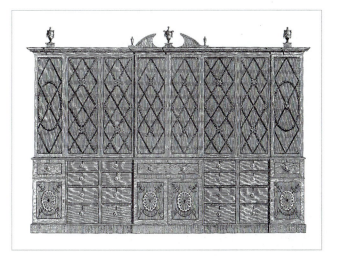

LIBRARY CASE.
A large and imposing piece, the library case was made from the finest woods, such as mahogany, and included optional inlay with colored woods. The middle drawer was used as a secretary, with wardrobe shelves beneath.

LIBRARY TABLES.
These were generally of mahogany with leather or green cloth on top. The design using a pedestal filled with drawers on each side has proven to be the most popular desk for two centuries. Even in the late twentieth century, this design is still used in residential libraries and executive offices.

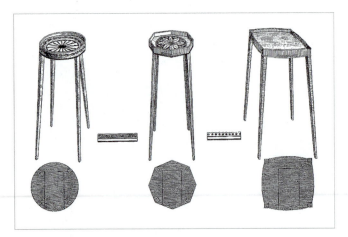

URN STANDS.
These small tables, about 26" high, have either plain or decorative inlaid tops. The outlined rectangle on the lower drawing indicates the slide, which pulls out to receive the teapot.

PIER TABLES.
Tables placed against a wall, usually set between two windows, are more for decoration as much as for use, so the tops are often elaborately inlaid or painted.

TOPS FOR PEMBROKE TABLES.
Decorated like the pier tables, with inlay or painted designs, the Pembroke table can be either oval or rectangular, with sides that fold down when a smaller size is needed.

TAMBOUR WRITING TABLE AND BOOKCASE.
Precursor to the popular nineteenth-century rolltop desk, this tambour writing table has a writing surface covered by the rolltop rather than one that either opens outward or slides forward. The upper portion serves as a bookcase covered by two doors decorated with metal and painting.

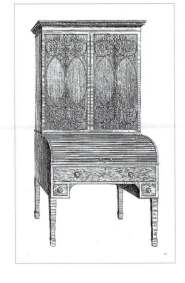

DRESSING DRAWERS.
Usually with bracket feet, these dressers have variously shaped forms, such as these with serpentine (top) and bowed (bottom) fronts. Finish can be paint or varnish, over plain or inlaid wood.

COMMODE.
Commodes, placed against a wall, are similar to pier tables with storage in the lower portion. Wood is usually highly decorated with inlay or paint, especially because these were used in more public spaces, such as drawing rooms.

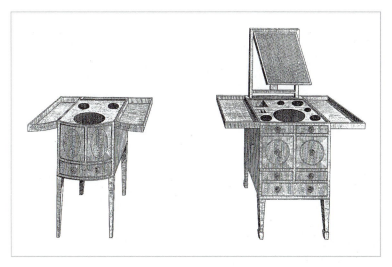

SHAVING TABLES.
"Two different kinds are fhewn; the tops of which turn over on each fide; the glafs to each draws up in the back, and is fupported by a fpring ftop; the fituation of the glafs is regulated by a foot in the back; within the doors is a place for water bottles, &c. The drawer is defigned to hold napkins, &c.; are made of mahogany."

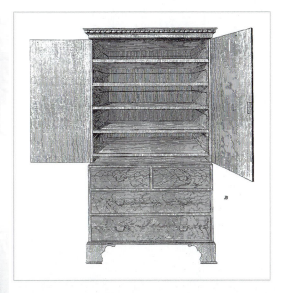

WARDROBE.
The wardrobe was considered to be a very important piece of storage furniture before the advent of built-in closet space. These were usually plain, but of the best mahogany. Typical dimensions are 5',6" height, 4' length, and 22" depth.

Sheraton

A name used almost interchangeably with Hepplewhite is that of a Baptist preacher, Thomas Sheraton (1751–1806). Although he had training as a cabinetmaker and a draftsman, it is unlikely that he ever had a workshop. His publication, *The Cabinet-Maker and Upholsterer's Drawing-Book* in 1792, marketed primarily to the trade, also served as a guide for virtually all fashionable furniture made in England and America in the late eighteenth century. Like Hepplewhite, there is no existing furniture known to have been actually made by him. Because a good deal of Sheraton's designs resemble, or are almost identical to, those of Hepplewhite, it will be more useful to point out some of the differences between them.

Where Hepplewhite used inlay, Sheraton preferred more carving and veneers with delineated grains. In addition to a tapered Marlborough or round leg with reeding or

1800
Thomas Jefferson elected third U.S. president; electric battery.

1801
Gas used for heat and light; punch cards.

1803
Napoleon sells the Louisiana territory to the United States for $3 million, probably the largest peaceful land transfer in history; John Dalton's table of atomic weights; Ralph Waldo Emerson (1803–1882).

fluting, often ending in a spade foot, Sheraton also used turning and features like curved sabre legs or a splayed foot. His shield-back chair with pierced upright splat looks like Hepplewhite's shield-back, only with stretchers. The area beneath the chair is the most likely place to find its design attribution. However, more of Sheraton's chairs had a square back than any other form.

Sheraton outlived Hepplewhite, so his oeuvre was broader. He also worked and published in a later Neoclassic style, which influenced American successors such as Phyfe and Hitchcock (Chapter 7). Some of Sheraton's late designs, such as for Grecian couches, were certainly more toward Regency style, with their heavier and more sculptural form. Experimenting with mechanical devices in furniture also fascinated Sheraton, and he continued to design both convertible and multipurpose pieces. His library steps/table was designed so that every part collapsed and folded.

A lesser known designer and craftsman of Neoclassical furniture was Thomas Shearer. Although almost nothing is known about the man, his book of furniture designs, intended for use by contemporary masters and craftspeople, is another valuable resource of eighteenth-century styles.

The illustrations on pages 108 through 112 are plates from Thomas Sheraton's *The Cabinet-Maker and Upholsterer's Drawing Book*. Captions are also from the *Drawing Book*, and the eighteenth-century convention of writing the letter "s" as "f" has been retained.

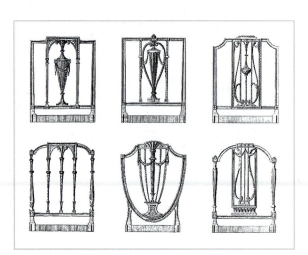

CHAIR BACKS.
Sheraton included suggested finishes for chairs, such as in white and gold, japanned, or mahogany with French finish.

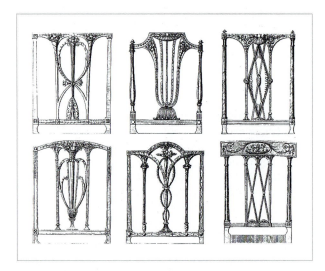

BACKS FOR PAINTED CHAIRS.

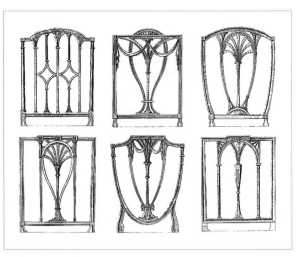

BACKS FOR PARLOUR CHAIRS.

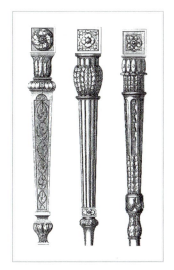

CHAIR LEGS.

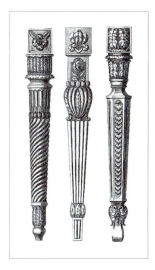

CHAIR LEGS.

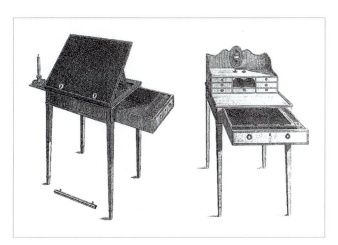

A READING AND WRITING TABLE AND A WRITING TABLE.

"The left-hand table is to write and read at. The top is lined with leather or green cloth, and crofs-banded. To ftop the book there are two brafs plates let in, with key-holes; and in the moulding, which is to ftop the book, are two pins, with heads and fhoulders, by which the moulding is effectually fecured.

"The right-hand table is meant to write at only. The top part takes off from the under part, which having a bead let in at the back and ends of the top, prevents the top part from moving out of its place. This table being made for the convenience of moving from one room to another, there is a handle fixed on to the upper fhelf, as the drawing fhews. In the drawer is a flider to write on, and on the right-hand of it ink, fand, and pens. The fizes are fhewn by the fcales."

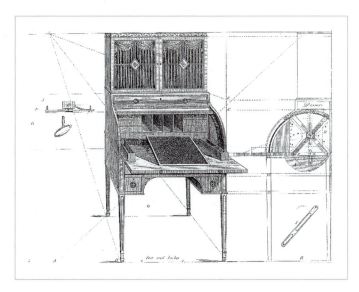

A CYLINDER DESK AND BOOKCASE.

"The ufe of this piece is plain, both from the title and from the defign. The ftyle of finifhing them is fomewhat elegant, being made of satin-wood, crofs-banded, and varnifhed. This defign fhews green filk fluting behind the glafs, and drapery put on at top before the fluting is tacked to, which has a good look when properly managed. The fquare figure of the door is much in fafhion now. The ornament in the diamond part is meant to be carved and gilt, laid on to fome fort of filk ground. The rim round the top is intended to be brafs; it may, however, be done in wood."

LIBRARY STEPS AND TABLE.

"The fteps may be put up in half a minute, and the whole may be taken down and enclofed within the table frame in about the fame time. The table, when enclofed, ferves as a library table, and has a rifing flap fupported by a horfe, to write on. The fize of the table is three feet ten inches long, thirty-three inches high, and two feet one inch in width. When the fteps are out they rife thirty-three inches perpendicular from the top of the table frame, and the whole height of the laft ftep is five feet five perpendicular from the ground."

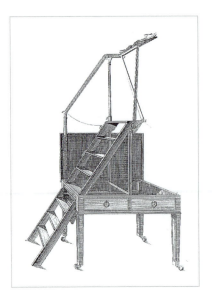

LIBRARY STEPS AND PEMBROKE TABLE.

"These fteps are confiderably more fimple than thofe already defcribed; and though not fo generally ufeful, will come vaftly cheaper. The upper flight of fteps turn down upon the under ones, both of which rife up and flide in as a drawer; after which a flap, which is fhewn in the defign, is turned up, and has the appearance of a drawer front. . . . The length of the table is three feet fix inches, its width twenty-two inches. The table is thirty inches high, the upper flight is thirty perpendicular, and the refting-loft thirty-three."

DRESSING CHESTS.

"These chefts are alfo on a new plan, particularly as the common flider for merely writing on is turned into a fhallow drawer, which contains a little writing flap which rifes behind by a horfe, and places for ink, fand, and pens, and alfo dreffing-boxes. When the drawer is in, it appears like a common flider, with a partition above and below, as that with the convex front. There is therefore no flip under the top, as the drawer fides muft run clofe up to it. The drawer below of courfe muft lock up into the under edge of the dreffing-drawer, and the dreffing drawer into the top, which is done at one time, by the bolt of the under lock forcing up that of the upper one.

The height of thefe chefts are always governed by the flider, which runs thirty-two or thirty-three inches from the floor. The fcale fhews their length, and their breadth is twenty-two or twenty-three inches."

A DRAWING TABLE.

"This table will be found highly useful to fuch as draw, it being defigned from my own experience of what is neceffary for thofe who practice this art. The top of this table is made to rife by a double horfe, that the defigner may ftand if he pleafe, or he may fit and have the top raifed to any direction. As it is fometimes neceffary to copy from models or flower-pots, &c. a fmall flap is made to draw out of the top, which may be raifed by a little horfe to fuit any direction that the top may be in, fo that the model or flower-pot may ftand level. The fliders at each end are neceffary for the inftruments of drawing, and for a light to ftand on. The long drawer holds paper, fquare and broad, and thofe drawers which form the knee hole are fitted up for colours."

A KIDNEY TABLE.
"The writing defk in the middle may be made to
flide forward, which will then ferve to draw
upon. . . . the small drawers will be found
convenient for colours. . . . The drawer in the middle
of the front ferves to put the drawings in. The top
is lined with green leather or cloth."

**"HORSE DRESFING-GLAFS AND HORSE DREFSING-GLAFS AND
WRITING TABLE".**
"The dreffing-glafs on the left rifes to any height, by lead weights inclofed
in the ftandards. . . . when the glafs is raifed, it may be turned to any
direction. . . . The boxes on each fide are intended to hold conveniences for
dreffing.
 "The other dreffing-glafs has a convenience for writing as well as for
dreffing, which convenience rifes by a little horfe. . . ."

A SIDEBOARD WITH VASE KNIFE CASES.
"The pedeftal parts of the fideboard may be made feparate,
and then fcrewed to the fideboard. The top extends the
whole length, in one entire piece, and is fcrewed down to
the pedeftals. The hollow plinths of the vafes are worked in
one length, and mitered round."

DRAWING ROOM CHAIRS.
"The frame of the right-hand chair is intended to be finifhed in
burnifhed gold, and the feat and back covered with printed filk.
 "In the front rail is a tablet, with a little carving in its
panel. The legs and ftumps have twifted flutes and fillets, done
in the turning, which produce a good effect in the gold.
 "The chair on the left may be finifhed in japan painting,
interfperfed with a little gilding in different parts of the
banifter, which has a lively effect. The covering of the feat is of
printed chintz, which may now be had of various patterns on
purpofe for chair-feats, together with borders to fuit them."

The last two figures in this group are plates from Thomas Shearer's *The Cabinet-Makers' London Book of Prices*.

SIDEBOARD AND TABLE.

At top is a serpentine-front cellaret sideboard. At bottom is 3'4" rudd table, all solid, with astragal, or two beads, and hollow round the edge of the top, the two outside drawers with no quadrant boxes, a glass hung to each drawer, supported by quadrants. This variety of dressing table, said by Hepplewhite to possess "every convenience which can be wanted or mechanism or ingenuity supply," was named after the notorious Mrs. Rudd, who was tried for fraud at the Old Bailey in 1775, and died neglected, in her early thirties, in 1779. Rudds remained fashionable until about 1800.

TWO CHESTS.

At left is a commode dressing chest with straight wings. This serpentine front dressing chest, also called a French commode, was comparatively expensive, especially when the front, ends, and top were veneered. At right is a commode dressing chest with O.G. ends. Also veneered and with a serpentine front, this variation has tapered legs and curved sides.

1804
Napoleon crowned emperor of France; Jefferson re-elected; first canning factory, glider, steam locomotive.

1804–1806
Lewis and Clark expedition opens American West.

1806
End of Holy Roman Empire.

1807
Coal-gas lighting in London streets; Fulton's steamboat is first practical and economical one; Geological Society of London; Britain abolishes slave trade.

Regency

The English Regency lasted only from 1811 to 1820, but the style called Regency (not to be confused with French *Régence*) was popular from the turn of the century until about 1830. Its highlight was a domed oriental palace built at Brighton and occupied by King George IV. An eccentric figure, with tastes that included both elegance and ostentation, his motto might have been "too much is not enough." The Regency style, a mixture of oriental, French Empire, Egyptian, and Greco-Roman revival, also ranged from the elegant to the flamboyant.

Unlike the smooth-lined inlay of early Neoclassic furniture, Regency became more sculptural and robust. Casters, though introduced earlier, became a necessity for moving the heavier furniture, no longer confined to placement along walls. Coromandel, a hard, dark wood from India, similar to ebony, was a favorite wood. The use of contrast was very baroque—black and equally deep colors delineated with bright gold. Brass inlay in classical motifs and multiple bands was used freely on tables and case pieces. The sofa table, with flaps on the short side (Pembrokes had the flaps on the long side), was fitted against the back of a sofa. Other tabletops of Italian colored stone inlay were supported by "dolphin" pedestals (apparently a new species, with scales like fish). Another favorite motif was the lyre, also used as a pedestal, and carved winged sphinxes became exaggerated chair supports.

1808
Elements barium, strontium, and calcium discovered; Beethoven's *Symphony No. 5*; Jefferson Davis (1808–1889).

A name almost synonymous with English Regency is Thomas Hope (1769–1831). Born in Amsterdam, he traveled extensively, studied Greek and Roman art, and then settled in London about 1796. Like other devotees of classical Greek style, he published design and pattern books, beginning with architecture in 1804, followed by the 1807 folio *Household Furniture and Interior Decoration*. He also wrote on both ancient and modern costume, philosophy, and a best-selling novel. Hope's Regency-style furniture, even with all of its brass inlay and casters, is among the most archaeologically correct of all the Greek revivalists. Not known for its comfort, but rather for its adherence to antique design, Hope's furniture relied on actual Greek sculpture and vase painting as much as on imaginative interpretation. His accurate copies of historic prototypes were a transition to, and perhaps an influence on, the Victorian historic revivals that followed. In fact, in his last years, Hope even studied Gothic architecture, the first of the coming wave of revivals.

TABLE, ENGLAND.
Regency pedestal table of mahogany inlaid with ebony and silver, designed by Thomas Hope in 1807 and illustrated in his book, *Household Furniture.* (*Jourdain*)

CHAIR, ENGLAND.
Regency armchair with four lion legs and lion head raised above the seat, designed and possibly owned by Thomas Hope, circa 1807. (*Jourdain*)

CHAIRS, ENGLAND
Regency gilt throne chair with sphinx supports; with painted and gilt **X**-frame chair with lion feet and lion head terminals. (*Jourdain*)

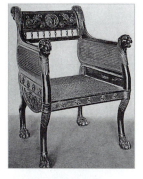

CHAIR, ENGLAND.
Regency armchair with four lion paw legs and caned seat and sides, designed by George Smith, upholsterer and furniture designer to George IV. (*Jourdain*)

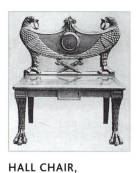

HALL CHAIR, ENGLAND.
Regency carved mahogany hall chair with two eagles forming the back, 1809. (*Jourdain*)

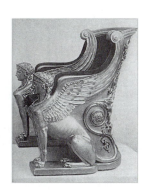

THRONE CHAIR, ENGLAND.
Regency gilt throne chair with huge carved sphinxes as the legs and sides, 1820. (*Jourdain*)

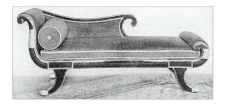

SOFA, ENGLAND.
Regency sofa in the form of a Grecian couch; asymmetrical design with round bolster cushion on one side, splayed legs. (*Jourdain*)

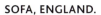

GERMANY

Biedermeier

The Neoclassical style was also popular in Germany in the late eighteenth century, but it followed more than led the French and English innovators and style codifiers. David Roentgen (1743–1807) was a German cabinetmaker who had the good fortune to be controlled neither by royalty nor the guilds. Where others, such as Sheraton and Hepplewhite, died penniless, Roentgen is considered to be the most successful eighteenth-century cabinetmaker. (Although he worked in Rococo style, his acclaim is more for his Neoclassical work, which he marketed internationally, enjoying patronage from Louis XVI to Catherine II of Russia.

Karl Friedrich Schinkel (1781–1841) is considered one of the greatest German architects and an impressive designer of furniture. His Grecian-style furniture was less ostentatious and probably more comfortable than Regency, and his use of lightly colored veneer and plainer surfaces in the early nineteenth century anticipated the Biedermeier style.

Originally an unflattering term, **Biedermeier** referred to a stereotypical middle-class person without culture. The furniture, in fashion from about 1820 until long after Neoclassicism, was stylish in France and England, about 1860. Although the German style borrowed from its neighboring predecessors—English Sheraton and Regency, French *Directoire* and Empire—it had a distinctly middle-class simplicity and charm. A preference for curving lines in chair backs and legs of tables and chairs contrasted the blocklike forms of most case pieces. Swans and dolphins (with scales) supported German chairs and sofas, just as they supported French and American Empire pieces.

Lighter woods—ash, pear, birch—typified Biedermeier, though deeper redder tones of cherry and mahogany were also used. Plant stands accommodated a widespread interest in plants, just as a sudden increase in letter writing created a fashion for writing desks and tables. As with many other styles, the later period saw less restraint, and a restlessness, perhaps a stylistic insecurity, appeared. By mid-nineteenth century the graceful Neoclassical Biedermeier curves suddenly seemed almost Rococo, until they did, indeed, turn into Rococo Revival.

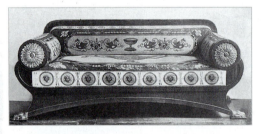

SOFA, GERMANY.
Biedermeier sofa in late Neoclassical style similar to Empire, but with less three-dimensional carving and smoother surfaces, 1820. *(Schmitz)*

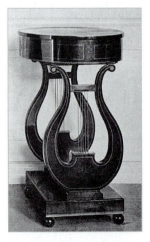

OCCASIONAL TABLE, GERMANY.
Biedermeier table supported by two large lyres on a platform base with four ball feet, 1820s. *(Schmitz)*

AMERICA

Federal

Even though the Colonies continued to follow English fashion throughout the eighteenth century, there was no Adam style in America. Elitist and costly furnishings designed for English country houses and palatial mansions had no place in the New World with its clearly anti-aristocratic society. The 1760s to 1780s, therefore, saw a continuation of Chippendale styles.

With Independence in 1776, Americans sought some stylistic independence as well. The new Federal Style, really Federal Period, adapted the designs of Hepplewhite and Sheraton to the new nation. No matter that the style was, in fact, English, it was given new symbolic meaning and identity in American interiors. Designs relied on those found in the pattern books, and decorative motifs—**bellflower**, husks, *paterae*, acanthus—took on new meaning. Ancient Greece, the ultimate source of inspiration, was portrayed as the first democracy, and its artistic motifs became associated with the newly established United States.

Carved motifs were important features of these Hepplewhite and Sheraton styles, and one of the most admired wood-carvers was Samuel McIntire (1754–1811). A prominent architect and builder from Salem, Massachusetts, McIntire executed delicate carvings on furniture made by other cabinetmakers. It is believed that he made some of his own furniture designs as well.

The first American cabinetmaker to successfully interpret English Neoclassical style, plus create his own version, was Duncan Phyfe (1768–1854). He is not only considered to be the greatest American cabinetmaker, he was an early founder of the industrial tradition in America. Born in Scotland, he arrived in the United States in 1783 or 1784. The family settled in Albany, New York, where his father was a cabinetmaker. By 1792, Duncan was a joiner in New York City, and two years later was listed as a cabinetmaker. He began working in the Sheraton style, closely following English pattern books. More an imitator than an innovator, he also worked in French *Directoire* and Empire styles. By the turn of the century, New York had become one of the richest cities in America and a leader of fashion. Phyfe both followed the fashion brought from Europe and led it in his use of carved mahogany and features such as lyres, tablet backs, splayed or flared legs, pedestal table supports, brass mounts, cast metal feet, swivel casters, and reeding. One of the identifying features of early nineteenth-century American furniture, especially by Phyfe, is the widespread use of convex parallel ribbing called **reeding**, rather than **fluting**. As other synthesizers of style before him—Chippendale, Hepplewhite, Sheraton—Phyfe became the first American to lend his name to a style of furniture.

CHAIR, AMERICA.
Early nineteenth-century painted chair with front stretcher repeating decorative design of the back. *(Hunter)*

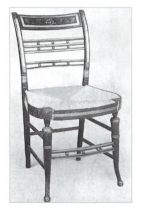

SEWING TABLE, AMERICA.
Sheraton sewing table with slender tapered legs and cloth bag hanging from the top, circa 1800. *(Hunter)*

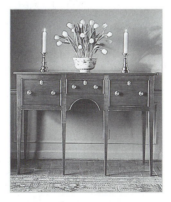

SIDEBOARD, AMERICA.
Reproduction of Williamsburg mahogany sideboard, with six slender tapered legs and three drawers. *(Courtesy of Baker Furniture)*

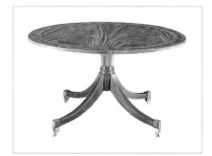

DINING TABLE, AMERICA.
Reproduction of Federal dining table with central pedestal and four splayed legs on casters, supporting a round top. *(Courtesy of Baker Furniture)*

Empire (Greek Revival)

Inspired by both French and English designs, the Empire style in America was the last of the pre-Victorian handmade furniture. The style was also called Greek Revival, and Americans were generally sympathetic toward the Greeks in their war of independence from Turkey (1821–1827). This "Greek temple style" predominated architecture, from monumental public buildings to modest residences. American cities—Athens, Ithaca, Sparta, Troy—were given Greek names. The two major furniture-manufacturing centers of American Empire furniture were New York and Philadelphia, where most of these bold classical revival pieces were made from about 1820 to 1840. During this period, about 1,600 furniture craftspeople were active in Philadelphia, about sixteen times the number of the pre-Revolution era.

There were many technical advances in the early nineteenth century, from the coil spring for upholstered seats to woodworking devices. Patents, a new concept introduced at the end of the eighteenth century, were issued for mechanical devices for planing, cutting, and grooving wood, and for making veneer sheets. Veneer could be made thinner and more quickly, and could be applied to curved surfaces, even to rounded columns, without splitting. The circular saw, used in upstate New York in 1814, was available in Philadelphia by 1825. Yet this woodworking machinery was not in general use for making Philadelphia Empire furniture, which was still made by hand.

The Empire style was a more literal interpretation of classicism than the earlier version. Actual forms of Greek and Roman furniture, and not just decorative motifs, were used. Where a more sculptural form of carving was popular in New York, Philadelphia Empire had more shallow carving—exactly the opposite of the eighteenth-century regional variation. Prominent furniture forms included the *mérridienne*, sleigh bed, girandole, pier glass, mirror-backed console tables, and the piano. Metal feet and metal mounts were used extensively until stencilling replaced actual metal for ornamentation.

Many cabinetmakers, such as Michel Bouvier (1792–1874) and Anthony Gabriel Quervelle (1789–1856) came from France. Working in Philadelphia at least as early as 1817, much of Querevelle's high-style furniture was based on George Smith's pattern books. Through Smith's designs, there was also a strong British influence on Philadelphia Empire furniture.

New York, however, was the largest center for high-style American Empire furniture. Becoming the busiest port, New York had trading relations with France and England, as well as with the American interior through the Erie Canal beginning in 1825. During the popularity of the Empire style, New York more than doubled its population, exceeding 300,000 by 1840.

In addition to Duncan Phyfe, New York boasted many fine cabinetmakers working in the style, especially those of French origin. Charles Honoré Lannuier (1779–1819) was born in France, came to New York in 1803, and worked there until he died. His beds, **pier**

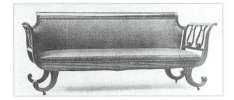

SOFA, AMERICA.
Duncan Phyfe Empire sofa with tight seat, straight back, and lyre supports at the sides.
(Hunter)

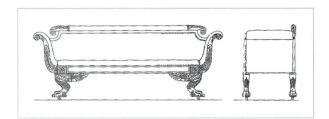

SOFA, AMERICA.
New York Empire sofa with animal paw feet supporting cornucopias, scrolled sides with carved acanthus leaves, tight seat, and cylindrical crest rail ending with carved scrolls at each end, 1820. *(Nye)*

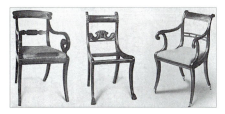

CHAIRS, AMERICA.
Examples of Neoclassical side chairs and
armchairs by Duncan Phyfe. *(Hunter)*

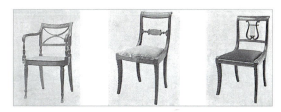

CHAIRS, AMERICA.
Examples of Duncan Phyfe chairs, the right with lyre
back. *(Hunter)*

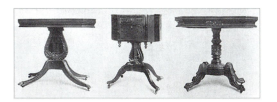

TABLES, AMERICA.
Three different examples of pedestal tables by
Duncan Phyfe, each with four legs, two with lyre
supports. *(Hunter)*

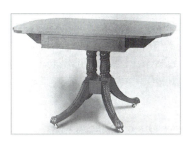

TABLE, AMERICA.
Duncan Phyfe table with four-part
pedestal supporting the rectangular
top with drop-leaf ends, 1800.
(Hunter)

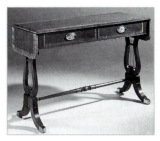

SOFA TABLE, AMERICA.
Reproduction of early
nineteenth-century Neoclassical
sofa table with drop leaves on
each of the short ends,
supported by lyres on two
splayed legs on each end.
(Courtesy of Baker Furniture)

1829
First steam-powered
railroad begins service.

1830
First single-thread chain-
stitch sewing machine.

1831
Michael Faraday discovers
electromagnetic induction;
Cyrus McCormick's first
version of the reaper;
London Bridge built.

1831–1879
James Clerk Maxwell,
theoretical physicist,
developed equations for
basic laws of electricity and
magnetism.

1832
Andrew Jackson re-elected;
stereoscope invented.

tables, wardrobes, chests, and chairs ranged in style from an earlier Louis XVI Neoclas-
sicism through American Empire. Lannuier is well known today because of the high qual-
ity of his work plus the fact that he signed his furniture—more than fifty signed pieces are
known so far.

In the midst of the influences from both France and England, America was beginning to
establish its own identity. With the oncoming industrialization and enthusiasm for novelty in
the nineteenth century, for better or for worse, America would begin to develop its own style.

Summary

- Curvilinear and asymmetrical Rococo was replaced by a series of Neoclassical
 styles, beginning in the 1760s.
- The Louis XVI style in France and the Adam style in England were graceful and
 refined, but formal and aristocratic.
- George Hepplewhite and Thomas Sheraton published pattern books that provided
 the basis for a more accessible and highly fashionable Neoclassical style in Eng-
 land and America.
- Biedermeier style in Germany borrows from English Neoclassicism.
- New York cabinetmaker and interpreter of English style, Duncan Phyfe was the
 first American to lend his name to a style.
- English Regency and French and American Empire were the most archaeologi-
 cally correct and sculptural of the Neoclassical styles.
- Empire was also the last of the handcrafted furniture before widespread industrial-
 ization and its resultant historic revivals.

1833
Abolition of slavery in
England.

Born 1833
Joannes Brahms (d. 1897).

1834
Mechanical refrigerator;
Braille writing.

1835
Repeating revolver.

1837
Queen Victoria crowned;
electric telegraph patented
by Morse.

Late 1830s
Daguerre's first practical
photography; bicycle.

1839
Baseball.

Chronology

French Political Periods
1774–1789	Louis XVI
1795–1799	*Directorate*
1804–1814	First Empire

English Political Periods
1760–1820	George III
1811–1820	Regency
1820–1830	George IV

1820–1860	German Biedermeier style
1776–1815	American Federal Period
Circa 1815–1835	American Empire style

Designers

James Adam (1730–1794, England) Architect and designer, brother and partner of Robert Adam.

Robert Adam (1728–1792, England) Architect, interior designer, and furniture designer who, with his brother James, completely coordinated the design of both exterior and interior of buildings and popularized the Classical Revival, or Neoclassical style.

Thomas Chippendale II (1749–1822, England) Son of Thomas Chippendale, carried on his work, mostly in the Regency style, until 1804.

Pierre François Léonard Fontaine (1762–1853, France) Architect and designer, leading figure in promotion of Empire style with partner Charles Percier.

Pierre Gouthière (1740–1806, France) Prominent metal sculptor known for ormolu mounts and ornament on marquetry furniture made primarily by Riesener under Louis XVI.

George Hepplewhite (d. 1789, England) Wrote the highly influential *The Cabinet-Maker and Upholsterer's Guide*, and popularized Neoclassical style in England.

Thomas Hope (1769–1831, Holland, England) Designer, publisher, and arbiter of taste, known for his work in Regency style, and the most archaeologically correct of all the Greek revivalists.

Charles Honoré Lannuier (1779–1819, France, United States) Arrived in New York in 1803 and made quality Neoclassical furniture, especially in the Empire style.

Samuel McIntire (1754–1811, United States) Prominent architect and wood-carver of Federal Period furniture.

Charles Percier (1764–1838, France) Architect and designer, leading figure in promotion of Empire style with partner Pierre François Fontaine.

Duncan Phyfe (1768–1854, Scotland, United States) New York cabinetmaker known for English Regency and Empire styles and use of straight-grained dark Cuban mahogany with fine sculptural carving; he was one of America's best-known craftsmen and the first American to have a style named after him.

Jean Henri Riesener (1734–1806, Germany, France) A student of Oeben, Riesener worked in the Rococo and then in Neoclasscal style for Marie Antoinette. As royal *ébéniste* to Louis XVI, he is considered the greatest cabinetmaker in the style.

David Roentgen (1743–1807, Germany) With varied European clientele and controlled neither by royalty nor the guilds, considered to be the most successful eighteenth-century cabinetmaker, particularly in Neoclassical style.

Thomas Sheraton (1751–1806, England) Wrote *The Cabinet-Maker and Upholsterer's Drawing-Book*, which helped to promote the Neoclassical style in England.

Adam Weisweiler (Germany, France) German admitted as master cabinetmaker in France in 1778 and worked for Marie Antoinette in the Pompeiian or Etruscan style.

Key Terms

acanthus	Empire style	Pompeiian (Etruscan) style
anthemion	fluting	reeding
antique	griffin	satinwood
bellflower	guilloche	sevres
Biedermeier	*patera*	sideboard
boxwood	pier table	sphinx
caryatid		

Recommended Reading

Beard, Geoffrey. *Craftsmen and Interior Decoration in England 1660–1820.* London: Bloomsbury, 1986.

De Ricci, Seymour. *Louis XVI Furniture.* New York: G.P. Putnam's Sons, 1900.

Hepplewhite, George. *The Cabinet-Maker and Upholsterer's Guide*, 3rd edition, originally published London, 1794. Reprinted New York: Dover, 1969.

King, Thomas. *Neo-Classical Furniture Designs.* Reprint of "Modern Style of Cabinet Work Exemplified," 1829. New York: Dover, 1995.

Sheraton, Thomas. *The Cabinet-Maker and Upholsterer's Drawing-Book*, originally published London, 1793. Reprinted New York: Dover, 1972.

Stillman, Damie. *The Decorative Work of Robert Adam.* London: Alec Tiranti, 1966.

Verlet, Pierre. *The Eighteenth Century in France: Society, Decoration, Furniture.* Rutland, VT: Charles E. Tuttle, 1967.

Chapter 6

VICTORIAN HISTORIC
Revival of the Fittest

CHAPTER CONTENTS

Industrialization enabled manufacturers to use historic styles and ornament to produce abundant and affordable furniture. Pattern books and illustrated company catalogs, plus several great expositions helped to spread the various fashions for a series of revivals in England and the United States from 1837 to 1901.

*F*or five thousand years, furniture had been crafted by hand. The expenditure of time and skill required to make each item often warranted the use of costly materials. It is understandable that all high-style furniture had been commissioned or purchased by the elite classes—the high born, the church, the wealthy, and those fortunate enough or clever enough to have earned their favors.

Changes in manufacturing technology, in social structure, and in attitudes made the nineteenth century, particularly the Victorian era from 1837 to 1901, quite different from any preceding period in history. Furniture was one of the most visible of the recipients of this enormous change. Ever since twentieth-century historians began to analyze the history of furniture, many of them also began to make unflattering generalizations about the Victorians and their furniture. It became almost fashionable to discount nearly an entire century as unworthy of serious study. This very act of generalization should have alerted scholars and other critics; yet, for many years, the focus of furniture scholarship ended abruptly at about 1830.

From a different point of view, some of the most significant, and certainly some of the most interesting, events occurred after 1830. Clearly, the value and contribution of Victorian material culture to history and to its apparent antithesis, Modernism, has been elusive and controversial. Both Neoclassical styling and its primarily handcrafted production methods, used at the beginning of the nineteenth century, have been viewed as distinct from later Victorian revival styles using industrialized production. Yet the publication of pattern books and the furniture itself make these distinctions less clear.

After publication of a series of highly influential pattern books on the stages of Neoclassicism of the late eighteenth to early nineteenth centuries, there was, understandably, a period of stylistic transition. Rather than fade as a furniture style, Neoclassicism both continued as one of several alternatives and contributed design elements to other revival styles. In England in the 1820s, designs for the late phases of classicism were still being published separately, or styles called Grecian, Etruscan, Egyptian, and Roman were published along with Gothic, Tudor, and Louis Quatorze.

By about 1830, England looked toward more national styles than could be provided by the classicism of ancient Greece and Rome. In a rapidly changing society, there was a symbolic stability represented by a remote past, especially if it was on native soil. Gothic, therefore, became the earliest of a series of romanticized historic styles to sweep through England. Elizabethan style soon followed, not replacing Gothic Revival, but rather accompanying it. The pace for change quickened in both technology and fashion. Soon English arbiters of taste showed revivals of French eighteenth-century style alongside their own native medieval and renaissance styles. Eventually, the distinctions disappeared, and elements of once-identifiable styles merged on single pieces of furniture. The stylistic free-for-all resulted in overstuffed Adam settees, Elizabethan chests decorated with Romayne work, and massive sideboards supporting carved motifs from every time and place. New forms such as the **lounge chair** and the **what-not** were introduced. Novelty replaced clarity and historic accuracy, and fashion embraced novelty.

The Preface of Blackie and Son's *The Victorian Cabinet-Maker's Assistant*, originally published in 1853, will help to illustrate the developing Victorian attitudes toward furniture. It reads:

> Every one connected with Cabinet-Making is aware of the difficulty of obtaining good and novel Designs for Furniture. When, however, such designs are obtained, every one is equally aware how comparatively easy it is to adapt them to the kind of work required; they may, in fact, be multiplied indefinitely, by engrafting the decorations of one on the forms of another, and in many other ways that will suggest themselves to every practical man. It is the object of the Cabinet-Maker's Assistant, to lay before the Trade a collection of such original and tasteful Designs; in which will be included examples of all the articles of superior furniture usually manufactured; those chiefly in demand being figured most copiously.

1840
Morse code.

Born 1841
Antonín Dvořák (d. 1904).

1842
First chemical fertilizer in England.

1843
First Christmas cards, England.

1844
Vulcanized rubber patented by Charles Goodyear; telegraph patented by Morse.

1845
Victor Hugo's *Les Miserables*; *Scientific American* magazine.

1846
William T. G. Morton invents anesthesia; Smithsonian Institution founded.

1847
Emily Brontë's *Wuthering Heights*; American Association for the Advancement of Science.

Born 1847
Thomas Edison (d. 1931), over 1,000 inventions.

Died 1847
Felix Mendelssohn (b. 1809).

The illustrations on pages 122 through 124 are plates from the Dover reprint of Blackie and Son's *The Victorian Cabinet-Maker's Assistant*, originally published in 1853. Many of the captions are also from the book.

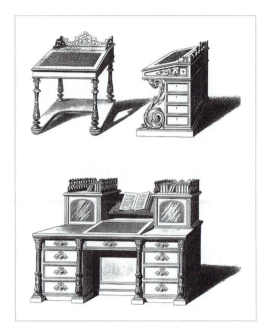

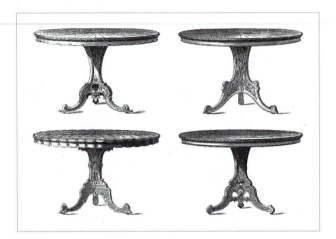

LOO TABLES.

"Throughout the whole range of cabinet furniture, there is probably no article which requires so much care and experience in the manufacture, as the Loo Table. The top, especially, presenting to the eye a large level surface, under such circumstances, that the slightest irregularity, or imperfection, is brought distinctly into notice."

In Figs. 1, 2, and 4 the veneers of wood burrs such as walnut, oak, yew, amboyna, and mahogany radiate from the center. Pedestals are constructed of solid wood portions jointed together.

WRITING TABLES.

"Figs. 1 and 2 are Davenports—the desk parts of which are made in the ordinary manner—requiring wood 3/4-inch thick of the body and hinged fold; the latter may be made of deal or of Bay mahogany, cross-headed—the solid wood forming the mouldings being planted around its front and ends; it is afterwards veneered below, and bordered above with veneer, and leather-covered. . . .

"Fig. 3. In this writing-table the plinth is made of deal dovetailed together, and veneered; the brakes in front are glued on, and the mouldings mitered round. . . . The gallery may either be of fret-work or of bronze. This design is well-adapted for mahogany, with the mouldings and portions of the columns ebony or ebonized—the ornaments containing the handles ebonized—and the handles either of bronze or silvered."

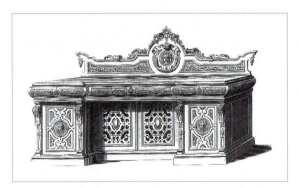

PEDESTAL SIDEBOARD.

This example, complete with variously historic medallions, fretwork, rosettes, scrolls, foliate borders, and architectonic backsplashes is most likely of oak. ". . . . it should be executed of large size, that sufficient space may be given for combining boldness with delicacy in the details of its decoration." In other words, if there isn't enough space for the entire gamut of decorative motifs and devices, then simply build the piece of furniture large enough to hold them.

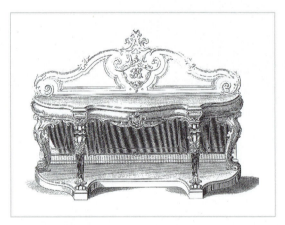

SLAB SIDEBOARD.

"Slab sideboards differ from pedestal sideboards in being more fitted for the display of plate or articles of *vertu*, and less for a place of deposit." Where pedestal sideboards at least had an implied function of storage, the slab was more in keeping with the medieval cupboard, or a surface on which to place cups and objects for display. The style of this Victorian example borrows from Baroque for its theatrical and imposing demeanor, and from Rococo for cabriole legs and frills.

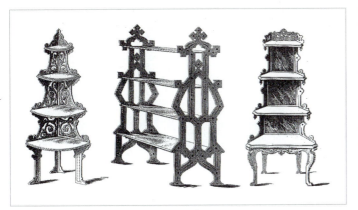

WHATNOTS.

"The whatnot is a piece of furniture which serves occasional or incidental use, and belongs, indifferently, to the dining-room, drawing-room, or parlour; but when especially designed for either, it should coincide with the proper character and general outfit of the apartment." This is a purely Victorian invention and necessity, because no proper corner or empty wall space was left uncluttered. The whatnot held anything in the category of bric-a-brac, whatever, or whatnot.

HALL CHAIRS.

Hall chairs were of modest proportion and even more modest comfort. The stiffness of form and the absence of upholstery, normally a Victorian obsession, indicates that they were intended for a low-status space, that is, the hall, and the sitters were most likely servants. These examples, however, are not wanting for embellishment, as seen in the apparently interchangeable historic ornamentation.

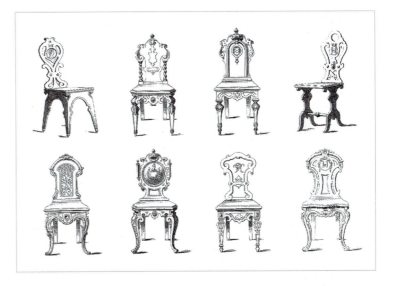

DRAWING-ROOM SOFAS.

These French Rococo derivations were of satinwood with gilding, entirely gilded, or of rosewood, with its high-contrast figured grain. Unlike their eighteenth-century inspiration, they probably were upholstered with coil springs, which had become fashionable earlier in the nineteenth century.

COUCHES.

"Fig. 1 . . . is best suited for execution in the lighter coloured woods, such as maple, or satin-wood, or birch . . . improved and illuminated by a judicious introduction of gilding. Fig. 2 is a design better adapted for rosewood or mahogany, in either of which woods it would prove a very effective and elegant couch."

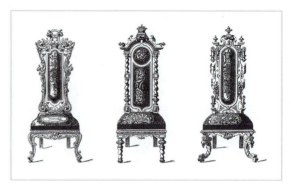

HIGH-BACKED CHAIRS.

"This is a variety of chair in which great scope is given for taste and embellishment. In most cases they are intended for covering with embroidery and needle-work." The exaggerated tallness of the backs, shortness of the legs, and the peculiar combination of historic features from different centuries are clues to their Victorian attribution.

ANTIQUE HIGH-BACK CHAIRS.

Although more elaborate and formal than the plainer high-backed chairs, these were also modeled after seventeenth-century styles and were every bit as uncomfortable.

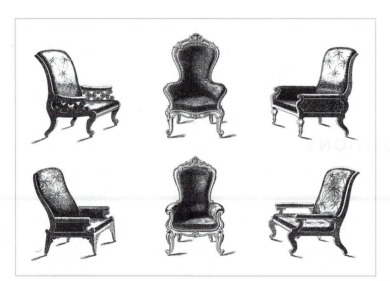

EASY CHAIRS.

Comfort was addressed in other types, especially the easy chair—"usually large, low-seated, and spring-stuffed, with a sloping back."

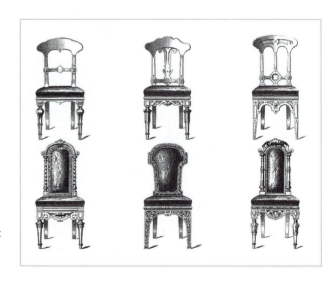

LIBRARY CHAIRS.

The legs of Figs. 1, 2, 4, and 6 are derived from late seventeenth-century William and Mary forms; Figs. 4 and 6 have backs similar to William and Mary and its preceding style, Charles II, except that the proportion is noticeably different—William and Mary being known for its height.

1848
Communist Manifesto by
Marx and Engels; California
Gold Rush.

Died 1849
Frédéric Chopin (b. 1810).

1851
Joseph Paxton's *Crystal
Palace* opens in London;
Singer patents continuous
stitch sewing machine.

1853
Aspirin, potato chips.

1854
Kerosene lamp; Elisha Otis
installs a workable elevator.

1855
Bunsen burner, safety match.

1856
Aniline dye; Bessimer process
for inexpensive steel;
Neanderthal skeleton found.

Died 1856
Robert Schumann (b. 1810).

The presentation of "original and tasteful designs" is not new. What seems to be the operative phrase is "multiplied indefinitely by engrafting the decorations of one on the forms of another." A feeling of arbitrariness results from the passage and from looking at examples of Victorian furniture because both decorations and forms were the products of imaginative furniture makers and/or borrowed from books and designers, and from history. What made this possible were the techniques to make a great deal of furniture relatively cheaply plus a large marketplace with more enthusiasm than discrimination.

In Blackie's description of drawing-room furniture, he gives additional insights into the Victorian attitude toward furnishings:

> The drawing-room being the principal apartment of a house, and appropriated to the elegances, refinements, and amusements of modern society, its furniture and decorations afford full scope for the display of taste in the owner and of ingenuity in the artists or tradesmen he may call to his assistance. . . . Beauty and elegance of expression being the main features to be studied in this apartment, there is not the same necessity for subordinating the ornamental to the useful, as in furniture intended for the dining-room or library; ornament may, consequently, be more freely introduced, richer materials employed, and greater license taken, both in the forms and in the colors adopted. Variety of form is very desirable, and playfulness of design may be freely introduced in such articles as are more for show or amusement than for actual use, and of these a drawing room usually contains a fair share; but while aiming at variety of form, consistency of style should be maintained, and no piece of furniture obviously at variance with the prevailing character of the furnishing of the room.

Form does not necessarily follow function, nor does function follow form. Another possible cliche, "ornament for ornament's sake" might apply, especially when playfulness, variety, and amusement are clearly valued more than either form or function. Statements such as these in Blackie's guide have certainly contributed to the Victorian reputation for stylistic chaos, or at least, confusion.

THE EXPOSITIONS

If there was indeed stylistic confusion in Victorian England, it was placed on view for the public to admire. Great expositions such as the famous Crystal Palace of 1851 and the London Exposition of 1862 served both as entertainment and marketing devices. Manufacturers displayed their most elaborate and ostentatious showpieces to an admiring public with widespread interest in a newly discovered consumerism. Competition for novelty and ornamentation were expected. What was not anticipated was serious criticism from another segment of society that would eventually inspire a major reform movement, the Arts and Crafts.

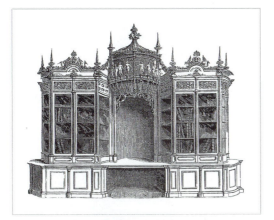

BOOKCASE, AUSTRIA.
Monumental bookcase of carved limewood with satinwood panels, made in Vienna for the 1851 Exhibition in London. *(Litchfield)*

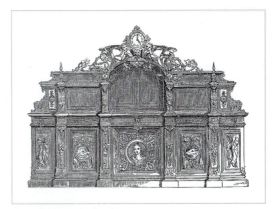

SIDEBOARD, FRANCE.
Carved oak sideboard, made in Paris for the 1851 Exhibition. *(Litchfield)*

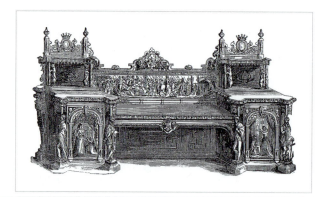

SIDEBOARD, ENGLAND.
Carved oak sideboard with characters from Sir Walter Scott's *Kenilworth*, made in Warwick, England, for the 1851 Exhibition. *(Litchfield)*

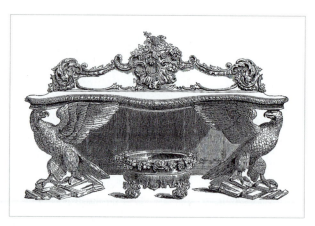

SIDEBOARD AND CELLARET, ENGLAND.
Carved oak sideboard with two huge carved eagles supporting the top, with open cellaret, made in London for the 1851 Exhibition. *(Litchfield)*

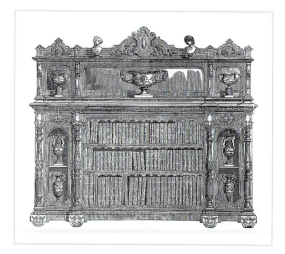

BOOKCASE, ENGLAND.
Cabinet with three shelves for books and an open top shelf fitted with a mirror, made in London for the 1851 Exhibition. *(Litchfield)*

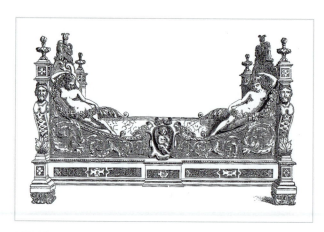

BEDSTEAD, BELGIUM.
Carved ebony Renaissance Revival bedstead, made in Antwerp for the 1851 Exhibition. *(Litchfield)*

TABLE AND CHAIR, ITALY.
Classical Revival-style pedestal table and chair, both with ivory inlay, made in Turin for the king of Sardinia and shown in the 1851 Exhibition. *(Litchfield)*

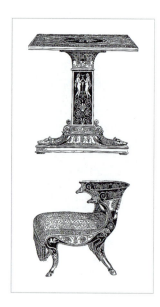

STATE CHAIR, ENGLAND.
Regal armchair with carved and gilt frame, upholstered in red silk, and embroidered with the royal coat of arms and Prince-of-Wales feathers, made in York for the 1851 Exhibition. *(Litchfield)*

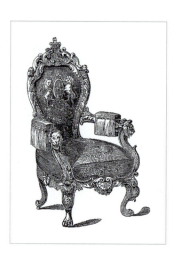

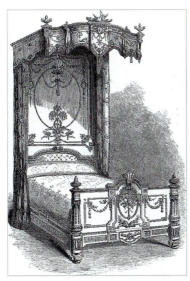

BEDSTEAD, ENGLAND.
Louis XVI Revival bedstead in carved, enamelled, and gilded mahogany with silk curtains and cover, made by Heal & Sons, London for the 1862 Exhibition.

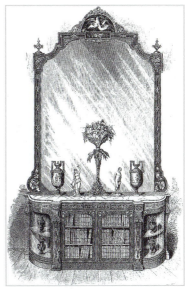

BOOKCASE, ENGLAND.
Low bookcase with curved glass on the side doors, marble top, and large mirror mounted across the entire width, made in London for the 1862 Exhibition.

CORLISS ENGINE, UNITED STATES.
Great Corliss engine, an example of the many technological advances shown at the 1876 Centennial Exhibition in Philadelphia.

Selections from the French exhibit at the Centennial Exhibition.

Circular settee and mantlepiece from the French exhibit at the Centennial Exhibition.

Renaissance Revival mantlepiece and seventeenth-century revival chairs from the Belgian exhibit at the Centennial Exhibition.

Selections from the Italian exhibit with *sgabello* chair at the Centennial Exhibition.

Monumental carved sideboard from the Spanish exhibit at the Centennial Exhibition. This is an example of one of the many popular forms that crossed national boundaries during the period.

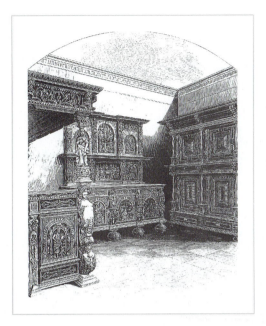

Baroque Revival selections from the Norwegian exhibit at the Centennial Exhibition.

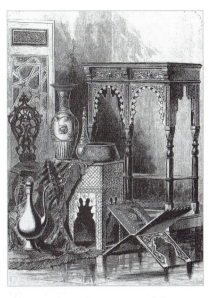

Selections from the Egyptian exhibit at the Centennial Exhibition, and an example of one of the exotic sources of Victorian taste.

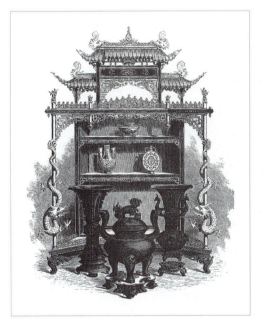

Selections from the Chinese exhibit at the Centennial Exhibition, and source of inspiration for *chinoiserie*.

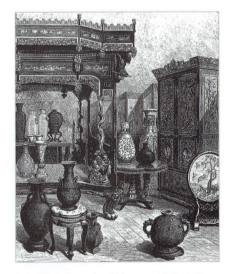

Selections from the Chinese exhibit at the Centennial Exhibition, with objects made to appeal to the Western consumer.

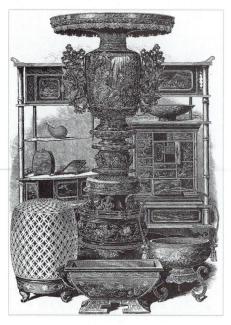

Selections from the Japanese exhibit at the Centennial Exhibition; the display piece in the back is an example of a design source for art furniture.

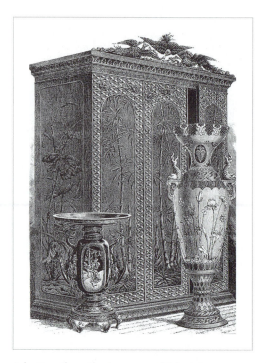

Selections from the Japanese exhibit at the Centennial Exhibition; here, the wardrobe looks European with only Japanese motifs—more like japonaiserie than Japanese furniture.

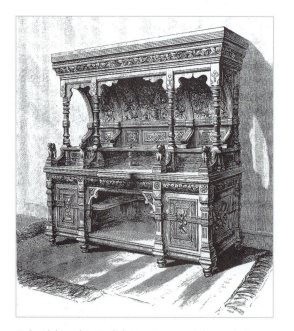

Oak sideboard in English Renaissance style, made in New York for the Centennial Exhibition.

Garden chair, an example of the elaborate ironwork in outdoor furniture at the Centennial Exhibition.

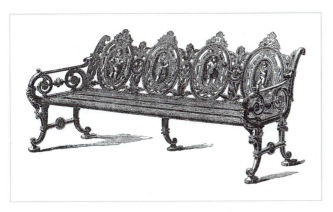

Garden settee, another example of the elaborate ironwork in outdoor furniture at the Centennial Exhibition.

New York Room, Women's Building at the World's Columbian Exposition, Chicago 1893. *(Shepp)*

Kentucky Room, Women's Building at the World's Columbian Exposition, Chicago 1893. *(Shepp)*

Cincinnati Room, Women's Building at the World's Columbian Exposition, Chicago 1893. *(Shepp)*

1857
Toilet paper in the United States.

1858
First aerial photograph from a balloon; Atlantic telegraph cable laid.

1859
Darwin's *On the Origin of Species*; first oil well drilled at Titusville, Pennsylvania, and beginning of petroleum industry.

1860
Abraham Lincoln elected; Lenoir's gas engine.

Crystal Palace

If the roots of the Arts and Crafts movement can be traced to the alleged adverse effect industrialization had on art, then the best negative example was the Great Exhibition of 1851 held in a remarkable structure called the **Crystal Palace**. According to the exhibition catalog, the purpose was "to connect the Fine Arts with the Industrial Arts. . . . having never been attempted elsewhere in Europe." (Curiously, the subsequent Arts and Crafts reform movement would have the same goal.)

The Crystal Palace was designed to house the industrial triumphs of the world in a building that measured 1,848 by 408 feet plus a 48- by 936-foot projection, with a 68-foot roof. The total area was 772,784 square feet and covered 19 acres, or four times the size of St. Peter's in Rome. The framework used 550 tons of wrought iron for 358 trusses and 3,500 tons of cast iron for its 2,300 girders. The discovery that iron ore could be smelted by using coke in a blast furnace made it possible to mass produce structural members. This incredible frame supported 896,000 superficial feet of glass, 600,000 feet of wood for floors and roof, and 30 miles of gutter to carry water.

Joseph Paxton, a self-educated horticulturist and ingenious greenhouse designer, designed this unique structure that could be called modern by any standard. It took only six months to make and assemble the components. The concept of prefabrication, the clever use of materials—iron and glass—and its enormous size must have awed spectators. If the building was awesome, its contents were considered by many critics to be awful. The

Great Exhibition was certainly great in size and scope, but it also caused great disappointment to those who expected a similar level of modernity in its contents. The structure probably would have elicited less criticism if it had been used for the giant greenhouse that it resembled.

This and other exhibitions were intended to display and market the benefits of a new machine age. Industrializing nations were invited to show off their best products to thousands of visitors, and clever mechanical devices, both practical and impractical, amused the crowds. The new machine techniques were also used to produce art objects and furnishings. What these all seemed to share was complete confusion of style, departure from handcrafting, and a general deterioration of quality. Eclectic historicism characterized objects smothered with machine-made ornamentation. The Victorian urge to clutter had reached its zenith at the Crystal Palace. The division of labor used to make the objects was one aspect of an overall separation between a once coherent and united process. Unlike the early craft industry in which designer, artisan, retailer, and consumer were in close touch, the new division of labor caused all connections in the process to unravel. Lack of communication and concern for the other members of the process caused standards of design and construction to fail.

It became obvious that the issues were far more complex than the choice of styles that filled exhibition halls. If "bad taste" had been the only shortcoming, there would have been no need for reform—just for artistic vision. The problem was an overall lack of understanding and/or concern by those in control of making products—industrialists, designers, artisans, and machine operators. It also included the users, the expanding class of Victorian consumers. Most Victorian visitors to great expositions, and the subsequent purchasers of industrially produced goods, were unaware or unmoved by the critics. They were delighted by the novelty and eager to own and to furnish their homes with any combination of historic styles.

Evidence that the reform movement spurred by the Crystal Palace Exhibition had not seriously affected either the manufacturers or the consumers could be seen in the many expositions that followed. For example, the 1862 International Exposition in London, the 1876 Centennial Exhibition in Philadelphia, and the 1893 World's Columbian Exposition in Chicago also contributed to the widespread fashions and appetite for the historic, the exotic, and the machine-made. With such well-organized exposure and promotion, it is understandable that these Victorian furnishings came to exemplify the era. This exposure also made it easy for manufacturers from one country to borrow designs, motifs, and techniques from another. Consequently, it is easier to identify many of these furnishings as products of the nineteenth century than to any particular country.

GOTHIC REVIVAL

The first of a series of historic styles to become fashionable, especially in England, was Gothic Revival, and the name associated most with the style is Augustus Welby Northmore (A.W.N.) Pugin. Born in 1812, the son of a French draftsman, Pugin began his career at the age of fifteen, when he designed Gothic furniture for Windsor Castle under his father's direction. In 1835 he began a focused study of the principles and applications of Gothic art. Then, in 1841 he published *The True Principles of Pointed or Christian Architecture*, which introduced the essence of his design philosophy: All features of a building should be for convenience, construction, and propriety, and all ornament should enrich essential construction. He felt that Gothic architecture was the only style that met these criteria, and Pugin's next publication, *Gothic Furniture of the Fifteenth Century*, applied the principles to furniture.

After organizing the Medieval Court at the Great Exhibition, Pugin became a major force in the Gothic Revival. He also influenced reformers, by stressing the need to reveal, rather than hide, construction techniques of Victorian furniture. For example, pegs that secure mortise and tenon joints were clearly shown on Pugin furniture. But he was not able

to influence most of the Victorian Gothic Revival furniture with its "flying buttresses on armchairs." Pugin observed Victorian rooms furnished with Gothic furniture—with all of the sharp ornaments and angular projections—and wrote that anyone escaping without injury was extremely fortunate.

American interpretations of Gothic style often bore even less resemblance to period Gothic prototypes. First, there had never been any real Gothic in America, and medieval Gothic was neither part of America's cultural history nor of the early Colonies. In the seventeenth century, even though Americans used English styles when they built the first architecture and furniture, Gothic was generally unknown to the colonists. Aside from pointed arches or sharp pinnacles on a few churches, it was rarely seen in colonial America. And by the nineteenth century, Gothic had even less meaning to most Americans.

But in England, the style had never disappeared. Original Gothic architecture could be seen in the great stone cathedrals still standing in the nineteenth century. When British designers looked to romanticize the past, the perfect authentic models were everywhere. Architecture led the revival, especially with the building of churches in the 1830s and the rebuilding of the Houses of Parliament beginning in 1836, after the devastating fire.

By the early nineteenth century, Gothic detailing gradually appeared on American architecture as well, especially churches. By the 1830s, it even spread to nonecclesiastical architecture. When Americans invented a Gothic past, they did it under the direction of architects like Andrew Jackson Downing, who wrote *The Architecture of Country Houses* in 1850. Downing was the first important landscape architect in America, and his country houses were designed with features like high chimney pots, sharply pitched gables, oriel windows, finials, and pendants. His villas even had towers, turrets, and battlements. Another influential architect and writer, Alexander Jackson Davis, helped to make the all frame-board-and-batten Gothic cottage the dream of every romantic Victorian. But they stopped at the gingerbread vergeboards and pointed arched windows, and furnished the houses in other styles.

When Americans interpreted Gothic style, no attempt was made to imitate medieval "interior design." Cold damp stone walls had little appeal to romantic Victorians, but they did choose to use spiral stairs to reach a tower, and they often used interior arches as decorative features. What little Gothic furniture was known would have been too heavy and impractical for the little frame cottages. Instead, when furniture companies made Gothic Revival furniture, they took contemporary furniture forms and superimposed Gothic motifs and cliches. Arches and tracery (originally of stone) were grafted onto chair backs and the fronts of case pieces, sometimes supporting glass panes. Trefoils and quatrefoils were shown as cut-out decoration on any solid wood surface, especially chair backs and table aprons. Hall stands, mirrors, and shelf clocks had pointed arches. Cluster columns were used as pedestal supports on tables, and bobbin turning was popular for the vertical members, especially legs of tables or chairs. Monumental architectonic head and footboards made beds look Gothic, but they were furniture forms that had never existed before.

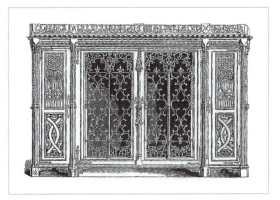

CABINET, ENGLAND.
Gothic Revival cabinet with motifs inspired by stone tracery, made in London for the Crystal Palace in 1851.
(Litchfield)

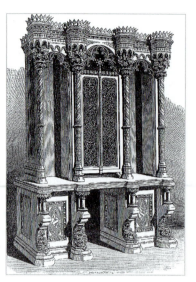

CABINET, ENGLAND.
Gothic Revival cabinet, more an architectural ornament than a functional or portable piece of furniture, made in London for the 1862 Exhibition.

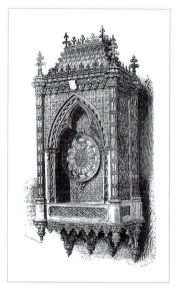

CLOCK, ENGLAND.
Gothic Revival clock with oak case richly carved with arches, columns, finials, pendants, and other gothic motifs, made in London for the 1862 Exhibition.

JOHN HENRY BELTER AND ROCOCO REVIVAL

The next (though also concurrent) revival also made good use of artistic license and romantic imagination. Its name, Rococo Revival, is even a misnomer, since it is so unlike its apparent inspiration, French Rococo of the eighteenth century. The original style is light in both visual weight and color. It was often made of delicately carved solid walnut and included many functional and/or decorative materials—ormolu, gilding, intricate marquetry, metal inlay, caning, colorful natural marble, and leather. The revival style of about one hundred years later typically used solid or laminated **rosewood** or other dark wood. The primary method of decoration was deep sculptural carving, and the dramatic and powerful effect is very baroque. Perhaps a more suitable label would be Baroque-Rococo Revival.

Regardless of its name, the revival style, with its "ruffles and flourishes," was first popular in England and France. Like other styles, it soon captivated American taste, and by the 1840s it crossed the Atlantic. Like other styles, too, it arrived with European cabinetmakers who emigrated to America.

Pattern books, periodicals, and actual pieces of furniture also inspired American cabinetmakers, as did the great international expositions of the 1850s. Yet, most cabinetmakers and furniture dealers in New York City in the 1850s had German or French names, and many had just recently emigrated. One of the most prominent is a name now almost synonymous with Rococo Revival furniture—John Henry Belter. After Phyfe, Belter became the most fashionable cabinetmaker in New York City, and he also lent his name to a style.

Born in southern Germany in 1804, Johann Heinrich Belter learned woodworking and cabinetmaking at an early age. He emigrated to the United States, anglicized his name, and is first listed in the New York City Directory in 1846. Belter worked in New York at various addresses and under different company names, so when a piece of his furniture is found with a label, it is fairly easy to date. Unfortunately, no labeled seating pieces have been found, and any labeled pieces of Belter furniture are rare. Since no company catalogs are known, Belter furniture must be identified by its attributes.

One of the distinguishing features of Belter Rococo Revival furniture is the use of laminated wood. Belter used between four and sixteen layers, or laminations, of primarily rosewood to make rather remarkable furniture. In an age characterized by industrialization, his parlor suites, tables, beds, and other forms included an enormous amount of hand-carved and hand-finished decoration. Besides the innovative lamination process, Belter's opulent carving that literally smothers his furniture is what his reputation was built on.

Curved barrel-like chair backs are often plain, with carving on the front, but he is also known for pierced carving that goes all the way through the wood and incorporates the negative spaces into the design. One of the most typical Belter motifs is a sausage-like scroll, especially on the frame of upholstered seating pieces.

As the most fashionable New York cabinetmaker of his time, until he died in 1863, Belter had many imitators and a few real competitors. Naturalistic carving of fruits and foliage, even suburb carving, cannot all be attributed to Belter. Joseph Meeks also worked in New York from 1836 to 1877 and made very fine Rococo Revival furniture, often so similar in style that Meeks's pieces have often been attributed to Belter. George J. Henkels also made good Rococo Revival furniture in Philadelphia from 1843 to 1877. Regardless of its maker, Rococo Revival is among the easiest to identify.

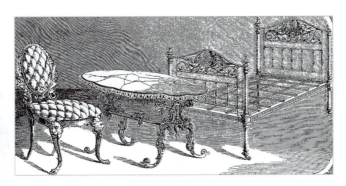

CHAIR AND TABLE, ENGLAND.
Rococo Revival side chair with cabriole legs and tufted upholstery; table also has exaggerated cabriole legs, from the 1862 Exhibition.

RENAISSANCE REVIVAL

If Rococo Revival is among the least difficult Victorian styles to label, then Renaissance Revival is among the most confusing. Though usually later, about 1865 to 1885, it was made and used concurrently with both Gothic and Rococo Revival furniture. Sometimes it even incorporated Gothic or Rococo features.

Some of its characteristics are consistent with period Renaissance pieces, such as massive symmetrical forms and deeply carved ornament. Others are more Baroque or Neo-classical, such as the use of architectonic pediments. However, these pediments were found on quite different places—the crest rails of chairs and sofas or on window valances—rather than just on the tops of case pieces. Portrait medallions were favorite embellishments for the more decorative pediments. The legs of these chairs and sofas were among the most identifiable features of Renaissance Revival style, with their distinct bulbous turning and tapered columns—not quite either William and Mary or Louis XVI, but resembling both. Gilded incised lines on the legs and other parts of the dark rosewood or mahogany made strong linear accents. **Tufted** upholstery on the seating pieces added to both the linear quality—the lines connecting the buttons—and the three-dimensional quality—by the mounds of upholstery between these little linear valleys.

The most monumental of the Renaissance Revival furniture used a mixture of materials and contrasts not seen since Louis XIV. Elaborate marquetry panels, inlay, columns, porcelain plaque inserts, sculptural carving, and gilt incised carving might all be used on one piece. Companies that made this expensive furniture included Kimbel & Cabus, first listed in the New York City Directory in 1863, and a competitor, Alexander Roux. Joseph Cabus may have been in partnership with Roux before joining Anthony Kimbel, and the

partners stayed together until 1882. Cabus then worked alone until 1897, and Kimbel's successor company, Kimbel & Sons, continued under Henry and Anthony Kimbel until 1941.

Because many styles were fashionable at one time, companies might specialize in more than one, listing them in separate parts of a catalog. Kimbel & Cabus, for example, made both "plain" and "artistic" furniture in either "Modern Gothic" or Renaissance Revival styles. While ebonized cherry might be featured for art furniture with a Gothic inspiration, they might ebonize portions of a Renaissance Revival piece.

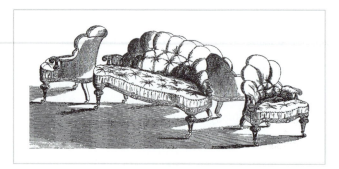

SEATING FURNITURE, ENGLAND.
Renaissance Revival easy chairs and sofas with Louis XVI style legs on casters and tufted upholstery, from the 1862 Exhibition.

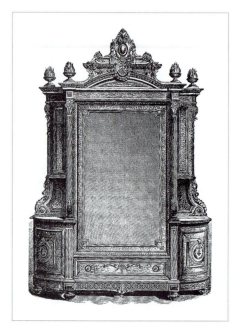

WARDROBE, UNITED STATES.
Renaissance Revival wardrobe with huge mirrored front and medallion on pedimental top, from the Philadelphia Centennial Exhibition.

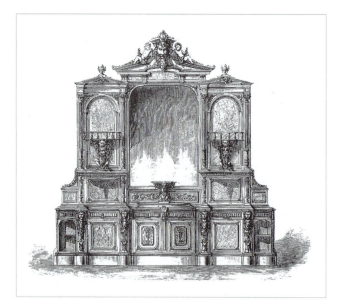

SIDEBOARD, UNITED STATES.
Imposing oak Renaissance Revival sideboard, 16 feet tall and 16 feet wide, made by George Schastey of New York for a Philadelphia mansion, and shown at the Centennial Exhibition.

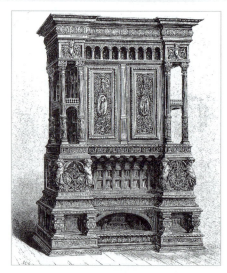

CABINET, UNITED STATES.
More in Italian Renaissance style than the more eclectic Victorian Renaissance Revival, this elaborately carved cabinet was made by the fashionable New York cabinetmakers Pottier and Stymus and was shown at the Centennial Exhibition.

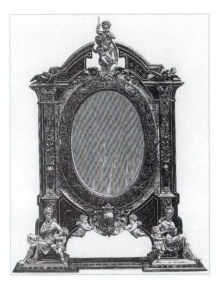

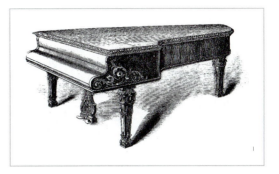

PIANO, ENGLAND.
Musical instrument cases followed the furniture styles, like this Renaissance Revival piano.

MIRROR, ENGLAND.
Accessories, such as this Venetian mirror, were in the same Renaissance Revival style as the furniture; made in London for the Centennial Exhibition.

Born 1864
Richard Strauss (d. 1949).

1865
Civil War ends, Lincoln assassinated; Mendel's *Principles of Heredity*; Tolstoy's *War and Peace*; Jules Verne's *From the Earth to the Moon*.

1866
Mendels "Experiments with Plant Hybrids"; dynamite.

Born 1866
David Ben Gurion (d. 1973).

1867
Marx's *Das Kapital*; Lister's first important paper on antiseptic surgery; reinforced concrete and the typewriter.

ART FURNITURE, EASTLAKE, AND HOUSEHOLD TASTE

Some furniture makers, known as art furniture manufacturers, considered themselves to be distinct from other companies because they made only artistic furniture from the late 1860s through the 1880s. Usually associated with the Aesthetic movement, **art furniture** was made in order to add beauty and "art" to the Victorian interior. This was often achieved by using an ebonized finish on pieces with pronounced geometric form—indicating a Japanese influence. The straight lines, slender turned supports, latticework, and rows of spindles, or galleries, were used by many furniture makers, but some of the most outstanding examples of Anglo-Japanese art furniture was by Edward William Godwin (1833–1886).

Born in Bristol, England, Godwin was trained as an architect. He worked initially in an interpretation of Gothic style and also found inspiration from other historic periods. In 1862, his tastes began to focus more on Japanese simplicity, when he began to study and collect Japanese art. In the late 1860s, his admiration for Japanese design became apparent in his own furniture designs in what became known as Anglo-Japanese style. He attracted clients who were also leaders of the Aesthetic movement, notably James A. M. Whistler and Oscar Wilde. The surprisingly straightforward design, without moldings, carving, or surface decoration, anticipates later Modern achievements as much as it characterizes Victorian art furniture.

Godwin's furniture was shown in an 1877 catalog of William Watt's Art Furniture Warehouse, entitled *Art Furniture, from Designs by E. W. Godwin, with Hints and Suggestions of Domestic Furniture by William Watt, London*. The furniture pictured had already been in production long enough to have attracted many imitators. By the 1880s, the fashion for Anglo-Japanese art furniture peaked, but where some was more ornamental and typical of the period, Godwin's designs stressed line and form. Godwin was one of the leading figures of the mainstream Victorian art furniture in Anglo-Japanese style. As one of the first Victorian designers to stress function more than style, Godwin is also considered to be one of the early pioneers of Modern design.

Art furniture was also popular in the United States. The Centennial Exposition held in Philadelphia in 1876 is known for introducing the Colonial Revival and a subsequent nostalgic passion for Early American styles. What is probably less well known is the Centennial's large-scale introduction of Japanese art and culture to the American public.

In 1854 Commodore Perry made the historic expedition that opened the ports of Japan to the West. Although artists such as John La Farge and James Abbott McNeill Whistler were interested in Japanese art as early as the 1850s and 1860s, it was not until the Philadelphia Exhibition of 1876 that the general American public became aware of Japanese design. Japan had shipped fifty carloads of building materials, objects for display, and a native work crew to the Centennial Exhibition. Japan even sent some of its choice works because members of the Japanese nobility needed capital.

Japonisme, the Western use of Japanese aesthetic principles and decoration, equally satisfied followers of both the Aesthetic and the Arts and Crafts movements (see Chapter 8). Followers of John Ruskin and William Morris delighted in Japan's nineteenth-century (as well as European medieval) oneness of art and industry. Japan also offered countless new possibilities for creating visual delight. Besides intentionally exporting beautiful objects for the benefit of its own economy, Japan unintentionally sent the West an inexhaustible design and color repertoire—a vast artistic undiscovered territory—and at no cost.

Mediocre artists and manufacturers simply copied, but good Western designers incorporated and interpreted Japanese style in refreshing ways. One of the leading American interpreters to the furniture industry was the German-born New York society decorator Christian Herter. Together with his brother Gustave, who came to America in the 1840s and designed silver for Tiffany & Co. (parents of Louis Comfort Tiffany, and the firm is still in operation), Christian Herter began the Herter Brothers decorating firm in the 1860s using historic styles. Because Christian Herter was in Paris before the rage for Japanese things swept the United States, he began to incorporate Japanese elements as early as the 1870s.

Herter Brothers furniture exemplified the best of American art furniture. Its use of ebonized finishes, inlay of Japanese motifs, reference to Japanese forms, and even decorative pottery tiles made by Japanese ceramic artists gave it a distinctly Japanese flavor. Herter clients were the American rich and famous: Jay Gould, Mark Hopkins, Darious Ogden Mills, J. P. Morgan, William H. Vanderbilt, and Lillian Russell. Industrialists and celebrities were prone to bouts of conspicuous consumption and ostentatious display, so it was not surprising that many Herter designs ultimately suffered from the same *horror vacui*, or fear of empty space, that plagued other Victorian interiors. Japanese design, at its worst, had been reduced to ornamentation that became part of the ubiquitous Victorian repertoire.

Besides ebonized Anglo-Japanese designs, a different aspect of art furniture borrowed its styling from a European medieval past, especially Gothic. Bruce J. Talbert was one of the leading British figures to promote this version of art furniture. Born in 1838, he was trained in both architecture and wood-carving. In the early 1860s he began to design furniture in Gothic style, based on frame construction with low-relief carving. After settling in London and designing for Holland and Sons, he wrote *Gothic Forms Applied to Furniture, Metal Work, and Decoration for Domestic Purposes*, published in 1867. Talbert became one of the most influential designers of the Aesthetic movement in Britain and also influenced cabinetmaking in the United States, where companies, such as Mitchell & Rammelsburg of Cincinnati, Ohio, were probably guided by Talbert's pattern book.

Though his style may be considered to be High Victorian, Talbert's philosophy was similar to reformers of the Arts and Crafts movement. He criticized the lavish display of ornament that characterized late Gothic style, preferring the simplicity of the twelfth and thirteenth centuries. Construction, he believed, should be honestly shown, using tenons,

1876
Elisha Gray files for a patent
for his invention of the
telephone a few hours after
Bell files his patent and
founds the Bell Telephone
Co.; Nikolaus August Otto
builds the first internal
combustion engine;
refrigeration; Custer's Last
Stand at Little Bighorn.

pegs, and iron clamps rather than glue. Applied ornament and glossy veneers only hide poor construction, Talbert insisted. He also believed in avoiding rounded forms, ornate carving, and polished finishes.

This philosophy of using Gothic simplicity and construction techniques rather than Victorian glued ornament was popularized by the British arbiter of taste, Charles Locke Eastlake. Born to an affluent Devonshire family in 1836, Eastlake had the same name as his uncle, Sir Charles Lock (without the *e*), with whom he is often confused. Though trained in architecture, he chose to theorize and criticize, rather than practice the profession. His enormously successful *Hints on Household Taste* in 1868 was reprinted four times in England. The milestone treatise on home decoration was even better received in the United States, where it was reprinted six times after 1872.

Eastlake, like Talbert, favored Gothic as the inspiration for furniture design. He especially favored paneled and boarded construction with visible joinery, and the furniture required neither glue nor polish. The most commonly found ornamentation on rectilinear Eastlake-style furniture is incised geometric carving, turned spindles, and galleries. Though the source of inspiration of this art furniture was different from the Anglo-Japanese version, the visual effects were similar. Eastlake also influenced many outstanding American art furniture makers, such as Herter Brothers, Daniel Pabst, Anthony Kimbel, and Joseph Cabus.

Unfortunately, Eastlake-style furniture acquired a bad reputation and fell from favor because of the practices of some furniture makers. The very Victorian manufacturing methods that Eastlake criticized—applied decoration and shoddy machine work—were ultimately used to make a good deal of so-called Eastlake-style furniture. Although good-quality and even handmade furniture was also made in the style, the proliferation of cheap copies obscured any reformist intentions and overshadowed the real contributions to furniture design. By 1890, Eastlake-style furniture was no longer in fashion.

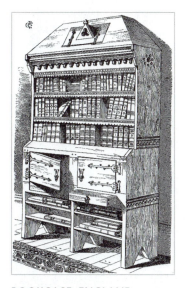

BOOKCASE, ENGLAND.
Library bookcase showing medieval influence, from Eastlake's *Hints on Household Taste.*

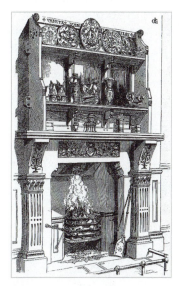

MANTELPIECE, ENGLAND.
Fireplace mantel with shelves, from Eastlake's *Hints on Household Taste.*

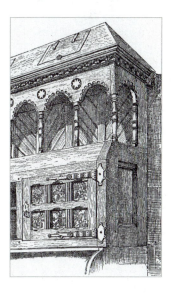

CABINET, ENGLAND.
Portion of a cabinet showing medieval influence, from Eastlake's *Hints on Household Taste.*

SIDEBOARD, ENGLAND.
Dining-room sideboard with upper shelves to hold bric-a-brac, from Eastlake's *Hints on Household Taste.*

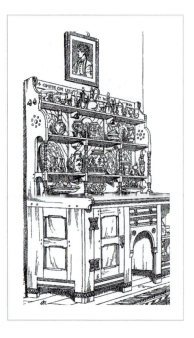

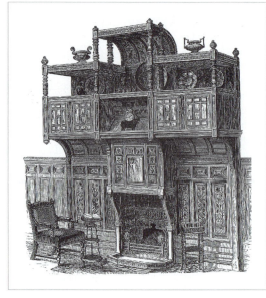

FIREPLACE SURROUND, ENGLAND.
Elaborate fireplace surround with attached paneled wall section and balcony-like shelves above: an example of the many rectilinear forms influenced by Eastlake and the fashion for art furniture; made in London for the Philadelphia Centennial.

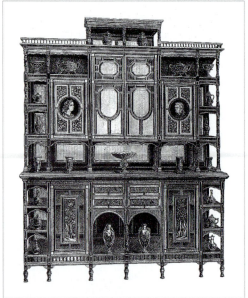

CHAIRS, UNITED STATES.
Eastlake-style dining side chair and "nurse" chair with rocker, both with caned seat, made by the Brooklyn Chair Co. in 1887.

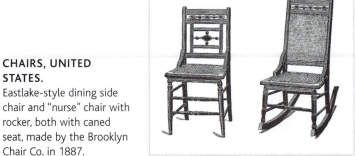

CABINET, ENGLAND.
Large inlaid drawing-room cabinet, another example of the many rectilinear forms influenced by Eastlake and the fashion for art furniture, made in London for the Philadelphia Centennial.

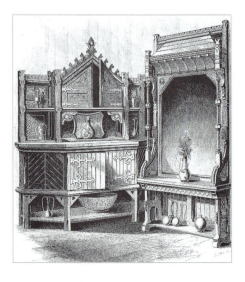

SIDEBOARD AND MIRROR, UNITED STATES.
Eastlake Gothic Revival-style sideboard with matching mirrored shelf unit, made in Cincinnati, Ohio, for the Centennial Exhibition.

WICKER FURNITURE AND HEYWOOD WAKEFIELD

At about the time Eastlake-style art furniture was losing its popularity, wicker furniture was reaching a peak. Wicker refers to a variety of woven materials, from straws and grasses to rattan, the tough stem of certain Asian palms. Although it has been used for furniture since the seventeenth century, and perhaps much earlier, it was made into every type of furniture and for every room of the house in the second half of the nineteenth century. By that time, **rattan** had generally replaced the earlier materials used for furniture, straw and willow.

The last quarter of the nineteenth century is frequently referred to as the eclectic period because of the wide range of styles available. The popularity of "artistic" furniture and of anything Japanese or exotic helped to fuel the passion for wicker. Although most wicker furniture was made in the United States, the material was imported from the Far East, and furniture makers capitalized on the exotic, even mysterious, foreign origins. Besides being artistic, handmade, and exotic, wicker furniture could adapt to any room or any need. Ornate wicker items in intricate designs were used as accent pieces, and entire parlor suites were made for the growing number of middle-class Victorians. By the 1880s the Wakefield Rattan Co. advertised its wicker in a range of colors as well as styles.

The Heywood Wakefield Company has become synonymous with Victorian wicker furniture in America. In 1826, long before the widespread fashion for wicker, the Heywood brothers began to make chairs in Garner, Massachusetts, about 58 miles northwest of Boston. Walter Heywood was the first chair maker, assisted by his brothers Levi and Benjamin, whose main occupation was running a country store.

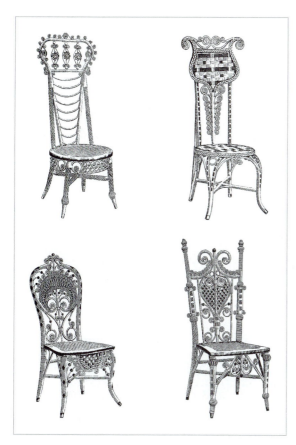

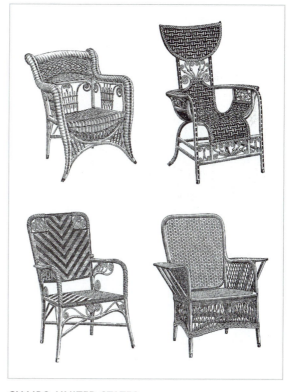

CHAIRS, UNITED STATES.
Examples of large armchairs made of wicker by Heywood Wakefield.

CHAIRS, UNITED STATES.
Examples of lady's reception chairs made of wicker by Heywood Wakefield in the 1890s.

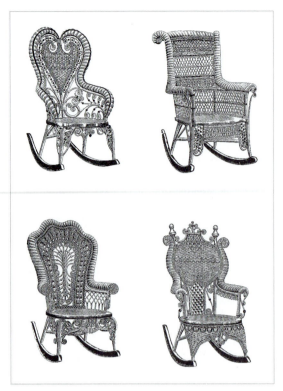

ROCKING CHAIRS, UNITED STATES.
Examples of lady's rocking chairs made of wicker by
Heywood Wakefield.

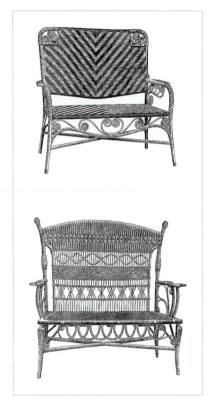

SETTEES, UNITED STATES.
Two of the many varieties of settees
made of wicker by Heywood Wakefield.

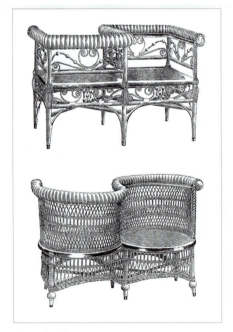

TÊTE-À-TÊTES, UNITED STATES.
Examples of tête-à-têtes, or conversation
chairs made of wicker in the 1890s by
Heywood Wakefield.

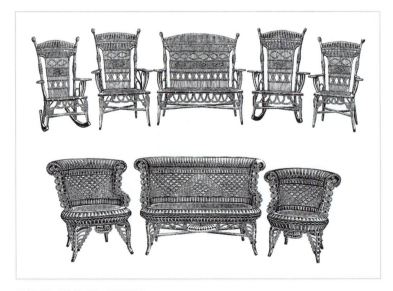

SUITES, UNITED STATES.
Five- and three-piece wicker suites by Heywood Wakefield.

TABLES, UNITED STATES.
Examples of round, oblong, and square wicker occasional tables by Heywood Wakefield in the 1890s.

STANDS, UNITED STATES.
Music stand, bric-a-brac stand, and fancy cabinets made of wicker in the 1890s by Heywood Wakefield.

OTTOMANS, UNITED STATES.
Variety of ottoman shapes, including an Egyptian Revival stool, made of wicker by Heywood Wakefield in the 1890s.

When Levi moved to Boston in 1831 to sell their chairs, he opened the first Heywood warehouse. Fire destroyed the chair shop in 1834, so they rebuilt on the shore of Crystal Lake and acquired their first machinery—turning lathes and a circular saw. Levi Heywood, the greatest advocate of machinery, became the sole owner of the company until he was joined by the younger generation of Heywoods. He developed a process of bending wood that impressed even the Thonets in Vienna, a name that was nearly synonymous with bentwood (see Chapter 9).

In 1897 Heywood merged with the Wakefield Rattan Co. and Heywood & Morrill Rattan Co. This was the result of an event in 1844, when Cyrus Wakefield unknowingly started the rattan and reed industry in America. Born in 1811 in Roxbury, New Hampshire, Cyrus Wakefield went to Boston to find work in 1826, the same year that the Heywoods

began making chairs. He and his younger brother Enoch ran a grocery business, until one day in 1844, Cyrus noticed a small bundle of rattan at the dock. The rattan, which had been used as ship's ballast, intrigued Wakefield, so he purchased it. Soon he began a jobbing trade in rattan and quit the grocery business. Because local processing was expensive, Wakefield began to import the cane from Canton, China. His efforts to use every part of the rattan—the reed as well as the cane—were successful. Cyrus Wakefield built his first plant, the Wakefield Rattan Co., in Boston in 1855 and eventually headed the largest rattan industry in the United States.

The merger with Heywood in 1897 resulted in the Heywood Brothers & Wakefield Co. Then, in 1921 the company liquidated, and the business was incorporated in Massachusetts as Heywood-Wakefield Co. Although they made a variety of products, the Victorian wicker is the most varied, the most innovative in design, and represents some of the best of late nineteenth-century styling.

JAPONISME AND BAMBOO FURNITURE

Wicker was not the only material used to express a romantic interest in Eastern cultures. Carved and lacquered furniture was imported from China and Japan in large quantities, and this, in turn, served as models for American-made imitations. While Chinese art had been imported and copied by Westerners for centuries, Japan had been closed to foreign contact before 1854. There were at least three categories of Japanese design influence in the United States: Japanese-made art, Western-made copies and adaptations, and original Western designs employing Japanese principles. When the Japanese saw the strong demand for their goods, they began to turn out items especially for export, as the Chinese had been doing. American and British companies quickly took advantage of the rage for Japanese things by manufacturing copies. J. E. Wall in Boston and Nimura and Sato in Brooklyn sold complete sets of bamboo bedroom furniture that were made in America from imported oriental bamboo. The third phase, resulting from an encounter between Western artists and Japanese art, followed. Japonisme, the name given to this phenomenon, indicates neither a particular style nor a period. The term was probably coined in 1872 in England in a series of articles written by Philippe Burty. The taste for Japonaiserie in England preceded the American by about a decade—initiated by the Great Exhibition in 1862 and led by figures like William Godwin.

Of all the motifs, symbols, and materials available to the West to express this infatuation with Japanese art and culture, bamboo was among the favorites. From bamboo-handled flatware to silverware in "Bamboo" patterns, Victorians wanted bamboo. British firms made bamboo furniture by the late 1860s, and some made furniture using combinations of bamboo with other woods. One of the most novel forms was faux, or false, bamboo furniture made of lathe-turned bird's-eye maple in the United States. New York companies such as C. A. Aimone, Bauman Brothers, and Kilian Brothers made suites of imitation bamboo furniture, especially for the bedroom, in the 1880s. Not only did these manufacturers use artistic license in the choice of material, the pieces of furniture were not at all Japanese forms. Instead, they made typically Victorian beds, dressers, and chairs in native wood—in order to appeal to the fashion for Japanese things. And it made perfectly good sense in the 1880s.

COLONIAL REVIVAL: OUT OF IDEAS

Of all the nineteenth-century Victorian revivals, one stands out as being the most historically or academically correct and also the least imaginative. American Colonial Revival, which began with the bicentennial of 1876 and peaked in popularity at the World's Columbian Exposition in 1893, has also been the most persistent. In spite of the fact that there has been more innovation and change in the design and manufacture of furniture in the century that followed the introduction of Colonial Revival than in all of history preceding it, Colonial Revival styles never lost their attraction. In fact, they have been the

mainstay of many furniture manufacturers, retailers, and consumers without interruption for more than a century.

As decorative arts historian Kenneth Ames suggested at a conference that resulted in an insightful book edited by Alan Axelrod, *The Colonial Revival in America*, "Healthy organisms live in the present; those who live mostly in the past cannot or will not deal with the present." Although the nostalgia-driven style was the offspring of the same Victorian parents that brought other historic revivals to the design community and to its clients, its impact has been the greatest and the longest lasting. Axelrod suggests that this revival is more than just an artistic or even cultural phenomenon—it is also the product of a nationalistic impulse that was stirred at the Philadelphia Centennial.

American followers of the revival probably never stopped to analyze its causes or explain its persistence. It became what Ames calls "the dominant paradigm for domestic Architecture in the United States" probably because architects and homeowners liked the way it looked and felt. Depending on the region of the country, if they are not completely modeled after the style, most homes still have Colonial Revival elements.

At the time of the Centennial, however, there were other concerns besides fashion. The Arts and Crafts movement in England had begun to cross the Atlantic, and anti-industrial sentiments had also independently risen in America as well. Colonial styles in America were compatible with Arts and Crafts ideals in their preindustrial and pre-Victorian (or anti- or nonindustrial and non-Victorian) connotations. The irony was that many of the advocates of preindustrial culture and its preservation were, in fact, the industrialists, whose fortunes were based on its demise.

Curiously, Colonialism had become as romanticized in America as Medievalism had been in England. Modern admirers of Colonial Revival usually referred to its aesthetic or symbolic content, yet there were those who seemed to feel some nostalgia over a period that they had never experienced. Colonial America outside of the few cities on the Eastern seaboard was very big. It was untraveled, unknown, and dangerous. Most colonists lived directly off the land; food was grown, harvested, and prepared at home. There were, of course, no supermarkets. In fact, there were no stores of any kind as we know them today; most furniture and clothing were homemade, handed down, or bartered for. When the sun set, families lingered briefly under candlelight and then went to bed. There was no plumbing, no city water, and probably no nearby city. Communication was limited and very slow. There was no postal service; there were no roads. Transportation was by horseback, by horse-driven cart, or by foot. Medical care, education, and anything resembling social services were improvised and uncertain. Isolation and dependence on the elements for crops and survival were a way of life and death, and life was hard for the colonists.

If these were the conditions that the nostalgic have selectively forgotten (even if they were not personally experienced), then there must have been other qualities worth remembering. Apart from the physical hardships, life was simple, even naive. Family and community connected individuals and provided a sense of belonging and of purpose. Values and beliefs were shared.

The early colonists had risked all and had left England to seek freedom, but few found it. A predominantly one-dimensional worldview enabled *both* qualified and well-intentioned and unqualified opportunistic individuals to control others. The puritanical system assured that the oppressive and stifling social conditions found in England would persist in the Colonies. The crafty invented witches and burned them to achieve social control and personal gain. As the puritanical severity eased, values of freedom and individuality began to develop. These culminated in the brilliant document that replaced personal surrender to church and state with "life, liberty, and pursuit of happiness." More than words, the thoughts of real personal freedom made adrenalin flow—and blood. "Liberty or death" were not only spoken words, they inspired a revolution that was fought—and won.

The Colonial Revival was born out of ideas and ideals. Independence, freedom, and democracy were the stuff that memories of colonial times were made of. The images of architecture and furniture from those days were revered and revived. It might also be argued that Victorians, the first Colonial Revivalists, had depleted their repertoire of

foreign historic designs and had essentially run out of ideas. By 1876, there was enough chronological and cultural distance between preindustrial colonial times and the present to justify having a revival. Whether they had run out of design ideas or were motivated by past ideals, hand-carved cabriole legs ending in ball-and-claw feet returned. They were frequently given curious Victorian touches because the original proportions and contexts were overlooked or were overshadowed by current ones. Chippendale had lost his English accent and had not only become Americanized, he had become Victorianized.

With any fashion, original meaning and intent is easily diluted or lost during the process of becoming popular. As a fashion, Colonial Revival came to mean anything colo-

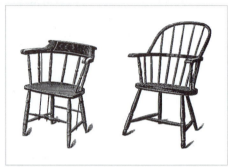

CHAIRS, UNITED STATES.
Office chairs made in Colonial Revival styles by the Brooklyn Chair Co. in 1887.

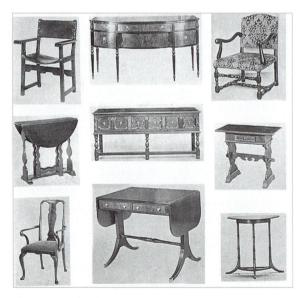

INTERIOR, UNITED STATES.
Re-creation of the interior of an early American New England kitchen as shown at the Centennial Exhibition.

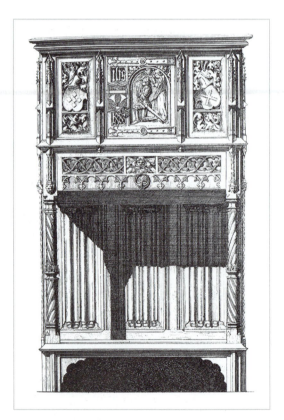

CABINET, UNITED STATES.
Ink drawing of an early English cabinet, made by Louis Rorimer in the 1890s and later used as a model for his company's Colonial Revival furniture.

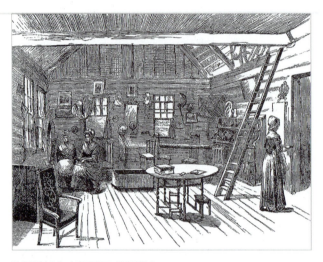

FURNITURE, UNITED STATES.
Example of Colonial Revival furniture in both seventeenth- and eighteenth-century styles, made by machine in the early twentieth century. *(Hunter)*

nial, and it indiscriminately included and idealized all aspects of colonial material culture. Crude, rustic furniture, first associated more with hardship than with the notion of a pastoral ideal, was elevated to levels that would have amazed its original users. Boundaries were blurred, and distinctions were ignored. Whether high-style, professionally made, and costly, or home-grown, homespun, and homely, they were both admired by genteel and patronizing Victorians.

TWENTIETH CENTURY

In the midst of the development of modernism in Europe, Americans continued to choose the comfort and security of colonial styles. Although this search for American origins was partly connected to the Arts and Crafts movement, there are other possible explanations. Though America had been a leader in the field of innovative furniture in the nineteenth century, this enthusiasm for engineered furniture had waned by the 1920s. Even with the new field of industrial design in the late 1920s, there was little interest in mechanizing the rooms in which people ate and relaxed. Instead, kitchens and bathrooms were the focus of inventiveness and labor-saving devices, leaving the living spaces to Colonial and other antique revivals.

The Victorian period from 1837 to 1901 is considered to be the age of **revivals**. During this time, every Western country participated in the fashion for reusing past styles. Although there were clear alternatives to historicism by the early twentieth century, many, perhaps most, manufacturers and consumers continued to choose historic styles. In America, even at the beginning of the new millennium, Colonial Revival persists.

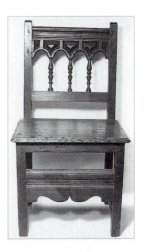

SIDE CHAIR, UNITED STATES.
Example of an early twentieth-century Colonial Revival side chair using old wood and distressing portions to closely imitate the antique, by Rorimer-Brooks.

CUPBOARD, UNITED STATES.
Colonial Revival press cupboard, made by Rorimer-Brooks of Cleveland, Ohio in the early twentieth century to closely imitate a sixteenth-century English/colonial piece.

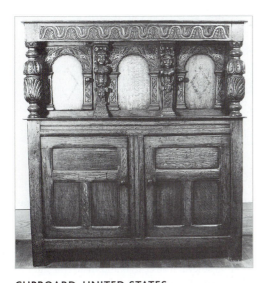

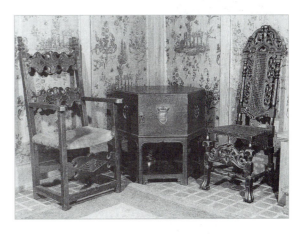

GROUPING, UNITED STATES.
Colonial Revival early seventeenth-century style armchair and a copy of Charles II side chair, flanking an Arts and Crafts hexagonal table, all made by Rorimer-Brooks about 1910.

Summary

- The Victorian period is considered the age of revivals. Nearly every historic period and geographic area became a source for styles and decoration in England and the United States.
- The great international exhibitions helped to spread the fashion for historicism.
- Charles Lock Eastlake, British author and arbiter of taste, became even more popular in the United States with his "Eastlake Style."
- Taste for Japanese and other Far Eastern and exotic art helped to make the American wicker furniture industry flourish. Bamboo and faux bamboo were also used for bedroom suites.
- Of all the revivals in the United States, the Colonial Revival has remained the most persistent, even in the twenty-first century.

Chronology

1837 Queen Victoria ascends the throne.

1830s–1840s Gothic Revival.

1851 Crystal Palace—Great Exhibition.

1854 Commodore Perry expedition to Japan.

1850s–1860s American Rococo Revival.

1862 London International Exhibition.

1860s–1880s Anglo-Japanese style art furniture.

1865–1885 American Renaissance Revival.

1870s–1880s Eastlake Style.

1876 Philadelphia Centennial Exhibition—introduces Colonial Revival.

1880s Bamboo furniture is popular.

1850s–1890s Wicker furniture is popular.

1893 World's Columbian Exposition—popularizes Colonial Revival.

1901 Queen Victoria dies.

Taste Makers and Furniture Makers

John Henry Belter (1804–1863, Germany, United States) Most fashionable New York cabinetmaker after Phyfe; leader of the Rococo Revival style in America; developed a process of lamination.

Charles Lock Eastlake (1836–1906, England) Designer and writer; his *Hints on Household Taste* in 1868 influenced the Aesthetic movement and taste in England and the United States through the remainder of the century.

Edward William Godwin (1833–1886, England) Architect, designer, and leading figure of Aesthetic movement, used Japanese design in his "art furniture" and influenced Modern design at the turn of the century.

George J. Henkels (1819–1883, United States) Philadelphia cabinetmaker known for Rococo Revival and Renaissance Revival furniture.

Christian and Gustave Herter (Germany, United States) New York society decorators who came to America in the 1840s, began the Herter Brothers decorating firm in the 1860s using historic styles, and became leading art furniture makers by the 1870s.

Levi Heywood (United States) Founder of Heywood Brothers furniture company in Gardner, Massachusetts, in 1826, which eventually became Heywood Wakefield.

John Meeks (1801–1875, United States) Son of Manhattan cabinetmaker Joseph Meeks, partner with his brother Joseph W. making Rococo Revival furniture.

Joseph W. Meeks (1806–1878, United States) Partner with his brother John, made Rococo Revival furniture in New York.

A. W. N. Pugin (1812–1852, France, England) Architect, furniture designer, and leading proponent of Gothic Revival style.

Bruce J. Talbert (1838–1881, England) Architect and designer, famous for art furniture in Gothic style.

Cyrus Wakefield (1811–1873, United States) Began the Wakefield Rattan Co. near Boston in 1855. His nephew and successor, Cyrus Wakefield sold the company in 1897 to the Heywood Brothers, and it became Heywood Brothers and Wakefield.

Key Terms

art furniture	lounge chair	rosewood
Crystal Palace	rattan	tufting
Japonisme	revival	what-not

Recommended Reading

Art & Antiques, ed. *Nineteenth Century Furniture: Innovation, Revival and Reform.* New York: Billboard Publications, 1982.

Axelrod, Alan, ed. *The Colonial Revival in America.* New York: Norton, 1985.

Eastlake, Charles L. *Hints on Household Taste*, 3rd edition. London: Longmans, Green, and Co., 1872.

Gems of the Centennial Exhibition. New York: D. Appleton & Co., 1877.

Heywood Brothers and Wakefield Company. *Classic Wicker Furniture: The Complete 1898–1899 Illustrated Catalog.* Reprinted New York: Dover, 1982.

Heywood–Wakefield. *A Completed Century 1826–1926: The Story of Heywood–Wakefield.* Boston: Heywood–Wakefield, 1926.

The Illustrated Catalogue of the Great Exhibition of London 1851. London, 1851.

The International Exhibition of 1862: The Illustrated Catalog of the Industrial Department. London: Her Majesty's Commissioners, 1862.

Tracy, Berry B., et al. *Nineteenth Century America: Furniture and other Decorative Arts.* New York: Metropolitan Museum of Art, 1970.

VICTORIAN MODERN

Paragon or Paradox?

CHAPTER CONTENTS

In the midst of the Victorian era, early participants in the modernization of the furniture industry contributed philosophies, designs, technologies, and new marketing techniques.

MODERN, MODERNISM, AND INDUSTRIALIZATION

Modern can be seen from several different perspectives. The most literal meaning is new, up-to-date, or contemporary, as opposed to old, dated, or historic. Yet, in the history of design, what may have once seemed new was often no more than the repeat of a cycle—a familiar idea in another context, seen through different eyes.

In the Victorian period from the 1830s to just past the 1900 marker, most furniture designs considered to be progressive and modern relied on the revival of past furniture styles or architectural features applied to furniture. Modern style without historic precedent did not interest the Victorian "ruling taste." It was not seriously explored until the end of the century and later, when a few brave designers consciously worked to escape the climate of eclecticism that had ultimately developed.

Modernism is a concept that embraces more than a time period; it includes a philosophy of design and resultant stylistic features. One aspect of modernism focuses on new technology, new materials, and innovative uses of both. This can lead to new forms, and ultimately design may be reduced to basic principles with function preceding form. But change in one aspect of culture rarely occurs at the same rate as another. Technology may not be at the same level of advancement as materials, or vice versa. Perhaps of greater consequence, societies often resist change before they embrace it, because people need to be convinced that it is in their best interest. Even when economic factors favor change, human nature tends to be conservative.

Aspects of Victorian society underwent vastly different rates of change, that is, modernization, and this is particularly clear in the case of furniture design. Nevertheless, the appearance and production methods that characterized Victorian furniture are considered to be closely related. Industrialization in the nineteenth century provided the means by which items such as furniture could be made more efficiently and more economically than in any previous time in history. Machinery suddenly made it possible to avoid the tedious processes of milling, forming, and decorating wood by hand. Where once only custom-made and individually commissioned pieces satisfied the fashion-conscious elite, the new manufacturing methods could make stylish ornate furniture universally available and affordable. Machine-made ornamental work flooded the market because handwork, though still required for high-quality carving and finishing, meant high cost, and only luxury items incorporated it. However, whether Victorian furniture was made and decorated inexpensively by the new machines or embellished with costly hand carving, the styles were essentially the same.

JOHN HENRY BELTER

While the new industrial methods of making furniture may have pointed toward modernization, styling faced surprisingly backwards to a remote past that was distant in both time and place. One of the most intriguing and extreme cases of a contradiction between old style and new technology can be seen in the work of New York cabinetmaker John Henry Belter (see Chapter 6). His completely curvilinear, abundantly fussy, yet elegant mid-nineteenth-century parlor sets are, for lack of a more appropriate label, called Rococo Revival or Victorian Rococo. It is the high-relief decoration—scrolls, flowers, and fruit—that is most reminiscent of the eighteenth-century French Rococo, but the furniture is dark, heavy, and too blatantly Baroque to warrant being accurately labeled Rococo. Nevertheless, Belter did superb work that delighted his wealthy clientele and exemplified the term "conspicuous consumption" long before it was coined. His style is paradoxical: It epitomizes mainstream Victorian historic revivalism while demonstrating remarkable technology and inventiveness. Belter developed and patented a process using thin wood laminations, a type of high-grade plywood, to form the curved chair backs and to provide an exceedingly strong base for the intricately carved flower petals. Where solid wood would have broken at the thinnest points, his multilayered, steamed, **laminated** rosewood supported the most challenging decorative motifs. Although Belter was very successful, in

retrospect, it seems that he had, at the same time, missed a great opportunity to modernize a portion of the furniture industry. With regard to inventiveness, he might be compared to his European contemporary Michael Thonet, but Belter seemed to have fallen into the design trap of following rather than leading taste. The Rococo Revival style came and went, and Belter is probably remembered most for the unique appearance of his furniture than for his significant, though underdeveloped, technological contribution.

United States Patent Office drawing of a method for sawing chair backs, by John H. Belter, issued July 31, 1847.

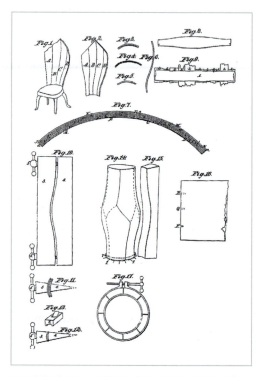

United States Patent Office drawing of "Improvement in the Method of Manufacturing Furniture," illustrating seven-layer laminated wood panels, by John H. Belter, February 23, 1858.

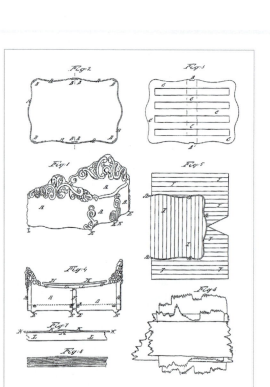

United States Patent Office drawing of a bedstead, by John H. Belter, issued August 19, 1856.

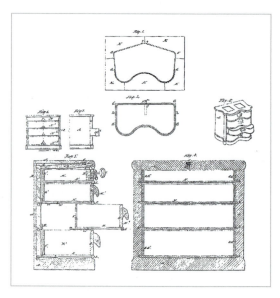

United States Patent Office drawing of a bureau drawer, by John H. Belter, January 24, 1860.

INDUSTRIALIZATION AND THE VICTORIAN INTERIOR

Nineteenth-century industrialization, while advancing production methods, did surprisingly little to modernize furniture styling. Mechanically produced ornament and industrial reproduction of art objects captivated a fashion-conscious audience. It was the birth of consumerism because the abundant production of fashionable goods made them more apt to become unfashionable, hence, disposable. The packing of rooms with cheaper and cheaper machine-made objects, with more and more ornament, led to what historian Siegfried Giedion calls the ultimate devaluation of symbols, and it pervaded all levels of society. Although materials and crafting techniques varied, the objects were essentially the same. If the wealthy filled their parlors with Belter furniture, then the poor wanted modest copies; if the rich had bronze art objects, others could achieve the same look with cast iron; marble sculpture for the rich, plaster for the poor; original paintings versus chromolithographs. Regardless of class, nearly anyone could fill an interior—all in historic and pseudohistoric styles. As one American material culture historian Ian Quimby stated, "The past was ransacked for visual ideas to feed the hunger for novelty. . . . As the technical problems of moving from handcraft to machine production were solved, there was a tendency to display technical proficiency by pushing novelty to the limit—very often at the expense of aesthetic sensibility."

Even later reform movements, though they may have managed to eliminate decoration, seemed unable to escape history's grip. Arts and Crafts proponents widely criticized the Victorian misuse of mechanization to imitate handicraft production. Yet, instead of improving and modernizing domestic furnishings with the aid of mechanization, they curiously preached an impractical return to handicraft and then chose medieval style, a simpler, more philosophically satisfying historic style to romanticize. What the anti-industrial reformers overlooked was that mechanization was not at fault, but that some who controlled it might have been.

MODERNIZING FORCES

In the midst of the ubiquitous Victorian historic revivals, separate and parallel events unrelated to both the mainstream furniture industry and the Arts and Crafts reform movement were taking place, and indications of future modernization in furniture design and manufacturing could be seen. It took a communal religious society far removed from the Victorian ruling taste to demonstrate that indeed form can follow function. Although they used traditional materials and simple technology, the Shakers' well-defined philosophy and lifestyle, stressing functionalism and minimalism, enabled them to create furniture that was, in effect, modern. There were other makers of traditionally styled furniture with modern aspects. Lambert Hitchcock is credited with being the first to apply labor-saving devices and methods of **mass production**, especially interchangeable parts, to the manufacture of furniture. It was Michael Thonet, however, who is associated with optimizing the potential of new technology. His innovative methods of bending wood and of efficient production made his company unique in the nineteenth century and so successful that it continues to thrive in the present. A third example of Victorian innovation and modernization has no single designer, company, or group name. It is a series of independent mechanical inventions from about 1850 to 1890, the so-called constituent, or **patent furniture**.

The concepts introduced by the Shakers, Hitchcock, Thonet, and inventors of patent furniture in the midst of the Victorian era collectively helped to direct and define modernism in the next century. These premodernists had not necessarily focused on style, which may have helped to explain their acceptance by contemporaries. Shaker was close to traditional colonial vernacular; Hitchcock followed the Sheraton style; Thonet furniture, though lightweight, was surprisingly compatible with Victorian tastes; and generic patent furniture usually ignored style altogether. Yet Shaker and Thonet furniture is appropriately included in lines of modern classics today, and patent furniture contributed to laying a foundation for modern office furniture and the science of ergonomics.

PATENT FURNITURE

According to historian Siegfried Giedion, Hellenistic Alexandria of the third and second centuries B.C. was closer to the nineteenth century in its spirit of experimentation than any other period in history. Alexandrian inventors combined simple concepts like the screw, wedge, wheel, axle, lever, and pulley. Powered by combinations of water, vacuum, or air pressure, they were able to perform complicated movements and manipulations. The temple gate would swing open when a fire was lit on the altar, and it would close when the fire went out. Yet these clever and sophisticated ancient inventions were not put to practical use. They did not move "from the miraculous to the utilitarian" until the nineteenth century.

Two of the first and most dramatically influential nineteenth-century inventions were the steam engine and machinery designed for the textile industry. There had been earlier inventions—Jacques de Vaucanson mechanized a silk factory in 1756, and the Jacquard loom was devised in 1804—but the dramatic changes would come later. Many of these changes would occur in America. The vastness of the sparsely populated land, the subsequent lack of trained labor, and relatively high wages all contributed to widespread mechanization.

The 1860s were a very inventive time. "Everyone invented; whoever owned an enterprise sought ways and means by which to make his goods more speedily, more perfectly, and often of improved beauty. . . . Never did the number of inventions per capita of the populations exceed its proportion than in America of the 'sixties." America did not have the highest degree of industrialization—England, for example, could boast more power looms—but Americans had become intoxicated on invention.

The assembly line was among the most significant innovations that contributed to full mechanization, and it became an American institution. From its beginnings in 1783 with Oliver Evans's continuous production line, through the meatpacking advances in the 1860s and 1870s, to the fully functional line at Henry Ford's Highland Park plant in 1915, the assembly line was the single most influential advancement toward mass production. Although the automobile was well known prior to 1915, it was a handmade and prestige product. Ford enabled a former luxury item to become affordable to the general population.

Similarly, before about the mid-nineteenth century, before there was any widespread mechanization in the manufacture of furniture, it too was primarily an elitist item. Fine furniture was handmade, one piece at a time with a patron–client arrangement. Machinery and factories provided the means to produce multiple copies of any design. It meant more furniture, more ornament, for more people at less cost. It was not necessarily better, just more prevalent.

The art of invention had been focused on the machinery. These machines were needed to perform various functions that had previously been done by hand. The product was not regarded as inventive, just the machinery that made it. But beginning in the 1860s a new wave of inventiveness began to swell. It did not, however, concern the ruling taste that was still captivated by carving, stuffing, and trim. Even the factory owners were untouched by mechanization and inventiveness in their own homes. Writes Giedion, "The interiors of this age, with their gloomy light, their heavy curtains and carpets, their dark wood, and their horror of the void, breathe a peculiar warmth and disquiet. . . . There is no difference between the pseudo-monumentality of the buildings and that of the furniture. Both belong to the transitory phenomena, unquenched by the blood of true inventiveness. Yet they dominate the feeling of their day and mercilessly stifle every impulse that springs from the deeper sources of the period."

Victorians have been portrayed as being preoccupied with facades. It might be said that they also seemed determined to be uncomfortable in their clothing, in their interiors, and in their behavior. It is therefore understandable that patent furniture was, in effect, contrary to that of the ruling taste. "Furniture of the ruling taste . . . is an outgrowth of fashion. Every period shapes life to its own image and drapes it in forms peculiar to itself. By a historical necessity, each fashion—indeed every style—is founded within its own limited time. But across and beyond this circumscribed period there enters another factor, of

fluctuating intensity: This is the quantum of constituent elements, of fresh impulses generated within the period. In them lies the historical import of an era." Most furniture of the Victorian ruling taste ignored the inventive and left it alone in the domain of patent constituent furniture. Patent furniture sought comfort, flexibility, and accommodation to the human form. It "revealed the century as it liked to relax when wearing none of its masks." The problems it chose to solve concerned motion rather than appearance. The Victorian urge to clutter had been complemented with an urge to invent, and the United States Patent Office added seventy new subdivisions for chairs alone, in order to organize this extraordinary event.

Patent furniture was often multifunctional. Where the wealthy may have had ample room in which to display their massive and monumental furniture, the middle classes had less floor space. If space could not be added, then the need for it could be minimized; one solution was multifunctional, convertible furniture. A chair could become a lounge, a lounge a bed, a bed a wardrobe; a bedroom could become a living room. This was neither necessary nor desirable for the upper classes, whose domain was fashion and conspicuous display. Instead, patent furniture was aimed at an audience that valued practicality out of necessity. Its features provided for one or more of the following: (1) economy of space; (2) comfort of posture; (3) mobility—folding chairs, often modeled on ancient forms; (4) resiliency—a rocking chair that revolves; (5) specialization—sewing machine chairs, typewriter chairs, barber chairs, dentist chairs, invalid chairs, railroad seats; (6) convertibility—the sofa bed; and (7) use of new materials or technology. In 1853, Peter Ten Eyck invented a rocking chair that enabled a new type of sitting—a precursor, at least in theory, to the modern ergonomic office chair. It was both resilient and oscillating. The sitter could shift positions and avoid the physical hazards of long-term stationary sitting. But his design was translated into large upholstered space-eating monsters that had lost the clarity of their structure and had become, as Giedion calls, "boneless"—a really missed opportunity that had been subjected to Victorian **ruling taste**. And just as rulers of taste lived in a world of frivolous ornament, a good deal of patent furniture succumbed to becoming frivolous novelty. But some of the convertible and multifunctional inventions, not unlike the Swiss army knife, had huge impact and success. For example, the Pullman sleeping car was based on an 1854 patent for a sleeping car based on a convertible seat and folding bed. George Pullman (1831–1897), though not the inventor, was the combiner of ideas at just the right time.

The inventors, as one might expect, were not the upholsterers because they already enjoyed a high degree of influence on fashion and the furniture industry. They were engineers and tinkerers interested in comfort and posture, and who therefore invented forms of

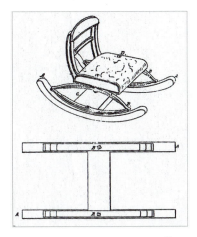

Very early United States Patent Office drawing of a rocking chair, designed by D. Harrington, issued April 23, 1831.

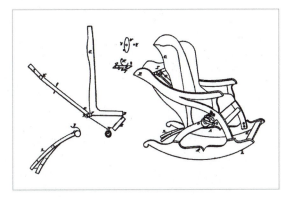

Very early United States Patent Office drawing of a rocking chair, designed by A. Wood, issued June 28, 1836.

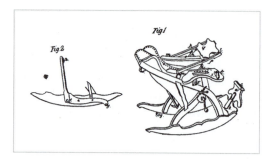

Very early United States Patent Office drawing of a rocking chair, designed by A. Wood, issued April 24, 1838.

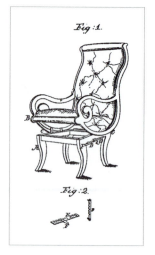

Very early United States Patent Office drawing of a rocking chair, designed by S. H. Bean, issued March 31, 1841.

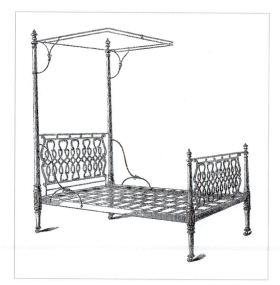

British patent iron half-tester bedstead, japanned to imitate walnut wood, shown at the London International Exhibition, 1862.

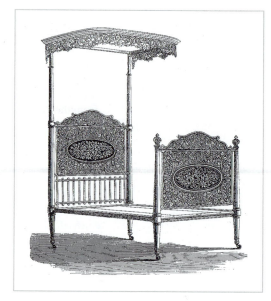

British patent metallic tubular bedstead for general use, military, and portable. Shown at the London International Exhibition, 1862.

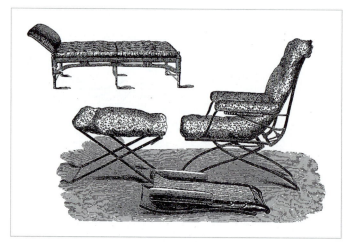

British patent folding bed and spring chair with footrest.

1892
Diesel engine; University of Chicago; fingerprints used for identification; Converse College in Spartanburg, South Carolina, burned to the ground, because mouse nests had clogged the fire hoses; *Vogue* magazine.

Born 1893
Charles Atlas (d. 1972); Mao Tse-tung (d. 1976).

1894
Marconi's wireless radio.

1895
Wilhelm Conrad Röntgen discovers X rays.

nonartistic furniture. Although individuals registered the patents, most inventors were unknown and were therefore considered anonymous. The practice of patenting furniture was not new—many of Sheraton's eighteenth-century designs had been patented—but in the second half of the nineteenth century, Americans took the practice of patenting to new levels.

Hunzinger Chair

Not all patent furniture was anonymous. The name Hunzinger stands out as both a mainstream Victorian furniture maker and an inventor with twenty-one patents to his credit. Hunzinger's folding chairs and platform rockers were among the countless other registered patents, but his designs also helped to promote a company and a style.

George J. Hunzinger was born in Germany near the Swiss border in 1835. The Hunzinger family had been in the cabinetmaking business in Germany since the early seventeenth century, and George Hunzinger would be the first to bring the name to America. He settled in Brooklyn in the 1850s and became a United States citizen in 1865. According to the 1860 census, New York City was the third largest German-speaking city in the world, with 120,000 German immigrants, or 15 percent of its population. By 1870, of the 5,000-plus cabinetmakers and upholsterers working in New York City, more than half were of German origin.

Hunzinger described himself variously as a maker of fancy chairs and ornamental furniture, or as a manufacturer of patent folding, reclining, and extension chairs. His first patent, in 1860, was for an extension table, followed in 1861 for a reclining chair, and in 1866 he patented a reclining chair with folding legs. Folding chairs were often considered "camp" furniture because it was used for traveling, picnics, and on battlefields. In 1869 he patented the diagonal brace chair, now called, simply, the Hunzinger Chair. Another popular nineteenth-century form was the platform rocker, which was patented in several forms from the 1860s to about 1900. Hunzinger's platform patent was registered in 1882. In 1887 disaster struck, and the Hunzinger factory burned to the ground. Insurance covered only part of the loss, but due to successful patents, Hunzinger was able to rebuild and continue the business.

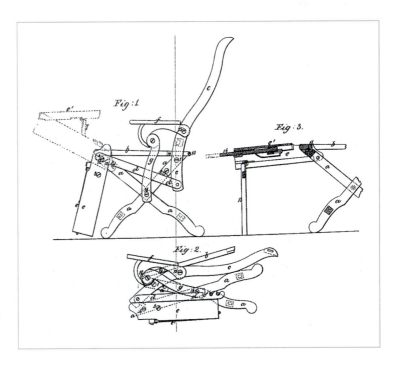

United States Patent Office drawing of a folding and reclining chair, by George Hunzinger, issued September 15, 1863.

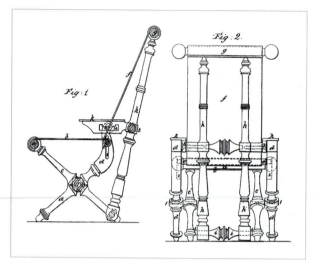

United States Patent Office drawing of a reclining chair, by George Hunzinger, issued February 6, 1866.

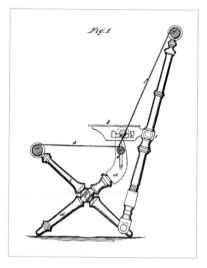

United States Patent Office drawing of a reclining chair, by George Hunzinger, reissued September 14, 1875.

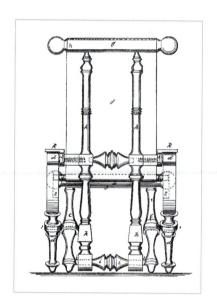

United States Patent Office drawing of a reclining chair, by George Hunzinger, reissued September 14, 1875.

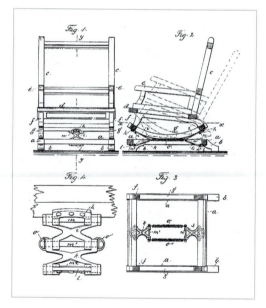

United States Patent Office drawing of a spring rocking chair, by George Hunzinger, issued September 26, 1882.

His sons George Jr. and Alfred joined the firm, which continued into the twentieth century, later owned by his six daughters. Hunzinger's patents for Renaissance Revival-style-furniture were part of the patent furniture craze of the later part of the century. Although, like other patent furniture items, they contributed to the early foundations of modernism, Hunzinger used traditional (though currently fashionable) styling. In 1892 he invented a combination table–chair, but by then, interest in both his style and of patent furniture had waned. Like any fad, patent furniture was subject to both peaks of popularity and to extinction. About the time of the 1893 Chicago World's Fair, tastes turned again toward more wealth and ostentation, and patent furniture all but disappeared from the domestic interior.

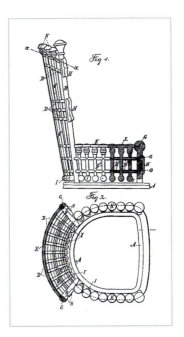

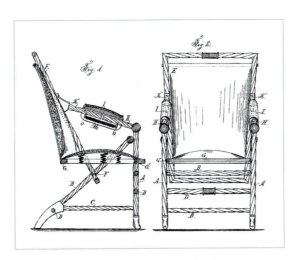

United States Patent Office drawing of a chair, by George Hunzinger, issued February 8, 1887.

United States Patent Office drawing of a chair, by George Hunzinger, issued April 3, 1888.

SHAKERS

The nineteenth century was unique and widely criticized. Writes Giedion, "At no other time in history did man allow the instinct for the goodly ordering of his surroundings to suffer such decay. Before then, cramming would have been unthinkable on economic grounds alone." Aside from a hyper-materialistic decadence enjoyed by many an aristocracy throughout history, most people in the preceding centuries had relatively few material belongings. As inventories of families sufficiently well-off to warrant inventories reveal, furnishings were actually used rather than collected or displayed. A four-person household required four seats. Land and livestock and other forms of economic investment were a measure of a person's wealth and status. Prior to the nineteenth century, furniture was often perceived as taking up space, and knickknacks were considered irrelevant in many cultures. The cultures and periods that did place greater value on decorative arts, such as Renaissance Italy or eighteenth-century France, became sources of inspiration for Victorian decoration.

Simplicity, economy, and efficiency were not highly valued in Victorian nouveau middle-class society. An aesthetic based on these principles was counterproductive because a new economy based on consumption was in place. Functional simplicity was a thing of the past; it was considered out of date. It was also the basis of a conservative expression of material culture that ironically became an inspiration to future modernism.

The name most associated with functional simplicity during the Victorian period was a group of unique communal religious societies called the Shakers, whose origin dates back to the beginning of the eighteenth century. A small group of French Protestants called Camisards were, as many small groups throughout history have experienced, being persecuted. They left France to seek religious freedom in England. When the Camisards arrived in Manchester in 1847, they met and joined another small group, the radical English Quakers. They, in turn, were joined by other dissidents—some from the Anglican church and some from the Methodist church. The new organization became known as the Shaking Quakers because of their pronounced physical movements while worshipping.

1896
Antoine Henri Becquerel discovers radioactivity; Henry Ford builds his first car; Tabulating Machine Co. (later IBM) founded; George Harbo and Frank Samuelson crossed the Atlantic in an 18-foot rowboat (McFarland 61); James Connolly is the first athlete to win a modern Olympic event; *House Beautiful* magazine; Puccini's *La Bohème*.

1897
Casein plastic.

Died 1897
Johannes Brahms (b. 1833).

Late 1890s
Young Benito Mussolini was expelled from school twice for assaulting fellow students with a knife.

1898
Hydrogen liquefied.

Born 1898
Alvar Aalto (d. 1976); Chou En-lai (d. 1976); Golda Meir (d. 1978).

Born 1899
Fred Astaire (d. 1987); James Cagney (d. 1986); Duke Ellington (d. 1974); Alfred Hitchcock (d. 1980).

The sect leaders, James and Jane Wardley were joined by Ann Lees (Lee) in 1758. Lee had been married and had four children who had all died in infancy. While in jail in 1770 for breaking the sabbath laws, Lee had a revelation that enabled her to become the sect's religious leader, and she was called Mother. Lee (Mother Ann) believed that sex was sinful, and her vows of celibacy became a focus for the Shakers. This mandatory celibacy, plus worship practices that appeared to outsiders as shaking and shouting, made them targets for further persecution by the "world," the larger society of nonbelievers. So Lee and seven others did what other persecuted groups had done—they sailed for America.

When they landed in New York in 1774, American colonial society was temporarily too occupied with its own political situation to pay attention to these newcomers, so Lee began to make missionary trips around New England. Obviously, the only means by which to enlarge, or even sustain, the group was by acquiring new converts. While persuading others to join, Lee attracted too much attention from the "world." Once again, the Shakers were persecuted for their beliefs and practices—celibacy, equality of men and women, pacifism, communal living, and even their style of worship.

In 1784 Mother Ann died, and despite problems from the outside, the New Lebanon community was established in New York state as the seat of the governing authority. (In 1861 the name was changed to Mount Lebanon.) Utopian ideals of a better life outside of society were promoted, and followers sought purity of mind and body, simplicity, hard work, kindness, and worship. The group was bound together by thought, word, and deed, and these were reflected in their furniture.

Shaker Furniture

We have spared no expense or labor in our endeavors to produce an article that cannot be surpassed in any respect, and which combines all the advantages of durability, simplicity, and lightness.

ELDER R. M. WAGAN, MT. LEBANON, NEW YORK

Shaker furniture, at first glance, is derived from the simple country furniture of the eighteenth and early nineteenth centuries. At closer inspection, the designs and workmanship go beyond the ordinary and seem to reflect the moral attitude of the Shakers. The purity of form corresponds to their desired purity of thought and spirit; the utter simplicity has a certain naive quality, an innocence, in its straightforwardness. But beyond this presumed spiritual quality, the visual and material aspects are sophisticated. The aesthetic principles can be compared to those of Japanese Zen Buddhism.

As the authors of *The Complete Book of Shaker Furniture* observed:

Much of the serious scholarship on the Shakers has focused on their peculiarity rather than on their continuity with their surrounding cultural environment. Many misconceptions about their products stem directly from this restricted view. Although strongly influenced by their own institutional setting, Shaker designs were not created in a vacuum. Since no one was born a Believer, the earliest converts learned their cabinetmaking skills in the world and brought the technical skills and stylistic biases of their trade with them when they joined the community.

Worldly influences on many Shaker forms came from similar sources as for other **vernacular furniture**. Pattern books illustrating Neoclassical styles by Sheraton and Hepplewhite were followed most closely in major urban style centers. However, regional interpretations combined personal expression, simplification of forms, and local materials. The Shakers knew of the high-style worldly designs, and they utilized features that were compatible with communal goals. They also recognized the value of progress. As articulated by Oliver Hampton of Union Village, Ohio, in 1887:

Forms, fashions, customs, external rules all have to bow to the fiat of evolution and progress toward that which is more perfect. This need not alarm the most conservative Believer. For unless we keep pace with the progress of the universe our individual progress will be an impossibility. We shall be whirled off at some side station and relegated to the limbo of worn out—superannuated and used-up institutions.

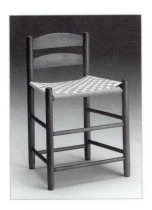

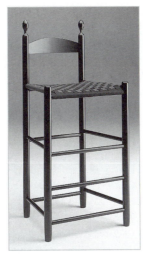

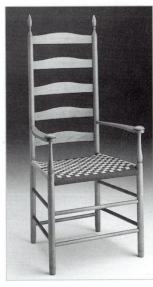

SHAKER LOW-BACK CHAIR
Designed with a low, two-slat back so it could be tucked under the table after mealtime. Back H 27; seat H 17; W 18-3/4. *(Courtesy of Shaker Workshops)*

SHAKER WEAVER'S CHAIR
At the Canterbury, New Hampshire, community, the large hand looms required chairs with high seats, so the weavers could sit close to their work; the chairs were also used at shop desks, laundry and ironing tables, and tailors' counters. Back H 39; seat H 26; W 18-3/4. *(Courtesy of Shaker Workshops)*

SHAKER ELDER'S CHAIR
Generously proportioned with slender finials on the rear posts, mushroom turnings on the armrests, of rock maple. Back H 51-1/2; seat H 18; W 22. *(Courtesy of Shaker Workshops)*

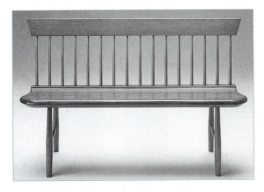

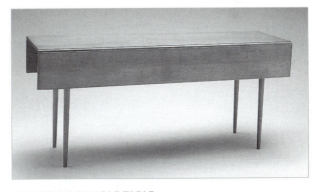

SHAKER MEETINGHOUSE BENCH
The Shakers used light, portable benches in their meetinghouses, like this example made at the Enfield, New Hampshire, community, circa 1840. Back H 31-1/2; seat H 17; W 50. *(Courtesy of Shaker Workshops)*

SHAKER DROP-LEAF TABLE
Attributed to the New Lebanon, New York, community, circa 1830, with turned legs and double-pinned mortise-and-tenon frame, of hard maple. H30; W38 with leaves up; W 21-3/8 with leaves down. *(Courtesy of Shaker Workshops)*

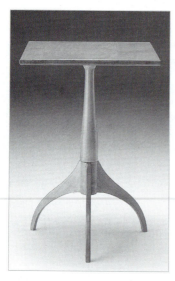

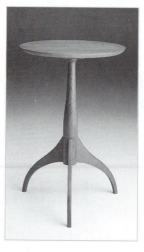

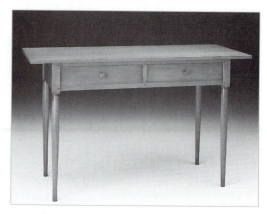

SHAKER RECTANGULAR CANDLESTAND

With arched legs dovetailed into the tapered base, top fastened to pedestal by a rectangular cleat, of clear maple. H 25-1/2; top 18 x 21. *(Courtesy of Shaker Workshops)*

SHAKER NEW LEBANON CANDLESTAND

Classic tripod stand with arched "spider" legs, made at the New Lebanon, New York, community, circa 1830–1840, of solid clear cherry. H 25-1/2; top D 18. *(Courtesy of Shaker Workshops)*

SHAKER TWO-DRAWER WORK TABLE

In 1839 as many as a dozen cabinetmakers were at work completing the interior of the Great Stone Dwelling at the Enfield, New Hampshire, community, and this table may have been in it, of clear maple with pine drawer interiors. H 30; top 50-3/4 x 20; drawers D 3-1/2. *(Courtesy of Shaker Workshops)*

SHAKER SERVING TABLE

Possibly intended for the ministry's dining room, with unusual tripod foot design, of clear maple. H 29-1/2; top 50-3/4 x 20. *(Courtesy of Shaker Workshops)*

SHAKER CREAMERY SHELVES

Broad-shelved milk pan and cheese racks were used in storage cellars and dairies, as seen in this adaptation from the Mount Lebanon, New York, community, of solid clear Eastern white pine. H 72; shelves W 35 x D 14-1/2. *(Courtesy of Shaker Workshops)*

Shaker Design Principles

One explanation for the enduring success of Shaker furniture is that it adheres to basic principles of design derived from classical architecture and late eighteenth-century design books (Chapter 5). The application of these principles—balance, hierarchy, pattern proportion, and scale—to Shaker furniture can be summarized as:

- **Balance**, the equilibrium between opposing forces, may be symmetrical or asymmetrical. Symmetrical balance, the use of equivalent forms on both sides of an axis, can be seen on Shaker counters, cupboards, and chests. Asymmetrical balance, using equivalent but nonmatching forms, can be seen on Shaker counters, sewing desks, and in their use of underhanging drawers.

- **Hierarchy**, the arrangement of elements or components according to importance in terms of function, shape, or size, is demonstrated by the Shaker use of a single feature, such as a door or drawer, centered at eye level. Even if the feature is no larger than one in a grouping, its placement and isolation gives it importance by subordinating the other elements.

- **Pattern**, the repetitive use of smaller shapes, forms, or spaces, is particularly evident in the arrangement of drawers in freestanding and **built-in** storage pieces.

- **Proportion**, the relationship of parts to the whole, is achieved by thoughtful selection from classical models and careful measurement. The use of visually pleasing proportion is one of the strengths of all Shaker furniture.

- **Scale**, size relative to surroundings, is used in unusual ways. Because of institutional needs, Shakers often required longer lengths for tables and greater heights for storage pieces, resulting in some exaggerated proportions. Pieces also range from very small to very large.

Shaker Tools

Shaker construction materials, methods, and tools were much like those of their worldly counterparts in the late eighteenth century. Hand tools—planes, saws, chisels, and drills—were standard for any woodworking shop. By the early nineteenth century, there was a gradual shift toward newly invented power tools, and their use by Shaker craftspeople also paralleled that of the world. Shakers have been credited with inventing the circular saw in 1813, but for the most part, they probably contributed more toward the refinement and modification of existing woodworking tools than to their invention.

By the 1860s, most larger workshops had become mechanized. Standard power tools included circular saws, planers, boring machines, and mortisers. As a result, subtle changes in furniture designs could be identified, such as the use of rounded edges. Although the Shakers often made their own tools, they also purchased commercially made machinery and tools.

The following is a list of the contents of a typical Shaker toolbox:

1. Workbench
2. Machine tools—buzz or table saw, mortiser, lathe
3. Cutting tools—ripsaw, crosscut saw, backsaw, bow saw, chisels, hatchet
4. Measuring and layout—marking gauge, tenon gauge, pocket ruler, squares, awl
5. Planes—block, smoothing, fore plane, jointing plane, plow plane, rabbet plane, panel plane, molding planes
6. Drilling tools—brace and set of bits, gimlet
7. Joining tools—mortising chisels, hammers, screwdrivers, clamps
8. Miscellaneous—marking dies, scrapers, draw knife, rasp (Rieman 76)

Where the Shakers made a good deal of furniture for their own use before the Civil War, communities increased their commercial production in the second half of the nineteenth century. The light, utilitarian furniture was marketed to cities, especially on the Eastern seaboard, and began to complement heavy Victorian pieces in fashionable interiors. Contact with the world also resulted in just what many Shakers had feared most, and the furniture makers succumbed to, or at least catered to, the ruling taste and market demand. Whether for the sake of progress or a loss of identity, some Shaker furniture temporarily lost its unique styling, and worse, its rare spiritual character. Yet considering the duration of its production and the rate of change in the world, Shaker furniture exhibits amazing consistency in material, construction, styling, and quality.

In the late twentieth century, a growing faction of the furniture industry responded to a desire to revive the modern classics. However, there is a hint of foreboding in an apparently welcomed event. Is modern just another style? Does the desire to revive earlier styles have the same connotations as it did in the last century? While these philosophical issues are being resolved, the industry and the public are enjoying the abundance of reintroductions of both well-known and forgotten designs. And while there is still some flexibility in the definition of modern, there is time for the inclusion of Shaker furniture. After all, if many of the recognized mainstream modernists appear to have been influenced by these supposedly "country" pieces, then the originals ought to be recognized as well. Companies as diverse as the Shaker Workshops in Massachusetts and Palazzetti in New York offer classic Shaker designs, which can still complement many contemporary interiors.

HITCHCOCK CHAIR

The Hitchcock chair, another example of early modernism in the Victorian era, can be compared to furniture by the Shakers. Although the chairs were the product of a single individual rather than a community or communities, the designs used by both Hitchcock and the Shakers were based on eighteenth-century English pattern books, and they were made both before and during the Victorian era. Yet what makes the Hitchcock chair different is its contribution to the evolution of modern furniture—its method of production.

Lambert Hitchcock was born in Connecticut in 1795. He worked as a journeyman for Silas E. Cheney of Litchfield, Connecticut, in 1814, specializing in Sheraton-style chairs. By 1818, at the age of 23, Hitchcock felt ready to open his own chair-making business. The location for his first factory was at the junction of the Farmington and Still Rivers. Water power and the surrounding forests filled with raw material would enable his business to flourish. However, the thirty-mile distance between the isolated village of Hitchcocks-ville (named after the factory) and Hartford would eventually contribute to its failure. If the road to Hartford was rough in good weather, it was impassable in winter, and when bad weather halted shipping, the Hitchcock factory would be forced to close down.

Hitchcock was not a designer of furniture, but an innovator in the areas of production and marketing. In 1798, Eli Whitney had pioneered the use of standardized parts and division of labor in a Connecticut firearms factory. In 1797, Thomas Sheraton published *The Cabinet-Maker and Upholsterer's Drawing Book*. With patterns provided, Hitchcock applied the concept of standardization along with other labor-saving devices and revolutionized the furniture business. He began by making completely interchangeable and very inexpensive chair parts to be purchased at local dry goods stores for assembly at home. It was an immediate success and very lucrative. Next, Hitchcock assembled his own chair parts and painted the chairs with such efficiency that he could retail them for between $.45 and $1.75. For the first time in the history of furniture manufacture, even before the beginning of the Victorian era and the

industrialization of the furniture industry, an item of furniture was made affordable to just about anyone.

By 1825, Hitchcock could afford to build a fine brick factory in which to process the green lumber and manufacture side chairs, armchairs, and rocking chairs. Backsplats, often in the form of stylized eagles or turtles, and chair posts were steamed and bent; front legs and other straight elements were turned on a lathe; and the parts were assembled while the wood was still green. After kiln drying the assembled chair, women workers wove rush or cane seats, painted each chair solid black, red, or green and then decorated the surface with stenciled designs or a faux wood grain. Favorite motifs were stylized fruits and/or flowers, especially in baskets. The assembly-line decoration substituted for the costly woods, inlay, gilding, and carving specified by Sheraton. Consequently, 15,000 of Hitchcock's efficient adaptations could be mass-produced annually. From 1825 to 1832, most were signed on the back of the seat, "L. Hitchcock. Hitchcocks-ville, Conn. Warranted." Those made between 1832 and 1843 were signed "Hitchcock, Alford & Co.," because Hitchcock and his brother-in-law Arba Alford were partners. Around 1843, Hitchcock attributed his financial difficulties to their location, so he moved to Unionville, Connecticut, at the site of a proposed canal and railroad station. Bad luck followed when work on the Farmington Canal was halted and the New York,

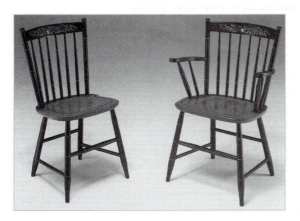

Hitchcock side chair and armchair with wood seat, black painted legs, stenciled black back.

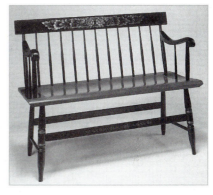

Hitchcock bench in same style and finish as chairs.

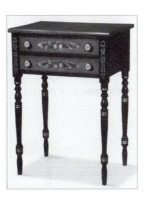

Hitchcock work table with black and harvest motif, porcelain knobs.

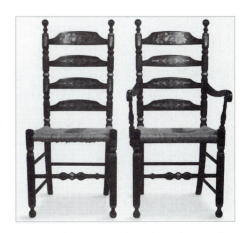

Hitchcock ladderback side and armchairs with rush seats.

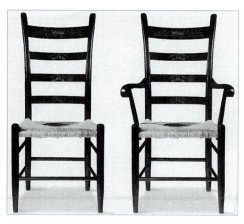

Simpler form of Hitchcock ladderback side and armchairs with rush seats.

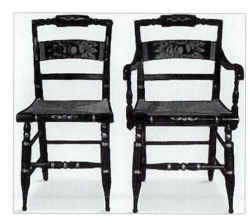

Hitchcock slat-back side and armchairs with rush seats.

New Haven & Hartford Railroad bypassed Unionville. Hitchcock died, heartbroken and insolvent, in 1852.

Like other nineteenth-century participants in early modernism, Hitchcock's contribution was not one of style. His was a revolutionary production method that democratized a portion of the furniture industry. Interchangeable parts, mass production, labor-saving methods of decoration, and unprecedented low cost were remarkable concepts. Style would come later.

THONET

The Shakers anticipated (or participated in) modernism by the stylistic minimalism and functionality of their chairs, tables, and built-ins; Lambert Hitchcock used a familiar style for interchangeable parts in what is considered to be the first furniture factory; patent furniture addressed ergonomics, convertibility, and mechanical function, but it usually bypassed aesthetics. However, Michael Thonet became a true pioneer modernist by combining technical innovation, optimal use of materials, efficient production and marketing methods, *and* aesthetic criteria. Long before the Arts and Crafts movement voiced its concerns, Thonet offered an alternative to the quagmire of interior clutter. Thonet was responsible for the most successful artistic reform and the production of timeless and modern forms.

Bentwood

The art and science of bending wood had been known and practiced by builders of items as diverse as ships, sleighs, carriages, and wagon wheels. Early eighteenth-century Windsor chairs, for example, relied on a technique of bending wood, and it was quite possibly known as early as the Egyptian Old Kingdom, circa 2800 B.C. As evidenced in pictures, the splayed leg of the classical Greek *klismos* chair may have been mechanically bent. Early nineteenth-century renditions of the *klismos* were made by various methods, including the use of specially selected, naturally grown curved timber. These early applications were all in the area of craft, and none were used as an industrial process. Thonet clearly did not discover or invent the bending of wood, but he was the first to utilize the process in mass production and contribute to the concept of mass consumption as well.

Bending veneers was a more time-consuming and costlier method than bending solid wood. Unfortunately, there is a natural tendency for bent solid wood to break apart. In order to equalize the strain, his solution was to attach a steel strap to the length of wood before bending. The steel could support the weakened wood throughout the process and absorb much of the stress. Boiled beechwood poles were therefore strapped between steel plates and mechanically bent, then slowly dried in ovens. The resulting parts were standardized and therefore interchangeable; chairs were assembled, knocked down, shipped, and finally reassembled with the use of screws. They were not only light-weight, durable, utilitarian, versatile, and inexpensive, they were aesthetically pleasing. The clean, continuous **bentwood** curves were as elegant as the clean straight lines of the Shakers.

Michael Thonet

Thonet was born in Boppard on the Rhine, Prussia, in 1796. Although his father, Franz Anton, was a tanner, young Thonet learned woodworking as a carpenter's apprentice. At age 23 he married Anna Crass and opened his own business as a joiner and cabinetmaker in the fashionable Biedermeier style.

His experiments in the 1830s enabled him to make chair parts and entire chairs of laminated wood veneers. Bundles of glue-saturated veneers were heated and formed in wooden molds, apparently earlier than similar experiments performed by Belter. In addition to gluing veneers, he tried taking thicker pieces of wood and boiling them in glue. Realizing the potential of the resulting lightweight and durable furniture parts, he applied for and was granted a patent by the kaiser of Vienna in 1842 for bending wood by chemical and/or mechanical means. In the same year, in order to escape from creditors in Boppard as well as capitalize on his success in Austria, Thonet and his family moved to Vienna. As Thonet continued to experiment, he discovered other time- and labor-saving methods; for example, by using longer continuous lengths, the number of pieces needed to construct a typical chair could be reduced from ten to five.

He founded a family firm in 1849 with his five sons, and in 1853 named it Gebrüder Thonet (Thonet Brothers). In late 1853 he purchased his first (4 horsepower) steam engine. Until then, his staff, now totalling forty-two workers, had been accustomed to manual labor, except for caning, which was contracted out. (Alvera 44) With the new machinery, with solutions to the problems inherent in bending wood, and with the patents to do so, Gebrüder Thonet would enjoy a monopoly on the production of bentwood furniture for more than a decade. By mid-century, Michael Thonet had become a pioneer industrialist by entering the world of mass production. In 1859 Gebrüder Thonet issued their first (known) catalog, offering twenty-six items, including settees and tables that could be mass-produced as effectively as chairs. Most of the chairs at the time were of solid bent wood.

Thonet was remarkably successful, but in 1869 his patent expired. Other companies were quick to produce exact copies—the process, the designs, and even model numbers were imitated. Although the company no longer enjoyed being a monopoly, when Michael Thonet died in 1871, Gebrüder Thonet already had factories in Germany, Austria-Hungary, and Poland. Despite increasing competition in the 1870s and 1880s, the firm continued to expand. By 1900, it employed about 6,000 workers who produced 4,000 pieces of furniture each day. Further refinements, mergers, and the later addition of architect-designed furniture and the use of tubular steel contributed to their continued success and leadership in both the design and manufacture of modern furniture. Yet many of the earliest designs continued to be the mainstay of the company. Classics like the Vienna Cafe Chair (Chair No. 14) had sold nearly fifty million in its first hundred years. It is considered to be not only the first modern mass-produced chair, but is among the best designs of the nineteenth century.

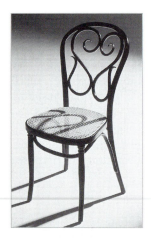

NO. 4 CAFÉ DAUM CHAIR

Designed by Michael Thonet, circa 1850. The selection of this design for the fashionable Café Daum coffeehouse, located near the Hofburg, marks the rapid acceptance of Michael Thonet's designs for the emerging affluent consumer society in the middle of the century. Later, this chair was altered for mass production and was known as the No. 4 Chair. Adaptation of steam-bent beechwood frame, natural cane seat. W 18, D 21, H 34-1/2; seat 15-3/4 x 15, H 18. *(Courtesy of Thonet)*

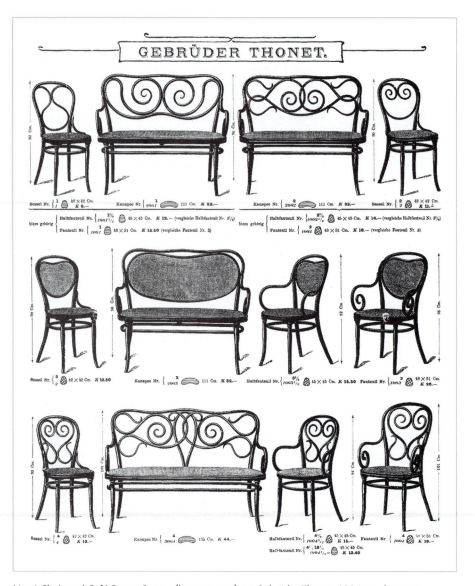

No. 4 Chair and Café Daum Settee (bottom row) on Gebrüder Thonet 1904 catalog page.

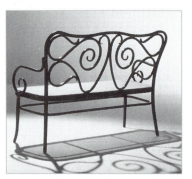

CAFÉ DAUM SETTEE

Designed by Michael Thonet, circa 1850. The elaborate scrolling back detail of this settee was indicative of the fashionable Rococo Revival style popular in Vienna during the mid-century. Bentwood was the only medium able to achieve such intricacy. Steam-bent beechwood frame, natural splined cane seat. W 57-1/2, D 22, H-38-1/2; seat 55-3/4 x 17-3/4, H 18. *(Courtesy of Thonet)*

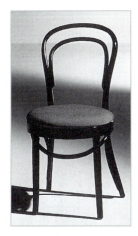

NO. 14 CHAIR
Designed by Michael Thonet, circa 1855. Simplicity, durability, and affordability made this design the most popular commercial chair of the nineteenth century, and it was later referred to as the first consumer chair. In the 1870s an estimated 1,200 of this model were sold daily, and by 1920 about 30,000,000 had been produced. Adaptation of steam-bent beechwood frame, shown with upholstered seat, though available with original cane. W 16, D 22, H 32; seat diameter 16, H 18.
(Courtesy of Thonet)

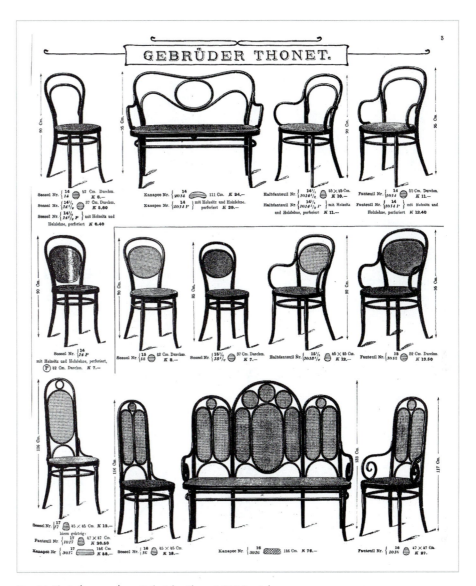

No. 14 Chair (top row) on Gebrüder Thonet 1904 catalog page.

VIENNA CAFÉ COSTUMER
Designed by Michael Thonet's sons, circa 1860. By 1887 costumers, hat racks, and music stands were a few of the utilitarian objects made of the fluid steam-bent wood. W 25, H 74. *(Courtesy of Thonet)*

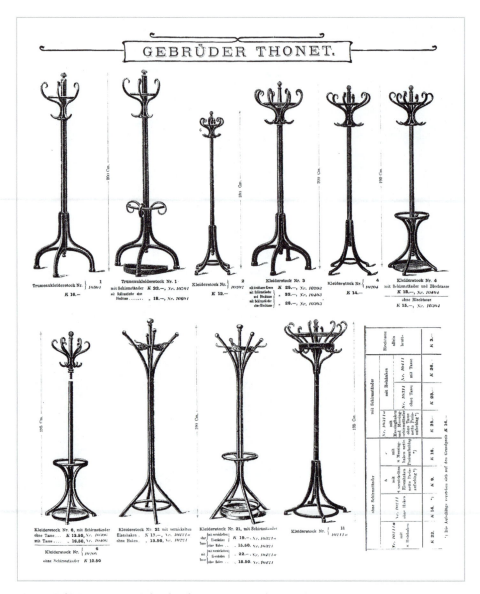

Vienna Café Costumer on Gebrüder Thonet 1904 catalog page.

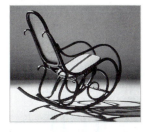

BENTWOOD ROCKER
Designed by Michael
Thonet, circa 1862. Perhaps
inspired by the Winfield
rocker, which combined legs
and runners, first exhibited
at the Crystal Palace
Exhibition in London in
1851, Michael Thonet used
his ingenious method to
produce the first bentwood
rocker shortly after. Various
models were introduced in
the 1850s and 1860s.
Steam-bent wood frame
with natural cane seat and
back. W 21, D 40, H 43; seat
17 x 17. *(Courtesy of Thonet)*

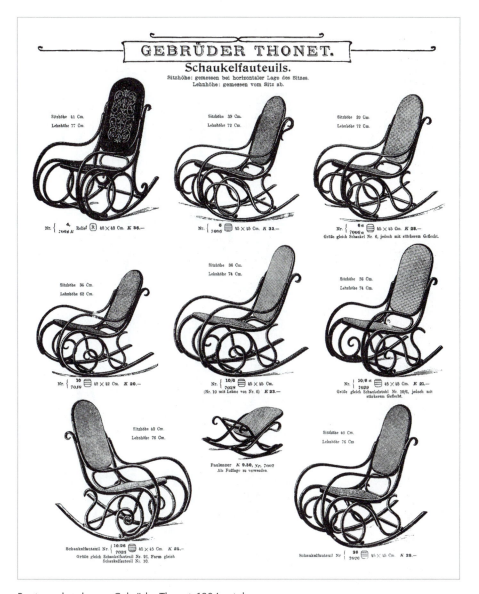

Bentwood rocker on Gebrüder Thonet 1904 catalog page.

BENTWOOD STOOLS

Designed by Michael Thonet, circa 1866. In 1866 Thonet issued their second catalog, displaying seventy items. Stools were among the new designs, and for the first time the leg brace, to improve stability, was added to all but the luxury models; steam-bent wood frames, wood saddle seat. H 18 or 30; W 17, D 17, seat diameter 14. *(Courtesy of Thonet)*

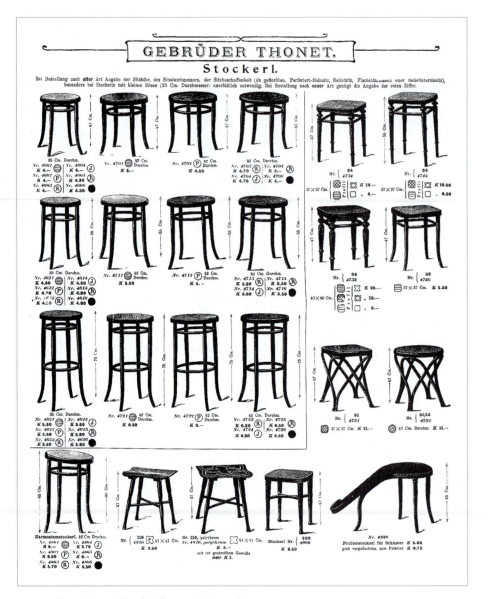

Bentwood stools on Gebrüder Thonet 1904 catalog page.

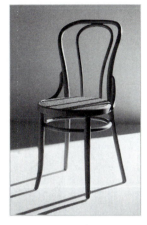

**CLASSIC VIENNA CAFÉ
CHAIR, NO. 18**
Designed by Michael
Thonet's Sons, circa 1876.
This No. 18 design became
the most important and
best-selling model produced
after the death of Michael
Thonet. Adaptation of
steam-bent beechwood
frame, natural cane seat. W
17-1/4, D 21, H 34-1/2;
seat diameter 16-1/2, H 18.
(Courtesy of Thonet)

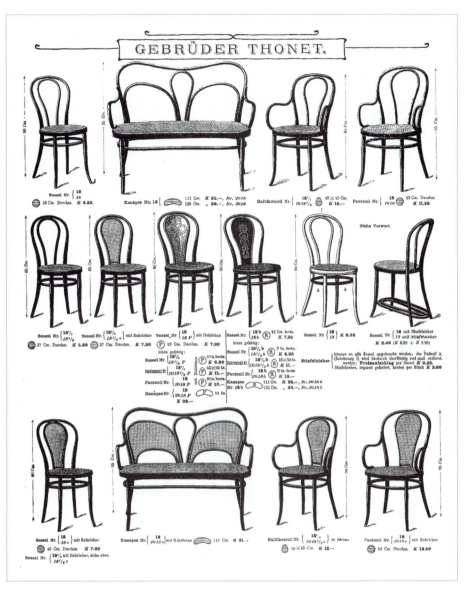

Chair No. 18 on Gebrüder Thonet 1904 catalog page.

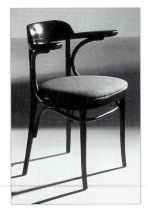

GROPIUS CHAIR
Designed by Michael
Thonet's sons, circa 1880.
This was an early bentwood
model used for an
adaptation by Walter
Gropius in 1952. Steam-
bent beechwood frame,
wood back, and saddle seat.
W 22-1/4, D 21, H 29-1/2;
seat 19 x 17-1/2, H 18; arm
H 27-1/4. *(Courtesy of
Thonet)*

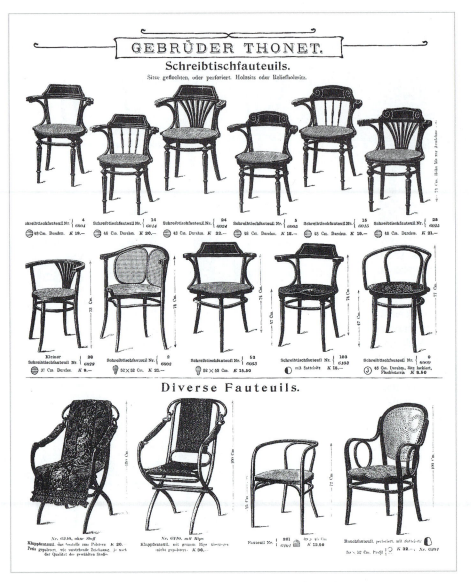

Original design of Gropius Chair on Gebrüder Thonet 1904 catalog page.

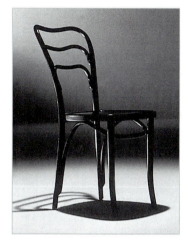

ADOLF LOOS CHAIR
Designed by Adolf Loos, circa 1899.
A new era of bentwood furniture
began when Thonet manufactured
this model by architect Adolf Loos
for his renovation of the Café
Museum in Vienna. Though similar
to the No. 14 model, it is more
complex and visually interesting.
Adaptation of steam-bent
beechwood frame, wood veneer
seat. W 22, D 17, H 33-1/2; seat 18
x 16, H 18. *(Courtesy of Thonet)*

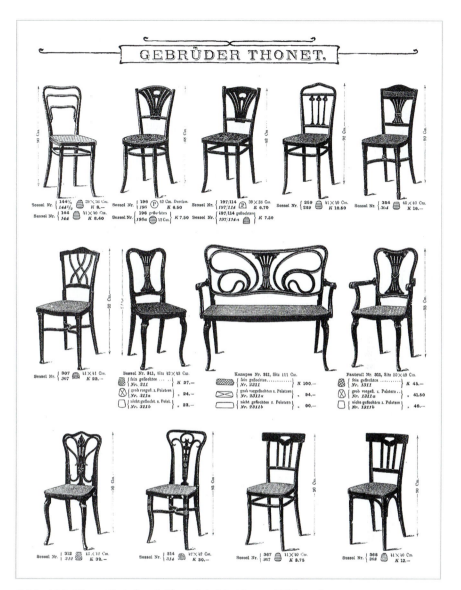

Original Adolf Loos Chair (top left) on Gebrüder Thonet 1904 catalog page.

Summary

- Mechanization of the furniture industry in the nineteenth century created a great supply and equally great demand for furniture.
- The new machinery was used more to produce superficial ornamentation in historic styles than for the invention of new forms.
- A group of religious communities called the Shakers produced simple, utilitarian, well-crafted furniture for their own use and later for sale to the public.
- Lambert Hitchcock first applied labor-saving devices and mass-production methods to the manufacture of furniture.
- Rather than influence the overall furniture industry, innovation was relegated to a specialized area of patented mechanical inventions and novelties.
- George Hunzinger combined current fashion with patent furniture.
- Thonet bentwood furniture of the mid-nineteenth century was the first to use innovative techniques and simple styling on a large scale, and became the first truly modern, mass-produced furniture.

Chronology

1774 Shakers leave England and arrive in New York.

1783 Oliver Evans develops the continuous production line.

1818 Lambert Hitchcock begins his chair-making business in Connecticut.

1930s Michael Thonet experiments with chairs of bentwood veneers.

1840s–1850s John Henry Belter patents methods of wood lamination and furniture construction.

1842 Michael Thonet is granted an Austrian patent for bending wood.

1849 Gebrüder Thonet is founded.

1852 Lambert Hitchcock dies after thirty-four years making chairs.

1850–1890 Patent furniture designs, especially chairs, are invented, patented, and sometimes manufactured in the United States.

1860s Most of the Shaker workshops are mechanized.

1866 George Hunzinger's patent is issued for the reclining chair with folding legs.

1869 Diagonal brace chair called the Hunzinger Chair is patented.

1871 Michael Thonet dies, and Gebrüder Thonet has bentwood furniture factories throughout Europe.

1882 Patent is issued for the Hunzinger platform rocker.

1893 Chicago World's Fair marks end of interest in patent furniture.

Designers and/or Manufacturers

Lambert Hitchcock (1795–1852, United States) Connecticut chair maker, primarily in the Sheraton style, and pioneer in the use of standardized interchangeable parts for mass-produced furniture.

George Hunzinger (1835–1899, Germany, United States) New York furniture manufacturer who worked in the Renaissance Revival style, known for patented folding and reclining chairs.

The Shakers (throughout nineteenth century) Religious communities known for making simple, utilitarian furniture; the Mount Lebanon, New York, community began to mass-produce chairs in the 1870s.

Michael Thonet (1796–1871, Germany, Austria) Patented a process for bending solid wood and founded Gebrüder Thonet in Austria; mass-produced millions of bentwood chairs, many of which have become classics and are still made and marketed internationally.

Key Terms

bentwood	mass production	ruling taste
built-in	modern	vernacular furniture
laminated	patent furniture	

Recommended Reading

Giedion, Siegfried. *Mechanization Takes Command: A Contribution to Anonymous History.* New York: Norton, 1948.

Hanks, David A. *Innovative Furniture in America from 1800 to the Present.* New York: Horizon Press, 1981.

Kenney, John Tarrant. *The Hitchcock Chair: The Story of a Connecticut Yankee—L. Hitchcock of Hitchcocks-ville, and an Account of the Restoration of This 19th Century Manufactory.* New York: Clarkson N. Potter, 1971.

Ostergard, Derek E. *Bent Wood and Metal Furniture 1850–1946.* New York: American Federation of Arts, 1987.

Rieman, Timothy D., and Jean M. Burks. *The Complete Book of Shaker Furniture.* New York: Harry N. Abrams, 1993.

Schaefer, Herwin. *Nineteenth Century Modern: The Functional Tradition in Victorian Design.* New York: Praeger, 1970.

Wilk, Christopher. *Thonet: 150 Years of Furniture.* Woodbury, NY: Barrons, 1980.

Zelleke, Ghenete, et al. *Against the Grain: Bentwood Furniture from the Collection of Fern and Hanfred Steinfeld.* Chicago: The Art Institute of Chicago, 1993.

Chapter 8

ARTS AND CRAFTS:
"As I Can"

CHAPTER CONTENTS

The Arts and Crafts movement developed to solve a variety of complex problems in Victorian society as well as to provide well-designed and constructed furnishings.

ORIGINS IN VICTORIAN ENGLAND

Creative acts are often born out of discomfort. Some of the best work of musicians, novelists, poets, and painters was inspired by personal or societal problems, even anguish. The intense and positive emotion of love, so often mixed with pain, has been the inspiration for great works of art, crossing boundaries of time and place. Comfort and complacency are enemies of creativity; they have never been known for inspiring works of art or scientific discoveries, or for motivating change. In fact, when things are too calm, human nature invents a problem just to be able to find a solution. If nature abhors a vacuum, people abhor a status quo.

The Arts and Crafts movement is an example of a rather widespread reaction to what was perceived as bad art, bad taste, and even worse social conditions in Victorian England. As with other artistic movements, most people were not aware of the problem because, frankly, most people were not aware of art. Historically, artistic decisions have rarely been life-threatening or even relevant to the general population, so like other activities sensitive to fashion, art was usually left up to specialists—both practitioners and critics.

In the midst of the Industrial Revolution, however, in the urban centers of Britain, a nation that had suddenly undergone very radical changes, art, especially decorative art such as furniture, was different. It was no longer just an elitist luxury enjoyed by the wealthy, the powerful, or the pious. What was being made and promoted as art was almost suddenly intended for a popular audience.

Throughout all of history, most decorative art objects had been thoughtfully designed, crafted by hand, often one of a kind, and costly; now they could be copied from a pattern book, made by machinery in large quantities, and affordable to the sizable new middle class. In addition to the material benefits of a newly industrializing society, there was another cost: Railroads and factories also brought pollution, disease, and unlivable conditions for the urban poor. As architect Louis Hellman observed, ". . . the rural poor flocked to the towns for work to be crammed into quickly erected back-to-back houses without sanitation, water, or ventilation and subject to the noise and smoke from the adjacent factory. [The neighborhoods] came in three grades: semi-slum, slum, and super slum." Industrialization was only one of a complex set of issues, but apparently it was the easiest to vilify. Blaming manufacturing methods for artistic and social problems made the Arts and Crafts movement unique, and, as we shall see, doomed to struggle with economically impossible goals, self-contradiction, and even hypocrisy.

The following are introductory statements from studies on the movement:

The Arts and Crafts movement was inspired by a crisis of conscience. Its motivations were social and moral, and its aesthetic values derived from the conviction that society produces the art and architecture it deserves. It was originally a British movement; Britain, first in the field as the workshop of the world, was the first to discover that factory conditions are far from ideal, and the realization that technical progress does not necessarily coincide with the improvement of man's lot brought with it the long campaign for social, industrial, moral and aesthetic reform that is still unresolved today. The Arts and Crafts movement represents one facet of that campaign, but because the movement marks a stage in man's efforts to come to terms with industrialization, it was not confined to England (Naylor 7).

The Arts and Crafts movement was founded by theorists, architects and designers in Victorian Britain. They sought to provide an alternative code to the harshness of late nineteenth-century industrialism, to foster spiritual harmony through the work process and to change that very process and its products. Its leaders encouraged individualism, the creation of hand-made goods in place of machine uniformity, and a reappraisal of design materials. The multi-talented figures of the movement . . . were to produce a generation of architect-designers who would reform design, accept technical and aesthetic challenges and be aware of their national heritage (Cumming 9).

The Arts and Crafts movement developed in England as a protest against the character of mid-Victorian manufactured products and slowly evolved during the period between 1850 and 1920 into an international campaign for design reform which affected all aspects of the environment, from architecture and gardens to interior furnishings, finishing materials, and accessories. Throughout its lifespan, its supporters argued that design affects society—that the character of the living and working environment molds the character of the individual (Naylor et al 7).

Each of these statements has a slightly different emphasis, but each presents the movement as a blend of moral, social, political, industrial, and aesthetic concerns. The label "Arts and Crafts" came into use in 1888 when an Arts and Crafts Exhibition Society was formed in London by members of the Royal Academy seeking to elevate the stature of applied and decorative arts. But the leaders of the so-named movement were socialists who operated in the existing middle-class social context. Unlike other artistic phenomena, rather than being identified by a style, the Arts and Crafts product was defined more by philosophical than visual criteria. The personality credited with initiating and disseminating this philosophy was John Ruskin.

John Ruskin (1819–1900)

Ruskin was a social critic and writer who condemned capitalistic industrialism. He was educated at Oxford and wrote influential books on architecture—*The Seven Lamps and Architecture* (1849) and *The Stones of Venice* (1851–1853). His writings and preaching, especially after the Great Exhibition in 1851, set the ground rules for an artistic-social movement.

In 1871 he founded the Guild of St. George and appointed himself master over members who lived and worked according to his religious and moral ideals —not unlike a cult. The communally owned farms and industries operated under Ruskin's direction and about 10 percent of his assets. The public was less than enthusiastic about the guild, which should have come as no surprise. Ruskin wanted the reformation of the existing social system at the expense of the industrial society. This was to be replaced by an idealistic medieval system of masters and servants, artists and artisans with a common interest in the quality of life and work. His paternalistic attitude did not make him popular, yet he did motivate others to form more practical and more successful guilds and societies important for the movement.

Ruskin was neither an artist nor a craftsman, and his contribution to the movement was through his ideas that were then materialized by others. His preaching was social, political, and religious, and although Ruskin is considered to be the founder of a primarily decorative arts movement, only one of his books, *The Two Paths*, was about decorative arts.

REFORM

Reformers feared that the kinds of machine-made objects seen at the Great Exhibition held at the Crystal Palace in 1851 would destroy aesthetic standards and lead not only to the debasement of English taste, but perhaps even morality. Industrialization was made a scapegoat for all societal ills. Mid-nineteenth-century demonstrations against the prevailing quest for inferior-quality goods inspired a movement that continued into the next century and changed appearance and direction as it crossed national boundaries. The English Arts and Crafts movement was spearheaded by John Ruskin, and William Morris practiced what Ruskin preached. A typical manufacturer or middle-class consumer would look at the heavily ornamented, machine-made, and stylistically confused objects and call them good—good for business and the economy, good for a growing consumerism, and good for a perceived need of a lifestyle that included a Victorian passion for conspicuous consumption, impression management, and fashion. If John Ruskin viewed the same objects, he would call them bad—bad for the perpetuation of miserable factory working conditions,

bad for the mind-numbing boredom it imposed on the workers, bad for the underemployment of designers, and bad for the debasement of consumer taste. William Morris would agree with Ruskin, also call them ugly, and proceed to do something about it.

William Morris (1834–1896)

Have nothing in your house that you do not know to be useful or believe to be beautiful.

William Morris designed some of the finest wallpapers and fabrics of the nineteenth century; he also mastered several crafts and wrote poetry. He is best known for his role in the Arts and Crafts movement—for joining art and labor and for producing aesthetically pleasing and well-made goods. Whether or not these goods were, as he believed, socially and morally uplifting is unimportant. What is important is his leadership and artistic accomplishments in one of the nineteenth century's most interesting events.

Morris, like Ruskin, came from a comfortable background; became a respected educator, lecturer, and writer; claimed to hate modern civilization; and became an active socialist. He was born in 1834 in a comfortable semicountry area on London's northeast fringe. His father, William Morris senior, was a city businessman who lived more like a country gentleman. The family could be called upwardly mobile, and they moved to a large home in a parklike setting. The Morris family business became more successful plus their investment in a copper mining company skyrocketed, and Morris senior became a quasi-squire. When he died in 1847, he left a fortune, and the eldest son William was left an enormous annual (unearned) income.

Beginning in 1853, Morris studied at Oxford and became increasingly interested in architecture and history. He met American-born architect-designer Philip Webb (1831–1915), whose style would influence British craft design in the 1880s and 1890s, and Edward Burne-Jones and Dante Gabriel Rossetti, who became key figures in the Pre-Raphaelite Brotherhood. Morris spent the years from 1856 to 1859 painting, but soon realized that he was much better suited to pattern design. In 1959 he married Jane Burden, and the Red House that Philip Webb designed for Morris and his new bride became a symbolic monument of Arts and Crafts.

The first William Morris workshops were founded in 1861 as kind of an artists' cooperative under the name of Morris, Marshall, Faulkner, and Company: Fine Art Workmen in Painting, Carving, Furniture, and the Metals. Their first wallpaper design, trellis with birds, was done in 1862, and Morris began to design textiles in the late 1860s. By 1865 Morris took charge of the company and reorganized it in 1875 as Morris and Company with William Morris as the only proprietor. Morris actually designed few pieces of furniture; many of the early furniture designs were by Ford Madox Brown and Philip Webb. They were a blend of traditional and new ideas with an emphasis on individualism and simplicity.

In 1877 Morris opened a new shop for hand-knotted rugs, followed by a tapestry weaving shop in 1881. The Kelmscott Press for the production of handmade, limited edition, costly books opened in 1890. The irony became increasingly apparent: The ideal of a democratic art in which good design could be made available to many was lost to the reality that only upper-class patrons could afford to buy Morris's handmade goods. Avowed socialists were in actuality working for the elite. Morris wanted a commercial revolution and not just a home craft or country craft revival. Yet, not only did he and the movement inspire a country craft revival, many of its participants saw Morris's socialism as a definite threat to British society. These rural home industries and a settlement house movement did, however, share Morris's concern for the workers' welfare and his desire for beautiful objects. They also saw craft as a possible tool for moral reform inasmuch as it was an uplifting leisure occupation. Through amateur handicraft, at least a portion of the movement reached the populous. Other organizations, such as Arthur Heygate Mackmurdo's Century Guild and Charles Robert Ashbee's Guild of Handicraft, shared the Arts and Crafts philosophy of raising the stature and quality of design. It was the designer and craftsman, however, that gave the movement its artistic identity and lasting contribution. Some key British names include the following five.

Rug designed by William Morris for Morris & Co. Ltd. *(The Studio 1906)*

Rug designed by William Morris for Morris & Co. Ltd. *(The Studio 1906)*

Textile designs, "Fruit" and "Chrysanthemums," by William Morris for Morris & Co. Ltd. *(The Studio 1906)*

Floral chintz designed by William Morris for Morris & Co. Ltd. *(The Studio 1906)*

Tapestry designed by William Morris and his artist friend Edward Burne-Jones (1838–1898) for Morris & Co. Ltd. *(The Studio 1906)*

Graphic designed by William Morris for the Kelmscott Press. *(The Studio 1906)*

Graphic border design by William Morris for the Kelmscott Press. *(The Studio 1906)*

Graphic designed by William Morris for the Kelmscott Press. *(The Studio 1906)*

Wallpaper designs by William Morris
for Morris & Co. Ltd. *(The Studio 1906)*

Charles Robert Ashbee (1863–1942)

As with many British leaders in the movement, Ashbee was trained as an architect and later began to design furniture and furnishings as well as write. His designs were intentionally modern by breaking away from the predominant historicism and sometimes ventured into Art Nouveau. In 1888 he organized the Guild and School of Handicraft in London, for which he designed metalwork and jewelry, and in 1898 founded the Essex House Press. Ashbee also influenced jewelry and silver design of Liberty's and the Vienna Seccesssion, met Frank Lloyd Wright, and wrote the introduction to one of his books.

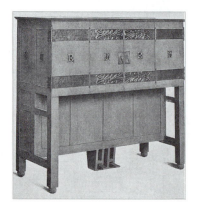

Piano designed by Charles Robert Ashbee and made by the Guild of Handicraft. *(The Studio 1906)*

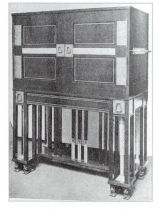

Writing cabinet designed by Charles Robert Ashbee and made by the Guild of Handicraft. *(The Studio 1906)*

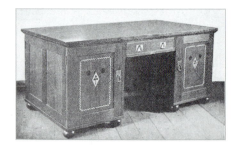

Writing table designed by Charles Robert Ashbee and made by the Guild of Handicraft. *(The Studio 1906)*

Arthur Heygate Mackmurdo (1851–1942)

Trained as an architect, Mackmurdo opened his own practice in 1875. He met Morris shortly after and consequently organized the Century Guild in 1882 with Selwyn Image (1849–1930) and other designers and craftsmen. They published the journal *Hobby Horse* beginning in 1884, but although the guild was a strong influence on the craft revival, it dissolved in 1888.

Mackay Hugh Baillie-Scott (1865–1945)

Scott was a British architect and designer. He specialized in furniture that was sold by Liberty's in London, the rather exclusive retailer known for its contribution to Art Nouveau, rather than to Arts and Crafts. He also became known and admired in Germany and Austria for his installations in Germany, and eventually his designs spread throughout Europe and to the United States.

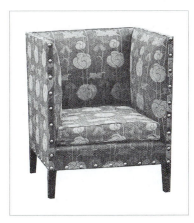

Easy chair with tapestry upholstery designed by Mackay Hugh Baillie-Scott. *(The Studio 1906)*

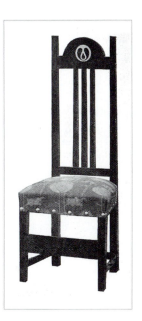

Dining chair with tall straight back and upholstered seat, designed by Mackay Hugh Baillie-Scott. *(The Studio 1906)*

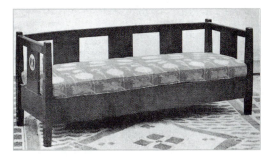

Couch with tapestry upholstery designed by Mackay Hugh Baillie-Scott. *(The Studio 1906)*

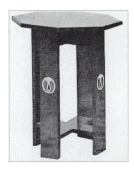

Octagonal-shaped mahogany occasional table designed by MacKay Hugh Baille-Scott. *(The Studio 1906)*

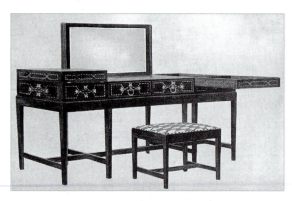

Rectilinear inlaid mahogany dressing table with stool, designed by MacKay Hugh Baille-Scott. *(The Studio 1914)*

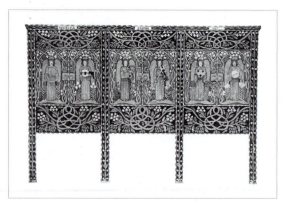

Music cabinet with painted decoration, designed by MacKay Hugh Baillie-Scott. *(The Studio 1914)*

Charles Francis Annesley Voysey (1857–1941)

A British architect-designer, Voysey set up his first office in 1882 for decorative work rather than architecture. He sold his first fabric and wallpaper designs in 1883, joined the Art Workers' Guild in 1884, and became master of the guild in 1924. Voysey's simple linear style without surface decoration was widely exhibited and influenced designers not connected to the movement, notably Charles Rennie Mackintosh.

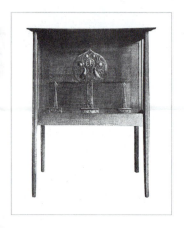

Oak writing cabinet with Art Nouveau decorative hinges, designed by C. F. A. Voysey. *(The Studio 1906)*

Philip Webb (1831–1915)

By age sixteen, Webb had begun his first architectural apprenticeship, joined a different firm in 1852, and opened his own office in London in 1858. He was then given the famous Red House commission, to design and build William Morris's home at Upton in Kent. Webb also designed much of the furniture for the house, the furniture produced by Morris, Marshall, Faulkner & Co., and for Morris and Co. until he retired in 1890. His Arts and Crafts style, with its simplified historic revivalism, continued to influence other designers in the movement through the 1890s.

AESTHETIC MOVEMENT

A concurrent and related phenomenon that shared many of the aesthetic ideas of both the Arts and Crafts movement and Art Nouveau was called the **Aesthetic movement**. Interestingly, many of the objects labeled as "Aesthetic" look no different from Arts and Crafts,

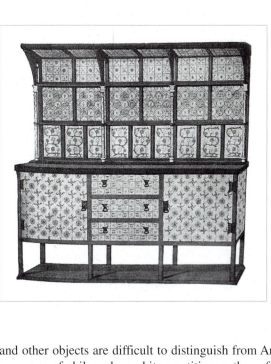

Dresser with elaborate painted motif, designed by Philip Webb.

and other objects are difficult to distinguish from Art Nouveau. The difference was often more one of philosophy and its practitioners than of style.

If the Arts and Crafts movement was a cult of social reform that preached salvation, then the Aesthetic movement was a cult of beauty that preached aesthetics. And, if the Arts and Crafts reformers were self-appointed saviors, the aesthetes were self-appointed cognoscenti. The Aesthetic movement was led by fashion, and the stimulus was Japanese (and to a lesser extent, Chinese) design. The interest in Japanese art was strong, possibly because it was so entirely different from any of the Western historicism familiar to Victorian society.

It began when Admiral Perry first visited Japan in 1853 and "opened the door" to a culture that had been in isolation for centuries. More than a curiosity, the Japanese had a highly developed and sophisticated artistic tradition, and Westerners soon recognized this. By the 1860s, Western artists began to collect Japanese art and to incorporate its principles into their own. Its influence strengthened for the remainder of the century, and from the French Impressionists to the all-American Winslow Homer, artists absorbed the Japanese use of asymmetry, diagonals, positive and negative space, and color. The Japanese motivated some of the most startling and refreshing Western artwork to date. Both Arts and Crafts and Aesthetic movement advocates incorporated elements of Japanese design. Japan was perceived not only as a source for sophisticated art, it was seen as a pure uncorrupted society where artist-craftsmen took pride in their work. It therefore appealed to both the social reformer and arbiter of taste.

The Aesthetic movement was primarily British and was initially influenced by William Morris. The figures associated with the movement, such as Christopher Dresser (1834–1904), were more occupied with aesthetic than social issues. Born in Glasgow, Dresser studied both botany and design in London. He illustrated several plates for the 1856 classic *The Grammar of Ornament* with botanical motifs, lectured and wrote books on decorative design, and edited the magazine *Furniture Gazette*. Dresser designed furniture, metalware, textiles, ceramics, and other items and is known for his use of simple, angular shapes that were easy to manufacture.

The movement became characterized by a passion for Japanese art, encompassing everything from greeting cards to domestic architecture. Its spokesmen were not reformers, but colorful and controversial figures, such as artist James McNeil Whistler and poet Oscar Wilde. They popularized the phrase "art for arts sake," which was the antithesis of Arts and Crafts philosophy. Wilde helped to spread the word to the United States on an eighteen-month lecture tour beginning in 1882. The term "art" was combined with

ordinary terms to make art pottery, art glass, art furniture, and artistic houses. Although originally British, the terms and their meanings were equally well suited to American taste.

Arts and Crafts followers borrowed the same motifs and other aspects of Japanese art as the Aesthetes, but justified their use by their inherent "medievalness," their practical philosophy of oneness of craft and industry. Art pottery companies, particularly in the United States, made one of the most genuine and lasting contributions to art based on the union of Eastern and Western design and technique. Painters who understood these Japanese principles revolutionized Western art and paved the way for a new attitude and era. But the concept of the void, so critical to Japanese design, would not be really understood or applied in the West until the gradual discovery of Modernism.

UNITED STATES ARTS AND CRAFTS

Morris and Company was synonymous with British Arts and Crafts, and personal contacts connected to the movement helped to make William Morris its best-known and marketed figure. Morris's written ideas and company's products were easily accessible in England and the United States. Philosophically he was a romantic idealist and a socialist. Artistically he was a patternist—a prolific designer of more than 600 wallpapers, textiles, and other patterned designs sold to the same upper-middle-class clientele who patronized the artwork of the Aesthetic movement. After Morris died in 1896, the company remained open until 1940. With the exception of the art pottery industry beginning in 1880, most American involvement in the movement took place after 1896.

Art Pottery

America's longest lasting and most varied contribution to the movement was pottery. The **art pottery** movement, as it came to be called, bridged at least three decorative arts phenomena: Arts and Crafts, Aesthetic, and Art Nouveau. It participated in the Arts and Crafts movement through the shared ideals of quality design and workmanship using handcrafting methods, even if in a factory setting. It was part of the Aesthetic movement with an emphasis on beauty, even over utility; and some of the designs were influenced by Japanese style (Rookwood Pottery even had an extraordinary Japanese artist on their staff). Potters often emulated the Chinese emphasis on glaze and form or the Japanese liking for asymmetrical understatement and subtle, muted color. Even within an Arts and Crafts context, some pottery companies, such as Van Briggle and Rookwood, also produced outstanding examples of its philosophical opposite, Art Nouveau.

Most American art pottery companies were east of the Mississippi, and Ohio boasted about three dozen of these. Because pottery decoration "china painting" was one of the few creative outlets for Victorian ladies, art pottery companies were often founded and managed by talented women. (A list of major American art potteries is in the chronology at the end of this chapter.)

STICKLEY AND THE CRAFTSMAN

The name William Morris is almost synonymous with British Arts and Crafts, and his influence was strong in the United States even after he died. A William Morris Society was founded in Chicago in 1903, one of the many Arts and Crafts societies popular in the United States around the turn of the century. Morris's designs were available in stores such as Marshall Field and Company and the Tobey Furniture Company in Chicago. Although Chicago was considered to be a major regional center of the Arts and Crafts movement, other cities such as Boston, Cleveland, and Pasadena were also active. But Eastwood and East Aurora, New York became famous for Morris's American counterparts—Gustav Stickley and Elbert Hubbard.

Gustav Stickley (1857–1942) was born in Wisconsin and trained as a stonemason. In 1876 he moved to Pennsylvania and apprenticed to his uncle making plain chairs with cane

1900
Baseball's American League; tennis Davis Cup; vacuum cleaner; paper clip; Kodak Brownie camera; Browning revolvers; public use of escalator; Beatrix Potter's *Peter Rabbit*; Freud's *Interpretation of Dreams*; Max Planck's early quantum mechanical theories; discovery of radon; Paris International Exposition; first Zeppelin flight; Commonwealth of Australia.

seats. After meeting Voysey, Ashbee, Bing, and other influential figures while in Europe in 1898, he returned to America and opened the Gustav Stickley Co. in Eastwood, New York, near Syracuse. Two years later, he exhibited at the Furniture Exhibition in Grand Rapids, enlarged the company, and began the Craftsman Workshops. The following year, 1901, was the beginning of the Craftsman years and the publication of his famous *Craftsman* journal, which helped to promote his product with his motto "Als ik Kan," which meant "As I can."

Stickley was a believer and promoter of Morris's artistic and socialistic ideals—taste without costliness; beauty without unnecessary ornament; simplicity of form; honesty of materials and methods. But Stickley openly used machinery to accomplish his goals, a departure from the British anti-industrial theme. He also behaved like any other good capitalist.

Craftsman became synonymous with Arts and Crafts style in America. His exposure through mail-order catalogs and coast-to-coast showrooms ensured his success and also brought a plague of plagiarism. Simple lines were easy to copy, and his superior manufacturing methods were easy to ignore. Cheap copies of Craftsman furniture contributed to Stickley's ultimate downfall and bankruptcy. There were also companies making good-quality and very similar furniture, such as J. M. Young Furniture Company of Camden, New York; the Brooks Manufacturing Co. of Saginaw, Michigan; and Charles P. Limbert and Co. of Grand Rapids, Michigan. In addition, his brothers Leopold and J. George Stickley were originally with the Craftsman Workshops for a short time, but left in 1900 to form their own company, L. & J. G. Stickley, in Fayetteville, New York, focusing on Colonial Revival styles. His other brothers, George and Albert, had opened the Stickley Bros. Co. in Grand Rapids in 1891. When Craftsman failed in 1915, L. & J. G. Stickley took it over, but the Arts and Crafts phase had ended, and the next year, the *Craftsman* ceased publication.

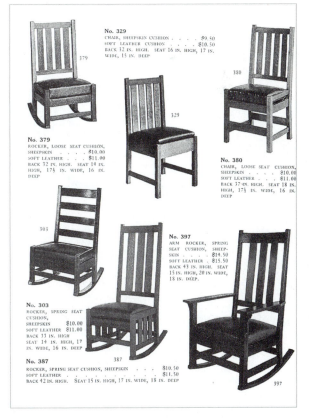

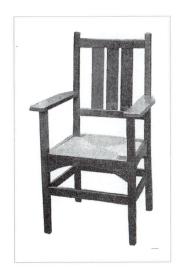

Oak armchair in Craftsman catalog, by Gustav Stickley. *(Dover)*

Oak side chairs and rockers in Craftsman catalog, by Gustav Stickley. *(Dover)*

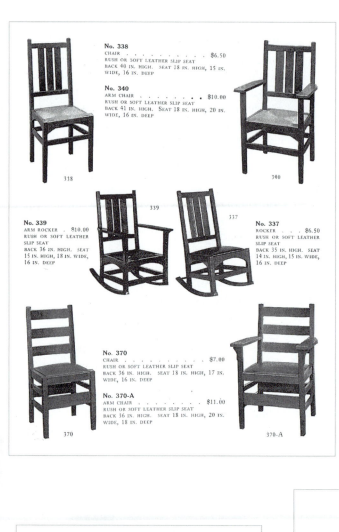

No. 338
CHAIR $6.50
RUSH OR SOFT LEATHER SLIP SEAT
BACK 40 IN. HIGH. SEAT 18 IN. HIGH, 15 IN.
WIDE, 16 IN. DEEP

No. 340
ARM CHAIR $10.00
RUSH OR SOFT LEATHER SLIP SEAT
BACK 41 IN. HIGH. SEAT 18 IN. HIGH, 20 IN.
WIDE, 16 IN. DEEP

338

340

339

337

No. 339
ARM ROCKER . $10.00
RUSH OR SOFT LEATHER
SLIP SEAT
BACK 36 IN. HIGH. SEAT
15 IN. HIGH, 18 IN. WIDE,
16 IN. DEEP

No. 337
ROCKER . . . $6.50
RUSH OR SOFT LEATHER
SLIP SEAT
BACK 35 IN. HIGH. SEAT
14 IN. HIGH, 15 IN. WIDE,
16 IN. DEEP

No. 370
CHAIR $7.00
RUSH OR SOFT LEATHER SLIP SEAT
BACK 36 IN. HIGH. SEAT 18 IN. HIGH, 17 IN.
WIDE, 16 IN. DEEP

No. 370-A
ARM CHAIR $11.00
RUSH OR SOFT LEATHER SLIP SEAT
BACK 36 IN. HIGH. SEAT 18 IN. HIGH, 20 IN.
WIDE, 18 IN. DEEP

370

370-A

Oak side chairs and rockers in Craftsman catalog, by Gustav Stickley. *(Dover)*

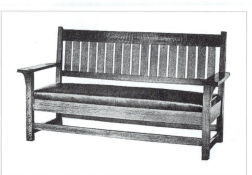

Craftsman sofa or couch in Craftsman catalog. *(Dover)*

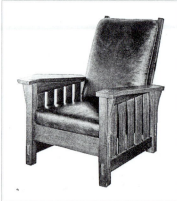

Oak lounge chair, after William Morris, in Craftsman catalog. *(Dover)*

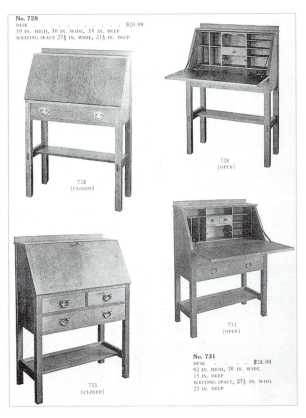

No. 728
DESK $20.00
39 IN. HIGH, 30 IN. WIDE, 14 IN. DEEP
WRITING SPACE 27½ IN. WIDE, 21½ IN. DEEP

728
(CLOSED)

728
(OPEN)

731
(OPEN)

No. 731
DESK $28.00
42 IN. HIGH, 30 IN. WIDE
15 IN. DEEP
WRITING SPACE, 27½ IN. WIDE
23 IN. DEEP

731
(CLOSED)

Drop-front desks in Craftsman catalog, by Gustav Stickley.
(Dover)

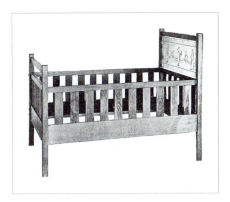

Crib or child's bed in Craftsman catalog.
(Dover)

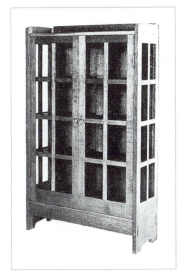

China cabinet with two doors and
glass front in Craftsman catalog.
(Dover)

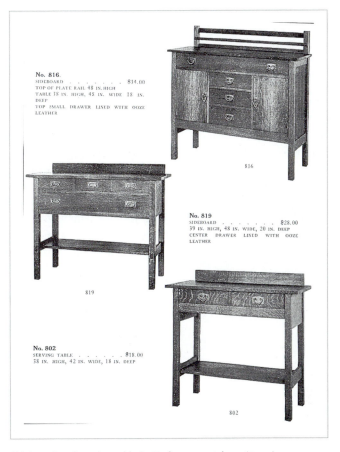

No. 816.
SIDEBOARD $34.00
TOP OF PLATE RAIL 48 IN. HIGH
TABLE 38 IN. HIGH, 48 IN. WIDE 18 IN.
DEEP
TOP SMALL DRAWER LINED WITH OOZE
LEATHER

816

No. 819
SIDEBOARD $28.00
39 IN. HIGH, 48 IN. WIDE, 20 IN. DEEP
CENTER DRAWER LINED WITH OOZE
LEATHER

819

No. 802
SERVING TABLE $18.00
38 IN. HIGH, 42 IN. WIDE, 18 IN. DEEP

802

Sideboard and serving table in Craftsman catalog. *(Dover)*

1901
U.S. Steel Corp.; first
transatlantic radio message;
first major oil strike near
Beaumont, Texas; Röntgen
receives first Nobel Prize in
Physics (for the X ray);
President McKinley
assassinated; football's Rose
Bowl; the Teddy Bear;
vacuum cleaner; electric
typewriter; Alcoa's Wear-
Ever cooking utensils;
Queen Victoria dies
(b. 1819).

Born 1901
Louis Armstrong (d. 1971);
Gary Cooper (d. 1961);
Marlene Dietrich (d. 1992);
Walt Disney (d. 1966); Clark
Gable (d. 1960); Margaret
Mead (d. 1978); Linus
Pauling (d. 1994).

1902
Air conditioner; polygraph
machine; radium isolated;
lawn mower; rayon; spark
plug; animal crackers;
United States Census
Bureau; baseball's World
Series; American National
Wildlife Refuge; Sir Arthur
Conan Doyle's *Hound of the
Baskervilles*.

Born 1902
Marcel Breuer (d. 1981);
Charles Lindbergh (d. 1974);
John Steinbeck (d. 1968).

Died 1902
Albert Bierstadt (b. 1830);
John Henry Twachtman
(b. 1853).

Craftsman Furniture Construction

Consistent with its desire for nationalism and regionalism, the British Arts and Crafts furniture and other decorative arts looked to England's Middle Ages for design inspiration. But Gothic meant little to Americans, so their Arts and Crafts expressions naturally preferred an early American colonial model, even if it was technically English at the time. Seventeenth-century colonial furniture was crude, simple, and rectilinear but not necessarily by choice. If the colonists had been less occupied with their struggle to survive, they might have had the time to learn about and construct finer furniture. It is easy and tempting to edit out the pain, discomfort, hard labor, and lack of choice from historical memory, and the Arts and Crafts followers and leaders were quick to romanticize America's colonial past.

Stickley furniture used **quartersawn** oak and joined or framed construction. These were described by decorative arts historian Leslie Bowman as follows:

> In the early colonial period, oak was riven, or quartered along its medullary rays, rather than sawn. Sawyers could rive or split the wood much faster than they could saw it. The resulting boards were slightly wedged-shaped, and distinguished by their unique, ribboned grain structure. Stickley's wood was cut in a sawmill, but along the same quartered configuration.
>
> In joined construction, case pieces "hang" on a vertical structure of four stiles, to which horizontal framing members are tenoned. The "walls" of the piece are created by panels inset in to grooves in the vertical and horizontal framing members. This type of construction became obsolescent in the early eighteenth century with the introduction of the dovetail joint.
>
> The thick riven oak boards with joined construction using mortise and tenon produced very strong and durable furniture. Case pieces were heavy, and the riven boards resisted warpage and shrinkage. Panel and frame construction also permitted the natural expansion and contraction that resulted from changes in temperature and humidity.

Stickley chose to reveal and even emphasize early construction methods by leaving pegs and pins visible, by protruding mortises and keys, and by using mortise and tenon or doweling rather than metal fasteners such as nails and screws. Chair legs were often joined together by stretchers to imitate early styles; upholstery was of leather with brass tacks. Early forms—trestle tables, gateleg tables, chests, joint stools, and settles—were copied.

Occasionally, a piece of Stickley is found with inlay, which softened the form and made it closer to the style of Mackintosh. These were the work of Harvey Ellis (1852–1904), who was only with the firm for a few years, just before he died.

Except for hardware in the form of forged drawer pulls and elongated strap hinges, there is no similarity between Stickley Craftsman furniture and British Arts and Crafts, which borrowed medieval stylistic features. Hammered metalwork was popular in America, because it was perceived as looking old. But the preindustrial craftsman would have gone to great lengths to remove any hammer marks, so he planished and polished the object. What was once considered to be crude, imperfect craftsmanship now signified superior, handcrafted quality. Once machinery became available to produce a quick smooth finish, Arts and Crafts needed something else. Early colonial images were symbolic of American "native" preindustrial times just as the Middle Ages were to Britain. But at least one leading American entrepreneur included a touch of Gothic in his work, Elbert Hubbard.

ELBERT HUBBARD AND THE ROYCROFTERS

Elbert Hubbard (1856–1915) was not a designer or craftsman, but an organizer and leader of a craft community. After meeting William Morris in England, Hubbard organized the Roycroft Shops, named after seventeenth-century English bookbinders, in East Aurora, New York, in 1893. He began by printing books that he and other authors had written, then binding them, and eventually opening his own leather shop. He used handmade

paper and hand-illuminated initials. The Roycrofters also published a journal called the *Philistine*.

Lighting was another item, but the glass used for fixtures was made outside, by companies such as Tiffany Studios or Fredrick Carder at Steuben. Roycroft metalwork was not as crude looking as some other Arts and Crafts shops. Forms were more linear, often based on a grid pattern indicative of Austrian Wiener Werkstätte style.

In 1896 the Roycrofters began to make furniture for in-house use, and by 1901 they were selling furniture by mail order and began a metalwork shop to make the hardware. Modeling the shops after English **guilds**, they used an apprentice system; modeling the furniture at least partly after English styles, they used Gothic elements. Unlike Stickley, they sometimes used mahogany or ash, but Roycroft furniture was like Stickley's in its joined construction and preference for quartersawn oak. In 1915 the Hubbards were lost with the Lusitania, and the shops were carried on by their son Bert until he sold them in 1938.

The following introduction to the *Roycroft Furniture Catalog, 1906* describes their product and conveys their philosophy:

> ROYCROFT FURNITURE is individual. It is appreciated for its attractiveness, its purity of design, its symmetrical lines, mechanical construction, and the rich, soft colors in the woods and finishes. These make a combination which brings lasting joy, for each piece is a classic. Our lumber is all specially prepared, being air-dried from two to five years, according to thickness, then kiln-dried for three months at a temperature of One Hundred and Sixty degrees, thus retaining to a great extent the lifelike appearance and natural strength of the woods.
>
> We would ask you not to class our products as "Mission," or so-called "Mission Furniture." Ours is purely Roycroft—made by us according to our own ideas. We have eliminated all unnecessary elaboration, but have kept in view the principles of artistic quality, sound mechanical construction and good workmanship.
>
> WOOD.—We make our Furniture in Quartered Oak, Mahogany from Santo Domingo and Africa, and native White Ash, and we have the following in stock: Oak—dark, medium and light weathered; Roycroft brown, Flemish, Golden, and Japanese gray. Mahogany—dark, medium and light. Ash—brown, Japanese gray and silver gray, all done in dull wax finish, each one emphasizing the natural beauty of the wood.
>
> LEATHER.—All padded leather seats are made of heavy cowhide, colored to match the wood, and by our special treatment are made soft and pliable—practically indestructible—and are fastened on with large-headed copper tacks or nails. All upholstered pieces have spring seats. The leather is American russet and India cowhide, and is very soft and pliable, and at the same time is the best wearing material known for this purpose.
>
> TRIMMINGS.—The trimmings of our Furniture are all made of hand-wrought copper or iron, by our own workmen, and are very near perfection, both from an artistic and mechanical standpoint.
>
> GLASS.—All small lights of glass are clear French papered stock; all large lights are plain polished plate. All coppered glass is made in design, with clear sheet glass and heavy ribbed copper, being almost as rigid as plate glass. For lamp shades we use the best imported opalescent glass, which has a wonderfully pleasing color. These are made in both plain and leaded, the latter being made by our own artists from special designs.

By the time the term "Mission" appeared on the cover of *The Grand Rapids Furniture Record* in 1903, this straight-lined and straightforward furniture style had become so popular with the public that specialists like Hubbard and Stickley could not satisfy the demand. Predictably, major commercial Grand Rapids furniture manufacturers, without the seemingly required political and social Arts and Crafts attitudes, saw the market potential, and companies including Berkey & Gay and Nelson & Matter produced Arts and Crafts lines.

No. 054 davenport with leather cushions and spring seat; available in oak, mahogany, or ash. 78″ length, 30″ depth, 16″ seat height, 26″ back height.

No. 052 davenport with leather sides, back, and spring seat; available in oak, mahogany, or ash. 78″ length, 24″ depth, 16-1/2″ seat height, 20″ back height.

No 053 Davenport with leather sides, back, and spring seat; available in oak, mahogany, or ash. 66″ length, 24″ depth, 16-1/2″ seat height, 24″ back height.

(Roycroft Furniture Catalog, 1906)

No. 015 extension dining table, in oak, mahogany, or ash. 54″ diameter.

No. 016 extension table, in oak, mahogany, or ash. 48″ diameter.

No. 0115 music cabinet, in oak, mahogany, or ash. 24″ width, 16″ depth, 39″ height.

No. 061 table in oak, mahogany, or ash.
Top 20" x 30", 29" height.

No. 076 library table in oak, mahogany, or
ash. 42" x 30", 30" height.
(*Roycroft Furniture Catalog, 1906*)

No. 04 sideboard in oak,
mahogany, or ash. 66" width, 28"
depth, 38" height to shelf with
18" mirror.

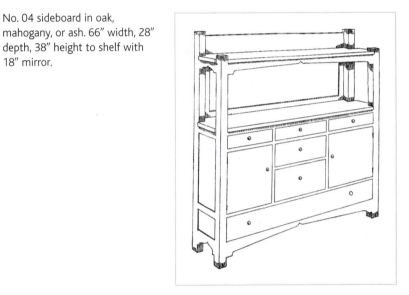

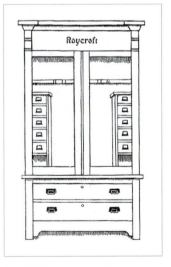

No. 0112 chiffonier in oak, mahogany, or
ash. 40" width, 20" depth, 50" height.
(*Roycroft Furniture Catalog, 1906*)

No. 07 china cabinet in oak,
mahogany, or ash; with doors and
sides of clear glass set in copper and
copper trim. 40" width, 18" depth, 64"
height.

No. 0102 gun cabinet in oak, mahogany, or
ash. 36" width, 14" depth, 66" height.
(*Roycroft Furniture Catalog, 1906*)

1905
Einstein's Special Theory of Relativity; neon signs; Grand Prix motorcar race; rayon made commercially; safety glass patented.

Born 1905
Clara Bow (d. 1965); Claudette Colbert (d. 1996); Christian Dior (d. 1957); Henry Fonda (d. 1982); Greta Garbo (d. 1990); Dag Hammarskjöld (d. 1961); Howard Hughes (d. 1976) Myrna Loy (d. 1995); Jean-Paul Sartre (d. 1980).

CHARLES P. LIMBERT AND COMPANY

The Grand Rapids firm of Charles P. Limbert and Company introduced their line in 1903 and is also considered to be a major contributor to American Arts and Crafts. Limbert was born in Pennsylvania in 1854 and moved to Ohio as a child. His father was a furniture dealer, and the young Limbert followed his path. He joined salesman Philip J. Klingman in 1889, and together they leased showroom space, and in 1890 they began to manufacture chairs. By 1895 Limbert had his own chair-making company and also represented other manufacturers, including the Old Hickory Chair Company with its rustic Arts and Crafts-compatible furniture.

In 1902 he introduced the "Dutch Arts and Crafts" furniture line, a blend of American and English Arts and Crafts style, and in the following year he issued a catalog. The handwork of the pen-and-ink sketches was intended to reinforce the concept of handicraft, which was so important in the marketing of furniture connected with the Arts and Crafts movement. The illustrations also enabled him to emphasize details like joinery techniques, even though the furniture was made in a factory. Limbert moved the company to neighboring Holland, Michigan, for the production of his appropriately named "Dutch" furniture. Although the company continued its operation until the 1930s, the Arts and Crafts styles disappeared by the beginning of the First World War to make way for an onslaught of historic revival styles.

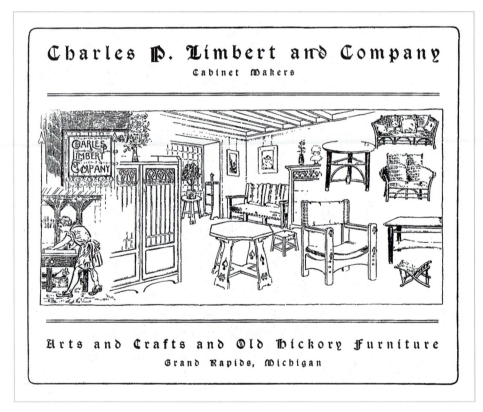

(Limbert Arts and Crafts Furniture: The Complete 1903 Catalog)

No. 400 buffet in ash, mortised, tenoned, and keyed together; decorated with Dutch tiles in doors, wrought-iron trim, finished in any color. 48" x 24" top, 56" total height.

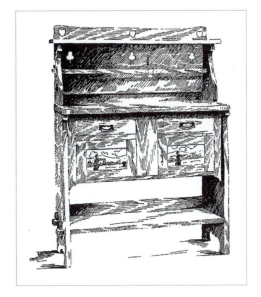

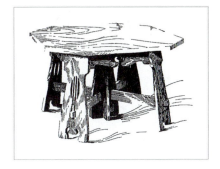

No. 403 table in quartered oak, with cut-out design used in backs of matching chairs.

No. 404 buffet in ash, finished in any color. 42" x 21" top, 54" total height.
(Limbert Arts and Crafts Furniture: The Complete 1903 Catalog)

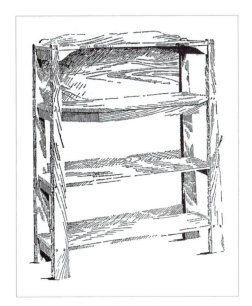

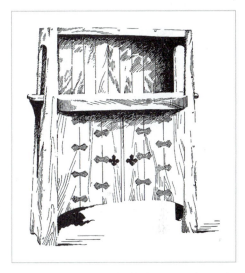

No. 410 buffet in ash, finished in any color; with flaring ends, dovetailed doors, and wrought-iron trim. 52" x 21" top, 57" total height.

No. 413 buffet in oak or ash, in regular brown or fumed finish, mortised, tenoned, and keyed together, with opalescent leaded glass doors and wrought-iron trim. 66" length, 23" depth, 53" height.
(Limbert Arts and Crafts Furniture: The Complete 1903 Catalog)

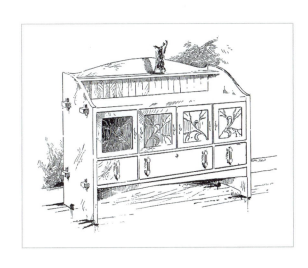

No. 517 settee in quartered oak, finished in any color, with wood slat seat and back. 48" length.

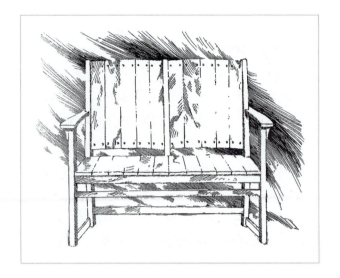

No. 602 cellarette in ash, finished in any color; with swivel bottle rack for four bottles, shelf for spoons and glasses, and rack on inside of door for spoons. 34" x 14" top, 36" height.
(Limbert Arts and Crafts Furniture: The Complete 1903 Catalog)

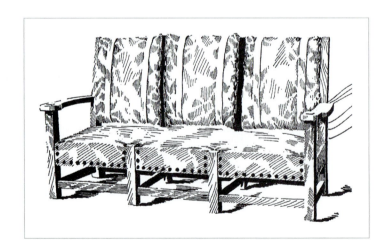

No. 849 settee, with oak frame finished to order, upholstered in Spanish leather, with full spring seat trimmed with hand wrought-iron studs, back cushions with leather laced on. 78" length.

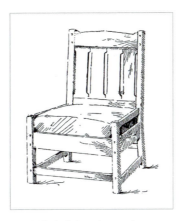

No. 851 chair in ash or oak, finished in regular oriental green, brown, or fumed; with large seat and "old fashioned" corded bottom under cushions.

No. 851 3/4 chair with oak frame, finished in any color, large seat, corded bottom and roan skin loose cushion on seat and back.
(Limbert Arts and Crafts Furniture: The Complete 1903 Catalog)

Died 1905
John Hay (b. 1838); Jules Verne (b. 1828).

1906
San Francisco earthquake; first ship through Northwest Passage.

Born 1906
Josephine Baker (d. 1975); Samuel Beckett (d. 1989); John Huston (d. 1987); Philip Johnson; Albert Sabin (d. 1993).

Died 1906
Susan B. Anthony (b. 1820); Paul Cézanne (b. 1839); Henrik Ibsen (b. 1828).

1907
Oklahoma; Arizona; and New Mexico become states; Picasso's *Les Demoiselles D'Avignon*, a milestone of modern art; first daily comic strip, *Mutt and Jeff*; Mothers' Day; color photography; teleprinter.

ARCHITECTURE

In accordance with Arts and Crafts philosophy, architecture was to reflect the country's particular culture, climate, history, and geography. Unlike England, the United States was anything but homogeneous by any of these respects. Variance in climate and geography is often dramatic when comparing distant regions such as the West and East. Cultural influences, especially English on the East Coast, Spanish on the West, or the prairie culture in the Midwest, were also distinct. In an effort to respond to the landscape and history of each region, builders began something of a vernacular revival with sensitivity to the site and use of local materials.

At first the reaction to Arts and Crafts was predictable—**Mission style** and the bungalow developed in the West, Tudor half-timbering was used in the East, and horizontal prairie houses were seen in the middle. But rather than develop only regionally, all of these styles spread in varying degrees to other areas of the country. As far as Arts and Crafts was concerned, it was more important to avoid classical and academic historic styles than to respond to specific regional differences.

There were also some architectural curiosities claiming affiliation with the movement. Gothic, which was even less authentically American than Tudor half-timbering, gained acceptance in New England, particularly for church design. Aesthetic movement Queen Anne houses with red brick and sunflower motifs were also associated with Arts and Crafts. These often included Palladian widows and broken pediments, even though there was a conscious attempt to avoid Greco-Roman classicism in the movement. So in architecture, as with the decorative arts, there was no single coherent Arts and Crafts style, but many styles. What the houses did share were use of local materials, the craft tradition, and elements of vernacular styles. By these criteria, the bungalow was a logical solution to any problem. With its one-story plan, overhanging roof, and front porch with oversized corner supports, the bungalow could be and was adapted to any region. Inexpensive and democratic bungalows promoted by Stickley and other leaders of the movement could even be built from prefabricated parts. But the high-style super bungalows of Greene and Greene were another matter.

Greene and Greene

Charles Sumner Greene (1868–1957) and Henry Mather Greene (1879–1954) were born in Cincinnati, Ohio, and studied architecture at Massachusetts Institute of Technology. They both became interested in Japanese art at the World's Columbian Exposition in Chicago in 1893 and were impressed by the Japanese use of timber construction with exposed joinery in their building. The Greenes established their practice in Pasadena, California, and became known for their design of super bungalows with a clear Japanese influence. Their homes were more decorative than their Prairie School counterparts, and their furniture designs used rounder corners, inlay, carving, and fruitwoods in addition to oak.

Greene and Greene are best known for four houses built between 1907 and 1909: (1) the residence of Robert R. Blacker in Pasadena, a huge wooden Mission Revival house; (2) the residence and furniture of Blacker's friends, Mr. and Mrs. David B. Gamble; (3) the residence, furniture, and grounds of Charles M. Pratt in Ojai Valley; and (4) the residence of William R. Thorsens in Berkeley (Mrs. Thorsens was the sister of Mrs. Blacker). But there were few large commissions after 1910 and even fewer for custom furnishings. The Greene brothers had helped to inspire and promote the California bungalow, but soon every developer and publisher of bungalow books and magazines made them cheaper and took over the field.

ARTS AND CRAFTS AS FASHION

In the United States, reformers had the same moral convictions as the British. The issue was not simply how people should decorate their homes (taste), but how they should live their lives (morality). But the ideal of the unification of all art forms ultimately became just another style of decorating in the United States, based largely on what Stickley or other reformers-businesspeople said. Neither Ruskin nor Morris visited the United States, but other spokespersons, books, journals, and goods did cross the Atlantic. And American craftsmen and decorators visited England to see the styles first hand. They were also seen at exhibitions right near home—at Philadelphia in 1876, in Chicago in 1893, Buffalo in 1901, and St. Louis in 1904.

Rather than as a philosophy, but as a style of decorating middle-class homes, Arts and Crafts was popularized by magazines like *Ladies Home Journal*. The new natural look became a fashion trend. Simplicity and appropriateness to the place in which it was made enabled native oak to rise above costly tropical woods in desirability. The unadorned rectangular form was considered lovely, which can be perceived as a bridge between the movement and the development of modernism.

Not all furniture shops emulated Craftsman or Roycrofters designs. Charles Rohlfs (1853–1936), for example, seemed to have one creative hand in Arts and Crafts and the other in Art Nouveau. Born in New York City, Rohlfs studied at the Cooper Union, and in 1872 began designing cast-iron stoves. He became an actor for a while, but in 1890 opened a furniture shop in Buffalo, New York. Since he wasn't far from East Aurora, Rohlfs lectured occasionally at the Roycrofters. His style tended toward the German Art Nouveau (Jugendstil), characterized partly by curved lines without the three-dimensionality of French Art Nouveau. His shop and output were small, but he gained international recognition by exhibiting at major shows, such as Turin in 1902. Rohlfs is connected to the Arts and Crafts because like Stickley and Roycrofters, he used mortise and tenons joints, flat surfaces, and oak for his furniture.

Metalworking shops were also important for the Arts and Crafts interior. Some of the better known names include: the Kalo Shops, founded in 1900 in Chicago by Clara Barck (1868–1965); the Jarvie Shop, founded in 1904 in Chicago by Robert Jarvie (1865–1941); and the workshop of Dirk Van Erp (1859–1933) in San Francisco. Copper and wrought iron (and silver rather than gold for jewelry) were preferred metals; semiprecious stones or found pebbles were sought after for aesthetic rather than monetary value. Hammer marks and other telltale signs of unselfconscious construction techniques became the vogue.

ADIRONDACK FURNITURE

At the end of the nineteenth century, when American Arts and Crafts furniture was becoming popular, a somewhat related type of rustic furniture was also introduced. Because it was widely used in camps, resorts, and summer houses in the Adirondack Mountains, in upstate New York, it was called Adirondack furniture.

Made primarily in Indiana, especially by the Old Hickory Chair Company (founded in 1898), it was sold throughout the United States. Its character was woodsy, and it was made from round, unmilled hickory sticks, often with the bark still attached. Chair seats and backs were woven from hickory bark; tabletops were generally oak; and chair rockers were sawn.

Gustav Stickley promoted Adirondack furniture in the *Craftsman* because of its use of native materials and forms, but its makers were not necessarily connected with the Arts and Crafts in any other way. By the 1930s and 1940s, before its popularity ended, designs became more streamlined, and nylon webbing or other modern materials sometimes replaced the woven bark.

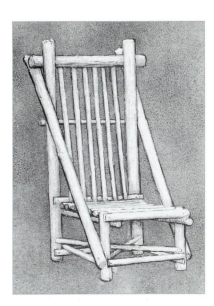

Rustic American table, circa 1920. *(Hunter)* Rustic chair, circa 1920. *(Hunter)*

MACHINE VERSUS HANDICRAFT

One of the most controversial issues within the Arts and Crafts movement was over the use of machinery in producing previously handcrafted items. On the one hand, the Industrial Revolution was held responsible for the proliferation of mass-produced tasteless goods that filled Victorian society, cluttered their parlors, and inspired those with any aesthetic sensibility to question. Others, however, recognized that the machine itself had no mind and no motive; only people could be held accountable for its use for good, bad, or ugly. For example, Oscar Triggs, a leader of the movement and founder of the Industrial Art League of Chicago in 1899, wrote that the machine had at least two positive effects on art. First, by turning out goods in such quantity, it created a demand, if not a need, for art objects. The next step was to enlighten the public through education to demand well-designed and tasteful objects. Second, the machine could do the dirty work—the boring and often dangerous operations—and free men and women to pursue more creative and satisfying jobs. The obvious pitfall was that greed and misuse of the machine for commercial gain was a temptation not easily resisted.

The craftsperson's place in society had been challenged by the Industrial Revolution. Craftsmen and women who had once embodied both artist and artisan were the unsuspecting victims of a machine age where "cheap and nasty" goods abounded. Reformers like Ruskin and Morris called for a return to craft and crafting by revitalizing art and elevating labor. According to Triggs, the return had to be within the context of industrialization if it was to be anything more than an episode of nostalgia. The machine would become the solution, not the problem.

The controversy was apparently never really reconciled. In a paper presented in 1925 at a convention of the American Federation of Arts at the Cleveland Museum of Art, pioneer interior designer Louis Rorimer also spoke of the relationship of machinery to art. "The machine has come to democratize art," he said. Rorimer and others believed that machine art was both appropriate and necessary to America because only quantity production could meet the needs of our technological society. Our failure was in the separation of artist and craftsperson and in the general lack of artistic education in American society. Rorimer's plea for an artist-artisan was an echo of Arts and Crafts reformers. He said, "Today we marvel at the skill of the guild craftsmen and bemoan our fate at being thrust into an age of speed, quantity production, and inartistic baubles. Art and industry today have little in common. . . . we have so far been more fascinated by [the machine's] fecundity than by the quality of its product" (Rorimer paper).

Rorimer saw the artist and machine operator of 1925 as separate as they had been in the late nineteenth century. "The work is executed by operators whose only incentive to feed their machines is the weekly pay envelope." His solution was not only to educate and train better designers, but also to "educate the manufacturers and proprietors of industry in the appreciation of art." And by stimulating art education in the public schools, Rorimer believed that American taste could be elevated. Public school teachers needed to be trained in art appreciation. Unless the public was educated in matters of taste and artistic quality, there would be no market for the creations of skilled artist-artisans. This recognition of the need for both an educated public and trained designers went even beyond the Arts and Crafts ideal of artistic excellence. America's dependence on Europe could be broken, and Rorimer concluded his talk by saying, "It seems clear that if we, as a nation are to develop and mature—reach self sufficiency, we must inevitably reach the point of expressing ourselves artistically as well as materially." This farsighted challenge would be answered, at least in part, by the development of an entirely new field to be called industrial design. In the next few years, by the 1930s, America would combine art and the machine as well as break its artistic dependence on Europe. For good or for bad, but probably not ugly, the democratization of design would become a New World reality.

Ultimately, the British socialist moralist reform movement was translated into one more style. "Morris' view of the noble worker was patronizing and romantic. Real workers were too busy organizing unions to worry about a return to joyful labor. But his ideas were a success with the newly-affluent middle class—they lapped up his craft-based work as the new architecture" (Hellman 96). The American "dos" were medieval, oriental, folk, and colonial; "don'ts" were baroque, rococo, and neoclassical. Americans were even less concerned with ideology or with class than the British. Anti-industrialism was far less attractive in a country with huge areas of largely unexplored wilderness than it was on a relatively small and well-populated island. The American Arts and Crafts was headed by comfortably capitalistic businesspeople more than by cult leaders, and moral ideals became either diluted or ignored. Ironically, it was the Americans and not the British who accomplished the goal of reaching a wider audience. As a result of the Arts and Crafts movement, "art enjoys broader definition in our society, and a broader spectrum of society enjoys art" (Volpe 24). Perhaps unfortunately, the audience was reached only with a decorating look, and as the winds changed, so went the style. With the onset of World War I and the collapse of Stickley's retailing empire, Americans resumed their infatuation with the American past. Not until the 1930s would a true modernism without historic precedent become an alternative to the style without end, Colonial Revival.

Summary

- Arts and Crafts began as a reaction against negative effects of industrialization.
- It attempted to combine art and industry without sacrificing quality.
- It began in Britain as a moral, philosophical, social, and political movement.
- Britain looked to medieval guilds and styles as models.
- Americans used models from colonial America rather than medieval Britain.
- Rather than a style, it was an attitude toward aesthetics and craft.
- It was intended to elevate taste among the general populous, but ironically, products were made for the middle classes.
- A central issue was machine versus handicraft; most accepted the machine.
- Arts and Crafts overlapped the Aesthetic movement and a Japanese aesthetic.
- America emphasized oak furniture and art pottery.

Chronology

A = America; B = Britain; E = Europe

B 1848 Pre-Raphaelite Brotherhood forms and has first exhibition.

B 1851 Great Exhibition of the Works of Industry of All Nations, Crystal Palace, London.

B 1853 Great Industrial Exhibition, Dublin.

A 1853 World's Fair of the Works of Industry of All Nations, New York.

E 1855 Universal Exhibition of Industrial Products of All Nations, Paris.

B 1856 Owen Jones *The Grammar of Ornament* with full-color chromolithography.

B 1859 Philip Webb designs the Red House for William Morris; furniture is designed by Webb, Morris, Rossetti, and Burne-Jones.

B 1861 Morris, Marshall, Faulkner & Co.—pre-Raphaelites work for and influence the firm.

B 1862 International Exhibition, London—first Japanese art and craft widely seen.

E 1867 Universal Exposition, Paris.

B 1873 Martin Brothers Pottery.

B 1875 Liberty & Co. opens, specializing in oriental art and artifacts; influence on Aesthetic movement.

A 1876 Centennial Exhibition, Philadelphia—Colonial Revival; oriental pottery influences American potters; Japanese display fuels Aesthetic movement.

A 1877 New York Society of Decorative Art is founded.

E 1878 Universal Exposition, Paris.

B 1878 International Exposition, South Kensington.

A 1879 Associated Artists founded in New York City by Louis C. Tiffany, Candace Wheeler, and Society of Decorative Art.

A 1880 Rookwood Pottery is founded by Maria Longworth Nichols (1849–1932) in Cincinnati, Ohio.

B 1882 Bretby Pottery.

A 1882 Oscar Wilde begins eighteen-month tour of United States and spreads aestheticism.

B 1884 Century Guild's *Hobby Horse*.

B 1888 Guild of Handicraft is founded.

E 1889 Paris International Exhibition.

B 1890 Kelmscott Press is founded.

A 1890 Charles Rohlfs furniture workshop, Buffalo, New York.

A 1891 George and Albert Stickley establish Stickley Bros. Co. in Grand Rapids, Michigan; Chelsea Pottery is begun in Chelsea, Massachusetts.

B 1893 Publication of *The Studio* promotes Arts and Crafts.

A 1893 World's Columbian Exposition, Chicago; Frank Lloyd Wright begins private practice; Greene and Greene arrive in Pasadena, California; George E. Ohr (1857–1918) begins producing pottery in Biloxi, Mississippi.

A 1894 Grueby Faience Co. is opened by William H. Grueby in Boston.

E 1895 Galeries l'Art Nouveau is opened by Siegfried Bing in Paris

A 1895 Newcomb College Pottery, New Orleans.

B 1896 William Morris dies; Charles Rennie Mackintosh wins competition for Glasgow School of Art.

A 1896 *The Song of Songs* is Roycrofters's first book; *House Beautiful* is published in Chicago.

B 1897 Pilkington Pottery is established.

A 1897 Boston hold America's first major Arts and Crafts exhibition; Boston Society of Arts and Crafts is founded.

B 1898 Ruskin Pottery is established.

E 1898 First Vienna Secessionist exhibition.

A 1898 Gustav Stickley goes to Europe and meets Ashbee, Bing, Voysey, and others; Gustav Stickley Co. is founded in Eastwood, New York.

A 1899 Ocsar Lovell Triggs founds Industrial Art League.

E 1900 Paris Universal Exposition introduces Art Nouveau to a wide audience.

A 1900 Guild of Arts and Crafts, New York City.

A 1901 *The Craftsman* is first published by Stickley; *House and Garden* is published in Philadelphia; Furniture Shop started by Roycrofters in East Aurora; Pan American Exposition, Buffalo; Tiffany changes company name to Tiffany Studios; Van Briggle Pottery is founded by Artus Van Briggle (1869–1904) in Colorado Springs.

A 1902 *Handicraft* is published in Boston; Handicraft Guild in Minneapolis; Society of Arts and Crafts in Grand Rapids; Gates Potteries (founded in 1886 in Chicago) begins its Teco line.

A 1903 William Morris Society, Chicago.

E 1907 Deutsche Werkbund is founded by Hermann Muthesius.

A 1908 Dirk Van Erp opens Copper Shop in Oakland.

E 1910 Brussels International Exposition.

A 1910 Fulper Pottery in Flemington, New Jersey, begins Vase-Kraft art line.

E 1911 Turin International Exposition.

A 1915 Gustav Stickley is bankrupt; Panama–Pacific International Exposition, San Francisco; Panama–California Exposition, San Diego.

A 1916 Last issue of *Craftsman* is published.

E 1919 Bauhaus is founded at Weimer by Walter Gropius—Arts and Crafts ideals blend with modern style and industrial production.

Designers/Leaders

Charles Robert Ashbee (1863–1942, England) Architect-designer who opened Guild and School of Handicraft.

Charles Sumner Greene (1868–1957, United States) Architect, designer of California-style bungalows and furniture.

Henry Mather Greene (1879–1954, United States) Architect, designer of California-style bungalows and furniture.

Elbert Hubbard (1856–1915, United States) Arts and Crafts proponent and leader of Roycrofters.

Arthur Heygate Macmurdo (1851–1942, England) Architect, founder of Century Guild and publisher of *Hobby Horse*.

William Morris (1834–1896, England) Leading British Arts and Crafts figure who is designer and producer of interior furnishings.

John Ruskin (1819–1900, England) Critic and founder of Arts and Crafts philosophy and movement.

Gustav Stickley (1857–1942, United States) Leader of Arts and Crafts movement in America; founder of Craftsman workshops and periodical.

Charles F. A. Voysey (1857–1941, England) Architect-designer known for decorative work, especially fabric and wallpaper.

Major Companies

Charles P. Limbert and Co.

Morris and Co.

Roycroft Shops

Stickley & Co. (Craftsman Workshops)

Key Terms

Aesthetic movement	Craftsman	Mission style
art pottery	guild	quartersawn

Recommended Reading

Anscombe, Isabelle, and Charlotte Gere. *Arts & Crafts in Britain and America.* New York: Van Nostrand Reinhold, 1983 (Academy Editions, London, 1978).

Cathers, David M. *Furniture of the American Arts and Crafts Movement.* New York: New American Library, 1981.

Clark, Robert Judson, ed. *The Arts and Crafts Movement in America 1876–1916.* Princeton, New Jersey: Princeton University Press, 1972.

Kaplan, Wendy. *The Art that is Life: The Arts and Crafts Movement in America 1875–1920.* Boston: Little, Brown, 1987.

Naylor, Gillian. *The Arts and Crafts Movement.* London: Trefoil, 1990 (first published 1971).

Stickley Craftsman Furniture Catalogs. Reprints of "Craftsman Furniture Made by Gustav Stickley" and "The Work of L. & J. G. Stickley." New York: Dover, 1979.

Volpe, Tod M. and Beth Cathers. *Treasures of the American Arts and Crafts Movement 1890–1920.* New York: Harry N. Abrams, 1988.

Chapter 9

MODERN MOMENTS
Individual Forces

CHAPTER CONTENTS

Individual designers and their affiliated organizations, though not necessarily considered major international styles, made unique and significant contributions to the history of furniture and modernism.

FRANK LLOYD WRIGHT
(1867–1959, United States)

CHARLES RENNIE MACKINTOSH
(1868–1928, Scotland)

WIENER WERKSTÄTTE

DE STIJL

Gerrit Rietveld
(1888–1964, Netherlands)

*T*he evolution of modernism is neither linear nor clear. Like any process of change, there are mainstream events and there are marginal, sometimes critical, ideas and individuals whose contributions are more qualitative than quantitative. The Arts and Crafts movement, though not a clear starting point of modernism, influenced the next wave of design that carried modern to shore. Modern can be expressed in philosophy, in style and design, in materials, and in manufacturing techniques. Most Arts and Crafts participants looked back toward a remote premodern period in history (Middle Ages) and in doing so cannot be considered modern. The Arts and Crafts movement did, however, influence a budding modernism in more subtle ways—in its attempt to remove Victorian superfluous ornamentation and reveal "honest" form and construction, in its attention to both design process and manufacturing techniques, and in its (unfulfilled) desire to democratize art and to reach a large audience. However, leading Arts and Crafts figures like Ruskin, Morris, Hubbard, and Stickley were not modernists but moralist reformers and (except for Ruskin) entrepreneurs.

Contemporary Victorian era designs, such as Thonet's bentwood chairs or Shaker built-ins, were probably more influential in creating a modern appearance, and Thonet should certainly be credited with advanced ideas for production and marketing. But these were still chronologically and culturally embedded in the Victorian nineteenth century and were therefore not recognized as being particularly revolutionary. In fact, these proto-modernist designs were casually accepted, rejected, and taken for granted along with other nineteenth-century fashions and curiosities. Nevertheless, their influence upon other individuals and organizations central to the evolution of modernism should not be underestimated.

Of the key names—not broad movements or unified styles, but individuals and relatively small organizations—that made potent contributions to early twentieth-century modernism, four stand out: American architect-designer Frank Lloyd Wright of the **Prairie Style**, Scottish architect-designer Charles Rennie Mackintosh of the **Glasgow School**, Josef Hoffmann of the Austrian workshops called the **Wiener Werkstätte**, and Dutch architect-designer Gerrit T. Rietveld of the **De Stijl** movement. Each of these early individual modernists and groups absorbed aspects of Arts and Crafts ideals and practice, relied heavily on linearity and abstract geometric form for their designs, and made unique contributions to both their contemporary worlds and to future twentieth-century design.

In a discussion of the evolution of furniture, as with any complex and overlapping field, names, organizations, and styles may not permit neat categorization, or in the case of a book, chapter placement. Individuals often participated in more than one style or period; organizations may have had conflicting opinions within their membership; styles can be continuous and long-lasting or cycle in and out of fashion—in other words, they defy neat chronological placement. With the possible exception of Mackintosh, who is also associated with Aesthetic and Art Nouveau styles, the names chosen to represent "modern moments" might, at first glance, just as well have been in an extension of the chapter on Arts and Crafts because of its undeniable inspiration and influence. But these designers looked more toward the future than to the past. Wright's furniture designs span a great distance—from Arts and Crafts oak to mid-century modern aluminum; the Wiener Werkstätte was stylistically connected to Art Nouveau and Art Deco as well as to Mackintosh; Rietveld's color and form parallel modern abstract painting.

FRANK LLOYD WRIGHT (1867–1959, UNITED STATES)

Frank Lloyd Wright left about 400 buildings, primarily single-family residences, as a legacy of his genius. Although he was not widely followed by other architects, he is regarded as one of the most significant American architects and pioneers of modernism. Wright created an essentially American modern architecture that relied heavily on vernacular indigenous forms. He was influenced by the English Arts and Crafts movement, native Mayan and Amerindian architecture, wooden structures built by American pioneers, and especially Japanese architecture with its direct relationship to nature.

Organic architecture, as it is called, was intended to be in harmony with the landscape, with natural connections between form and function. This was expressed by horizontality, rather than a more commonly used verticality, which symbolized domination over nature. Low ceilings and central hearth conveyed feelings of warmth and protection—a new interpretation of "home sweet home." By merging the structure with its site in a more Japanese architectural style, the division between inside and outside was softened. Natural light and natural views were integrated into the interior design through the thoughtful placement of windows. In keeping with both oriental and Arts and Crafts aesthetic principles, the materials—brick, stone, tile, wood, metal—were natural and used naturally. Each house had its individual character, and no two were alike. Although this uniqueness was considered desirable by his well-to-do clients and is still admired today, it does help to explain why more of Wright's houses were not built.

The theme of organic architecture and the underlying unity of building elements was carried inside to the furnishings, which Wright often designed, even dictated. Furniture, metalwork, stained-glass windows, light fixtures, and murals were given attention equal to the building components. Although the proverbial whole was greater than the sum of its parts, those parts were also strong enough to stand on their own. Wright's furniture not only helped to define the interior spaces, it stood independently as works of art and design.

Visually, Wright's furniture seems to be part of the Arts and Crafts movement, but Wright, the quintessential individual, belonged to no one's group or movement. He made no excuses for capitalism, and his open acceptance of machinery in the creation of art put him at odds with both British purists and American interpreters. Besides, his profound admiration of traditional Japanese design and first-hand acquaintance with Japanese art and architecture would have aligned him more closely with the British Aesthetic movement than with the Arts and Crafts. But Wright was unique, and other than his title as the leader of the Prairie School of architecture, he does not fit comfortably inside any label, movement, or "ism."

Wright was born in southern Wisconsin, and from an early age was intrigued with nature and design. His mother gave him toy building blocks; his musician father showed him how the structure of music is like the structure of design. But his father abandoned the family while Wright was still in his teens, and Wright would later follow in these tragic footsteps with his own family. His model was nature, and its influence was never absent from his thoughts or designs. "Everything in nature was architecture. . . . I wanted to design using the elements of nature," he said. Then, Wright went out to appeal to human nature with his work.

First, he studied engineering at Wisconsin State University at Madison. He began his career by working as a draftsman for the firm of Adler and Sullivan in 1887 and then started his own architectural office in 1893. If nature was his positive influence, then contemporary architecture was his negative model. Wright considered the eclectic pseudohistoric Victorian house to be out of place in America's heartland. His reaction to the prevailing fashion motivated him to create a new architecture for a new age. In opening up the boxlike cut-up interior of the typical turn-of-the-century house, Wright introduced the Prairie style with its open plan. By 1900 Wright had designed over fifty homes and interiors.

Since Wright considered the living space to be the essence of the building, these interior spaces were his first priority. Building from the inside out was central to modernist philosophy, of which Wright was a pioneer; his ability to also bring the outside surroundings into this interior space became his special trademark. The Prairie style was at the height of its popularity in the first decade of the new century, but by 1909 Wright had exhausted it. In that year he also left his architectural practice in Oak Park, Illinois, and his family. His personal life would have an effect on both his career and his acceptance by others. Returning to Wisconsin, he built Taliesin and attempted to begin again with another woman. Tragedy followed, and his lover and her children were murdered by an insane servant. Then Taliesin burned, and although Wright rebuilt it, his life was already in shambles.

In 1915 he began the Tokyo Imperial Hotel project. When completed, the modern building resisted the 1923 earthquake, Wright's professional reputation was renewed. However, his personal life continued on a roller coaster with an unhappy marriage, his wife's refusal to give him a divorce, and a new affair. By the mid-1930s, although on the outside of desirable social circles, Wright was on the threshold of the second great era of

his career. The S. C. Johnson Wax Administration Building would become one of the great landmarks of American architecture. Contrary to the outside-in philosophy for residential design, Wright created a self-contained environment to purposefully set it apart from the urban setting. In this building of never-ending surprise, Wright used technology to materialize his innovative and modern ideas. Other architectural projects included Taliesin West in an Arizona desert landscape in 1937, the famous Falling Water in southern Pennsylvania, and the affordable ($5,000) Usonian homes complete with carports.

Among the modern innovations Wright used in his architecture are the cantilever, central heating and air conditioning, double glazing, open planned kitchens, under floor heating, and carports. His modernist idea of designing from the inside out was practiced by more of his successors than his contemporaries.

Since Wright worked with total design, his furnishings are as important as their respective buildings. In 1895 he designed a cube chair, described by his son John as the first piece of modern furniture made in the United States. Although made of wood, its lines seemed to anticipate those of the International style (Chapter 11), which ironically Wright was not associated with. He also is credited with designing the first metal office furniture, a desk with a swivel chair designed in 1904 for the Larkin Administration offices. His straight angular furniture designs in the Arts and Crafts manner were usually for individual homes rather than for mass production. In the mid-1930s, however, when he designed the Johnson Wax Building, he also designed its unique metal desks and chairs manufactured by Steelcase (reintroduced by Cassina). Wright's contribution to office furniture design is discussed in Chapter 13. In 1955, he designed the Taliesin line of furniture intended for a mass market and manufactured by Heritage Henredon Co. His Midway chair of 1914 was reintroduced by Cassina and distributed by Atelier International. The hexagonal form was used for another chair for Midway Gardens in 1914 and for his upholstered aluminum side and armchairs designed for the Price Tower in Bartlesville, Oklahoma, circa 1953.

Wright's furniture designs spanned more than half a century. Although others have shared his views and even attempted to follow his direction, few have succeeded in creating either the totally harmonious designs or such compelling individual elements, such as furniture. His goal of creating beauty in everyday life has become his legacy.

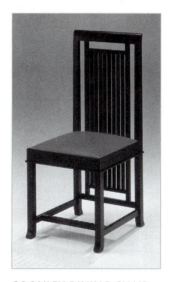

COONLEY DINING CHAIR.
Designed by Frank Lloyd Wright, 1906. Coonley 1: frame in natural cherry, cherry stained walnut, or beech stained black. H 27-1/2; seat H 18-1/8; base W 17, D 18-1/2; Coonley 2: H 37. *(Courtesy of Cassina)*

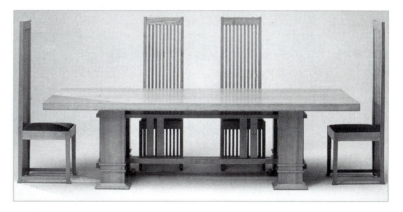

ALLEN TABLE AND ROBIE CHAIRS.
Allen table designed by Frank Lloyd Wright, 1917. The rectangular dining table with wide overhanging top and vertical slats at each end was designed for the Henry J. Allen house in Wichita, Kansas in 1917. L 101-1/4 or 110-1/4, W 41-3/4, H 27-3/4. Robie chairs designed by Frank Lloyd Wright, 1908. High-backed cherrywood side chair with nine wooden slots made for the Robie House in Chicago in 1908. H 52-1/2, W 15-3/4, D 18; seat H 18-1/2. *(Courtesy of Cassina)*

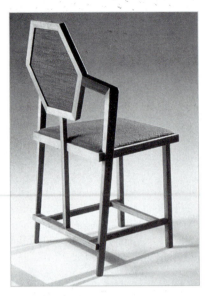

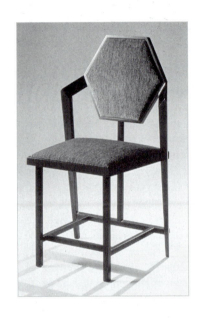

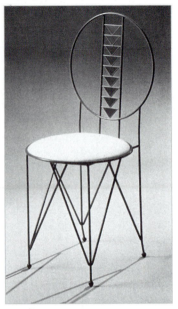

MIDWAY 1 CHAIR.
Designed by Frank Lloyd Wright, 1914. The hexagonal-backed side chair with upholstered seat and back was designed to be used in the dining room of Midway Gardens in Chicago in 1914. Reissue frame of cherrywood, natural or stained walnut, or black. H 34-1/4, W 20-1/4, D 19; seat H 18. *(Courtesy of Cassina)*

MIDWAY 2 CHAIR.
Designed by Frank Lloyd Wright, 1914. The disc-shaped steel-rod side chair was designed for the outdoor garden court of Chicago's Midway Gardens in 1914. Reissue frame in glossy white, red, blue, or gray enameled steel rod. H 34-1/2, W 15-3/4, D 18-1/2, seat H 18-1/4. *(Courtesy of Cassina)*

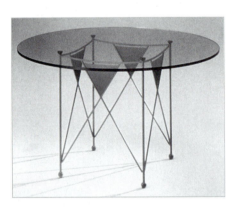

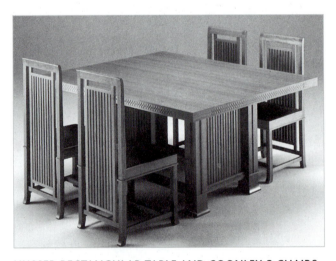

MIDWAY 3 TABLE.
Designed by Taliesen Architects, 1914. The glass-topped dining table with steel base was created by Wright's successor firm, Taliesen Architects, Ltd. as a companion to Wright's Midway 2 chair. Reissue frame enameled in white, red, or gray. H 29, square or round top 47-1/4. *(Courtesy of Cassina)*

HUSSER RECTANGULAR TABLE AND COONLEY 2 CHAIRS.
Designed by Frank Lloyd Wright. Reissue H 29-1/8; top L 60-1/4, W 50; base L 39–3/4, W 26. *(Courtesy of Cassina)*

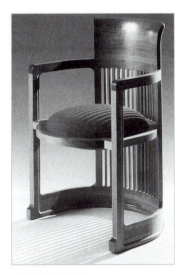

BARREL CHAIR.
Designed by Frank Lloyd Wright, 1937. Wright designed the first version of this chair in oak for the Darwin Martin house in Buffalo, New York in 1904. This version of the armchair with curved back and upholstered seat was made for the Herbert Johnson house, Wingspread, in Racine, Wisconsin in 1937. When Wright saw the completed chairs he ordered twelve for his own living room at Taliesen. Reissue in cherrywood or natural or stained walnut. H 32; arm H 24-3/4; seat H 19-5/8; base W 21-1/2, D 22. *(Courtesy of Cassina)*

FRIEDMAN ARMCHAIR WITH STOOL.
Designed by Frank Lloyd Wright, 1956. Wright designed the armchair with footstool for the Allen Friedman house in Bannockburn, Illinois, in 1956. It was based on two earlier designs, a prototype for the Kaufmann store offices in 1935 and another version for Wright's son David in 1951. Wright also had three made for his office at Taliesen. Chair H 28-1/2, W 29, D 27-1/2; seat H 15-1/2; footstool H 15-1/2, W 23-1/4, D 23-1/4; seat H 15-1/2. *(Courtesy of Cassina)*

CHARLES RENNIE MACKINTOSH (1868–1928, SCOTLAND)

Wright fell in and out of favor during his career, but eventually was recognized as one of the greatest modern American architects. There were other controversial pioneers of modernism, however, whose contribution had to be rediscovered. "The history of the arts of the twentieth century is littered with examples of individuals whose great works, renown and reputation have fallen into obscurity as fickle tastes and styles have passed them by, only to be rediscovered and reclaimed by delighted later generations. Such is the case of one of the most defiantly innovative, original and fervent creators, the Scottish architect-artist-designer, Charles Rennie Mackintosh" (Jones 7). This statement about Mackintosh also aptly describes a fair percentage of great talents throughout history—simply substitute the century and the individual name with another from the arts, sciences, and so on. As Albert Einstein observed, "great spirits always meet violent opposition from mediocre minds." George Bernard Shaw insisted even more cynically that "the majority is always wrong." Fortunately, in the case of Mackintosh and others like him, notoriety did follow, if only in a future generation. He had been relatively unappreciated at home in Scotland or even in England, but he found acceptance in Vienna where other creative visionaries could also be found swimming against the current at the turn of the century. Mackintosh fought his way out of the "revival-ridden clutches of the Victorian-Edwardian continuum" (7) in Britain

only to be recognized by other outsiders on the continent. But these outsiders, not their critics, would later earn recognition for their contributions to modern design.

Mackintosh was born in 1868 in Glasgow, one of eleven children. His father was superintendent of the Glasgow Police and also something of an amateur horticulturist. Like his American contemporary, Frank Lloyd Wright, Mackintosh grew up close to nature and realized at an early age that nature would be his lifelong inspiration. Mackintosh was a frail child, and a club foot was among his physical disadvantages. Fortunately, his parents were advised to provide him with fresh air and exercise, so young Mackintosh spent his youth wandering around the Scottish landscape, sketching both nature and indigenous architecture.

In 1884, at age sixteen, he was accepted as an apprentice at the architectural practice of John Hutchison. He also began a ten-year term as a part-time student at the Glasgow School of Art, where in 1886, he began his formal architectural training. His full schedule of school in the early morning, architectural practice during the day, and school again in the evening worked well for the energetic young Mackintosh—he won prizes and scholarships at school while he established himself as a professional architect. In 1889 Mackintosh completed his apprenticeship and joined the practice of Honeyman and Keppie, which was interrupted in 1891 for a tour of Italy.

Mackintosh became friends with Herbert MacNair (1868–1955), a fellow evening school classmate and employee at Honeyman and Keppie. Two Glasgow School day students, Margaret MacDonald (1865–1933) and Frances MacDonald (1873–1921), joined Mackintosh and MacNair to form the "Glasgow Four." The Glasgow style, as it was called, was led by the "Four," which was headed by Mackintosh. In 1899, Herbert MacNair married Frances MacDonald; then in 1900 Mackintosh married Margaret MacDonald. Although he finished school in 1894, Mackintosh stayed with the Four until 1896 and produced work in painting and decorative arts characterized by stylized roses and other themes from nature, elongated figures, and literary references. To their disadvantage, their work was identified with the Aesthetic movement, Art Nouveau, and the controversial British artist Aubrey Beardsley. Art Nouveau, though embraced in France, Belgium, and Italy, was all but rejected by the British, and any presumed association with the style made it very difficult for Mackintosh to find acceptance.

Mackintosh's opportunity came in 1896, in the personage of Miss Catherine (Kate) Cranston, an advocate of the Temperance movement. Her disapproval of alcohol led to her founding of "art tearooms" throughout Glasgow, and from 1896 to 1909, Mackintosh enjoyed his most fruitful years as Miss Cranston's designer of Japanese tearooms in the Glasgow style.

Cranston had hired Mackintosh to design wall decorations and light fittings for her Buchanan Street Tea Rooms in 1896. Then, she hired architect-designer George Walton (1867–1933) to design the furniture and other decorations of her trend-setting Argyle Street Tea Rooms. Mackintosh worked for him, and when Walton moved to London in 1897, Mackintosh was put in charge of designing the free-standing furnishings—chairs, benches, settles, tables, umbrella stands. The now-famous oak chair for the Argyle Luncheon Room is typical of Mackintosh's vertical exaggerations. He and his wife Margaret, who collaborated on many designs, used the same chairs in 1900 for their flat, probably in the dining room. The high-backed chair has a wide oval panel with a cut-out stylized bird in flight, possibly a dove with its spiritual symbolism. When seated at the table, patrons felt like they were in a room within a room, just as diners in one of Wright's residences felt when seated in one of his cozy enclosed arrangements. His designs for the Ingram Street Tea Rooms in 1900 and Willow Tea Rooms in 1903 were also among his best. One of the most famous Mackintosh furniture designs was used on Sauchiehall Street (Gaelic for "Street of Willows"), a chair or settle used by the cashier or manageress. Cranston's showpiece, the Willow Tea Rooms, were designed totally by Mackintosh and his wife and partner Margaret—furniture, curtains, wall panel decoration, carpets, light fixtures, down to the menu. The chair is in the form of a stylized willow tree with central trunk and symmetrically spreading branches, and the upholstered seat is like a visual pool of water.

As James A. M. Whistler popularized the phrase and the practice of "art for arts sake," with his refreshing approach to painting, Mackintosh believed in design for the sake of the

Died 1910
Winslow Homer (b. 1836);
William James (b. 1842);
Florence Nightingale
(b. 1820); Leo Tolstoy
(b. 1828); Mark Twain
(b. 1835).

1911
Mexican dictator Diaz is
overthrown; Inca ruins are
discovered at Macchu
Picchu; Chinese revolution;
Indianapolis 500 auto race;
tungsten replaces carbon
filaments in electric lamps;
Marie Curie is first person
to win two Nobel Prizes;
escalator; Oreo cookies; exit
doors of the Triangle
Shirtwaist Factory in New
York are locked to prevent
employees from leaving
during working hours, and a
fire kills 147 women
workers; Franz Boaz *The
Mind of Primitive Man*.

Born 1911
Lucille Ball (d. 1989); Hubert
Humphrey (d. 1978);
Mahalia Jackson (d. 1972);
Marshall McLuhan (d. 1980);
Georges Pompidou
(d. 1974); Ronald Reagan;
Ginger Rogers (d. 1995);
Robert Taylor (d. 1969);
Tennessee Williams
(d. 1983).

Died 1911
Gustav Mahler (b. 1860).

1912
Theodore Roosevelt is
elected president; 1,513
people die as Titanic sinks;
South Pole is reached;
China's Manchu Dynasty is
overthrown; F.W. Woolworth
Co.; self-service food stores
in United States; first photo
finish in Olympic games;
first baseball player strike;
Cracker Jack prizes;
DuChamp's painting *Nude
Descending a Staircase*.

design. His exaggerated proportions and subordination of materials, construction, and even function and comfort for the sake of design, characterized his departure from pure Arts and Crafts tenets. Mackintosh's tearoom chairs provided visual interest and divided the interior space with their bold outlined high backs. A sense of vertical harmony created by the chairs and an overall integrative design relying on the rectangular grid interested Mackintosh more than joinery or finishes. ". . . for Mackintosh, beauty lay in art, not in mindless utility. . . . He preached individuality [while] others searched for uniformity and all too often found it in mediocrity" (Billcliffe 21).

His interior design and furniture for the tearooms were as significant as his architecture. It was during those years (1897–1899 and 1907–1909) that he also received his most prestigious architectural commission, considered to be his masterpiece, the new Glasgow School of Art. Louis Hellman described it as a combination of all the new developments— "Scottish vernacular-inspired Arts and Crafts and Art Nouveau's fusion of structure and decoration through the use of iron and glass. The relation of the building to its steep site and the informal planning combine in a sure and confident exploitation of space heralding a new urban architecture, robust yet delicate in detail, functional yet inspiring and human in scale, economic yet rich in imagination."

Another commission was the Hill House for Glasgow publisher Walter Blackie in 1902–1904. Just west of Glasgow at Helensburgh, Mackintosh built a house with an exterior like a modernized Scottish castle ornamented with his trademark grid or checkerboard design for the windows. The interior is also geometric, but warm. Rich woods and earthy colors create perpendicular patterns with a strong Japanese flavor and striking similarity to Wright's interiors. But the ubiquitous rose motif identifies it as unmistakenly Mackintosh. The really radical room of the Hill House is the white bedroom. Like Whistler's painting *White Girl*, the stark white on white could not have been more shocking to Victorian sensibilities. The Japanese simplicity was predictably viewed as austerity by those living in comparatively claustrophobic interiors. The only accents were the exquisite black ladder-back chairs against the walls.

Another significant commission was given to him in 1900 by a wealthy Austrian art patron, Fritz Waerndorfer (1869–1939). The Austrian "Secessionists" were artists who dropped out of the official Kunstlerhaus; they were also known as Die Jungen and creators of the Jugendstil or young style. When they saw Mackintosh's graphic designs in the British art journal *The Studio*, they invited him to exhibit in the Eighth Secession Exhibition. Mackintosh entered into a friendship with architect-designer and central figure of the Wiener Werkstätte, Josef Hoffmann (1870–1956), and with Waerndorfer. His modernism was better suited to Austrian than British tastes, and Mackintosh won the admiration of many avant-garde Viennese. Not unlike other budding modernist designers, Mackintosh was influenced by a combination of his familiar native architectural heritage, his unusual interpretation of the Arts and Crafts writings of Ruskin and Morris, progressive ideas of men such as Voysey, and Japanese architectural forms and design. Filtered through his own artistic imagination, the results were uniquely Mackintosh, yet intriguingly similar to those of Wright and members of the Wiener Werkstätte.

In determining the direction of the influence, it is more likely that Wright was influenced by Mackintosh, rather than the other way around. The two architects were not known to have met, yet there are strong parallels in their early furniture designs, at least until 1901. Since Wright's work was not published in Europe until 1910, and since Mackintosh was already known in America through *The Studio*, it is likely that Wright saw Mackintosh's designs—unless the similarities are simply coincidental.

The Wiener Werkstätte was founded in 1903, following the Seccession, several years after Mackintosh had exhibited in Vienna. He was openly admired and accepted by Viennese modernists, and his influence is evident in their predilection for white paint, colored inlays, strong linearity of design, and the grid motif—all Mackintosh trademarks. Despite any inevitable exchange of ideas and regardless of who actually initiated specific ideas, Mackintosh and other modernists, such as Wright and members of the Wiener Werkstätte, shared something more important: They sought not to use history in their design, but to make it.

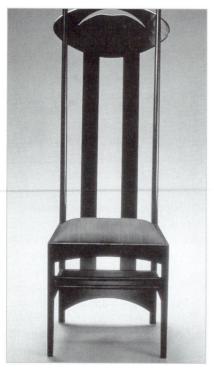

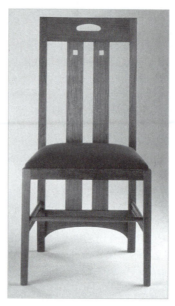

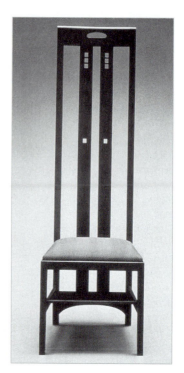

ARGYLE TEAM ROOM CHAIR.
Designed by Charles Rennie Mackintosh, 1897. Originally dark stained (ebonized) oak, horsehair upholstery on seat, which narrows toward the back, with front legs tapering toward the bottom, and front and side legs connected with pairs of thin circular stretchers. H 53-1/2 x 19-3/4 x 18.
(Courtesy of Cassina)

INGRAM CHAIR (MEDIUM).
Designed by Charles Rennie Mackintosh, 1900. Originally dark stained oak with horsehair upholstered seat, used in the White Dining Room of the Ingram Street Tea Rooms. H 41-3/4 x 19 x 17-1/4.
(Courtesy of Cassina)

INGRAM HIGH CHAIR.
Designed by Charles Rennie Mackintosh, 1900. Taller version of dining chair also made for the White Dining Room, but it is not known exactly where these were used, four surviving examples. H 59-3/4 x 19 x 17-1/4.
(Courtesy of Cassina)

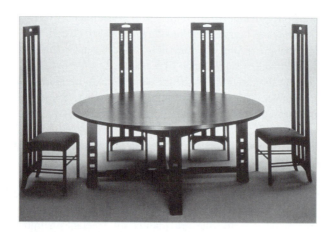

INGRAM HIGH CHAIRS AND G.S.A. TABLE.
(Courtesy of Cassina)

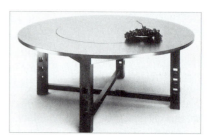

G.S.A. TABLE.
Designed by Charles Rennie Mackintosh, 1900. L 74-3/4, H 29. *(Courtesy of Cassina)*

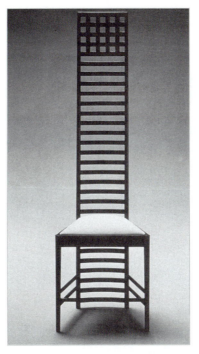

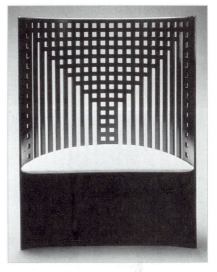

HILL HOUSE LADDERBACK CHAIR.
Designed by Charles Rennie
Mackintosh, 1902–1904. Originally of
ebonized oak with upholstered seat,
one of two chairs not painted white
for the Bedroom of the Hill House.
H 55-1/2; seat H 17-3/4; base W 16,
D 13-3/4. *(Courtesy of Cassina)*

WILLOW TEAM ROOM CHAIR.
Designed by Charles Rennie Mackintosh,
1903–04. Curved lattice-back chair of
ebonized oak, not actually circular, but
segmental with a stylized willow tree in the
grid back, the bottom of the seat serving as
a small locker or chest, used at the order
desk of the Willow Tea Room. H 46-3/4 x
37 x 15-3/4. *(Courtesy of Cassina)*

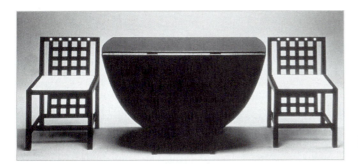

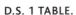

D.S. 1 TABLE AND D.S. 3 CHAIRS.
(Courtesy of Cassina)

D.S. 1 TABLE.
Designed by Charles Rennie
Mackintosh, 1918. Folding
top on two sides. H 29-1/4
x 69 x 48-3/4. *(Courtesy of
Cassina)*

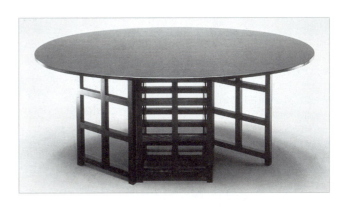

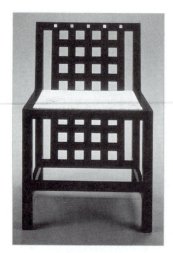

D.S. 3 SIDE CHAIR.
Designed by Charles Rennie
Mackintosh, 1918. Reissue of
ebonized frame inlaid with
mother-of-pearl, sea-grass seat.
19 x 17-1/2 x 29-1/4. (*Courtesy
of Cassina*)

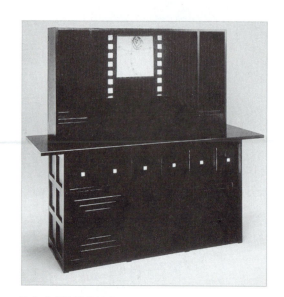

D.S. 5 SIDEBOARD.
Designed by Charles Rennie Mackintosh, 1918.
Closed cabinet on bottom, open shelves on top, of
ebonized ashwood, decorated with colored glass
mosaic with lead, inlaid with mother-of-pearl.
63-1/2 x 22-1/4 x 59. (*Courtesy of Cassina*)

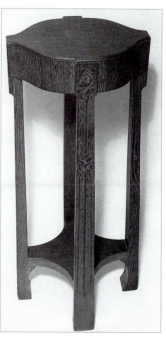

Plant table designed by Louis
Rorimer in Cleveland, Ohio, 1912.
Glasgow School style plant table
in oak, with stylized rose, a
Mackintosh emblem.

Born 1912
Julia Child; Woody Guthrie
(d. 1967); Gene Kelly
(d. 1996); Jackson Pollock
(d. 1956)

Died 1912
Joseph Lister (b. 1867);
Wilbur Wright (b. 1867).

1913
U.S. federal income tax;
Rockefeller Institute founded
with $100 million; Geiger
counter; electric refrigerator;
assembly line in Ford factory;
Woolworth Building in New
York; Vitamin A isolated; New
York Armory Show brings
modern art to America;
Stravinsky's *Rite of Spring*.

WIENER WERKSTÄTTE

England and America were by no means the only cultures affected by the modern crafts movements of the late nineteenth and early twentieth centuries. In 1903 Viennese Joseph Hoffmann (1870–1956) established the first workshops on the European continent for the design and manufacture of applied arts in the English Arts and Crafts tradition. The Wiener Werkstätte (Viennese Workshops) were anti-industrial art workshops where individual style and creativity were encouraged and where craftsmen and women enjoyed equal status to artists. This description also applied to the Arts and Crafts movement in England. What set the Werkstätte apart from Arts and Crafts while relating it to the German Bauhaus (Chapter 11) was its modernism. Austria was in fact one of the earliest cultures to support modernism. There were three aspects to the Viennese modern movement: (1) the Secession, an artists' association that began to hold exhibitions in 1898; (2) the Kunstgewerbeschule, a teaching institution that began in 1867; and (3) the Wiener Werkstätte, an organization of design and craft workshops emphasizing the decorative arts.

The origin of the Werkstätte can be traced to the **Vienna Secession**, founded in 1897 by designers Josef Hoffmann, Kolomon Moser, and Joseph Maria Olbrich, with painter Gustav Klimt as its first president. In the following year, 1898, the journal *Ver Sacrum*

was launched, and the first Secession exhibition was held. When the World's Fair was held in Paris in 1900, Josef Hoffmann was represented by his interior designs, along with other applied artists including Ashbee, Mackintosh, and Van de Velde. In 1902, Hoffmann traveled to Britain and stayed with Ashbee in London and with Mackintosh in Glasgow, and evidence of their association is evident in stylistic similarities of many designs. The next year the Wiener Werkstätte was registered under the artistic direction of Hoffmann and Moser, with financial backing of Waerndorfer. In 1904 they held the first exhibit, in Berlin.

The Werkstätte spanned three decades from 1903 to 1932 and incorporated styles ranging from Art Nouveau and Art Deco to Bauhaus. But unlike the Bauhaus, the Wiener Werkstätte members did not concern themselves with mass production. Chronologically, philosophically, and stylistically the Werkstätte bridged and blended the Arts and Crafts, Art Nouveau, Art Deco, and Bauhaus. One explanation for the variety of styles was the emphasis placed on individual creativity in the workshops. Each artist and artisan was encouraged to develop his or her own style, and the objects carried the signature of both designer and artisan.

Major projects included the Pukersdorf Sanitorium near Vienna 1904–1906, Palais Stoclet in Brussels 1905–1911, Cabaret Fledermaus in Vienna 1907, and the Villa Ast, Hohe Warte, Vienna 1909–1911. Financial pressures were ever present, and in 1914 the Werkstätte was liquidated and immediately reorganized. In 1922, designer Josef Urban opened an American branch in New York City, but it lasted only until 1924. In 1926, the Zurich branch (opened in 1917) declared bankruptcy, and a Berlin branch opened in 1929. By 1931, financial problems were unsolvable and the Werkstätte disbanded. The assets were liquidated, and the organization was deregistered in 1932.

Josef Hoffmann was the artistic leader throughout its existence and participated in all of its exhibits. An instructor at the School of Arts and Crafts in Vienna and a talented and versatile figure, Hoffmann designed metalware, glass, ceramics, textiles, jewelry, floor coverings, and furniture. His use of the black-and-white grid, similar to Mackintosh's, earned him the nickname "Quadrati Hoffmann"—Little Square Hoffmann. The similarity ends here. Mackintosh was a designer, but his designs also had flaws—they were not well crafted. Rather than choosing the most capable craftsmen to execute his designs, Mackintosh often settled for shipbuilders, untrained in the fine art of furniture. The results were often inferior, and the furniture relied more on visual effect than on quality or function. Hoffmann's furniture had the same modern features as Mackintosh—rectilinearity, grid motif, black and white—but without the flaws. The Werkstätte employed the best cabinetmakers to execute Hoffmann's furniture designs because of the belief in good design plus high regard for materials, construction, and function.

If Mackintosh believed in modern design for "design's sake," and if Ruskin and Morris insisted on quality of design, materials, and construction, then Hoffmann was able to accomplish both. Another consistency between Arts and Crafts and Wiener Werkstätte was the belief that silver was as worthy as gold, and copper was as worthy as silver in a well-designed and crafted object. The belief in equal status of craftsman, painter, or sculptor was both a preindustrial Western notion and an aspect of Japanese aesthetic philosophy. The Japanese use of floral arabesques and squares as design motifs was another Werkstätte parallel. But one reason for the ultimate failure of both the Arts and Crafts and then the Werkstätte, even with its modern styling, was the resistance to modern production techniques. Where handicraft could address the issues of design, artisan status, and quality, production costs were high, and the market was limited. Until the issue of machine-art and mass production could be reconciled, the Werkstätte was destined to be little more than a modern-looking phase of Arts and Crafts.

Sitting room designed by Kolo Moser, 1911. *(The Studio)*

Entrance hall and bentwood furniture designed by Josef Hoffman, 1910. *(The Studio)*

Buffet designed by Josef Hoffman and executed by the Wiener Werkstätte, 1911. *(The Studio)*

Drawing room designed by Josef Hoffman and executed by the Wiener Werkstätte, 1911. *(The Studio)*

Sitting room designed by Josef Hoffman and executed by the Wiener Werkstätte, 1911. *(The Studio)*

Bedroom designed by Joseph Urban, 1911. *(The Studio)*

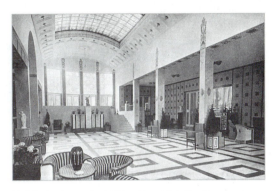

Hall in Budapest in 1914 with wicker furniture designed by Josef Hoffman. *(The Studio)*

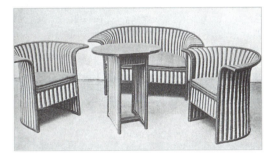

Wicker furniture in the style of Josef Hoffman. *(The Studio)*

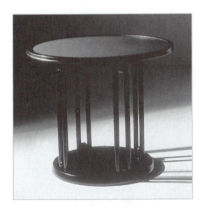

FLEDERMAUS TABLE.
Designed by Josef Hoffmann, circa 1908. Using classicism for inspiration, Hoffmann introduces the imagery of a fluted column with decorative balls. Reissue of steam-bent maplewood frame, round top, optional brass trim on base, inset top covered in vinyl or plastic laminate. H 30 with 30, 36, or 42 diameter top, and 19 or 26 diameter base. *(Courtesy of Thonet)*

FLEDERMAUS CHAIR.
Designed by Josef Hoffmann, circa 1907. Hoffmann designed this chair for the Cabaret Fledermaus, a theater-bar where members of the Werkstätte and Viennese avant-garde socialized. Limited cabaret space and Werkstätte design philosophy directed Hoffmann to design a small, lightweight, durable chair. The spherical element was integral to Secessionists' visual language, as well as its replacing conventional support elements such as metal brackets or ring stretchers. Steam-bent beechwood frame, upholstered seat. H 29-1/2, W 22-1/2, D 18; seat 16-1/4 x 17, H 18. *(Courtesy of Thonet)*

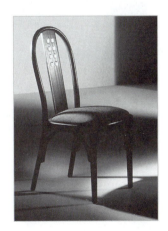

VIENNESE NOUVEAU CHAIR.
Designed by Josef Hoffmann, circa 1908. The characteristic fluid quality of bentwood is combined with geometric decorative elements to suggest a Viennese Modern design. Steam-bent beechwood frame and upholstered seat. H 36, W 18, D 21; seat 17-1/2 x 15-3/4, H 18. *(Courtesy of Thonet)*

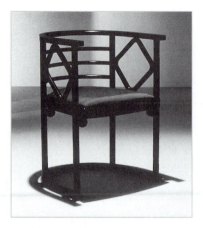

HOFFMAN CHAIR.
Designed by Josef Hoffmann, circa 1909. As the Fliedermaus chair became a generic type, many variations evolved. Hoffmann designed this with a more accommodating scale and either a circular or diamond motif connecting the arm with the seat. Steam-bent beechwood frame with upholstered seat. H 29, W 24, D 20-1/2; seat 18-1/2 x 19; arm H 29. *(Courtesy of Thonet)*

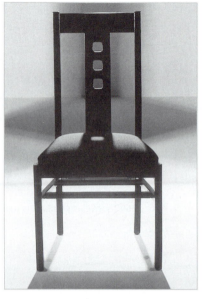

VIENNESE CAFÉ CHAIR.
Designed by Josef Hoffmann, circa 1911. The geometric motif in the splat is typical of Viennese Modern design. Hardwood frame, upholstered seat. W 18, D 21-1/2, H 39; seat 17-1/2 x 16-1/2, H 18. *(Courtesy of Thonet)*

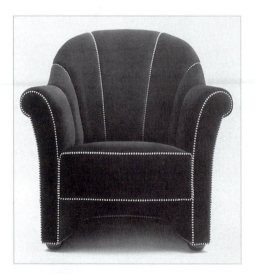

HANS KOLLER ARMCHAIR.
Designed by Josef Hoffmann, 1911. From the Koller Lounge Seating Collection: seat and back foam-covered hardwood frame with rubber webbed springing; upholstered to specification with piped or welted edges. H 37, W 35-1/2, D 32. *(Courtesy of ICF Group)*

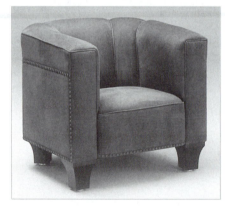

PALAIS STOCLET CHAIR.
Designed by Josef Hoffmann, 1911. Chair with continuous line from arms to curved back; solid hardwood frame, foam-covered upholstery to specification, with covered nail heads; legs of ebonized wood. H 31-1/2, W 35-1/2, D 33-1/2. *(Courtesy of ICF Group)*

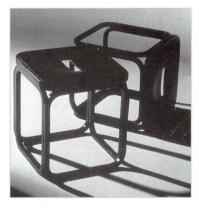

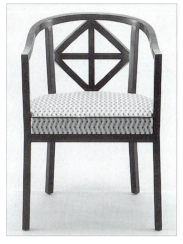

AUSTRIAN POSTAL SAVINGS BANK STOOL.
Designed by Otto Wagner, circa 1906. Steam-bent beechwood leg and seat frames with aluminum cap detailing; veneer molded plywood seats with perforated design and hand hold; adaptation of original Thonet design by Wagner. H 18-1/2, 16-1/4 square. *(Courtesy of Thonet)*

VILLA AST CHAIR.
Designed by Josef Hoffman, 1911. Classic executive pull-up chair with geometric design. H 32-1/2, W 23-5/8, D 21-1/4. *(Courtesy of ICF Group)*

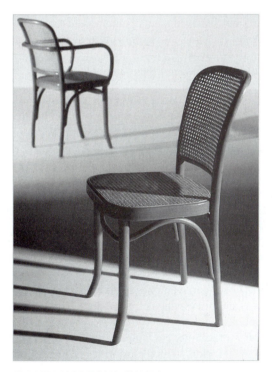

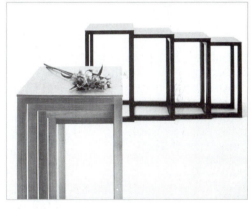

HOFFMAN NESTING TABLES.
Designed by Josef Hoffman, 1905. Set of four rectangular nesting tables in natural or ebonized finish. H 23-5/8 to 27-1/2, W 11-1/2 to 19-3/4, D 12 to 16. *(Courtesy of ICF Group)*

CLASSIC HOFFMAN CHAIRS.
Designed by Josef Hoffman, circa 1933. Hoffman's versions of twentieth-century bentwood with emphasis on geometric form. H 31-1/2, W 17-1/2 or 20-1/2, D 20. *(Courtesy of Thonet)*

Died 1915
Booker T. Washington
(b. 1856).

1916
First American birth control
clinic (Brooklyn); first radio
news report; windshield
wipers on cars.

1916–1919
Bogor, Java, Indonesia
averages 322 days of
thunder each year.

Born 1916
Francis Crick; Walter
Cronkite; Yehudi Menuhin
(d. 1999); François
Mitterrand (d. 1996);
Gregory Peck.

Died 1916
Sholem Aleichem (b. 1859);
Thomas Eakins (b. 1844);
Jack London (b. 1876); Franz
Marc (b. 1880); Rasputin
(b. 1869).

1917
United States declares war
on Germany; Russian Czarist
government is overthrown;
first element change—
nitrogen to oxygen;
Clarence Birdseye develops
frozen food; first jazz
recording by Original
Dixieland Jazz Band.

Born 1917
Nat King Cole (d. 1965);
Indira Gandhi (d. 1984);
Dizzy Gillespie (d. 1993);
Lena Horne; John F.
Kennedy (d. 1963);
Ferdinand Marcos (d. 1989);
Robert Mitchum (d. 1997);
Thelonious Monk (d. 1982);
I.M. Pei; Andrew Wyeth.

DE STIJL

Gerrit Rietveld (1888–1964, Netherlands)

Of all the early modernists associated with furniture design, Rietveld is probably the most marginal. Yet, though the quantity of his output is not significant, the few designs bearing his name are, especially in the evolution of modern abstract art. Born in Utrecht in 1888, Rietveld left school at age twelve to work in his father's cabinetmaking shop. At the age of eighteen, he began to attend evening classes in art and architecture, while working by day as a draftsman for a local jeweler. In 1917, Rietveld set up his own cabinet-making shop in Utrecht. Though influenced by the designs of Frank Lloyd Wright, Rietveld was guided by more radical principles, which led him to join the newly formed "movement" called De Stijl.

This loosely organized group of artists was formed in politically neutral Holland in the midst of the First World War. It was held together by the Dutch painter, art critic, and essayist Theo van Doesburg (1883–1931) in order to produce a style and a new language of plastic art. In 1915, while still in the military, van Doesburg thought about starting a journal. The idea incubated as the artistic and political climate evolved, and paths crossed. While Piet Mondrian (1872–1944) was visiting Holland in 1914, the war broke out, preventing him from returning to Paris, so he began to work on his plus-and-minus paintings in Holland; Vilmos Huszan began working on the stylization of form while living at Voorburg; Robert van't Hoff discovered Frank Lloyd Wright while studying in the United States, and he returned to Holland and built Wrightian-style houses near Utrecht; architect J. J. P. Oud was working in Leiden. Free of the military in 1917, van Doesburg began to realize his dream by starting the journal *De Stijl*. He encouraged others with similar philosophy and ideas about abstraction, simplification, and mathematics to join him. By condemning Impressionism and baroque and by excluding the curve, representation, and sentiment from their art, they believed that only then could they embrace clarity, certainty, and order. Only by totally rejecting all historicism in architecture and subject matter in painting could the new art be invented.

The introduction of the first issue of the journal *De Stijl* stated the objective:

> to contribute something towards the development of a new sense of beauty. It wishes to make modern man aware of the new ideas that have sprung up in the Plastic Arts. It wants to set up the logical principles of a maturing style which is based upon a clearer relation between the spirit of the age and the means of expression, against the archaic confusion, the "modern baroque." It wants to combine in itself the present-day ideas on modern plastic art, ideas which, though fundamentally the same, have been developed individually and independently. . . .

By applying these principles to all design, the movement could include more than painting and architecture. Rietveld offered furniture, and in 1919 he joined the group and began to make his contribution to radical artistic unity. Van Doesburg's interior designs included Rietveld furniture just when the periodical *De Stijl* was becoming more international by creating links with Europe and the new Soviet Republic. In 1921 van Doesburg's ideas spread to the Weimar Bauhaus and were picked up by Marcel Breuer. De Stijl influenced Breuer for several years, and his versions of wood-slat chairs from 1922 to 1924 looked remarkably like Rietveld designs.

Rietveld's first wooden furniture, the famous armchair of 1918, has become a classic of radical modern design and, along with the paintings of Piet Mondrian, a symbol of the movement. The original stained chair was made of machined solid wood with a frame joined by dowels and the seat and back nailed to the frame. In 1923 he made another version painted in primary colors, hence the name "Red and Blue chair." Furniture, along with painting and architecture, was to start from scratch, as if the forms were being invented for the first time. Unlike invention based on function, as seen in the patent furniture of the nineteenth century, this early twentieth-century furniture saw invention based on form. Plus, it was no longer anonymous, because the designer's name was now important.

Furniture was presented by Rietveld and De Stijl as a combination of parts with visible points of connection. Horizontal and vertical planes were meant to be as distinct as possible. Space was allowed to enter the design, and the concept of positive and negative became part of the visual effect. The resulting geometric three-dimensional pieces of furniture with air flowing around the parts were comparable to the two-dimensional paintings by Mondrian. "Pure" form and primary colors—color-wheel red, yellow, and blue—with black, white, and gray could cross dimensional boundaries.

Rietveld designed and built the Schröder house at Utrecht in 1924, the first De Stijl architecture. He also designed a block of houses in 1928. But his abstract sculptural chair, this anti-ergonomic contribution to modern art, is what art historians remembered him by. When the Italian furniture manufacturer Cassina began to produce his Red and Blue chair and other early pieces in 1971, Rietveld's modest contribution to modern furniture design became accessible to all through the techniques of mass production.

RED AND BLUE.
Designed by Gerrit T. Rietveld, 1918. Rietveld's original armchair was made of machined solid wood with the frame joined by dowels and seat and back nailed to the frame, and stained. In 1923 he made a version in primary colors, which was mass-produced by Cassina beginning in 1971, beechwood marine plywood frame with black and yellow aniline finish, seat with blue lacquer finish, back in red lacquer finish. H 34-5/8; front seat H 13; base W 25-3/4, D 32-5/8. *(Courtesy of Cassina)*

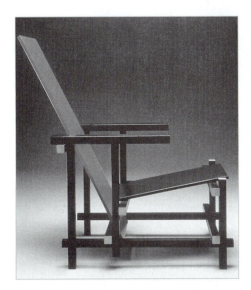

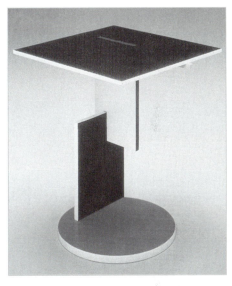

SCHROEDER TABLE.
Designed by Gerrit T. Rietveld, 1922–1923. Of black, red, and white geometric planes, creating an abstract sculptural effect. H 23-3/4, top 20-1/4 sq. *(Courtesy of Cassina)*

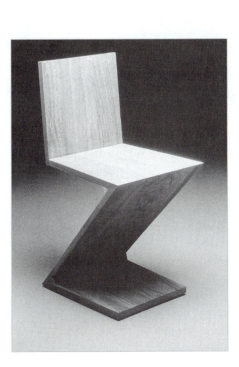

ZIG-ZAG CHAIR.
Designed by Gerrit T. Rietveld, 1934. Construction uses dovetailing and nuts and bolts; in the permanent collection of Museum of Modern Art (MOMA) in New York. Reissued in finished or unfinished edge-grain laminated elm. H 29; seat H 17; base W 14-1/2, D17. *(Courtesy of Cassina)*

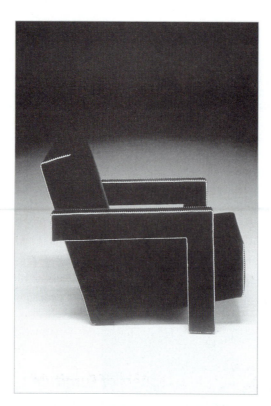

UTRECHT ARMCHAIR.
Designed by Gerrit T. Rietveld, 1935. An example of Rietveld's later Art Deco designs. Upholstered lounge chair in geometric form, with open arms in L-shape, contrasting welting to emphasize the lines. H 27-1/2, W 25-1/2, D 33-1/2. *(Courtesy of Cassina)*

UTRECHT SOFA.
Designed by Gerrit T. Rietveld, 1935. Curved back and seat, with open arms in L-shape, contrasting welting to emphasize the Art Deco lines. H 40, W 80. *(Courtesy of Cassina)*

Summary

- English Arts and Crafts ideals influenced the beginnings of most early twentieth-century modernism in Europe and the United States.
- Diverse modern styles shared smooth lines, rectilinear forms, and geometric and stylized motifs.
- Furniture was designed by architects striving to create functional holistic designs integrating interiors and exteriors.
- Most early modern design reached a limited audience, because it was still made by handicraft methods.
- Wright, whose career reached to the 1950s, was among the first to use modern principles, materials, and technology.

Chronology

1893 Frank Lloyd Wright opens his first architectural office.

1896 Charles Rennie Mackintosh meets Miss Cranston and begins to design Glasgow tearooms.

1897 Mackintosh begins Glasgow School of Art project.

1898 Newly formed Vienna Secession begins to exhibit.

1900 Paris World's Fair.

1900 Mackintosh's Ingram Street Tea Rooms.

1903 Wiener Werkstätte is formed.

1903 Mackintosh's Willow Tea Room.

1900–1909 Popularity of Wright's Prairie style houses.

1917 Gerrit Rietveld opens his first cabinetmaking shop, in Utrecht.

1919 Rietveld joins the De Stijl group.

1922 Josef Urban opens a branch of the Wiener Werkstätte in New York City.

1923 Wright's Tokyo Imperial Hotel resists earthquake.

1932 Wiener Werkstätte disbands.

Mid-1930s Wright designs Johnson Wax Building and furniture.

Major Architect-Designers of Furniture

Josef Hoffmann (1870–1956, Austria) Founder of Wiener Werkstätte, designs combined modern styling with Arts and Crafts philosophy.

Charles Rennie Mackintosh (1868–1928, Scotland) Leader of Glasgow School, known for interior designs of Glasgow Tea Houses and modern furniture.

Margaret MacDonald Mackintosh (1865–1933, Scotland) Wife of Charles Rennie Mackintosh and silent collaborator in many of his designs.

Gerrit Rietveld (1888–1964, Netherlands) Member of De Stijl movement, reduced design to minimal basic horizontals, verticals, and primary colors.

Frank Lloyd Wright (1867–1959, United States) Pioneer American modernist, leader of Prairie style and organic architecture, developed very early systems furniture.

Key Terms

De Stijl	organic architecture	Vienna Secession
Glasgow School	Prairie style	Wiener Werkstätte (Viennese Workshops)

Recommended Reading

Billcliffe, Roger. *Charles Rennie Mackintosh: The Complete Furniture, Furniture Drawings and Interior Designs*, 3rd ed. New York: E.P. Dutton, 1986.

Fahr-Becker, Gabriele. *Wiener Werkstaette 1903–1932*. Köln: Taschen, 1995.

Filippo, Alison. *Charles Rennie Mackintosh as a Designer of Chairs*. Milan: documenti di Casabella, 1973.

Jaffé, Hans Ludwig C. *De Stijl 1917–1931*. Cambridge: Harvard University Press, 1986.

Lind, Carla. *The Wright Style*. New York: Simon & Schuster, 1992.

Chapter *10*

ART NOUVEAU AND ART DECO
New or Déjà Vu?

CHAPTER CONTENTS

French styles at the end of the nineteenth and early twentieth centuries that relied on exotic materials and expensive handcrafting techniques ironically contributed to the beginnings of modernism. Their conscious departure from historic stylistic influence eventually led to the use of modern methods of mass production as well.

ART NOUVEAU: NEW OR DÉJÀ VU?

If you can imagine a bastard version of Louis XV furniture, decorated with carved escarole lettuce and cuivre tomatoes, in a room so overheated that the whole thing starts to melt into long running drips, you are visualizing Art Nouveau.

ROBSJOHN-GIBBINGS

In the nineteenth century, French furniture design paralleled that of England and the United States. Where Victorian revivals borrowed aspects of various European historic styles—Gothic, Rococo, Renaissance—the French revivals focused on the "Louis" for their interpretations. The resultant hybrids are easily identified as nineteenth-century products.

Contemporary British criticism resulted in various reform movements, such as Arts and Crafts, but there was no equivalent in France. However, the French search for a "new art" resulted in a style that could be used for all of the arts, including furniture. Like the Arts and Crafts movement, Art Nouveau established a common aesthetic ideal that could at least visually unify architecture, interior decoration, and the applied, or decorative, arts. Yet the styles had little in common visually. The French and Belgian Art Nouveau was curvilinear and often fussy, while the British Arts and Crafts was rectilinear and consciously anti-fussy.

Art Nouveau was primarily a French and Belgian phenomenon, partly because the visual elements were considered too shocking for most other late nineteenth-century audiences. Germany and Austria used a limited amount of the style, and Finnish designers such as Eliel Saarinen (1873–1950) used a restrained variant of Art Nouveau called Jugendstil. Although nature had always been a suitable subject for art, the extremes to which the Art Nouveau designers went frequently evoked strong criticism from its contemporaries. Confronted with little more than two choices—the hodgepodge of historic revivals or the "new art" with its "menacing tentacles"—the public usually opted for the former, because it was both familiar and safe. Yet the style's relatively few followers, short lifespan, and limited production was, nevertheless, adequate to include it in the history of style.

Siegfried Bing (1838–1905)

The man most responsible for promoting the style was Siegfried Bing (mistakenly called Samuel in a death notice, some historians have unknowingly perpetuated the error). Bing was born in Hamburg, Germany, in 1838 to a family of prosperous merchants. His father Jacob ran a business in Paris dealing in porcelain, and after graduating from school in Hamburg, Siegfried joined his father in Paris.

In 1868 Jacob Bing died, leaving Siegfried and his brother Auguste the money resulting from liquidating the business. Siegfried married Johanna Baer, from a wealthy Hamburg family, and the couple moved to Paris. Bing became interested in Japanese art and began to import and sell it in his shop. Martin Baer, Bing's brother-in-law, was acting consul for the German Ligation in Tokyo during most of the 1870s, and he had access to Japanese high society and knew of their collections. With Baer as his contact, Bing was able to purchase larger quantities of Japanese art, which by the 1878 Paris World's Fair, had become very popular in Europe. Bing made his first trip to the Far East in 1880, making purchases of both antiques and the work of contemporary Japanese artists.

Baer continued to make purchases for Bing's shop, as the business expanded to other European countries. In 1884 S. Bing et Cie was formed as a commercial trading company for contemporary art and raw materials from the Far East. This enabled Siegfried and Auguste Bing to keep the antiquities business separate. In 1888 Bing started publishing a journal devoted to Japanese art, called *Le Japon Artistique*, with beautiful color illustrations. Since it appealed to a popular audience, the journal promoted both Japanese art and Bing's business. Bing also helped to elevate the *ukiyo-e*, Japanese woodblock print, to a more serious level, he held Japanese art exhibits, and he was an innovator of the traveling exhibit.

Though not a reformer, Bing wished to elevate the decorative arts from a minor art to a level equal with the fine arts. In December 1895, he opened his galleries, named L'Art Nouveau. Bing wanted to show the work of artists, such as Louis Comfort Tiffany, who he had been introduced to in New York in the preceding year. The catalog accompanying the gallery opening explained that the exhibiting artists were opposed to historicism and to historic styles. They were against pretentious storytelling or mythology in painting as much as they were against heavy or ugly shapes in furniture. The new art that they sought would represent the unity of all arts and the beauty of utilitarian objects.

It was no surprise that Bing was severely criticized for trying to undermine established artistic dogma and for promoting so many non-French works of art. The local press considered him a rebel and even criticized the gallery exhibit space, his model rooms, and the interior and exterior design of the building. The foreign press was less harsh. As Bing's biographer Gabriel Weisberg points out, there were several possible explanations for Bing's initial failure: Bing worked alone rather than in an organized group; viewers were unprepared for the opening exhibit, which was shocking to them; they were also unprepared for the amount of foreign art; Bing never should have invited the conservative daily press; and Bing may have overestimated his own role as an arbiter of taste.

Yet, Bing continued to support foreign artists, such as Tiffany, who worked in the new style, while he also supported British Arts and Crafts and continued to deal in Japanese art. But acting as an artist agent was not enough if the style and his business were to succeed, so he began to produce his own furnishings, decorative arts, and especially jewelry in his ateliers, beginning in 1900. He hired leading Belgian architect-designer Henri Van de Velde (1863–1957) to design furniture and rooms for his shop, L'Art Nouveau. Van de Velde incorporated the ideals of the British Arts and Crafts, the style of Art Nouveau, and the beginnings of German modernism (see Chapter 11).

Nineteen hundred was the year of the Exposition Universelle Internationale—the 1900 Paris World's Fair. Although not included in the original catalog, Bing had a pavilion called L'Art Nouveau Bing, which contained everything from original cabinetwork to embroidered upholstery. Furniture by leading Art Nouveau designers was arranged with other decorative arts in Bing's rooms. The Exposition spawned the idea of an exhibition devoted entirely to modern applied arts; so in 1902, Turin, Italy, hosted the first International Exhibition of Modern Decorative Arts. The public could view the work of modernist Charles Rennie and Margaret Mackintosh (see Chapter 9), but they did not necessarily understand or appreciate it. The rooms of Victor Horta (1861–1947), leading Belgian Art Nouveau architect and designer were also misunderstood by many critics. However, Art Nouveau had been generally accepted at the fair, and individual designers, including Bing, won awards.

No sooner had the style found some degree of acceptance, than the curvilinear vegetal patterns began to lose favor, and the flowering of Art Nouveau began to wilt prematurely. In 1904, Bing closed L'Art Nouveau Bing, and his contemporary Julius Meier-Graefe closed La Maison Modern, leaving a great void in the Paris art community. Bing died in 1905.

Decorative Arts

Of all the Art Nouveau products, the most widely produced and admired objects were small in size. The interior at the turn of the century was generally filled with knickknacks. Where a building requires a tremendous commitment of resources, and is therefore intended to be long-lasting, interior accessories can be moved around, used in groups, or hidden. Glassware, pottery, bronzes, and other ornamental items were made into the new style, as well as personal adornment, such as jewelry.

The major center for making Art Nouveau objects, especially glassware, was Nancy, France. Emile Gallé and other glass artists and companies working in or near Nancy produced colorful multilayered vases and objects called cameo glass. Each color required a separate layer of glass, that was coated with an acid-resistant material over the design

motif. A dip in an acid bath removed the unwanted area of the particular color and layer of glass. They used primarily botanical subjects, and the extraordinary color combinations and craftsmanship exemplified Art Nouveau.

In the United States, Louis Comfort Tiffany of Tiffany Studios in Corona, New York, designed equally compelling glassware. His glass artists used hot glass techniques (rather than "cold" techniques of cameo decoration) to create new color combinations and new forms of "Favrile" handblown glass. Tiffany is also known for his works of art in leaded stained glass, especially lamp shades and lighting fixtures. In fact, the generic term "Tiffany lamp" has since come to refer to any decorative leaded stained glass shade, regardless of its design or quality.

Another leading American glass designer was Frederick Carder, founder of the Steuben Glass Company in Corning, New York, in 1903. Carder created countless models of colorful Art Nouveau (and Art Deco) glass until the early 1930s, when Steuben chose to discontinue all colored wares and devote the entire output to clear crystal. Where Tiffany only designed, Carder was both a designer and a master glassmaker. Although his interpretations of the French style were unlike Tiffany's, both exemplify American Art Nouveau.

Besides vases and lamps, glass was used in combination with precious metals to make Art Nouveau jewelry. French designer René Lalique made fantastic combinations of insects and human females, using enamel or plique-à-jour, a technique similar to cloisonné. The transparent colored-glass design is suspended between thin metal wires (without metal backing, as in cloisonné). The resultant jewelry is like miniature stained glass windows in the form of dragonfly wings or other elements of nature. Lalique's jewels, though rarely seen outside museum cases, are among the most exquisitely crafted objects of the period.

Besides materials of glass and metal that require light for their sparkle and color effects, the Art Nouveau style was also suited to pottery. Companies in Europe and the United States did not necessarily specialize in the style, but used it as one of the styles used in their production. For example, American art pottery firms designed Art Nouveau vases as well as less flamboyant items. Van Briggle in Colorado made vases of single colors with molded sculptural female nudes integrated into the form; Rookwood of Ohio painted floral motifs equaling those on French cameo glass. In Europe, companies such as Rohrstrand in Sweden made delicately molded and colored Art Nouveau porcelain. Others, like Amphora in Austria, made both porcelain and heavier sculptural pottery in the style.

Furniture

While the majority of Art Nouveau objects were smaller decorative arts—glass, pottery, or metal—the style also influenced architecture and furniture design. Examples are rarely seen, however, and most are French or Belgian. Where bronze nymphs with sprays of lightbulbs in the form of flowers were temporarily amusing, furniture was always taken more seriously, especially in a country known for furniture of the Louis. French furniture had a reputation for some of history's finest cabinetwork and wealthiest monarch patrons. In the eighteenth century, France had set the standards of quality for form and decoration, if not function. Whether the highly ornamental pieces are recognized today as being functional, they were intended as such in their time. Designs required appropriate construction before any thought was given to decoration. It is generally agreed that part of the success of this eighteenth-century furniture lies in its balance of structure, function, and ornament.

Critics observed that furniture design in the nineteenth century lost all of the qualities that had made it great in the eighteenth. After the Empire style, copies and combinations characterized most nineteenth-century French furniture. Since this lack of originality was perceived as the most obvious shortcoming, designers strived for something very new. In many cases their search for novelty was so intense, they overlooked the basics of structure

and function. In the resultant Art Nouveau pieces, only the ornament was new, and it was not necessarily considered better.

Like other Art Nouveau objects, nature was its only theme. Where exaggeration may have succeeded for other art forms, it pushed furniture into the realm of sculpture. Stretched, twisted, and smothering tendrils were beautifully carved in wood, obscuring its form as a piece of furniture. While intriguing as novelty or even as a work of art, it had lost its status as functional decorative art. Whether a chair or a cabinet, an Art Nouveau piece of furniture could mimic tree roots or a giant insect holding onto them.

In addition to sculptural carving, intricate marquetry was used to present the same themes pictorially. Where earlier Rococo designers might have used marquetry to compliment an already elegant form, Art Nouveau practitioners often used it in place of one. Where decorative plants worked well on glass vases, they were less successful for the shelves upon which the vases were placed. Instead of showing off objects, the case pieces were themselves objects of display. Not all Art Nouveau furniture was extreme or excessively ornamented, but those that were gave the style its reputation for eccentricity. Regardless of its appearance and whether its owner's taste was questioned, Art Nouveau furniture was made at great expense of material, skill, and time. Its subsequent costliness explains its rarity today.

Perhaps the most curious aspect of the style was the name "new art." In the evolution of modernism and of modern art, one of the issues has been that of handicraft versus industrial production. The Arts and Crafts proponents struggled with the question of machine-made art, and later, industrial designers were suspected of being more devoted to industry than to design. Art Nouveau clearly is not modern, unless shear novelty is considered enough to warrant the label. At closer look however, even the novelty can be questioned. The elements that help to define Rococo furniture—asymmetrical, curvilinear, use of nature as subject, feminine, finely handcrafted, use of marquetry, ornamental carving, bronze mounts, costly—also define Art Nouveau. It only added some ornamental exaggeration and subtracted some structural integrity and function. The similarities to Rococo seem to outweigh any connection to modernism. Yet, as with any period or style, it is unfair to generalize. If Art Nouveau ranged from Rococo interpretations to truly unique forms, then these special pieces should be acknowledged. Two designers in particular, Emile Gallé and Louis Majorelle, can be credited with providing some of the best examples of both the typical and atypical designs.

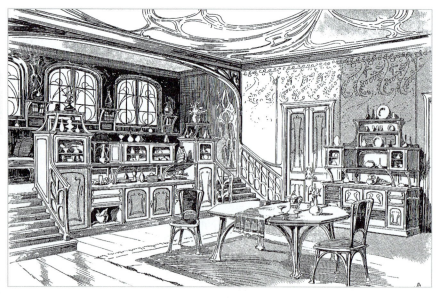

French Art Nouveau interior, circa 1900. *(Benn 1904)*

Emile Gallé (1846–1904)

Gallé's father Charles Gallé-Riemer had a small faience factory in St. Clément, near Nancy, France. Emile Gallé was born in 1846, and as a child was interested in botany and in drawing flowers and plants. He was able to apply some of his skills decorating pottery in the family factory, and then at age sixteen he studied in Germany and apprenticed as a glassmaker.

Gallé returned to France in 1870 and worked for his father before opening his own glass studio in Nancy in 1874. He gradually became interested in furniture design and in 1884 opened a cabinetmaking shop. At first Gallé hired woodworkers, but eventually he learned enough from them to personally work on some of the furniture. The first product was not in Art Nouveau, but rather in combinations of historic styles. He used marquetry as a decorating technique as early as 1885, but it was nothing like the Art Nouveau marquetry that Gallé would soon become known for.

Gallé used delicate Japanese-inspired designs using a variety of exotic woods in contrasting tones and crafted by artists such as Victor Prouvé and Louis Hestaux. Art Nouveau and/or Japanese themes of poppy, waterlily, orchid, chrysanthemum, iris, butterfly, and dragonfly were used for the flat marquetry designs, while sculptural dragonflies might also form furniture legs or borders around pieces such as cabinets. Plants native to Lorraine—thistle, cow parsley, pine, wheat, grape—were other favorite Gallé motifs.

By the turn of the century, the style was widespread enough to warrant a school, and Gallé, along with other artists, Eugene Vallin and Louis Majorelle, founded L'Ecole de Nancy (**School of Nancy**). By 1904, Gallé's furniture was not only available from the factory in Nancy, but in his shops in Paris, Frankfurt, and London as well. Then in that year, he died, but his factory continued to produce furniture and glass until 1935.

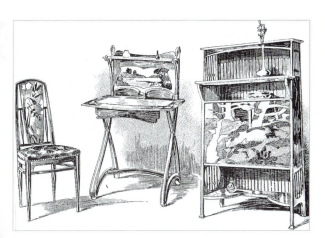

Examples of Art Nouveau furniture with extensive use of marquetry, a trademark of Emile Gallé. *(Benn 1904)*

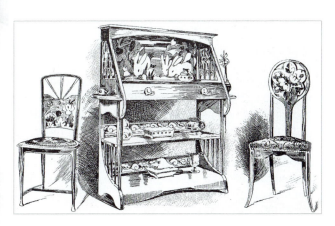

Examples of Art Nouveau furniture with extensive use of marquetry, Emile Gallé, circa 1900. *(Benn 1904)*

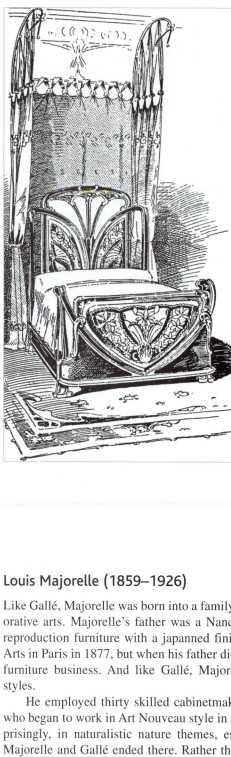

Art Nouveau bed emphasizing carving, typical of Louis Majorelle, and heavier than the delicate furniture by Gallé. *(Benn 1904)*

Louis Majorelle (1859–1926)

Like Gallé, Majorelle was born into a family that was already established in making decorative arts. Majorelle's father was a Nancy cabinetmaker who specialized in antique reproduction furniture with a japanned finish. Majorelle studied at L'Ecole des Beaux Arts in Paris in 1877, but when his father died in 1899, he returned home to continue the furniture business. And like Gallé, Majorelle's early furniture was made in historic styles.

He employed thirty skilled cabinetmakers, marquetry artists, and bronze workers, who began to work in Art Nouveau style in the early 1890s. The marquetry was, not surprisingly, in naturalistic nature themes, especially flowers, but the parallel between Majorelle and Gallé ended there. Rather than focus on decoration, Majorelle was most interested in form and proportion, and from the 1890s to about 1910, he produced some of the most outstanding pieces of Art Nouveau furniture known. Then, from about 1910 to 1914, when the style faded, his furniture became heavier and less inspired. But the decline had already begun in 1906, when Majorelle industrialized his workshops. In an attempt to produce a larger volume at a lower cost, the furniture lost the luxuriousness that made it so unique.

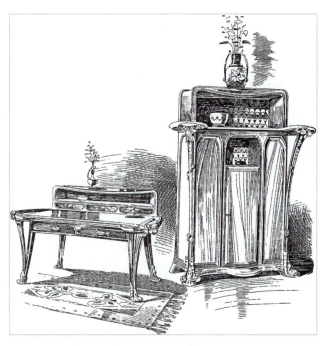

Art Nouveau furniture by Louis Majorelle. *(Benn 1904)*

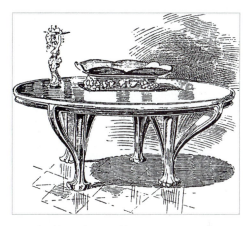

Round table with carved legs, Louis Majorelle.
(Benn 1904)

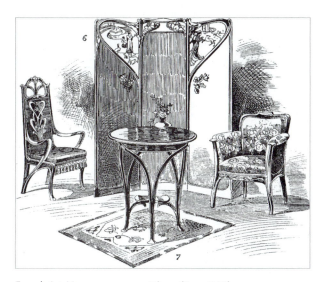

French Art Nouveau room setting. *(Benn 1904)*

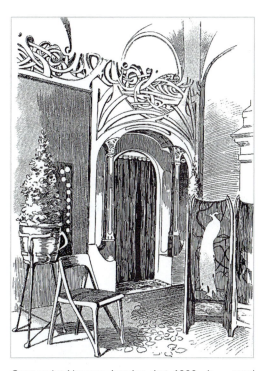

German Art Nouveau interior, circa 1900. *(Benn 1904)*

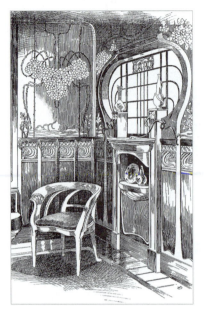

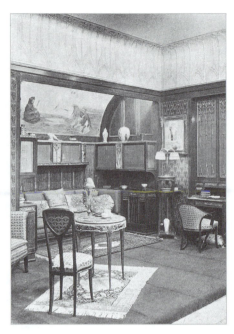

Austrian Art Nouveau interior, circa 1900. *(Benn 1904)*

Boudoir designed and executed by Louis Majorelle. *(The Studio 1914)*

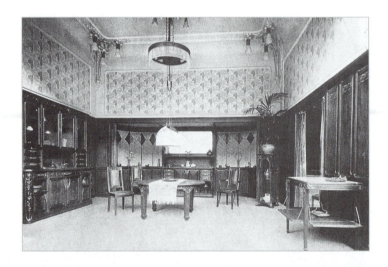

Dining room designed and executed by Louis Majorelle. *(The Studio 1914)*

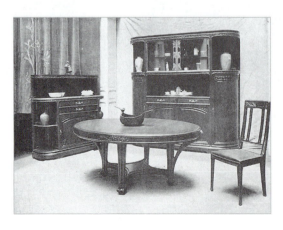

Art Nouveau interior by Louis Majorelle, 1914. *(Sedeyn)*

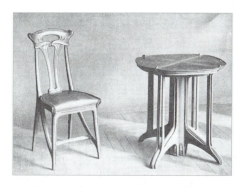

Art Nouveau chair and table designed by
Eugène Gaillard, 1913. *(Sedeyn)*

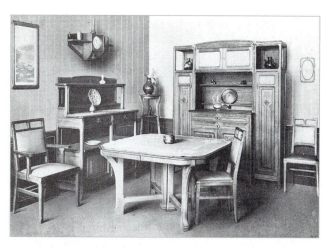

Art Nouveau interior, 1908. *(Sedeyn)*

1918
World War I ends with 65
million mobilized, 8.5
million killed, 21 million
wounded, and 7.5 million
prisoner and missing; U.S.
airmail and airmail stamps;
electric mixer; plasterboard;
Eighteenth Amendment
(prohibition).

Born 1918
Spiro Agnew (d. 1996);
Ingmar Bergman; Leonard
Bernstein (d. 1990); Howard
Cosell (d. 1995); Billy
Graham; José Greco
(d. 2000); Susan Hayward
(d. 1975); Rita Hayworth
(d. 1987); William Holden
(d. 1981); Nelson Mandela;
Gamal Abdel Nasser
(d. 1970); Robert Preston
(d. 1986); Anwar el-Sadat
(d. 1981); Haile Selassie I
(d. 1975); Alexander
Solzhenitsyn.

Died 1918
Claude Debussy (b. 1862);
Gustav Klimt (b. 1862).

AMERICAN ART NOUVEAU

American Art Nouveau furniture was never particularly inspired or representative of the
style. Nor was it well understood or popular. Unlike the handcrafted French furniture,
American versions were commercially produced, blending elements of "Mission"
or other styles. In attempting to imitate Majorelle, American companies ultimately
standardized the motifs until they became no more than clichés. Female figures with
flowing hair, vegetation, and whiplash curves were forced onto contemporary furniture
in the same manner that Gothic motifs had been grafted onto early Victorian pieces.
After all, furniture makers were already accustomed to arbitrarily plunking most any
historic motif onto another historic form. Mixing periods and styles were the hallmark
of the nineteenth century. With Art Nouveau, the practice continued, and the motifs
changed.

Chicago companies such a S. Karpen Bros. and The Tobey Furniture Company
advertised carved furniture using the Nancy method. But since marquetry was purchased
in completed panels, it was neither related to the form of the piece nor its quality. Fine
marquetry work might be added to a crude chair, or crude marquetry could just as eas-
ily be incorporated in a well-constructed piece. These panels and inlays were often
imported from France, and when they were used correctly, it caused difficulties with
later attribution.

The better quality American furniture was usually made of mahogany, and one of the
few designers to experiment with the style in the French manner was Louis Rorimer of
Cleveland, Ohio. His interior design company produced the latest fashions, because Ror-
imer was educated in Europe and made frequent trips to the major design capitals. How-
ever, some American furniture makers used cheap mahogany or other hardwood, and even
an unlikely Art Nouveau material, oak. Stain was used to imitate natural wood tones of
French pieces. Paint, burning, or decal designs were also used to make cheap imitations of
the costly French furniture. Perhaps an even more important explanation for the general
failure of American Art Nouveau was the connotation of decadence and sensuality. Amer-
icans at the turn of the century preferred the associations of Mission oak—"cleanliness,
simplicity, and honesty."

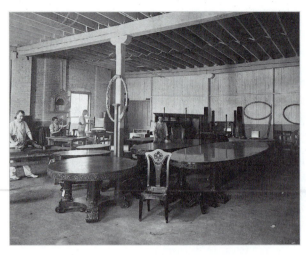

Workshops of the Rorimer-Brooks Studios showing craftsmen finishing large tables and one Art Nouveau chair (center front), circa 1910.

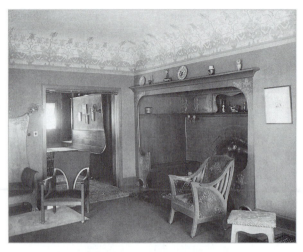

Art Nouveau interior designed by Louis Rorimer, executed at Rorimer-Brooks Studios, circa 1910.

ART DECO: NEO NEO CLASSIC

Art Deco is a convenient label for a complex range of styles that evolved from the earlier French Art Nouveau. An elitist attempt at a "new art" (**Art Nouveau**) in Europe was transformed into an elitist "modern art" (**Art Moderne**) at the time of the First World War. Shortly before, around the turn of the century, several organizations were formed to promote the applied arts, notably the nonhistoricist and democratic (Austrian) Wiener Werkstätte (see Chapter 9) and the (German) Deutscher Werkbund (see Chapter 11). In France, the Société des Artistes Décorateurs was founded in 1907, also to promote the applied arts. It too held annual exhibits, but the society was reluctant to acknowledge industrial production, preferring historical references. It was also an elite rather than democratic organization. Austria and Germany, however, did help to bridge the two styles of Art Nouveau and Art Deco in organizations such as the Wiener Werkstätte.

The term "Art Deco" is a relatively recent one, coined in the 1960s. The contemporary label of the 1910s and 1920s was "Art Moderne." Although Art Moderne had its spirit in the present modernizing world, its traditional manufacturing methods connected it to the past. Sumptuous objects were handcrafted by techniques reminiscent of French *ébénistes* in the courts of the Louis. Design had the distinct flavor of classicism along with its later interpretive revivals. Exotic tropical woods, ivory, **shagreen**, and metals embellished the furnishings of the fashion-conscious wealthy class. French Art Moderne, as shown at the 1925 Paris International Exposition, was closer to a modern style than its predecessor, Art Nouveau, but its handicraft methods and subtle historicism made it more of a transitional style.

L'Exposition des Arts Décoratifs et Industriels Modernes, better known as the 1925 Paris Exposition, spotlighted the achievements of contemporary design and industry. From April through October, the center of Paris displayed 130 individual showplaces of art, commerce, and industry, plus individual artists, manufacturers, and commercial establishments. Twenty nations participated, but Germany was not invited, and the United States had declined. Leading designers and manufacturers of French Art Moderne furniture were prominently shown: Maurice Dufrene (1876–1955), Paul Follot (1877–1941), Léon Jallot (1874–1967), Francis Jourdan (1876–1958), André Mare (1887–1932), Louis Süe (1875–1968), and Jacques-Emile Ruhlmann (1879–1933).

Art Moderne designers can be categorized as being either primarily traditionalists or tending toward modernism. Dufrene, a prolific and versatile designer, was a founding

1920
National Football League; Babe Ruth sold to the Yankees for $125,000; New York City population ten times that of Los Angeles; Agatha Christie's first novel; first commercial radio station; U.S. women vote; "tommy gun" patented.

member of Salon des Artistes Décorateurs in 1904, where he exhibited for thirty years. A modernist and an advocate of the use of machinery as a tool, he participated in the transition from wood to the use of metal and glass in the 1930s. The other name associated with modern, rather than traditional, French Art Deco furniture is Francis Jourdan. His geometric furniture was exhibited at Salon d'Automne at the height of Art Nouveau, in 1902. His philosophy of pro-simplicity and anti-excess place him as a pre-Bauhaus modernist. Jourdan used wood, but by 1925 he also experimented with steel, aluminum, and wrought iron.

Jallot headed Bing's furniture workshop for La Maison de L'Art Nouveau, and his furniture had simple lines and was often lacquered or covered in shagreen. Follot's "pure" Art Deco style was neoclassical, luxurious, and aristocratic. Other important designers of French Art Deco furniture include Jean-Michel Frank (1895–1941), known for his use of unusual materials such as straw, vellum, parchment, snake and shark skin, and gypsum; and André Groult (1884–1967) whose use of sumptuous materials were accused of being too theatrical. The names most associated with French Art Deco furniture are also traditionalists, Süe et Mare and Ruhlmann.

Upholstered tub chair and side chair in traditional Art Deco style with strong neoclassical influence, by André Groult, 1920. *(Sedeyn)*

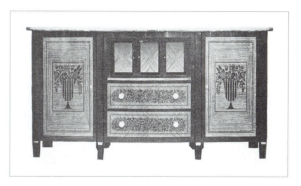

Sideboard with inlaid decoration, designed and executed by André Groult, 1914. *(The Studio)*

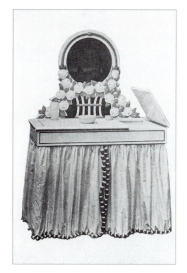 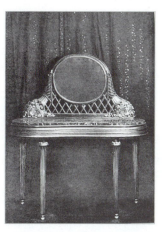

Toilet table with round mirror and draped fabric, designed and executed by André Groult, 1914. *(The Studio)*

Toilet table with strong Neoclassical influence, by Paul Follot, 1919. *(Sedeyn)*

Inlaid cabinet with curved front and thin tapered legs, by Paul Follot, 1920. *(Sedeyn)*

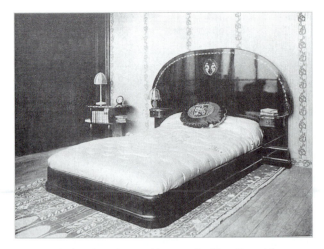

Art Deco bed with no legs and large arched headboard, by Maurice Dufrène, 1920. *Sedeyn*

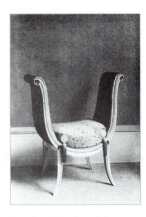

Bench with splayed legs and exaggerated high sides, by Maurice Dufrène, 1918. *(Sedeyn)*

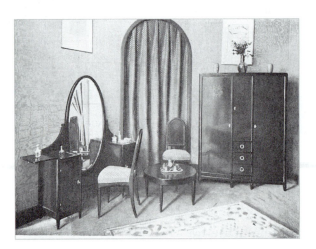

Bedroom suite with smooth lines, by Léon Jallot, 1919. *(Sedeyn)*

Armchair designed by Jean Michel Frank, circa 1930. *(Courtesy of Palazzetti)*

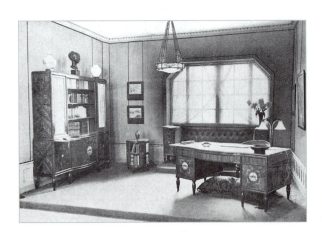

Veneered cabinet, low cylindrical bookcase, and desk, by Léon Bouchet, 1920. *(Sedeyn)*

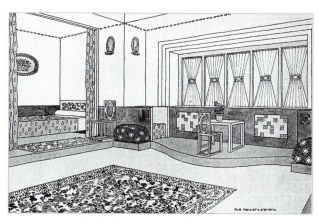

Sketch of bedroom design with bed recessed in nook, designed by Mallet-Stevens, 1914. *(Sedeyn)*

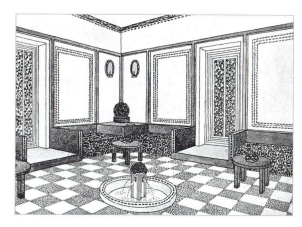

Sketch of entrance hall design with paneled walls and circular fountain, designed by Mallet-Stevens, 1914. *(Sedeyn)*

Stacking chair attributed to Robert Mallet-Stevens, 1930. *(Courtesy of Palazzetti)*

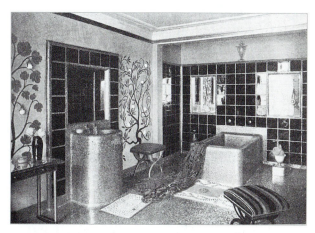

Art Deco bathroom with tiled and painted walls and built-in sink and tub, by "Martine" in 1914.

Born 1920
Dave Brubeck; Timothy Leary (d. 1996); Julie London (d. 2000); Walter Matthau (d. 2000); Mickey Rooney; Ravi Shankar; Isaac Stern (d. 2001).

Died 1920
Amedeo Modigliani (b. 1884); Max Weber (b. 1864).

1921
Adolf Hitler becomes leader of Nazi party; insulin; British Broadcasting Co.; first Miss America beauty pageant; cultured pearls.

Jacques-Emile Ruhlmann (1879–1933)

Ruhlmann's exquisitely designed and crafted furniture represents the epitome of early French Art Deco style. He was born in Paris in 1879 and had no formal training in furniture design or cabinetry. In 1900 he joined his father's decorating business, which specialized in paint, wallpaper, and mirrors. His father died in 1907, the same year that Ruhlmann married Marguerite Seabrook. His interest in furniture increased, and his first exhibit was at Salon d'Automne in 1913. Since Ruhlmann had served in the military as a young man, he did not participate in World War I, like many of his contemporaries, so the years 1914 to 1918 were productive years for his furniture design.

In 1919 Ruhlmann began a partnership in a decorating business with Pierre Laurent. The cabinetry workshops were housed in the same building as their showroom and soon began to fill the building with thirteen artisans making furniture. Ruhlmann made ink sketches, which his draftsman completed. Each piece was made by hand of the finest materials—veneers of palisander, amboyna, amaranth, macassar ebony, Cuban mahogany, inlays of ivory, tortoise shell, and horn, plus leather, parchment, and silk tassels. The costliness and time required to produce his luxurious furniture prevented him from becoming recognized outside of a small group of elite clients. The 1925 Paris Exposition brought sudden exposure and fame for the work done between 1913 and 1924. But he had only a few more productive years. Ruhlmann died in 1933, and his firm dissolved.

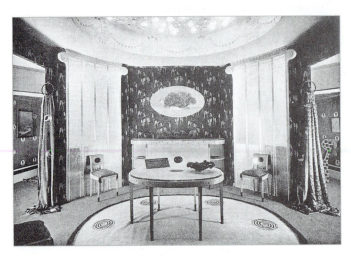

Circular reception room designed and executed by Jacques Ruhlmann, 1914. *(Sedeyn)*

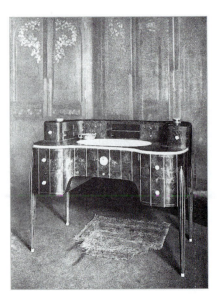

Kidney-shaped two-tiered bureau by Jacques Ruhlmann, circa 1910s. *(Sedeyn)*

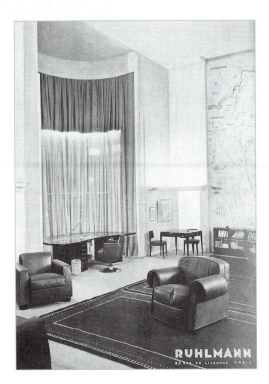

Advertisement for Ruhlmann furnishings with overstuffed chairs, in *Decorative Art 1930.*

Süe et Mare

Next to Ruhlmann, the names most associated with fine French Art Deco furniture are Louis Süe and André Mare. Süe was born in Bordeaux in 1875. His father, a doctor, wanted his son to follow a career in medicine, but Louis Süe left for Paris in 1895 to study at L'Ecole Nationale des Beaux-Arts. After earning a diploma in 1901, he also studied architecture.

Süe both exhibited paintings at the Paris Salons and designed houses. He established his own decorating firm before forming the famous partnership with André Mare in 1919.

For the next ten years, the firm produced a variety of furnishings. The furniture was made from macassar ebony, mahogany, palisander, burl walnut, ash, beech, and birch. Comfort and luxury were its hallmarks, as seen in the colorful tufted velour upholstery and ormolu. Like modernized French Rococo, their more traditional furniture received almost as much attention in their pavilion at the 1925 Paris Exposition as Ruhlmann's.

André Mare was born in Argentan in 1887. After studying painting at Académie Julian, he began to exhibit at the Salons. By 1910, he became more interested in decorative arts, especially furniture. Between 1911 and 1913 he collaborated with several important artists and met Süe, but they did not enter a formal relationship until after the war, in 1919. Mare established his own business before the war, and while serving in the military, his wife Charlotte took over and produced furniture, carpets, and fabrics. After the war, the partnership of Süe et Mare was formed, and it continued until 1928, producing some of the finest French Art Deco furniture.

Table-bureau, by Süe et Mare, 1920. *(Sedeyn)*

Commode with marble top and oval mirror, by L. Süe, A. Mare, and P. Vera, 1919. *(Sedeyn)*

Inlaid cabinet on exaggerated tall slender legs, by Clément Mére, 1913. *(Sedeyn)*

Eileen Gray

Eileen Gray was one of the few female designers known for working in Art Deco style—both the traditional and the modern versions. She was born in Wexford County, Ireland, the youngest of five children, and the family also had a house in London, in South Kensington. Her father, James Maclaren Gray, liked to paint, and he often traveled to Italy and Switzerland, accompanied by Eileen. He died in 1900, but he had already instilled an interest in both art and the European continent in his daughter. She attended the Slade School in London and then settled in Paris, where she continued her education at L'Ecole Colarossi and Académie Julian. By 1902 Gray was spending more time in Paris than London, and in 1907 she moved to Paris. Like a few other fortunate designers, her family was of comfortable means, which made it easier for her to take risks, and Gray was one of the very early advocates of women's liberation.

Artistically, she was very interested in lacquer applied to wood, and she made screens and furniture using this ancient oriental technique. In 1913 she exhibited at the Salon des Artistes Décorateurs, where Emile-Jacques Ruhlmann was also exhibiting for the first time. Gray's work showed well with Ruhlmann's, not so much in style as in its crafting,

originality, and luxuriousness. Her lacquerwork attracted the attention of art collector Jacques Doucet, who became Gray's most important patron. In 1915 she returned to London with her Japanese lacquer teacher, Sougawara.

Her first full interior project was in Paris in 1919. By 1922 she was able to open her own gallery, Galerie Jean Désert, in order to exhibit and sell avant-garde designs, namely, expensive lacquered furniture and abstract modernist rugs and carpets. It lasted until 1930, when after losing interest in lacquer and luxury, Gray moved on.

Her attention then focused more on architecture and modern furniture, something that interested her as early as 1922. At an exhibit in Amsterdam, Gray had met members of the Dutch avant-garde, such as Jan Wils of the De Stijl group (see Chapter 9), and she designed a table for him in the geometric De Stijl spirit. From 1926 to 1929 Gray collaborated with Romanian architectural critic, Jean Badovici, and built a house near Monte Carlo, called E-1027. The tubular steel furniture she designed for the house, such as the asymmetrical one-armed chair, was different from most Bauhaus (see Chapter 11) tubular steel. In 1930, the first exhibit of the new French organization, Union des Artistes Modernes (U.A.M.) was held, and Gray and Badovici showed the plans of E-1027. From 1932 to 1934 she designed another house for herself.

In 1937 Gray retired, with only a small body of work to her credit. But it was the quality more than the quantity that she is recognized for. By the 1970s, especially after the auction of the Doucet estate, there was a revival of interest in her designs, ranging from lacquered wood with carved ivory and inlay to chrome-plated tubular steel. She died in Paris in 1976. During her career, Gray designed a De Stijl style geometric table, French Art Deco lacquer, tubular steel with or without exotic woods, and a free-form plywood table on metal legs. Both the originality and variety of Gray's Art Deco style place her in the company of other important early modernists. Her work with tubular steel has the same blend of elegance with modern functionality as that of Finnish designer, Pauli Blomsted (see Chapter 11).

CREDENZA.
Designed by Pauli Blomsted, circa 1930. Black credenza in modernist Deco style, with four drawers, extra shelf supported by circular tubular steel, open rounded shelves at one end, and tubular steel continuous legs. *(Courtesy of Arkitektura)*

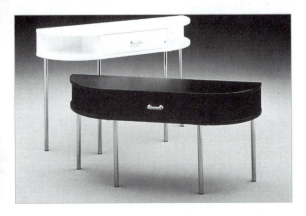

CONSOLE TABLES.
Designed by Pauli Blomsted, circa 1930. Black-and-white console tables with curved front and tubular steel legs. *(Courtesy of Arkitektura)*

AMERICAN ART DECO

American modernism was relatively late blooming. The United States was noticeably absent at the milestone event that introduced modern decorative arts to the design-conscious world. When Secretary of Commerce Herbert Hoover received the French invitation to show American modern art, he declined. However, Hoover appointed a group of delegates from manufacturing, retail, and decorating fields to visit the exhibit and report back on what America was apparently missing. Their return home from Paris late in 1925 marked a significant beginning to a transformed, commercialized, Americanized Art Moderne, or as it was later called, Art Deco.

By 1925, France and other European nations began to grow tired of the style with design clichés of leaping gazelles and nudes. But after the style crossed the Atlantic, it was transformed. America was like a giant petri dish with an environment hospitable to the design elements of Art Moderne plus new industrial materials and the concept of mass production.

Art Deco entered America at the port of New York in the display windows of major department stores. First, fashion—clothing, accessories, perfume bottles, and furnishings used as props—caught the eye and the imagination of the American consumer. Originally intended to be relatively inaccessible and absolutely costly, items were soon desired for their appearance rather than for materials and crafting techniques. The new Americanized look was no more costly than the tired historic and bland generic "styles" it soon replaced. Art Deco graphic design quickly appeared in periodicals and on posters, and the style was equally suited to the manufacture of useful objects. Infatuated by mass production, speed, metallic sparkle, and the new age that they represented, American designers adapted the French look to a different culture. From architecture and furniture to plastic jewelry, American Art Deco had its spirit in the future and its body in a rapidly transforming present.

But design elements were soon trivialized without apology. In the late 1920s and 1930s the United States developed its own clichés and promises of a brave new world—rounded corners and three parallel lines signifying streamlining, a stepped or tiered pattern resembling a skyline of skyscrapers, and an Americanized female dancing nude. The geometry of Cubism replaced the representational motifs of tradition. With added ingredients from ancient Egypt—after the discovery of King Tut's tomb in 1922—Pre-Columbian Mexico, some less-explainable European peasant art, and the austere simplicity of the German Bauhaus, the American Art Deco stew was ready for mass consumption. This meant, of course, that mass, or at least factory, production and marketing were needed. America was the logical place, and the furniture industry was one of several ready to accommodate. Among the best marketing devices were once again the great exhibitions. The Chicago Century of Progress Exposition of 1933 helped to introduce America's modern interiors by designers such as Gilbert Rohde. Then in 1939, two great shows—the San Francisco Golden Gate Exposition and the New York World's Fair—became milestones in the history of modernism and the Art Deco style.

Some American designers who did not necessarily focus on furniture design nevertheless made significant contributions to the Art Deco style. For example, Joseph Urban (1872–1933) was born in Austria and was active in Vienna and United States. He was the designer for Ziegfeld's *Follies*, art director of Metropolitan Opera, founder of the Wiener Werkstätte of America, and he designed numerous interiors in Art Deco style. Another influential figure, Eliel Saarinen, was born in Finland and was active in Finland and United States. A major force in modern architecture and design, Saarinen moved to the United States in 1923. He designed the buildings and Art Deco furniture of Cranbrook Academy of Art, where he also became its president. Eugene Schoen (1880–1957) was an American architect and designer. His Art Deco furniture had a neoclassical influence and used exotic veneers. Other American designers, such as Gilbert Rohde (1884–1944) made significant contributions to both Art Deco furniture and to the new field of industrial design, and are therefore included in Chapter 12. Karl Emanuel (Kem) Weber (1889–1963) worked in zigzag modern and then streamlined style in his Hollywood office. Louis Rorimer did the Chrysler Suite in the Chrysler Building, the New York City Art Deco icon designed by William Van Alen. Two designers in particular stand out for their contributions to American Art Deco furniture—Donald Deskey and Paul Frankl.

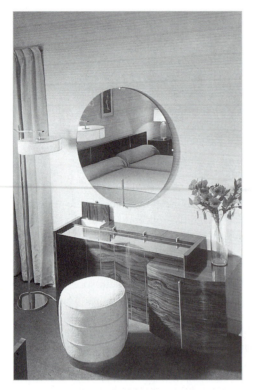

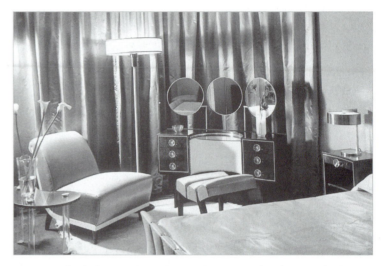

Vanity of Brazilian rosewood with mahogany inlay, designed by Gilbert Rohde for Herman Miller in 1937, with ottoman designed in 1933. *(Courtesy of Herman Miller, Inc.)*

Herman Miller bedroom group of East India rosewood and sequoia burl, designed by Gilbert Rohde in 1939. *(Courtesy of Herman Miller, Inc.)*

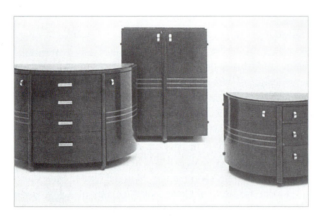

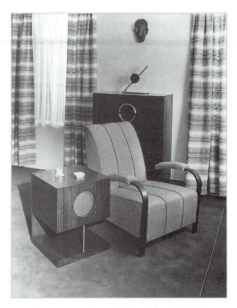

Bedroom set with inlaid horizontal bands, designed by Gilbert Rohde for Herman Miller for the 1933 World's Fair in Chicago. *(Courtesy of Herman Miller, Inc.)*

Armchair and radio table designed by Gilbert Rohde for Herman Miller in 1934. *(Courtesy of Herman Miller, Inc.)*

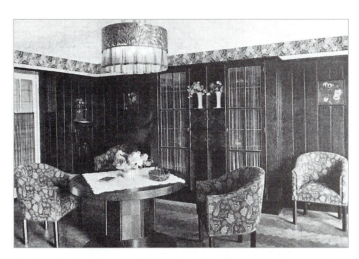

Austrian Art Deco interior, 1914.

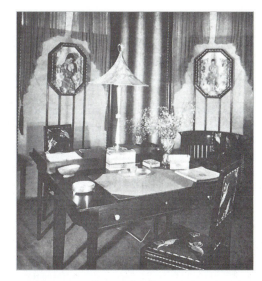

Austrian interior by Joseph Urban, 1910s. *(Hunter)*

Ornate chair and table with Wiener
Werkstätte and Art Deco styling, by Joseph
Urban, 1910s. *(Hunter)*

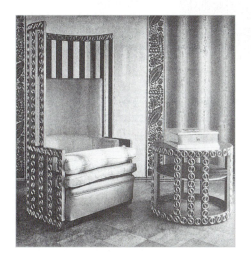

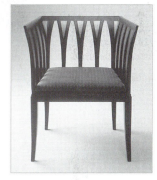

BLUE CHAIR.
Designed by Eliel Saarinen,
1929. Art Deco inspired design
of lacquered solid birch and
painted detail. *(Courtesy of ICF
Group)*

HANNES CHAIR.
Designed by Eliel Saarinen,
1908. Designed for the
home of his brother
Hannes in Finland, this
modern design anticipates
the later Art Deco style.
(Courtesy of ICF Group)

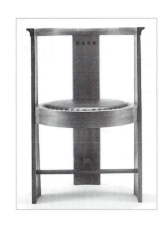

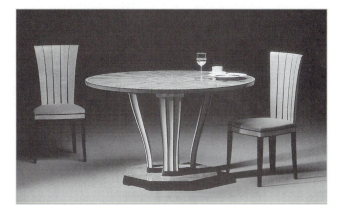

DINING TABLE AND CHAIRS.
Designed by Eliel Saarinen, 1929. Made for the Saarinen House at
Cranbrook, the ebonized pine and natural maple shows the
influence of French Art Deco. *(Courtesy of Arkitektura)*

Born 1927
Günter Grass; Sidney
Poitier; George C. Scott
(d. 1999); Neil Simon.

1928
Amelia Earhart is first
woman to fly across the
Atlantic; Vitamin C
discovered; penicillin
discovered; Joseph Schick
invents electric razor; Frank
Whittle invents the jet
engine; D.H. Lawrence's
Lady Chatterley's Lover; first
Mickey Mouse film with
sound; Ravel's *Bolero*;
although there were only
15,000 registered voters,
Liberian president Charles
King was re-elected by a
600,000 vote lead.

Born 1928
Maya Angelou; Stanley
Kubrick (d. 1999); Vidal
Sassoon; Shirley Temple;
James Watson.

Died 1928
Thomas Hardy (b. 1840).

1929
New York stock market
crash and $26 billion
securities devaluation; first
Academy Awards—*Wings*
best picture; first television
tube; FM radio; comics *Buck
Rogers* and *Popeye the
Sailor*; William Faulkner's
The Sound and the Fury;
songs "Stardust," "Singin' in
the Rain," "Tiptoe Through
the Tulips," "Makin'
Whoopie," and "Button Up
Your Overcoat."

Born 1929
Yasir Arafat; King Hassan II
(d. 1999); Audrey Hepburn
(d. 1993); Jacqueline
Kennnedy Onassis (d. 1994);
Martin Luther King, Jr.
(d. 1968); Arnold Palmer.

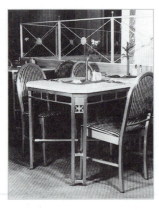

Art Deco aluminum chairs and table designed by William Green and Andrew Probala of Rorimer-Brooks Studios for the Silver Grille Restaurant in Cleveland, Ohio, 1930.

Art Deco bench with stylized silver plant, in front of tiered "skyscraper" footboard of Louis Rorimer's bedroom set in his summer home, 1929.

Donald Deskey (1894–1989, United States)

Known for his dazzling Art Deco designs, Donald Deskey was one of the first to integrate modern art into advertising design and manufactured products and also one of the first to introduce tubular steel furniture in the United States. Originally from Minnesota, he studied at Mark Hopkins Institute (California School of Fine Arts), the University of California at Berkeley, and in Paris. After serving in the military, he moved to New York City in 1921 to work in advertising, but since his work was considered too modern, he opened his own agency. After traveling to Paris twice and seeing the 1925 Decorative Arts Exhibition, he worked in the Art Moderne style for stage sets, furniture, and screens. Deskey was a founding member and exhibiter of the American Designers' Gallery in 1928 and 1929, and the American Union of Decorative Artists and Craftsmen in 1930 and 1931. Best known for the interior of Radio City Music Hall, he also developed a striated fir plywood called Weldtex; did the first modern interior for an American ocean liner, the S.S. *Argenta;* and designed items such as pianos, billiard tables, clocks, office equipment, silverware, oil burners, radios, glassware, and slot machines, as well as package designs for Procter & Gamble. His 1950 design for the Crest toothpaste package is still in use.

Paul Frankl (1887–1958; Austria, United States)

Paul Frankl is considered to be the first American Modernist in the decorative arts. He was born in Vienna and educated in architecture and engineering in Berlin, Vienna, Paris, and Munich, and received his diploma from the University of Berlin in 1911. In 1914 he came to the United States and worked as a decorator and a furniture designer—his first commission was a beauty parlor for Helena Rubenstein. Then, in 1922 he opened a gallery in New York selling his own furniture and imported textiles and wall coverings.

Frankl became known for rectilinear stepped designs after introducing his skyscraper furniture in 1926, but it was never mass produced. He also designed tubular chromed metal furniture in the early 1930s. Frankl published five influential books, including *Form and Re-Form* and *New Dimensions*, and he was a major force in the formation of the pro-modernist organization, the American Union of Decorative Artists and Craftsmen, AUDAC (see Chapter 12).

After World War II he relocated to California and practiced interior design using a simple geometric style called California Modern. Frankl continued to be an innovator. His mid-century modern designs include novel materials and shapes, such as a cork veneer biomorphic coffee table for Johnson Furniture.

FLIGHT CHAIR.
Designed by Paul T. Frankl, circa 1930s. Upholstered armchair with exaggerated streamlined arms and two-tiered back cushion; H 30, W 35-1/2, D 41. *(Courtesy of Design America)*

Skyscraper bookcase by Paul Frankl. *(Courtesy of Design America)*

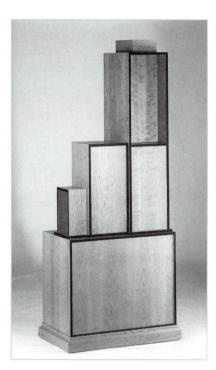

Back view of Frankl bookcase. *(Courtesy of Design America)*

Died 1929
Wyatt Earp (b. 1848); Thorstein Veblen (b. 1857).

1930
Photoflash bulb; Chrysler building in New York; Le Corbusier's Villa Savoye; *Blondie* comic; *Fortune* magazine; planet Pluto discovered; James Hargis and Charlie Creighton drive a Model A Ford from New York to Los Angeles and back in reverse; William Faulkner's *As I Lay Dying*.

Born 1930
Neil Armstrong; James A. Baker III; Sean Connery; Clint Eastwood; Sandra Day O'Connor; Helmut Kohl; Andy Warhol (d. 1987).

Died 1930
D.H. Lawrence (b. 1885).

Summary

- German/Parisian art dealer Siegfried Bing promotes Japanese art and Art Nouveau with his shop L'Art Nouveau.
- French Art Nouveau furniture is characterized by organic forms with opulent carving and marquetry.
- Art Nouveau is fashionable in Europe, but only marginally in England and United States.
- Except for the Glasgow School, which is considered to have followed its own unique version of Art Nouveau, England prefers more of an Arts and Crafts or Aesthetic style.
- Austria and Germany use more geometric and angular forms and decoration (i.e., Wiener Werkstätte), which stylistically and chronologically bridge Art Nouveau and Art Deco.

- Art Deco in Europe actually begins and fades at an earlier date than usually thought (about 1910–1930 rather than 1920–1940).
- Though not an exhibitor, the 1925 Paris Exposition is the first exposure America has to European Art Deco.
- Both French Art Deco and German Bauhaus styles influence American modernism.
- The styles are interpreted and adapted to the developing profession of industrial design in the United States, the first large-scale merger of modern art, mass production, and marketing.

Chronology

1885 Emile Gallé adds cabinetry and marquetry to his glassworks.

1889 Exposition Universelle in Paris.

1893 London publication of *The Studio*.

1894 Gallé workshops are mechanized.

1900 Exposition Universelle in Paris.

1901 School of Nancy is founded.

1903 Steuben Glass is founded by Frederick Carder and Wiener Werkstätte is founded.

1906–1908 Industrialization and modernization of French ateliers provide larger volume and lower priced furniture.

1914 World War I begins.

1925 L'Exposition Internationale des Arts Decoratifs et Industriels Modernes in Paris.

1926 Metropolitan Museum of Art in New York opens decorative arts gallery.

1927 Macy's Department store Art-in-Trade exposition; Bel Geddes begins industrial design career.

1929 Museum of Modern Art (MOMA) founded in New York; Wall Street stock market crash.

1930 William Van Alen's Chrysler Building in New York; *Fortune* magazine.

1930 Gilbert Rohde joins Herman Miller Furniture Company.

1931 Empire State Building in New York.

1932 Radio City Music Hall opens.

1933 Chicago Century of Progress Exposition.

1933 Prohibition ends; Nazis close the Bauhaus.

1939 New York World's Fair "World of Tomorrow"; San Francisco Golden Gate Exposition; World War II begins.

Designers and Leaders

Siegfried Bing (1838–1905) Born in Germany, worked in France as an art dealer and entrepreneur, promoted Japanese art and Art Nouveau; his shop L'Art Nouveau named the style.

Donald Deskey (1894–1989) American industrial and interior designer in the Art Deco style, known for the interior of Radio City Music Hall.

Paul Frankl (1887–1958) Born in Austria, worked in the United States in the Art Deco style; known for skyscraper furniture and California Modern style.

Emile Gallé (1846–1904) Leading French Art Nouveau glassmaker and furniture maker, known especially for his use of naturalistic marquetry.

Eileen Gray (1878–1976) British architect-designer who began making lacquer furniture in traditional Art Deco style but later emphasized modern design using tubular steel.

Louis Majorelle (1859–1926) Important French Art Nouveau furniture maker, stressing form and proportion even more than decoration.

André Mare (1887–1932) French artist and major designer and producer of fine handcrafted Art Deco furniture, partner of Louis Süe.

Jacques-Emile Ruhlmann (1879–1933) French designer and producer of the finest and most costly Art Deco furniture, used the most exotic materials in traditional crafting techniques.

Louis Süe (1875–1968) French architect, artist, and designer and major producer of fine Art Deco furniture, partner of André Mare.

Key Terms

Art Deco	Art Nouveau	shagreen
Art Moderne	School of Nancy	

Recommended Reading

Duncan, Alastair. *Art Nouveau Furniture*. New York: Clarkson N. Potter, 1982.

————. *Art Deco Furniture*. New York: Holt, Rinehart, and Winston, 1984.

Garner, Philippe. *Eileen Gray: Design and Architecture 1878–1976*. Köln: Benedikt Taschen, 1993.

Hanks, David A., and Jennifer Toher. *Donald Deskey: Decorative Designs and Interiors*. New York: E. P. Dutton, 1987.

Heller, Carl Bruno. *Art Nouveau Furniture*. Germany: Berghaus Verlag, 1994.

Weisberg, Gabriel P. *Art Nouveau Bing: Paris Style 1900*. New York: Harry N. Abrams, 1986.

Chapter 11

EUROPEAN MODERNISM
From Bauhaus to Our House

CHAPTER CONTENTS

From the theoretical origins at the Deutcher Werkbund and the Bauhaus in Germany, modern design was intended for the use of mass-production methods. Although not fully realized, the foundations of modernism were laid in the early twentieth century.

O ne of the most dominant and persistent issues in the emergence of modernism is the debate of machine-made versus handicraft. The question "can art be mass-produced and still be considered art" has occupied critics and historians as much as elements of style. The Deutcher Werkbund and Bauhaus bridged the two apparently contradictory themes of Arts and Crafts handicraft and modern industrial design. The Bauhaus produced the theory and trained designers, but it was not actually responsible for product. The field of industrial design then employed these concepts and many of the designers affiliated with the Bauhaus.

DEUTCHER WERKBUND

Throughout history, art and industry had been joined, because most industry was based on handicraft. Critics of the Industrial Revolution claimed it had forced the art out of industry, and leaders of the Arts and Crafts movement distrusted the use of machinery. The **Deutcher Werkbund**, on the other hand, sought compromise and collaboration between art and industry. Unfortunately, there were irreconcilable differences between its members. Contradictory views on economic progress versus antimaterialism, machine-made versus hand-made, even traditionalism versus modernism prevented the Werkbund from accomplishing its goals. But although it may have failed at finding satisfactory answers, they were able to pinpoint some of the crucial questions.

The German Werkbund was formed in 1907. At the time there was a widespread feeling that the rapid industrialization and modernization of Germany posed a threat to the national culture. Unlike the Arts and Crafts reform movement, the Werkbund rejected the backward-looking handicraft romanticism of most English and continental cultural critics. But like the Arts and Crafts, the Werkbund sought to restore dignity to labor, bridge the gap between art and industry, and create a national style, or at least one suited to its place of origin. It also shared the idealistic belief in the social power of art—that aesthetic reform would facilitate social reform and even create a new order. Unlike Arts and Crafts, it did not blame machinery, but sought to use it wisely to accomplish its goals. By joining industry and designers, mass production would enable efficiency and promote nationalism. In theory, this sounded good, but the reality was that pre-war Germany was far from being mechanized. The same problem experienced by Arts and Crafts proponents followed the Werkbund: Well-designed furnishings were made by craftsmen, so limited quantities caused high prices, and the best work ultimately remained a part of the luxury trade.

In its desire to bring art and industry together, the Werkbund brought diverse people together: University professors, craftsmen, fine artists, industrialists, designers, and politicians, and its founding meeting in Munich on October 5 and 6 in 1907 did just that. The problem they aspired to solve was an old one—how to rejoin the designer and producer. They also sought to combine art and industry as it had not been done before, because industry was in the midst of the process of reinventing itself. Medieval and Renaissance designers and craftsmen were obviously joined, because they were most likely to be the same individual. When nineteenth-century industrialism had suddenly and radically separated them by introducing the factory system and its machinery, the medieval model was seen by some as a solution to more than the problem of handicraft.

Progress waits for no reformer, no matter how charismatic or persuasive he or she might be. Once individuals living in relatively free societies saw the material advantages of machine production, it was impossible to stop the clock, or as some reformers had naively tried to do, set it back. Germany and other industrializing countries were becoming mechanized. If art, especially applied art, was to advance and to succeed, there was no longer a choice—it would do so in the context of industry. Initial success came in areas where traditional forms had not previously existed—in the creation of factories rather than residences, in the design of appliances rather than furniture.

Architecture professor Fritz Schumacher delivered the keynote speech stating the Werkbund's objective: to reform the German arts and crafts through a genuine rapprochement

between artists and producers. Schumacher regretted the loss of preindustrial artistic traditions; he recognized the unavoidability of progress based on industrialization and mechanization. "The Werkbund must strive to counter the excessive materialism and rationalism that were its by-products without sacrificing the positive benefits of modernity." This was in 1907, however, and Germany was not as mechanized as some might assume. Hindsight has obvious advantages, and from the vantage point of the present (the Werkbund's future), it is clear that design issues and modernization were more theoretical than actual. Modernization in 1907 was still an idea more than a way of life. In fact, the Werkbund's founders also had a conservative goal—to restore what they perceived as the lost moral and aesthetic unity of German culture. This combination of romantic nostalgia (the past), plus a quest to recognize and meet real contemporary needs (the present), and acknowledgement of where the most logical conclusion might be (the future) would contribute to both the success and the failure of the Werkbund and similar organizations.

Besides philosophical issues, the Werkbund was about applied arts and economics, and their practical and immediate task was to improve the design and the quality of German consumer goods. But in addition to this straightforward materialistic goal was another agenda, and Schumacher made it clear that the Werkbund was not created just to combat a perceived ugliness of current products. He supported quality, arguing that it would both strengthen the nation's competitive position in world markets and improve social conditions at home. The Arts and Crafts of Ruskin and Morris was closer than they might have admitted.

Membership was never large, but grew from 492 in 1908 to 731 in 1909 and about 3,000 in 1929. It used the international exhibition as a vehicle to extend its influence beyond German borders: Cologne in 1914 and Stuttgart-Weissenhof in 1927. Problems arose, perhaps more because of its place and time than its goals or methods of realizing them. Links with artistic avant-garde and with the liberal-democratic politics of members like Friedrich Naumann and Theodor Heuss, brought them under attack from the National Socialists and their conservative allies. The Werkbund finally closed in 1934 because of German political pressures and paranoia, but returned after World War II.

Between 1919 and 1930 the Werkbund was led by Bauhaus leaders Walter Gropius (1883–1969) and Ludwig Mies van der Rohe (1886–1969), vice-president 1926–1932. Other founders and leaders included: Friedrich Naumann (1860–1919), Hermann Muthesius (1861–1927), Henry van de Velde (1863–1957), Theodor Fischer (1862–1938) president 1908, Peter Bruckmann (1865–1937) president 1909–1919 and 1926–1932, Hans Poelzig (1869–1936) president 1919–1921, Richard Riemerschmid (1868–1957) president 1921–1926, Ernst Jäckh (1875–1959) president 1932.

Hermann Muthesius (1861–1927)

The figure most associated with the founding of the Werkbund was a civil servant in the Prussian Ministry of Trade—Hermann Muthesius. Born in Thuringia in 1861, he learned masonry from his father and then studied architecture in Berlin. Travel broadened his views. While still a student, Muthesius visited Japan; in 1896 he was appointed architectural attache at the German embassy in London. There he experienced firsthand the state of English architecture and crafts and made close contacts with leaders of the Arts and Crafts Movement (with the exception of Morris who died in 1896).

When Muthesius returned to Germany, he built English style villas, promoted arts and crafts, and was instrumental in placing leading designers in key positions—Peter Behrens at the Art Academy in Düsseldorf, Hans Poelzig at the Breslau Academy, and possibly Bruno Paul at the Berlin School of Applied Arts. But Muthesius and his sympathizers would have an even more difficult time than their nineteenth-century counterparts convincing the consuming public of the merits of reform, especially those "corrupted by social snobbery, sudden wealth, and the ready availability of 'luxury' goods cheaply made by machine." (14). It would take more than Muthesius's optimism and equating good taste and quality with virtue to successfully juggle so many ideas and ideals.

Henri van de Velde (1863–1957)

A Belgian architect, designer, painter, and art critic, van de Velde was active in Belgium, France, Germany, and the Netherlands. After studying painting in Paris and beginning his career as a post-impressionist painter, he became inspired by the work and words of William Morris. Van de Velde spoke Arts and Crafts, complete with its views on arts, society, and use of machinery. Claiming not to be an advocate of "art for arts sake," but a socialist, van de Velde spread mainstream Arts and Crafts, though pro-machine, rhetoric. He was appointed head of the Weimar Art Academy in 1902, and although he wasn't actually one of the Deutcher Werkbund founders, he took credit for instilling it with his ideas.

However, his own decorative style was Art Nouveau, a superficial ornamental style, rich with symbol but not reform. Unlike the organic flowing lines of the French, van de Velde's version of the style was simpler, more angular, and symmetrical. Although van de Velde advocated the use of machinery for good artistic production, his own work required costly handwork and not only appealed to, but was affordable only to the wealthy.

With regard to his contribution to the Werkbund, it was more important that he verbally promoted the group than actually participate in its style or methods. Van de Velde was not the only artist to speak for the Werkbund but act differently. By 1914 at the outbreak of World War I, there was still no "German style" as a result of the Werkbund's efforts; in fact levels of taste and quality had not been elevated to their standards at all. They had also failed to convert Germany's prosperous bourgeoisie to its ideals. Though it may not have found answers to current problems, the Werkbund did succeed at identifying the issues. But by overestimating the importance of technology, efficiency, standardization, and rationality, they missed things like history, ornament, individuality, and perhaps even human freedom.

BAUHAUS AND PARALLELS

Tom Wolfe wrote, and it is worth quoting in its entirety:

> Every great law firm in New York moves without a sputter of protest into a glass-box office building with concrete slab floors and seven-foot-ten-inch-high concrete slab ceilings and plasterboard walls and pygmy corridors—then hires a decorator and gives him a budget of hundreds of thousands of dollars to turn these mean cubes and grids into a horizontal fantasy of a Restoration townhouse. I have seen the carpenters and cabinetmakers and search-and-acquire girls hauling in more cornices, covings, pilasters, carved moldings, and recessed domes, more linen-fold paneling, more (fireless) fireplaces with festoons of fruit carved in mahogany on the mantels, more chandeliers, sconces, girandoles, chestnut leather sofas, and chiming clocks than Wren, Indigo Jones, the brothers Adam, Lord Burlington, and the Dilettanti working in concert, could have dreamed of.

Like a cold winter landscape, there is also something compelling about a cool, clean interior landscape—in theory. But once the building is a reality, human physical and psychological comfort require things like color, texture, contrast, warmth, and visual interest. We can laugh at Wolfe's portrayal of historic decorating oddities, but the reality is that humans cannot function well in plain boxes. Robert Hughes demonstrated it brilliantly in his "Trouble in Utopia" segment of *Shock of the New*, as he took the viewer through some of the more spectacular failures of modern architecture.

The characteristic features of what would be termed the **International style** in architecture naturally had both positive and negative aspects. Its proponents presented a new design concept, one no longer based on classical principles of proportion, symmetry, and decoration. Form reduced to its essence required no ornament, so International style buildings were to succeed based solely on their form. Lightness was considered more desirable than the massive load-bearing masonry walls of the past, and this lightness was achieved

by the use of sheets of glass as a thin skin wrapped around a supportive steel structure. Steel, concrete, and glass replaced wood, brick, and stone as the major building materials. The mass-produced exterior and interior surfaces replaced traditional handcrafted architectural features of carved stone and wood. The changes were radical. To many the results were liberating; to others they were oppressive in their austerity.

The unadorned glass box is as impractical as grafting a Hollywood set for a historic novel onto a glass box. To equate the Bauhaus with the anti-historical unadorned glass box and to blame the ills of modern architecture on a single German institution would be too simplistic. Besides, the idea of the box in architecture can be attributed to the Americans—the Bauhaus visionaries and extremists took it further. Two of the most powerful symbols of the American myth were the skyscraper and the metropolis. Bauhaus student Paul Citroen designed a series of collages on the "big city" theme in which skyscrapers tower to the horizon.

The origins of the Bauhaus philosophy can be traced to the nineteenth century when countries in Europe watched England enjoy great success in both the area of handicraft and industrial production. First, a Museum of Arts and Crafts opened in Austria and in Berlin in 1871. Then in 1896 the Prussian government sent Hermann Muthesius to England to learn the secrets of the British success, and art academies were soon established in major Prussian cities by Peter Behrens, Bruno Paul, Hans Poelzig, and Henry van de Velde. As the climate in Germany became more nationalistic, the Deutcher Werkbund was founded in 1907 to unite art and industry and to create a German national style. In 1919 Walter Gropius founded the Bauhaus school in Weimar and also took over leadership of the Werkbund. By 1924 the right-wing political environment forced the Bauhaus to move to Dessau. Gropius's new building became a model for the International style, with its steel framing, large expanses of glass, flat white concrete bands, and flat roof. It was the birth of the thin-walled box in modern architecture.

Bauhaus was not exactly a style, but its teachers and students sought a common denominator of form in order to develop a science of design. Its objective was to reunite arts and crafts—sculpture, painting, applied art, and handicrafts—as the permanent elements of a new architecture. It encouraged architects, sculptors, and painters to turn to crafts, because there is no natural distinction between art and craft. A basic distinction was that art cannot be taught, but craft can be taught. Therefore, all students of art and architecture needed a foundation in hands-on workshops in order to maximize creativity. Teaching methods stressed creativity and individual freedom along with strict scholarship. An antibourgeois craft design suited for mass production was the ultimate material goal, but like the Arts and Crafts, it had its share of unresolvable contradiction and irony. The grandiose intentions, assumptions about people, and belief that either the design or manufacture of material objects could really influence lives were peculiar to both movements. Return to handicraft was not the answer; nor was technology. Even if it had been, there was no time to find out, because the Nazi predilection for action without thought forced the school to close in 1932. German creativity not already extinguished or transported to other nations would rest dormant until the end of Nazi rule and World War II.

Perhaps the greatest legacy of the Bauhaus was not so much what it had accomplished in Germany, but what its members—Gropius, Breuer, van der Rohe, and the "Bauhaus Blitzkrieg"—brought out and exported, especially to the United States. Other European countries had parallel design movements, such as the Finnish Functionalist group called Funkis. Teaching strategies were adopted internationally into curriculums of art and design schools, but the content produced mixed results. Walter Gropius and Ludwig Mies van der Rohe were leading proponents of the new International style of architecture that developed in the 1920s. Today, the ugliness of many cities is blamed on the monotonous box forms and soulless mass housing, indicative of the International style. Yet this style of architecture had matured at the Bauhaus based on ideas, from the rural grain silo to urban skyscraper, that had originated in the United States. In turn, American innovations in home furnishings both paralleled and borrowed from those of

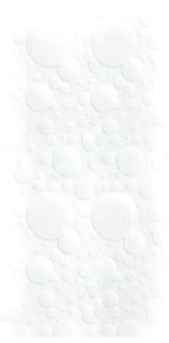

the Bauhaus. But Americans were divided between following historicism and leading in industrial design, and when a dichotomy became clear, the furniture industry succumbed to the former. The original Arts and Crafts path changed direction at the Bauhaus, in theory, to one of contemporary design for industrial production. In practice the new field of industrial design would, however, be led by Americans, most of whom were even native to the United States. But at first, the focus of industrial design was on new inventions, machines, and transportation rather than the home furnishings of the Bauhaus.

The following were key figures affiliated with the Bauhaus, International style, and/or parallel movements outside of Germany:

Pauli Blomsted (1900–1935, Finland)

Blomsted is little known today, because his life was short, and consequently, his designs were few. Born in Finland and educated in architecture, his brief career focused more on interiors and furniture design. As a member of the Finnish Functionalist group called Funkis, he was also a leading theorist in the early 1930s. Blomsted advocated industrial mass-production methods to produce a functional artistic whole. His tubular steel designs were used primarily in banks, hotels, and offices. The New York-based company, Arkitektura, began to reissue several Blomsted designs in the late 1980s.

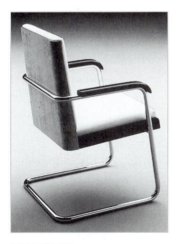

ARM CHAIR.
Designed by Pauli Blomsted, circa 1930. Cantilevered chair with continuous tubular steel frame, designed by Finnish modernist Pauli Blomsted. *(Courtesy of Arkitektura)*

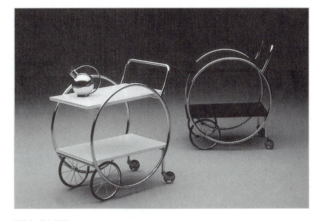

TEA CART.
Designed by Pauli Blomsted, circa 1930. Two-tiered tea cart with large circular tubular steel side supports and large bicycle wheel-style front wheels. *(Courtesy of Arkitektura)*

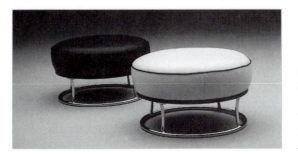

POUF.
Designed by Pauli Blomsted, circa 1930. "Post Deco" pouf, or hassock, with upholstered circular seat with tubular steel support. *(Courtesy of Arkitektura)*

Marcel Breuer (1902–1981; Hungary, United States)

Marcel Breuer is best known for the introduction of tubular steel furniture for interiors, notably the Bauhaus-designed Wassily chair of 1925. His cantilevered Cesca chair of 1928, which combines steel, wood, and cane, has become one of the most influential twentieth-century chair designs and is also still being produced by Thonet. Other designs include the aluminum chair in 1933 and Isokon lounge chair in 1935. Many of these early classic chair designs have enjoyed continuous popularity in both residential and public interiors, adding to the significance of his contribution to the evolution of modern design.

Born in Pécs, Hungary, Breuer studied at the Vienna Academy of Fine Art and at the Weimar Bauhaus in 1920–1924, where he became a master of the furniture workshop. His plywood chairs and tables of 1920–1922 and wood-slat chairs of 1922–1924 have a marked De Stijl influence. His cupboards and cabinets seem to anticipate George Nelson's designs at mid-century. In the late 1920s he formed Standardmöbel Lengyel with Kalman Lengyel and Anton Lorenz. After the Bauhaus moved to Dessau in 1925, he remained for two more years, then opened his own architectural office in Berlin (1928–1931) and then in London (1935–1937). He worked on aluminum furniture in 1932. At the invitation of Walter Gropius in 1937, Breuer emigrated to the United States and became an associate professor at the School of Design at Harvard University 1937–1946. Also during those years he had an architectural practice with Gropius in Cambridge, Massachusetts (1937–1941). In 1946 he headed his own firm of Marcel Breuer & Associates in New York City and retired in 1976. Breuer is perhaps best remembered for revolutionizing design and technique with his tubular steel furniture intended for serial production, and he is considered one of the most significant designers of furniture and interiors of the twentieth century.

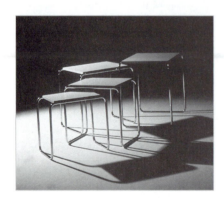

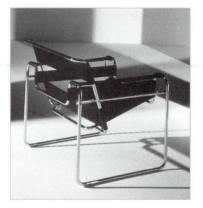

NESTING TABLES.
Designed by Marcel Breuer, circa 1925. One of Breuer's favorite designs, this was originally intended as a stool. It was used in Breuer's early interiors, such as the canteen at the new Bauhaus building designed by Walter Gropius in Dessau. Breuer may have come up with the idea of the cantilever chair independently of Mart Stam, when he turned his new stool on its side. Original models were of bent nickled steel and laminated wood and manufactured after 1927, probably by Gebrüder Thonet. W 26, D 20, H 24; W 24, D 18, H 22; W 22, D 16, H 20; W 20, D 14, H 18. *(Courtesy of Thonet)*

WASSILY CHAIR.
Designed by Marcel Breuer, circa 1925. Breuer was inspired by the form and materials of bicycles, and translated them into a revolutionary new chair. Early tubular metal prototypes made of nickeled steel required the aid of a plumber and were only theoretically suited for mass production. Original fabrics included canvas, leather, or Eisengarn (iron cloth), which could be used outdoors. Breuer named the chair thirty years later, after his artist friend Wassily Kandinsky, who also taught at the Bauhaus and was fond of the design. Gebrüder Thonet manufactured the chair after 1928; it was reissued by Gavina in Italy from 1962 to 1968; Knoll, which purchased Gavina, produced the chair from 1968 to the present; it was also distributed by Thonet. W 31, D 26-1/2, H 28-1/2; seat 20 x 16, H 17; arm H 22-1/2. *(Courtesy of Thonet)*

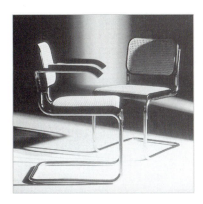

B3 CLASSIC BREUER "CESCA" CHAIR.

Designed by Marcel Breuer, circa 1928. Considered to be the essence of classic design and one of the most significant seating developments of the twentieth century, the Cesca chair has endured for more than seven decades. By combining traditional bentwood and cane with colder tubular steel, Breuer achieved warmth and more universal appeal plus suitability for mass production. He was the first to successfully combine these three materials and also introduced a noncontinuous frame on a cantilevered chair with a back support curved or bent on the vertical plane. It was named Cesca after his daughter Francesca. The original side and seat rails were made from a rod of solid wood bent into a C shape secured by a straight front rail. After World War II the seat frames were made from four pieces of wood joined together. It was made by Gebrüder Thonet from 1931, Gavina of Italy from 1962 to 1968, and Knoll (which purchased Gavina) from 1968 to the present, and also distributed by Thonet. Breuer side chair W 18-1/4, D 22-1/2, H 32; seat 18-1/4 x 17, H 18. Breuer armchair W 23, arm H 27; other dimensions the same. *(Courtesy of Thonet)*

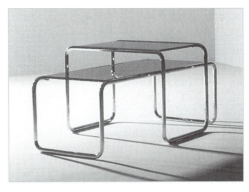

BREUER OCCASIONAL TABLES.

Designed by Marcel Breuer, circa 1930. These occasional tables evolved from Breuer's stool/nesting table design. W 20, D 48, H 16; W 30, D 30, H 16; W 30, D 30, H 21. *(Courtesy of Thonet)*

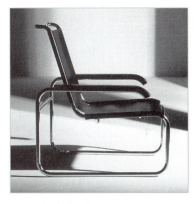

B35 LOUNGE CHAIR.

Designed by Marcel Breuer, circa 1928. This achievement in tubular steel design was shown extensively at the 1930 Salon des Artists Décorateurs in the Deutcher Werkbund. It appears to be constructed of one continuous piece of steel, enabling economical production. The design introduces two cantilevers, giving it excellent resiliency and bounce. W 24, D 31-1/2, H 32-3/4; seat 20 x 20, H 14-3/4; arm H 20-1/2. *(Courtesy of Thonet)*

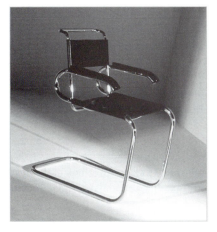

B55 ARMCHAIR.

Designed by Marcel Breuer, circa 1928. Another early variation of Breuer's cantilever designs. *(Courtesy of Thonet)*

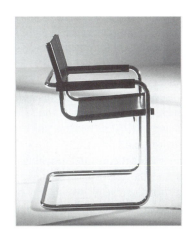

B34 ARMCHAIR.

Designed by Marcel Breuer, circa 1933. Breuer's continuous version of the cantilever concept with a stretch fabric seat and back eliminated the need for traditional upholstery techniques. W 22, D 23, H 31; seat 19 x 13-3/4, H 18; arm H 25 (side chair W 19, D 23, H 33). *(Courtesy of Thonet)*

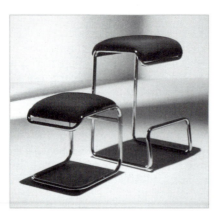

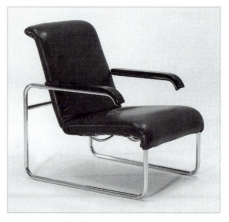

BREUER STOOLS.
Designed by Marcel Breuer, circa 1933.
Breuer enployed tubular steel in a
cantilever design as a stool, and it is still
used extensively. Fitting stool W 16-1/2,
D 17-1/2, H 18; barstool W 18, D 19-1/2,
H 28; seat 18 x 24, H 28; footrest H 10.
(Courtesy of Thonet)

BREUER LOUNGE CHAIR.
Designed by Marcel Breuer, 1928. Frame is
chrome-plated steel tube; the seat and back
are natural wicker or natural leather in black,
brown, or natural. H 32-1/2, W 25-1/2,
D 31-1/2. *(Courtesy of ICF Group)*

Walter Gropius (1883–1969, Germany)

Gropius was born in Berlin in 1883 and later studied architecture at the Technical University in Munich in 1903 and in Berlin 1905–1907. From 1908 to 1910 he was chief assistant to Professor Peter Behrens in Berlin and met Ludwig Mies van der Rohe. His first private architectural practice began in 1910 in Berlin. In 1918 he was appointed director of the Grandducal School of Arts and Crafts and the Grandducal College of Fine Arts. When he unified them as the Staatliches Bauhaus in Weimar in April of 1919, Gropius became the founder and first director of the Bauhaus, and in 1921 headed its first furniture workshop. Pieces were made as prototypes intended for industrial production with form dictated by function above art.

Together with most of the faculty and students, Gropius moved to Dessau and reopened the school as a city institute under the name Bauhaus Dessau Hochschule für Gestaltung and designed the new Bauhaus building. Though he did not visit the United States until leaving the Bauhaus in 1928, Gropius was intrigued by American architecture, especially the standardization of building parts, the "monumentality and power" of grain silos, and the designs of Frank Lloyd Wright. When he returned to Germany, he brought photographs of grain silos and of skyscrapers. In 1934 he left his practice and moved to London, where he opened an office with Maxwell Fry. Gropius was the first of the Bauhaus architects to migrate to the United States, and in 1937 he was given an appointment at Harvard. One of his first projects was to organize a Bauhaus exhibition, which opened in 1938 at the new (founded 1929) Museum of Modern Art. Also in 1938 he was made chairperson of the Department of Architecture at the Graduate School of Design at Harvard and a fellow of the American Institute of Architects, and he practiced architecture with Marcel Breuer. In 1946 Gropius founded the Architects Collaborative in Cambridge, Massachusetts, and in 1952 he became professor emeritus at Harvard and continued to win international awards and honors.

In addition to practicing and teaching architecture, Gropius published widely on Bauhaus ideas and the philosophy of design education. In 1964–1965 he designed the Bauhaus Archiv for Darmstadt, which was built in Berlin (1976–1979). Until he died in 1969, Gropius was an international leader in architecture, and his books continued to influence architecture and design education for many years to come.

Charles Edouard Jeanneret (Le Corbusier) (1887–1965, Switzerland)

Tom Wolfe described Le Corbusier as "the sort of relentlessly rational intellectual that only France loves wholeheartedly." It is easy to poke fun of greatness, and his greatness was not without controversy.

Though not of the Bauhaus, Le Corbusier was affiliated with its designers and its principles. In 1908 Charles Edouard Jeanneret worked briefly with Josef Hoffmann at the Wiener Werkstätte, then apprenticed in the Perret brothers' architectural office, where he learned about reinforced concrete. He then worked in the architectural office of Peter Behrens in Berlin, where he became interested in mass-produced furniture and met van der Rohe and Gropius. He took the name Le Corbusier as an author in 1920, as an architect in 1922, and as a painter in 1928.

His cousin Pierre Jeanneret joined his architectural office in 1921, and Charlotte Perriand joined in 1927. In the same year, Le Corbusier began to design tubular steel furniture with Jeanneret and Perriand, who actually worked on most of the furniture designs. Originally produced by Thonet, the designs have become icons of twentieth-century design, especially because they have become so familiar due to mass production.

From 1920 to 1964 Le Corbusier designed major examples of modern architecture in the International Style from Moscow to Rio de Janeiro, but only one building in North America, the Carpenter Center for Visual Arts at Harvard University. (His United Nations building was executed by Wallace K. Harrison and Max Abramovitz.) Among his best-known works are the Villa Savoye in Poissy, France and (the surprisingly un-International style) Notre-Dame-du-Haut Chapel at Ronchamp, France.

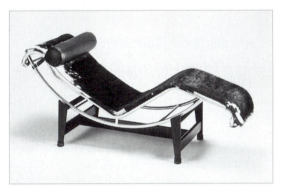

LC4 CHAISE LOUNGE.
Designed by Le Corbusier, Pierre Jeanneret, and Charlotte Perriand, 1925/1928. Chaise lounge with adjustable chromed or matte black cradle, matte black base, upholstered in pony skin, with black leather headrest. L 63, W 22-1/4. *(Courtesy of Cassina)*

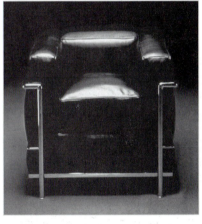

LC2 (GRAND CONFORT).
Designed by Le Corbusier, Pierre Jeanneret, and Charlotte Perriand, 1925/1928. Armchair with tubular steel frame in a variety of finishes; fabric or leather upholstered cushions. H 26-3/8, W 30, D 27-1/2. *(Courtesy of Cassina)*

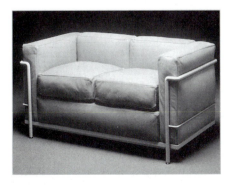

LC2 GRAND CONFORT.
Designed by Le Corbusier, Pierre Jeanneret, and Charlotte Perriand, 1925/1928. Sofa with tubular steel frame in a variety of finishes; fabric or leather upholstered cushions. H 26-3/8, W 51-1/4, D 27-1/2. *(Courtesy of Cassina)*

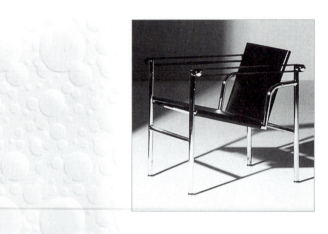

B301 ARMCHAIR.
Designed by Le Corbusier, circa 1929. This bent and chromed tubular steel chair with fabric seat and back was manufactured by Gebrüder Thonet in 1929. Le Corbusier had reinterpreted an inexpensive wood campaign chair featuring a pivoting canvas seat and back that was retailed by Maples & Co. of London. However, because numerous models were made, and the joints were welded and finely finished, the chair was costly to produce and only affordable to the wealthy. W 24, D 24, H 26; seat H 16. *(Courtesy of Thonet)*

Pierre Jeanneret (1896–1967, Switzerland)

Born in Geneva, Pierre Jeanneret studied architecture at L'Ecole des Beaux Arts in 1913–1915 and again in 1918–1921. He worked with the Perret brothers until 1923 and also collaborated with his cousin Charles Edouard Jeanneret (Le Corbusier) 1921–1940 as a quiet partner playing a significant behind-the-scenes role in Le Corbusier's architecture. Furniture designs include the Grand Confort chairs and sofa in International style, originally made by Gebrüder Thonet and reissued by Cassina in Italy from 1965. Jeanneret also worked with Jean Prouvé, Charlotte Perriand, Georges Blanchon, and A. Masson. From 1951–1965 he was involved in architecture and directed the School of Architecture at Chandigarh, India. While in India, he experimented with low-cost furniture made of native materials such as cord and bamboo.

Ludwig Mies van der Rohe (1886–1969; Germany, United States)

A leading proponent of International style, Ludwig Mies van der Rohe's designs have come to symbolize both Bauhaus and later modernism. Born in Aachen, Germany, and trained as a builder, he moved to Berlin in 1904 to study under Bruno Paul. He practiced architecture in the office of Peter Behrens, then a self-employed architect (1908–1911). From 1921 he was a member of the Deutcher Werkbund and became vice president in 1926. He organized the Stuttgart Exhibition of 1927 and designed the German Pavilion for the 1929 Barcelona International Exhibition and the classic Barcelona chair, which was reissued by Knoll Associates in 1948. From 1929–1930 he designed the Tugendhat house in Brno, Czechoslovakia, along with the Brno and Tugendhat chairs. In 1930 he served as the last director of the Bauhaus until it closed in 1933 and in 1937 emigrated to the United States. He became a U.S. citizen in 1944 and was director of the Illinois Institute of Technology in Chicago. Among his furniture designs are the MR chair of 1927, MR lounges of 1931, Brno chair of 1929, Barcelona chair and stool of 1929, and the Tugendhat chair, couch, and table of 1930.

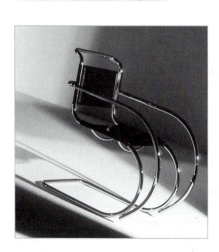

MR 534 MIES ARMCHAIR.
Designed by Ludwig Mies van der Rohe, circa 1927. Introduced in the same year as Stam's, and the only other cantilever design shown at the 1927 Stuttgart exhibit sponsored by the Deutcher Werkbund under the artistic direction of its vice president Mies van der Rohe, this design is considered to be the most graceful of the early cantilevered chairs. Originally Model No. MR10 of bent nickled tubular steel, cane, bent solid steel, and wood, it was produced by two firms in Berlin and then by Thonet from 1932, when it became referred to as MR533 and MR533g with a woven cane seat. The lightweight design provided resiliency and easy movement in modest living areas for low-income residents. MR533 side chair: W 19, D 28, H 33; seat H 17-1/2. MR534 armchair: W 22, D 32, H 34; arm H 28. *(Courtesy of Thonet)*

BRNO CHAIR.
Designed by Ludwig Mies van der Rohe, circa 1930. This was designed for the dining area of a house overlooking Brno, Czechoslovakia, which was commissioned by Grete and Fritz Tugendhat in 1928. The Tugendhat House is best known for the harmonious relationship between Van der Rohe's architecture and interior furnishings. Thonet acquired the rights to this design in 1932. W 22, D 24-1/2, H 29-1/2, seat 20 x 17-3/4; arm H 26. *(Courtesy of Thonet)*

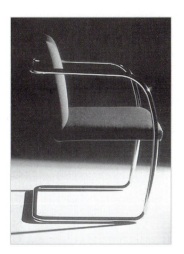

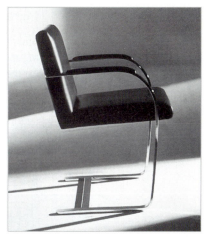

BRNO ARMCHAIR MR50.
Designed by Mies van der Rohe, circa 1930. Similar to the tubular steel Brno chair, this version is of bent chromed flat steel, wood, and upholstery (later) and used in the Tugendhat bedroom. It was first manufactured in Berlin and then by Thonet from 1932. W 22-1/2, D 25, H 32; with foam padded cushions: W 23-1/2, D 25–1/2, H 33-1/2. *(Courtesy of Thonet)*

Charlotte Perriand (1903–, France)

Born in Paris, Perriand studied at Ecole de l'Union Centrale des Arts Décoratifs from 1920 to 1925. Beginning in 1927 she worked in the architectural office of Le Corbusier with his cousin Pierre Jeanneret. The two, especially Perriand, were responsible for all of the furniture designed in the office for the next ten years.

In 1929 she became a founding member of the organization Union des Artistes Modernes, where she exhibited her work, and the following year began a long friendship with artist Fernand Léger. Her work has been exhibited extensively and continuously, especially in France, from the 1920s through the 1980s. She was the consultant to Cassina in the 1980s when the company issued reproductions of Le Corbusier/Jeanneret/Perriand tubular steel classics.

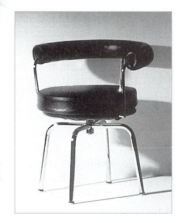

B302 REVOLVING CHAIR.
Designed by Charlotte Perriand, circa 1928. Charlotte Perriand, one of Le Corbusier's colleagues, exhibited at the Salon des Artistes Décorateurs and unveiled the revolving chair in her dining room. More of a reinterpretation of the past than a revolutionary statement, the form expressed overtones of the Thonet bentwood B9 chair, which Le Corbusier was very fond of using. Perriand reduced the cold tubular steel quality by adding padded components. It was manufactured by Gebrüder Thonet after 1929. W 24-1/2, D 22, H 28-1/2; seat 22 x 22, H 20; arm H 28. *(Courtesy of Thonet)*

Mart Stam (1899–1986, Netherlands)

Stam studied drawing and architectural drafting in Amsterdam and Rotterdam before living in Berlin and in Paris. He participated in a Bauhaus exhibit and designed three houses for the Deutcher Werkbund in Stuttgart. In 1924 he is said to have developed a tubular steel cantilever chair, which was not produced until 1926, so there is some controversy over whether he was the first to accomplish the design. From 1930 to 1934 he practiced architecture in Russia, and in 1939 was the director of the Institute for Industrial Art Academies in Dresden and Berlin.

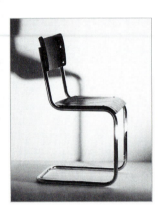

STAM CHAIR.
Designed by Mart Stam, circa 1926–1927. Stam is credited with inventing the cantilever principle (as is Breuer), which was first seen at the Weissenhof exhibition in Stuttgart, circa 1929. The design is also significant for its departure from the four-legged chair. Stam armchair: W 20-1/2, D 19-1/2, H 30-3/8; seat 16 x 15-3/4, H 17-1/2; arm H 25-1/2. Stam side chair; W 16, other dimensions the same. (*Courtesy of Thonet*)

TUBULAR STEEL FURNITURE

One the most widely admired, accepted, and copied furniture forms associated with the Bauhaus and modernism is tubular steel furniture. The tubular steel chair has become an icon of **modernism** and one of the most persistent forms in the twentieth century.

Like other innovations, its appearance was like a new chicken—developing for a long time unseen, until it finally bursts out of its shell in its complete form, feathers and all. The metaphor can be taken further—as the chick grows, its appearance changes, but it has all of its original parts and functions.

Tubular steel furniture, especially chairs, had antecedents in the nineteenth century. Around 1830 in England, iron tubes were used in bed construction; in 1844 bent tubular chair legs were used in France, but they were painted to resemble wood; in the 1860s in the United States, tubular steel seats were used in agricultural machines. The basic principles had already been well-established by Thonet, though his material was bent wood. It was Thonet's example that helped to predispose the public (including industrialists) to consider and eventually support steel.

The modern goal was for a lightweight hovering chair. The concept of a free hovering resilient seat was actually used in agriculture in the 1860s to the 1880s; and a United States patent for Elastic Cantilever Seats for Seagoing Ship Saloons was filed in 1889, but American sitters just didn't connect the idea to home use. Just as the technologically oriented Americans watched Modernism develop in Europe, these American inventors of cantilevered tubular steel seating watched while Europeans introduced the "first" tubular steel **cantilever** chair in the 1920s.

Once the new idea was in the air, other creative talents joined in. Rather than a sequence of separate designs, the inventive process becomes more a collaboration. Between 1925 and 1929, several Europeans independently invented a chair that achieved its resilience from the material and the design form, rather than from a mechanical device. In Holland, architect Mart Stam was credited with the first successful cantilevered (but not yet resilient) example in 1927. Only weeks later, Mies van der Rohe showed his version using thin, resilient steel tubing. Then Marcel Breuer made a slightly improved model, and in the 1930s it was manufactured in America for a fraction of the European

production cost. (As one story goes, Stam visited Breuer and saw his newly created tubular steel table. When Breuer placed it on its side, the idea of the cantilever came to both of them.) Unlike the European avant-garde chair, this affordable American Breuer chair was used everywhere from barber shops to kitchens. Not surprisingly, Thonet also decided to enter the new market, and the company produced tubular steel as well as its mainstay of bentwood furniture. Thonet also combined these two bent materials in classics like Breuer's Cesca chair of 1928. Others followed, because plagiarism is inherent in the furniture business. It may seem unfair to spotlight the tubular steel designs of a few key figures—Stam, Mies, Breuer. Yet it was the very concept of designer names that proved to be an approach to marketing, and for the first time in modern history, the names of furniture designers were used to sell furniture. The invention was significant, and whether it was to be a designer luxury item or an anonymous mass-produced chair, the tubular steel pie was large enough for many enterprising manufacturers to cut a slice. Yet, by the mid-1930s the initial creativity had slowed. Copies of Breuer or Mies models were made in, or imported to, other countries, but the designers turned to bands of flat steel, aluminum, or plywood.

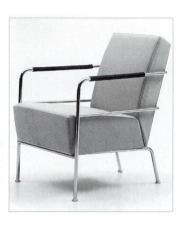

CINEMA.
Designed by Gunilla Allard. Chair (also ottoman and lounge) of steel tube frame with powder coat or chrome finish, arms covered in leather, seat and back cushions upholstered in fabric or leather. H 31, W 22, D 29-1/2. *(Courtesy of ICF Group)*

MAKERS OF TUBULAR STEEL FURNITURE

Thonet

Its founder Michael Thonet was born in Boppard, Germany, in 1796. He began to make furniture in 1819 and experimented with bentwood beginning in 1830. His invention of bentwood was patented in 1841 and then exhibited in London at the Crystal Palace in 1851. In 1853 he created a family firm with his five sons and built a large factory in Moravia in 1856. Michael Thonet died in 1871, and the company continued to expand and create prototypes, which were then mass-produced. Between 1850 and 1871 Thonet had produced more than 4 million pieces of bentwood, mostly chairs. By 1900 there were approximately 6,000 Thonet employees in Central Europe making 4,000 pieces daily; in 1929, there were 20,000 employees making 18,000 chairs daily. In 1930, 50 million units of Chair No. 14 had been sold.

The advantages of Thonet's chairs, nesting tables, and other items of furniture were: chairs were reasonably comfortable without the use of upholstery; they were both lightweight and strong; parts were interchangeable and therefore suited to **mass production**; and the continuous freely curving forms made from long lengths of wood were incredibly varied and aesthetically pleasing. (See Chapter 7 for more detail on bentwood.)

Thonet's tubular steel furniture followed the principles of the bentwood and could be used in combination with plywood, cane, or fabric. Top designers included Marcel Breuer, Mart Stam, Mies van der Rohe, Le Corbusier, and Charlotte Perriand, and their latest designs could be seen throughout Europe. When a Thonet Bros. showroom

opened in London in 1929, the British public, who had just been introduced to the concept of the cantilever chair, were exposed for the first time to designs combining simplicity of form and the aesthetic potential of the metal. Thonet's tubular steel chairs subsequently influenced English tubular steel furniture—varying between inspiration and plagiarism.

Chairs were used in public places, such as restaurants, but were considered to be too severe and cold for domestic use by the general public. Tubular steel enjoyed a brief period of trendiness with the London chic, but the more generally accepted it became throughout England, the less appeal it held for the affluent design-conscious market.

The Great Depression actually contributed to the success of this new product. The British had traditionally valued the comfort of upholstered furniture and were at first reluctant to accept tubular steel into their homes. They saw it instead as suited to office or health care environments where hygiene was a priority, or for tropical environments where coolness and resistance to insects was needed. When the Depression created a need for smaller and cheaper living spaces, tubular steel was suited because of its relatively small size, its durability, and low cost, and not necessarily for aesthetic criteria.

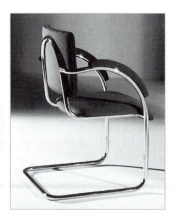

CHURCHILL CANTILEVER CHAIR.
Designed by Thonet staff, circa 1931. By the mid 1930s, many variations of tubular steel designs were offered in the Thonet catalog. This design was used in Winston Churchill's underground headquarters in London during World War II. W 22-3/4, D 24, H 31-1/2; seat 20 x 18; arm H 25-1/2. *(Courtesy of Thonet)*

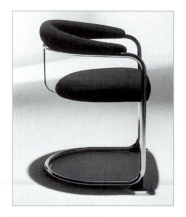

LORENZ CHAIR.
Designed by Anton Lorenz, circa 1930. A reinterpretation of the Luckhardt chair, designed by Anton Lorenz, the founder of a small furniture manufacturer in Desta. Thonet purchased Desta in 1932 and acquired all design rights. Lorenz armchair: W 23-1/2, D 22, H 29; seat 21 x 18-1/2, H 19; arm H 26-1/2. *(Courtesy of Thonet)*

Cox and Company

Roland Wilton Cox was manager of the British auto parts manufacturer, Rotax Accessories Ltd., and in 1927 he purchased the company. By 1930 the Depression had so adversely affected the demand for auto parts, that Cox searched for new products. He began to make tubular steel seats for automobiles, then folding garden furniture, and eventually domestic furniture, but they did not hire professional designers.

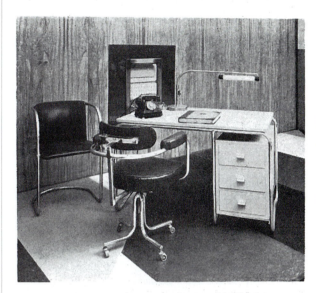

Advertisement for Cox & Co. tubular steel furniture, 1933.

PEL

The British manufacturer of seamless tube steel, Accles and Pollock, began to use its own product to make furniture. Along with other British steel tube products manufacturers, such as Tubes Ltd., they formed Tubular Investments in 1919. One part of the company was called Tube Products, and modeled after Thonet, they began to seriously produce furniture. In 1931 Tubular Investments registered a new company, Practical Equipment Limited (PEL), and produced their first catalog the following year. They promoted the new tubular steel as efficient and hygienic rather than simply novel, because they believed that the public needed more than just change—they needed improvement.

PEL hired Russian architect-designer Serge Chermayeff (b. 1900) to design tubular steel items, including nesting chairs in 1932. Chermayeff became active in modern design in Great Britain and the United States from 1939 on, and taught and/or headed departments at Illinois Institute of Technology, Brooklyn College, Harvard, and Yale.

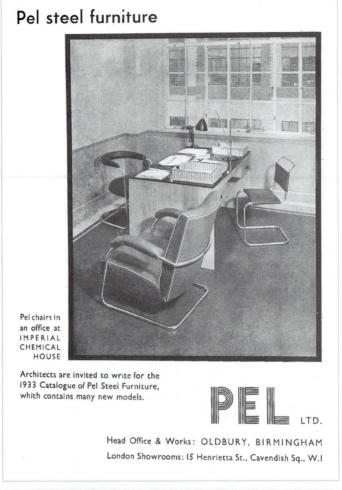

Advertisement for PEL tubular steel furniture, 1933.

Gispen

Willem Gispen (1890–1981) was a major Dutch designer and maker of metal furniture. He was trained in architecture at the Royal Academy of Fine Arts and Technical Sciences in Rotterdam and began his career as a draftsman. When he "became bored drawing foundations and sewerage," he sought a job that would allow him to develop more creatively. In 1911 Gispen began to design artistic wrought iron at an ironworks factory, but soon quit because of the low pay. He purchased his own smith's workshop and began to design the wrought iron for other architects and became so successful that within three months there were twenty-two employees in the shop. In 1935 the Gispen factory moved from Rotterdam to Culemborg with 100 employees; in 1951 they had 500 employees working for the firm. Between 1922 and 1951 Gispen designed and made lamps and furniture, and they made tubular steel chairs beginning in 1926. He also designed tubular steel for other companies, such as Rotterdam-based Fabriek voor Metaalbewerking, and he was instrumental in introducing tubular steel furnishings in Holland. The Gispen catalog advertised the chairs as being ergonomic, as the designs were based on "the scientific analysis of the needs of sitting."

Though not widely accepted in their day, several of the first Bauhaus or Bauhaus-related tubular steel furniture designs were produced by Thonet and some were reissued by Gavina of Italy, which was later purchased by Knoll. Neither avant-garde whims nor remedies for ailing companies during a time of economic depression, these tubular steel designs have passed the proverbial test of time. These modern classics that once demonstrated an almost perfect union between art and industry, while addressing the "needs of sitting," have endured for that very reason.

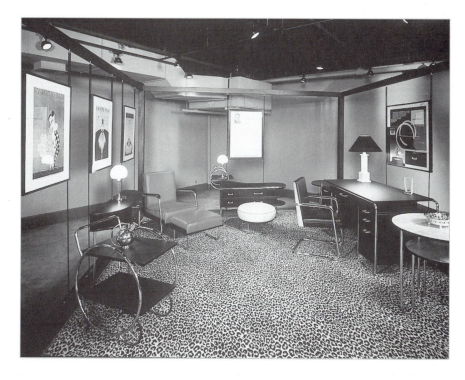

Room setting with furniture designed by Finnish designer Pauli Blomsted (1900–1935), who contributed to the Finnish counterpart of the Bauhaus. *(Courtesy of Arkitektura)*

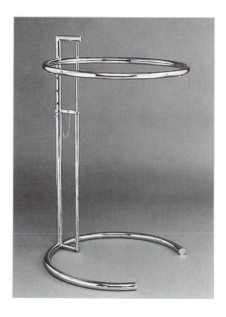

TABLE.
Designed by Eileen Gray in 1927. Mirror polished and chrome-plated steel tube frame with transparent glass or mirrored top. D 20.
(Courtesy of Palazzetti)

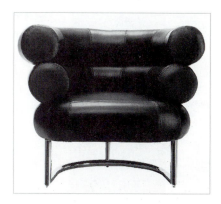

ARMCHAIR.
Designed by Eileen Gray in 1925. Hardwood frame covered in molded foam and leather or fabric; base of mirror-polished and chrome-plated tubular steel. H 29, W 35-1/2. *(Courtesy of Palazzetti)*

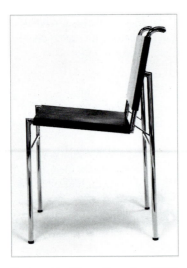

Designed by Eileen Gray, circa 1927. Tubular steel frame with seat and back upholstered in heavy cowhide. H 31, W 22-1/2. *(Courtesy of Palazzetti)*

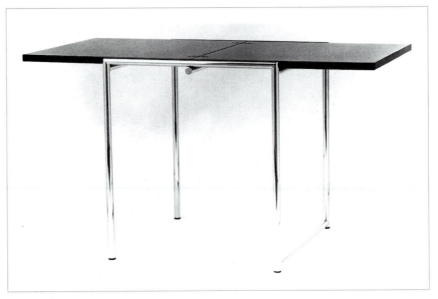

FOLDING TABLE.
Designed by Eileen Gray, circa 1927. Mirror-polished and chrome-plated tubular steel frame, matt black high-pressure laminate top. H 28, W 25 to 50-1/2. *(Courtesy of Palazzetti)*

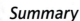

Summary

- The Bauhaus was a major force in developing the concepts and laying the foundations of industrial design.
- Closing of the Bauhaus prevented its leaders from realizing their goal of mass production.
- European designers affiliated with the Bauhaus introduced tubular steel furniture that was to be mass-produced by Thonet as well as British and American companies.

Chronology

1907 Deutcher Werkbund is founded.

1919 Bauhaus is founded by Walter Gropius.

1925 Marcel Breuer designs the tubular steel Wassily chair.

1927 Mart Stam designs first cantilevered tubular steel chair.

1928 Breuer designs the Cesca chair.

1932 Bauhaus is closed by the Nazi regime.

1934 Deutcher Werkbund closes.

Designers of Furniture

Marcel Breuer (1902–1981, Hungary) One of the most influential modern furniture designers, who brought tubular steel from the Bauhaus to the United States.

Le Corbusier (1887–1965, Switzerland) Architect, master of Bauhaus philosophy and style, who designed tubular steel furniture with Pierre Jeanneret and Charlotte Perriand.

Eileen Gray (1878–1976, England) Architect-designer who began making lacquer furniture in traditional Art Deco style but later emphasized modern design using tubular steel.

Pierre Jeanneret (1896–1967, Switzerland) Architect, who joined Le Corbusier's architectural office in 1921, and in 1927 began to design tubular steel furniture with Perriand.

Anton Lorenz (1891–1964; Hungary, Germany) Furniture designer and manufacturer who was active in Berlin in the 1920s and 1930s; worked with Breuer in their firm Standardmöbel, which was purchased by Thonet.

Ludwig Mies van der Rohe (1886–1969; Germany, United States) Master of International style, who brought the Bauhaus philosophy and style to the United States; designed classic tubular steel chairs.

Charlotte Perriand (1903–, France) Joined Le Corbusier's architectural office in 1927 and began to design tubular steel furniture with Jeanneret.

Mart Stam (1899–1986, Netherlands) Credited with designing the first cantilevered tubular steel chair, produced in 1926.

Companies Producing Tubular Steel Furniture

Cox & Co., Britain
Gispen, Netherlands
PEL, Britain
Thonet, Austria

Key Terms

Bauhaus	International style	modernism
cantilever	mass production	tubular steel
Deutcher Werkbund		

Recommended Reading

Campbell, Joan. *The German Werkbund: The Politics of Reform in the Applied Arts*. Princeton, N.J.: Princeton University, 1978.

Campbell-Cole, Barbie, and Tim Benton, eds. *Tubular Steel Furniture*. London: Art Book Co., 1979.

Droste, Magdalena. *The Bauhaus: Masters and Students*. New York: Barry Friedman, 1988.

————. *Bauhaus 1919–1933*. Köln, Germany: Benedikt Taschen, 1990.

Droste, Magdalena, et al. *Marcel Breuer Design*. Köln, Germany: Taschen, 1992.

Neumann, Eckhard, ed. *Bauhaus and Bauhaus People*. Rev. ed. New York: Van Nostrand Reinhold, 1983.

Sharp, Dennis, et al., eds. *PEL and Tubular Steel Furniture of the Thirties*. London: Architectural Associations, 1977.

Chapter 12

INDUSTRIAL DESIGN
Coming to America

CHAPTER CONTENTS

Because of the closing of the Bauhaus and emigration of its key figures to the United States, it is there that industrial design in the modern sense was born. The United States of the late 1920s and 1930s was, along with this new profession, making its debut on the international art scene.

INDUSTRIAL DESIGN

Tubular steel furniture, originally developed in Europe, was among the early products of the field of industrial design in America, but furniture was neither the first nor the most important item produced. Most of the pioneers in the field focused on designing a variety of items, which may or may not have included furniture. Norman Bel Geddes is credited with opening the first industrial design office in 1927; Joseph Sinel claimed to be the first established industrial designer in the United States; in 1934 *Fortune* magazine listed George Sakier as having been in the field since 1923; yet none of these men were necessarily furniture designers.

No single item characterized industrial design. The new field was dependent upon materials and technologies that had not previously existed, and it drew for its aesthetic philosophy from an equally new phenomenon, abstract art. Though it may not have been fashionable to admit at the time, they were also influenced by the opulent, elitist, and craft-driven French **Art Moderne**, which had been transplanted onto American soil via fashion and merchandising. Designers from a variety of primarily two-dimensional design backgrounds were called upon to add style to both new and existing items. As industrial design historians Sheldon and Martha Cheney wrote: "The most obvious style mark, the streamline, came from the one totally ancestorless invention, the airplane. Most rapid progress had occurred in connection with those commodities that are either substantially new things in the world or also so essentially utilitarian that they had escaped artistic treatment before."

In the past, machines had been designed by engineers or proto-engineers without art training and then decorated, if at all, by artists. Neither the engineers nor the artists necessarily understood each other, and it was the artists or machine decorators who were the most severely criticized. One explanation for the problem was in the choice of decoration. In the nineteenth and early twentieth century, few items escaped historicism, and even machinery was made to superficially resemble other decorated forms. On both sides of the Atlantic the impulse to decorate persisted. According to Cheney, all cultural periods and geographic areas of the past had long been raided, and their treasures reduced to patterns, numbered ready to be laid on to the machine and its products. Forms were obscured rather than enhanced by these embellishments. There was an aesthetic time warp: Neither the machine-made objects nor the machines of the Industrial Revolution looked very revolutionary, because familiar historic revivalist motifs of handicraft were arbitrarily applied to the machines.

Industrial design as it emerged in the late 1920s was not machine decoration, but machine art. Just as past styles reflected their respective cultures, so would the new styles reflect modern culture. These new styles were also affected by twentieth-century manufacturing techniques, namely, **mass production**. This mass production required a different set of aesthetic values plus a means to market them to the consumer. At least two significant influences can be credited to two-dimensional art: abstraction in painting, something only a specialized minority had access to, and graphic design, which had already absorbed and synthesized elements of both abstract art and the often-criticized but freely copied French Art Moderne.

This modern art was not only aesthetically sensible for mass-produced design, it made perfect sense functionally and economically. Essentially geometric forms were lifted from a two-dimensional context to fill three-dimensional space. Not just any art—modern art—was injected into, rather than applied onto, industrial design; the design came from the inside out. The seemingly opposite extremes of new technology and equally new theoretical abstract art suddenly came in to contact. So a simplified definition is formed: mass production + abstract art = industrial design. Modernist design becomes the machine aesthetic, and the practitioners of the new field of industrial design who spoke the language of modern art became pioneer modernists in a new medium.

Since industrial design was not just transformed, but new in the 1930s, its pioneering practitioners came from other fields. Most came with education and/or experience in

two-dimensional arts: theater set design, painting, illustration, advertising, and packaging design. Modern styles of the 1920s, particularly those being imported from Europe, affected those areas first. When artists and designers moved from two-dimensional stylization and abstraction into three-dimensional formats, they carried this modernism to industry. They also brought along the skills to market it. And as long as they had already made a dimensional move (from two to three dimensions), some took advantage of this ability and continued to design theater sets or product packages as well. After all, once the principles of design are understood, movement between fields becomes relatively easy.

Industrial design is one of the most significant concepts in the history of modern furniture, and any discussion about industrial design would not be complete without including some of its major practitioners. Although not necessarily designers of furniture, the following were pioneers in the new field:

Egmont Arens (1888–1966, United States)

Arens was a typesetter and then a magazine editor in Albuquerque, New Mexico, in 1916; after moving to New York, he headed the industrial styling division of Calkins-Holden Advertising from 1929 to 1933. Arens became a leading packaging designer of coffee bags for the A & P food chain and items for Bristol-Myers, Aluminum Company of America (Alcoa), Seeman Bros., and Louis L. Libby. Product designs included electrical switches for Federal Electric Products, lamps, coffee mills, meat slicers, dishwashers, scales, mixers for Kitchen Aid, and other electric appliances.

Alfons Bach (1904–; Germany, United States)

Born in Germany, Bach studied in Berlin and in Italy. After emigrating to the United States, he designed for a variety of clients: furniture for Heywood Wakefield, carpets for Bigelow, and electrical appliances for General Electric. He was president of the Industrial Designers Society of America and exhibited at the Metropolitan Museum of Art in New York in the 1930s. His tubular metal table has been reissued by Design America.

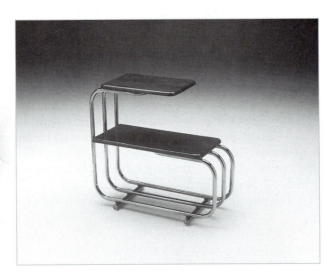

BACH TABLE.
Designed by Alfons Bach, circa 1930s. German-born industrial designer, emigrated to the United States. Table with tubular metal base and two wood shelves. H 23, L 25-1/2, W 11. *(Courtesy of Design America)*

Norman Bel Geddes (1893–1958, United States)

Bel Geddes studied briefly at the Art Institute of Chicago, then worked in advertising, theatrical arts, painting, illustrating, exhibit design, set design, architecture, and industrial design. He was called the P. T. Barnum of industrial design because of his showmanship.

Among his many designs were scales for Toledo Scale, radio cabinets for Philco, a Graham Page automobile, and the Futurama exhibit for General Motors at the 1939 New York World's Fair.

Henry Dreyfuss (1904–1972, United States)

Dreyfuss was born in New York City, and without formal design training became one of the first major industrial designers. After working for Norman Bel Geddes in the 1920s and designing sets, costumes, and lighting for the Strand Theater in New York, he opened his own design office on Fifth Avenue in 1929. He also had a West Coast office in South Pasadena. One of his earliest and longest lasting clients was Bell Telephone Laboratories. As a consultant designer of telephones for AT & T from 1930, his designs include the Princess and Touch Tone models. Dreyfuss designed for John Deere and Co. (1937), Hyster (1951), Polaroid (1961), and American Airlines (1963); he collaborated on the model city at the 1939 New York World's Fair; he redesigned the cars and interiors of New York Railroad's Mercury in 1936 and the 20th Century Limited in 1938; his interiors were also found in ocean liners S.S. *Independence* and S.S. *Constitution*; he designed airplane interiors for Lockheed's Super Constellations, American Airlines, Boeing, and Pan Am and the spill-proof lunch trays to use during flight; he designed vacuums for Hoover, clocks for Western Clock, oil drilling rigs for National Supply Co., farm machinery for Deere and Co., china lavatories for Crane Co., construction equipment, washing machines, refrigerators, thermos bottles, a hook for amputees, typewriters, pens, pencils, and flyswatters. Dreyfuss was interested in human values, pioneered the field of ergonomics, and wrote books including *Designing for People* in 1955 and *Measure of Man* in 1959. It was said that for years he liked to design for a Broadway show each season because his clients liked to see his name in theater programs.

Lurelle Guild (1898–1986, United States)

Guild was from Syracuse, New York, and graduated from Syracuse University in fine arts and went into acting, painting, advertising art, and illustration. His experience in theater and advertising led to industrial design, where he became so prolific that he held patents for more products than any other designer. He was also a prolific writer in the field of antique furniture and a master at promotion. His designs included refrigerators for Norge, vacuum cleaners for Electrolux, and items for Wear-Ever Aluminum and Chase Copper and Brass. Guild designed most of the extensive line of Kensington Ware aluminum giftware and domestic items for Alcoa in the 1930s as well as modern aluminum furniture made by Alcoa and then by General Fireproofing. He designed the Kensington showroom in Rockefeller Center and the museum at the New York offices of Alcoa.

Wolfgang Hoffmann (1900–1969; Austria, United States)

Wolfgang Hoffmann was the son of Viennese architect and Wiener Werkstätte leader Josef Hoffmann (1870–1956). He was born in Vienna, where he studied architecture at the School of Arts and Crafts. In 1925, he and his wife, designer Pola Hoffmann, moved to the United States and worked briefly for Joseph Urban and for Elly Jacques Kahn. Hoffmann is known for his tubular steel chairs made by Howell Company in Geneva, Illinois, in the 1930s. He moved to Illinois in 1933 to design exclusively for Howell. From 1933 to 1942, his S-chairs used for dinette sets in small kitchens or in combination living-dining rooms were very successful. He patented several tubular metal chair designs and numerous smoking stands. Much of the popular mass-produced tubular steel furniture seen today was designed by Hoffman and made by Howell.

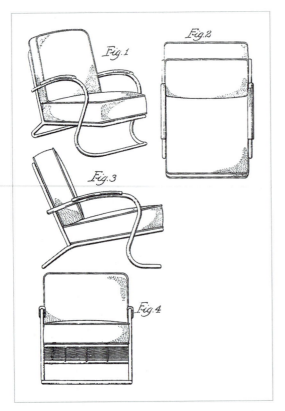

United States Patent Office drawing for a tubular steel frame lounge chair, designed by Wolfgang Hoffman for Howell Co. of St. Charles, Illinois; issued February 11, 1936.

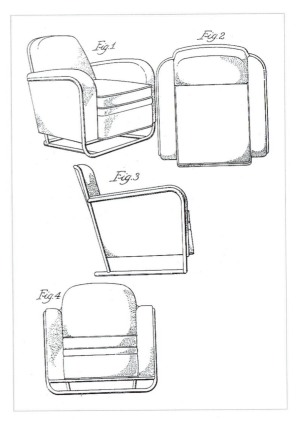

United States Patent Office drawing for a tubular steel frame lounge chair, designed by Wolfgang Hoffman for Howell Co. of St. Charles, Illinois; issued February 11, 1936.

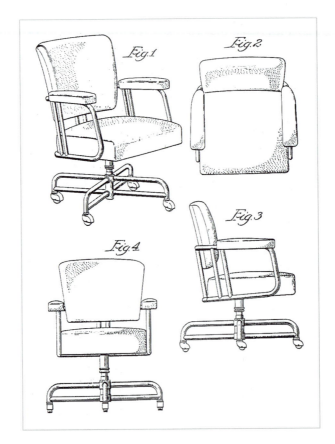

United States Patent Office drawing for a tubular steel frame swivel chair, designed by Wolfgang Hoffman for Howell Co., issued May 26, 1936.

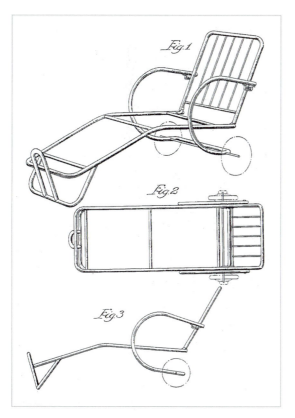

United States Patent Office drawing for a tubular steel chaise lounge frame, designed by Wolfgang Hoffman for Howell Co. of St. Charles, Illinois; issued May 26, 1936.

United States Patent Office drawing for a tubular steel refreshment cart, designed by Wolfgang Hoffman for Howell Co., issued May 26, 1936.

United States Patent Office drawing for a tubular steel table, designed by Wolfgang Hoffman for Howell Co., issued May 26, 1936.

Leo Jiranek (United States)

Leo Jiranek studied engineering at Princeton and graduated in 1922. In 1934 he and Donald Deskey formed a short-lived company called Amodec Inc. to manufacture modern furniture designs. He worked for Heywood-Wakefield as a design consultant from 1935 into the 1950s designing their Modern line, rattan summer furniture, theater seating, and baby carriages for their Lloyd Division. As a leading furniture designer, he was one of the organizers of the American Furniture Mart Designers Institute in 1936, which changed to American Designers Institute (ADI) in 1939. In 1941 Jiranek chaired the National Emergency Committee of the ADI to help the United States with the war effort in the area of manufacturing and materials shortages.

United States Patent Office drawing of end standard for theater chairs designed by Leo Jiranek for Heywood-Wakefield, filed July 8, 1940.

United States Patent Office drawing of end standard for theater chairs designed by Leo Jiranek for Heywood-Wakefield, filed July 8, 1940.

Raymond Loewy (1893–1986; France, United States)

Loewy was born in Paris, where he studied engineering and enjoyed sketching locomotives and airplanes. He served in the French Army Corps of Engineers during World War I and became a highly decorated captain. When he left France in 1919, he memorized the New York City street map on the trip across the Atlantic. His first jobs in the United States were for major New York department stores dressing windows. He did fashion drawings for *Vogue*, *Vanity Fair*, and *Harper's Bazaar* magazines, designed costumes for Ziegfeld, and went into product design in the late 1920s and opened his own office in 1929. His designs included the Coldspot refrigerator for Sears Roebuck; buses for Greyhound; Studebaker

and Huppmobile automobiles; airplane interiors for Curtiss-Wright, Douglas, and Boeing; speedboats; the S-1 locomotive for the Pennsylvania Railroad; the bottle for Coca-Cola; the package for Lucky Strike; corporate logos for British Petroleum, Shell, and Exxon; Air Force One for President Kennedy; and Skylab interiors for NASA.

Gilbert Rohde (1894–1944, United States)

Born in New York City, Gilbert Rohde learned cabinetmaking at his father's shop. He is considered a pioneer industrial designer and key figure in the introduction of modern design in the United States. In 1923 he worked full time as a furniture illustrator for Abraham & Strauss department store in New York. After traveling in Europe (he married Gladys Vorsanger in Paris) and becoming acquainted with the Bauhaus, he opened an industrial design office in New York and produced his own furniture.

Rohde is particularly important for introducing modern design at Herman Miller, which started the company in a totally new direction beginning in 1930. To his credit are modular units, sectional sofas, storage units, a variety of seating pieces, and the company's first metal furniture. Rohde's modern designs using tubular steel bases on wood furniture in the 1930s were concerned more with aesthetics than with the ability to mass-produce. But the concept of mass-production was foremost when he later brought Herman Miller into the office furniture business with his 1942 Executive Office Group (EOG) in which fifteen pieces combined to make 400 groupings.

He also designed furniture for John Widdicomb, Thonet, Brown-Saltzman, Kroehler, Lloyd, Valentine Seaver, Valley Upholstery, the Z stools and other chromed metal furniture for Troy Sunshade in Troy, Ohio, in the 1930s, and a line of indoor-outdoor furniture for Heywood-Wakefield in 1930. Other items included clocks for Howard Miller, water coolers, boilers, pianos, stokers, and gas ranges; exhibits included the "Design For Living" house at the 1933 Chicago World's Fair, Texas Centennial, San Francisco Golden Gate Exhibition, and several installations at the 1939 New York World's Fair. He headed the industrial design program at the New York School of Architecture from 1939 to 1943.

ROHDE DINING SET.
Designed by Gilbert Rohde, circa 1933. Tubular steel frame table and chairs manufactured by Herman Miller, 1930s. *(Courtesy of Herman Miller, Inc)*

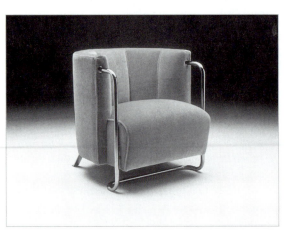

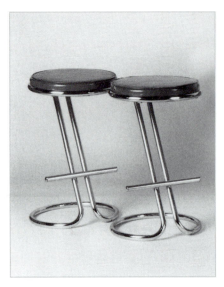

ROHDE LOUNGE CHAIR.
Designed by Gilbert Rohde, circa 1930s. Tub back
upholstered chair with overstuffed seat and tubular metal
arm fronts and base. H 30, W 29, D 32-1/2. *(Courtesy of
Design America)*

Pair of **Z**-stools designed by Gilbert Rohde
for the Troy Sunshade Co. in Troy, Ohio, circa
1930, red vinyl upholstery, chromed tubular
steel frames. *(Courtesy of Skinner, Inc)*

George Sakier (1897–1988, United States)

George Sakier was born in 1897 in Brooklyn, New York. He studied at Pratt Institute and Columbia University. An industrial and product designer and an oil painter, he exhibited at the Metropolitan Museum of Art, the Museum of Modern Art, the Philadelphia Museum of Art, and the Louvre. As a full-time designer at American Standard designing bath fixtures, Sakier was one of the first professional industrial designers. His Art Deco fixtures were installed in the new Waldorf Astoria Hotel in New York. He also was art director for *Harpers Bazaar* from 1927 to 1929, designed packaging for liquor and cosmetics, designed theme exhibits at the 1939 New York World's Fair, and directed the Municipal Art Society of New York City,

Around 1950, Sakier moved to Paris (and also kept a studio on Long Island), where he focused on oil painting, especially abstract designs in vivid colors. He also continued to design Art Deco glassware for the Fostoria glass company. For a period of 50 years, from 1929, he sent designs to the Moundsville, West Virginia, company.

Joseph Sinel (1889–1975, New Zealand, United States)

Sinel came to the United States from New Zealand via Australia and England in 1918. He was trained in lithography and illustration, became a leading trademark and packaging designer, and wrote *A Book of American Trademarks and Devices* in 1923. Sinel also claimed to be the first established industrial designer in the United States and was a founding member of the American Society of Industrial Design.

Walter Dorwin Teague (1883–1960, United States)

Teague was a pioneer American industrial designer who promoted the Streamlined style. Born in Decatur, Indiana, he attended evening classes at the Art Students League in New York from 1903 to 1907, did freelance drawing and sign lettering, joined the Ben Hampton Advertising Agency in 1908, and then joined the Calkins-Holden agency

before starting his own office in 1911. His advertising designs included the Metropolitan Museum of Art industrial art exhibit in 1922. After going to Europe in 1926 and studying the work of Le Corbusier, he returned to his practice and focused on product designs. Teague designed cameras (notably the Baby Brownie) for Eastman Kodak from 1934 to 1941, A. B. Dick showrooms, weather instruments for Taylor Instrument Co., dinnerware for Taylor, Smith & Taylor, passenger cars for the New Haven Railroad, and Texaco service stations. He was on the Board of Design for the New York World's Fair and designed exhibits for Consolidated Edison, Ford Motors, United States Steel, du Pont, National Cash Register, Eastman Kodak, and A. B. Dick. In 1944 Teague became the first president of the newly formed Society of Industrial Designers (SID). Fifties designs included pens for Scripto, cans for Schaefer Beer, and 707 interiors for Boeing. He wrote the book *Design This Day: The Techniques of Order in the Machine Age* in 1940. His firm Walter Dorwin Teague Associates continued after his death.

Harold Van Doren (1895–1957, United States)

Van Doren was born in Chicago, studied painting in Europe, and worked at the Louvre. He returned to the United States and became an assistant at the Minneapolis Institute of Art, and opened a design office in the late 1920s in partnership with John Gordon Rideout (d. 1951); clients included Toledo Scale, Swartzbaugh Mfg. Co., Air King Products, Maytag, Goodyear Tire, Philco, and DeVilbiss. He was known for using Art Deco and streamlining, and designed streamlined tricycles for American National. In 1940 he wrote *Industrial Design: A Practical Guide*.

John Vassos (1898–?; Greece, United States)

Vassos was born in Greece and trained in commercial art, drew political cartoons for his father's newspaper in Constantinople, left Turkey in 1915, fought in the war for Britain, and came to the United States in 1919. He studied art and illustration at the Art Students League and with John Singer Sargent in Boston and John Sloan in New York. He did illustrations for magazines such as *Harper's* and *The New Yorker.* His first industrial design was a cosmetic bottle in 1924, and then he worked for clients such as RCA and Coca-Cola. Vassos helped to found the American Designers Institute (ADI).

Karl Emanuel Martin (Kem) Weber (1889–1963; Germany, United States)

Born in Berlin, Kem Weber became a pioneer American industrial designer, and one of the few on the West Coast while most were on the East Coast in the 1920s and 1930s. While still a student, he supervised the construction of the German portion of the 1910 Brussels World's Fair, and then graduated from the School of Decorative Arts in Berlin in 1912. While helping to design the German section of the 1915 San Francisco International Exhibition, he was stranded in California at the outbreak of World War I; he stayed and became a United States citizen in 1924. Weber worked as an art director and furniture designer and then opened his own industrial design studio in Hollywood in 1927. He designed in the Streamlined style and in 1934 designed the Airline chair, made of plywood hinged together and produced by the Airline Chair Co. in Los Angeles. His use of tubular steel, for furniture manufactured by Lloyd, was considered to be flamboyant, as opposed to the austere look of the International style used by others. Weber designed prefabricated housing as well as conventional architecture and eventually turned to exclusive use of natural materials, namely wood, brick, and fieldstone.

1931
Empire State building and
George Washington Bridge
completed; radio waves
from space discovered;
vitamin A isolated; German
banks close; Scrabble game;
Dick Tracy comic; Boris
Karloff in *Frankenstein*; first
color film (Disney); "Star
Spangled Banner" becomes
U.S. national anthem; songs
"Minnie the Moocher" and
"Goodnight Sweetheart."

Born 1931
James Dean (d. 1955);
Mikhail Gorbachev; James
Earl Jones; Mickey Mantle
(d. 1995); Dan Rather;
Desmond Tutu; Massimo
Vignelli; Boris Yeltsin.

Died 1931
Thomas Edison (b. 1847);
Daniel Chester French
(b. 1850); Anna Pavlova
(b. 1881); Knute Rockne
(b. 1888).

1932
Werner Heisenberg wins
Nobel Prize in physics for
creation of quantum
mechanics; Ernest Walton
and John Cockcroft split the
atom; Amelia Earhart's solo
Atlantic flight; Franklin
Roosevelt wins election;
vitamin D discovered;
Aldous Huxley's *Brave New
World*; songs "Night and
Day," "April In Paris," and
"Brother, Can You Spare a
Dime?"

Russel Wright (1904–1976, United States)

Wright was born in Ohio and was a child prodigy painter. In 1920 he studied at the Cincinnati Academy of Art, and then at the Art Students League in New York, where he also began designing theater costumes and sets. A versatile designer, Wright became best known for interior furnishings and domestic items such as the first modern blond maple furniture for Conant Ball. He designed glassware for Imperial Glass Co., Old Morgantown Glass Guild, and Fostoria Glass Co. Some of his best-known designs were for pottery, especially the enormously successful American Modern dinnerware for Steubenville Pottery Co. (1939–1959), plus Iroquois Casual for Iroquois China Co., and lines for other pottery companies—Padden City, Sterling China, Harker, Edwin M. Knowles, and Bauer Art Pottery. He also designed streamlined radios for Wurlitzer, metalware for Chase Brass and Copper, spun aluminum items, cocktail gadgets, pianos, chewing gum dispensers, Linotype machines, packaging, and World's Fairs exhibits.

All of these men had art backgrounds, whether by studying, teaching, or practicing. Consumers were far less vocal about engineering deficiencies, than they were about the dreary appearance of useful items. They placed a high value on appearance, and demanded more than applied design clichés. Although it would seem that, if the goal was to design from the inside out, a designer with engineering skills had an obvious advantage, Sakier was almost alone with a background in engineering as a road to industrial design.

Deskey, Rohde, Sakier, Teague, and Wright visited Paris and returned with modern art, including one with a French accent—Art Moderne. The famous, or infamous, L'Exposition des Arts Décoratifs et Industriels Modernes held in Paris in 1925 was the first real exposure most Americans had to modern design. It was no coincidence that shortly after the Paris Expo, in the late 1920s, both the Modernist movement (introduced in 1913 at the Armory Show) and the field of industrial design came alive in New York.

AMERICAN UNION OF DECORATIVE ARTISTS AND CRAFTSMEN (AUDAC)

As we have seen, acceptance and promotion of the machine as a legitimate means of producing art and artistic industrial products was a theme of both the Bauhaus and of the field of industrial design that developed largely in the United States. It was also the theme of a short-lived but influential quasi-industrial design organization called the American Union of Decorative Artists and Craftsmen (AUDAC), headquartered in New York City. The purpose of the society, as written in the *Architectural Record*, was "to give direction to contemporary design in America, particularly as it applies to industry." As stated in the preamble of its constitution, "the undoubted benefits which the world has derived from the development of machine industry and the spread of popular education have been accompanied by certain unfortunate effects. It is evident to most of us that the more obvious of these effects are the discrepancy between the life of the people today and the setting in which it is lived, and the inappropriateness of one to the other." AUDAC was formed to help remedy this discrepancy between modern lifestyles and traditional, historically based interior environments. In other words, twentieth-century life and technology needed to look and act modern as well. Exhibitions were the method of bringing their message to the public. A major event was held at the Brooklyn Museum from June through September of 1931, and 70 of its 117 active members displayed decorative and industrial art. Exhibits included furniture by leading modern designers such as Donald Deskey, Paul Frankl, Norman Bel Geddes, Hugo Gnam, Eugene Schoen, Joseph Urban, Kem Weber, and Frank Lloyd Wright. Besides furniture, accessories and textiles were also shown. The work was all produced especially for the exhibit in order to illustrate the newest in American design.

American modernity was the theme, and AUDAC's goal was to create a single national style suited to contemporary American life rather than a European copy. Ironically, there were so many German-born members that meetings were often held using the

German language. Until this time, and with few exceptions, American designers had followed Europe. According to AUDAC, it was time for designers to elevate American design standards by developing "a distinctive, practical, and beautiful style rather than many conflicting vogues." This new singular style would become America's contribution to international modern design. The combination of function and form would change the face of American interiors over the next thirty years.

The *Annual of American Design 1931*, produced and published by AUDAC, also furthered the cause by illustrating members' work and including essays on their philosophy. In one of the essays, noted critic Lewis Mumford observed, "Whatever the policies of a country may be, the machine is a communist! . . . The machine . . . if properly used, will do away with industrial slavery and create, for every member of the community, and equal share in the essentials of life." Mumford saw that through standardization in the industrial arts, there are two possible outcomes. The least desirable result had already been seen in the nineteenth century with the superficial ornamentation that had motivated reformers. Mumford saw the need for the new machine-made art to focus on utility, simplicity, and form. Innovative manufacturing techniques plus aesthetically pleasing designs and appropriateness to the changing American lifestyle equaled Mumford's formula and philosophy of AUDAC.

Paul Frankl's contribution to the *Annual* was more than speculative, because he was already recognized as one of America's leading modernists. He wrote, "True modernism . . . aims to satisfy the needs of modern living and to express the spirit and the flexibility of modern life" (Glassgold 26). However, Frankl's description of the modern home as "a more or less harmonious assemblage of machine-made parts" and his prediction that "we shall be able to discard our old home as we discard an old set of clothes" were among the most radical and economically impractical statements made by an AUDAC spokesperson. Critics found Frankl's extremism discomforting and regarded the implication that his latest whims were necessarily better than anything from history presumptuous. But without controversy, change would not occur.

FLIGHT CHAIR.
Designed by Paul T. Frankl, circa 1930s. Upholstered armchair with exaggerated streamlined arms and two-tiered back cushion. H 30, W 35-1/2, D 41.
(Courtesy of Design America)

Another of AUDAC's aims was to combat design piracy, something that was presenting a problem for the industrial arts. Manufacturers had become accustomed to borrowing traditional designs. However, when they began to borrow original and current modern designs, it threatened the designer's livelihood. In their efforts to solve the problem, AUDAC was instrumental in organizing the League for Suppression of Design Copyright Bill by the United States House of Representatives. The plagiarism issue continued to plague the industry in subtle and not-so-subtle ways.

1934
FCC; Chrysler Airflow is first streamlined car; comics *Donald Duck, Flash Gordon,* and *L'il Abner*; a surface wind of 231 mph was recorded at the peak of Mount Washington, in the White Mountains of New Hampshire; novels Robert Graves's *I, Claudius*, John O'Hara's *Appointment in Samarra*, F. Scott Fitzgerald's *Tender Is the Night*, Evelyn Waugh's *A Handful of Dust*, James M. Cain's *The Postman Always Rings Twice*; song "Blue Moon."

Born 1934
Jane Goodall; Michael Graves; Sophia Loren; Shirley MacLaine; Ralph Nader; Carl Sagan (d. 1996); Gloria Steinem; Junior Wells (d. 1998).

Died 1934
Marie Curie (b. 1867).

1935
Radar; U.S. Social Security Act; Works Progress Administration; Alcoholics Anonymous organized in New York; Olympic star Babe Didrikson Zaharias is first athlete to appear on a Wheaties box; game *Monopoly*; James T. Farrell's novel *The Studs Lonigan Trilogy*; film *Mutiny on the Bounty*; Gershwin's *Porgy and Bess*; songs "I Got Plenty O' Nutin'" and "It Ain't Necessarily So."

Born 1935
Woody Allen; Julie Andrews; Sonny Bono (d. 1998); Eldridge Cleaver (d. 1998); King Hussein I; Luciano Pavarotti; Elvis Presley (d. 1977).

In retrospect, it is ironic that an elitist style, accused of being shallow and seductive, which entered the United States via department stores and museums, would have so strong an influence on a budding profession professing to be born from engineering and pure abstract art. French Art Moderne decorative arts—furniture, screens, art glass, ceramics, metalware, jewelry—were excessively costly because their production methods and producers represented the antithesis of industrial design. The French took rare and exotic materials, used traditional handicraft methods, and made sumptuous objects. Many of the modernists, especially architects who were often from or influenced by the Bauhaus, had socialist leanings, so any blatantly upper-class French fashion was rejected as much on philosophical as aesthetic grounds. Nonetheless, many of the designs were extraordinary.

Regardless of politics, the designs were also modern. Neoclassical references aside, the highly stylized and bold motifs and shapes were new interpretations, and the public found them to be refreshing. They were also relatively easy to reduce to clichés and copy. It wasn't long before American manufacturers began to trivialize Art Moderne symbols and to indiscriminately apply them to inexpensive mass-produced goods, not unlike the way they had once cluttered them with fruits and flowers. Though the 1851 Great Exhibition at the Crystal Palace seemed like a long way off, an echo of its exhibit catalog could still be heard by Cheney: "ornament is now as material an interest in a commercial community as the raw materials of manufacture itself."

The new ornament indeed carried commercial interest. Eventually it was reduced to what historian Martin Grief calls "the strange cult of the three little lines, three parallel lines intended to suggest modernity." These and the aerodynamic **streamline** shape and line—a curved line with a sharp parabolic curve at one end—became "a way of marketing items which were never intended with speed in mind."

There was also a positive side to the new style or styles introduced through European decorative arts. Though the leaders and followers of Art Moderne were usually not industrial designers, they provided a design vocabulary expressive of America's new machine age. This vocabulary could in turn be applied to consumer product by new designers. These "new designers" were the industrial designers who were able to translate this design vocabulary from French to American. There was nothing inherently wrong with the three little parallel lines, the streamline, rounded corners, or classical references of Art Moderne (to the contrary, many would consider them to be very right), as long as their application to mass-produced goods was appropriate. Consumers had grown tired of dreary looking goods. Streamlined form and the streamline symbols were appropriate for trains, planes, ships, and automobiles. Though electric irons had no practical use for aerodynamic styling, consumers preferred it. Sales of newly styled items often increased twofold, even sixfold. Thanks to efficient design and mass-production techniques, industry could reduce costs at one end, while increasing sales at the other. If the industrial designers were even partly responsible for the huge profits, then they had earned their extraordinarily high incomes, and in the 1930s top industrial designers were among the highest paid professionals in America.

Neither copyists of abstract painting nor of modern decoration, the designers for industry were creating a new art form. Its modern vocabulary borrowed from the fine and decorative arts, engineering, as well as marketing. Since most entered the field with training and expertise in art and advertising, their immediate successes were of no surprise. These designers were multitalented, plus they were in exactly the right place at exactly the right time. Grief went so far as to write, "Few generations have better understood themselves and their times than the designers of the '30s. They knew what they were creating, they knew why they were creating it, and they even had a premonition of what their place in history would be because they had created it." Yet, when asked to predict what housing would be like in the next century, Sakier rather insightfully answered, "It is impossible to predict the future in design unless one knows social changes." The decade in which he spoke was to see the rise of totalitarianism and World War II.

An economic climate that gives rise to tremendous competition for a market share is one where the total market is small; this small market may not be due to any lack of desire to purchase products, but on a shortage of money. An economic depression is such a climate, and the Great Depression of the 1930s was when industrial design came into being, because consumers required not just low cost and practical use from their goods, they also wanted appearance. Beyond superficial ornament, they wanted good-looking design integral to the item's function that also contributed to ease of manufacture and resultant low cost. Industrial design may have been art, but first, it was business. Designers coming directly from advertising brought their marketing skills, and others learned on the job. In 1940 Harold Van Doren defined the industrial designer's job: "to interpret the function of useful things in terms of appeal to the eye; to endow them with beauty of form and color; above all to create in the consumer the desire to possess. To accomplish these things one needs not only talent but technique." This "desire to possess" was the key; the industrial designer's primary goal was to instill this desire.

Not all designers looked only at marketing through visual appeal. Henry Dreyfuss, for example, defined the field in a broader and more socially responsible way: "We bear in mind that the object being worked on is going to be ridden in, sat upon, looked at, talked into, activated, operated, or in some other way used by people individually or en masse. When the point of contact between the product and the people becomes a point of friction, the industrial designer has failed. On the other hand, if people are made safer, more comfortable, more eager to purchase, more efficient—or just plain happier—by contact with the product, then the designer has succeeded." Yes, Dreyfuss included "more eager to purchase," and that was, after all, the bottom line.

Van Doren's definition of industrial design is succinct: "Industrial design is concerned with three-dimensional products or machines made only by modern production methods as distinguished from traditional handicraft methods. Its purpose is to enhance their desirability in the eyes of the purchaser through increased convenience and better adaptability of form to function through a shrewd knowledge of consumer psychology and through the aesthetic appeal of form, color, and texture." Whatever noble causes industrial designers might also have had, their purpose was to sell the product by making it look irresistible.

The appearance factor became eminently clear in 1927 when the man who said "They can have it in any color so long as it's black" gave in to the reality of the appearance factor. After buying 15 million Tin Lizzies, the public tired of black. In order to compete with General Motors and other companies, Henry Ford had to revamp his facilities at considerable expense. The emerging concept of planned obsolescence depended on the consumer's desire for newness. At the same time, the system of mass production and interchangeable parts made it even more profitable.

Henry Dreyfuss, who also designed with the appearance factor in mind, did emphasize that function was still the first priority. Far removed from his nineteenth-century predecessors, the modern industrial designer is not a decorator who is called upon after the item assumes its final form. "The industrial designer began by eliminating excess decoration, but his real job began when he insisted on dissecting the product, seeing what made it tick, and devising means of making it tick better—then making it look better."

America hosted this new field of industrial design because it had demonstrated leadership in both the "tick" and the "look" of technology. Siegfried Giedion sees this as no surprise, and writes, "The process leading up to the present role of mechanization can nowhere be observed better than in the United States, where the new methods of production were first applied, and where mechanization is inextricably woven into the pattern of thought and customs." Yet, up until that time, America's energy and contributions had been expressed primarily in mechanization and technology; art was not an area of leadership. If there was to be a modern movement, it needed more than mechanical curiosities, and the American patent furniture of the second half of the nineteenth century proved to be no more than a false start. As Giedion wrote, "Purely technical solutions, when unsupported by feeling, perish all too easily. The solutions of the engineer found no real response in the

emotional temper of the time . . . the modern movement was robbed of its naturally appropriate soil. All that the American had devised and developed, before their surrender to ruling taste, was wholly unknown to the Europeans then taking the lead."

The situation was further complicated by events occurring in England. While America was busy inventing mechanized patent furniture, England was beginning its revolt (or at least reform) *against* mechanization in the arts. The promotion of self-sufficiency, individuality, and handicraft were counter to the goals of patent furniture in America. When the British Arts and Crafts Movement moved to America, the Craftsman movement lacked inventiveness and inventive artists. The American Arts and Crafts Movement was doomed, because it had entered an environment already heading toward full mechanization. Then, when *Popular Mechanics* taught the amateur how to make Mission furniture, the movement was to end as a hobby. If America was to make any significant original contribution to art, it would be logical to look in new places.

According to Sakier, the appropriate scientific forms were based on geometry; therefore, a new appreciation of geometric form became the essence of modern style. America, Sakier believed, was THE modern country and said: "We do not have to strive for modernity; we simply cannot help being modern." He saw Europeans as trying to get away from the antique partly because they had seen so much of it and partly because they associated the unmodern inconveniences of their lives with the antique backgrounds in which they lived. The new form of art, industrial design, was well suited to America, and America's classics were being created as he spoke. Another modernist, William Lescaze, concurred: "We are the classicists of tomorrow and none of us doubts it."

SOCIETY OF INDUSTRIAL DESIGNERS (SID)

Several industrial designers who had been responsible for exhibits at the 1939 World's Fair joined others in the field to found a professional organization in New York City in 1944. The new Society of Industrial Designers (SID) was chartered by fourteen leading design practitioners—Egmont Arens, Donald Deskey, Norman Bel Geddes, Lurelle Guild, Raymond Loewy, Ray Patten, Joseph Platt, John Gordon Rideout, George Sakier, Jo Sinel, Brooks Stevens, Walter Dorwin Teague, Harold Van Doren, and Russel Wright. The first annual meeting was held on August 20, 1944, with Teague as president, Dreyfuss as vice-president, Loewy as chairman of the executive committee, Van Doren as treasurer, and Arens as secretary.

It was an elite club. Charter member Brooks Stevens said, "I remember vividly the feeling of pride I had in being invited to join the gods on Mount Olympus at the first meeting in New York." Mount Olympus was an appropriate metaphor, especially if parallel lines and other clichés of streamlining are equated with fluting and other elements of classicism. Qualifications for membership were specific:

> Membership in the Society shall be limited to practicing Industrial Designers, and members of Industrial Design departments in institutions of higher learning. . . . A candidate must have practiced Industrial Design for several years . . . must have had three or more of his products manufactured and offered for sale in the usual marketing channels. He must have honorably and satisfactorily served three or more manufacturers. . . . The term Industrial Designer is defined to include persons who are professionally engaged in designing a diversity of products for machine and mass production.

Both SID and the field of industrial design evolved rapidly. According to Arthur Pulos, "Before the war [industrial designers] had been associated with and in many cases responsible to businessmen and merchandisers; now they were directed by scientists and engineers." In 1955 the organization's name was changed to the American Society of Industrial Designers (ASID); in 1965, as a result of a merger between several professional organizations, it became the Industrial Designers Society of America (IDSA).

AMERICAN TUBULAR STEEL AND ALUMINUM FURNITURE

In the early stages of industrial-designed furniture, metal was a favored material because it was economical and well suited for mass production. European designers and Bauhaus theory laid the foundation for Americans who were quick to learn and adapt the imported ideas to the new machine production. A number of European-born architects and designers emigrated to the United States, such as Marcel Breuer, Ludwig Mies van der Rohe (see Chapter 11), Alfons Bach, and Richard Neutra. An architect in the International Style, Neutra also designed tubular steel furniture to fill large open interior spaces.

SPRINGER CHAIR.
Designed by Richard Neutra, circa 1930s. The Austrian-born architect and designer was active in Los Angeles. Cantilevered tubular steel chair with upholstered seat and back. H 29-1/2, W 22, D 29. *(Courtesy of Design America)*

Some companies, such as Herman Miller, produced tubular steel furniture along with that of traditional wood. But traditional styles were soon to be phased out, and Herman Miller was to become the first American company to devote its entire line to modern furniture. Gilbert Rohde can be credited with encouraging this significant event and for designing all of the modern furniture from 1930 until he died in 1944.

Other American companies produced modern tubular steel and aluminum furniture, much of which was also designed by Rohde. The following are some of the major American producers.

Lloyd Manufacturing

Lloyd Manufacturing in Menominee, Michigan, is best known for its tubular steel furniture designed by Kem Weber in the 1930s. It began in 1900 when Marshall Burns Lloyd (1858–1927) purchased a manufacturing company in Minneapolis and introduced baby carriages of handwoven reed, and furniture. In 1907 he moved to Menominee, and together with Lewis Larsen, patented a method for making metal tubing by rolling flat steel and welding it. They became the exclusive supplier of windshield frame tubing for the Ford Model T. They also introduced power looms, which made the company one of the largest producers of baby carriages. In 1921 the company was acquired by Heywood-Wakefield, and they continued to produce baby carriages and children's toys until the 1930s, when they made tubular steel furniture designed by German-born American industrial designer Alfons Bach (b. 1904) and Kem Weber.

Troy Sunshade

The Troy Sunshade Company of Troy, Ohio, was a leading American company in the design and production of tubular steel furniture. With offices and salesrooms in major American cities—New York, Chicago, and Los Angeles—and in Europe—Stockholm, Copenhagen, and The Hague—Troy made its presence known internationally. The entire 1934 line was designed by Gilbert Rohde, and the company boasted that "Made by Troy

Died 1941
Lou Gehrig (b. 1903); James Joyce (b. 1882); Rabindranath Tagore (b. 1861).

1942
Fermi's nuclear reactor splits the atom in Chicago; Gestapo plans "Final Solution" to exterminate the Jews; 487 die in Coconut Grove Boston nightclub fire when exit doors open inward; first jet flight; magnetic tape; songs "White Christmas" and "That Old Black Magic."

Born 1942
Muhammad Ali; Jerry Garcia (d. 1995); Jimi Hendrix (d. 1970); Calvin Klein; Paul McCartney; Muammar al-Qaddafimm; Barbra Streisand.

Died 1942
John Barrymore (b. 1982); Franz Boaz (b. 1858); Grant Wood (b. 1891).

1943
Vitamin K discovered; jitterbug popular; songs "Oh What a Beautiful Morning" and "I'll Be Seeing You."

Born 1943
Arthur Ashe, Jr. (d. 1993); John Denver (d. 1997); George Harrison (d. 2001); Janis Joplin (d. 1970); Jim Morrison (d. 1971); Lech Walesa.

Died 1943
Beatrix Potter (b. 1866); Sergei Rachmaninoff (b. 1873).

and designed by Gilbert Rohde means the highest standard of materials, workmanship, and design." In addition to a variety of minimalist tables, stools, and cantilevered chairs, Troy specialized in upholstered lounges, settees, and easy chairs. Spring-filled channels and deep cushions were covered in a range of fabrics, including bold patterns of stripes or polka dots. Troy and Rohde became known for combining industrial design and fashion.

Aluminum Furniture

Although aluminum is a common element found in the earth's crust, an economical way of separating it from bauxite ore was unknown until the late nineteenth century. In 1886, Charles Martin Hall (1863–1914), a young scientist who had graduated from Oberlin College in Ohio, perfected the electrochemical reduction process that became the foundation of the aluminum industry. In 1888, he founded the Pittsburgh Reduction Company, better known as the Aluminum Company of America (Alcoa) since 1907.

Alcoa had begun to experiment with aluminum furniture as early as 1924, and their first large commission was for the Mellon Bank in Pittsburgh, Pennsylvania. They manufactured 100 desks, 300 chairs, and accessories such as waste containers and coat racks. Their primary goal was not to become furniture manufacturers, but to entice other furniture makers to use aluminum. Alcoa was the only supplier of raw aluminum in the United States and was always seeking new markets and promoting new uses for the metal. The benefits of aluminum, although not widely known at first, were its light weight (about one-third that of steel or brass) and its resistance to rust and corrosion. Although it had obvious potential, it was not without pitfalls: Aluminum is relatively difficult to weld or solder, and it reacts electrolytically when in contact with some other metals.

These first American examples of furniture were rather odd, because instead of using appropriately modernistic, even futuristic, designs for this modern metal, as a few Europeans were beginning to do, Alcoa made aluminum chairs to look like wood. The styles were totally traditional with upholstery covering most of the metal, and faux wood-grain enamel covering whatever remained exposed. In the 1920s, most Americans were just too conservative in their tastes to accept anything else. By the early 1930s, however, a few machine-age, even Art Deco designs crept into the line, especially for counter stools. Other excursions into modernism did occur in America. In 1931, Louis Rorimer, head of the Cleveland, Ohio, interior design firm of Rorimer-Brooks, had his designers William Green and Andrew Probala design high-style modern aluminum furniture, which was made by Alcoa and by General Fireproofing in Youngstown, Ohio.

Unlike furniture for residential use, the public has had a different attitude toward office furniture. Function and utility have been of primary concern, and as one author observed, "Office furniture has always been less reliant on historical precedent, generally lacking ornamentation, and often employing 'modern' attitudes toward function and honesty in material for the sake of utility" (Smith 56). In 1929 Alcoa had a line of institutional furniture and manufactured over 35,000 aluminum chairs, and by 1931 they were making over fifty designs of chairs, table, and stools. But what Alcoa really preferred was to encourage others to manufacture the furniture, and in 1929 and 1930 they published a series of articles in trade journals detailing the chair-making process for others.

In 1934, the year Alcoa introduced their Art Deco aluminum giftware line called Kensington Ware, designed by Lurelle Guild, the company sold its aluminum furniture subsidiary to General Fireproofing. It wasn't until after World War II that they re-entered the furniture manufacturing business with their Kensington line of furniture. In 1947 Alcoa reintroduced Kensington aluminum and hardwood furniture, with the wood components made in Jamestown, New York, and the aluminum parts made by General Fireproofing. Guild designed pieces for the living room, dining room, and bedroom such as chairs, tables, consoles, a vanity, desks, bed headboards, nightstands, chests, and a glazed cabinet. Guild's designs were, of course, modern, because by the 1940s, at least part of the American public was recovering from its love affair with historic style. Alcoa sold over 400,000 of these Kensington and Wear-Ever chairs before they were discontinued in 1952.

1944
D-Day landings at Normandy; Paris liberated; Roosevelt elected to third term; first general-purpose digital computer; kidney machine; quinine synthesized; women vote in France; film *Going My Way*; songs "Swinging on a Star," and "Don't Fence Me In."

Born 1944
Michael Douglas; Diana Ross.

Died 1944
Wassily Kandinsky (b. 1866); Glenn Miller (b. 1904); Piet Mondrian (b. 1872).

Warren McArthur (1885–1961)

One American industrial designer, Warren McArthur, was both a pioneer in the technology for mass production and in the aesthetic capabilities of aluminum. McArthur was born and raised in Chicago. He graduated from Cornell in 1908 with a degree in mechanical engineering and began working in the budding field of industrial design—patenting ten lamps between 1911 and 1914. He moved to Arizona in 1913, where he and his brother opened car dealerships and Warren patented improvements for radiator caps. They both contributed to the culture of Phoenix with both commercial and civic enterprises. Warren originally ventured into furniture design and construction as a hobby, but at age 44, at the beginning of the Depression, he moved to Los Angeles to design and manufacture metal furniture. He was among the pioneers in the use of aluminum for furniture, and his contribution included improvements and patents to facilitate mass production. He relocated his factory back East to Rome, New York, in 1933 where he designed and manufactured remarkable and unique aluminum furniture. Unable to succeed financially, the company went bankrupt in 1948.

Today, aluminum furniture is produced in a variety of forms by numerous companies worldwide. Tubular steel also continues to be a major material for the manufacturing of furniture. Industrial design is now taken for granted as the primary method of the furniture industry, which uses an array of materials from woods to plastics, and of course, metals.

TABLE AND CHAIRS.
Designed by Warren McArthur, circa 1930s. Tubular aluminum library table with dining chairs.
(Courtesy of David Rago Auctions)

Summary

- The new profession of industrial design developed in the United States in the late 1920s and 1930s in response to economic depression and loss of consumer markets.
- Manufacturers perceived a need to make products more desirable by making them visually attractive.
- Abstract art plus mass production were key elements—art plus industry.
- Styles were inspired by French Art Moderne and/or Bauhaus principles; streamlining became the American interpretation.

Chronology

1907 Deutcher Werkbund is founded.

1919 Bauhaus is founded by Walter Gropius.

1924 Aluminum Company of America experiments with aluminum furniture.

1925 Marcel Breuer designs the tubular steel Wassily chair.

1926–1927 Mart Stam designs first cantilevered tubular steel chair.

1927 Norman Bel Geddes opens the first industrial design office in America.

1928 Breuer designs the Cesca chair.

1929 Museum of Modern Art (MOMA) is founded in New York City.

1932 Bauhaus is closed by the Nazi regime.

1933 Chicago Century of Progress World's Fair.

1937 Walter Gropius appointment at Harvard University.

1939 New York World's Fair.

1944 Society of Industrial Designers (SID) is founded.

Designers of Furniture

Alfons Bach (1904–; Germany, United States) Designed a variety of industrial products including furniture for Heywood-Wakefield.

Marcel Breuer (1902–1981; Hungary, United States) One of the most influential modern furniture designers, who brought tubular steel from the Bauhaus to the United States.

Donald Deskey (1894–1989, United States) Known for his interior design of Radio City Music Hall in New York, designed furniture mass-produced by Widdicomb and other companies.

Paul Frankl (1887–1958; Austria, United States) Born in Austria, worked in the United States in the Art Deco style; known for skyscraper furniture and California Modern style.

Lurelle Guild (1898–1986; United States) Prolific designer and redesigner of a variety of items, designed Alcoa's line of Kensington aluminum furniture.

Wolfgang Hoffmann (1900–1969, Austria) Came to the United States and designed tubular steel furniture at Howell.

Warren McArthur (1885–1961, United States) Pioneer in the technology for mass-producing aluminum furniture; manufactured it in Los Angeles.

Ludwig Mies van der Rohe (1886–1969, Germany, United States) Master of International Style; brought the Bauhaus philosophy and style to the United States; designed classic tubular steel chairs.

Richard Josef Neutra (1892–1970; Austria, United States) Important modern architect and designer active in Los Angeles; designed furniture for specific architecture including a cantilever chair in 1929.

Gilbert Rohde (1894–1944) Designer for Herman Miller, Troy Sunshade, and other companies; instrumental in bringing tubular steel and other modern furniture into the American home.

Karl Emanuel Martin (Kem) Weber (1889–1963; Germany, United States) West Coast designer in the streamlined style; designed plywood furniture for the Airline Chair Co. in Los Angeles and tubular steel furniture for Lloyd, which was considered flamboyant compared to the austere look of the International style.

Russel Wright (1904–1976) A prolific and versatile designer, Wright became best known for interior furnishings and domestic items such as the first modern blond maple furniture for Conant Ball.

Companies Producing Tubular Steel or Aluminum Furniture

Aluminum Company of America (Alcoa)

Herman Miller

Lloyd Manufacturing

Troy Sunshade

Key Terms

Art Moderne industrial design mass production streamlined

Recommended Reading

Cheney, Sheldon, and Martha Chandler. *Art and the Machine: An Account of Industrial Design in 20th-Century America*. New York: Whittlesey House, 1936.

Davies, Karen. *At Home in Manhattan: Modern Decorative Arts 1925 to the Depression*. New Haven: Yale University Press, 1983.

Meikle, Jeffrey. *Twentieth-Century Limited*. Philadelphia: Temple University Press, 1979.

Ostergard, Derek E. *Bent Wood and Metal Furniture 1850–1946*. New York: American Federation of Arts, 1987.

Pulos, Arthur J. *American Design Ethic: A History of Industrial Design to 1940*. Cambridge: MIT Press, 1983.

Wilson, Richard Guy, Dianne Pilgrim, and Dickran Tashjian. *The Machine Age in America 1918–1941*. New York: Harry N. Abrams, 1986.

Chapter *13*

POSTWAR MODERN
Designed and Signed

CHAPTER CONTENTS

A period of growing economic prosperity, consumerism, and bursts of creativity in modern furniture design also brought individual designers into the spotlight. Name recognition, already influential in the fashion industry, carries to furniture.

SCANDINAVIA

FURNITURE DESIGNERS
 Alvar Aalto (1898–1976, Finland)
 Eero Aarnio (born 1932, Finland)
 Harry Bertoia (1915–1978; Italy, United States)
 Robin Day (born 1915, England)
 Charles Ormand Eames (1907–1978, United States)
 Ray Kaiser Eames (1912–1988, United States)
 Geoffrey Harcourt (born 1935, England)
 Irving Harper (born 1916, United States)
 Arne Jacobsen (1902–1971, Denmark)
 Finn Juhl (1912–1989, Denmark)
 Vladimir Kagan (born 1927; Germany, United States)
 Poul Kjaerholm (1929–1980, Denmark)
 Florence Schust Knoll (Bassett) (born 1917, United States)
 Hans Knoll (1914–1955; Germany, United States)
 Paul László (1900–1993, Hungary)
 Bruno Mathsson (1907–1988, Sweden)
 Roberto Sebastian Matta (born 1911, Chile)
 Paul McCobb(1917–1969, United States)
 George Nakashima (1905– 1990; Japan, United States)
 George Nelson (1908–1986, United States)
 Isamu Noguchi (1904–1988, United States)
 Verner Panton (born 1926; Denmark, Switzerland)
 Pierre Paulin (born 1927, France)

 Warren Platner (born 1919, United States)
 Gio Ponti (1897–1979, Italy)
 Ernest Race (1913–1964, England)
 Jens Risom (born 1916; Denmark, United States)
 Terrance Harold (T. H.) Robsjohn-Gibbings (1905–1976; England, United States)
 Eero Saarinen (1910–1961; Finland, United States)
 Carlo Scarpa (1906–1978, Italy)
 Richard Schultz (born 1926, United States)
 Hans Wegner (born 1914, Denmark)
 Edward J. Wormley (1907–1995, United States)
 Russel Wright (1904–1976, United States)
 Sori Yanagi (born 1915, Japan)

COMPANIES
 Artek O Y (Finland)
 Artifort (Netherlands)
 Cassina (Italy)
 Dunbar Furniture Corp. (United States)
 Charles and Ray Eames (Offices of) (United States)
 Evans Products Co., Molded Plywood Division (United States)
 Fritz Hansen Furniture (Denmark)
 Herman Miller (United States)
 Heywood-Wakefield (United States)
 Knoll (United States)
 Laverne Originals (United States)
 Nessen Studios (United States)

As we have seen, before there was mass production or mass consumption, before there were materials such as plastics, before there were techniques for molding **fiberglass**, bending plywood, or tubing metal, furniture was made by hand of solid wood. Designers and makers of postwar "fifties" furniture have enjoyed a different kind of relationship from designers and makers of the past, where in many instances they were one and the same. Evidence suggests that attributes such as comfort, accessibility, and affordability were regarded little, if at all, by furniture makers in the remote past. European craftsmen and their clients were usually more interested in the aesthetics of ornament and in the technical feats performed in producing it. An elite clientele could afford to pay for the time and the skills invested in hand carving a ball-and-claw foot on a cabriole leg from a single block of wood or the carving, inlay, or gilding of elaborate surface decorations. As long as these wealthy patrons supported this labor-intensive handicraft, its designers and craftsmen continued to provide ornamental furniture for centuries.

Ordinary people in Europe and colonial America, if they owned any furniture, probably built it themselves or had it made locally by a builder or a joiner. Practicality, function, and low cost were necessarily top priorities. Design of common furniture was therefore straightforward, and neither comfort nor aesthetics were given much attention. Until social, political, and economic change provided for a middle class, one of these two extremes—either fancy or plain, either rich or poor—described most historic pieces. Styles of the plainer vernacular or country furniture, though often difficult to identify, persisted much longer than high-style goods in fashion-conscious palaces and cities.

Industrialization in the nineteenth century provided a third category of furniture production and consumption. Still made of wood, this machine-made furniture supplied the new middle class with the good, the bad, and the ugly. Emphasis was placed on manufacture rather than on design, because it was acceptable, even desirable, to copy existing styles made available through books and printed drawings. Machinery could and did turn out historic ornament that was arbitrarily applied to equally arbitrary forms. This democratization of design gone amuck inspired reform movements such as the Arts and Crafts. Though intended to elevate popular tastes, reform styles were not for everyone. The market in later nineteenth-century America had broadened to concurrently support endless combinations of historicism as well as so-called "honest" furniture embodying Arts and Crafts ideals; there were also elegantly simple and functional furnishings, including the first built-ins, built by the Shakers throughout the century; and since the mid-1800s, Michael Thonet had produced economical bentwood furniture ranging from the appropriately Victorian to a simplicity that anticipated, as well as influenced, Modernism. While the eclectic decades of the late nineteenth century produced some of the most bizarre examples of tongue-in-cheek historicism, they also saw the beginnings of modernism through the eyes of visionary designers such as Charles Rennie Mackintosh and Frank Lloyd Wright (though neither of these architects appeared to value human comfort).

While glimpses of modern style were previewed earlier, Modernism developed in the twentieth century, because style was only part of the story. A zealous attitude toward the use of new machinery and materials was developed at the Bauhaus in Germany and by the new group of professionals in the United States called industrial designers. Popular perceptions of progress, marketing propaganda, and the reality of the Great Depression enabled the new system of mass production to become an alternative to both handicraft and the tiresome generic historic reproductions in the 1920s and 1930s.

The first industrial designers, with backgrounds in art and advertising more often than in engineering, joined industry to offer affordable, alluring, streamlined products to a mass market. Most designers of modern furniture came with architectural training and joined design staffs of companies or worked like the new consultant industrial designers. Techniques for bending plywood splints for the United States Navy were the basis for modern furniture designed by Charles and Ray Eames; creative applications for wire accommodated designs by Warren Platner and Harry Bertoia; technologies for molding plastics and fiberglass enabled the success of designs by Eero Saarinen, Eames, and others; Gilbert

Rohde and George Nelson's ideas for sectional and modular furniture and the new science of ergonomics were some of the solutions to the problems that faced designers and manufacturers of modern furniture.

Problems of taste were another matter. As P. T. Barnum reportedly said, "You'll never get rich trying to educate American taste." Modern furniture could not be called popular, in the sense of enjoying wide acceptance. It was appropriate for the times, but that did not prevent the majority from furnishing their homes with mass-produced furniture in historic styles—what Robsjohn-Gibbins called "canonization of the obsolete"—and in no styles. Like buildings without architects, furniture without designers was made by firms mimicking both past designs and the new modern ones.

Just as all colonial styles from the seventeenth to the early nineteenth centuries had been somehow clumped together in the late nineteenth century, in the twentieth century, the insatiable appetite for historic American styles was also fed by French, English, and other traditions. As Robsjohn-Gibbings put it, "Starting from the Italian macaroni days of Sanford White, and the French pastry of Elsie de Wolfe, every possible variation of the antique menu has been scooped in and gobbled up." He described the early twentieth-century Beaux Arts binge "as though one had bought Versailles from a dry goods store by the bolt, and just draped it from floor to ceiling." Rooms looked like " a combination of the tapestry department at Wannamaker's and the lower level of Grand Central Station." The taste for tradition persisted, and even after World War II, the majority of American homes had not changed. Nevertheless, a wave of talented designers and some farsighted companies gave the period, even if represented by a minority of homes, a distinctly modern appearance.

SCANDINAVIA

In the middle of the last century, four small countries with a total population no larger than New York City impacted the world of design to a degree never before seen and unlikely to be repeated. Designers, artisans, manufacturers, distributors, arts organizations, and government agencies joined forces to get fine-quality goods to the international market at affordable prices. They had what the post–World War II world wanted, and they knew how to get it there. Scandinavian Modern design already had a solid domestic audience, and the timing was perfect to introduce their wares to the hungry American market.

"Scandinavia" is generally accepted to mean the five northernmost European countries—Norway, Sweden, Denmark, Finland, and Iceland—which have for centuries been culturally connected. Although each country has its own special identity, they generally cooperate more than they compete, particularly when it comes to presentation to the non-Scandinavian world. While the German Bauhaus designers are generally credited with the foundation of what might be called "true" modernism, or **"functionalism"**—a start-from-scratch, reject-tradition approach—serious studies on human beings in relation to their domestic environment actually began in the Scandinavian countries immediately after the First World War, that is with Kaare Klint in Denmark and Gregor Paulsson in Sweden. A few Scandinavian designers—notably Alvar Aalto and Poul Henningsen—were initially attracted to the pure functionalism of the Bauhaus in the late 1920s, but they quickly modified their approach to a softer, more "organic" one. Perhaps this was due to market pressures or perhaps, as some have speculated, because the long, cold winters in Scandinavia required warmer, friendlier domestic environments than the Bauhaus's angular furniture could provide.

Most early modern Scandinavian designers were influenced by the approach of great teachers like Carl Malmsten of Sweden and Kaare Klint who believed in analyzing traditional designs and extracting those elements that still worked in their world. Although the balance between the purely functional approach and the more "artistic" sculptural approach has shifted from time to time and with the particular designer, the combination is what has probably made Scandinavian design so popular. Adding to this

1946
Electronic calculator; Dr. Spock's *Baby and Child Care*; Robert Penn Warren's *All the King's Men*; George Orwell's *Animal Farm*; songs "Zip-a-de-doo-dah" and "Come Rain or Come Shine."

Born 1946
Dolly Parton, Sylvester Stallone, Oliver Stone, Gianni Versace (d. 1997).

Died 1946
W. C. Fields (b. 1879), Alfred Stieglitz (b. 1864), Gertrude Stein (b. 1874), H. G. Wells (b. 1866).

1947
Supersonic airplane flight; Roswell UFO incident; British rule ends in India and Pakistan; Philippine independence from United States; aluminum foil; Malcolm Lowry's novel *Under the Volcano*; film *Gentleman's Agreement*.

mix an unsurpassed level of quality, it is easy to see how a group of countries with relatively small populations could have such a profound influence on the world of modern design.

By 1950, the Scandinavians had already made unprecedented inroads into the international home furnishings market, which was to continue for several decades. To a great degree, their success came from designing and producing what the postwar public wanted—high-quality, affordable goods that were functional in modern homes and, at the same time, comfortably beautiful. Scandinavians had already come to expect and demand these qualities from their manufacturers. In other countries, however—with notable exceptions like Knoll and Herman Miller in the United States and Thonet in Germany—furniture makers continued producing conservative, often heavy, furniture. Moderately priced goods were, for the most part, cheaply made.

Besides having the right styling, quality, and pricing for foreign markets, other factors contributed to Scandinavian success. The development of techniques to lower the cost of shipping was critical, particularly with regard to furniture. With the exception of Kaare Klint's "safari" chair, the early 1930s furniture of Alvar Aalto was the first to be designed in pieces that could be easily assembled after shipping (later known as "knockdown" furniture). Although Aalto's furniture still seems fresh and relevant today, the styling did not change over the years, and the appeal has always been limited to lovers of functionalism. Ilmari Tapiovaara, a younger Finn who had learned Aalto's techniques working in the Artek factory and then for Finmar (Artek's distribution subsidiary in the United Kingdom) in the late 1930s, devoted his considerable talents to producing lightweight, easily transportable furniture. From the end of the Second World War, he created a wide range of styles utilizing new materials and techniques as soon as they became available. Despite this variety, however, Tapiovaara remained a devotee to the functionalist tradition, and it fell to the other Scandinavian countries to provide softer, less-radical designs.

The first major Danish breakthrough—in terms of design, transportability, and wide distribution—was the "Ax" series of chairs and tables created by the team of Peter Hvidt and Orla Mølgaard-Nielsen for the manufacturer Fritz Hansen. After some years of experimentation with a new lamination process akin to that used for tennis rackets, the line went into production in 1950. Besides the novel construction, it was the first successful Danish line of "knockdown" furniture. Although the term might seem to imply cheap quality in today's vernacular, it was the opposite. Master cabinetmakers were still turning out expensive pieces for the wealthy, but factories used the same care with "knockdown" furniture as with any of their other production. The method of distribution for the "Ax" line was also novel. Fritz Hansen commissioned Herman Miller, the high-quality American manufacturer, to sell the line in the United States. Herman Miller advertised the line as "The Hansen Line," and it became the first of several similar arrangements Miller would make over the following decades, in addition to manufacturing several Scandinavian-designed lines itself.

Scandinavian companies and trade organizations also set up their own showrooms in foreign countries for direct sales and promotion. Most notable of these was actually started by a far-sighted individual, Frederik Lunning, who quit his job as head of the Georg Jensen Silversmithy shop in Copenhagen to establish Georg Jensen, Inc. in 1923, a first-class retail store in Manhattan. At first the sole American distributor for Georg Jensen's line, he continued to add high-quality products from other Danish companies over the years. In 1951, he funded the Lunning Prize, presented to two Scandinavian designers each year through 1970. Prize money was large enough to allow winners to travel and study for several years, and the awards quickly became the most prestigious within the world of Scandinavian design.

The first major foreign import company to deal with **Scandinavian Modern** furniture was probably FINMAR in London. Architectural critic Philip Morton Shand and G. M. Boumphrey founded the company in 1933 immediately after a successful show of Alvar Aalto's furniture at Fortnum & Mason department store. Although the designs

were considered shocking by most of the public, as they had been at the Milan Triennale earlier that year, the ability to price competitively assured FINMAR a foothold in the market.

Several American importers prospered on high-quality Scandinavian furniture. First and foremost was George Tanier of New York. In 1946, he started Swedish Modern with two financial partners and began importing the designs of Folke Ohlsson produced by DUX of Sweden. After a tour of Europe the following year, he became enamored with the innovations of Danish designers. His partners, however, did not share his enthusiasm, so he left to found George Tanier, Inc., first taking over a floor at the Georg Jensen store in 1949 where he presented designs by Hans Wegner, then moving to his own headquarters on Madison Avenue in 1951 where he also introduced the work of Børge Mogensen to huge acclaim. Over the next two decades, George Tanier introduced many more world-class Scandinavian furniture designers to the American public (and, in the late 1950s, French designers as well). Some of their work was specifically commissioned by Tanier and bore his "George Tanier Selection" branding incorporating the name of the manufacturer.

The astonishing sweep of major awards at the 1951 Milan Triennale, the premier international design exposition of its time, brought Scandinavian designers celebrity status in the world market. Besides participation in every international exhibition, Scandinavian arts and trade organizations began mounting major shows of their own in other countries, sometimes as a group (e.g., "Design in Scandinavia," which toured twenty-four North American cities from 1954–1957) or as single-country presentations (e.g., "The Arts of Denmark," which circulated throughout the United States in 1960–1961 in conjunction with an official visit by the king and queen of Denmark). These exhibitions drew enormous crowds, and the generally glowing press coverage familiarized even the non-cognoscenti with Scandinavian Modern household products.

Scandinavian Modern style—known by the mid-1950s as "Danish Modern"—became so popular in the United States that American companies started copying the style in domestic factories and commissioning production of less-expensive variants from countries like Yugoslavia and Taiwan. For the most part, the quality was far less than that of the Scandinavian originals. "Danish Modern" came to cover the entire panoply of goods from abominable knockoffs to the finest handcrafted pieces from Danish workshops. The term has become so diluted and misunderstood that it is difficult to know if it refers to Danish Modern or Modern Danish.

On the other hand, Scandinavian design also influenced first-rate American manufacturers, not as knockoffs but as truly original designs. Finnish émigré Eliel Saarinen raised his son Eero in the fundamentals of Finnish modernism and taught a generation of top designers such as Charles Eames and Florence Knoll at the Cranbrook Academy of Art in the 1930s. He also designed several popular lines for Johnson Furniture of Grand Rapids, Michigan. Guest professors like Alvar Aalto at M.I.T., Ilmari Tapiovaara at the Illinois Institute of Technology, and Vilhelm Wohlert of Denmark at the University of California helped to disseminate these ideas throughout the U.S. design community. Premier Grand Rapids manufacturer, Baker Furniture, contracted with Finn Juhl in 1950 to produce his previously handcrafted line from Niels Vodder, as well as to design a number of pieces specifically for Baker. Baker can be credited as the first manufacturer to see the potential in mass-producing Juhl's designs, although Bovirke of Denmark debuted its factory-produced line of Juhl designs shortly thereafter.

By the mid-1950s and through the 1960s, a steady progression of new materials and manufacturing processes allowed more adventuresome designers novel avenues of expression. Lightweight fiberglass shells provided the structure for innovative upholstered furniture by Arne Jacobsen and Ib Kofod-Larsen. Designers like Vernor Panton of Denmark and Eero Aarnio of Finland would chuck the upholstery in favor of plain fiberglass or fiber-based plastics lacquered in bright primary colors. At this point, the most innovative Scandinavian designs became more closely aligned with those of Italy and the United States.

1952
Polio vaccine; hydrogen bomb; nuclear reactor; Eisenhower elected president with 442 electoral votes; first jet airline service; Sony pocket transistor radio; microwave oven; radio carbon dating; Hemingway's Pulitzer Prize for *The Old Man and the Sea*; John Steinbeck's *East of Eden*; Ralph Ellison's *Invisible Man*; films *Moulin Rouge*, *High Noon*, and *The Greatest Show on Earth*; songs "I Saw Mommy Kissing Santa Claus," "Your Cheatin' Heart," and "It Takes Two to Tango."

Born 1952
Robin Williams.

Died 1952
John Dewey (b. 1859), Maria Montessori (b. 1870).

FURNITURE DESIGNERS

The following designers are some of the names who have left a legacy of forms, materials, and technologies of postwar or fifties furniture and have made them accessible. The focus is on designers who were born and/or worked in the United States. Until this time, the United States had been more of a follower than a leader in the story of Western furniture. The birth of industrial design gave the United States a head start in the arena of mass-produced modern furniture. Though clearly influenced by both the German Bauhaus and Scandinavian Modern designs, the new applications and interpretations have been original. Called "organic design" after the 1940 exhibit by that name at the Museum of Modern Art in New York, its goal was to create a harmonious organization of parts. Without unnecessary ornament, its success depended on exquisitely simple forms that both followed and preceded function. Perhaps for the first time in the history of style, designs intended for both elite and popular audiences and pieces that were neither one of a kind nor crafted by traditional methods could stand on their own.

Alvar Aalto (1898–1976, Finland)

One of the leading Scandinavian modernist architects and town planners, Alvar Aalto became known for the use of laminated bent plywood furniture, because he believed that warm wood is preferable to cold metal. He was born in Kuortane, a small town in Finland. After joining the battle for Finnish independence from Russia, he graduated from the Helsinki Institute of Technology in 1921. After serving in the military, he opened his own architectural office in 1923; in 1924 he married architect Aino Marsio, who joined his practice. (She died in 1949, and Aalto married architect Elissa Makiniemi in 1952, and they practiced together for the rest of his life.) Aalto influenced Finnish building practices by helping to form the Finnish Standardization Institute. Impressed by Marcel Breuer, he experimented with tubular metal furniture in the 1920s. Aalto and Finnish designer Otto Korhonen patented a design for plywood, then continued working with formed **laminated plywood** in forms suited for mass production, including stackable furniture. They eventually improved the process of wood lamination by developing the multi-planar process.

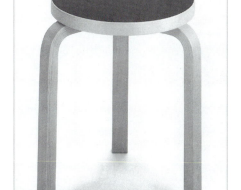

AALTO STOOL.
Designed by Alvar Aalto, 1930–1933. Birch stool with three or four bent plywood legs and circular top. Although a 1930s design, this is also a mid-century classic. *(Courtesy of ICF Group)*

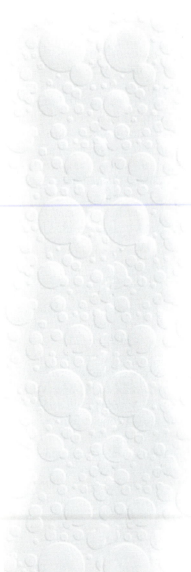

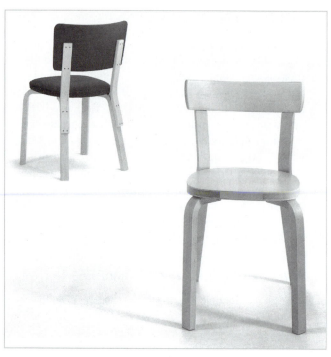

AALTO 60 SERIES CHAIRS.
Designed by Alvar Aalto, 1930–1933. Birch seating based on the
design of the Aalto stools and tables. *(Courtesy of ICF Group)*

Aalto's participation in the Milan Triennale and the London furniture exhibition in
1933 established his international reputation as a furniture designer. He went on to win
numerous international awards, and his work was exhibited alone or with others in muse-
ums throughout Europe and the United States. In 1935 he and associates established Artek
for the international distribution of his plywood furniture. Among his many furniture
designs, the Cantilevered armchair of 1946 and the Fan Leg stool of 1954 are considered
modernist classics. Other important designs include the Paimio armchair of 1931; the

BALL (GLOBE) CHAIR.
Designed by Eero Aarnio, 1963.
Sixties classics: Clairtone
rosewood console stereo cabinet
on brushed chrome pedestal,
with two black mesh "globe"
speakers; and Aarnio Globe
Chair, produced by Asko, with
white fiberglass shell on swivel
pedestal base, ultra-suede
upholstered interior. *(Courtesy of
David Rago Auctions)*

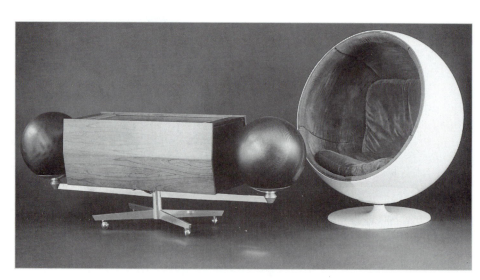

Viipuri collection 1933–1935; the serving cart in 1936; the bent knee or L-leg; the Y-leg in 1947; and the Fan Leg or X-leg stool in 1954. Furniture was only part of his contribution to modern design, which in addition to architecture, included lighting and glassware. He also taught at M.I.T. from 1940 to 1949.

Eero Aarnio (b. 1932, Finland)

Born in Helsinki, Eero Aarnio was trained at the School of Industrial Arts in Helsinki from 1954 to 1957. In the 1960s he experimented with plastics and opened his own design studio in Helsinki in 1962. His designs were produced in plastic and in steel by the Finnish firm Asko, a major Scandinavian furniture manufacturer. In addition to furniture design, he worked in interior design, industrial design, graphic design, and photography. In 1968 he received the American Industrial Design award for his Pastilli or Gyro chair. Other memorable 1960s furniture included the Mushroom chair in 1965, the Bubble chair in 1965, Kantarelli table in 1965, and the Ball or Globe chair in 1966. He then returned to the use of wood and other traditional materials for his later work.

Harry Bertoia (1915–1978; Italy, United States)

Born in San Lorenzo, Italy, Harry Bertoia came to the United States in 1930 and studied at the Art School of the Society of Arts and Crafts in Detroit from 1936 to 1937. After receiving a scholarship and studying at Cranbrook Academy of Art in 1937, he stayed at

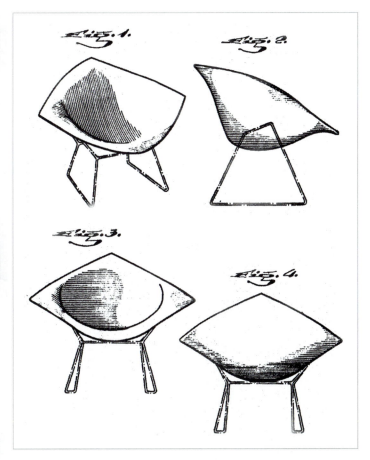

United States patent drawing of Diamond Chair, designed by Harry Bertoia, filed July 23, 1952 and issued November 10, 1953.

Cranbrook to teach metalwork from 1938 to 1943. Due to metal shortages of the war, the metal shop closed, and Bertoia taught graphic art from 1942 to 1943. He then moved to California and worked briefly with Charles and Ray Eames designing furniture. In 1943 he married Brigetta Valentiner, daughter of the director of the Detroit Institute of Arts, and in 1946 he became a United States citizen.

Some of Bertoia's most significant contributions to modern design include a line of metal wire furniture for Knoll Associates in the early 1950s. His Diamond chair and Bird chair based on wire grids were introduced in 1952; he then stayed with Knoll as a consultant. In 1954 Bertoia won a Gold Medal from the Architectural League of New York for a steel screen combined with other metals for Manufacturers Hanover Trust Co. Other awards include a Gold Medal in 1973 from the American Institute of Architects, and the Academy Institute Award in 1975 from the American Academy of Letters.

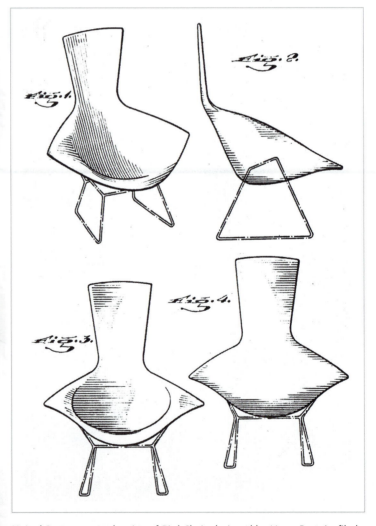

United States patent drawing of Bird Chair, designed by Harry Bertoia, filed July 23, 1952 and issued November 10, 1953.

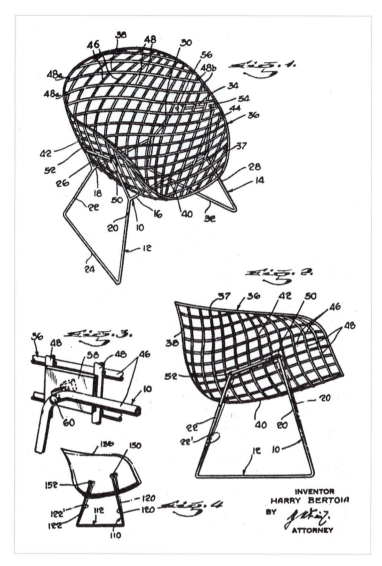

United States patent drawing of flexible contour chair, designed by Harry Bertoia, filed July 5, 1952, but not issued until September 18, 1956.

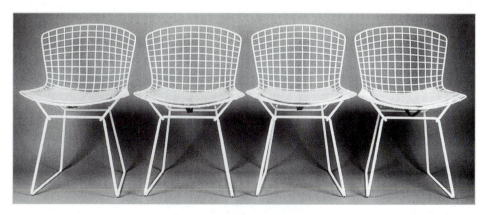

SIDE CHAIRS.
Designed by Harry Bertoia, 1952. Classic wire mesh chair with white finish, made by Knoll. *(Courtesy of Skinner, Inc.)*

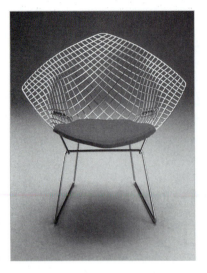

DIAMOND CHAIR.
Designed by Harry Bertoia, 1952. Frame of welded steel rods with upholstered seat cushion or fully upholstered. A Knoll classic. H 30, W 33-1/2, D 28-1/2. *(Courtesy of Knoll)*

1954
Nuclear-powered submarine *Nautilus*; Ho Chi Minh president of North Vietnam; segregation in public schools is ruled unconstitutional; TV dinners; Teflon utensils; American department stores sell copies of Parisian styles; J. R. R. Tolkein's *Lord of the Rings*, and William Golding's *Lord of the Flies*; films *On the Waterfront*, *Rear Window*, and *Three Coins in the Fountain*; Audrey Hepburn wins Oscar for *Roman Holiday*; songs "Mister Sandman" and "Hernando's Hideaway."

Robin Day (b. 1915, England)

A furniture and industrial designer, Robin Day, along with Clive Latimer, won first prize for Low-Cost Furniture Design in the 1948 competition by the Museum of Modern Art in New York. Their prize-winning tapered wooden and tubular metal storage units led to Day's collaboration with Hille, one of Britain's leading contract furniture manufacturers, in 1949. Day designed primarily for molded plastic, plywood, and upholstered metal frames. He is known for the 1963 Poly or Polyprop stacking chair, a single piece polypropylene shell, available in a variety of colors, on a tubular steel frame. Day also designed aircraft interiors, carpets, and exhibitions.

Charles Ormand Eames (1907–1978, United States)

Born in St. Louis, Missouri, Charles Eames studied architecture at Washington University in St. Louis from 1925 to 1928. After marrying Catherine Dewey Woermann, he traveled in Europe in 1929. He was a partner in the architectural firm Gray and Eames (later with

Plywood splints used in World War II, designed by Charles Eames, which led to his plywood furniture of the 1950s. *(Courtesy of Herman Miller, Inc.)*

Died 1954
Enrico Fermi (b. 1901),
Henri Matisse (b. 1869).

Pauly) in St. Louis from 1930 to 1933, and lived in Mexico in 1934. Then from 1934 to 1938 he was a partner in the firm Eames and Walsh. After studying at the Cranbrook Academy of Art on scholarship from 1938 to 1939, Eames taught at Cranbrook from 1939 to 1941, while also working for Eliel and Eero Saarinen.

In 1941 Eames divorced Catherine to marry Ray Kaiser. The couple moved to Los Angeles and developed new techniques for molding plywood. The new husband and wife partnership would be the source of significant modern design under the name, the Offices of Charles and Ray Eames. He was awarded the Kaufmann International Design Award in 1961, an American Institute of Architects Award in 1977, and the Queen's Gold Medal for Architecture in London, posthumously in 1979.

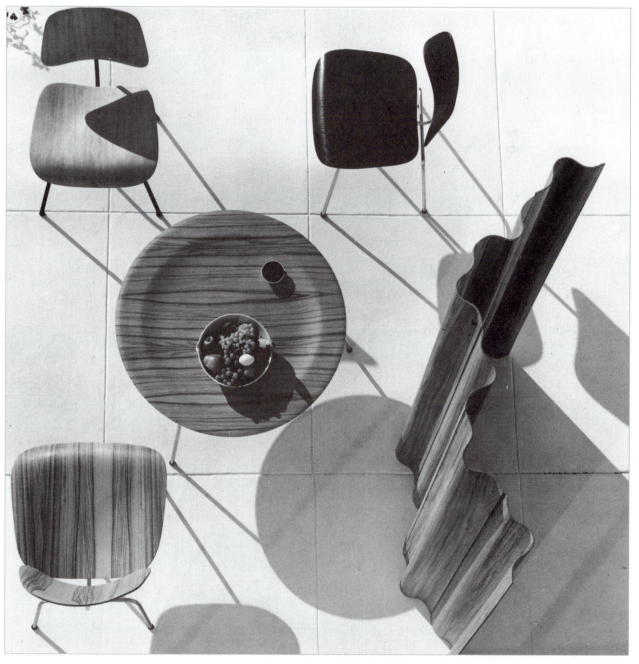

Bird's-eye view of Eames molded furniture, a version of the photo used in a 1948 Herman Miller advertisement. *(Photo Charles Eames, courtesy of Herman Miller, Inc.)*

Interiors magazine described him in the special 1965 anniversary issue: "He cares terribly for the human condition and his philosophy is simple: you do those things you believe in and avoid those which you do not." Hugh DePree wrote that Eames "had great personal discipline, was obsessed with quality and excellence, made outrageous demands on those who worked for and with him. . . ." Ralph Caplan wrote, "Charles Eames was not always teaching, but when you were with him you were always learning."

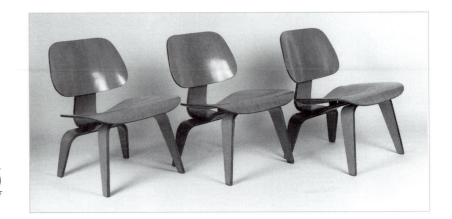

LCW CHAIRS.
Designed by Charles and Ray Eames, 1946.
Molded plywood LCW (lounge chair wood) chairs made by Herman Miller. *(Courtesy of Skinner, Inc.)*

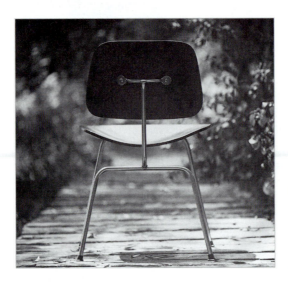

DCM CHAIR.
Designed by Charles and Ray Eames, 1946. Back view of molded plywood DCM (dining chair metal) chair with metal legs and frame. *(Photo by Charles Eames, courtesy of Herman Miller, Inc.)*

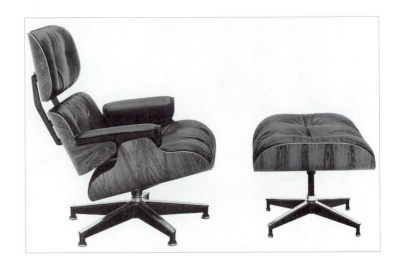

LOUNGE CHAIR AND OTTOMAN.
Designed by Charles and Ray Eames, 1956. Made by Herman Miller, black leather cushions in molded rosewood shells, mounted on cast aluminum five-pronged base. chair W 34 x D 28 x H 33; ottoman W 26 x D 24 x 16. *(Courtesy or Herman Miller, Inc.)*

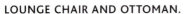

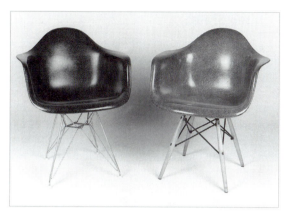

DAR CHAIRS.
Designed by Charles and Ray Eames, 1949. Left, DAR armchair designed by Charles and Ray Eames for Herman Miller, circa 1949, blue molded fiberglass seat, steel rod base, label; right similar DAR swivel armchair, circa 1949, with gray seat on swivel base with wooden legs and black finished steel struts, label. *(Courtesy of Skinner, Inc.)*

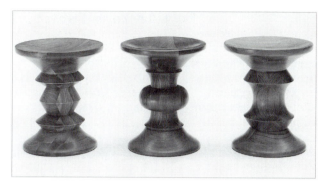

WALNUT STOOLS.
Designed by Charles and Ray Eames, 1960. Walnut Stools in three different profiles, designed by Charles and Ray Eames in 1960 as stools or low tables for the Time-Life Building in New York; DM 13-1/4 x H 15. *(Courtesy of Herman Miller, Inc.)*

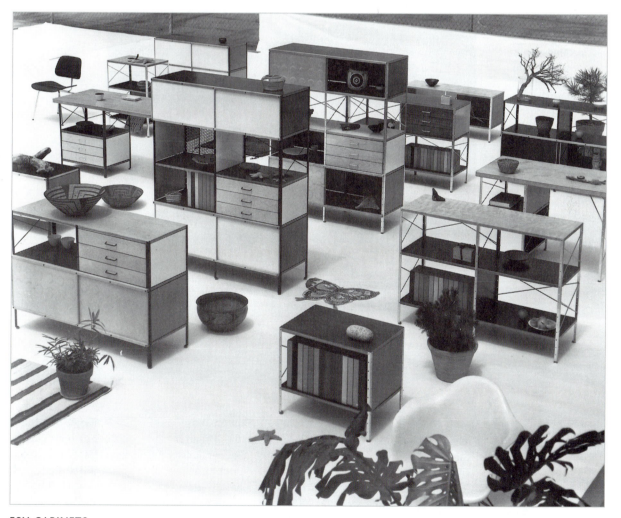

ESU CABINETS.
Designed by Charles and Ray Eames, 1949. Cabinets produced by Herman Miller from 1950–1955, of angled iron frame and Masonite panels in bright primary colors. *(Courtesy of Herman Miller, Inc.)*

1955
Atomically generated power in United States; Peron overthrown; Civil Rights movement begins with bus boycott in Montgomery, Alabama; Disneyland opens in California; velcro patented; hovercraft; J. P. Donleavy's *The Ginger Man*; songs "Rock Around the Clock," "Yellow Rose of Texas," "Davy Crockett," and "Sixteen Tons."

Died 1955
Albert Einstein (b. 1879), Alexander Fleming (b. 1881), Fernand Léger (b. 1881).

1956
Transatlantic cable telephone service; Suez crisis; neutrino produced; Eisenhower re-elected with 457 electoral votes; Grace Kelly marries Prince Rainier of Monaco; Marilyn Monroe marries Arthur Miller; first oral contraceptives used in field test; Rock 'n' Roll dancing; FORTRAN is first computer programming language; videotape recorder; films *Ten Commandments*, *Around the World in 80 Days*, and *The King and I*, Elvis Presley songs "Blue Suede Shoes," "Hound Dog," and "Don't Be Cruel."

Born 1956
Larry Bird, Joe Montana, Martina Navratilova.

Died 1956
Bela Lugosi (b 1882), A. A. Milne (b. 1882), Jackson Pollock (b. 1912)

Ray Kaiser Eames (1912–1988, United States)

Ray Kaiser was born in Sacramento, California. She attended the May Friend Bennett School in Millbrook, New Jersey, from 1931 to 1933, then at the Art Students League in New York before studying painting at the Hans Hoffman School from 1933 to 1939. She attended Cranbrook Academy of Art from 1940 to 1941 and then married Charles Eames. Although some work, such as designs for covers of *Art & Architecture* magazine in the early 1940s, was individual, most of her work was in partnership with her husband in the Offices of Charles and Ray Eames from 1941 to 1978. After Charles died in 1978, she continued their work in what is considered to be one of the greatest husband and wife design collaborations of the century.

Geoffrey Harcourt (b. 1935, England)

Geoffrey Harcourt studied at High Wycombe and at the Royal College of Art. He spent a year in the United States and then joined the Artifort Design Group. His comfortable 1960s designs include Chair 506 fully upholstered tilted chair on a pedestal, and the Cleopatra sofa, a sculptural form of upholstered molded foam.

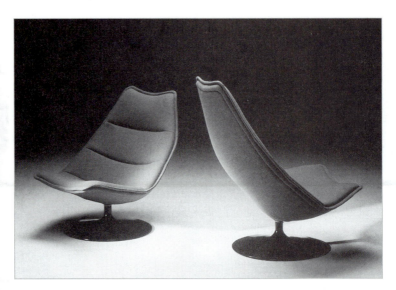

584–585–592 SWIVEL CHAIRS.
Designed by Geoffrey Harcourt. Chairs on swivel metal pedestal base, pressed beechwood shell, upholstered with molded foam covered in fabric. H 37-1/2 or 38-1/2 x W 33, 36, or 38-1/2. *(Courtesy of Artifort)*

Irving Harper (b. 1916, United States)

Irving Harper studied at Brooklyn College, Pratt Institute, and Cooper Union Architectural School, graduating in 1938. He worked for the industrial design offices of both Gilbert Rohde and Raymond Lowey before joining George Nelson Associates. Harper is credited with the designs of the famous Ball Clock of 1948 produced by the Howard Miller Clock Co., many of the eighty pieces in Nelson's first Herman Miller Collection in 1946, the upholstered seating system in 1950, the Marshmallow Sofa in 1956, and other designs produced by Herman Miller. In 1963 he joined Philip George in the firm Harper and George and designed graphics and interiors for Braniff Airlines and Pennsylvania Central Railroad. Harper continued as an independent designer.

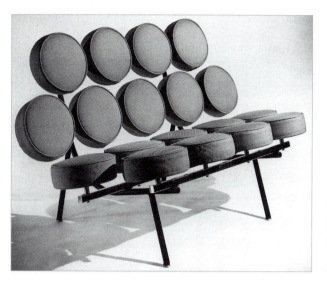

MARSHMALLOW SOFA.
Designed by Irving Harper,
1956. Marshmallow sofa
designed by Irving Harper for
George Nelson Associates in
1956, produced by Herman
Miller in limited quantities until
1965, of eighteen orange
upholstered cushions fastened
to bars, connected to a black
tubular steel frame, a mid-
century classic, 51 W x 30
D x 33 H. *(Courtesy of Herman
Miller, Inc.)*

Arne Jacobsen (1902–1971, Denmark)

Arne Jacobsen was born in Copenhagen, was trained as a mason at the School of
Applied Arts in Copenhagen from 1917 to 1924, and then studied architecture at the
Royal Danish Academy of Arts in Copenhagen, graduating in 1927. After working in
the architectural office of Paul Holsoe from 1927 to 1930, he established his own office,
which he headed until he died in 1971. In addition to working independently as an
architect and a designer of furniture, he designed textiles, carpets, stainless steel flat-
ware, glassware, ceramics, lighting fixtures, bathroom fixtures, and interiors. From
1956 on, he was professor of architecture at the Royal Academy of Art in Copenhagen.
In addition to architectural work, such as St. Catherine College at Oxford, Rødovre

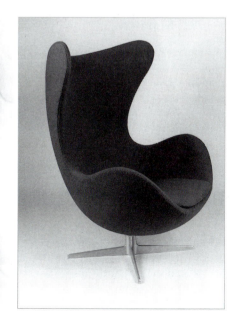

EGG LOUNGE CHAIR.
Designed by Arne Jacobsen, 1958. Sculptural lounge
chair fully upholstered over fiberglass shell, on
polished aluminum X-base, produced by Fritz
Hansen, Denmark. *(Courtesy of Skinner, Inc.)*

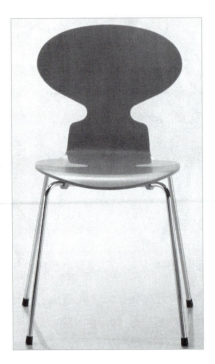

ANT CHAIR.
Designed by Arne Jacobsen, 1952. After its first showing in 1952 it was named Ant Chair for its pinched waist and thin legs. Molded laminated natural wood with beech or maple veneer, lacquered in sixteen colors, chrome-plated tubular steel legs, black nylon feet. H 30-1/2, W 19, D 19. *(Courtesy of ICF Group)*

1957
USSR's Sputnik I and II first satellites; European Common Market; Sabin polio vaccine; Eisenhower sends troops to Little Rock, Arkansas; Frisbees; Dr. Seuss's *The Cat in the Hat*; Jack Kerouac's *On the Road*; musical *West Side Story*; films *Bridge on the River Kwai*, *Twelve Angry Men*; Elvis Presley songs "All Shook Up" and "Jailhouse Rock," Everly Brothers "Bye Bye Love," Diamonds "Little Darlin," and Jimmy Rodgers "Honeycomb."

Died 1957
Humphrey Bogart (b. 1899), Constantin Brancusi (b. 1876), Christian Dior (b. 1905), Oliver Hardy (b. 1892), Joseph McCarthy (b. 1908), Diego Rivera (b. 1886), Arturo Toscanini (b. 1867).

Town Hall, Royal Hotel Copenhagen, the SAS Hotel in Copenhagen, houses, schools, and factories, he is known for his furniture design for Fritz Hansen of Allerød, Denmark. His three-legged molded plywood chair in 1952 is considered to have been a turning point in Danish Modern furniture design. Other important fifties designs include elegantly simple pressure-molded beech plywood chairs, such as the Ant chair in 1955. The classic Swan chair and settee and the Egg chair designed in 1957 have been produced continuously since their introduction. Among his awards is a silver medal at the 1957 Milan Triennale.

Finn Juhl (1912–1989, Denmark)

Finn Juhl studied at the Royal Danish Academy of Fine Arts from 1930 to 1934 and studied architecture at the Copenhagen Academy of Art. From 1934 to 1945 he practiced architecture, and in 1937 started a collaboration with cabinetmaker Niels Vodder. In 1945 Juhl opened his own office in Copenhagen and began a teaching career, heading the School of House Furnishings (Interior Design) at Frederiksberg from 1945 to 1955.

The 1940s and 1950s were significant for furniture design, and Juhl won thirty-six prizes in competitions in Copenhagen, plus five gold medals at Milan Triennales in 1954 and 1957. Believing in a strong connection between fine and applied arts, he preferred **free-form** sculpture, primitive art, and organic architecture and design. His seating designs, crafted by Niels Vodder, represented the organic look in Scandivanian design, exemplified by the chieftain armchair of 1949. He also designed a series for Baker Furniture in Grand Rapids, Michigan from 1949 to 1951; sofas, chairs, and tables with metal frames for Bovirke in Denmark in 1953; wooden pieces to be mass-produced by France & Son in Denmark in the late 1950s; and other items such as glassware.

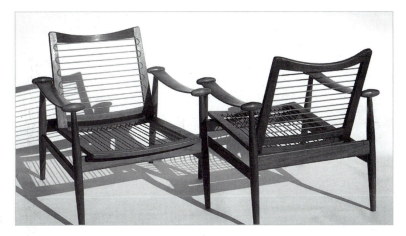

ARMCHAIRS.
Designed by Finn Juhl, 1952–1953. Teak frame, fabric-covered loose cushions (not shown), manufactured by France & Son. 30 H x 28-1/2 W x 29 D.

Vladimir Kagan (b. 1927; Germany, United States)

Vladimir Kagan was born in Worms am Rhein, Germany, the son of a Russian furniture maker. The family moved to the United States in 1938, and he studied architecture at Columbia University in New York City. In 1947 he began to work in the woodworking shop run by his father, a modernist influenced by the Bauhaus. Kagan soon began to design furniture, and then opened his own New York showroom in 1950. Corporate clients included General Electric, General Motors, Monsanto, Warner Communications, American Express, the United Nations, and Walt Disney; his individual clients included Marilyn Monroe, Xavier Cougat, and Lily Pons. He later established Vladimir Kagan Design Group and became a design consultant to the home furnishings and contract furniture industries, and also designed furniture that was manufactured by several companies. After joining retired textile manufacturer Hugo Dreyfuss, Kagan-Dreyfuss became one of the first Manhattan design firms with its own textile division. Kagan served as president of the New York chapter of the American Society of Interior Designers, taught at Parsons School of Design, and displayed his work in the 1956 Good Design exhibition at the Museum of Modern Art. He married needlepoint expert Erica Wilson in 1957, and they had three sons. Some of his most successful mid-century seating designs have sculpted wood frames and nubby natural-colored upholstery. Although he went on to work in other styles, such as architectural minimalism in the 1970s and post-modernism in the 1980s, Kagan is best known for his pioneering modern free-form **biomorphic** furniture that he described as "organic sculpture modern."

Poul Kjaerholm (1929–1980, Denmark)

A leading designer of Danish Modern furniture, Poul Kjaerholm was trained as a cabinet-maker in a private workshop before studying at the School of Arts and Crafts in Copenhagen from 1949 to 1952. After receiving a degree, he lectured at the school from 1952 to 1956. Beginning in 1955 he designed furniture using a variety of materials—chromed steel, cast aluminum, wood, wicker, leather, marble, plastic, cane, canvas—for E. Kold Christensen.

Died 1959
Cecil B. De Mille (b. 1881), Billie Holiday (b. 1915), Wanda Landowska (b. 1879), George C. Marshall (b. 1880), Paolo Venini (b. 1895), Frank Lloyd Wright (b. 1867).

His simple, high-quality construction combined comfort with function, and his designs were intended for mass production. The No. 22 steel-framed chair with leather won a grand prize at the Milan Triennale in 1957, one of many international awards. Kjaerholm also won the Year Prize from the Danish Society of Arts and Crafts in 1957, followed by the Lunning Prize in 1958, the Eckersberg Medal in 1960, the Grand Prix at the XII Milan Triennale in 1960, the Legacy of K. V. Engelhardt in 1965, and the 1972 Annual Prize from the Danish Furniture Manufacturers Association. In 1973 Herman Miller introduced the Kjaerholm Group in the United States (it had been in production in Denmark from 1955 to 1965), and it remained in production until 1977.

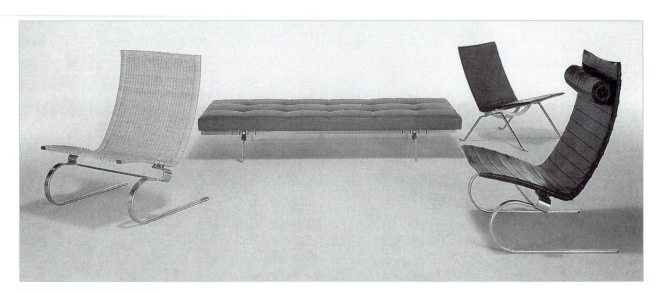

KJAERHOLM COLLECTION.
Designed by Poul Kjaerholm, 1956–1979. Lounge Chair, Low-back Lounge Chair, High-back Lounge Chair with removable headrest, and Bench: frame of chromium-plated springsteel; chairs upholstered in leather; lounge also in canvas or natural wicker. H 28 or 35, W 25 or 31-1/2, D 25, 26-3/4, or 30; bench H 12, W 31-1/2, L 70-3/4. *(Courtesy of ICF Group)*

1960
John Kennedy is elected president with little more than 100,000 popular votes than Nixon; FDA approves the first contraceptive Enovid; laser; OPEC formed; Cassius Clay (Muhammad Ali) wins light-heavyweight boxing title; Ethiopian Abebe Bikila wins the marathon barefoot at Rome Olympics; Vance Packard's *The Waste Makers*; films *Exodus, Psycho, The Apartment*; songs Paul Anka "Puppy Love," Chubby Checker "The Twist," and Elvis Presley "Are You Lonesome Tonight?"

Florence Schust Knoll (Bassett) (b. 1917, United States)

Born in Saginaw, Michigan, Florence Schust studied at the Cranbrook Academy of Art from 1934 to 1937, with one semester at the Columbia University School of Architecture. She also studied architecture in London from 1938 to 1939 and then worked in the office of Walter Gropius in Cambridge and Marcel Breuer in New York City in 1940. She studied architecture at the Illinois Institute of Technology under Mies van der Rohe from 1940 to 1941.

Schust joined Knoll in 1943 and married Hans Knoll in 1946, and she was considered an arbiter of taste for the company, designing showrooms and controlling overall design from graphics to display. She didn't consider herself a furniture designer, but rather the one to create what she called the "fill-in" pieces that needed to be done but that no one else was designing. She was responsible for "meat and potatoes" case goods and office furniture in the 1950s. When Hans died in 1955, Florence took over the company; when she married Harry Hood Bassett in 1958, she resigned as president and remained as a consultant. Once the heart of Knoll design, Florence Bassett ended the relationship with the company in 1965 and went into private design practice. She was awarded a gold medal from the American Institute of Architects for her role in the service of contemporary architecture in the United States and abroad.

Died 1960
Albert Camus (b. 1913), Clark Gable (b. 1901), Oscar Hammerstein (b. 1895), Boris Pasternak (b. 1890), Emily Post (b. 1873).

1961
Russia sends first man, Yuri Gagarin, into space; Berlin Wall built; Bay of Pigs, CIA invasion of Cuba fails; Peace Corps; Amnesty International; World Wildlife Fund; Irving Stone's *The Agony and the Ecstasy*; Joseph Heller's *Catch 22*; films *West Side Story*, *The Hustler*, *Judgment at Nuremberg*, and *Breakfast at Tiffany's*; songs Ray Charles "Hit the Road Jack," Kingston Trio "Where Have All the Flowers Gone?" and Marvelettes "Please Mr. Postman."

Died 1961
Gary Cooper (b. 1901), Dashiell Hammett (b. 1894), Dag Hammarskjöld (b. 1905), Ernest Hemingway (b. 1899), Carl Jung (b. 1875), Eero Saarinen (b. 1910), James Thurber (b. 1894), Max Weber (b. 1881).

1962
Cuban Missile Crisis; Jasqueline Kennedy redecorates the White House; Wal-Mart founded; Tennessee Williams's *Night of the Iguana*; films *Cleopatra*, *Lawrence of Arabia*, *Manchurian Candidate*, *Days of Wine and Roses*; songs "Days of Wine and Roses," Ray Charles "I Can't Stop Loving You," Four Seasons "Big Girls Don't Cry," Elvis Presley "Return to Sender," and Bob Dylan "Blowin' in the Wind."

Hans Knoll (1914–1955; Germany, United States)

Hans Knoll was born in Stuttgart; his father was a pioneer manufacturer of modern furniture in Weimar and made early Bauhaus furniture for Gropius, Breuer, and Mies. Educated in Switzerland and England, Hans Knoll started an interior design firm Plan Ltd. in England. In 1937 he went to New York, and in the following year he opened his one-room furniture company, Hans G. Knoll Furniture Co. He had two children with his first wife, and then married Florence Schust in 1946. The couple organized Knoll Associates, with Hans as president and Florence as vice president and director of planning. Their company was one of the pioneers of modern furniture in the United States. Where Herman Miller became known for introducing modern American design, Knoll became known for bringing modern European design to America. When Hans was killed in an automobile accident in Havana, Cuba, in 1955, his widow took over as president and owner of Knoll Associates.

Paul László (1900–1993, Hungary)

Born in Budapest, Hungary, Paul László studied architecture in Vienna, Paris, and Berlin. He opened a decorating firm in Vienna in 1923; then in 1927 he moved to Stuttgart and established a reputation. In 1936 he moved to Beverly Hills, California, and specialized in modern houses and interiors. Clients included Cary Grant, Barbara Hutton, Barbara Stanwyck, Elizabeth Taylor, and Robert Taylor. He designed stores as well as casinos and showrooms in Howard Hughes's Las Vegas hotels. László designed upholstered pieces and table groups for Herman Miller in the late 1940s, and his chair with matching sofa and circular coffee table were shown in the 1948 Herman Miller catalog. In addition to his architectural and interior design commissions, other designs included custom furniture, textiles, and lamps.

Bruno Mathsson (1907–1988, Sweden)

Bruno Mathsson was born in Värnamo, Sweden, and was trained as a cabinetmaker by his father Karl Mathsson from 1923 to 1931. In 1933 he began designing furniture for his father's company and then for the firm of Dux Mobel. He developed new ways for bending and laminating using industrial processes. Although his focus was on architecture from 1945 to 1958, he became a leading figure in the development of Scandinavian Modern furniture.

International recognition included the 1937 Paris Exhibition of Modern Applied Arts; the Gregor Paulsson Medal in Stockholm in 1955; and furniture designs exhibited in Stockholm in 1963, Oslo in 1976, Dresden in 1976, and New York in 1982. His Eva chair of bent plywood, solid birch, and hemp webbing was made by the firm of Karl Mathsson and then reissued by Dux, of Sweden from 1966. From 1958 on, he designed furniture in collaboration with Piet Hein.

Roberto Sebastian Matta (b. 1911, Chile)

Roberto Sebastian Matta was born in Santiago and studied at Catholic University in Chile and received a degree in architecture from the University of Chile in 1931. He worked in the office of Le Corbusier in Paris. In 1937 he met René Magritte, Joan Miró, and Pablo Picasso and exhibited in 1938. The next year Matta left for New York, and in 1940 had a one-man show at the Julien Levy Gallery. He returned to Paris in 1948, and in the late 1950s turned more to sculpture. During the 1960s and 1970s he was politically active against the junta in Chile. His sculptural Malitte seating system, comprised of blocks of polyurethane foam covered with upholstery, was produced by Gavina in Italy from 1966 to 1968 and then by Knoll International from 1968 to 1974.

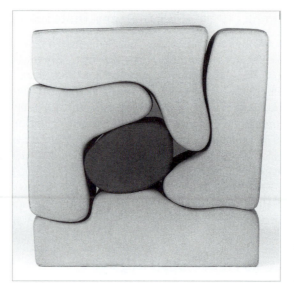

MALITTE SEATING SYSTEM.
Designed by Surrealist painter Roberto Sebastian Matta in 1966. Produced by Gavina, Italy 1966–1968 and by Knoll International 1968–1974, blocks of polyurethane foam, orange stretch wool upholstery, cobalt blue center piece. W 64, D 25, H 63. *(Courtesy of Skinner, Inc.)*

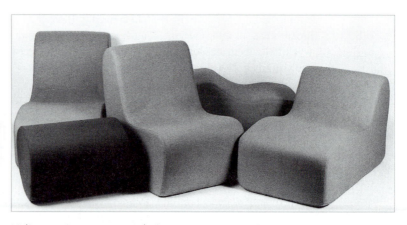

Malitte seating group opened. *(Courtesy of Skinner, Inc.)*

Paul McCobb (1917–1969, United States)

Rather than a background in art or architecture, Paul McCobb had experience selling furniture and creating displays. In 1945 he formed his own company for reasonably priced furniture aimed at the young market. His 1949 Planner Group of modular furniture made of hard birch was produced by the Winchedon Furniture Co. in Winchedon, Massachusetts, and was a great success. It included a platform bench after the classic Nelson design; in 1952 he introduced wrought-iron bases to the group. Alternative bases, hardware, and finishes provided choices while maintaining economical manufacture. The Irwin Collection for Calvin Furniture of Grand Rapids, Michigan, was also designed in 1952. This included the use of brass in the overall structure, and included a room divider of polished brass and mahogany. The series also offered tops of white vitrolite glass or marble. The Calvin Group for Calvin Furniture was introduced in 1954 with solid brass square tubing, mahogany, and leather on some pieces.

Other McCobb furniture groups include Directional, Predictor, Linear, and Perimeter, and additional McCobb designs were for wrought-iron dining groups, plant stands, and chaises made by Arbuck in Brooklyn, New York; the chaise won a Good Design Award from the Museum of Modern Art in 1953. A walnut frame armchair was made by Meyer-Gunther-Martini in New York; in the late 1950s he developed a system of mass-produced modular cabinet and counter components for the Mutschler Co.; and he also designed ceramic accessories for Phil Cutler of New York.

George Nakashima (1905–1990; Japan, United States)

Born in Washington state, George Nakashima studied at L'Ecole Fontainebleau outside Paris, and earned a B.A. degree in architecture from the University of Washington, and a Masters degree in architecture from M.I.T. in 1930. He spent the 1930s abroad, mostly in Japan, and worked for Antonin Raymond's architectural firm from 1937 to 1939. When he returned to Seattle in 1940, he married Marion Okajiima and then established his first furniture shop in 1941. He moved to New Hope, Pennsylvania, in 1946 and established a new shop. After meeting Hans Knoll, Nakashima agreed to design furniture for mass production; in 1957 he also designed a line for Widdicomb-Mueller. The American Institute of Architects awarded him a Craftsmanship Medal in 1952; in 1962 he won a National Gold Medal, Exhibition of Building Arts; in 1979 Nakashima became a Fellow of the American Craft Council; in 1981 he won the Hazlett Award for Crafts. Nakashima was a philosopher, a writer, an architect, a craftsman, and a designer of furniture. He has been appropriately called the "elder statesman of the American craft movement."

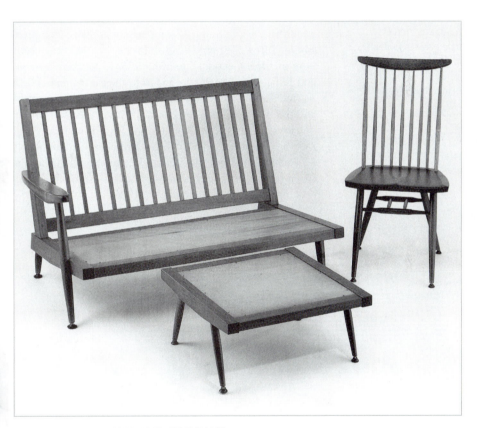

LOVESEAT, OTTOMAN, AND SIDECHAIR.
Designed by George Nakashima. Slatted back one-arm loveseat and side chair with matching ottoman, all in walnut with short flaring dowel legs. Loveseat 31 x 51 x 30. Side chair 37-1/2 x 18-1/2 x 16-1/2. Ottoman 11 x 24 x 24. *(Courtesy of David Rago Auctions)*

George Nelson (1908–1986, United States)

One of the great designers of the twentieth century, George Nelson was born in Hartford, Connecticut, in 1908. His father Simeon came to the United States from Russia at age fifteen and later became a pharmacist with his own drugstore. His mother Lilian Canterow Nelson was born in the United States; both her parents were physicians. In 1924,

at the age of sixteen, Nelson entered Yale University to study architecture and graduated in 1928; he also earned a Bachelor of Fine Arts degree from Yale in 1931 and did graduate work at Catholic University in Washington D. C. From 1932 to 1934 he went to graduate school on a fellowship at the American Academy in Rome and was awarded the Prix de Rome for architecture. More interested in writing about than practicing architecture, he joined the staff of *Architectural Forum* as associate editor and then co-managing editor from 1935 to 1944. During those years, he also developed his career as an industrial designer, became a registered architect in the state of New York, and joined the faculty at Yale. Nelson was design director of Herman Miller from 1946 to 1972 and then remained as a consultant designer until he died in 1986. While designing for Herman Miller, Nelson also ran his own design firm, Nelson & Associates (and variations of the name), which he formed in 1947 in partnership with Gordon Chadwick. His first marriage to Frances Hollister in 1933 ended in divorce, and in 1960 he married Jacqueline Wilkenson; he had three sons.

The list of Nelson's accomplishments (see Abercrombie) is astounding—from publications on design and design philosophy to furniture that would help form the definition of Modernism. His first Herman Miller collection in 1946, totaling about eighty pieces, was a collaboration with Irving Harper and Ernest Farmer. Important designs include Herman Miller Basic Storage Components in 1946; Comprehensive Storage System in 1958; Action Office System with Bob Probst in 1965; numerous classics such as Marshmallow Sofa in 1952, Coconut Chair in 1956, Kangaroo Chair in 1956, Catenary group in 1963, and Sling sofa, which was added to the permanent collection of the Museum of Modern Art in 1964. In addition to furniture, Nelson designed the 1949 collection of modern clocks and the Bubble lamps for Howard Miller, Herman Miller showrooms, graphics, textiles, dinnerware, glassware, and interiors. Awards include 1953 Best Office of the Year from the *New York Times*; Gold Medal, Art Directors Club of New York; 1954 Good Design award, Museum of Modern Art; Product Design Award, Milan Triennale; 1954 Trailblazer Award for Furniture Design, National Home Furnishings League; and numerous other awards for design excellence until he died in 1986.

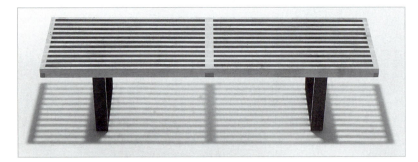

PLATFORM BENCH.
Designed by George Nelson, 1946. The platform bench (1946–1967) was originally called a slat bench until 1961, when the Black Frame Group was introduced. It was a wood bench with a slatted top that rested on trapezoid-shaped frames of either light or ebonized wood. The shape of the platform bench was unique to these pieces and different from the Black Frame bench. Platform benches often appeared with basic cabinet series cases, which rested atop. Dimensions were H 24 x D 18-1/2. Widths varied according to year of manufacture: Widths in 1946 were 48, 68, 72, and 102; widths of 56-3/16 and 92 were added in 1949. Bench tops came in both natural birch or ebonized wood. Bases had the same options, plus satin chrome or black metal legs. *(Courtesy of Herman Miller, Inc.)*

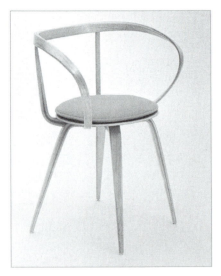

Nelson Pretzel chair of bent plywood with circular seat, for Herman Miller. *(Courtesy of Herman Miller, Inc.)*

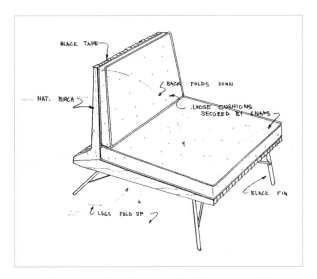

Original drawing of "Knock-Down Chair" by George Nelson for Herman Miller. *(Courtesy of Herman Miller)*

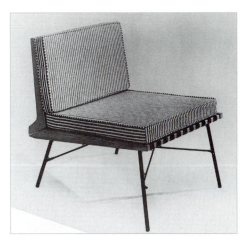

Nelson Steelframe Knock-Down Chair, photo 1954. *(Courtesy of Herman Miller, Inc.)*

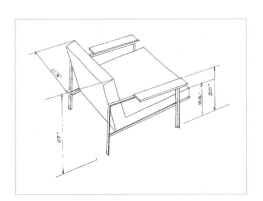

Original drawing of "Angle Frame Open Armchair" by George Nelson for Herman Miller. *(Courtesy of Herman Miller, Inc.)*

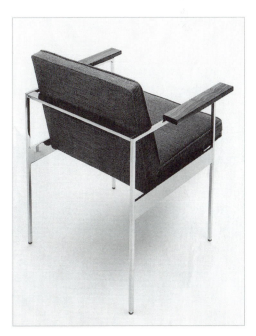

Nelson Angle frame Open Armchair, photo 1958. *(Rooks Photography, courtesy of Herman Miller, Inc.)*

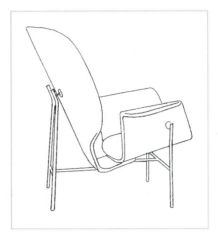

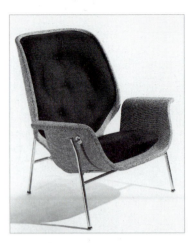

Original drawing for "Molded Plywood Highback Chair" by George Nelson for Herman Miller. *(Courtesy of Herman Miller, Inc.)*

Nelson Kangaroo Chair, the name given to the Molded Plywood Highback Chair. *(Courtesy of Skinner, Inc.)*

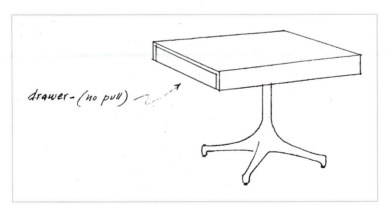

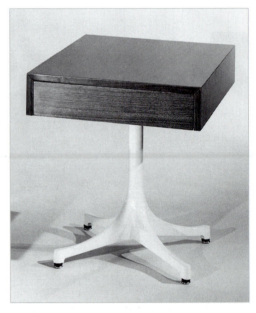

Original drawing of "Pedestal End Table" by George Nelson for Herman Miller. *(Courtesy of Herman Miller, Inc.)*

Nelson Pedestal End Table with single drawer and white enamel pedestal, photo 1956. *(Rooks Photography, courtesy of Herman Miller, Inc.)*

Isamu Noguchi (1904–1988, United States)

Isamu Noguchi was born in Los Angeles but lived in Japan until 1918. He returned to the United States and studied medicine and then sculpture in New York. He was awarded a Guggenheim Fellowship and studied with Constantin Brancusi in Paris from 1927 to 1928. Noguchi returned to the United States in 1931, and his major sculpture commissions were often associated with architecture.

His first furniture design was in 1939 for a rosewood and glass table in the biomorphic style for Conger Goodyear, president of the Museum of Modern Art. Noguchi was recruited by Herman Miller and designed a similar table with a free-form sculptural base and biomorphic glass top in 1947. In 1954 he designed a chromed steel rocking stool and other pieces for Knoll, as well as furniture for Alcoa. Lamp design was another mid-century interest, and in 1948 he designed a simple three-legged cylinder lamp for Knoll. This led to his series of Akari lights made in Japan. These paper spheres, sculptural versions of traditional Japanese paper lamps, were produced for twenty-five years.

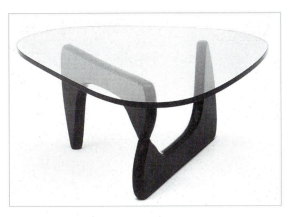

NOGUCHI TABLE.
Designed by Isamu Noguchi, 1948. Two curved solid walnut or ebonized walnut legs that interlock to form a tripod for stability, with a 3/4-inch clear plate glass top in biomorhic shape; produced by Herman Miller 1948–1973 and reissued in 1984 in the Herman Miller for the Home line. Top 50 x 30. *(Courtesy of Herman Miller, Inc.)*

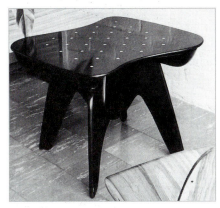

GAME TABLE.
Designed by Isamu Noguchi, circa 1948. Amorphically shaped wooden legs and top; top supported by a lacquered cast aluminum shell, with inlaid white plastic dots. *(Photo 1950 by Michael Booth, courtesy of Herman Miller, Inc.)*

Verner Panton (b. 1926; Denmark, Switzerland)

Trained at the Odense Technical School and the Royal Danish Academy of Fine Arts in Copenhagen, Verner Panton joined Arne Jacobsen's architectural practice from 1950 to 1952. In 1955 he opened his own design office in Bissingen, Switzerland, and is credited with designing the first single-form injection-molded plastic chair. He designed for Thonet and for Herman Miller in steel wire and molded plywood and plastic. His single-form plastic stacking chair of 1960 to 1967 was also produced by Herman Miller from 1968 to 1979 and is in the permanent collection of the Museum of Modern Art. Panton's upholstered Cone chair was made from 1958 to circa 1966, the Wire Cone chair from 1959, Pantonova wire furniture from 1961 to 1966, and the Panton System 1–2–3, consisting of free-form sculptural chairs with three different seat heights, in 1974. He also designed lighting, textiles, and carpets, and he won the Interior Design Award in 1963 and 1968 in the United States.

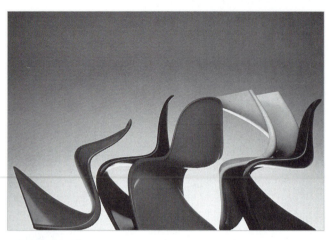

PANTON CHAIR.
Designed by Verner Panton, 1960. Originally produced by Vitra in 1968 under the Herman Miller label. Single-piece molded plastic stacking chair in primary colors or neutral; indoor/outdoor use. H 33-1/2, W 19-3/4, D 21-1/2. *(Courtesy of Vitra International)*

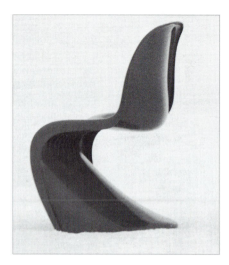

PANTON CHAIR.
(Photo Carl Ruff, courtesy of Herman Miller, Inc.)

Pierre Paulin (b. 1927, France)

Pierre Paulin studied sculpture at L'Ecole Camondo and graduated from L'Ecole Nationale Supérieure des Arts Décoratifs in Paris. He designed furniture for Thonet in 1954 and for Artifort from 1958. His work is fluid and sculptural and stresses comfort and ergonomics. In the mid-1960s he designed upholstered foam chairs for Artifort; his Chair 577 called both the Birds-in-Flight and Tongue chair, is in the permanent collection of the Museum of Modern Art in New York and in the Musée des Arts Décoratifs in Paris. In 1968 he was commissioned to refurbish the Louvre; in 1969 he won an American Industrial Design Award for the Ribbon Chair, and he has won gold medals at the Brussels International Exposition and at Milan Triennales. In 1970 he designed seating for Expo '70 in Osaka, Japan; in 1975 he founded ADSA and Partners. In addition to furniture, Paulin has designed telephones, packaging, and interiors.

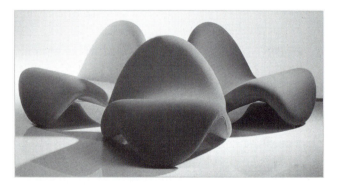

TONGUE CHAIR.
Designed by Pierre Paulin, 1967. Single continuous sculptural form of tubular steel frame with horizontal springing, upholstered with fabric on molded foam. H 25-1/4, W 33-1/2, D 35-1/2. *(Courtesy of Artifort)*

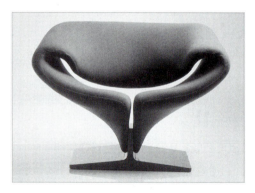

RIBBON CHAIR.
Designed by Pierre Paulin, 1966. Sculptural ribbon form seat with matching ottoman, on high-frequency pressed wooden base. H 29-1/8, W 39-3/8, D 29-1/8. *(Courtesy of Artifort)*

Warren Platner (b. 1919, United States)

"It is important that if you design a chair you produce something which enhances the person in it, because the basic premise in the first place is ridiculous from a visual standpoint. I think that's why chairs are so difficult to design. Buildings are easy." (Platner quoted in Larrabee 157.) Warren Platner was born in Baltimore. He studied at the School of Architecture at Cornell University and graduated in 1941. From 1945 to 1950 he worked in the design office of Raymond Loewy and the architectural firms of I. M. Pei and Keven Roche & John Dinkeloo. In 1960 he worked for Eero Saarinen and Associates in Birmingham Hills, Michigan, until 1965 when he began his own firm, Platner Associates, in New Haven, Connecticut, with an emphasis on architecture. Between 1953 and 1967 Platner worked on a group of chairs and tables under a Graham Foundation grant. The designs are based on a cagelike structure of curved wires welded together. His most noted furniture design is the Platner Collection of nickel-plated steel wire furniture for Knoll in 1966, which is still being produced.

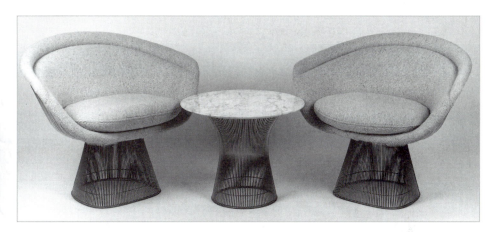

LOUNGE CHAIRS AND TABLE.
Designed by Warren Platner, 1966. Chairs of steel rod frames and upholstered fiberglass shell and matching side table with marble top, made by Knoll. (*Courtesy of Skinner, Inc.*)

Gio Ponti (1897–1979, Italy)

Born in Milan, Gio Ponti studied architecture at the Milan Polytechnic and graduated in 1921. A major modernist designer in Italy, Ponti designed ceramics for Richard Ginori, architecture, stage sets, interiors, appliances, lighting, metalware, textiles, and furniture. In 1928 he founded the important design journal *Domus* and became its first editor;*Stile* was founded in 1941. His multifaceted career included directing the Monza Biennale from 1925 to 1979, collaborating in the development of the Milan Triennale Exhibitions and the Compasso D'Oro award programs, teaching architecture at the Milan Polytechnic from 1936 to 1961, designing ocean liner interiors such as the *Conte Grande* and the *Andrea Doria* in 1950, and contributing regularly to *Domus* and to *Casabella*. In the 1950s he collaborated with Piero Fornasetti to design furniture and interiors. Ponti designed the classic Superleggera chair (1955–1957), which has been produced by Cassina from 1957 to the present. Other companies that have produced his designs include Altamira, Artflex, Arredoluce, and Nordiska Kompaniet. Ponti also wrote nine books and about 300 articles.

1966
During 1966–1976 tens of millions of civilians are killed in China in Mao's Cultural Revolution; television series *Star Trek*, *World of Jacques Cousteau*; films *Batman*, *The Chase*, *Fahrenheit 451*, *A Man for All Seasons*; songs "Born Free," "Ballad of the Green Berets"; Beach Boys "Good Vibrations," Beatles "We Can Work It Out," and "Eleanor Rigby," Lovin Spoonful "Did You Ever Have to Make Up Your Mind?" Mamas and Papas "Monday Monday," Young Rascals "Good Lovin'," Simon and Garfunkel "I Am a Rock."

Died 1966
Jean (Hans) Arp (b. 1887), Walt Disney (b. 1901), Alberto Giacometti (b. 1901), Buster Keaton (b. 1895).

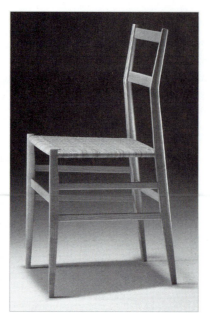

SUPERLEGGERA CHAIR.
Designed by Gio Ponti, 1955. Gio Ponti Superleggera (super light) chair of ashwood frame with cane seat, by Cassina from 1957. H 32-5/8, W 16-1/8, D 18-1/2.
(Courtesy of Cassina)

Ernest Race (1913–1964, England)

Ernest Race was born in Newcastle-upon-Tyne. He studied at the Bartlett School of Architecture in London from 1932 to 1935 and then worked as a draftsman for Troughton & Young Lighting Co., which made very modern Bauhaus-type lighting. In 1937 he visited his missionary aunt, who managed a weaving village in Madras, India. When Race returned to London, he incorporated his own modern abstract patterns onto the Indian textiles and sold them through his shop. Numerous architects, such as Walter Gropius, used the textiles.

Due to shortages of materials during the war, most British furniture design and manufacture was controlled by the Board of Trade and called Utility Furniture. Race's involvement with the design and production of this economical furniture led to the founding of Ernest Race Inc. in partnership with Noel Jordan in 1945. Jordan, an engineer, became managing director, and Race was director and chief designer for the mass production of

ANTELOPE CHAIR AND TABLE.
Designed by Ernest Race, 1951. Considered one of the best British post-war designs, part of the outdoor furniture line Race designed for the 1951 Festival of Britain; frame of bent steel wire lacquered in black or white PVC, spherical feet of lacquered brass, Baydur seat. H 31-1/2 x W 21-5/8 x D 23. Table H 27-1/2 x DM 24. *(Courtesy of Palazzetti)*

inexpensive high-quality contemporary furniture. Race's antelope chair and table, produced from 1950 on, was shown at the Festival of Britain in 1951 and won a silver medal at the 1954 Milan Triennale. His cast aluminum alloy BA chair was shown at the "Britain Can Make It" exhibit at the Victoria and Albert Museum in 1946, and it won a gold medal at the 1954 Milan Triennale. In 1953 Race was made a Royal Designer for Industry. His Neptune deck chair of 1953 marked the company's entry into the contract furniture industry, followed by the mermaid steamer chair in 1953 and the award-winning cormorant folding outdoor chair in 1959.

Jens Risom (b. 1916, Denmark, United States)

Originally from Copenhagen, Jens Risom studied at the School for Art and Applied Design in Copenhagen from 1935 to 1938. He then emigrated to the United States in 1939 and worked for Dan Cooper Studio designing textiles and interiors. He met Hans Knoll (who was one year older to the day), and along with their wives, they traveled around the United States for four months talking to architects and designers. Risom joined Knoll and designed his first furniture line in 1942. The first item was a simple straight chair made with surplus army webbing, which inspired about fifteen pieces in the line and brought Knoll into the modern furniture business. Risom also designed the first Knoll showroom. The two collaborated on other projects, such as interiors for the General Motors Pavilion press lounge and a modern kitchen in the "America at Home" exhibit of the New York World's Fair. After serving in the United States army, in 1947 he began Jens Risom Design Inc., and ended the relationship with Knoll. He ran his design business until 1971 when it was sold to Dictaphone, and Risom stayed on as chief executive until he headed a freelance design service called Design Control, in New Haven, Connecticut. Risom won the Brooklyn Museum Modernism Design Award for Lifetime Achievement.

KNOLL (STUDIO) RISOM CHAIRS.
Designed by Jens Risom, 1941. Side chairs and armless lounge chair of clear maple, mortise and tenon construction, upholstery of 2-inch cotton webbing.
(Courtesy of Knoll)

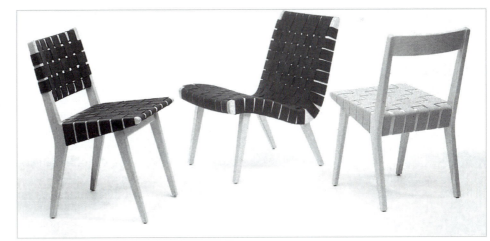

Terrance Harold (T. H.) Robsjohn-Gibbings (1905–1976; England, United States)

T. H. Robsjohn-Gibbings was born in London and studied architecture at the University of Liverpool and London University. He worked as a designer and a film art director in London, worked in New York from 1929, returned to London in 1933, and in 1936 moved to New York and opened a showroom on Madison Ave. In 1945 he became an American citizen. His interior designs combined modernism and classicism with the opulence of

the decorating trade; he designed furniture for the John Widdicomb Co. from 1946 to 1957, including a biomorphic glass-topped coffee table in the manner of Noguchi's model for Herman Miller, and he designed pieces for Baker Furniture. In 1936 he designed prototypes for a line of classic Greek furniture that was produced by Saridis in Athens in 1961, notably a *klismos* chair of walnut and woven leather, which is at the Cooper-Hewitt Museum. After settling in Athens in 1964, he designed for clients such as Aristotle Onassis. An author as well as a designer, Robsjohn-Gibbings wrote *Goodbye Mr. Chippendale* in 1944, a spoof on American interior decorating; *Mona Lisa's Mustache* in 1947, poking fun at modern art; *Homes of the Brave* in 1954, which poked fun at both extremes of traditional and modern decorating; and a serious exhibition catalog *Furniture of Classical Greece* in 1963.

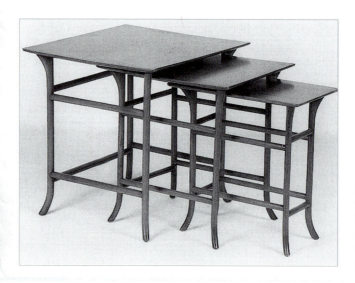

Robsjohn-Gibbings nest of tables manufactured by Widdicomb, blond finished mahogany and veneered, decal, L 26" x W 23 x 24. *(Courtesy of Skinner, Inc.)*

Eero Saarinen (1910–1961; Finland, United States)

Son of the famous Finnish architect and designer Eliel Saarinen, Eero was born in Kirkkonummi, Finland, and came to the United States in 1923. He studied sculpture in Paris and then earned a B. F. A. degree in architecture from Yale in 1934. He returned to Finland in 1934 and worked for Karl Eklund in Helsinki until 1936, when he joined his father's architectural firm. Saarinen opened his own firm and had many major architectural commissions of colleges, airports, and public buildings, such as the Smithsonian Institution Art Gallery; Dulles International Airport Terminal Building; IBM Corp. in Rochester, Minnesota and in Yorktown, New York; the University of Michigan Master Plan; and CBS headquarters in New York City.

His furniture was designed to be sculptural, comfortable, and economical, and was already shown in 1940 with Charles Eames at the Museum of Modern Art Organic Design Furniture competition and won two first prizes. His designs for Knoll Associates include the plywood chair in 1946, womb chair in 1946, grasshopper chair in the late 1940s, and pedestal furniture in 1958. Saarinen married Lily Swann in 1939, divorced, and married Aline Louchheim in 1953 and had three children, Eric, Susan, and Eames. He was honored with many awards, such as a Gold Medal from the American Institute of Architects (AIA), and was an AIA Fellow. He taught at Cranbrook, where the Saarinen house stands and can be toured by the public.

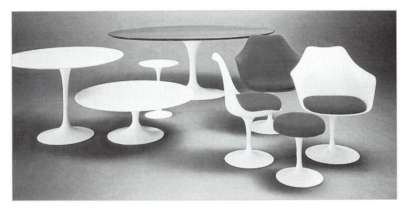

KNOLL (STUDIO) SAARINEN COLLECTION.
Designed by Eero Saarinen, 1956. (Tulip Dining Table, End Table, Coffee Table, Tulip
Chairs: bases of rilsan-coated cast aluminum; chair shell of molded fiberglass
reinforced plastic; table tops of round or oval laminate or marble. *(Courtesy of Knoll)*

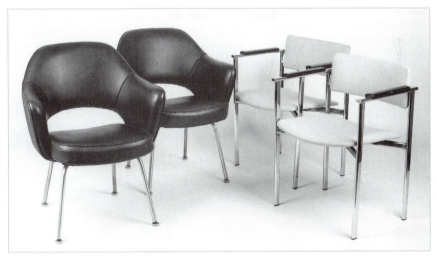

Left, pair of armchairs designed by Eero Saarinen for Knoll Associates in 1957, blue
upholstered seats on tubular steel legs, W 25-3/8 x H 31-1/2. *(Courtesy of Skinner, Inc.)*

Carlo Scarpa (1906–1978, Italy)

Born in Venice, Italy, Carlo Scarpa studied architecture at Accademia di Bella Arte in
Venice until 1926. He is known for his glass designs for Venini from 1933 to 1977, but he
also designed silver, furniture, and interiors. He designed exhibits and pavilions at the
Venice Biennales and Milan Triennales and an exhibit of Frank Lloyd Wright designs in
Milan in 1960. Renowned for his interior design, such as the Olivetti showroom in Venice,
he was also responsible for important rennovations, notably the Venice Academy in 1952,
the National Gallery of Sicily from 1953 to 1954, and six rooms of the Uffizi. Scarpa
taught at the Venice Art Institute from 1945 to 1947, directed the Institute of Architecture
at the University of Venice from 1972 to 1978, and was elected Honorary Royal Designer
for Industry, London. His Bastiano upholstery system for Knoll consisted of simple rec-
tangular furniture after Wright. His son Tobia Scarpa (b. 1935) also designed furniture for
Knoll and for Cassina, known for its soft form, including the Sirano chair for Cassina in
1968.

1969
Apollo II Neil Armstrong first lunar landing; Vietnam War protests across the United States; 300,000 stoned spectators at Woodstock Music Festival; DOW at 631; in order to escape from Cuba, Socarras Ramirez flew to Madrid while inside the landing gear of a Boeing 707, surviving eight hours with temperatures as low as −8 degrees F.; Sharon Sites Adams in a 31-foot ketch is first woman to sail across the Pacific alone; Stonewall riots mark the beginning of gay liberation; Kurt Vonnegut's *Slaughterhouse-Five*, James Dickey's *Deliverance*; films *True Grit, Midnight Cowboy, Easy Rider, Bullitt*; songs Beatles "Get Back," Bob Dylan "Lay Lady Lay," Fifth Dimension "Aquarius," The Archies "Sugar Sugar," Creedence Clearwater Revival "Proud Mary."

Richard Schultz (b. 1926, United States)

Richard Schultz studied at Iowa State University, the Illinois Institute of Technology, and the Chicago School of Design. He joined Knoll in 1951 and worked with Harry Bertoia designing a group of wire furniture in 1952. "We knew from the very beginning that these chairs were going to be extraordinary. . . . I can remember feeling that I was working on something that was on a very high level." (Larrabee 22.) Schultz got the job at Knoll by showing Florence Knoll some freehand sketches he had done in Europe. Other Knoll designs include a small petal table, a stacking chair, a steel-wire chaise lounge in the early 1960s, the 1966 Leisure Collection of outdoor furniture, which won a design award from the American Institute of Interior Designers in 1977, and lounge furniture in 1981. He attributed Knoll's success to hiring designers who were trained to think creatively and for being a design company first, and then a furniture company. Schultz continues to design furniture for manufacturers such as Conde House.

Hans Wegner (b. 1914, Denmark)

Hans Wegner was born in the small town of Tøndor in Denmark. At the age of thirteen he began a four-year apprenticeship with a local cabinetmaker. After studying at the Danish Institute of Technology in Copenhagen and at the Copenhagen School of Arts and Crafts, he lectured at the latter school from 1938 to 1942 and taught there from 1946 to 1955. Wegner designed furniture in the architectural office of Arne Jacobsen and Erik Moeller, where he met and married Inga Helbo. In 1943 he started his own design office, and he designed furniture for Johannes Hansen and Fritz Hansen of Denmark, and his designs were also distributed by Knoll. He was a member of the Royal Association of Danish Architects, and in 1959 he was made Honorary Royal Designer for Industry by the Royal Society of Arts in London. Wegner has been represented at major international exhibitions and won the Lunning Prize in 1954, the Eckersberg medal in 1956, and the Grand Prix at the Milan Triennale in 1951 and a gold medal in 1954. Considered a major designer of

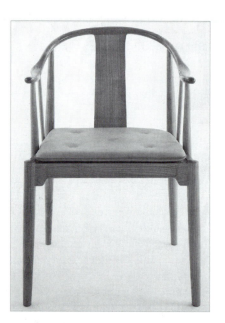

CHINA CHAIR.
Designed by Hans Wegner, 1944. Hand-sculpted Danish classic of solid bentwood and cushion seat. W 21-1/2 x D 21-1/2 x H 32-1/4. *(Courtesy of ICF Group)*

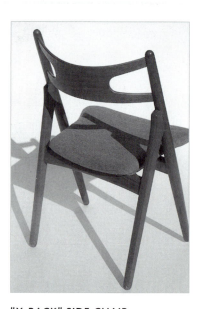

"X-BACK" SIDE CHAIR.
Designed by Hans Wegner, 1952. Teak frame, fabric-covered seat pad, manufactured by Carl Hansen. H 28 x W 20 x D 22.

Danish Modern, many museums have Wegner chairs in their collections. His first chair for mass production was the Chinese chair, made by Fritz Hansen in 1944; it was followed by others, such as the simple armchair of tapered wood form with a woven seat in 1949, called the Classic chair, and the Folding chair of 1949; the Peacock chair of 1947, based on the design of the Windsor chair, which became a symbol of Danish Modern furniture; the valet chair in 1953; and the bull chair and ottoman in 1960.

Edward J. Wormley (1907–1995, United States)

Born on New Year's Eve in Illinois, Edward Wormley studied at the Art Institute of Chicago from 1926 to 1927. He became chief designer and director of design for Dunbar Furniture Co. from 1931 to 1941 and again in 1970 just before retiring. Although he continued his affiliation with Dunbar after the war, he operated his own firm in New York City specializing in interior design from 1945 to 1967. His many designs and clients included carpets for Alexander Smith & Sons, furniture for Drexel, cabinets for RCA, lamps for Lightolier, and textiles for Schiffer Prints. In 1951 and 1952 he won Good Design Awards for six designs at the Museum of Modern Art; he was made a Fellow of the American Institute of Decorators in 1960; and he exhibited at the Milan Triennale in 1964.

Interlocking tables designed by Edward Wormley for Dunbar, from the 1956 catalog. *(The Dunbar Book of Contemporary Furniture)*

Side tables and coffee table made of open cage of laminated ash with marble top, designed by Edward Wormley for Dunbar, from 1956 catalog.

Wormley's classic Coffee Table in free-form-shaped glass top supported by three wooden legs, in Dunbar 1956 catalog.

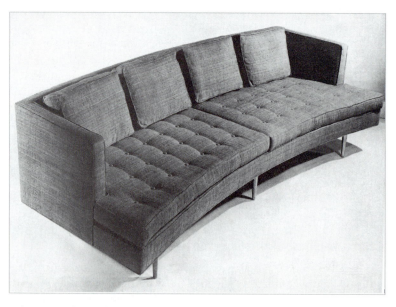

In keeping with the classic fifties curve, Wormley designed this curved sofa, in 1956 Dunbar catalog.

Wormley barrel chair suspended in laminated wood cradles and available in fully upholstered model (shown) and with cane back, in 1956 Dunbar catalog.

Wormley was a versatile and prolific designer of furniture, responsible for an average of 100 designs annually for Dunbar, in both traditional and modern styles. Among his designs are the Riemerschmid armchair #4797 circa 1946, the "listen to me" chaise in 1947, a classic free-form coffee table, and a 150-piece Janus line with an Arts and Crafts influence in 1957.

Russel Wright (1904–1976, United States)

Born in Lebanon, Ohio, Russel Wright was a child prodigy painter, and in 1920 studied at the Cincinnati Academy of Art, the Columbia School of Architecture, and the Art Students League in New York, where he also began designing theater costumes and sets. In 1935 he formed Russel Wright Associates with his wife Mary Einstein Wright and Irving Richards and was instrumental in bringing modern design to middle-class Americans from the 1930s through the 1950s. A versatile designer, Wright became known for interior furnishings and domestic items such as the first modern blond maple furniture for Conant Ball in the 1930s and modern furniture for Heywood-Wakefield. Some of his best-known designs were for pottery, especially the enormously successful American Modern dinnerware for Steubenville Pottery Co. (that sold more than 80 million pieces from 1939 to 1959), plus Iroquois Casual for Iroquois China Co., and lines for other pottery companies—Harker, Edwin M. Knowles, Paden City, Sterling China, and Bauer Art Pottery. He designed glassware for Imperial Glass Co., Old Morgantown Glass Guild, and Fostoria Glass Co. Wright also designed melamine dinnerware, streamlined radios for Wurlitzer, toys for Ideal, metalware for Chase Brass and Copper, spun aluminum items, cocktail gadgets, pianos, chewing gum dispensers, linotype machines, packaging, fabrics, carpets, lighting fixtures, showrooms, and World's Fair exhibits.

Sori Yanagi (b. 1915, Japan)

Sori Yanagi studied painting and architecture at the Tokyo Academy of Fine Arts from 1936 to 1940. He then assisted Charlotte Perriand while she worked in Japan, until 1942. In 1952 Yanagi won a Japanese Competition for Industrial Design and also founded the Yanagi Industrial Design Institute. He taught at Tokyo Women's College of Art from 1953 to 1954 and at Kanazawa University of Arts and Crafts from 1954. He came to the United

States in the 1950s. His butterfly stool of molded plywood with a metal stretcher was designed in 1956 and represents a synthesis of Eastern and Western culture. In addition to other wooden furniture and plastic stacking stools, Yanagi also designed ceramics, metal tableware, appliances, and tractors. He became director of the Japan Folk Crafts Museum in Tokyo in 1977.

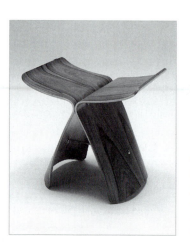

BUTTERFLY STOOL.
Designed by Sori Yanagi, 1956. The exuberant curves of Japanese architecture resemble a butterfly when applied to a stool; made by Tendo of two molded plywood shells connected with metal rods that can be assembled at home. H 15-3/4 x W 16-1/2 x D 12-1/4. *(Courtesy of Tendo)*

COMPANIES

Many of these classic designs, produced by companies such as Herman Miller and Knoll, have stood on their own in museums and in production lines since their introductions. Herman Miller was an American corporation founded by Americans to produce designs by Americans. Knoll was also an American company, but it was founded by Europeans, and it depended on many foreign designers. Having passed the proverbial test of time, these classics have stood on the merits of good design—measured by both aesthetics and function. Many were shown in "Good Design" exhibits held at both the Museum of Modern Art in New York and at the Chicago Merchandise Mart. As George Nelson had already observed in 1949, "There has probably never been a period in the history of furniture when there was so much variety in design, when so many kinds of shapes, materials, and techniques were being explored." Some have been produced continuously, and others have been recently reissued because of growing interest in and appreciation of Modernism, especially mid-century design. Ironically, Modern may have become another period style.

Artek OY (Finland)

Artek (art + tek for technology) was formed in Helsinki in 1935 by partners Nils-Gustav Hahl and Maire Gullichsen and Alvar and Aino Aalto as the principal shareholders. It was intended as a cultural center to promote design through exhibitions and educational programs. Although Artek never became a museum of modern art and design or a publisher of radical art literature that its founders had hoped for, it did become an excellent furniture company with an art gallery. Their major source of income was in the wholesale and retail sales of Aalto's plywood furniture and other interior design products, such as lighting, and they expanded with United States distribution after the war. An American-affiliated firm, Artek-Pascoe, maintained a shop in New York City to distribute the Aalto designs, but Pascoe eventually dropped the association; Scandinavian Design, also in New York City, became the United States distributor, which I.F.C. later took charge of. By the 1970s, Artek expanded to include numerous international markets.

Artifort (Netherlands)

The firm of Artifort in Maastricht, The Netherlands, has been the manufacturer for most of the biomorphic designs by Pierre Paulin, notably the Tongue chair and Ribbon chair, sculptural upholstered forms on foam and metal frames. Artifort also made the Cleopatra sculptural sofa and Chair 506 designed by Geoffrey Harcourt in the 1960s, as well as other seating.

Cassina (Italy)

One of the first Italian furniture companies to produce modern designs for an international market, Cassina was founded in 1927 by Cesare Cassina and his brother Umberto in Meda, a suburb of Milan, Italy. Before 1940 they catered to popular tastes, but after the war they produced new designs by Italian modernists Franco Albini and Mario Bellini. During the years 1947 to 1952 a huge order from the Italian Navy required new production facilities. That, plus the guaranteed revenues from the order enabled Cassina to develop their new modern design philosophy. In addition to Bellini, other important designers in the 1950s included Carlo De Carli, Gianfranco Frattini, Vico Magistretti, Ico Parisi, Nino Zancada, and Gio Ponti. Significant designs include Ponti's Distex chair in 1953 and Superleggera chair (engineered by Fausto Redaelli) from 1952 on. In addition to Bellini and Magistretti, Tobia and Afra Scarpa designed in the 1960s; Gaetano Pesce worked in the 1970s. The company also reintroduced Frank Lloyd Wright's Robie chairs, Allen table, midway chair, and barrel chair as well as early classics by Mackintosh, Rietveld, and the Le Corbusier/ Jeanneret/Perriand 1920s designs of Grand Confort chairs and sofa from 1965 on.

Dunbar Furniture Corp. (United States)

In 1919 Riney Dunbar's Buggy Works in Linn Grove, Illinois, began to manufacture furniture under the name Dunbar Furniture Inc. in Berne, Indiana. A new plant was added in 1920 and a showroom in 1927. The versatile and prolific designer Edward J. Wormley began as design director in 1931. In the late 1930s Dunbar produced two distinctly different lines of furniture—traditional and modern (Swedish). Wormley was responsible for an average of 100 designs each year, and many of his early pieces remained in production for decades. One of his most important projects for the company was his 150-piece Janus collection with an Arts and Crafts influence, in 1957. Wormley remained with the company until 1968. Dunbar also produced chairs and sofas by Michael Graves recalling the streamlined style of the 1930s, and in the 1980s produced the Keps Bay sofa for John Saladino.

Charles and Ray Eames (Offices of) (United States)

After architect Charles Ormand Eames married artist Ray Kaiser, they formed a design partnership that became an important source of modern design from 1941 to 1978. Some of their work includes: 1941–1942 developed plywood splints for the United States Navy, formed the Plyformed Wood Co., which later became the Molded Plywood Division of Evans Products; 1945 experimented with plywood chairs, children's furniture, and tables; 1946 Eames plywood furniture exhibit in New York brought Evans Products into the furniture business, and Herman Miller was granted exclusive marketing and distribution rights for Eames plywood furniture; Eames was a major source of Herman Miller furniture designs such as the 1946 LCM dining chair, DCW molded plywood chair, and the plywood Folding Screen; 1950 Storage units; 1950–1953 DAR Shell chairs; 1951–1953 Wire mesh chairs, DKR Shell chair, and Wire sofa; 1953 Hang-It-All; 1954 Compact sofa and Stadium seating; 1955 Stacking chair; 1956 Lounge chair and ottoman; 1958 Aluminum Group furniture; 1960 Time-Life chair and stool; 1961 La Fonda chair and Contract storage; 1962 Tandem Sling seating; 1963 Tandem Shell seating; 1964 3473 Sofa; 1964–1965 Segmented base tables; 1968 Chaise; 1969 Soft Pad

group; 1970 Drafting chair; 1971 Two-piece Plastic chair and the Loose Cushion Armchair. They also designed The Toy in 1951, House of Cards 1952, and Giant House of Cards 1953; they designed the IBM Corp. Pavilion at the 1964 New York's World's Fair, Herman Miller showrooms, other exhibits, graphics, and houses. They also did photography, and made many films from 1946 to 1978.

Evans Products Co., Molded Plywood Division (United States)

In 1941 Charles and Ray Eames and three colleagues established the Plyformed Wood Co. in West Los Angeles. After getting the United States Navy contract for plywood splints, the company moved to nearby Venice, California. In 1943 Edward Evans, head of Evans Products Co. in Detroit, bought the rights to produce and distribute the Plyformed Wood splints, and the company was renamed Molded Plywood Division, a subsidiary of Evans Products.

When the Eameses began to make chairs and other furniture out of plywood, Herman Miller gained exclusive rights to distribute the products in 1946. The next year, the Venice plant closed and moved to Grand Haven, Michigan. Herman Miller purchased the Molded Plywood Division and made the Eames lines under its name.

Fritz Hansen Furniture (Denmark)

Fritz Hansen was a cabinetmaker who started a business in Denmark in 1872 specializing in wood turning. The company of Fritz Hansen became interested in bentwood furniture and hired architects in the 1930s to design it, and in 1932 began a relationship with Arne Jacobsen. Fritz Hansen produced his designs, such as the plywood and chromed stacking chair beginning in 1951; the Ant chair, a simple dining chair of pressed wood and fiberglass in 1952; the molded plywood chair from 1955 on; the Swan upholstered armchair from 1957 on, and the Egg chair and ottoman, also beginning in 1957. The company also produced the work of many other modern designers such as Kaare Klint's Church chair in 1936 and Hans Wegner's Peacock chair in 1947.

Herman Miller (United States)

The Star Furniture Co. was founded in Zeeland, Michigan, in 1905 by Herman Miller and others to produce high-quality furniture, especially bedroom suites, in historic revival styles. Dirk Jan De Pree began as a clerk in 1909 and became president of the company by 1919, when it was renamed the Michigan Star Furniture Co. DePree and his father-in-law, Herman Miller purchased 51 percent of the stock in 1923 and renamed the company Herman Miller Furniture Co. In 1969 it became Herman Miller, Inc.

Until 1930 the company produced only wood traditional furniture. With the shrinking market of the Depression, they hired Gilbert Rohde and reluctantly took a chance with modern design. Rohde helped to turn the company in a totally new direction, and in 1933 its modern furniture debut was held at the Century of Progress exposition in Chicago. A showroom in the Chicago Merchandise Mart opened in 1939, and another opened in New York in 1941. Herman Miller entered the office furniture market in 1942 with its modular Executive Office Group (EOG) system designed by Rohde. When Rohde died in 1944, his replacement for modern design was architect George Nelson, who was hired in 1946 and carried on with the EOG concept. In addition to Nelson's enormous personal contribution over the next four decades, he helped to bring in other designers. Isamu Noguchi is known for his biomorphic coffee table of 1947; Charles and Ray Eames popularized many designs for molded plywood and plastics; Alexander Girard designed textiles. Another important name is Robert Propst, head of Herman Miller Research division, formed in 1960, and inventor of the Action Office. Designs for Action Office I

(1964–1970) and Action Office II (1968–1976) were by the George Nelson Office. Other furniture designers included Poul Kjaerholm, Fritz Haller, and Verner Panton. Although original mid-century classics and those reissued as part of the "Herman Miller for the home" collection have been used in residences, the focus of Herman Miller has been and is today on modern office environments. Belief in the importance of good design, honest products, and respect for individuals and the environment have been driving forces. As Hugh De Pree said, "Herman Miller has always operated with the designer as the creative force. Perhaps the most important consequence of that force has been the design of Herman Miller itself."

Heywood-Wakefield (United States)

Heywood Brothers & Co. was founded in 1826; by 1896 it had eight warehouses and three factories producing reed and rattan furniture, wooden school desks, and train seating. When the Lloyd Manufacturing Co., a maker of tubular metal items and woven baby carriages, was acquired in 1921, they became reincorporated as Heywood-Wakefield Co. Gilbert Rohde, who brought modern design to Herman Miller in 1930, also worked to develop a modern line at Heywood-Wakefield in the early 1930s, followed by Russel Wright for a brief time. By 1935 the first streamlined modern design was introduced by Heywood-Wakefield, and modern designers Leo Jiranek and Count Alexis de Sakhnoffsky designed for them. By 1940 the modern light furniture with rounded corners, smooth edges, and pieces bent from solid wood was the fastest-selling modern furniture in America. But in the 1950s financial problems mounted, and by the 1960s their modern lines were phased out. In 1979 production stopped in all but two plants, and in 1987 the company filed for bankruptcy. Their thirty years of modern wood furniture production have left many classics of mid-century design.

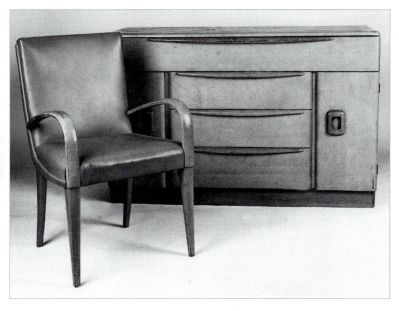

Heywood-Wakefield upholstered armchair, design attributed to Count Alexis De Sakhnoffsky, circa 1935, W 22-1/4 x H 35; Heywood-Wakefield buffet, #M593, circa 1954, shaped top over long drawer and three short drawer, two cabinet doors, decal and stencils, W 54 x D 18 x H 34. *(Courtesy of Skinner, Inc.)*

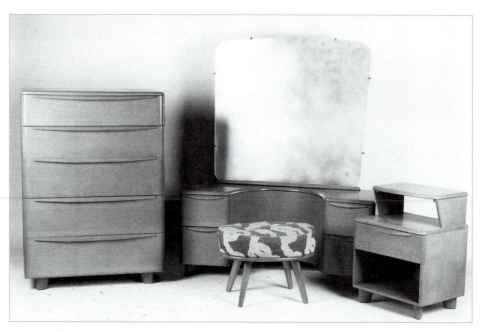

Heywood-Wakefield bedroom set, circa 1950, champagne finish five-drawer bureau, mirrored vanity with stool, and bedside stand, branded and stamped marks; bureau W 34 x D 19-1/2 x H 46. *(Courtesy of Skinner, Inc.)*

Knoll (United States)

In 1938 Hans Knoll formed the Hans G. Knoll Furniture Co. in New York City. His first modern furniture was a chair designed by Jens Risom in 1941, followed by a line of about fifteen items. In 1943 Florence Schust joined the company. An important early commission was the office of Nelson Rockefeller at Rockefeller Plaza in 1945; in the same year Florence started the Knoll Planning Unit. In 1946 Hans and Florence were married and started Knoll Associates (name used until 1959), and in 1947 the Knoll textile division was formed. The associates were internationally known designers and artists who worked on a royalty basis, and the style tended more toward the Bauhaus than Scandinavia. In 1948 Mies van der Rohe gave Knoll the right to reproduce his Barcelona chair and then Brno and other classics. Other early Knoll designers included Franco Albini, Hans Bellmann, Pierre Jeanneret, Isamu Noguchi, and Eero Saarinen, known best for his Womb chair of 1948 and then Pedestal chairs and tables in 1956. In the early 1950s Harry Bertoia introduced his wire seating.

In 1955 Han Knoll was killed in an automobile accident, and Florence Knoll took over the company, which she sold to Art Metal Inc., an office furniture manufacturer, in 1959. Knoll then became a subsidiary of Walter E. Heller International in 1965. In 1967 they hired Massimo Vignelli to design graphics, and in 1968 Knoll acquired the company Gavina, along with designs by Marcel Breuer, Cini Boeri, Roberto Sebastian Matta, and others. The company name was changed to Knoll International in 1969, although that name had been used in Europe since 1951. Then in 1977 Knoll was acquired by General Felt Industries; from 1990 to 1995 the company went by the name The Knoll Group. Today, Knoll emphasizes office furnishings in the United States, and both office and residential furnishings in Europe.

Laverne Originals (United States)

Erwine Laverne (b. 1909, New York) and Estelle Lester Laverne (b. 1915, New York) both studied painting with Hans Hofmann and Kuniyoshi at the Art Students League in New York. They met in 1934, married, and founded a manufacturing and retail wallpaper com-

pany called Laverne Originals in 1938, with design studios at the L. C. Tiffany estate in Oyster Bay, New York. They changed the name to Laverne International in 1948, the same year they won the American Fabrics Award at the Metropolitan Museum of Art. Other awards included the Good Design awards from the Museum of Modern Art in 1949 for textiles, in 1952 for wallcoverings, and in 1953 for furniture; and awards by the American Institute of Decorators in 1947, 1949, 1951, 1952, and 1957.

Many artists and designers worked for Laverne Originals, such as Alexander Calder, whose Constellation design for textiles and wallcovering resembled George Nelson's famous ball clock, William Katavolos, Douglas Kelly, Gyorgy Kepes, Ray Komai, Ross Littell, Alvin Lustig, and Oscar Niemeyer. Their molded furniture was popular with interior designers in the late 1950s, and a series of lucite chair designs in their Invisible Group were produced from 1957 to 1972.

Nessen Studios (United States)

Greta von Nessen (1900–ca. 1978) and Walter von Nessen, trained in Bauhaus design in Germany (d. 1942), founded Nessen Studios in New York in 1927. They specialized in the design and production of modern lamps, such as the classic double swing arm table lamps designed by Walter. After Walter died, Greta continued to operate the firm and designed and produced the Anywhere lamp in 1952. This versatile lamp could be hung, wall-mounted, or set on a table, and it was shown in the Good Design Exhibit at the Metropolitan Museum of Art in the same year.

Summary

- There was further development of the industrial design phenomenon, which had begun before the war.
- A postwar housing boom enabled a new focus on furniture and furnishings.
- For the first time new products were intended for both an elite and a mass audience.
- Prototypes by named designers were intended for mass production.
- New materials and techniques included molded plastics, bent plywood, and uses of metals.
- Scandinavian influence was felt in the use of natural woods, textiles, and bent plywood.
- Simplification and removal of ornamentation placed the emphasis on form and color.
- There was a sudden focus on modern style with no obvious historic references.

Designers

1898–1978 Alvar Aalto
1932– Eero Aarnio
1915–1978 Harry Bertoia
1915– Robin Day
1907–1978 Charles Eames
1912–1988 Ray Kaiser Eames
1935– Geoffrey Harcourt
1916– Irving Harper
1902–1971 Arne Jacobsen
1912–1989 Finn Juhl
1927– Vladimir Kagan
1929–1980 Poul Kjaerholm

1917– Florence Schust Knoll
1914–1955 Hans Knoll
1900–1993 Paul László
1911– Roberto Sebastian Matta
1917–1969 Paul McCobb
1905–1990 George Nakashima
1908–1986 George Nelson
1904–1988 Isamu Noguchi
1926– Verner Panton
1927– Pierre Paulin
1919– Warren Platner
1897–1979 Gio Ponti
1913–1964 Ernest Race
1916– Jens Risom
1905–1976 T. H. Robsjohn-Gibbings
1910–1961 Eero Saarinen
1906–1989 Carlo Scarpa
1926– Richard Schultz
1914– Hans Wegner
1907–1995 Edward Wormley
1904–1976 Russel Wright
1915– Sori Yanagi

Key Terms

biomorphic	functionalism	plywood
fiberglass	laminated	Scandinavian Modern
free-form		

Recommended Reading

Abercrombie, Stanley. *George Nelson: The Design of Modern Design*. Cambridge: MIT Press, 1995.

Blake, Peter. *No Place Like Utopia: Modern Architecture and the Company We Kept*. New York: Alfred A. Knopf, 1993.

Eidelberg, Martin, ed. *Design 1935–1965: What Modern Was*. New York: Harry N. Abrams, 1991.

Ellison, Michael, and Leslie Piña. *Scandinavian Modern Furnishings 1930–1970: Designed for Life*. Atglen, Pa.: Schiffer, 2002.

Fehrman, Cherie, and Kenneth Fehrman. *Postwar Interior Design 1945–1960*. New York: Van Nostrand Reinhold, 1987.

Jackson, Lesley. *The New Look: Design in the Fifties*. New York: Thames Hudson, 1991.

Kirkham, Pat. *Charles and Ray Eames: Designers of the Twentieth Century*. Cambridge: MIT, 1995.

Larrabee, Eric, and Massimo Vignelli. *Knoll Design*. New York: Harry N. Abrams, 1981.

Nelson, George. *Problems of Design*. New York: Whitney, 1957.

Neuhart, John, Marilyn Neuhart, and Ray Eames. *Eames Design*. New York: Harry N. Abrams, 1991.

Piña, Leslie. *Classic Herman Miller*. Atglen, Pa.: Schiffer, 1998.

Zahle, Erik, ed. *A Treasury of Scandinavian Design*. New York: Golden Press, 1961.

Chapter 14

THE OFFICE
Nine to Five

CHAPTER CONTENTS

In the second half of the twentieth century, furniture for the workplace advances with new technologies, materials, and designers. The office becomes the area with the fastest rate of innovation and change, and contract furniture becomes a distinct field.

*A*fter the postwar period of widespread creativity and change, the pace of furniture innovation in the residential interior slowed considerably. However, the second half of the twentieth century was rich with ideas, many of which were expressed in the furniture industry. If not in the residence, then where? The answer would have to be in the workplace, in the office. More workers were sitting at desks in front of computer monitors than ever before. Furniture companies like Herman Miller, Knoll, Haworth, and Steelcase had almost always designed well for the office, and the single biggest change that ever occurred in this setting was systems furniture. For better or for worse, concepts of mass-produced modular elements and movable mini-wall partitions changed the office landscape.

Employers also realized that productivity was related to employee comfort and health, and the furniture companies addressed the needs of workers' bottoms and their own bottom lines by complying. **Ergonomics**, the study of human comfort and well-being in an environmental context, had been seriously considered much earlier in the century. By the 1980s and 1990s it was in every manufacturer's vocabulary. Function was the number one priority—with form to follow—as if it was a new idea. Seating in the home addressed the issue of comfort unscientifically. Perceived comfort of overstuffed sofas and armchairs was sufficient, because people were not forced to sit in one place for any length of time at home. Home represents freedom: Residents lounge; they move freely from room to room; they leave the house or apartment. The human body is adaptable and can withstand or ignore discomfort in short stints. But the workplace does not permit the same degree of flexibility and freedom of movement as the residence. Furniture must support the back, prevent injury to the wrist, attempt to reduce glare, and afford some visual and auditory privacy.

In the later part of the twentieth century, a good deal of the innovation and advances in furniture design moved out of the residence and into the workplace. Form finally followed function, and style was close behind with an eye on the fifties. Some of the color, form, and playfulness seen earlier at Herman Miller and Knoll, also entered Steelcase, especially through the doors of their Design Partnership and acquisition of several specialized furniture companies.

EARLY OFFICE INNOVATIONS

The office furniture story begins before there was concern for either ergonomics or style, because the workplace required, so it was thought, only utilitarian furnishings. One example of a proto-ergonomic invention was a swivel chair designed in 1853 by Peter Ten Eyck with a shaped seat, swiveling height adjustment, and a movable back. Other nineteenth-century patent furniture and inventions led to specialization of the office building and the

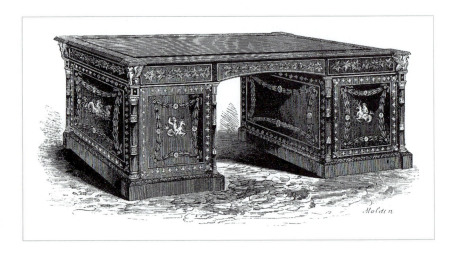

Victorian library table exhibited at one of the many World's Fairs.

office as a separate environment in which to conduct business. The telegraph, telephone, and especially the typewriter increased the amount of paper generated and created a need for designated space for business communication. The desire for specialized furniture generated office desks, tables, and chairs, but at first these were not unlike comparable residential items. The rolltop desk, notably the Wooton patent desk, provided space for storage. Then the standardization of paper sizes led to new forms of equally standardized filing cabinets and desks. One of the early twentieth-century innovations in office furnishings was the use of steel to replace the more traditional wood furniture.

Victorian library table of oak and ebony with central decorative panel inlaid with malachite, lapis lazuli, cornelian, and serpentine.

Example of Victorian revolving chair with patent spring.

Another version of a Victorian revolving chair.

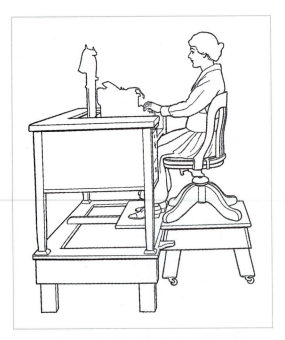

Diagram from 1918 publication (Galloway) on office management showing a stenographer sitting at an adjustable desk.

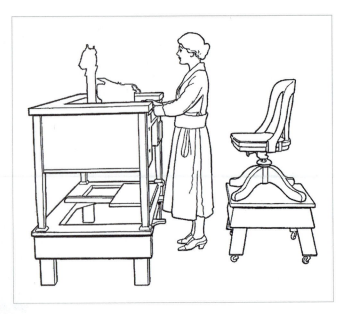

Stenographer standing at adjustable desk, 1918.

STEELCASE

The Metal Office Furniture Co. was founded in Grand Rapids in 1912 by Peter M. Wege, and was affiliated with the Macey Co. until 1918. The Steelcase trademark was adopted in 1921. In the late 1930s they collaborated with Frank Lloyd Wright to produce furniture for the offices of S. C. Johnson & Co. (Johnson Wax) in Racine, Wisconsin. On December 1, 1954 Steelcase became the official company name because of the importance of product recognition. Also in 1954, they introduced color into otherwise drab offices with furniture in colors of the Arizona desert.

By 1970 sales passed the $100 million mark and employment was 4,000. A new headquarters housing 1,000 office workers opened in 1983. In 1985 sales broke the $1 billion mark, and Steelcase purchased Stow Davis, also in Grand Rapids. Known as manufacturers of high-quality traditional wood furniture, Stow Davis introduced several lines of modern office furniture throughout the 1950s and 1960s, some using free-form shapes. Today, the Steelcase Design Partnership includes the companies Brayton, Design Tex, Details, Health Design, Metro Furniture, Stow Davis, and Vecta. Although mid-century office designs other than the classic Wright desk and chair (Cassina) are not being reissued, there is clearly a strong fifties influence in many of the contemporary designs of furniture offered today.

Other companies active during the fifties, like Cassina (Chapter 13), continued to introduce new designs. Even those with rich historical backgrounds, like Thonet (Chapters 7 and 11), both revived modern models and addressed the current design issues admirably. And dozens of others participating or specializing in **contract furniture** offered their own interpretations of ergonomics plus style. Luminaire represents at least seventy different European manufacturers of contemporary contract furniture and lighting; ICF also supplies the contract market with modern design by representing a number of different companies; and there are hundreds of large and small companies that manufacture their own lines. Of these, the international companies Steelcase, Haworth, Herman Miller, and Knoll have by far the largest American market shares.

Steelcase "Colorama" introduced color into the metal office furniture line at mid-century. *(Courtesy of Steelcase, Inc.)*

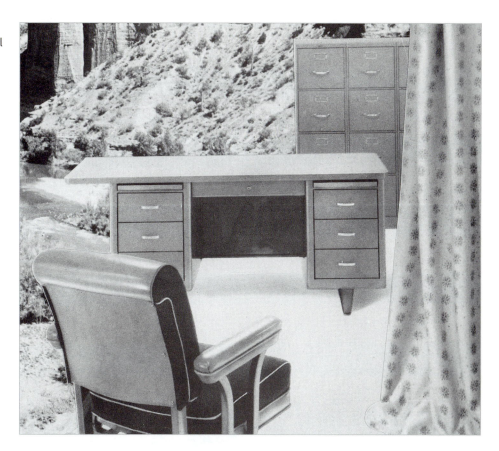

Stow & Davis Sigma items in American walnut with No. 6 Gunstock finish and brushed brass or brushed chrome hardware, produced in 1956–1961: 3202–29 desk. *(Courtesy Stow & Davis/Steelcase)*

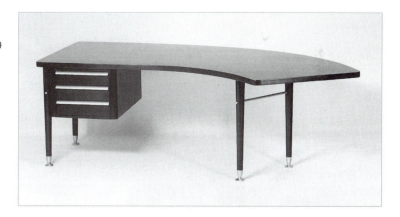

Stow & Davis No. 6098–36 Custom Executive desk, with brushed chrome finish tubular steel frame, produced 1959–1967. *(Courtesy of Stow & Davis/Steelcase)*

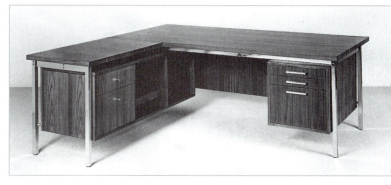

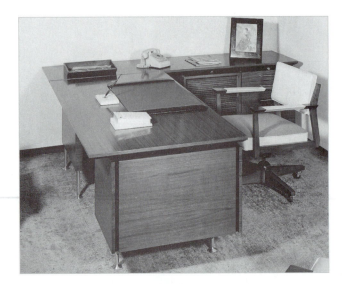

Stow & Davis Executive Predictor series No. 5604–36 desk with three-pronged attachment for round legs, produced in 1963–1964. *(Courtesy of Stow & Davis/Steelcase)*

Stow & Davis Custom Executive No. 6011–13 conference table (120" long) with 59A armchairs. *(Courtesy of Stow & Davis/Steelcase)*

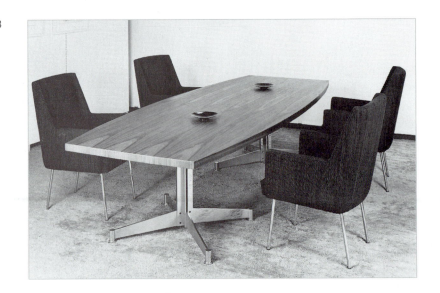

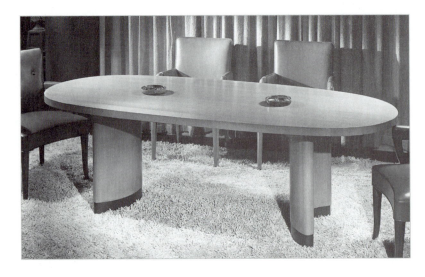

Stow & Davis table with free-form double pedestals, part of Executive Group Office, inspired by Rhodes earlier EOG design. *(Courtesy of Stow & Davis/Steelcase)*

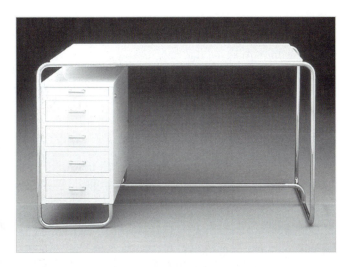

Modern single pedestal desk with stark white column of drawers and top supported by tubular steel, designed by Finnish modernist Pauli Blomsted, circa 1930. *(Courtesy of Arkitektura)*

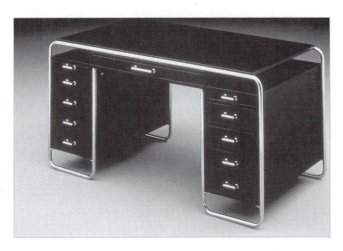

Modern double pedestal desk with black columns of drawers and top supported by tubular steel, designed by Pauli Blomsted, circa 1930. *(Courtesy of Arkitektura)*

FRANK LLOYD WRIGHT AND THE OFFICE

Designers of modern furniture have most often been trained as architects. One of the pioneers in the development of the modern office was Frank Lloyd Wright, and his most memorable design would be produced by Steelcase. Wright believed that it was not possible to separate the building from its furnishings, and throughout his career furniture design complimented his architecture. In 1904 he designed the Larkin Administration Building in Buffalo, New York. In a much later press release, shortly after designing the Johnson Administration Building, Wright explained that "modernity" is often misinterpreted as "the new look for something old rather than new look of something really new." The slogan "Form follows Function" has been used to "rationalize its irrational acts and succeeded in making thin buildings that look as though cut from cardboard with scissors, the cuttings folded into opposing planes without ornament. A branch to the right got to making thick buildings that carried ornament too far—'Function following Form'." The Larkin Administration Building was Wright's answer to Modernism and in his words, "the first air conditioned building in America; the first steel furnished and absolutely fire-proof building wherein simplicities like the wall-water closet and suspended water closet partitions, cushioned floors (magnasite as a building material), etc. appeared for the first time." It was a cornerstone of what must be recognized as "modern architecture."

The Larkin Building was to house eighteen-hundred secretaries, clerks, and other employees of a mail-order company, and they would all need furniture. So Wright accommodated with the first metal office furniture and used Mackintosh-Wiener Werkstätte

styling. His single-pedestal metal desk with pigeon holes for filing is considered a pioneering design for the twentieth-century office. For Wright, furniture followed architecture just as form followed function.

Wright is also credited with introducing the idea of contemporary open office furniture with sophisticated paper handling systems in 1936 for the Johnson Wax Administration Building in Racine, Wisconsin. Wright described the building as "an interpretation of modern business conditions, and of business too, itself designed to be as inspiring to live and work in as any cathedral ever was to worship in." Yes, Wright does bring new meaning to the term "egomania," but like other geniuses, attempts at humility would have seemed unnatural. He used brick and glass in what he promised to be earthquakeproof and fireproof construction. "Work itself is correlated in one vast room, the room to be air conditioned summer and winter, day lit by the walls and roof. . . . Artificial lighting is introduced by way of neon tubes between these glass walls and skylights. . . . There are no corridors in the building—no dead spaces—no wasted motion anywhere. All space is not only alive and working but so treated as in some way to contribute to the sense of a well organized activity in harmonious circumstances. A consistent whole."

He designed the furniture to be made of metal, which was ultimately made from tubular steel and sheet metal. Although Warren McArthur had bid on its manufacture, the contract was awarded to Steelcase in 1938. However, Steelcase subcontracted the wooden work surfaces to Stow-Davis, the tubular steel frames to American Seating Company, also of Grand Rapids, and the seat upholstery to the Chase Furniture Company. Steelcase made the sheet metal, assembled all the components, and finished the pieces.

Wright's three-legged chair design was intended to keep the chair's front legs out of the sitter's way. He also claimed that the chair would force the sitter to have "correct" posture, because otherwise he or she would literally topple over. He designed the seats and backs with foam rubber padding and made them adjustable; the seat backs were upholstered on both sides and pivoted to extend the life of the fabric. Colors were coded for spe-

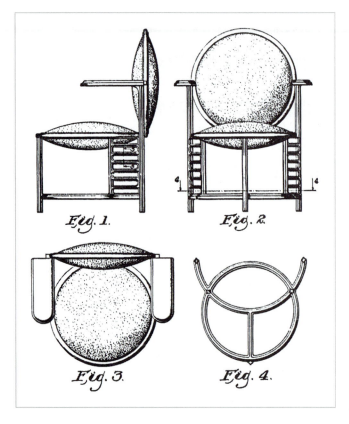

United States Patent Office drawing of chair designed by Frank Lloyd Wright, filed December 20, 1937 (used for the Johnson Wax Building).

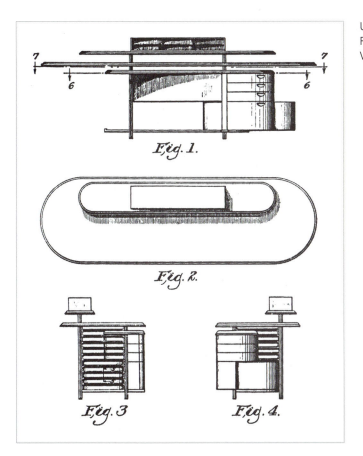

United States Patent Office drawings of desk designed by Frank Lloyd Wright, filed December 20, 1937 (with Johnson Wax Building chair).

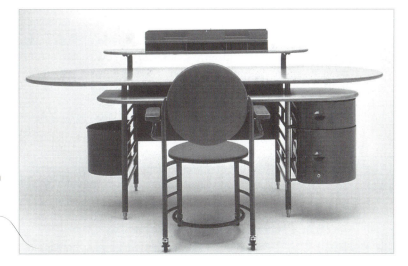

JOHNSON'S WAX DESK AND CHAIR.
Designed by Frank Lloyd Wright, 1937. Painted metal and walnut desk and upholstered chair designed for the S. C. Johnson Wax Administration Building in Racine, Wisconsin, in 1938, a forerunner of systems furniture; originally manufactured by Metal Office Furniture Co. (Steelcase). Chair H 34, W 21-1/2, D 20; desk H 33-1/4, W 84, D 35. *(Courtesy of Cassina)*

cific departments: red for credit, blue for branch house records, green for billing, and beige for sales promotion. Metal frames were painted Cherokee red.

The basic clerical desks came in nine variations, but most were 84 × 32 inches. Including various tables and one-of-a-kind pieces, Wright designed more than forty different pieces of furniture for the building. According to author Jonathan Lipman, "The Johnson company's employees were pleased with the desks, and most found the three-legged chairs comfortable after they learned to sit in them." However, the chairs really were unstable, and employees kept falling out of them. Even Wright was reported to have fallen out of one of his chairs, but he insisted that everyone would get used to them.

Modernism, such as it was expressed in tubular steel furniture, was a likely candidate for an office setting, as seen in the Johnson Wax Building. But tubular steel was originally offered as a solution to the mass housing problem, so many residences were given a more modern appearance than places of work. Nor did modern architecture necessarily influence its contents. Even the revolutionary modern architecture, like the Empire State Building, housed interiors with small rooms, bullpens for office workers, and traditional furniture.

TAYLOR CHAIR

The kind of traditional office furniture used in the early decades of the century can be better understood by looking at one of the companies that made it. Taylor Chair Co. is one of the earliest furniture manufacturers in America that is still producing. According to a history published by the company, it began when a skilled woodsman by the name of Benjamin Franklin Fitch settled in Bedford Township, in the portion of Northeast Ohio called the Western Reserve or "New Connecticut." The "slat-backed" chairs that he made for his cabin were just like the well-dried and constructed chairs he had known in New England, and soon, everyone wanted "Fitch Splint Bottom Chairs." To accommodate the new business, he built another cabin, hired workers, and developed a strap-lathe to allow continuous turning (which later became standard in the furniture industry).

From 1816 to 1844 Fitch made all types of chairs and rockers. In 1841 one of his employees, William Orville Taylor, married Fitch's daughter and soon took over management of the company, named the W. O. Taylor factory. The business continued to grow, and in 1885 it became the Taylor Chair Company with a catalog offering forty-eight chair types, including eight varieties of office chairs, one of which revolved and tilted. By 1904 the line contained ninety-one designs, including nineteen swivel office chairs.

The 1920s saw a trend of period office suites in various European and early American historic styles, and in order to accommodate, Taylor began a collaboration with a desk factory, Horrocks Desk Company of Herkimer, New York. They coordinated styling, jointly produced catalogs, and sold Horrocks Taylor Executive Suites to a select group of prestige office furniture dealers. By 1930, a few modern designs were included in the primarily traditional line. One called "the Future" was described in the catalog: "For the executive who is planning an office in the Trend of Today, whose office design must reflect his own aggressive personality and leadership in the business world, Taylor Chair offers this modern group. Designed by one of America's foremost contemporaries, the Future has Vigor and Smartness . . . conservatively streamlined in keeping with the tempo of modern interior architecture. The interior of the desk is engineered for efficiency and convenience, to eliminate loss of time and wasted motion. The fine woods and excellent craftsmanship guarantee it for a lifetime service."

These luxury office pieces exemplified American Art Deco, not as industrial design, but as inspired by the handcrafted French Art Moderne. Features included meticulously matched veneers, smooth lines without raised moldings, and rounded corners (claimed to be an exclusive Taylor feature). One of the hallmarks of French Art Deco furniture was its use of rare exotic woods and other rich materials, and these American office pieces used several—amboina burl, bleached walnut finish, black lacquer trim, chromium drawer pulls, and V-matched striped veneer patterns. What made these pieces identifiable as being American was a pronounced rectilinearity. In fact, if the decorative features—geometric patterned veneer, stylized carved feet, and canted corners resembling classical fluting—were eliminated, the desks look more like the plain inexpensive "Depression Modern" prevalent in the 1930s.

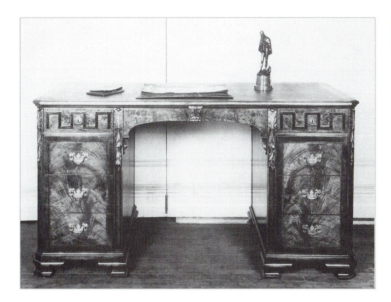

Desk with two side pedestals with drawers, designed by Rorimer-Brooks Studios and produced by Taylor Chair of Bedford, Ohio, circa 1930.

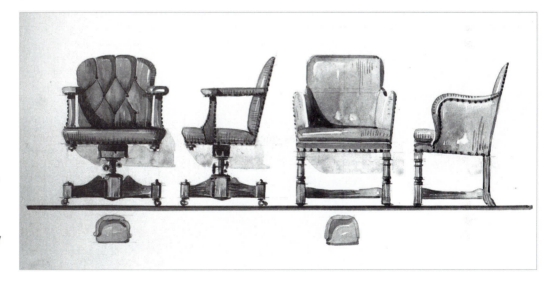

Drawings for office chairs by Rorimer-Brooks chief designer, William Green, produced by Taylor Chair, circa 1930.

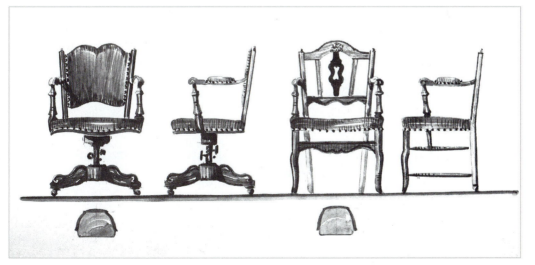

Drawings for office chairs by Rorimer-Brooks chief designer, William Green, to be made by Taylor Chair, circa 1930.

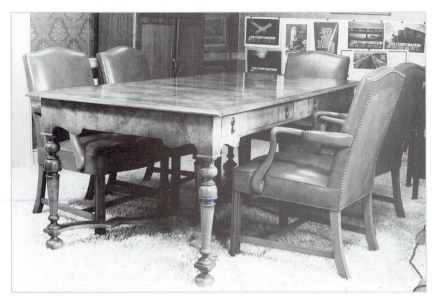

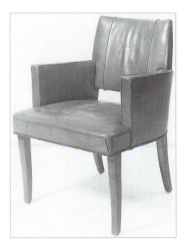

Conference table in William and Mary revival style, by Rorimer-Brooks for the Greenbriar Suite of the Terminal Tower in Cleveland, Ohio. The VanSweringen brothers, who owned a railroad empire in the 1920s, kept the suite for guests and entertaining.

Typical executive office chair before the need for ergonomic seating was recognized—this example designed and made by Rorimer-Brooks for the Cloisters office at the Metropolitan Museum of Art in New York City, 1938.

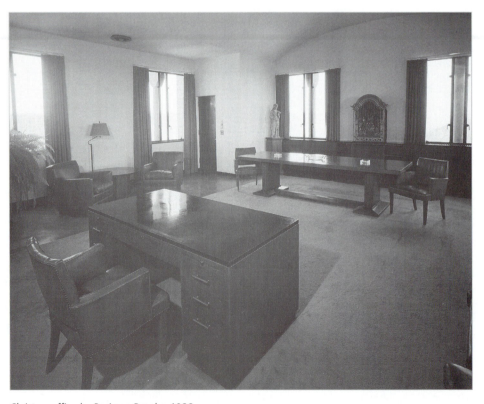

Cloisters office by Rorimer-Brooks, 1938.

EARLY OFFICE

These executive suites symbolized the rewards of management and reminded others of the lack of status and individuality that characterized the rest of the workplace. Offices in the early twentieth century depended on a hierarchical system of work, space, and furnishings. In fact the American office has been compared to a factory in its organization, especially with the appearance of the time clock. By the 1920s, the organization of work in large, well-managed American offices could be compared to many factories. Only the product— information and paper—was different. Before about 1940, most office furniture looked mechanical and industrial, especially that used by the clerical workers, who made up the majority of the workforce.

In the nineteenth century, desks had been fitted with various racks, shelves, drawers, and compartments. Their design afforded some privacy to the user, and they were used for storage as well as work. When the job of filing became separated from other clerical work, the desk no longer needed filing space, and more specialized pieces of office equipment served that purpose. Besides its other advantages, the rolltop desk had allowed the clerk to cover his work or his mess. With its disappearance, clerks lost control of privacy, and work was constantly exposed. The desktop was expected to be organized so that anything could be found at a moment's notice, and in the interest of efficiency, clerks were to be taught to arrange the contents of their desks according to a prescribed system.

The so-called scientific management that controlled the office-factory was, of course, absent in the executive office. Here, furniture was used to symbolize status; drawers were often vestigial appendages, no longer functioning as space for filing or storing "work." The Taylor-Horrocks suites, whether in Jacobean or Louis XVI revival style or Art Deco, were more like residential furniture. Even the modern kidney-shaped desks and tables offered by a high-end company like Stow & Davis (later part of Steelcase) in the 1950s helped to perpetuate the hierarchical fantasy. While perceptions of efficiency and the appropriate furniture forms evolved, the focus on office hierarchy did not. The Seagram Building in New York City (1954–1958) was one of the first steel frame and glass curtain wall buildings, and it set the standard for modern architecture

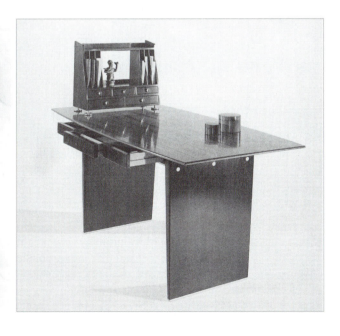

Edward Wormley, who designed primarily residential lines for Dunbar, also designed modern office furniture. This writing table, from the 1956 Dunbar catalog is as light and versatile as any desk design several decades later.

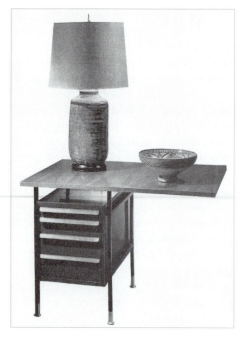

Wormley's drop-leaf writing table on pedestal with drawers folds into a small versatile piece for any room, in Dunbar 1956 catalog.

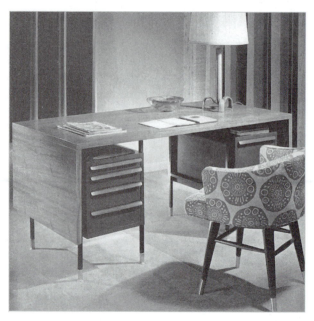

Larger drop-leaf writing table used in home office or living room, in Dunbar 1956 catalog.

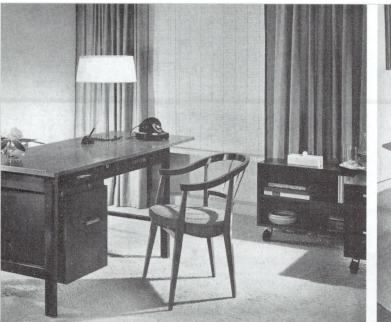
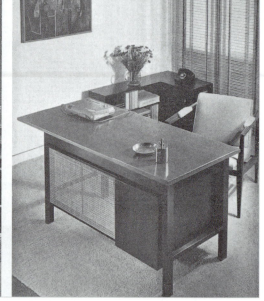

Wormley's Portfolio collection of desks and flexible component units is designed for home and office, in Dunbar 1956 catalog.

for years, even decades, to come. But with all of its modern advances, the interior was broken up into rigid cubicle spaces furnished with traditional office furniture. In 1959 the Union Carbide headquarters, down the street from the Seagram headquarters on Park Avenue, used custom-designed or specially adapted furniture to express the corporate hierarchy more than to accommodate the employees' needs. According to author Lance Knobel, office size, location, presence or absence of windows, and type of furnishings

were used as status symbols and incentives, and the model set the standard for other mid-century office environments.

Though the trend for residential historic styles and comfort in the boardroom and executive office continued, the 1950s also saw major changes in the office environment that both preserved and diminished the established hierarchical system. Modernization required more than superficial change in styling, even if the superficial change was good. Early attempts at modernizing the office—uncomfortable swivel chairs, unstable three-legged chairs, or counterproductive space plans—did contribute to later developments. The first major breakthrough in office furniture design, however, was in 1942 when Gilbert Rohde designed the Executive Office Group (EOG) for Herman Miller. The concept of interchangeable parts revolutionized office design and made way for George Nelson's 1947 version and other modern office design. EOG marked the entry of Herman Miller into the office furniture market. By designing an L-shaped desk with one arm at typing height and storage at the ends, the result was more of a workstation than a piece of furniture. Although originally an executive desk, and even named as such, the concept became the model for desk designs for the next thirty years. Companies such as Stow & Davis also developed quality executive office furniture using the concept. The British firm Hille and Co. made stylish furniture like Herman Miller's (and even licensed their designs from 1958). They also combined or compromised the idea of status versus egalitarianism by using the same styling and materials for all of the furniture. "The Hille range of desks thus gave a semblance of common identity and even of equality to everyone in the office, while the differences between the desks made it clear that there were still hierarchies." In other words, as Adrian Forty observed, "the problem of office management in the 1960s was to create an illusion of equality while preserving hierarchies."

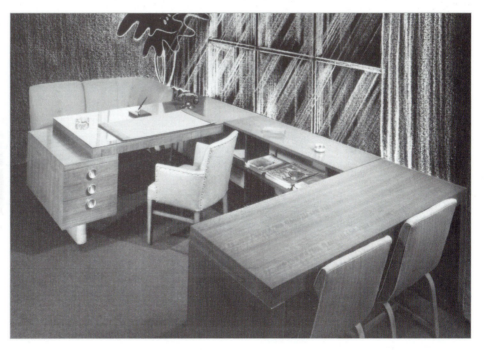

Arrangement of Executive Office Group (EOG) designed by Gilbert Rohde for Herman Miller in 1942. The concept of multiple interchangeable parts revolutionized office design and made way for George Nelson's later version and other modern office design. EOG marked the entry of Herman Miller into the office furniture market. (*Courtesy of Herman Miller, Inc.*)

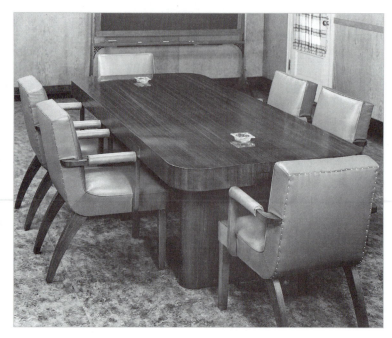

EOG end pedestal conference table with rounded corners, by Gilbert Rohde for Herman Miller, 1942. *(Courtesy of Herman Miller, Inc.)*

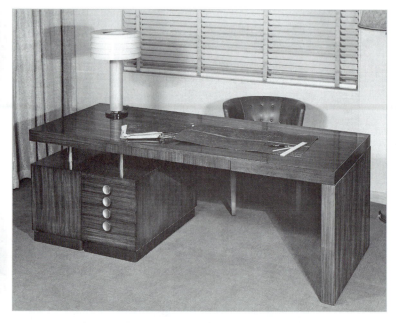

EOG senior professional desk with two pedestals on one side, by Rohde for Herman Miller. *(Courtesy of Herman Miller, Inc.)*

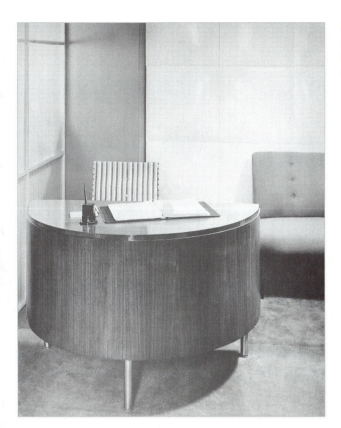

EOG half cylindrical receptionist desk by Rohde for Herman Miller. *(Courtesy of Herman Miller, Inc.)*

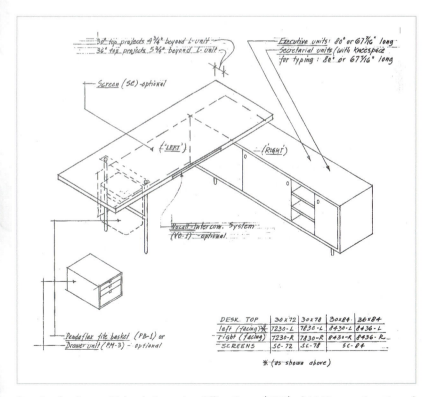

Drawing for George Nelson's Executive Office Group (EOG) of 1946, a continuation of Rohde's concept. *(Courtesy of Herman Miller, Inc.)*

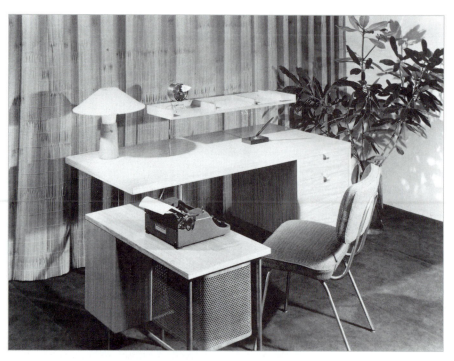

Example of Herman Miller EOG by Nelson, 1946. *(Courtesy of Herman Miller, Inc.)*

SYSTEMS

It was this need to protect the workplace hierarchy that contributed to the development of screen-mounted **systems furniture**. The innovator was once again Herman Miller, with its Action Office system that dramatically changed the office in the late 1960s and 1970s. The open plan of the landscaped office relied on cubicles formed by screens rather than walls. Mobility and versatility of modular components enabled a more flexible form of office efficiency while maintaining an imposed system of symbolic hierarchy.

Herman Miller's Action Office

In 1960 Herman Miller formed the Herman Miller Research Corporation under the direction of Robert Propst. Though their mission was to find and solve problems outside the furniture industry, the first major project was the office.

By the early 1960s it had become clear that the radical change taking place in the office, as well as outside the office, was occurring at an accelerating rate. Society had almost suddenly come from needing more information to having too much information, and the physical environment had failed to accommodate the change. In the 1960s precomputerized world, not only was there too much information, it was often repetitive and redundant, out of date by the time it was printed, or too specialized. A good deal of the new abundance of information flowed through the office.

An extraordinary variety of tasks are performed in the office. Yet, historically, rather than vary the facilities accordingly, the tendency has been to standardize the environment, leaving the only physical variations oriented toward status and performance. The office facility has reflected the belief that ultimate knowledge lies at the top, so independence was discouraged, and mistakes called for penalties. The opposite point of view regards

each individual as a potential decision maker and manager, and individuals at any level need challenge and encouragement to gain top performance. But the typical office system of the 1960s was rigid and suffered from clogged communication channels and tended to smother creativity and innovation.

There was too much printed material placed on workers' desks and laps, information that was apt to become counterproductive. It followed that a concept as simple as the physical office environment could contribute to the goal of efficient information management. The first step toward major change in the physical surroundings can be credited to a German consulting firm called the Quickborner Team, in the mid-1950s. The idea was to plan the office around the flow of paper and communications.

Placement of this facility was also critical. The open office grid plan with row after row of rectangular desks and unrectangular people afforded neither privacy nor interaction, yet office workers require both. The existence of ample information does not necessarily imply ample communication.

In order to improve the state of the American office and its workers, the main issues to address were reduced to: (1) organization of information, (2) organization of people, and (3) organization of facilities. And once a new system is in place to address these needs, the only constant variable is change. In other words, the only thing that we can predict with absolute certainty is that everything will change. This does not mean that anything we do will not matter; on the contrary, it means that everything we do will matter. But in order to accommodate this inevitable change, we must prepare for it.

Action Office 2 was a facility based on change. It was an environment designed to accommodate change by its built-in flexibility and adaptability. In order to provide the most efficient physical space for communication, the facility must provide both enclosure and access. Up until then, the choice was either an open system of desks lined up in a space or a closed system of "bull pens" of individual enclosed offices. A third alternative was neither all open nor all closed. The premise had been that people are more comfortable and therefore more productive with a territorial enclave, and that they are uncomfortable in totally open space. Yet people also require vista, a view of the outside. The concept of "back-up" is a two- or three-sided vertical division that defines territory and affords privacy without hindering the ability to view or participate.

The office system was based on the mobile wall-like element that defined the space. It also supported multiple **workstation** functions, many of which could be vertically oriented. These panels provided selective visibility or enclosure and supported a collection of human-scale, standardized, interchangeable, and versatile components called work surfaces, shelves, drawers, covers, and counter caps. Simple, very basic components were do-it-yourself building blocks that enabled any office worker to become his or her own designer, builder, and manager of a personalized and functional space. They also reduced the required square footage by utilizing the vertical space and surfaces for storage, privacy, and display. Items that are more desirable as nondisplay, like electrical wiring, could be hidden in the panels. The options of using both sitting and standing workstation areas relieved the problem of becoming overly sedentary, and details like padded edges invite leaning. Systems furniture is really more system than furniture.

The focus of furniture design and innovation turned to the chair, and the goal was ergonomics. Comfortable, adjustable posture had previously eluded chair designers and sitters. With the new mobility and flexibility of the wall-mounted system came the adjustable chair. Besides back and bottom support, chairs, as well as other portable furniture, could be wheeled around to accommodate formal or informal meetings. Like the overly specialized species that becomes extinct when its environment changes, the rigid office environment becomes dysfunctional with new situations, information, technology, or people. Stylistic change was not enough. The office system was designed to be so generalized that it could adapt physically as its users grew and changed. It was also very easy for manufacturers to imitate.

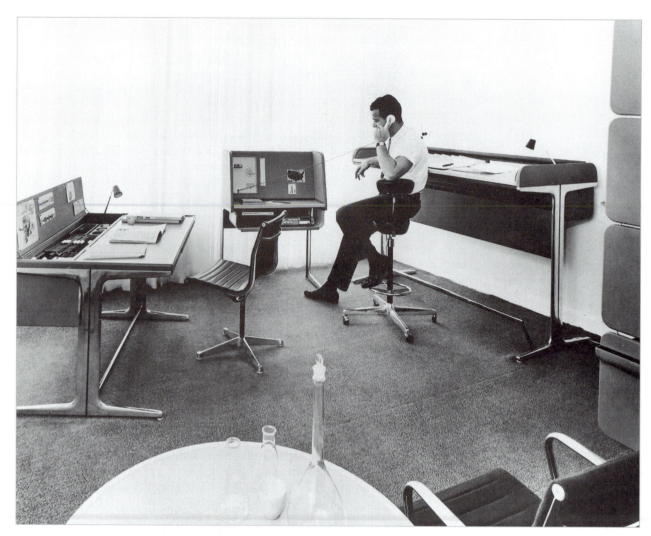

Herman Miller Action Office, introduced in 1964, showing stand-up desk with footrest and man on a perch. Action office was invented by Robert Propst, head of the Herman Miller Research Division, while George Nelson's Office designed the components. *(Courtesy of Herman Miller, Inc.)*

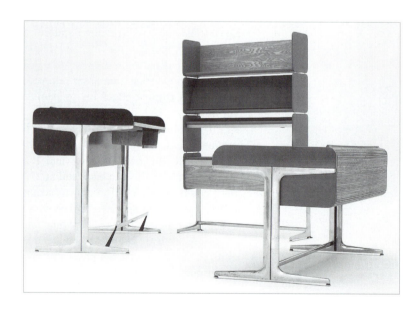

Herman Miller Action Office components, 1964.
(Courtesy of Herman Miller, Inc.)

PERCH.
Designed by Robert Propst, 1964. Originally part of Action Office 1 as an alternative seating unit to relieve sedentary workers; suited for home or office for temporary mobile sitting or perching at any "stand-up" work surface; small foam-padded seat with separate padded backrest (also used as a leaning siderest or frontrest) attached to chrome-finished metal spline; pedestal base with adjustable heights, foot ring, four-star base with casters. Max H 43, max seat H 33, W 10-5/8, D 15-1/2. (*Courtesy of Herman Miller, Inc.*)

ALUMINUM GROUP CHAIR.
Designed by Charles and Ray Eames, 1958. Available in choice of seven fabrics; die-cast aluminum four-star base, frame (and arms); tubular steel column with enamel finish; layered vinyl cushioning and nylon suspension; seat height adjustment and tilt-swivel mechanism; casters or glides. (*Courtesy of Herman Miller, Inc.*)

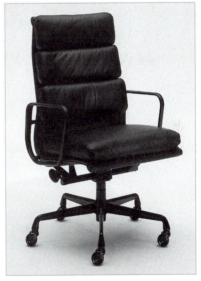

SOFT PAD EXECUTIVE CHAIR.
Designed by Charles and Ray Eames, 1969. From the Soft Pad Collection: available in choice of two leathers, seven fabrics; polished die-cast aluminum five-star base, frame, and arms; tubular steel column with enamel finish; seat height adjustment and tilt-swivel mechanism; nylon suspension; glides or casters. H 41 max, W 23, D 15-1/2. (*Courtesy of Herman Miller, Inc.*)

Plagiarism

George Nelson included an essay entitled "Plagiarism, or How to Be Creative When No One Is Looking" in his now-classic book *George Nelson on Design*. On the positive side, Nelson saw imitation as a sign of success. But what happened in industry was something like this: As manufacturing methods became fairly standard and ubiquitous, anyone with some degree of manufacturing capability could just as easily copy someone else's design as create one of their own. New product development is risky and costly. Nelson observed that the best way to avoid the risk and the cost is to steal the design of an item that is already a market success. New product development begins with a problem or idea and works from the ground up to design, test, modify, and hopefully market the item. The ripoff operator, Nelson aptly points out, begins at the end of the process with the production sample. Plus, the stolen sample can be reengineered and downgraded and then marketed as the "same" product for less cost to the consumer.

Though Nelson's thoughts on plagiarism go beyond the furniture industry, they are worth mentioning here, because the implications apply to modern civilization and notions of progress. Civilizations advance, because "we stand on the shoulders of giants." Humans learn very fundamental things, like speech, largely by copying. Scientists and artists discover, uncover, and find as much, if not more, than they actually invent. According to Nelson, the difference between a scientist and a designer is curious: When a scientist presents a paper, he or she gains necessary credibility by referring to the work of predecessors. Yet, he states, "I have never yet run across a designer who did this, although we are all powerfully affected by the ideas and accomplishments of others."

Copying can be looked at in at least two ways: either as an essential part of the evolutionary process or as theft. Nelson goes further to identify two different kinds of copyists: "those who start with what there is and by adding something, move up to another level, and the parasites." The former, he considers more interesting, but the latter, the one that survives by feeding off of another organism and develops no muscles of its own, is in the majority. Then he really lets loose and explains why large numbers of children with creative potential grow up and exhibit none. "The society apparently, despite its vast assortment of technical breakthroughs, must still be functioning on a rather primitive level, not unlike the Roman model, with great dedication to the tranquilizing of unruly populations, to the elimination of curiosity in both schools and places of work, to the glorification of material values, and to the 19th-century distortions of the survival-of-the-fittest doctrines so useful to the Victorian establishments. The inevitable result of all this is to take the miraculous potential of children and squeeze it, like Wonder Bread, into the uniform shape of mediocrity. Mediocre people do mediocre things like plagiarizing and they are taught how to do this in mediocre societies." In a more civilized society, he adds, "the parasitism of the plagiarist would fare much worse than it does now. The Mickey Mouse mentality, so comforting to the modern masses, would vanish, and the practice could be seen much more clearly for what it is: behavior eminently suited for a timid, helpless, sly, not very bright, and rather lazy little rodent. . . . " No offense intended to Mickey Mouse, I assume, and I hope none taken.

Post-Systems

By the mid- to late 1970s, screen-based office systems were made by many companies entering the huge American office systems industry. One change that was not anticipated in the 1960s was one generated from outside. As the economy of the 1980s and 1990s changed, companies practiced something called downsizing. The elimination of employees and/or workspace obviously exceeded the adaptability of systems furniture made by the giants—Herman Miller, Haworth, Steelcase, Knoll—and every other manufacturer for the office. In addition to the workstation and an increased number of furniture configurations for conferencing and team work, many offices needed something different.

As more employees were spending time away from the office—on the road, at home, or someplace else—the need for permanent personalized space became less consistent. Then the technology revolution that succeeded the office facilities revolution of the 1960s enabled electronic communication to gradually overcome the workplace. And electronic communication was not limited to any particular place or computer screen. The concept of wireless communication added to the mobility of workers and to communicators in general. In order to conserve valuable space and equipment—after all, the purpose of downsizing was economic—the idea of "hoteling" entered the office. Employees phoned in a reservation to use the space and its facilities, used it, and left. Rather than an office with ten workstations serving ten workers, it could accommodate twice that number. Even the structure of systems changed, and Herman Miller, the pioneer of systems furniture, was the first to offer an alternative. In 1984 Jack Kelley and Bill Stumpf designed a nonsystem called Ethospace, with tilelike panels that snap into place without tools, resulting in a versatile enclosure with the ability to provide room-like privacy. Earlier, in 1981, Bruce Burdick had designed the Burdick Group of freestanding beams with interchangeable work surfaces and storage and display components. This was followed in 1987 by the Tom Newhouse freestanding modular furniture as an alternative to hanging components in panel systems, and in 1990 with Geoff Hollington's Relay office furniture, in which the individual pieces could "dock" next to each other. Their acceptance showed that systems was only one office solution, and that it could be combined with other forms.

Flexibility and changeability are perhaps the most critical features of any office environment. Electronic communication has replaced previous methods and forms, and furniture must accommodate the fast pace imposed by these other industries. Consequently, ergonomic concerns have become increasingly important to employees and their employers. Yet, while function and efficiency are of the highest priorities, there are other needs, perhaps not unlike the needs that have always influenced the evolution of furniture in history. Color, texture, form, materials, and construction—the way a piece looks and feels—can delight or disappoint the user. Designers and manufacturers of furniture for the workplace have a dual responsibility. Furniture design may appear to have left the traditional fields of upholsterer and decorator far behind, but they must not be forgotten until basic human needs have also changed.

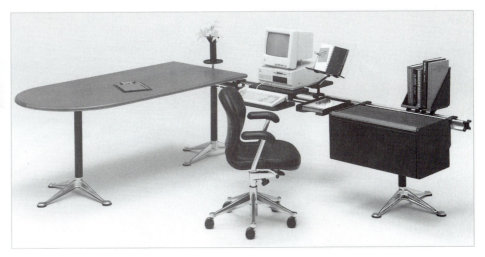

BURDICK GROUP FURNITURE.
Designed by Bruce Burdick, 1981. Group consists of tables and other items with glass or wood tops and aluminum bases, originally designed for executive offices, also used in residential settings; shown in one of many possible configurations. (*Courtesy of Herman Miller, Inc.*)

BURDICK DINING TABLE.
Designed by Bruce Burdick, 1981. Originally designed as
a conference table for an executive office, it has become
a popular residential dining table; rectangular top with
two attached half round sections of 5/8-inch plate glass
with polished edge; polished aluminum base and beam.
H 28-7/8, W 120, D 36. (*Courtesy of Herman Miller, Inc.*)

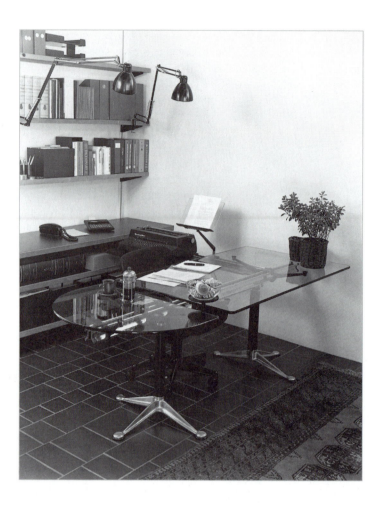

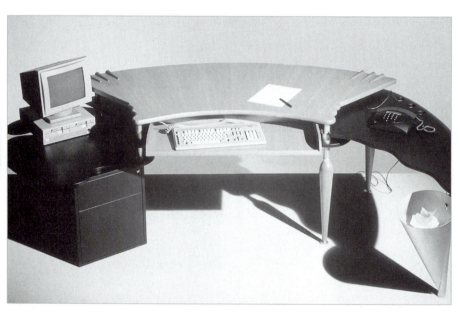

SIPEK OFFICE.
Designed by Borek Sipek, 1992. Worktable combination with extensions, organizer, and waste
paper basket; black lacquered wood, pear veneer, metal basket, by Vitra. H 29-1/2, L 118, D 59.
(*Courtesy of Vitra International*)

PERSONAL HARBOR.
Steelcase self-contained private workspace provides seclusion for concentration; with ready access to surrounding collaborative spaces; easily configured, adaptable, and customized for multiple tasks; shown closed. (*Courtesy of Steelcase, Inc.*)

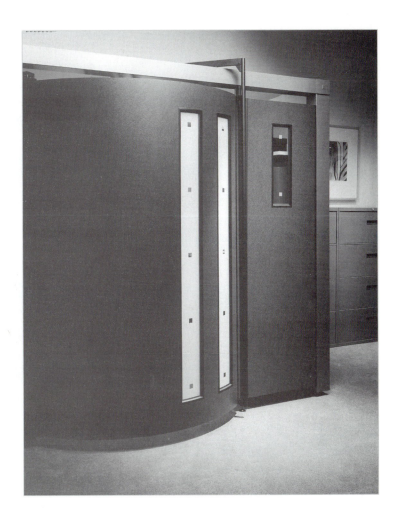

PERSONAL HARBOR.
Steelcase self-contained private workspace provides seclusion for concentration; with ready access to surrounding collaborative spaces; easily configured and adaptable, easily customized for multiple tasks; shown clustered around common area. (*Courtesy of Steelcase, Inc.*)

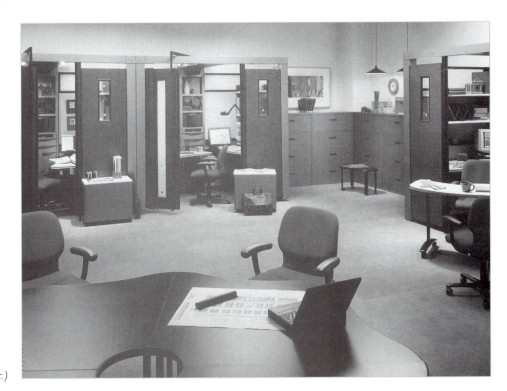

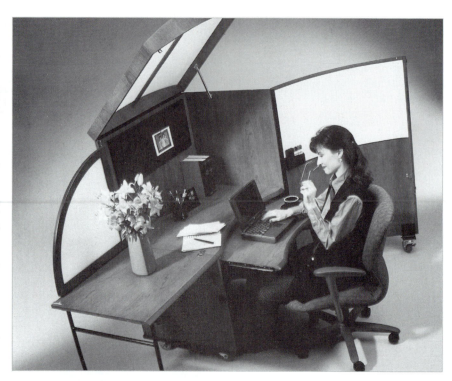

CORRESPONDENT.
Haworth Mobile office for temporary work environment with more than 14 square feet of surface space, including a pull-out work surface for keyboard or laptop, tackboard, marker board, security lock, cord-drop, and air duct for heat release, if needed. Case cherry veneer on particle board; door cherry veneer on formed plywood. Closed H 57-1/2, W 36, D 30.
(*Courtesy of Haworth*)

Haworth correspondent, shown closed.
(*Courtesy of Haworth*)

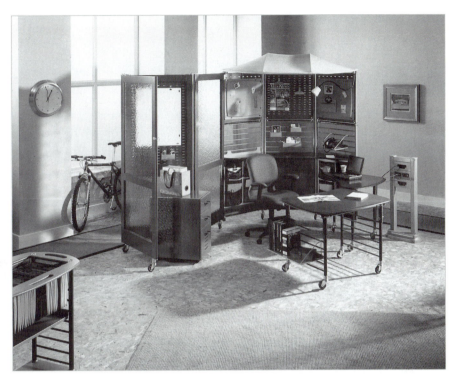

CROSSINGS.
Haworth modifiable, open-ended workstation designed to give the individual working in the space control over the surroundings; components are functionally independent for improved space utilization and multitasking ability. *(Courtesy of Haworth)*

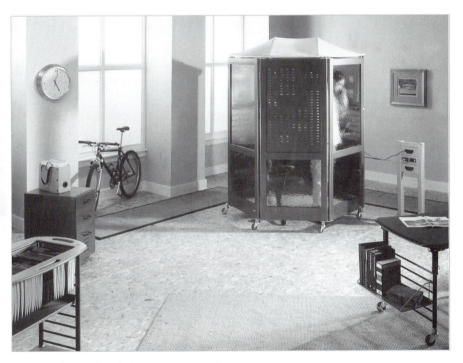

Crossings shown closed. *(Courtesy of Haworth)*

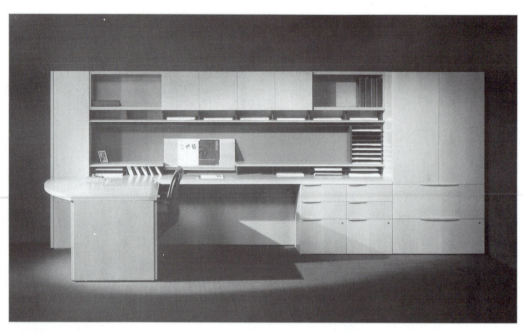

HALCON AGENDA.
Designed by Brian Kenneth Graham. "L" workstation from a collection of case pieces with work surfaces; offered in a variety of woods, finishes, and colors. H 71, W 171, D 79 (desk 55 + worksurface 24).
(*Courtesy of Halcon*)

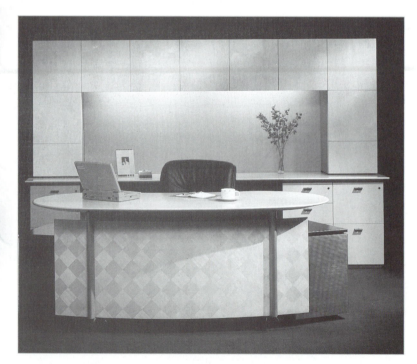

HALCON GEMINI.
Designed by Edward F. Weller III. Workwall, mobile kidney desk with distinctive geometric veneer pattern, and boby pedestals. Workwall H 86, W 110, D 25; desk H 29-3/4, W 73, D 32; pedestals H 21-1/2, W 15-3/4, D 20. (*Courtesy of Halcon*)

ICF ATLANTIS.
Designed by Toshiyuki Kita. Steel frame with flexible polyurethane articulating back, five-star aluminum swivel base, upholstered in fabric or leather. H 34 to 37 or 35-3/4 to 38-1/2, W 26, D 26. *(Courtesy of ICF Group)*

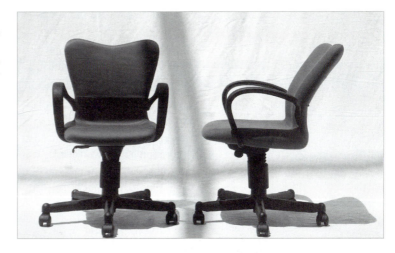

HAWORTH TAZ CHAIR.
Designed by D5, 1997. TAZ (Torsional Action Zone) provides freedom of movement by moving backward, forward, left, and right; excellent ergonomic support, available in three sizes, armless or with stationary or height-adjustable arms; choice of upholstery fabric and trim colors. *(Courtesy of Haworth)*

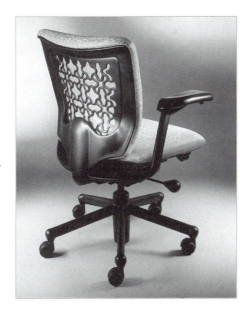

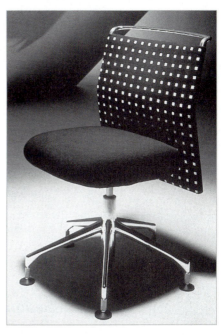

VITRA AC1 TASK CHAIR.
Designed by Antonio Citterio and Glen Oliver Löw, circa 1988. Armless with upholstered back shell, pneumatic height, on five-star base with cast aluminum frame, with variable back lock, lumbar support, and adjustable tension. *(Courtesy of Vitra International)*

HERMAN MILLER AERON CHAIR.
Designed by Bill Stumpf and Don Chadwick, 1994. The lightweight and breathable Pellicle material conforms to the sitter's body, distributes the weight evenly, and retains its original shape. The Kinemat tilt allows the body to naturally pivot at the ankles, knees, and hips; and the two-stage pneumatic lift provides a wide range of height adjustment. Three sizes: H 41 to 45 max., W 25-3/4 to 28-1/4, D 15-3/4 to 18-1/2. *(Photo Nick Merrick, Hedrich-Blessing; courtesy of Herman Miller, Inc.)*

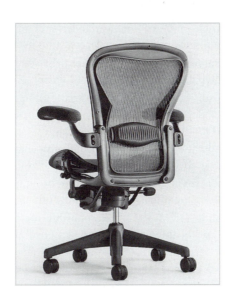

Summary

- The pace of innovation and change in the residential interior slowed in the second half of the twentieth century.
- Widespread change occurred in office furniture.
- Frank Lloyd Wright and Gilbert Rohde were pioneers in reconfiguring the office environment in the 1930s.
- Systems furniture, introduced at Herman Miller in the 1960s, was the first major alteration of the workplace.
- Systems combined with alternative compatible concepts using freestanding furniture address the needs for flexibility and comfort at the close of the century.

Chronology

1853 Peter Ten Eyck invents a proto-ergonomic swivel chair.

1885 Taylor Chair Co. established (with beginnings in 1816); offers 48 chair types, eight for office.

1904 Frank Lloyd Wright designs office furniture for the Larkin Administration Building.

1912 Metal Office Furniture Co. (Steelcase) is established.

1936 Wright designs the Johnson Wax Administration Building and its proto-systems office furniture.

1942 Gilbert Rohde designs the innovative Executive Office Group (EOG).

1947 George Nelson takes the EOG further and influences the marketplace.

1954 Metal Office Furniture becomes Steelcase and introduces color to office furniture.

1964 Robert Propst develops and George Nelson designs systems furniture for Herman Miller, called Action Office 1.

Designers

Bruce Burdick (b. 1933) Designer of alternatives to traditional executive office furniture also suited to the residence.

Don Chadwick (b. 1936) Industrial designer important in the development of modular seating and ergonomic office seating from the 1970s on.

Geoff Hollington (b. 1949) Designer of post-systems freestanding office furniture both compatible with systems and humane as residential furniture.

George Nelson (1908–1986) Director of design at Herman Miller, further developed Rohde's Executive Office Group and designed pioneering systems furniture, Action Office 1.

Robert Propst (b. 1921) Developed the first major systems furniture, Action Office 1, followed by Action Office 2.

Quickborner Team German consulting firm that, in the 1950s, pioneered the idea of planning the office around the flow of paper and communication.

Gilbert Rohde (1894–1944) Responsible for introducing modern furniture on a large scale in the United States, designed Executive Office Group at Herman Miller.

Frank Lloyd Wright (1867–1959) Pioneer modernist architect-designer, designed some of the earliest modern office furniture and proto-systems.

Key Terms

contract furniture systems furniture
ergonomics workstation

Recommended Reading

Forty, Adrian. *Objects of Desire*. New York: Pantheon, 1986.

Knobel, Lance. *Office Furniture: Twentieth-Century Design*. New York: E. P. Dutton, 1987.

Propst, Robert. *The Office: A Facility Based on Change*. Zeeland, Mich.: Herman Miller Inc., 1968.

————. *Action Office: The System that Works for You*. Ann Arbor, Mich.: Herman Miller Research Corp., 1978.

Steelcase, Inc. *Steelcase: The First 75 Years*. Grand Rapid: Steelcase, Inc., 1987.

Taylor Chair Company. *The Taylor Chair Company: Seven Generations Since 1816*. Bedford, Ohio: Taylor Chair, 1982.

Chapter *15*

A ROUND 2000
Full Circle

CHAPTER CONTENTS

Residential furniture relies on three distinct sources: tradition, a revival of the modern classics, and new ideas and technologies often shared with contract design. We have come full circle in the history of furniture styles, and all are available in the new millennium.

1970

Boeing 747; floppy disc; National Guard shoots and kills four Kent State students at antiwar protest; 448 U.S. colleges and universities close or strike; Congress passes Occupational Safety Act; Nike founded; Environmental Protection Association (EPA) begins operation; New York City Ballet's 500th performance of *The Nutcracker*; fiction, Richard Bach *Jonathan Livingston Seagull*, James Dickey *Deliverance*, Irwin Shaw *Rich Man Poor Man*; films *Five Easy Pieces*, *M*A*S*H*, *Patton*, *True Grit*, *Topaz*; songs Beatles "Let It Be," "The Long and Winding Road," Led Zeppelin "Whole Lotta Love," Diana Ross "Ain't No Mountain High Enough."

Died 1970

Charles de Gaulle (b. 1890), Jimi Hendrix (b. 1942), Janis Lyn Joplin (b. 1943), Gypsy Rose Lee (b. 1911), Gamal Abdel Nasser (b. 1918), Mark Rothko (b. 1903), Bertrand Russell (b. 1872), Sukarno (b. 1901).

1971

Intel's microprocessor; Mariner 9 orbits Mars; cigarette commercials are banned on U.S. television; Attica prison uprising; voting age in United States lowered to 18; long-distance direct dialing; soft contact lenses; New York begins first U.S. off-track betting; U.S. currency taken off the gold standard; films *French Connection*, *Clockwork Orange*, *Dirty Harry*; rock musical *Jesus Christ Superstar*; songs Doors "Riders In the Storm," George Harrison "My Sweet Lord," John Lennon "Imagine," T. Rex "Get It On."

THE LULL AFTER THE STORM

The development of modernism in the twentieth century took more than one direction, as seen in phenomena as diverse as the German school known as the Bauhaus and in American industrial design infused with French Art Deco styling. Simple, cost-effective forms and new materials suited for mass production introduced before World War II came together after the war effort ceased to monopolize materials and industry. Ideas poured out along with moldable plastics and plywood and manufacturing facilities no longer committed to the military. Industry shifted gears to quickly provide homes and furnishings for the returning troops. The major modern furniture companies and designers who were willing to take risks were rewarded by a new brand of consumer in an economic climate of unbridled optimism. This golden age of modern furniture of the 1950s began to wane in the 1960s, until innovation began to waver and slip into eccentricity.

Although the fifties home furnished in modern style was really the exception and not the rule, "modern" was at least enjoyed by the fashion-conscious segment of the population. And although a fair number purchased fifties modern, only a very small minority really understood and appreciated the design, the quality, and the timelessness of the era's best furniture. As predictable as their predecessors, the fad-followers soon began to discard the mid-century classics in favor of something else. The new American consumer sought change for its own sake. Alternatives in the 1960s and 1970s included oddly finished, boxy derivations of Scandinavian Modern; dark, clumsy forms collectively referred to as "Mediterranean"; and endless spans of giant sectional sofas (**modular furniture** gone mad) devouring the space of large and small rooms without discrimination. Mechanical recliners resembling upholstered hospital beds were another species of space eaters. They replaced the earlier rocking chair in many American living rooms, except that the gender of its primary user changed, and males, usually the "man of the house," claimed the recliner as his turf. It often faced a new focal point in the room—the television. For the bedroom, came a trendy and different form of furniture—the waterbed. The idea of sleeping on top of a heated pool of water without fear of drowning captivated a sizable market, especially the younger set. It came with its share of superlatives as being one of the heaviest pieces of furniture ever devised, certainly the ugliest, and it could compete with some of the most bizarre Victorian eccentricities. As long as the bedroom floor was well-constructed and the owner carried flood insurance, the waterbed worked. Soon, it ceased to be a novelty and became one more uninspired choice with which to furnish a bedroom through the remainder of the century.

To these "innovations" were added the usual array of bland generic traditional forms that had no memory of their original period prototypes. Since shortly after World War II, the furniture industry in America has been divided between two extremes: (1) following Europe and its centuries-old inventory of new and recycled historic styles, and (2) leading in modernism and industrial design. Colonial revival is really only another set of European copies, as the term "colonial" means, and it has been the most enduring of all with the American consumer. Robsjohn-Gibbings's observations were as applicable fifty years later as when he made them in 1945. "There is a . . . generation of Americans to whom it seems as natural to find antique and reproduction furniture in the living room as it does to find an electric refrigerator in the kitchen. . . . America stands facing this vast future of the post-war world with a furniture industry that is obsolete, and a public which is punch-drunk from antique decorating." If the manufacturers and consumers of fifties modern had taken two steps forward, many of its successors had taken three steps backward.

ALTERNATIVES AND PROBLEMS OF DESIGN

Some furniture designers carried on the spirit of the fifties, but although a variety of alternatives to conventional materials, forms, and functions were introduced, their brief lifespan in retail stores and homes has been exaggerated by their stardom in museums and

Died 1971
Louis Armstrong (b. 1901),
Coco Chanel (b. 1883),
Nikita Khrushchev (b. 1894),
Jim Morrison (b. 1943), Igor
Stravinsky (b. 1882).

1972
Nixon re-elected with 520
electoral votes and is first
U.S. president to visit China;
Strategic Arms Limitation
Talks (SALT) I; swimmer
Mark Spitz wins seven
olympic gold medals, one
for each event; DOW is
above 1000; military draft
ends; *Life* magazine ceases;
Ms. magazine begins; *Fiddler
on the Roof* closes on
Broadway after 3,242
performances and rock
musical *Hair* after 1,742
performances, musical
Grease opens on Broadway;
films *Cabaret, Deliverance,
The Godfather, Poseidon
Adventure*; Monty Python's
*And Now for Something
Completely Different* is first
shown to American
audiences; debut of Bryan
Ferry and "Roxy Music;" Lou
Reed album *Transformer,*
David Bowie album *The Rise
and Fall of Ziggy Stardust
and the Spiders from Mars;*
songs T. Rex "Metal Guru,"
Bill Withers "Lean On Me."

Died 1972
Charles Atlas (b. 1893),
J. Edgar Hoover (b. 1895),
Mahalia Jackson (b. 1911),
Howard Johnson (b. 1897),
Louis Leakey (b. 1903),
Jackie Robinson (b. 1919).

1973
Watergate scandal; vice-
president Spiro Agnew
resigns; U.S withdrawal from
Vietnam; Israel wins "Yom
Kipper" War; energy crisis;

exhibition catalogs. There were unique designs, such as Eero Aarnio's 1960s Ball or Globe Chair, a hollow fiberglass ball cut in section, with an aluminum swivel base, and optional speakers and/or telephone mounted inside (Chapter 13). The first successful beanbag chair, part of the "anti-design movement," was produced by the Italian firm Zanotta in the late 1960s. Rather than a frame or any conventional fixed form, tiny polystyrene balls covered in vinyl or leather enabled the sitter to individually shape the chair each time it was used. Another frameless, but not boneless design, was the Malitte system by surrealist painter Roberto Sebastian Matta. Individual upholstered foam components were arranged to created a free-form sculptural seating landscape and then assembled like a three-dimensional puzzle for storage or display (Chapter 13). There were other high-style versions of foam pillow build-your-own furniture, whose lives were also condemned to loneliness in museums and books. However, they did ultimately lead to the inexpensive, commercially successful, and designless "futon" that replaced the spare bed or folding cot. Standard cushions, arranged as a chair by day, become a lightweight, portable, and instant guest bed by night.

Another item, the glass-topped table, by no means a new idea, reached new levels of popularity from the 1960s on. Large, thick, extremely heavy slabs of glass were mounted on and in wrought iron, brass, wood, stone, and even plastic bases and frames. Though visually light, their material weight and tendency to chip or break, inspired the use of an alternative—plastic. From crystal clear, costly, designer Lucite furniture, to items of opaque, brittle colored plastic, the material had obvious advantages. Unlike glass, relatively lightweight Lucite could be used for anything from tabletops to shelving without the fear of catastrophic breakage. Other plastics, in solid form or as laminates, entered the home in the form of tables in every size and every ability—from stacking to packing by removing the legs.

In the 1980s and into the 1990s something called "contemporary" seemed to denote anything that was not blatantly traditional. For the most part, rather than introducing new and better forms or materials, an extraordinary amount of energy was expended on finishes. Lacquers, acrylics, and applied patterns—especially **faux finishes**—masked wood surfaces until it no longer mattered what was underneath. Both traditional and contemporary forms of wood furniture and exposed wood frames were disguised as marble, malachite, and exotic wood. The texture craze spread to interior woodwork, walls, floors, and any other surface that could not escape the brush, sponge, twisted rag, or crumpled daily news. A fear of plain or smooth surfaces became as endemic a phobia in the 1980s and 1990s as the fear of uncluttered interior space, the "horror vacuui," experienced a century earlier.

MODERN CLASSIC REVIVAL

Instead of continuing with the quickened pace of innovation, the mid-century excitement subsided in the decades that followed. By the end of the psychedelic sixties, a good deal of furniture design seemed to take no direction in particular, but went in circles or vacillated between faux modern and bland traditional. The unthinkable occurred, and a new low was tested when, for the general population, bland traditional forms seemed to dominate. The designless and the colorless filled American family rooms as well as model homes, motel guest rooms, and office waiting rooms from coast to coast. Without the uninspired and readily identifiable color formulas, like the overworked mauve and gray cliche (Ken Charbonneau, head of color marketing for Benjamin Moore Paints called it "the mauving of America"), or its successor—the equally overused washed-out rose and teal—it would be challenging to even guess which decade it represented, based on furniture design. The monotony was broken only by the glossy pages of the good design-oriented periodicals that obviously never made it to the coffee tables of these rooms.

In the midst of the ubiquitous blandness, an almost ironic phenomenon began to gain momentum—a fifties revival appeared on the magazine pages, among a growing cult of urban collectors and dealers, and at big furniture companies. Herman Miller and Knoll reintroduced many of their great mid-century classics by Eames, Nelson, and Bertoia and increased production and marketing of other items that had never been discontinued; Cassina reintroduced earlier modern classics by Wright, Rietveld, and Mackintosh; Thonet offered the modern gamut from classic bentwood to Bauhaus tubular steel to contemporary adaptations; and more European and American companies followed.

The conclusion that might be drawn from the modern design revival at the end of the century (and the millennium) is that it is the best that we had come up with so far, or at least the last identifiable style worthy of serious study. A less optimistic possibility is that designers were temporarily out of ideas again. At the risk of sounding biased, this author would endorse the former. We as a society were not out of ideas, but the overwhelming majority was either disinterested in anything visual that was not moving on a screen, too aesthetically complacent to take risks, or under too much stress to care. There were talented furniture designers and exciting designs at the millennium's end, but for the moment they were only making rare appearances in the American home.

ALTERNATIVE STYLES

One striking alternative to the array of bland styles was called **Postmodernism**, characterized by playfulness and humor and a risk-taking approach to design. Its proponents, such as architect Michael Graves, were dissatisfied with modern architecture, especially in the International Style, which typically lacked color and wit. By bringing back color and ornament, often with historic references, the Postmodernists sought to add local content, metaphor, ambiguity, and interest, even if it appeared to be tongue-in-cheek. The eclectic, sometimes arbitrary, style was easily imitated, but its inventors usually delivered what they promised.

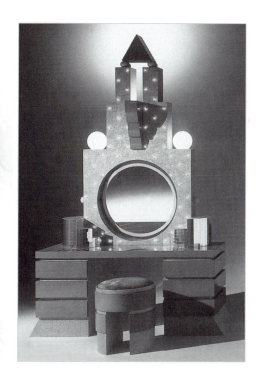

MEMPHIS PLAZA.
Designed by Michael Graves, 1981. Dressing table with six drawers and stool; in briar, lacquered wood, glass, mirrors, and brass; H 92-1/2, W 60-1/4, D 20-1/4. *(Courtesy of Memphis)*

In 1980 Ettore Sottsass, Jr., organized a radical design group in Milan, Italy, called Memphis, named after the Bob Dylan song *Memphis Blues* that was reportedly playing while the group was searching for a name. This Postmodernist group of architects and designers made outrageous, witty, and usually impractical furniture and other decorative arts in bold combinations of color and shape. Although Memphis (still active) has enjoyed relatively limited commercial success, its contribution to late twentieth-century design is significant. However, like its predecessors of alternative furniture, for the majority of its life, Memphis would be restricted to public display and art historical analysis rather than popular practical use.

MEMPHIS DUBLIN.
Designed in 1981 by Marco Zanini. Couch in plastic laminate, metal, and nonflammable synthetic fabric; W 72-3/4, D 30. *(Courtesy of Memphis)*

There were other relatively short-lived experiments in the later part of the century. In the 1970s and 1980s a phenomena called **high tech** could be identified as easily as Post-modern. Its focus was the structure, materials, and process of technology that had advanced so recently and so rapidly. It employed several devices, from a sleek and glossy futuristic appearance to a mundane and unself-conscious industrial look using products such as rubber flooring materials. In furniture, the use of utility shelving, or steel mesh in designs such as Shiro Kuramata's How High the Moon for Vitra in 1987 exemplify the style.

At the other extreme, various expressions of regionalism and craft revival influenced modern designers toward the end of the century. Architect Frank Gehry's experiments with laminated cardboard furniture turned to the use of bentwood strips resembling basket-weaving techniques. His line of woven furniture for Knoll, and Gaetano Pesce's coated felt Feltri chairs in 1987 are some of the most prominent craft revival designs.

DESIGNERS

In keeping with the spirit at mid-century, major furniture companies continued to hire consultant and/or staff designers. Many had been trained as architects, some as sculptors; all came with an understanding of new materials and the continual need for new forms. Many of the most innovative designs were considered to be for the contract market, but the more imaginative professionals and their clients recognized their suitability to residential inte-

rior design as well. Originality, color, and sometimes humor characterized the most prominent designs. And, as at mid-century, the designer's name was an important feature, even though most of the furniture was to be mass-produced. The following are some of the leading designers from the later part of the twentieth century.

Ron Arad (b. 1951, Israel)

Born in Tel Aviv, Arad studied at the Jerusalem Academy of Art from 1971 to 1973. He moved to London where he worked with Peter Cook at the Architectural Association until 1979. He started the design firm One Off in 1981. In 1985 Vitra produced his Well-Tempered Chair out of four pieces of springy tempered steel, which were folded and then bolted into place. Other furniture designs include the 1986 Rover Chair made from a salvaged automobile seat, and his Bookworm shelving for Kartell. He was active in London where he designed sculptural sheet metal furniture as well as wood furniture in the late 1980s, some of which was manufactured in Italy. His interior design work includes the Tel Aviv Opera House foyer in 1990. Arad's work has been shown at international exhibitions throughout Europe.

VITRA SCHIZZO.
Designed by Ron Arad in 1989. Molded plywood joined with steel tube; can be used as single chairs or combined to form a bench; H 35, W 1-1/2, D 22-3/4. *(Photo Hans Hansen, courtesy of Vitra International)*

Michele De Lucci (b. 1951, Italy)

Architect and designer, De Lucci is perhaps best known for his Memphis Postmodern design and other work in Milan, Italy. He studied architecture at the Universita di Firenze, where he also dabbled in film and other art forms. From 1975 to 1977 he taught architecture. Then in 1978 he settled in Milan where he met Ettore Sottsass and worked with him to create the first Memphis exhibit in 1981. He was a consultant designer for Olivetti and collaborated with Sottsass Associati on the design of over fifty European interiors. In addition to his colorful and playful Memphis furniture deigns in the 1980s, De Lucci also designed furniture for Acerbis and other Italian firms, lighting for Artemide, and plastic tableware. In 1984 he started his own studio, and in the early 1990s he founded a group of young international designers called Solid. His work has been shown in major international exhibits including the 1983 Milan Triennale, the first Memphis exhibit, and Mobili Italiani (1961 to 1991).

1978
Israeli Menachem Begin and Egyptian Anwar Sadat win Nobel Prize; disc drive for PC introduced by Apple Computer; Epson introduces dot-matrix printer for PCs; Gutenberg Bible sells for $2 million; first 'test-tube' baby; films *Grease, National Lampoon's Animal House, Coming Home, The Deer Hunter*; songs Bee Gees "Night Fever" and "Stayin' Alive," Village People "Macho Man" and "Y.M.C.A."

Died 1978
Charles Boyer (b. 1897), Giorgio De Chirico (b. 1888), Hubert Humphrey (b. 1911), Margaret Mead (b. 1901), Golda Meir (b. 1898), Norman Rockwell (b. 1894).

1979
Three Mile Island nuclear meltdown; Muslims overthrow Shah of Iran; Sandinistas take control of Nicaragua; Margaret Thatcher is first woman prime minister of Britain; Voyager I discovers Jupiter ring; Pittsburgh Steelers win third Super Bowl in a row; cellular phone; roller disco; *Evita* opens on Broadway; Chuck Berry serves a four-month prison term for income tax evasion; William Styron's *Sophie's Choice*; films *Alien, Apocalypse Now, The China Syndrome, Kramer vs. Kramer, Norma Rae*; songs, Gloria Gaynor "I Will Survive," and Rod Stewart "Do Ya Think I'm Sexy?"

Died 1979
Al Capp (b. 1909), Arthur Fiedler (b. 1894), Emmett Kelly (b. 1898), Nelson Rockefeller (b. 1908), Gio Ponti (b. 1891).

MEMPHIS LIDO.
Designed by Michele De Lucchi in 1982. Couch in wood, plastic laminate, and metal, upholstered in wool or cotton; H 35-1/2, W 59, D 37-1/2. *(Courtesy of Memphis)*

MEMPHIS CONTINENTAL.
Designed in 1984 by Michele de Lucchi. End table in plastic laminate; H 27-1/2, W 35-1/2. *(Courtesy of Memphis)*

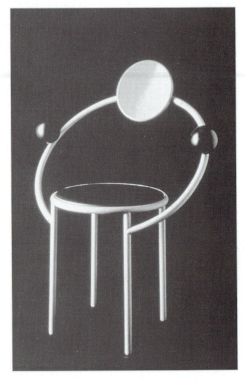

MEMPHIS FIRST.
Designed in 1983 by Michele De Lucci. Chair in metal and wood; W 23-1/4, H 35-1/2. *(Courtesy of Memphis)*

1980

Mount St. Helena volcanic eruption; Reagan elected president with 489 electoral votes; Polish Solidarity; Iraq invades Iran; Iran hostage crisis; WHO announces worldwide elimination of smallpox; fifty nations boycott Moscow Olympics protesting Russian invasion of Afghanistan; films *The Empire Strikes Back, Airplane!, Ordinary People*; songs, The Pretenders "Brass in Pocket," Blondie "Call Me," Lipps Inc. "Funky Town," and Captain and Tennille "Do That to Me One More Time."

Died 1980

Jimmy Durante (b. 1893), Erich Fromm (b. 1900), Alfred Hitchcock (b. 1899), John Lennon (b. 1940), Marshall McLuhan (b. 1911), Steve McQueen (b. 1930), Peter Sellers, (b. 1925), Barbara Stanwyck (b. 1907), Mae West (b. 1893).

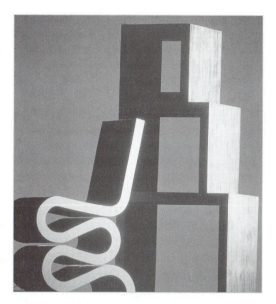

EASY EDGES WIGGLE TABLES AND CHAIR.
Designed by Frank O. Gehry, 1972–1992. Approximately fifty layers of corrugated cardboard with edges finished in hardboard. Tables H 19-1/2, 15-3/4, 20-1/2, or 24-3/4 square; chair H 32-1/4, W 14-1/4, D 24. *(Courtesy of Vitra International)*

Frank O. Gehry (b. 1930, Canada)

Born Frank Goldberg in Toronto, Frank Gehry studied architecture at the University of Southern California in Los Angeles from 1949 to 1951 and 1954 and then at Harvard Graduate School of Design from 1956 to 1957. He worked for Victor Gruen Associates in Los Angeles and for André Remondet in Paris before establishing his own architectural office in Los Angeles in 1962. Some of his many architectural commissions include the Vitra Design Museum at Weil am Rhein, Germany, the Disney Concert Hall in Los Angeles, and the American Cultural Center in Paris. His work is considered to be eccentric, and along with similar architecture of the 1970s, has been given names such as "ad hoc" or "punk" design. His Easy Edges epoxy-laminated cardboard chairs of 1971, originally produced by the Swiss firm Cheru Enterprises, are considered to exemplify "ad hoc" design and brought him international recognition. Gehry later designed a series of bentwood furniture for Knoll from 1989 to 1991. He is a Fellow of the American Institute of Architects and won the top American architecture award, the Pritzker Architecture Prize, in 1989.

VITRA EASY EDGES SIDE CHAIR AND DINING TABLE.
Designed by Frank O. Gehry, 1972–1992. Approximately fifty layers of corrugated cardboard with edges finished in hardboard. Chair H 32-1/4, W 14-1/4, D 21-1/2; table H 29, L 78-3/4, W 35-1/2. *(Courtesy of Vitra International)*

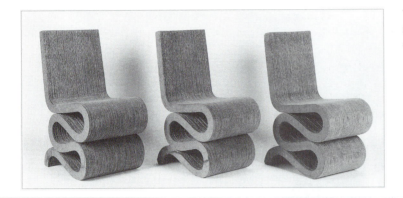

Three Frank Gehry Easy Edges laminated cardboard side chairs, early 1970s, W 15-1/4, H 33. *(Courtesy of Skinner, Inc.)*

1981
Iran releases the fifty-two hostages; President Reagan and James Brady are shot; AIDS identified; *Ramapithecus* more likely ancestor to orangutan than humans; IBM introduces DOS; Microsoft incorporates; MGM takes over United Artists; John Lennon and Yoko Ono win Grammy Award for *Double Fantasy*; Salman Rushdie's *Midnight's Children*; films *Raiders of the Lost Ark, On Golden Pond, An Officer and a Gentleman*; songs Depeche Mode "Just Can't Get Enough," Kim Carnes "Bette Davis Eyes," Rick Springfield "Jessie's Girl," Blondie "The Tide Is High."

Died 1981
Marcel Breuer (b. 1902), Moshe Dayan (b. 1915), William Holden (b. 1918), Natalie Wood (b. 1938).

1982
Vietnam War Memorial dedicated; first genetically engineered commercially produced insulin; Compaq makes IBM clone; NFL players strike for higher pay; EPCOT opens at Disney World; world title boxing reduced to twelve rounds; AIDS begins to devastate the gay world, dramatically affecting the creative fields; films *First Blood, Gandhi, Tootsie, Sophie's Choice*;

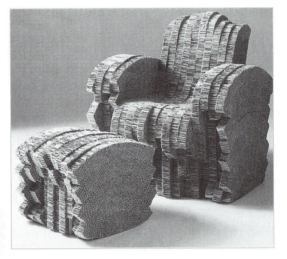

VITRA LITTLE BEAVER.
Designed by Frank O. Gehry, 1980–1987. Sculptural lounge chair and footstool of multilayers of bonded corrugated cardboard. Chair H 34-1/4, W 32, D 34; footstool H 16-1/4, W 17-1/2, D 22. *(Courtesy of Vitra International)*

Shiro Kuramata (1934–1991, Japan)

Kuramata studied woodworking and architecture at the Tokyo Municipal Polytechnic High School until 1953, and then studied design at the Kuwazawa Design Institute in Tokyo. After graduating in 1956, he worked in department store retail design. In 1965 he started his own practice, the Kuramata Design Studio, where he specialized in furniture and

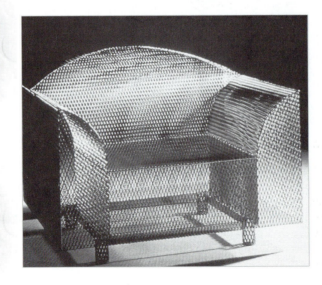

VITRA HOW HIGH THE MOON.
Designed by Shiro Kuramata, 1987. Sculptural chair has volume without mass, of nickel-plated expanded metal; H 29-1/2, W 37-1/2, D 33-1/2. *(Courtesy of Vitra International)*

interior design. His Furniture in an Irregular Form series in the 1970s brought him international acclaim. He continued to experiment with new materials and forms, and in 1986 designed his How High the Moon metal mesh chair. He won the Japanese Cultural Award for Design in 1981 and then became one of the Postmodern Memphis designers until 1983. His designs have been produced by both Japanese and European companies, such as Vitra and Cappellini, and his work has been shown in major international exhibits.

Vico Magistretti (b. 1920, Italy)

After studying architecture in Milan, Magistretti joined his father's studio in 1945. His initial interest in architecture and town planning after World War II expanded to include interiors and furniture design. Around 1960 he began to design consumer products, and he entered into a relationship with Cassina. As one of the first Italian designers to work with plastics, he designed furniture for Artimede. Also in the 1960s his clients included Asko, B&B Italia, De Paadova, Knoll, Stendig, and others. His work was widely published and exhibited. As one of the foremost industrial designers of the twentieth century, Magistretti has exhibited at most of the Milan Triennales, where he won a gold medal and grand prize. Other notable awards include two Conpasso d'Oro awards and a gold medal from the Society of Industrial Artists and Designers (SIAD). He served as a jury member at Triennales and taught as a guest professor in major universities throughout Europe and received an honorary fellowship at the Royal College of Art in London. As a leading Modernist, Magistretti advocates a union of usefulness and beauty that can withstand the pressures of a "throw-away" society.

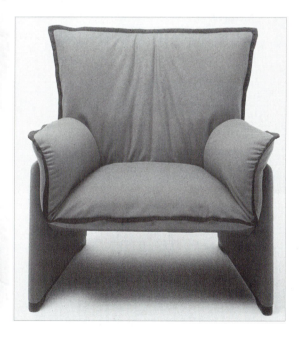

CASSINA PALMARIA.
Designed by Vico Magistretti.
Armchair with flexible backrest; single cushion seat, back, and arms; removable upholstery on tubular steel frame; H 36-1/2, W 40-1/2 D 36.
(Courtesy of Cassina)

Jorge Pensi (b. 1949, Argentina)

Pensi was born in Buenos Aires, where he later studied architecture. He was most active in Barcelona, and in 1977 became a Spanish citizen. He specialized in lighting and furniture design, also writing articles for the Spanish journal *On Diseño*. He won numerous awards for his classic cast-aluminum Toledo chair of 1986 made by Amat and marketed by Knoll. His 1989 *Orfila* chair was made by Thonet. One of Spain's leading designers, Pensi has been a design consultant throughout Europe, South America, and the United States.

1984
Reagan is re-elected president with 525 electoral votes; CD ROM; cellular radio; more than seventy U.S. banks fail; Ethiopian drought kills millions; 5-million-year-old human fossil ancestor found; DNA shows chimpanzees closer to humans than other apes; Michael Jackson wins eight Grammy Awards for album *Thriller*; films *Amadeus,*

Gaetano Pesce (b. 1939, Italy)

Pesce studied architecture and industrial design at the University of Venice from 1958 to 1965, while establishing his career. While in school, he worked as an independent film-maker and artist in Padua. His design focus was on Pop Art and kinetic and conceptual design movements. He joined the Anti-Design movement and other avant-garde groups. His 1965 publication *Manifesto on Elastic Architecture* illustrated the alienation between people and object by using distortion and exaggeration. He began to experiment with plastics in furniture in 1964 and his 1969 innovative plastic furniture was produced by B&B Italia. He also created quilt-draped furniture for Cassina. He continued to explore innovative, often humorous, design and exhibit. In the 1990s he designed a folding Umbrella Chair for Zerodisegno and the 543 Broadway Chair on spring-mounted feet for Bernini. His work has been shown in major museums and galleries worldwide, and he has had important one-man shows throughout Europe.

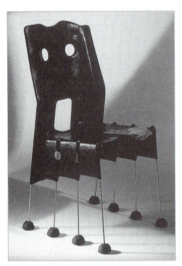

VITRA GREENE STREET.
Designed by Gaetano Pesce, 1984. Seat and back of black plastic with three cut-out holes; eight metal rod legs ending in plastic feet, resembling an insect; H 37-1/2, W 21. *(Courtesy of Vitra)*

ZERO U.S. UMBRELLA CHAIR.
Designed by Gaetano Pesce. Unique alternative to the folding chair, collapsible chair with gas spring movement; of anodized drawn aluminum; seat, handle, joints, and feet of polypropylene and nylon reinforced with glass fiber; H 31-7/8, closed DM 6-1/4; open W 17-3/4, D 19-1/4. *(Courtesy of Zero U.S.)*

Ghostbusters, Beverly Hills Cop, Killing Fields, Romancing the Stone, Places in the Heart, Gremlins; songs Madonna "Like a Virgin," Prince, "When Doves Cry;" Tina Turner "What's Love Got to Do with it?" Thompson Twins "Hold Me Now," Dali's Car album "The Waking Hour."

Died 1984
Ansel Adams (b. 1902), Richard Burton (b. 1925), Indira Gandhi (b. 1917), James Mason (b. 1909), Ethel Merman (b. 1908), Johnny Weissmuller (b. 1904).

1985
Evidence of black hole in space; catalytic converters mandatory in Switzerland; films *Back to the Future, Out of Africa*; songs Tears for Fears "Shout," Mr. Mister "Broken Wings," and Jan Hammer "Miami Vice Theme."

Died 1985
Laura Ashley (b. 1925), Yul Brynner (b. 1915), Marc Chagall (b. 1887), Rock Hudson (b. 1925), Roger Maris (b. 1934), Michael Redgrave (b. 1908), Phil Silvers (b. 1911), Orson Welles (b. 1915).

1986
Chernobyl nuclear reactor blows up; Marcos driven out of the Philippines; Voyager 2 discovers ten more moons around Uranus; old films colorized; films *Crocodile Dundee, Platoon, Children of a Lesser God*; songs Madonna "Papa Don't Preach," Bangles "Walk Like an Egyptian," Robert Palmer "Adicted to Love."

CASSINA FELTRI.
Designed by Gaetano Pesce, 1987. High armchair and low armchair made of thick wool felt; the seat fixed to the supporting frame with hempen strings; available in various colors of quilted fabric; H 38-1/2 or 51-1/4, W 28-3/4, D 26. *(Courtesy of Cassina)*

Peter Shire (b. 1947, United States)

Although Shire was based in Los Angeles, he also designed for Europeans such as the Murano glass firm Vistosi. His playful forms and color caught the attention of Ettore Sottsass, who invited Shire to join the Memphis project in 1981. Designs for Memphis in the 1980s included the Brazil, Peninsula, and Hollywood tables, Big Sur sofa, Peter sideboard, Bel Air armchair, Cahuenga and Laurel lamps, and Anchorage teapot. His geometric Postmodern Memphis furniture designs led to his design of a sixty-three-piece collection of Italian furniture and other furnishings in 1989.

MEMPHIS BEL AIR.
Designed by Peter Shire, 1982. Asymmetrical armchair with dramatic back of quarter circle; in wood with wool or cotton upholstery; H 49-1/4, W 45-1/4, D 43-1/4. *(Courtesy of Memphis)*

Died 1986
James Cagney (b. 1899), Cary Grant (b. 1904), Henry Moore (b. 1898), Georgia O'Keeffe (b. 1887), Ray Milland (b. 1905), Robert Preston (b. 1918).

Ettore Sottsass (b. 1917, Italy)

Born in Innsbruck, Ettore Sottsass's parents were Italian; the family moved to Turin in 1928 where he studied architecture at the Polytechnic school from 1934 to 1939. After the war he practiced architecture in Turin. In 1946 Sottsass moved to Milan and organized an important international abstract art exhibit, and in the following year showed a chair design at the Milan Triennale. During the 1950s he moved from Functionalism to Organic design using plywood, metal, and plastics, and he worked briefly for George Nelson in New York in 1956. In 1957 he collaborated with Olivetti as a consultant for designing products such as typewriters. Sottsass traveled in India in 1961 and produced ceramics. A pioneer of Postmodernism, he designed furniture for Poltronova in 1965. In 1980 he formed Sottsass Associati and in 1981 started the Memphis group, known for its design focus on popular culture and use of brilliant color.

MEMPHIS CASABLANCA.
Designed by Ettore Sottsass, 1981. Sideboard in plastic laminate with internal shelves; with protruding appendages in anthropomorphic gesture; H 90, W 59-1/2. (*Courtesy of Memphis*)

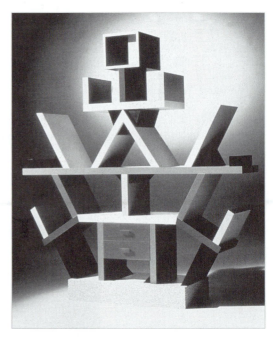

MEMPHIS CARLTON.
Designed by Ettore Sottsass, 1981. Room divider in multicolored plastic laminate; lower drawers, levels of shelves with diagonal sides; H 77-1/4, W 74-3/4, D 15-3/4. (*Courtesy of Memphis*)

1987
Apple Macintosh II and SE; Van Gogh's *Irises* sells for $49 million; $600 million fraud involving fake Dali paintings; Mozart notebook sells for $4 million; films *Dirty Dancing, Fatal Attraction, Lethal Weapon, Wall Street, The Last Emperor*; songs U2 "With or

Philippe Starck (b. 1949, France)

Considered to be one of the leading late-twentieth-century furniture designers, Starck studied interior architecture at L'Ecole Camondo in Paris. He served as artistic director at Pierre Cardin, where he designed a line of sixty-five pieces of furniture. In 1980 he opened his own company, Starck Products, to produce and distribute his designs, but other companies, such as Driade, Baleri Italia, and Vitra also distribute Starck furniture.

His style is sometimes called "new wave" and combines elements of high tech and postmodern. In addition to furniture, Starck has designed interiors for hotels, clubs, cafes, and even sailboats. He also designs products such as glassware and lighting. In 1981 he was chosen as one of five designers to furnish the private apartments of the French president.

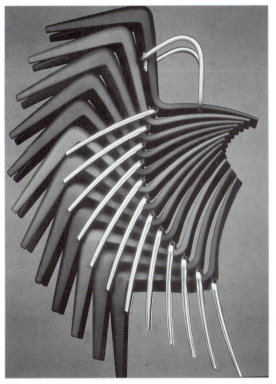

VITRA LOUIS 20.
Designed by Philippe Starck, 1991. Multipurpose stacking chair made of blow-molded polypropylene to achieve mass without weight; rear legs and arms of natural polished aluminum; recyclable, for indoor or outdoor use; H 33, W 23-1/2, D 23. *(Courtesy of Vitra International)*

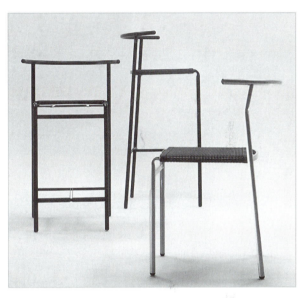

Starck Stools. *(Courtesy of ICF Group)*

Massimo Vignelli (b. 1931, Italy)

Born in Milan, Vignelli studied architecture at the Politecnico di Milano from 1950 to 1953 and from 1953 to 1957 at the Università di Architettura in Venice. He then taught at the Illinois Institute of Design in Chicago before returning to Milan to open a design firm with his wife—the Lella and Massimo Vignelli Office of Design and Architecture. He cofounded the international design firm Unimark International, moved to New York, and began designing for major companies such as Ford Motors, American Airlines, and Knoll. Their New York firm Vignelli Associates produced corporate identity programs for Xerox, Cinzano, and Bloomingdale's; book design for Chanticleer, Rizzoli, and Fodor Travel Guides; glass for Venini and Steuben; and furniture for Poltronova, Sunar, and of course, Memphis.

The Vignellis won numerous important prizes including a grand prize at the 1964 Milan Triennale, Premio Compasso d'Oro, Industrial Arts Award from the American Institute of Architects, and gold medal from the American Institute of Graphic Artists (AIGA). A retrospective of the Vignellis' work was shown worldwide in 1990.

1988
George Bush is elected president; Colombian drug war; crack cocaine popular in United States; cigarette smoking banned on short flights; U.S. student infects 6,000 military computers with a virus; Canadian/U.S. free trade agreement; McDonalds opens in Moscow; United States patents a genetically engineered mouse; films *Die Hard, Good Morning Vietnam, Rain Man;* songs Cheap Trick "The Flame," Bobby McFerrin "Don't Worry Be Happy," INXS "Need You Tonight," and The Pet Shop Boys and Dusty Springfield "What Have I Done to Deserve This?"

Died 1988
Trevor Howard (b. 1916), Louise Nevelson (b. 1900).

1989
Berlin Wall is torn down; U.S Savings & Loan $300 billion bailout; computer virus epidemic; Voyager 2 reaches Neptune; Time purchases Warner Communications; Richard Isay's seminal book, *Being Homosexual: Gay Men and Their Development;* films *Field of Dreams, Driving Miss Daisy, Dead Poets Society;* songs Gloria Estefan "Don't Wanna Lose You," Bette Midler "Wind Beneath My Wings," and Tracy Chapman "Fast Car."

Died 1989
Lucille Ball (b. 1911), Samuel Beckett (b. 1906), Salvador Dali (b 1904), Hirohito (b. 1901), Vladimir Horowitz (b. 1904), Ferdinand Marcos (b. 1917), Sugar Ray Robinson (b. 1921).

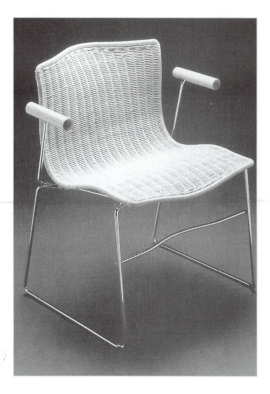

Rattan Handkerchief Chair designed by Massimo Vignelli. (*Courtesy of Knoll*)

CONTRACT VERSUS RESIDENTIAL

Technology has influenced work styles and lifestyles. For many people, the separation between home and office is becoming less rigid. Yet the perception of designers, manufacturers, dealers, and other people who work with and talk about furniture is that there are two disparate categories—contract and residential. **Contract furniture** is for the workplace and public places away from home; residential furniture, as the name denotes, is for the home. In other words, one is for places where people work, and the other is for places where people live. In the United States (more than in Europe) there is little crossover. To keep this segregation clear, even the styles differ.

A good deal of twentieth-century residential furniture has been, and still is, based on historic styles. Antiques and their reproductions are often suitable, especially for homes built in traditional historic styles, but they have been overused. Even as we cross the threshold of the millennium, it is no more surprising to see a room filled with uninspired eighteenth-century adaptations as it is to see state-of-the-art electronics perched on them. Most people have an uncanny capacity for accepting visual and cultural anomalies.

The creation of new forms with a conscious effort to avoid historic style and redundant ornament has found wider acceptance in the area of contract furniture than residential. Even in the early twentieth century, office furniture, though basically without style, was designed to be utilitarian. The attempt at function was a carryover from the mechanical inventions called patent furniture in the Victorian era, and it took precedence over style and decoration. After the Second World War, alert designers began to introduce inspired forms of truly functional furniture that even looked original. It was designed from the inside out, and it could be appreciated from the outside in. Plus, it could be mass-produced and marketed for huge populations of people in the workplace who suddenly needed furniture to accommodate new ways of doing business and better systems for organizing information. Inspired by what had formerly been perceived as a handful of prewar tubular steel Bauhaus prototypes and other eccentricities, it was the beginning of a revolution. By mid-century, with super-designers and thinkers like George Nelson, Charles and Ray

1990
Iraq occupies Kuwait; Van Gogh protrait *Dr. Gochet* sells for $82.5 million; Monet's *At the Moulin* sells for $78.1 million; rap music becomes popular; Cincinnati Contemporary Arts Center and its director are indicted for obscenity after Mapplethorpe exhibit; films *Presumed Innocent, Total Recall, Teenage Mutant Ninja Turtles, Dick Tracy*; songs Madonna "Vogue," Sinead O'Connor "Nothing Compares 2 U."

Died 1990
Leonard Bernstein (b. 1918), Greta Garbo (b. 1905), Ava Gardner (b. 1922), Rex Harrison (b. 1908).

1991
Soviet Union dissolves, seventy-four-year Communist reign ends; Persian Gulf War; European physicists sustain a nuclear fusion reaction; DOW Jones above 3,000; best film *Dances with Wolves*, top-grossing film *Terminator 2: Judgment Day*; songs Nirvana "Smells Like Teen Spirit," R.E.M. "Losing My Religion," Enigma album "MCMYC AD."

Died 1991
Miles Davis (b. 1926), Robert Motherwell (b. 1915), Gene Roddenberry (b. 1921), Dr. Seuss (b. 1904), Rufino Tamayo (b. 1899).

Eames, and many others, modern furniture was being reinvented. Then, in 1968 with the debut of the first open office system, with interchangeable components and flexibility, a revolution began.

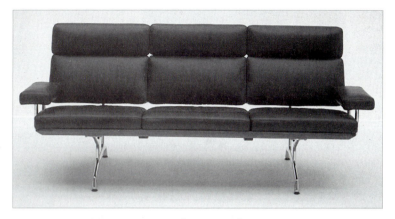

HERMAN MILLER 3-SEAT SOFA (SOFT PAD).
Designed by Charles and Ray Eames in 1984. Walnut frame and back, polished aluminum legs and arm supports, black leather upholstery; H 33, W 80, D 30.
(Photo Phil Schaftsma; courtesy of Herman Miller, Inc.)

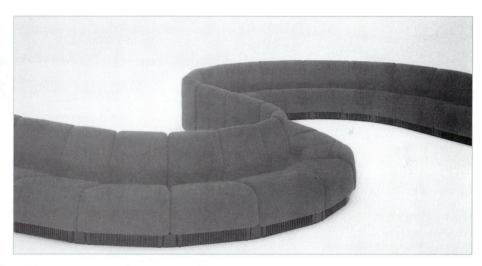

HERMAN MILLER MODULAR SEATING.
Designed by Don Chadwick, 1974. Fully upholstered molded foam modules with black molded base; modules link together in any curved or straight combination with two connectors. This design was selected by *Interior Design* as one of the forty-six most influential modern furnishings of the past fifty years; H 27, widest end W 27-28, D 30. *(Courtesy of Herman Miller, Inc.)*

However, with few exceptions, the American home still looked about the same as it did before this radical reconfiguring of the American office. As the millennium came to a close, neither the retail residential furniture industry nor the American home appeared to have changed significantly. Choices were available but not always utilized. Designers such as Mario Bellini, Giandomenico Belotti, Don Chadwick, Antonio Citterio, Stanley Jay Friedman, Frank Gehry, Michael Graves, Toshiyuki Kita, Alberto Meda, Jorge Pensi, Gaetano Pesce, Ettore Sottsass, Philippe Starck, Massimo Vignelli, Michael Wolk, and many others have provided innovative solutions. Yet their use does not appear to be nearly as widespread as the equally innovative designs at mid-century.

1992
Bill Clinton elected president; the number of divorces in the United States is 1.2 million, more than half the number of recorded marriages; official end to Cold War; Yugoslav Civil War spreads to Bosnia; Earth Summit held in Rio de Janeiro; United States, Canada, and Mexico sign NAFTA; Los Angeles riot after Rodney King verdict; best film *The Silence of the Lambs*, top-grossing film *Batman Returns*; songs U2 "One," Eric Clapton "Tears in Heaven," Whitney Houston "I Will Always Love You," Red Hot Chile Peppers "Under the Bridge," Luna album debut "Lunapark."

Died 1992
Isaac Asimov (b. 1920), Menachem Begin (b. 1913), Marlene Dietrich (b. 1901), Alex Haley (b. 1921), Anthony Perkins (b. 1932), Lawrence Welk (b. 1903).

1993
Israel and PLO sign Palestinian self-rule accord; GATT signed; NAFTA approved; World Trade Center bombed; cult compound in Waco, Texas, raided; Internet use grows exponentially; best film *Unforgiven*, top-grossing film *Jurassic Park*; films *Schindler's List, The Piano, Philadelphia, Six Degrees of Separation, In the Name of the Father*; songs Radiohead "Creep," UB40 "I Can't Help Falling in Love," and R.E.M. "Everybody Hurts."

Died 1993
Don Ameche (b. 1908), Arthur Ashe, Jr. (b. 1943), Anthony Burgess (b. 1917), Federico Fellini (b. 1920), Dizzy Gillespie (b. 1917), William Golding (b. 1911), Audrey Hepburn (b. 1929),

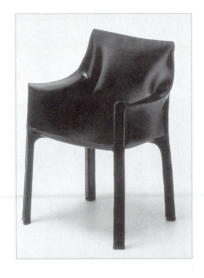

CASSINA CAB ARMCHAIR.
Designed by Mario Bellini, 1976. Armchair with steel frame, polyurethane padding, and zippered saddle leather cover stretched over the entire frame; H 32-1/4, W 23-5/8, D 20-1/2. *(Courtesy of Cassina)*

BRUETON INDUSTRIES BED MAXIMUS.
Designed by Stanley Jay Friedman, 1993. King, queen, or double bed with wood case construction head and footboard; concealed hinge at headboard for storage compartment; continuous wrapped leather frame; three-inch channel-quilted bedding. *(Courtesy of Brueton)*

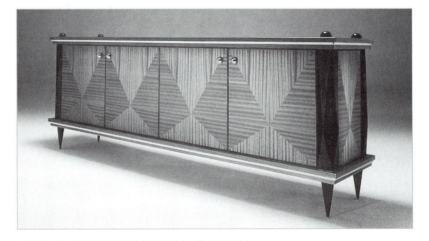

BRUETON INDUSTRIES MALAGA CREDENZA.
Designed by Stanley Jay Friedman, 1991. Art Deco style four-door credenza with geometric design veneer, metal trim, and exaggerated tapered legs; H 29, W 84, D 24. *(Courtesy of Brueton)*

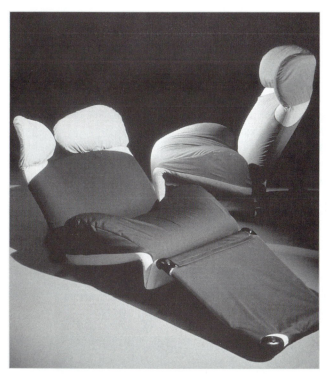

CASSINA WINK.
Designed by Toshiyuki Kita, circa 1980. Armchair that transforms into a lounge by adjusting the back and folding out the base; steel construction, and fabric or leather upholstery over foam; H 15 to 40-1/8, L 35-1/2 to 78-3/4, W 32-5/8. *(Courtesy of Cassina)*

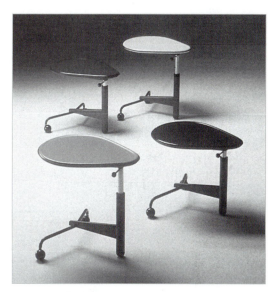

CASSINA KICK.
Designed by Toshiyuki Kita, circa 1983. Adjustable side table on casters, with dark grey enamel base and pneumatic gas cylinder for height adjustment; oval top in lacquered acrylic; H 15-3/4 to 20-5/8, W 19–5/8. *(Courtesy of Cassina)*

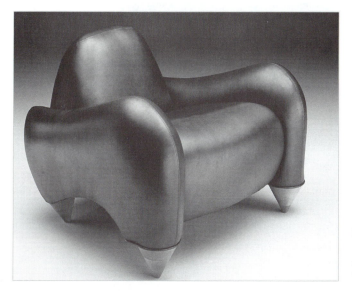

DESIGN AMERICA TUCKER CHAIR.
Designed by Michael Wolk, circa 1990. Sculptural overstuffed chair with wood-finish legs and a cartoonish character; H 28, W 38, D 33. *(Courtesy of Design America)*

Myrna Loy (b. 1905), Rudolf Nureyev (b. 1938), Albert Sabin (b. 1906), Frank Zappa (b. 1940).

In addition to an apparent underuse of good furniture design in the late twentieth century, what is really curious is the division between work place and living place. Don't people in fact live where they work and also work where they live? Most workers spend about one-third of their day, maybe a fourth of their lives, in the workplace. The majority of the other three-fourths is probably spent at home (including sleep time). Between the two, we live most of our lives with furniture. We eat on it, write on it, place things on it, work at it,

1994
The U.S. national debt tops four trillion dollars; Rwandan Tutsis murder more than a million Hutus; Nelson Mandela elected president of South Africa; O. J. Simpson arrested for double murder; U.S. Congress approves GATT; English Channel tunnel opens, connecting Britain and France; major league baseball players strike; films *Forrest Gump, Pulp Fiction, The Shawshank Redemption, Quiz Show, Nobody's Fool*; songs, The Cranberries "Zombie," R.E.M. "What's the Frequency Kenneth," and Green Day "Longview."

Died 1994
Cab Calloway (b. 1907), John Candy (b. 1951), Helen Hayes (b. 1900), Burt Lancaster (b. 1913), Henry Mancini (b. 1924), Richard Nixon (b. 1913), Jacqueline Kennedy Onassis (b. 1929), Thomas Philip (Tip) O'Neill (b. 1912), Linus Pauling (b. 1901).

1995
United States opens diplomatic relations with Vietnam; Israel and PLO reach a new agreement; Israeli Prime Minister Yitzhak Rabin slain by Jewish extremist at peace rally; Whitewater hearings; Bosnian Serbs seize U.S. hostages; O. J. Simpson is found not guilty of two murders; Republicans win control of Congress; U.S. population at 263 million with 3/4 urban and 1/4 rural; films *Babe, Braveheart, Leaving Las Vegas, The Usual Suspects, Dead Man Walking*; songs Alanis Morissette "You Oughta Know," Seal "Kiss from a Rose."

and store things in it and on it. We decorate with it, put our feet up on it, lose things in crevices, and watch the cat jump on it. We sit, lounge, play, make love, sleep, give birth, and die on it. Furniture is as much a part of our lives as any material object can be. Yet we casually retain professionals to design, build, and even select it for us. Most people give little thought to, or have little say in, the posture of their backs or the objects that they must look at daily. They are more particular about details when ordering a meal than of ordering a chair that will support a species-specific weak back and give comfort to a hyper-sedentary body for years, perhaps decades.

So why not have well-designed, functional, comfortable, durable, and good-looking furniture in both the workplace and the residence? And if it happens to have modern styling consistent with a modern lifestyle, why not use it at home as well? Mid-century and later designs perceived primarily as contract have become classics, and they have been attracting the attention of modernism collectors and of a growing number of people who have noticed the lack of choice in the residential marketplace. The successful designs are classics because they are still successful, and some may be able to soften the barrier between good contract and residential furniture.

DESIGN AMERICA ZEPHYR LOVE SEAT.
Designed by Dan Friedlander and Ken Gilliam, circa 1990. Overstuffed sofa with scalloped back, upholstered in fabric or Spinneybeck leather; H 35-1/4, W 64-1/2, D 41-3/4. *(Courtesy of Design America)*

ARTIFORT LAGOS.
Designed by Nel Verschuuren. Two-seat unupholstered unit; H 28, W 46, D 31-1/2. *(Courtesy of Artifort)*

Died 1995
Warren Burger (b. 1907), Howard Cosell (b. 1918), Eva Gabor (b. 1921), Jerry Garcia (b. 1942), Burl Ives (b. 1909), Mickey Mantle (b. 1931), Rollo May (b. 1909), Yitzhak Rabin (b. 1922), Ginger Rogers (b. 1911), Jonas Salk (b. 1914), John Cameron Swayze (b. 1906).

1996
Martian meteorite fragment contains evidence of life; Bill Clinton is elected to second term as U.S. president; U.S. Congress temporarily shuts down the federal government; Centennial Olympic Park bombing; Boris Yeltsin wins Russian election; South Africa adopts a democratic constitution; Ebola virus spreads in Zaire; mad cow disease hits Britain; gas attack in Tokyo subway; Oklahoma City bombing; New York Yankees win the World Series; weather-related natural disasters plague the United States; and *Twister* is the year's second best grossing film; films *The English Patient, Fargo, Jerry Maguire, The People vs. Larry Flynt, Shine, Sling Blade*; songs The Wallflowers "One Headlight," Garbage "Only Happy when It Rains," Eric Clapton "Change the World;" album Celine Dion "Falling Into You."

Died 1996
Spiro Agnew (b. 1918), George Burns (b. 1896), Claudette Colbert (b. 1905), Ella Fitzgerald (b. 1917), Gene Kelly (b. 1912), Timothy Leary (b. 1920), Marcello Mastroianni (b. 1924), François Mitterrand (b. 1916), Carl Sagan (b. 1934).

ZERO U.S. JESSICA.
Designed by Donato D'Urbino and Paolo Lomazzi, circa 1992. Chair frame and legs of a single curved steel wire, double back of translucent polypropylene, upholstered seat; H 31, W 18. *(Courtesy of Zero U.S.)*

BRUETON INDUSTRIES TUX HIGH AND LOW BACK.
Designed by Stanley Jay Friedman, 1993. Polished or satin tubular steel frame, leather or fabric upholstered seat and back, the back and back legs in the form of coattails extending to the floor; H 32 and 36, W 20, D 27 and 28. *(Courtesy of Brueton)*

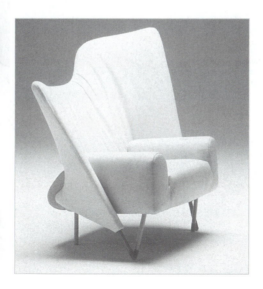

CASSINA TORSO.
Designed by Paolo Deganello, circa 1982. Armchair with steel structure, polyurethane foam, and polyester padding upholstered in fabric or leather, seat and back may be of different fabrics; H 45-5/8, W 43, D 35-1/2. *(Courtesy of Cassina)*

1997
DOW hits 8,000; septuplets born; British au pair on trial for murder; Hale-Bopp comet visible; Hong Kong is returned to China; Pathfinder sends back images of Mars; sheep are cloned; world's tallest buildings built in Kuala Lumpur; Tiger Woods wins Masters Tournament; films *As Good as It Gets*, *The Full Monty*, *Good Will Hunting*, *The Ice Storm*, *L.A. Confidential*, *Titanic*; song Shawn Colvin "Sunny Came Home;" albums Bob Dylan "Time Out of Mind," Radiohead "OK Computer."

Died 1997
Jacques Cousteau (b. 1910), Willem de Kooning (b. 1904), Deng Xiaoping (b. 1904), John Denver (b. 1943), Princess Diana (b. 1961), Allen Ginsberg (b. 1926), James A. Michener (b. 1907), Mother Teresa (b. 1910), James Stewart (b. 1908), Gianni Versace (b. 1946).

1998
India and Pakistan test nuclear weapons; Viagra marketed for male impotence; President Clinton accused in White House sex scandal with intern Monica Lewinsky; President Clinton outlines first balanced budget in thirty years; President Clinton impeached; 77-year-old Senator John Glenn, the first American to orbit the earth, returns to orbit in the space shuttle *Discovery*; *Titanic* becomes the highest-grossing film of all time, raking in more than $580 million domestically and wins a record-tying eleven Academy Awards; an estimated 76 million viewers watch the last

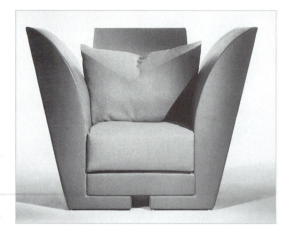

BRUETON INDUSTRIES SOPHIA CHAIR.
Designed by Stanley Jay Friedman, 1996. Dramatic lounge chair with winglike arms flaring outwards at back level; large loose pillow in contrasting colors. H 42, W 56, D 42. *(Courtesy of Brueton)*

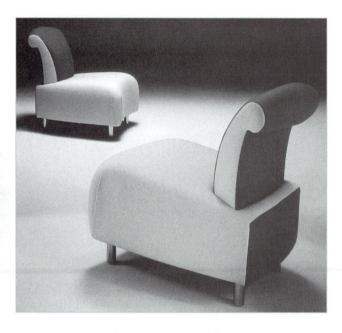

BRUETON INDUSTRIES MORPHEUS CHAIR.
Designed by Stanley Jay Friedman, 1993. Upholstered armless chair with scroll back in contrasting colors, tubular metal legs; H 28, W 22, D 28. *(Courtesy of Brueton)*

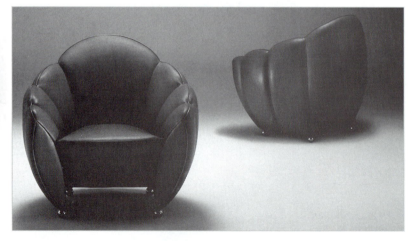

BRUETON INDUSTRIES CHAMPAGNE CHAIR.
Designed by Victor J. Dziekiewicz, 1992. Upholstered lounge chair shaped like an opening flower or a baseball glove, with eight sections, on round metal feet; named "champagne" because it was called the "bubble chair" during production; H 33, W 34, D 36. *(Courtesy of Brueton)*

Until that happens, the proliferation of innovative, functional, and good-looking contract furniture might offset its underuse in the residence at the end of the century and into the new millennium. As the modern revivals, new interpretations, and new solutions for contract furniture become more apparent in the home, a picture of late-twentieth-century furniture will come into focus. Then we will have come full circle in our travel through time.

Antiques and new designs each have a place in the contemporary interior. All historic and modern styles and their adaptations are accessible today, and all are used to varying degrees. Some antique reproductions and interpretations, such as by Baker, fill a need for both quality historic styles and fresh interpretations. We have seen remarkable solutions and spectacular failures in the history of furniture. Historically, until the very recent past, there have been relatively few functional, material, or technological innovations in furniture. Through the centuries, most of the time, only superficial style and ornament has changed.

BAKER SEMANIER.
Designed by Michael Vanderbyl. From the Arthetype Collection—contemporary adaptation of classic form; tall, elongated chest on tapered legs, seven drawers, of English sycamore veneer in diamond motif, in light marina finish; H 72, W 24, D 20. *(Courtesy of Baker)*

BAKER CHEST ON CHEST.
Designed by Michael Vanderbyl. From the Arthetype Collection—contemporary adaptation of classic form; top section with six drawers and bottom with seven, of English sycamore veneer in diamond motif, in presidio finish; H 65-3/4, W 34, D 20. *(Courtesy of Baker)*

Even the more radical innovations have limitations. Unless the human body changes, there will always be certain practical limitations in furniture design, which may help to explain the continual reference and return to the past for ideas. Change in the future may be based on factors other than outward appearances. Technology may replace the drawing board (perhaps it already has). Function and new materials or manufacturing methods may distinguish furniture more than another rearrangement of stylistic features. Yet a romantic yearning for roots (regardless of whose), an undeniable almost unconscious attachment to historic forms, and a human need for visual and tactile warmth and excitement will hold a place for antiques and even their reproductions.

The ultimate judge of style, taste, comfort, or need will not be a manufacturer or an arbitrary contemporary critic; it will be individuals in society over time. There have always been perceptions of good, bad, and ugly designs, and it is probably safe to say that there always will be. Every society, every period including the present, contributed to the history of furniture. The present is neither the best nor the worst; it is certainly not the most important. Good design can be found in the past and in the present—and in the future. We must first become familiar with its many appearances throughout history, if we are to recognize and use it today and prepare for tomorrow.

VITRA DOCUMENTA CHAIR.
Designed by Paolo Deganelllo. Steel tube base with aluminum; turquoise woven wicker seat; black leather-covered flexible back; yellow plastic leg; H 41-1/2, W 25-1/2, D 21-1/2. *(Courtesy of Vitra International)*

Summary

- A clear distinction between residential and contract furniture was made after mid-century.
- There was an explosion of creativity in both residential and contract furniture design during the postwar period.
- Later in the century, rather than explore new forms, technologies, and materials, there was a return to traditional styles, plus an array of styleless forms that filled the residential marketplace.
- Innovation, modern styling, and ergonomics was less pronounced in residential than contract furniture.
- A revival of mid-century classics influenced late twentieth-century contract furniture manufacturers, who also began to re-enter the residential market.
- All historic and modern styles are available today. This almost unlimited choice, while exciting, puts greater responsibility on professionals and their clients.

1999
Euro the new European currency; fear of Y2K bug; killing spree at Columbine High School; NATO attacks Serbia; Panama Canal is returned to Panama; Melissa and Chernobyl viruses afflict computers worldwide, forcing several large corporations to shut down their e-mail servers; Brian Jones (UK) and Bertrand Piccard (Switzerland) make the first nonstop, nonrefueled around-the-world balloon flight; Woodstock 99 kicks off in Rome; *Star Wars Episode I—The Phantom Menace* opens and breaks a string of box office records; films *Blair Witch Project, American Beauty, Three Kings, The Sixth Sense*; albums Luna "Days of Our Nights," Santana "Supernatural," Sting "Brand New Day."

Died 1999
Joe DiMaggio (b. 1914), King Hassan II (b. 1929), John F. Kennedy, Jr. (b. 1960), Stanley Kubrick (b. 1928), George C. Scott (b. 1927).

Chronology

Mid-1960s	Eero Arnio's experiments with plastic; Gyro, Globe, and Mushroom chairs.
1966	Roberto Sebastian Matta's Malite seating system.
1966	Pierre Paulin's Ribbon Chair for Artifort.
1967	Pierre Paulin's Tongue Chair for Artifort.
1972	Frank O. Gehry's Easy Edges laminated cardboard furniture.
1974	Don Chadwick's Modular Seating for Herman Miller.
1980	Ettore Sottsass, Jr., organizes Postmodernist Memphis design group in Milan, Italy.
1982	Philippe Starck's designs for Baleri Italia and Driades.
1984	Charles and Ray Eames last design for Herman Miller, Soft Pad Sofa.
1985	Ron Arad's Well Tempered Chair for Vitra.
1987	Gaetano Pesce's Feltri chairs for Cassina.
1987	Shiro Kuramata's How High the Moon chair for Vitra.
1990	Michael Wolk's Tucker Chair for Design America.
1990s	Stanley Jay Friedman's chairs for Brueton.
1991	Philippe Starck's Louis 20 Chair for Vitra.

Companies

Artifort (Netherlands)	Herman Miller (USA)
Baker (USA)	Knoll (USA)
Baleri Italia (Italy)	Memphis (Italy)
Breuton (USA)	Thonet (Austria/Germany)
Cassina (Italy)	Vitra (Germany)
Design America (USA)	

Designers

Frank O. Gehry (b. 1930, Canada) Architect-designer who became known for laminated cardboard Easy Edges furniture in the 1970s.

Geoffrey Harcourt (b. 1935, England) Designed sculptural furniture, such as the Cleopatra sofa, for Artifort in the 1960s.

Vico Magistretti (b. 1920, Italy) Architect-designer who designed for most of the major Italian firms and one of the first to experiment with plastics in furniture.

Sottsass, Ettore (b. 1917, Italy) Architect-designer and who started the Memphis group in 1981, with colorful designs based on popular culture.

Philippe Starck (b. 1949, France) Interior designer who became known for imaginative furniture designs in postmodern and high-tech style

Massimo Vignelli (b. 1931, Italy) Architect-designer instrumental in the Postmodern Memphis group.

Key Terms

contract furniture	high tech	postmodernism
faux finish	modular furniture	

Recommended Reading

Dormer, Peter. *Design Since 1945*. London: Thames and Hudson, 1993.

Fiell, Charlotte, and Peter Fiell. *Modern Furniture Classics Since 1945*. Washington D.C.: AIA Press, 1991.

Hiesinger, Kathryn B., and George H. Marcus. *Landmarks of Twentieth-Century Design: An Illustrated Handbook*. New York: Abbeville, 1993.

Nelson, George. *George Nelson on Design*. New York: Whitney Library of Design, 1979.

Piña, Leslie. *Furniture 2000: Modern Classics and New Designs in Production*. Atglen, Pa.: Schiffer, 1998.

Sembach, Klaus-Jürgen, et al. *Twentieth-Century Furniture Design*. Köln, Germany: Taschen, 1989.

Sparke, Penny. *Furniture: Twentieth-Century Design*. New York: E. P. Dutton, 1986.

GLOSSARY

Acanthus Ornamental motif based on the leaf of the Mediterranean plant *Acanthus spinous,* originally used on Corinthian columns in ancient Greece; later used on furniture with neoclassical features, especially in the Renaissance and again in the late eighteenth century.

Acorn turning Also called cup-and-cover, turned bulbous elements, especially on Elizabethan and Jacobean table and chair legs.

Aesthetic movement Late nineteenth-century movement encompassing all of the arts from architecture to painting, characterized by an emphasis on aesthetics and a strong Japanese design component; it bridged Victorian historic with later modern styles such as Art Nouveau and the Vienna Secession.

Alcove bed Eighteenth and early nineteenth-century French bed highly decorated on one side only, because it was meant to be placed in an alcove.

Alder Pale brown European and American hardwood that gets a darker golden brown patina; American red alder is commonly used to make solid wood furniture, especially on the West Coast.

Amboyna wood Named for the Moluccan island of Amboina, a light red to golden brown Asian hardwood with a curly grain, popular in French Rococo and later Art Deco furniture.

Ambry Wall niche enclosed by doors; storage furniture preceding the cupboard.

Anthemion A stylized honeysuckle motif derived from ancient Greek art, used on neoclassical furniture of the late eighteenth and early nineteenth centuries.

Antique Term used in the eighteenth century to describe ancient Greek or Roman art; U. S. Customs term for a decorative art object at least 100 years old; loosely describes any period piece, even if from a much more recent date.

Antique nail Brass nail with a domed head.

Applique Detail or ornament attached to a surface such as furniture.

Apron Decorative or plain board placed perpendicular to the bottom of a horizontal structure, such as a shelf; often used to conceal the underside of drawers, tabletops, etc.

Arabesque Intricate decorative scroll and leaf pattern derived from Spanish-Islamic culture and used on flat surfaces in the West beginning in the sixteenth century.

Arcading Decorative motif of a series of arches on columns or pilasters, derived from classical architecture and later used on medieval furniture.

Arch Roman invention applied to Greek architecture used to frame an opening and sometimes spanning considerable distance, usually curved, later used on furniture.

Architrave In classical architecture, the lower portion of the entablature, resting on the column.

Ark Term for coffer or chest with a domed or hipped lid in the Middle Ages.

Armchair Chair with arms; originally one and later two used at the ends of a dining table.

Armoire Wardrobe or upright cupboard, sometimes with interior shelves behind doors, generally without drawers below the cupboard.

Art Deco Term coined in the 1960s for the modern style characterizing the L'Exposition des Arts Décoratifs et Industriels Modernes held in Paris in 1925.

Art furniture Furniture in Anglo-Japanese style, often with an ebonized finish, or an interpretation of Gothic, popular from the 1860s through 1880s, and associated with the Aesthetic Movement in England and the United States.

Art Moderne French "modern art" style of the 1910s and 1920s, especially in decorative arts and furniture, using stylized and geometric forms but primarily handicraft manufacturing techniques; inspiration for American industrial design style called streamlining, later grouped under the broader term Art Deco.

Art Nouveau French "new art" style from 1890 to before the First World War, characterized by organic forms and decoration—tendrils, female with flowing hair, and other stylized curvilinear nature motifs. The style was most successful for glassmaking, but some furniture was produced.

Art pottery Term used for a movement within the Arts and Crafts and Aesthetic movements and a type of factory-produced yet finely crafted pottery known for its high aesthetic standards, popular in the late nineteenth and early twentieth centuries especially in Ohio and other areas east of the Mississippi.

Arts and Crafts movement Primarily British late nineteenth-century social, philosophical, and political craft revival movement led by John Ruskin and William Morris, and American turn-of-the-century version emphasizing Craftsman oak furniture and art pottery.

Ash Pale hardwood of white to yellow, sometimes with brown or black markings, strong and flexible and often used for bentwood.

Astragal A half-round or beaded molding used to conceal joints on the edges of case pieces; glazing bars on glass-fronted case pieces.

Backstool Medieval stool with three legs, one of which extend up to form a crude back; later refers to a four-legged chair without arms; term used by Chippendale for a side chair, usually with an upholstered back.

Bail handle, drop handle Hardware comprised of a metal loop attached at both ends to small knobs that hang against the drawer so it can be easily grasped and pulled.

Ball-and-claw foot Carved foot in the shape of a dragon foot with claws clutching a ball, introduced on Queen Anne and popular on Chippendale furniture.

Ball foot Turned foot of rounded or ball form.

Balloon-back chair Nineteenth-century Rococo Revival chair with rounded wood frame back, resembling the shape of a hot-air balloon, usually without upholstery as in the Louis XV original.

Baluster (banister) Turned or carved upright post or pillar used in staircases; in furniture it is also used split and applied as decoration.

Bamboo Hollow woody stem of tropical grasses used to make furniture in the East, or imitated in wood in the eighteenth and nineteenth centuries.

Banderole Narrow scroll, usually bearing an inscription.

Banding Narrow strip of wood used as decorative inlay.

Bandy leg Term for cabriole leg, used in America.

Banquette Long, low upholstered stool, French Baroque form.

Barley-sugar twist Type of wood turning with a spiral shape.

Baroque Style of architecture, art, and decoration characterized by drama, large scale, and bold detail; developed during the late Italian Renaissance.

Bauhaus (1919–1931) German school of art and design with strong belief in unity of the arts; founded by Walter Gropius and led by him and other modern architects of the International Style. Although it didn't actually realize the goal of mass production, Bauhaus style is equated with radical modernism, functionalism, tubular steel furniture, and mass production.

Bed of estate In the Middle Ages and Renaissance, an elaborate canopied bed used by high-ranking individuals, often to receive visitors.

Bead Slender wood molding of rounded form used on case pieces, such as around drawers, often resembling a string of beads.

Bedstead Frame of a bed used to hold the mattress and textiles.

Beech Hardwood of very light brown color, lightweight, used for bentwood and painted or gilded furniture in Europe and America.

Bellflower Decorative classical motif of bell-shaped flower used during the Federal period.

Bend Curved runner of a rocking chair.

Bentwood Steam-treated solid wood framing part used especially for Windsor chairs and a variety of forms by Thonet; also bent laminated wood in the nineteenth century by Belter and molded plywood by Eames and other twentieth-century designers.

Bergère French Rococo fully upholstered chair similar to a low wing chair, popular in modern reproductions and variations.

Bevel Chamfer or cutting away of the edge where two plain surfaces meet.

Biedermeier Design based on classicist principles, popular in Germany and Austria for most of the first half of the nineteenth century; the furniture uses classical form and ornament and primarily light-colored woods.

Binding Narrow trim used to strengthen and ornament the edges of draperies and other textiles.

Biomorphic Free-form organic shape, also called "amoeboid," typical of 1950's two- and three-dimensional design.

Birch Hardwood of pale yellow color used for solid and plywood pieces in both Europe and America; popular for Scandinavian Modern furniture.

Bird's-eye maple Hardwood popular as a decorative veneer in late eighteenth and nineteenth century American furniture; distinctly figured with brownish "eyes" on yellowish maple.

Birdcage support Mechanical device connecting the tilt top to the pedestal base of eighteenth-century table.

Black rosewood Brownish-black Brazilian wood from the species *Dalbergia nigra.*

Blind door Solid door on a case piece that conceals the contents.

Block foot Cube-shaped foot at the end of a Marlborough leg.

Blockfront Popular feature of eighteenth-century New England case pieces, especially Townsend and Goddard's

Newport Chippendale furniture; the front is formed by two convex "blocked" shapes on each side and a concave center, like an angular reversed serpentine form.

Bolster Long cylindrical cushion or pillow, popular on Empire sofas.

Bolster top Crest rail of a chair carved in the shape of a narrow bolster cushion, popular on "fancy" chairs of the Federal period.

Bombé Convex swell of the sides on a case piece.

Bonnet top Covered scroll pediment extending back to cover the top of a case piece, especially American Chippendale.

Boss Oval or circular ornament used to cover a joint in moldings.

Boston rocker New England rocking chair with a seat that curved down in front and up at the back, popular from about 1840 on.

Boulle work Ornate patterns of marquetry using tortoise shell and metals, introduced by André Charles Boulle under Louis XIV and imitated through the nineteenth century.

Bowed Convex curved form of case pieces, such as dressers and commodes, especially in the late eighteenth century.

Boxwood Hardwood of pale yellow color and fine texture, popular in decorative inlay on late eighteenth-century neoclassical furniture.

Bracket Bracing and strengthening device with one part fixed to a vertical surface and the other attached at the top at a right angle.

Bracket foot Used on case pieces requiring extra support, the foot is in the form of a bracket and is a continuous piece from the body.

Brads Small nails without heads.

Braid Decorative woven band to trim or outline textiles.

Brasses Term for hardware such as drawer pulls and keyhole covers.

Breakfast table Table with two hinged flaps and an enclosed lower shelf, like a small elaborate Pembroke table, popular in England and America in the eighteenth century.

Breakfront Case piece popular in the eighteenth century with a projecting center portion (opposite of blockfront).

Brewster chair American Jacobean chair of turned spindles at the back, under the arms, and under the plank or rush seat.

Buckram Coarse two-ply open-weave linen stiffened with gum or paste.

Buffet General term for serving table or cupboard used for serving meals; tiered and used to display valuables in the Middle Ages.

Built-in Furniture that is permanently built into a structure, such as a wall, rather than freestanding. Because it takes up no apparent floor space, leaves no surfaces to collect dirt, and is extremely functional and efficient, built-in storage was developed and used by the Shakers.

Bun foot Turned foot in the shape of a squashed or compressed ball.

Bureau plat Large rectangular writing table and three wide drawers, used in France since the seventeenth century.

Bureau table Desk with drawers and a fall-front lid that covered a storage area, used in Britain from the late seventeenth century.

Burl (burr) Decorative wood from a growth on a tree, with extraordinary figuring sometimes resembling tortoise shell, and usually used for veneer.

Butterfly table American variant of the gateleg in the late seventeenth and early eighteenth century in which a swing leg without a lower stretcher is used in place of the gate.

Butt joint Square ends of two planks meet head to head, or one end meets the side of the other.

Cabinetmaker Specialized woodworker who builds furniture.

Cabriole leg Slightly S-curved form, narrowing at the point just above a foot, commonly used on high-style eighteenth-century furniture.

Cabochon Oval or round convex or concave decoration.

Camelback sofa Sofa with serpentine top popular in eighteenth-century England and America.

Camp bed Portable bedstead with a light folding frame.

Canapé French upholstered settee or sofa.

Candle screen Small adjustable table screen used in the eighteenth century.

Candle slide Retractable wooded support for a candle on desks and bookcases.

Candlestand Portable stand to hold a candle or lamp, also called a torchère.

Cane Strips of rattan or similar grass, used to weave seats and backs, originally from India, popular in England and Holland from the seventeenth century, and became widespread from the nineteenth century on.

Canopy Ornamental covering above an altar, niche, or bed; framed covering supporting the textiles over a bed.

Cantilever Revolutionary architectural principle applied especially to tubular steel furniture, which allows horizontal members supported only at one end to project, without the usual vertical (leg) supports.

Capital Top portion of a column.

Caquetoire Light "conversation" chair form popular in the French Renaissance with straight back, curved arms, and a flat seat made wider in the front than the back to accommodate ladies' wide skirts.

Carcase Body of a piece of furniture to be covered with veneer or other material.

Card rack Small hanging rack for holding letters or cards.

Card table Square table with folding top for easy storage, popular in the eighteenth century.

Cartouche Ornamental form of unrolled scroll or shield shape, enclosing a plain surface.

Carver chair Similar to the seventeenth-century American Jacobean Brewster chair but less elaborate because decorative turned spindles were only used for the back; named for John Carver, first governor of Plymouth Colony.

Caryatid Winged nude female figure used as a support on neoclassical furniture.

Case piece Furniture form used for storage or display; chests, bureaus, bookcases, etc.

Cassapanca Large chest with arms and a back, used especially in Florence during the Renaissance.

Cassone Italian Renaissance chest with a hinged top, often richly decorated with painting and/or carving.

Castor Small wheel with a swivel attached to the foot or base for easy portability.

Cedar One of several fragrant and generally insect-resistant softwoods or hardwoods used to make boxes and storage chests.

Cellarette, cellaret Small chest usually lined with metal and used as a wine cooler, or unlined and used to store wine or liquor bottles, especially popular in Britain and the United States in the eighteenth and nineteenth centuries.

Chair of estate Chair used only by the highest ranking person of the household in medieval times. The word *chairman* is derived from this.

Chair table Armchair with a large round or rectangular back attached so it could be converted to a table, used in the Middle Ages.

Chaise lounge Form of daybed, literally "long chair" in French.

Chamfer, champfer Corner that is cut away to form a narrow flat surface or bevel.

Channeling Depression or groove running along a surface.

Cherry Hardwood that ages to a deep reddish brown and used for fine furniture.

Cheval glass Full-length mirror mounted between two uprights on pins so it can be tilted.

Chevron Pattern shaped like a V, found especially on Art Deco furniture.

China shelf Open hanging shelf for displaying china, often with latticework sides.

Chinoiserie Western art form using Chinese or other oriental decorative motifs.

Chintz Cotton cloth decorated with printed designs and a glazed finish to give it a sheen and slight stiffness.

Chip carving Simple form of carving by chipping out the pattern, especially on a panel on medieval through seventeenth-century furniture.

Circular front Rounded or bowed front, usually refers to a case piece or table.

Cistern Open wine cooler.

Club foot Type of Dutch foot used on a cabriole leg in England and America in the eighteenth century, characterized by a flat circular or ovoid bottom.

Cockbeading Thin molding along a drawer edge to protect the veneer from damage.

Coffer Chest used especially in the Middle Ages for storage and transport, with domed or hipped lid to shed water.

Comb Top rail of a Windsor chair.

Commode Chest of drawers on legs, of various forms, especially popular in the French Rococo; bedroom or night commodes were night tables or pot cupboards.

Console table Table fixed to a wall and supported on one or two front legs.

Contract furniture Furniture designed and made specifically for the workplace and other public places. It is marketed to the trade, especially designers who often specify large quantities, and it is usually not available through retail stores.

Cornice Horizontal molding that projects from the top of case pieces; uppermost portion of an entablature.

Cornucopia Decorative motif of a horn of plenty overflowing with fruit and flowers, especially popular in American "fancy furniture" of the Federal period.

Court cupboard Open two-tiered cupboard with elaborate carving, used for displaying plate, popular in seventeenth-century England and the American colonies.

Cove Simple concave molding profile, used on cornices of case pieces.

Craftsman American version of British Arts and Crafts movement led by Gustav Stickley with his oak furniture and magazine *The Craftsman*.

Credence Any small table used during meals, especially in the Tudor and Elizabethan periods.

Credenza Serving table over a cupboard, used in the Italian Renaissance.

Crest rail Top rail of chair or sofa, often carved.

Cross banding Narrow strips of veneer with the grain going perpendicular to the adjacent piece of wood or veneer.

Crossrail Horizontal bar in a chair back.

Crystal Palace Huge iron and glass building that housed the Great Exhibition of London in 1851, made from prefabricated parts and considered the first truly modern building, in contrast to its contents of machine-made historic ornamentation commonly equated with the epitome of tasteless Victorian art.

Cup-and-cover Turned member shaped like a chalice with a domed lid, often heavily carved, used as legs and other supports on Elizabethan and Jacobean furniture.

Cupboard Storage or case piece with shelves; some or all can be enclosed by doors.

Curly maple Unusual wavy grain pattern in maple, also called tiger maple.

Curule chair Chair with X-shaped base and curved legs, named after the Roman magistrate or curule.

Cyma curve Of double or compound curvature.

Damask Textile with a woven figure, often a floral motif.

Deal Fir or pine wood.

Dentils Rectangular equally spaced blocks, usually decorating a cornice.

De Stijl (1917–1931) Dutch avant-garde journal and organization of modern artists who sought to reduce forms and color to basic principles; they were anti-curve, anti-representation, and anti-sentiment; Gerrit Rietveld applied the principles to furniture.

Deutcher Werkbund (1907–1934) German organization founded by Hermann Muthesius (1861–1927) that sought to restore dignity to labor, bridge the gap between art and industry, and create a national style; it was in favor of mass production to improve German consumer goods and was led by influential members and leaders of the Bauhaus.

Diamond cut Bevelled edge on glass.

Diaper Surface decoration of regular repeats, often forming a diagonal pattern.

Dimity Thin cotton fabric woven with a stripe or check of heavier yarn.

Dovetail Wedge-shaped joint used in a series at right angles to each other, especially in drawer construction; machine cut are regular, while hand cut show variations.

Dowel Round pin fitted into holes of two adjacent pieces to prevent slippage.

Drake foot Three- or four-toed foot with prominent ribs on its surface, popular on mid-eighteenth-century British and American furniture.

Draw table Table with flat leaf or leaves that extend from beneath the tabletop to extend its size.

Dresser Medieval variant of the buffet (also *dressoir*), used to prepare or dress food; modern bedroom chest of drawers.

Drop-leaf table Table with leaves hinged to the top that can open or close to make the table surface larger.

Drop pendant, pendant finial Finial that points downward, used on aprons especially in the late seventeenth and early eighteenth centuries

Dustboard Thin piece of wood separating the drawers of a chest, to prevent dust from entering a drawer and to prevent contents from catching on the drawer above.

Ear Extension of the crest rail on a chair, especially in Chippendale style.

Easy chair Upholstered winged armchair with a high back.

Ebéniste Originally referring to French craftsmen who worked with ebony, the term was used for other highly skilled cabinetmakers, especially those working with marquetry and veneer in the eighteenth century.

Ebonized Black-stained wood resembling ebony.

Ebony Tropical hardwood with a dense black color, used mostly for decorative inlay.

Egg and dart Molding used in classical architecture and Georgian furniture in which an egg shape alternates with a dart shape.

Eglomisé Painting or gilding on the reverse side of glass panels.

Elbow chair Armchair with open arms and padded rests.

Elizabethan English Renaissance style during the reign of Queen Elizabeth.

Empire style French neoclassical style, named after the Napoleonic Empire and characterized by its sculptural classical and Egyptian motifs; American Empire style followed similar lines, but made greater use of mahogany.

Entablature In classical architecture, between the top of the column and the eaves.

Ergonomics The science of human health, safety, and comfort in relation to the environment. The focus of late twentieth-century contract furniture has been to provide seating support and comfort and to prevent wrist damage and glare for workers sitting in front of computers.

Escritoire Writing desk or bureau.

Escutcheon Decorative metal keyhole plate that also protects surrounding veneer.

Etagère Display piece with tiered shelves on slender supports, doors or drawers below, and sometimes a mirrored back.

Faldstool Portable folding seat, similar to a camp stool.

Fancy furniture Light, mobile, decorative furniture in America, usually based on Sheraton designs and ornamented with paint, gilding, or stencils.

Farthingale chair Low, armless, upholstered chair with a wide seat to accommodate the wide farthingale skirts worn by fashionable women in the early seventeenth century.

Fauteuil Upholstered armchair with open sides, originally French.

Faux finish Method of painting the surface of furniture or other interior architectural feature to resemble a different material, such as an exotic wood grain or stone. (*See* marbling.)

Festoon Garland of flowers or fruit or swag motif, used on baroque and neoclassical furniture.

Fiberglass Material of fine glass filaments embedded in resins, used to make molded seating and other furniture components.

Fiddleback Figured veneer resembling finely marked sycamore used in violin-backs; also a violin-shaped splat in Chippendale-style chairs.

Fillet Narrow flat molding or area raised or sunk between larger moldings or areas; narrow part of a column between the flutes.

Finial Decorative vertical ornament at the topmost part, or at the intersection of cross stretchers.

Floor cloth Canvas floor covering, often painted to look like marble or woven carpet, or decorated with stencilled patterns.

Fluting Shallow vertical channels or grooves in regular parallel stripes mainly used to decorate columns or legs, especially on neoclassical furniture.

Folding doors Hinged double doors with overlapping edges.

Folio slide Retractable slide for folios and large books.

Foot Ending of a leg, where it meets the floor, often distinguishable from the rest of the leg by its design and/or materials.

Form Medieval seat with legs and no back, large enough to accommodate two or more persons (modern bench).

Free-form Shape with an irregular contour, used in nonrepresentational art and industrial design, especially at mid-twentieth century.

French polish Clear furniture finish introduced in the eighteenth century.

French provincial Seventeenth- to twentieth-century styles of French furniture found in the provinces; less ornamented and of fewer forms than high-style furniture, modeled especially after Rococo style.

Fret table Tea table with a pierced trellis gallery.

Fretwork Open or relief carving in a repetitive geometric pattern, often resembling a lattice.

Frieze Portion above a capital, or the horizontal section below a tabletop, often decorated with carving, inlay, or paint.

Frieze drawer Drawer in the frieze of a table.

Functionalism Early twentieth-century design movement advocating the emphasis on utility and function and the elimination of ornament.

Gadrooning Decorative carved motif usually used as a molding, of convex form resembling short reeding.

Gallery Small fencelike border around a tabletop or case piece.

Gateleg Hinged leg that opens outward to support a tabletop; popular in the sixteenth and seventeenth centuries, especially with turned legs and stretchers.

Georgian Era of the three King Georges, 1714–1820.

Gesso Plaster mixture used to make molded relief decorations, then applied to wood or other surface and painted or gilded.

Gilding Gold (gilt) surface treatment to give the appearance of solid or thicker gold, used as a finish or decoration.

Gimp Flat woven trimming of silk, wool, or other cord to cover upholstery nails on seating pieces.

Girandole Branched candle holder or wall candle bracket, often attached to a mirror, popular in the eighteenth century.

Glasgow School Art school where Charles Rennie Mackintosh and the "Glasgow Four" studied and developed the style of modern applied arts that they became known for; Mackintosh designed the new building, considered to be his architectural masterpiece.

Glastonbury chair Late Tudor folding X-frame chair with arms connecting the crest rail to the seat front.

Glazed door Glass-fronted door used on a case piece in order to display its contents.

Gold lacquer Varnish simulating a gilt finish.

Gold leaf Extremely thin sheets of pure gold used in gilding.

Gondola chair Neoclassical-style chair with a deep concave back and stiles that curve continuously forward and down to the seat rail; introduced in France about 1760 and popular in Europe and America for nearly a century.

Gothic Medieval period noted for elaborate cathedral architecture with stone tracery; refers to Gothic-style decorative motifs interpreted by Chippendale and later in the nineteenth century as revivals.

Griffin Mythological creature with body of a lion and head and wings of an eagle, popular decoration on neoclassical furniture.

Grotesque A mythological or imaginative hybrid of human with animal or plant form.

Guild Medieval trade association based on apprenticeship and mutually agreed upon control of standards to protect the craft and its members.

Guilloche Popular neoclassical (especially Regency) decorative motif of two bands of ribbons intertwined around a row of bosses; originally an ancient Greek architectural ornament.

Hadley chest Early American rectangular chest on feet, usually with a drawer, decorated with incised or chip carving.

Haircloth Durable fabric usually made of horse hair, used by Chippendale.

Harewood Sycamore dyed a grayish brown.

Hickory Strong flexible wood used to make American Windsor chairs and Adirondack furniture.

Highboy American furniture form of a stand with drawers supporting a taller chest of drawers, usually with a cornice or pediment, like a British chest-on-stand or tallboy.

High style Usually found and used in the palaces or cities where the style originated or was fashionable; normally more elaborate than its subsequent provincial styles.

High tech Style that uses the structure, materials, and/or process of technology; its manifestations range from sleek and glossy or mundane and industrial.

Horse Adjustable rear strut engaging a ratchet, designed to support a hinged flap.

Husk Drop or pendant ornament used in eighteenth-century woodwork; neoclassical motif derived from the ancient Greek ear of wheat.

Hutch Chest or case piece with a series of shelves above a cupboard base.

Incised Ornament cut into or engraved (opposite of relief).

India chair Chair incorporating "Chinese" latticework on the back or arms.

India paper Hand-painted oriental wallpaper.

Inlay Decorative technique of removing small areas of wood and replacing them with another color wood or other material. (Different from marquetry, which is more of an "onlay.")

Inscrolling foot Also called a knurl foot, a variation of the scroll, but it curves inward and back on itself.

Intarsia Inlay of colored woods, placed into a cut-out space of the same shape, especially popular in the Italian Renaissance.

International style Modern architectural style developed at the Bauhaus and brought to the United States when its members fled Nazi Germany; characterized by boxy form, bands of glass windows, flat roofs, and use of unadorned steel and concrete for economical as well as so-called aesthetic reasons.

Jacobean Seventeenth-century period and style of James I, immediately following Elizabethan.

Japanned Finish simulating lacquer, also used by Chippendale to refer to genuine oriental lacquer. Black followed by red were the colors used most.

Japonisme Late nineteenth-century fashion in Great Britain and America for things of Japanese make or inspired by Japanese design.

Joinery Craft of working with wood and connecting or joining parts together.

***Kas*, kast** Large wardrobe developed by the Dutch in the seventeenth century, usually elaborately carved and decorated, originally of shelves and later with shelves and drawers.

Kidney table Table shaped like a kidney, introduced by Sheraton, and popular in modern furniture from the 1930s to 1950s.

Klismos Ancient Greek chair form with all four saber legs splayed to the back and the front.

Kneehole desk Desk with open space in the front center to enable the sitter to come closer, with drawered pedestals on each side.

Lacquer Chinese and Japanese finish using the sap from the lac tree; refers to any clear varnish, in the eighteenth century.

Ladder-back, slat-back chair Chair with a back resembling a ladder with three or more horizontal slats.

Laminated Made in a succession of layers, especially in materials used for furniture, such as plywood.

Lattice Open framework of narrow strips of wood or other material, in a repeating pattern of diamond shapes.

Leaf Extra board that can be inserted, pulled out, or lifted up to extend the top of a table.

Library steps Convertible furniture form of the eighteenth century, of folding steps that convert into a chair or table.

Linenfold Carved motif of vertical folds of cloth, used in late Gothic paneling and furniture.

Loose seat Removable slip seat that fits into the framing of a chair or stool.

Loo table Oval table made for the game of loo.

Lounge chair Overstuffed armchair, completely upholstered and popular from the mid-nineteenth century.

Lowboy Dressing table or low chest of drawers popular in eighteenth-century America.

Low relief Carving in which the ornamental surface does not project far from the groundwork.

Lozenge Diamond-shaped motif.

Lug Wing of a wing chair.

Lyre Neoclassical ornamental motif of the ancient Greek musical instrument; besides its use as a surface decoration, the lyre form was used as a table support.

Macassar ebony Ebony from the Dutch East Indies seaport by that name.

Mahogany Tropical hardwood of reddish brown to pinkish color, important in furniture making since the eighteenth century, especially in Britain and America.

Maple Hardwood similar to birch, though lighter in color, popular for American provincial furniture; curly or bird's-eye are used for veneers.

Marbling Painting (faux finish) to simulate the veining of marble.

Marlborough leg Straight four-sided leg used on later Chippendale furniture; a tapered version was popular on the following Neoclassical style.

Marquetry Decorating technique where small pieces of veneer in contrasting shades/colors are arranged in a pictorial or geometric design on the surface of a piece of furniture; inlaid marquetry is the use of sections of marquetry veneer that are placed into the solid wood rather than on top of the surface.

Mass production Industrial method of manufacturing multiple identical versions of a design prototype, enabling items to be affordable and accessible to large markets.

Medallion Plaque or medal figures or heads in low relief.

Méridienne French Directoire and Empire-style canape with one scrolled arm higher than the other.

Misericord Small projection on the underside of a hinged seat of a church stall that enables one to perch when the seat is lifted.

Mission style Alleged resemblance to the furniture of California missions; furniture style characterized by simple lines and craft details, usually of golden oak, used by Stickley and his Arts and Crafts followers and imitators.

Miter Beveled ends of two boards joined at right angles.

Modern New and appropriate to the present, rather than relying on the past; in the case of furniture, the term is used most in the twentieth century, when styles followed new materials and technologies; function was stressed as the basis for design; and ornamentation was spare or absent.

Modular furniture Developed in the early twentieth century by Gilbert Rohde and others, individual pieces of seating or storage that can be arranged or added together to create flexible and expandable furniture.

Molding Decorative band with a shaped profile.

Morocco [leather] High-grade goat skin, colored red, green, or blue and used on writing tables and chair upholstery.

Mortise Shaped cavity intended to receive a similarly shaped projection (tenon) and used as a joining technique.

Mother-of-pearl Shiny pearly lining of various mollusk shells, such as the pearl oyster, used in decorative inlay and marquetry.

Mount Decorative metal element, especially hardware, added to a piece of furniture.

Mullion Vertical member separating panes of glass.

Muntin Vertical member within a wooden panel; also used interchangeably with mullion.

Night table Portable toilet, bedside pot cupboard, or commode, used in the eighteenth century.

Oak Hardwood found extensively in Europe and America, one of the most important materials used in furniture throughout history.

Ogee Curve shaped like an S, made by two opposite cyma curves.

Ogee bracket foot Double curved shape convex at the top and concave at the bottom, used as a foot on case pieces.

Oil cloth Cloth treated with oil to give a leather-like waterproof surface, for table covers and packing.

Oil gold Form of gilding using a linseed oil medium, but cannot be burnished.

Organic architecture Design of buildings in harmony with nature and the landscape, developed by Frank Lloyd Wright; use of horizontal lines, low ceilings, and central hearth conveyed a feeling of warmth and security.

Ormolu Decorative ornaments of gilded cast bronze, used primarily by the French in the eighteenth century to cover the delicate veneer on edges and seams.

Ottoman Low upholstered seat or bench, or a smaller version used as a footstool, popularized in the nineteenth century.

Pad foot Type of Dutch foot used to terminate a cabriole leg in eighteenth-century Europe and America, characterized by a flat circular or ovoid bottom.

Papier-maché Molded paper pulp used to make furniture in the Victorian period.

Parquetry Small pieces of wood usually used in repeating geometric patterns, primarily for flooring; also used like thick marquetry to decorate furniture.

Parsons table Low square occasional table of molded plastic, named for the Parsons School of Design in New York, and popular in the mid-twentieth century; simple table in which the corner of the top is flush with square corner of the legs.

Pastiglia Gilded or painted low-relief gesso decoration, often used on Italian Renaissance *cassoni*.

Patent furniture Various mechanical inventions for furniture that was adjustable, convertible, or simply novel, especially abundant in the late nineteenth century in the United States.

Patera Circular or oval motif used in Neoclassical design.

Patina Surface color on wood, metal, or other material as a result of oxidation, polishing, and wear.

Pedestal Central column supporting a tabletop; multiple pedestals may support larger tops.

Pediment In architecture, a low gable or similar feature, typically triangular; in furniture an ornamental element on top of case pieces popular in the eighteenth century, usually of triangular or rounded scroll shape, often with a gap or "break" in the center. Terms like *broken-scroll pediment*, *scroll pediment*, *bonnet scroll*, and *swan-neck pediment* were used to describe the commonly found "broken" version.

Pembroke table Small occasional table with two hinged flaps along the long ends (opposite of a sofa table) and one drawer.

Pendant Hanging ornament.

Petit point Fine-stitch needlework, smaller than needle point.

Piecrust table Small circular table with top edge resembling a pie crust, popular on Chippendale style.

Pier table Table meant to stand against a pier, the section of wall between two tall windows, especially in the Empire period.

Pietra dura Use of colorful semiprecious stones as decorative inlay, especially on Italian Renaissance tables and cabinets.

Pigeonhole Small storage compartment in desks and bureau bookcases.

Pilaster Pillar or column set flat against a wall or furniture surface.

Pine White, or soft pine was a major softwood used for furniture, usually painted; yellow, or hard pine has a natural yellow color that is often stained dark.

Pin hinge Concealed hinge made of a metal peg, set into the end of a door, and fits into the top and bottom of the frame.

Planer Machine used to reduce the thickness or smooth the surface of lumber.

Plinth Slablike portion at the base of a column; solid base section used in place of legs on case pieces.

Plywood Veneers glued together at right angles and then molded to make furniture seats and other parts.

Pompeiian (Etruscan) style Fashionable neoclassical style of interior decoration and furnishing under Louis XVI using ornamental bronze and porcelain and "antique taste."

Postmodernism Architectural and design style intending to restore color and ornament to modern design, especially with references to the past. Practitioners are considered to be risk-takers and results are often witty or even tongue-in-cheek.

Prairie style Name given to the style used by Frank Lloyd Wright, employing the principles of organic architecture, Japanese design, and the Arts and Crafts that he felt were most appropriate for America's heartland, the flat prairie.

Press cupboard Cupboard with two tiers, the lower enclosed by doors, usually of elaborately carved oak, and popular in seventeenth-century England and American colonies.

Provincial Style used in the provinces or outlying areas away from the court or urban center where a fashionable style originated or was used; usually a simplified version of the high-style.

Putti Cupids or cherubs used as decorative elements.

Quartersawn Method of sawing wood, especially oak, in which the log is riven or quartered along its medullary rays, producing a ribboned grain structure, preferred by Stickley for his Craftsman furniture.

Quatrefoil Gothic motif of a formalized four-leaf form.

Quilted Tufted upholstery; padded and stitched in the manner of a quilt.

Rabbet Rectangular channel cut into the edge of a board, used for tongue-and-groove joinery.

Rail Horizontal bar connecting vertical posts.

Rattan The tough stem of certain Asian palms, used to make caning and wicker.

Récamier French Directoire and Empire style daybed named for the Parisian salon hostess, Mme. Juliette Récamier (1777–1849).

Reeding Convex parallel ribs, a reversed version of fluting.

Relief carving Carved ornamentation projecting from the surrounding background.

Revival Accurate or inaccurate use of historic style or element of historic style in a later context.

Ribband-back Carved ribbon design used on Chippendale chair backs.

Riven Tree trunk split along its medullary rays, from the bark to the center.

Rocaille Rockwork, specifically the artificial grottoes with natural irregular stones built in French gardens; the decorative shell motifs from which the term *Rococo* is derived.

Rococo Architectural and decorative style originating in the French *Régence* as an outgrowth of the Baroque, and reaching its height during the reign of Louis XV; furniture is identified by lightness, curvilinearity, asymmetry, and frivolity.

Romayne work Decorative motif of a human head, on Northern European and English Renaissance furniture that refers to Roman or Italian Renaissance classicism.

Rosewood Brazilian and West Indian wood of the species *Dalbergia*, with a prominent reddish and dark grain pattern; the name is derived from the scent when cut.

Roundabout chair Made especially in India in the eighteenth century with six legs, a circular seat, and semicircular back; when exported to Holland, it was known as a burgomaster chair. Also a term for a corner chair.

Ruling taste The notion that a particular level or class of society with manufacturing and/or purchasing power determines what is fashionable and, in effect, dictates to the greater society and determines how that culture is stylistically portrayed in history.

Runner Curved base of a rocking chair; rectangular piece of wood attached to the carcase that receives the corresponding groove on the side of a drawer, enabling it to slide in and out.

Rush Aquatic plant used to weave chair seats.

Sabot "Hoof"—metal fitting at the bottom of a leg to protect veneer, especially on French furniture from the late seventeenth century on.

Satin Smooth glossy silk.

Satinwood Lustrous golden yellow wood, usually from the West Indies and used in neoclassical furniture.

Savonarola chair Later named after Girolama Savonarola (1452–1498), an Italian medieval and Renaissance X-frame chair with multiple frames and usually decorated with inlay and carving.

Scandinavian Modern (also Danish Modern and Swedish Modern) Modern design of the 1930s through 1950s, characterized by functional simplicity, but using natural woods, finishes, and fabrics in a craft tradition giving it a warmth lacking in Bauhaus-inspired modernism.

Scroll Spiral-shaped form or line used as a decorative motif or element, such as an arm, foot, or leg.

Seat rail Horizontal rail that supports the seat of a chair or sofa.

Secondary wood Inexpensive wood used in unseen furniture parts, such as shelves, drawer interiors, and backboards.

Secretary Writing desk or cabinet with a fall-front for writing.

Semainier French chest of drawers in the eighteenth century with up to seven drawers, one for each day of the week.

Serpentine Curve that is convex at the center and concave at the two ends; double curved front of a case piece, popular in the eighteenth century.

Settee Light seat for more than one sitter, with low back and arms.

Settle Wooden bench with a high back and arms.

Sevres Royal porcelain company just outside of Paris beginning in 1756; in addition to ornate table and decorative wares, they made round and oval plaques to be mounted on fine neoclassical furniture.

Sgabello Italian word for "stool" or "bench" applied to a Renaissance portable wooden chair in which the seat is normally supported by slabs of wood rather than legs.

Shagreen Skin of a shark or ray, used as a veneer in some Art Deco furniture.

Show wood Visible wood on an upholstered piece.

Sideboard Wide and relatively low case piece intended to be placed against a dining-room wall and used for serving, popular in neoclassical styles.

Side chair Small chair without arms used at a dining table and originally placed along a wall when not in use.

Silver wood Sycamore veneer dyed gray.

Slat Horizontal bent boards of a chair back.

Sleigh bed American Empire form with a high headboard and footboard resembling a horse-drawn sleigh, usually placed lengthwise against a wall.

Slide Flat surface that slides out from a piece of furniture, such as a writing surface from a desk.

Slipper foot Type of Dutch foot that is somewhat elongated and flat on top.

Slip seat Set-in upholstered seat that does not cover the frame and can be easily changed; popular in the eighteenth century.

Smoker's chair Chair with the back rail continuous with the arms.

Sofa A less formal settee designed for comfort, with upholstered seat, back, and arms; developed in the mid-eighteenth century.

Sofa table Long table with drop leaves at the short ends (opposite of a Pembroke table), used behind a sofa.

Spade foot Four-sided foot on a tapered leg.

Spanish leather Leather with stamped or embossed patterns, often gilded.

Sphinx Decorative motif used on Renaissance and Empire furniture, after the ancient Egyptian winged lion with human female head and torso.

Spider leg table Table with very slender supports.

Spindle Slender piece of turned wood, especially in chair backs, or used split as an applied ornament.

Splat Central upright member of a chair back.

Splay Angling of legs outward, rather than vertically.

Spoon back Queen Anne chair back resembling the curve of a spoon when viewed from the side.

Squab Loose seat cushion.

Stile Vertical framing member.

Strap hinge Early metal (usually iron) hinge overlapping both door and frame.

Strapwork Renaissance ornamental motif of carved or painted interlacing bands resembling leather straps.

Streamlined Designs based on aerodynamics using bullet shapes, rounded edges, parallel lines, and other symbols of speed, and also used for stationary household items from toasters to furniture.

Stretcher Horizontal crossbar connecting furniture legs, used to strengthen.

Stringing Fine lines of metal or wood inlay.

Stubs and keys For fixing cornices to the window lath; the stub is a metal plate that slides into a flat staple on the lath.

Stuffed seat Seat upholstered over the seat rail.

Sunflower chest Oak or pine boxy chest, usually with three chip carved panels, the center one with sunflower motif; often with applied split spindles and bosses, this late seventeenth-century American Jacobean chest was popular in Connecticut, so it was also called a Connecticut chest or Connecticut sunflower chest.

Swag Form of draping ornament, often of festoons of flowers and fruit.

Systems furniture Flexible arrangements of various panels, work surfaces, storage components, accessories, and other items to create adaptable custom-designed work places.

Table a l'Italienne French Renaissance monumental table with rectangular wood or marble top supported by massive ends carved especially in the form of mythological figures, with carved curtain connecting the top with one long stretcher.

Tabouret, taboret French, low rectangular stool on four short legs, originally shaped like a drum (term means "little drum"), popular in the seventeenth and eighteenth centuries.

Tallboy English eighteenth-century case piece with one chest of drawers on top of another slightly wider one; in America, called a highboy.

Tambour Flexible door or cover, especially on rolltop desks, made by gluing thin strips of wood onto a cloth.

Teak Brown hardwood native to Burma, important for Scandinavian mid-twentieth-century furniture.

Tea tray Round or oval tray with a gallery and handles for lifting.

Tenon Projection at the end of one piece of wood to fit into a depression, or mortise, on another piece to form a joint.

Term/therm Freestanding tapering column of architectural design; elaborate corner truss.

Term figure Decorative column with male or female torso as the upper portion; a popular Renaissance motif.

Tester Canopy, often of wood, over a two- or four-posted bedstead; the wooden framework on which the textiles hang to form the canopy.

Tête-à-tête Sofa or double armchair with rounded backs and seats facing in opposite directions, a popular Victorian form.

Thrown chair Also "Harvard" chair; a turned chair, often elaborate.

Tilt top Hinged top that could be tilted upward when not in use, especially on eighteenth-century tripod tables with birdcage supports.

Tongue-and-groove Joint made by cutting a channel centrally into the edge of one board and a rabbet on each edge of another; the resulting tongue fits into the corresponding groove.

Top rail Horizontal structural rail at the top of a chair back.

Tracery Ornamental lattice-like carving derived from the masonry decoration on Gothic cathedrals, especially in window openings.

Trefoil Gothic motif of a formalized three-lobed leaf shape.

Trestle Support for furniture, especially tables, in which a vertical member joins the top and a horizontal floor member.

Trifid foot Three-toed drake foot, with prominent ribs on its surface, popular on mid-eighteenth-century British and American furniture.

Trompe l'oeil To trick the eye; a technique in painting and decorative arts using extremely realistic technique and detail to create the illusion of three-dimensional objects on a two-dimensional surface.

Tubular steel Hollow steel tubing, bent to form the framework of modern furniture, especially by designers affiliated with the Bauhaus in the late 1920s to 1930s, and continues to be used in furniture manufacture.

Tudor English dynasty beginning with Henry II in 1485 and ending with James I in 1603.

Tudor arch Four-centered pointed arch with low rise to the point, used on early English Renaissance architecture.

Tudor rose Heraldic emblem of Tudor dynasty with one five-petaled rose superimposed on a larger one.

Tufting Upholstery held tightly with buttoning in a regular pattern.

Tulipwood Finely variegated Brazilian wood with striped red and pale markings.

Turkey-work Upholstery or other textile imitating Oriental knotted rugs, popular in English Renaissance.

Turned chair Medieval form of chair in which all of the parts are turned, except for the seat, which is often triangular.

Turnery Wood furniture parts made by turning on a lathe.

Urn Vase shape popular on Adam style.

Valance Border of drapery hangings around the canopy of a bed.

Vanity Twentieth-century term for dressing table.

Varnish Transparent finish of a resinous material that dries to a hard shine.

Velvet Fabric with a short smooth pile surface, usually of silk.

Veneer Thin sheet of wood, selected for its pattern and color, covering and decorating a plainer wood carcase or body.

Vernacular furniture Simple, often well-constructed furniture made locally; unlike high-style and more sophisticated furniture made in urban centers, it is not necessarily made by professionals in workshops.

Vernis martin Type of imitation Chinese lacquer developed in the eighteenth century by the brothers Guillaume, Simon Etienne, Julien, and Robert Martin.

Vertu, virtu Excellence in objects of art or curios.

Vienna Secession Artists' association founded in 1897 by Josef Hoffmann (who later founded the Wiener Werkstätte), Kolomon Moser, and Joseph Maria Olbrich, with painter Gustav Klimt as its first president; it began to hold exhibitions in 1898 and introduced Charles Rennie Mackintosh to the Continent.

Walnut Hardwood native to Europe and America, well suited to fine carving, and of extreme importance in furniture making.

Webbing Straps of material, such as jute, interwoven across a frame to support the springs and stuffing of upholstered seats.

What-not Victorian invention, tiers of shelve to hold anything in the category of bric-a-brac, whatever, or whatnot.

White varnish Clear hard spirit varnish used for coating delicate surfaces such as gilding or marquetry.

White wood Any pale wood used for inlay.

Wicker Woven rattan used for furniture and other objects.

Wiener Werkstätte (Viennese Workshops) (1903–1932) First workshops on the Continent for the design and manufacture of applied arts in the English Arts and Crafts tradition, but in modern styles; led by Austrian designer Josef Hoffmann.

Wilton Pile carpet woven at Wilton in Wiltshire.

Windsor chair Informal wooden chair with saddle-shaped seat, turned or cabriole legs, and multiple back spindles in a variety of configurations; introduced in the Queen Anne period, still popular today.

Wing Side projection, or lug, on upholstered wing chairs to protect the sitter from drafts, from the eighteenth century onward.

Work station Individual cubicle or arrangement comprised of systems furniture that also provides space for portable freestanding furniture, such as chairs and tables.

X-frame Structural element in furniture, especially chairs, in which the two supports from the arms to the floor resemble the letter **X**.

X-stretcher, cross-stretcher Stretcher connecting legs on the diagonal and therefore intersecting.

Yellow wood Tropical wood used for veneer.

Yew Fine-grained elastic wood from one of the evergreen conifers of the genus *Taxus*.

Yoke-back Double curved crest rail used in early eighteenth-century Queen Anne chairs.

Zebrawood Light-colored tropical wood with prominent dark stripes used especially for veneer.

BIBLIOGRAPHY

Abercrombie, Stanley. *George Nelson: the Design of Modern Design*. Cambridge: MIT Press, 1995.

Alvera, Alessandro. "Michael Thonet and the Development of Bent-Wood Furniture: From Workshop to Factory Production," in Ostergard, *Bent Wood and Metal Furniture 1850–1946*. New York: American Federation of Arts, 1987.

American Union of Decorative Artists and Craftsmen. *AUDAC Exhibition*. New York: Brooklyn Museum, 1931.

Anscombe, Isabelle, and Charlotte Gere. *Arts & Crafts in Britain and America*. New York: Van Nostrand Reinhold, 1983 (Academy Editions, London, 1978).

Antiques Collectors' Club. *Pictorial Dictionary of British 19th Century Furniture Design*. Antique Collectors' Club, 1977.

Art & Antiques, ed. *Nineteenth Century Furniture: Innovation, Revival and Reform*. New York: Billboard Publications, 1982.

Aslen, Elizabeth. *The Aesthetic Movement*. New York: Excaliber, 1969.

Ausgabe, Neue. *C. Percier un P.F.L Fontaine*. Berlin: Ernst Wasmuth, 1888.

Austin, John Osborne. *Geneological Dictionary of Rhode Island: Comprising Three Generations of Settlers Who Came Before 1690*. Albany, N.Y.: J. Munsell's Sons, 1887.

Axelrod, Alan, ed. *The Colonial Revival in America*. New York: Norton, 1985.

Baker Furniture Co. *English and French Furniture of the Eighteenth Century by Baker Furniture, Inc*. Holland, Mich.: Baker Furniture, 1900.

Baker, Hollis S. *Furniture in the Ancient World, Origins and Evolution 3100–475 B.C.* London: The Connoisseur, 1966.

Beard, Geoffrey. *Craftsmen and Interior Decoration in England 1660–1820*. London: Bloomsbury Books, 1981.

Benn, R. Davis. *Style in Furniture*. New York: Longmans, Green & Co., 1904.

Benn, H. P., and H. P. Shapland. *The Nation's Treasures: Measured Drawings of Fine Old Furniture in the Victoria and Albert Museum*. London: Simpkin, Marshall, Hamilton, Kent & Co., 1910.

Benton, Tim and B. Campbell-Cole, eds. *Tubular Steel Furniture*. London: Art Book Co., 1979.

Benton, Tim and Charlotte Benton. *Architecture and Design: 1890–1939*. New York: Watson-Guptill, 1975.

Billcliffe, Roger. *Charles Rennie Mackintosh: The Complete Furniture, Furniture Drawings and Interior Designs*. 3d ed. New York: E. P. Dutton, 1986.

Birch, Samuel. *Manners and Customs of the Ancient Egyptians*. Boston: S. E. Cassino and Co., 1883.

Blackie and Son. *The Victorian Cabinet-Maker's Assistant*. Originally published 1853. Reprinted New York: Dover, 1970.

Blake, Peter. *No Place like Utopia: Modern Architecture and the Company We Kept*. New York: Alfred A. Knopf, 1993.

Blakemore, Robbie G. *History of Interior Design & Furniture from Ancient Egypt to Nineteeth-Century Europe*. New York: Van Nostrand Reinhold, 1997.

Boger, Louise Ade. *The Complete Guide to Furniture Styles*. Enlarged edition. Prospect Heights, Ill.: Waveland Press, 1997.

Bordes, Marilynn Johnson. "Christian Herter and the Cult of Japan," in Clark, ed., *Aspects of the Arts and Crafts Movement in America*. Record of the Art Museum, Princeton University, Vol. 34, No. 2, 1975.

Bowman, Leslie. "Introduction," in Volpe and Cathers, *Treasures of the Arts and Crafts Movement 1890–1920*. New York: Harry N. Abrams, 1988.

Boyce, Charles. *Dictionary of Furniture*. New York: Facts on File, 1985; reprinted Henry Holt & Co., 1985.

Brooklyn Chair Company Catalog of 1887. Reprint. Watkins Glen, N. Y.: American Life Foundation Library of Victorian Culture, 1978.

Brooks Manufacturing Co. *Arts and Crafts Furniture: The Complete Brooks Catalog of 1912*. Reprint. New York: Dover, 1993.

Brown, Nicholas H. "Warren McArthur: an Industrial Designer with the Soul of an Artist." *Echoes* 7 (Spring 1999).

Buchwald, Hans H. *Form from Process—The Thonet Chair*. Cambridge: Harvard University, Carpenter Center for Visual Arts, 1967.

Butler, Joseph T. *Field Guide to American Antique Furniture*. New York: Facts on File, 1985.

Byars, Mel. *The Design Encyclopedia*. New York: John Wiley & Sons, 1994.

Campbell, Joan. *The German Werkbund: The Politics of Reform in the Applied Arts*. Princeton, N.J.: Princeton University Press, 1978.

Caplan, Ralph. *The Design of Herman Miller*. New York: Whitney Library of Design, 1976.

Cathers, David M. *Furniture of the American Arts and Crafts Movement*. New York: New American Library, 1981.

Cescinsky, Herbert. *English and American Furniture*. New York: Garden City Pub., 1929.

Cheney, Sheldon and Martha Chandler. *Art and the Machine: An Account of Industrial Design in 20th-Century America*. New York: Whittlesey House, 1936.

Chippendale, Thomas. *Gentleman and Cabinet-Maker's Director*. 3d ed. Originally published London, 1762 (first edition published in 1754); reprinted New York: Dover, 1966.

Clark, Robert Judson, ed. *The Arts and Crafts Movement in America 1876–1916*. Princeton, N.J.: Princeton University Press, 1972.

———., ed. *Aspects of the Arts and Crafts Movement in America*. *Record* of the Art Museum, Princeton University, Vol. 34, No. 2, 1975.

Clark, Robert Judson, et al. *Design in America: The Cranbrook Vision 1925–1950*. New York: Harry N. Abrams, 1983.

Colling, James Kellaway. *Examples of English Medieval Foliage*. Boston: James R. Osgood and Co., 1875.

Conway, Hazel. *Ernest Race*. London: Design Council, 1982.

Cumming, Elizabeth, and Wendy Kaplan. *The Arts & Crafts Movement*. New York: Thames and Hudson, 1991.

Davies, Karen. *At Home in Manhattan: Modern Decorative Arts 1925 to the Depression*. New Haven: Yale University Press, 1983.

DePree, Hugh. *Business as Unusual*. Zeeland, Mich.: Herman Miller, 1986.

De Ricci, Seymour. *Louis XVI Furniture*. New York: G.P. Putnam's Sons, 19

Dormer, Peter. *Design Since 1945*. London: Thames and Hudson, 1993.

Dreyfuss, Henry. *Designing for People*. New York: Simon & Schuster, 1955.

Driscoll, David B. "Furniture as Machinery: Nineteenth-Century Patent Rocking Chairs," in Ward, ed., *Perspectives on American Furniture*. New York: W. W. Norton, 1988.

Droste, Magdalena. *The Bauhaus: Masters and Students*. New York: Barry Friedman, 1988.

———. *Bauhaus 1919–1933*. Köln, Germany: Benedikt Taschen, 1990.

Droste, Magdalena, et al. *Marcel Breuer Design*. Köln, Germany: Taschen, 1992.

Dubrow, Eileen, and Richard Dubrow. *Furniture Made in America 1875–1905*. Exton, Pa.: Schiffer, 1982.

Duncan, Alastair. *Art Nouveau Furniture*. New York: Clarkson N. Potter, 1982.

———. *Art Deco Furniture*. New York: Holt, Rinehart, and Winston, 1984.

———. *American Art Deco*. New York: Harry N. Abrams, 1986.

Eames, Penelope. *Medieval Furniture*. London: Furniture History Society, 1977.

Eastlake, Charles L. *Hints on Household Taste*. 3d ed. London: Longmans, Green, and Co., 1872.

Edwards, Clive D. *Twentieth-Century Furniture: Materials, Manufacture and Markets*. Manchester and New York: Manchester University Press, 1994.

Eidelberg, Martin, ed. *Design 1935–1965: What Modern Was*. New York: Harry N. Abrams, 1991.

Ellison, Michael, and Leslie Piña. *Scandinavian Modern Furnishings 1930–1970: Designed for Life*. Atglen, PA: Schiffer, 2002.

Emery, Marc. *Furniture by Architects*. New York: Harry N. Abrams, 1983; expanded edition 1988.

Fahr-Becker, Gabriele. *Wiener Werkstaette 1903–1932*. Köln, Germany: Taschen, 1995.

Fairbanks, Jonathan, and Elizabeth Bidwell Bates. *American Furniture 1620 to the Present*. New York: Marek, 1981.

Fastnedge, Ralph. *Shearer Furniture Designs from the Cabinet-Makers' London Book of Prices 1788*. London: Alec Tiranti, 1962.

Fehrman, Cherie, and Kenneth Fehrman. *Postwar Interior Design 1945–1960*. New York: Van Nostrand Reinhold, 1987.

Fiell, Charlotte, and Peter Fiell. *Modern Furniture Classics Since 1945*. Washington D.C.: AIA Press, 1991.

———. *Modern Chairs*. Köln, Germany: Taschen, 1993.

————. *Design of the 20th Century*. Köln, Germany: Taschen, 1999.

Filippo, Alison. *Charles Rennie Mackintosh as a Designer of Chairs*. Milan: documenti di Casabella, 1973.

Fitzgerald, Oscar P. *Four Centuries of American Furniture*. Radnor, Pa.: Wallace-Homestead, 1995.

Forrest, Tim. *The Bullfinch Anatomy of Antique Furniture*. Boston: Little, Brown and Co., 1996.

Forty, Adrian. *Objects of Desire*. New York: Pantheon, 1986.

Frankl, Paul T . *Form and Re-Form*. New York: Harper & Bros., 1930.

————. *New Dimensions*. New York: Payson & Clarke, 1928.

Galloway, Lee. *Office Management: Its Principles and Practices*. New York: Ronald Press, 1918.

Gandy, Charles D., and Susan Zimmermann-Stedham. *Comtemporary Classics: Furniture of the Masters*. New York: Whitney Library of Design, 1990 (originally McGraw-Hill, 1981).

Garner, Philippe. *Twentieth-Century Furniture*. New York: Van Nostrand Reinhold, 1980.

————. *Eileen Gray: Design and Architecture 1878–1976*. Köln, Germany: Benedikt Taschen, 1993.

Geck, Francis J. *French Interiors & Furniture: the Period of Francis I*. Boulder, Colo.: Stureck Educational Services, 1982.

Gems of the Centennial Exhibition. New York: D. Appleton & Co., 1877.

Giedion, Siegfried. *Mechanization Takes Command: A Contribution to Anonymous History*. New York: Norton, 1948.

Gilbert, Christopher. *The Life and Work of Thomas Chippendale*. London: Studio Vista, 1978.

Glaeser, Ludwig. *Ludwig Mies van der Rohe: Furniture and Furniture Drawings*. New York: Museum of Modern Art, 1977.

Gloag, John. *A Short Dictionary of Furniture*. London: Allen & Unwin, 1969.

Greenberg, Cara. *Mid-Century Modern: Furniture of the 1950s*. New York: Harmony, 1984; reprinted 1995.

Greif, Martin. *Depression Modern: The Thirties Style in America*. New York: Universe, 1975.

Habegger, Jerryll, and Joseph H. Osman. *Sourcebook of Modern Furniture*. 2d ed. New York: W. W. Norton, 1997, 1989.

Hanks, David A. *Innovative Furniture in America from 1800 to the Present*. New York: Horizon Press, 1981.

Hanks, David A., and Jennifer Toher. *Donald Deskey: Decorative Designs and Interiors*. New York: E. P. Dutton, 1987.

Harwood, Barry W. *The Furniture of George Hunzinger: Invention and Innovation in Nineteenth-Century America*. Brooklyn N.Y.: Brooklyn Museum, 1997.

Heinz, Thomas A. *Frank Lloyd Wright Furniture Portfolio*. Layton, Utah: Gibbs Smith, 1993.

Heller, Carl Bruno. *Art Nouveau Furniture*. Germany: Berghaus Verlag, 1994.

Hellman, Louis. *Architecture for Beginners*. New York: Writers and Readers, 1988.

Hennessey, William J. *Modern Furnishings for the Home*. 2 vols. New York: Reinhold, 1952 & 1956.

————. *Russel Wright: American Designer*. New York: MIT Press, 1983.

Hepplewhite, George. *The Cabinet-Maker and Upholsterer's Guide*. 3rd ed. Originally published London, 1794; reprinted New York: Dover, 1969.

Herman Miller Furniture Co. *The Herman Miller Collection*. 1952 catalog. Zeeland, Mich.: Herman Miller Furniture Co., 1952; reprinted New York: Acanthus Press, 1995.

————. *Herman Miller for the Home*. catalog. Zeeland, Mich.: Herman Miller, 1995.

————. *The Herman Miller Collection*. 1955/56 catalog. Reprinted Atglen, Pa.: Schiffer, 1997.

————. *Herman Miller 1939 Catalog: Gilbert Rohde Modern Design*. Reprinted Atglen, Pa.: Schiffer, 1998.

Heywood Brothers and Wakefield Company. *Classic Wicker Furniture: The Complete 1898–1899 Illustrated Catalog*. Reprinted New York: Dover, 1982.

Heywood-Wakefield. *A Completed Century 1826–1926: The Story of Heywood-Wakefield*. Boston: Heywood-Wakefield, 1926.

Hiesinger, Kathryn B., and George H. Marcus. *Landmarks of Twentieth-Century Design: An Illustrated Handbook*. New York: Abbeville, 1993.

Hirth, Georg. *Das Deutsche Zimmer der Gothik und Renaissance des Barock, Rococo und Zopfstils*. München: G. Hirth's Verlag, 1899.

Holme, C. Geoffrey, and S. B. Wainwright, eds. *Decorative Art 1930*. New York: Albert & Charles Boni, 1930.

Holme, C. G., ed. *Decorative Art: the Studio Yearbook 1933*. London: The Studio, 1930, 1931, and 1933.

Honour, Hugh. *Cabinet Makers and Furniture Designers*. New York: G. P. Putnam's Sons, 1969.

Horn, Richard. *Fifties Style*. New York: Friedman/Fairfax, 1993.

Howe, Katherine S., and David B. Warren. *The Gothic Revival Style in America 1830–1870*. Houston: Museum of Fine Arts, 1976.

Hunter, George Leland. *Decorative Furniture: A Picture Book of the Beautiful Forms of All Ages and All Periods*. Grand Rapids, Mich.: Good Furniture Magazine, 1923.

Hurrell, John Weymouth. *Old Oak English Furniture*. London: B. T. Batsford, 1902.

The Illustrated Catalogue of the Great Exhibition of London 1851. London: Spicer Brothers, 1851.

The International Exhibition of 1862: The Illustrated Catalog of the Industrial Department. London: Her Majesty's Commissioners, 1862.

Jackson, Lesley. *The New Look: Design in the Fifties*. New York: Thames Hudson, 1991.

———. *Contemporary Architecture and Interiors of the 1950s*. London: Phaidon, 1994.

Jaffé, Hans Ludwig C. *De Stijl 1917–1931*. Cambridge: Harvard University Press, 1986.

J. M. Young Furniture Company. *J. M. Young Arts and Crafts Furniture*. Reprint, New York: Dover, 1994.

Jones, Anthony. *Charles Rennie Mackintosh*. London: Studio Editions, 1990.

Jourdain, Margaret. *English Decoration & Furniture of the Later XVIIIth Century 1760–1820*. New York: Charles Scribner's Sons, 1922.

———. *English Decoration and Furniture of the Early Renaissance 1500–1650*. London: B. T. Batsford, [1924].

Joy, Edward. *Pictorial Dictionary of British 19th Century Furniture Design*. Woodbridge: Antique Collectors Club, 1977.

Julier, Guy. *Encyclopedia of 20th Century Design and Designers*. New York: Thames and Hudson, 1993.

Kaplan, Wendy. *The Art That Is Life: The Arts and Crafts Movement in America 1875–1920*. Boston: Little, Brown, 1987.

Kardon, Janet, ed. *Craft in the Machine Age 1920–1945*. New York: Harry N. Abrams and American Craft Museum, 1995.

Kempton, Richard. *Art Nouveau: An Annotated Bibliography*. Los Angeles: Hennessey & Ingalls, 1977.

Kenney, John Tarrant. *The Hitchcock Chair: The Story of a Connecticut Yankee—L. Hitchcock of Hitchcocksville, and an Account of the Restoration of This 19th Century Manufactory*. New York: Clarkson N. Potter, 1971.

Ketchum, William C. *Furniture 2: Neoclassic to the Present*. New York: Cooper-Hewitt, circa 1981.

Killen, Geoffrey. *Ancient Egyptian Furniture I 4000–1300 B.C.* Warminster, England: Aris & Phillips, 1980.

———. *Ancient Egyptian Furniture: Boxes, Chests and Footstools*. Warminster, England: Aris & Phillips, 1994.

King, Carol Soucek. *Furniture: Architects' and Designers' Originals*. Glen Cove, N. Y.: PBC International, 1994.

King, Thomas. *Neo-Classical Furniture Designs*. Reprint of "Modern Style of Cabinet Work Exemplified," 1829. New York: Dover, 1995.

Kirkham, Pat. *Charles and Ray Eames: Designers of the Twentieth Century*. Cambridge: MIT, 1995.

Knobel, Lance. *Office Furniture: Twentieth-Century Design*. New York: E. P. Dutton, 1987.

Knoll Group. *75 Years of Bauhaus Design 1919–1994*. New York: Knoll Group, 1994.

Labarte, M. Jules. *Handbook of the Arts of the Middle Ages and Renaissance*. London: John Murray, 1855.

Larrabee, Eric and Massimo Vignelli. *Knoll Design*. New York: Harry N. Abrams, 1981.

Learoyd, Stan. *A Guide to English Antique Furniture: Construction and Decoration 1500–1900*. New York: Van Nostrand Reinhold, 1981.

Leonard, R. L., and C. A. Glassgold, eds. *Annual of American Design 1931*. New York: Ives Washburn, 1930.

Limbert, Charles, and Company. *Limbert Arts and Crafts Furniture: The Complete 1903 Catalog*. Reprinted New York: Dover, 1992.

Lind, Carla. *The Wright Style*. New York: Simon & Schuster, 1992.

Lindquist, David P., and Caroline C. Warren. *Colonial Revival Furniture*. Radnor, Pa.: Wallace-Homestead, 1993.

Lipman, Jonathan. *Frank Lloyd Wright and the Johnson Wax Buildings*. New York: Rizzoli, 1986.

Litchfield, Frederick. *Illustrated History of Furniture: From the Earliest to the Present Time*. London: Truslove & Hanson, 1893.

Lockwood, Luke Vincent. *Colonial Furniture in America*. New York: Charles Scribner's Sons, 1901.

Lucas, A., and J. R. Harris. *Ancient Egyptian Materials and Industries*. Rev. ed. London: Histories & Mysteries of Man, 1989.

Lyon, Irving W. *The Colonial Furniture of New England*. New York: E. P. Dutton, 1977; reprint of 1891 edition.

Madigan, Mary Jean Smith. *Eastlake Influenced American Furniture 1870–1890.* Yonkers, N.Y.: Hudson River Museum, 1974.

Magne, Henri Marcel. *French Furniture.* Paris: Henri Laurens, 1920

Mang, Karl. *History of Modern Furniture.* New York: Harry N. Abrams, 1978.

Mayhew, Edgar, and Myers Miner. *A Documentary History of American Interiors from the Colonial Era to 1915.* New York: Scribner, 1980.

Meadmore, Clement. *The Modern Chair: Classics in Production.* New York: Van Nostrand Reinhold, 1975.

Meikle, Jeffrey. *Twentieth-Century Limited.* Philadelphia: Temple University Press, 1979.

Mercer, Eric. *Furniture 700–1700.* London: Weidenfeld & Nicolson, 1969.

Moses, Michael. *Master Craftsmen of Newport: The Townsends and Goddards.* Tenafly, N.J.: Americana Press, 1984.

Naylor, Gillian. *The Arts and Crafts Movement.* London: Trefoil, 1990 (first published 1971).

Naylor, Gillian, et al. *The Encyclopedia of Arts and Crafts: The International Arts Movement 1850–1920.* New York: E. P. Dutton, 1989.

Negus, Arthur, and Hugh Scully. *The Story of English Furniture.* 2 vols. video. London: BBC Enterprises, 1986.

Nelson, George. "Both Fish and Fowl." *Fortune* 9 (Feb. 1934): 40–43, 80, 90–98.

———. *Chairs.* New York: Whitney, 1953; reprinted New York: Acanthus, 1994.

———. *Display.* New York: Whitney, 1953.

———. *Storage.* New York: Whitney, 1954.

———. *Problems of Design.* New York: Whitney, 1957.

———. *George Nelson on Design.* New York: Whitney Library of Design, 1979.

Neuhart, John, Marilyn Neuhart, and Ray Eames. *Eames Design.* New York: Harry N. Abrams, 1991.

Neumann, Eckhard, ed. *Bauhaus and Bauhaus People.* Rev. ed. New York: Van Nostrand Reinhold, 1983.

Northend, Mary H. *Colonial Homes and Their Furnishings.* Boston: Little, Brown, and Co., 1920.

Noyes, Eliot N. *Organic Design in Home Furnishings.* catalog. New York: Museum of Modern Art, 1941.

Nye, Alvan Crocker. *Colonial Furniture.* New York: William Helburn, 1895.

Odom, William M. *A History of Italian Furniture from the Fourteenth to the Early Nineteenth Centuries.* 2nd ed. New York: Archive Press, 1966.

Ostergard, Derek E., ed. *Bent Wood and Metal Furniture 1850–1946.* New York: American Federation of Arts, 1987.

———. *George Nakashima: Full Circle.* New York: Weidenfeld & Nicolson, 1989.

Ostergard, Derek, and David Hanks. "Gilbert Rohde and the Evolution of Modern Design 1927–1941." *Arts Magazine* (Oct. 1981).

Pile, John. *The Dictionary of 20th Century Design.* New York: Da Capo Press, 1994.

Piña, Leslie. *Louis Rorimer: A Man of Style.* Kent, Ohio: Kent State University, 1990.

———. *Fostoria Designer George Sakier.* Atglen, Pa.: Schiffer, 1996.

———. *Fifties Furniture.* Atglen, Pa.: Schiffer, 1996.

———. *Classic Herman Miller.* Atglen, Pa.: Schiffer, 1998.

———. *Herman Miller Interior Views.* Atglen, Pa.: Schiffer, 1998.

———. *Furniture 2000: Modern Classics & New Designs in Production.* Atglen, Pa.: Schiffer, 1998.

———. *Alexander Girard Designs for Herman Miller.* Atglen, Pa.: Schiffer, 1998.

Propst, Robert. *The Office: A Facility Based on Change.* Zeeland, Mich.: Herman Miller Inc., 1968.

———. *Action Office: The System that Works for You.* Ann Arbor, Mich.: Herman Miller Research Corp., 1978.

Pulos, Arthur J. *American Design Ethic: A History of Industrial Design to 1940.* Cambridge: MIT Press, 1983.

———. *The American Design Adventure 1940–1975.* Cambridge: MIT Press, 1988.

Quimby, Ian, and Polly Anne Earl, eds. *Technological Innovation and the Decorative Arts.* Charlottesville, Virginia: University Press of Va., 1974.

Ransom, Caroline L. *Couches and Beds of the Greeks, Etruscans and Romans.* Chicago: University of Chicago Press, 1905.

Riccardi-Cubitt, Monique. *The Art of the Cabinet.* New York: Thames & Hudson, 1992.

Richter, G. *Ancient Furniture.* New York: Oxford University Press, 1926.

Rieman, Timothy D., and Jean M. Burks. *The Complete Book of Shaker Furniture.* New York: Harry N. Abrams, 1993.

Robsjohn-Gibbings, T. H. *Good-Bye Mr. Chippendale.* New York: Alfred J. Knopf, 1945.

———. *Homes of the Brave.* New York: Alfred J. Knopf, 1954.

Robsjohn-Gibbings, T. H., and Carlton W. Pullin. *Furniture of Classical Greece*. New York: Alfred A. Knopf, 1963.

Rouland, Steve, and Roger Rouland. *Heywood-Wakefield Modern Furniture*. Paducah, Ky.: Collector Books, 1995.

The Roycrofters. *Roycroft Furniture Catalog, 1906*. Reprinted. New York: Dover, 1994.

Saarinen, Eero, and Aline B. Saarinen. *Eero Saarinen on His Work*. New Haven: Yale University Press, 1962.

Sakier, George. "Modern Classic Design Is More Than A Passing Style." *Crockery and Glass Journal* (Dec. 1933): 42–43.

Sandhurst, Phillip, et al. *Great Centennial Exhibition*. Philadelphia: P. W. Ziegler & Co., 1876.

Santini, Pier Carlo. *The Years of Italian Design: A Portrait of Cesare Cassina*. Milan: Electa, 1981.

Schaefer, Herwin. *Nineteenth Century Modern: the Functional Tradition in Victorian Design.* New York: Praeger, 1970.

Schildt, Göran. *Alvar Aalto: The Decisive Years*. New York: Rizzoli, 1986.

Schottmuller, Frida. *Furniture and Interior Decoration of the Italian Renaissance*. New York: Bretano's, 1921.

Schweiger, Werner J. *Wiener Werkstaette: Design in Vienna 1903–1932*. New York: Abbelville, 1984.

Sedeyn, Emile. *Le Mobilier*. Paris: R. Rieder et C. Editeurs, 1921.

Sembach, Klaus-Jürgen, et al. *Twentieth-Century Furniture Design*. Köln, Germany: Taschen, 1989.

Sharp, Dennis, et al., eds. *Pel and Tubular Steel Furniture of the Thirties*. London: Architectural Associations, 1977.

Shaw, Henry. *Specimens of Ancient Furniture.* London: William Pickering, 1836.

Shepp, James W., and Daniel B. Shepp. *Shepp's World's Fair Photographed*. Chicago: Globe Bible Publishing, 1893.

Sheraton, Thomas. *The Cabinet-Maker and Upholsterer's Drawing-Book*. Originally published London, 1793; reprinted New York: Dover, 1972.

Smith, Gregory W. "Alcoa's Aluminum Furniture: New Application for a Modern Material 1924–1934." *Pittsburgh History* 78 (Summer 1995): 52–64.

Society of Industrial Designers. *U.S. Industrial Design 1949–1950*. New York: Studio Publications, 1949.

———. *51 U.S. Industrial Design.* New York: Studio Publications, 1951.

———. *Industrial Design in America, 1954*. New York: Farrar, Straus & Young, [1954].

Sparke, Penny. *Furniture: Twentieth-Century Design.* New York: E. P. Dutton, 1986.

———. *Italian Design 1870 to the Present.* London: Thames and Hudson, 1988.

Steelcase, Inc. *Steelcase: The First 75 Years.* Grand Rapid: Steelcase, Inc. 1987.

Stickley, Gustav. *The 1912 and 1915 Gustav Stickley Craftsman Furniture Catalogs.* Reprinted New York: Dover, 1991.

Stillman, Damie. *The Decorative Work of Robert Adam.* London: Alec Tiranti, 1966.

Stimpson, Miriam. *Modern Furniture Classics*. New York: Whitney Library of Design, 1987.

Strange, Thomas Arthur. *English Furniture, Decoration, Woodwork & Allied Arts.* New York: Charles Scribner's Sons, 1903.

———. *An Historical Guide to French Interiors, Furniture, Decoration, Woodwork & Allied Arts.* London: McCorquodale & Co., 1903.

"The Studio" Yearbook of Decorative Art 1909, 1910, 1911, 1914. London: Studio, 1909–1914.

Taylor Chair Company. *The Taylor Chair Company: Seven Generations Since 1816.* Bedford, Ohio: Taylor Chair, 1982.

"Taylor-Horrocks Executive Suites, Authentic Period Designs." *Catalogue No. 122 Special Recorded Edition*, book no. 406. Bedford, Ohio: Taylor Chair [1930].

Thonet Industries. *Thonet Bentwood & Other Furniture: The 1904 Illustrated Catalog.* Reprinted. New York: Dover, 1980.

Tracy, Berry B., et al. *Nineteenth Century America: Furniture and Other Decorative Arts.* New York: Metropolitan Museum of Art, 1970.

Uncommon Places. PBS Video on Frank Lloyd Wright. Public Broadcasting Corp., 1988.

United States Patent Office. Drawings of design/invention patents.

Van Doren, Harold. *Industrial Design: A Practical Guide.* New York: McGraw-Hill, 1940.

Verlet, Pierre. *The Eighteenth Century in France: Society, Decoration, Furniture.* Rutland, Vt.: Charles E. Tuttle, 1967.

Volpe, Tod M., and Beth Cathers. *Treasures of the American Arts and Crafts Movement 1890–1920.* New York: Harry N. Abrams, 1988.

Ward, Gerald W. R., ed. *Perspectives on American Furniture.* New York: W.W. Norton, 1988.

———. *American Furniture with Related Decorative Arts 1660–1830.* New York: Hudson Hills Press, 1991.

Watkinson, Ray. *William Morris as Designer*. New York: Reinhold, 1967.

Weber, Eva. *Art Deco In America*. New York: Exeter, 1985.

———. *American Art Deco*. New York: Crescent, 1992.

Weisberg, Gabriel P. *Art Nouveau Bing: Paris Style 1900*. New York: Harry N. Abrams, 1986.

Weisberg, Gabriel P., and Elizabeth K. Menon. *Art Nouveau: A Research Guide for Design Reform in France, Belgium, England and the United States*. New York: Garland, 1998.

Whitney Museum of Art. *High Styles: Twentieth-Century American Design*. New York: Whitney Museum, 1985.

Whiton, Sherrill. *Interior Design and Decoration*. 4th ed. New York: J.B. Lippincott, 1974.

Wilk, Christopher. *Marcel Breuer: Furniture and Interiors*. New York: Museum of Modern Art, 1981.

———. "Furnishing the Future: Bent Wood and Metal Furniture 1925–1946," in Ostergard, ed. *Bent Wood and Metal Furniture 1850–1946*. New York: American Federation of Arts, 1987.

———. *Thonet: 150 Years of Furniture*. Woodbury, N.Y.: Barrons, 1980.

Wilk, Christopher, ed. *Western Furniture: 1350 to the Present Day*. New York: Cross River Press, 1996.

Wilkie, Angus. *Biedermeier*. New York: Abbeville, 1987.

Wilkinson, Sir John Gardner. *Manners and Customs of the Ancient Egyptians*. 3 vols. Boston: S. E. Cassino and Co., 1883.

Wilson, Richard Guy, Dianne Pilgrim, and Dickran Tashjian. *The Machine Age In America 1918–1941*. New York: Harry N. Abrams, 1986.

Zahle, Erik, ed. *A Treasury of Scandinavian Design*. New York: Golden Press, 1961.

Zelleke, Ghenete, et al. *Against the Grain: Bentwood Furniture from the Collection of Fern and Hanfred Steinfeld*. Chicago: The Art Institute of Chicago, 1993.

Margin Notes

Austin, John Osborne. *Geneological Dictionary of Rhode Island*. Albany, N.Y.: Joel Munsells Sons, 1887.

Bondi, Victor, ed. *American Decades 1970–79*. Detroit: Gale Research, 1995.

Grun, Bernard. *The Timetables of History*. 3d ed. New York: Simon & Schuster, 1991.

Hart, Michael H. *The 100: A Ranking of the Most Influential Persons in History*. New York: Hart Publications, 1978.

Hellemans, Alexander, and Bryan Bunch. *The Timetables of Science*. New York: Simon & Schuster, 1988.

Layman, Richard, ed. *American Decades 1960–69*. Detroit: Gale Research, 1995.

Lee, Stan. *The Best of the World's Worst*. Los Angeles: General Publishing Group, 1994.

McFarland, Kevin. *Incredible People*. New York: Hart, 1975.

"Olympic Firsts." *U.S. News & World Report*. July 15–22, 1996.

Panati, Charles. *Extraordinary Origins of Everyday Things*. New York: Harper & Row, 1987.

Smith, Godfrey, ed. *1000 Makers of the Twentieth Century*. London: Times Newspapers, 1971.

Stewart, Robert. *Illustrated Almanac of Historical Facts*. New York: Prentice Hall, 1992.

Wallechinsky, Irvin, et al. *The Book of Lists*. New York: William Morrow, Co., 1977.

Yarwood, Doreen. *A Chronology of Western Architecture*. New York: Facts on File, 1987.

INDEX